The Tiger in the Smoke

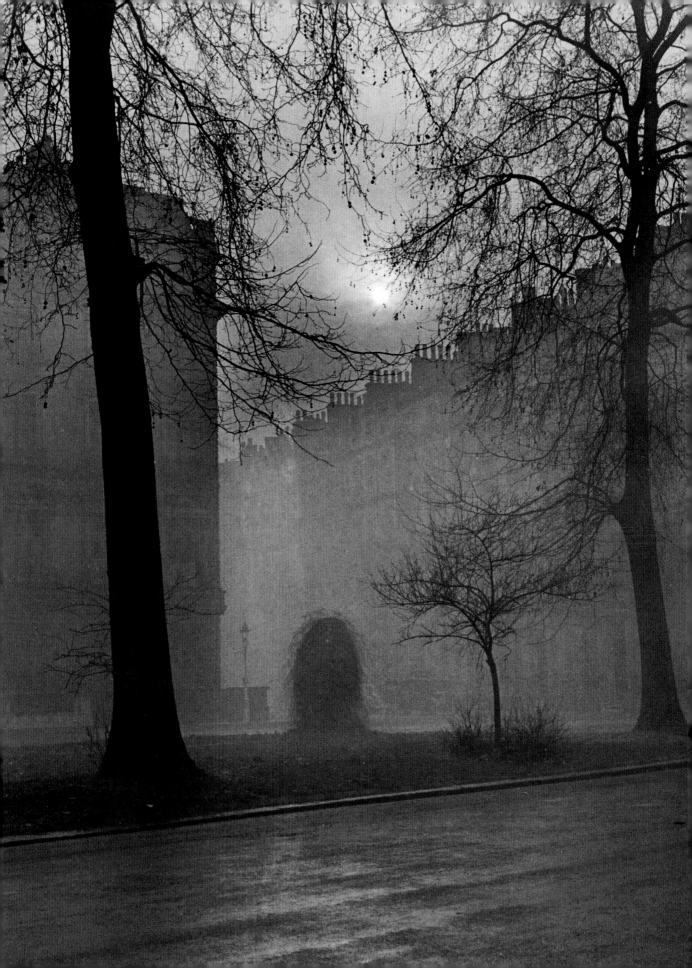

THE
TIGER IN THE
SMOKE

Art and Culture in Post-War Britain

LYNDA NEAD

Published for the Paul Mellon Centre for Studies in British Art
by Yale University Press • New Haven and London

Designed by Emily Lees
Printed in China

Library of Congress Cataloging-in-Publication Data
Names: Nead, Lynda, author. | Historical Design, Inc., organizer, host institution.
Title: The tiger in the smoke : visual culture in Britain c.1945–1960 / Lynda Nead.
Description: New Haven : Yale University Press, 2017. |
Includes bibliographical references and index.
Identifiers: LCCN 2017008587 | ISBN 9780300214604 (cl : alk. paper)
Subjects: LCSH: Art and society – Great Britain – History – 20th century. |
Domestic space – Great Britain – History – 20th century. | Color in visual
communication. | Visual perception. | Great Britain – Social conditions – 20th century.
Classification: LCC N72.S6 N42 2017 | DDC 709.41/09045 – dc23
LC record available at https://lccn.loc.gov/2017008587

A catalogue record for this book is available from the British Library

Frontispiece Bill Brandt, 'The Square Where the Nightingale Died with the Fog in its Throat',
Picture Post, 18 January 1947, p. 32 (detail of fig. 11).
Image on p. vi Haywood Magee, 'Many Young Women Arrive Alone . . .', *Picture Post*,
9 June 1956, pp. 28–9 (detail of fig. 111).

Contents

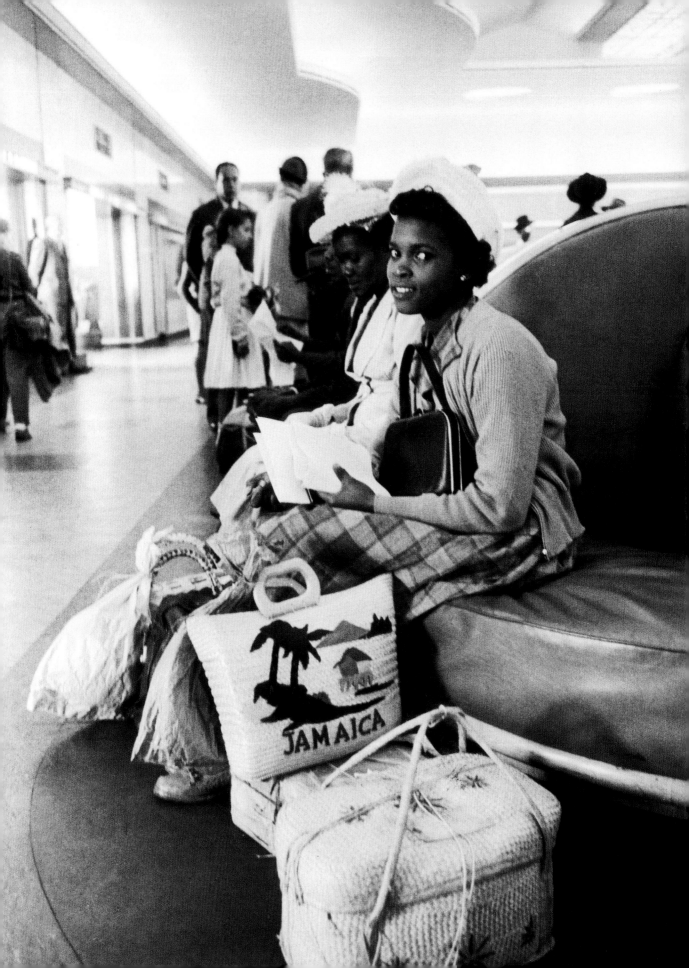

Acknowledgements

The research and writing of this book was made possible by a Leverhulme Trust Research Fellowship; my thanks to the Trust and its ongoing support for interdisciplinary work. I am also grateful to Birkbeck's School of Arts Research Committee for providing assistance with the illustrations for the book and to Kirstie Imber for her work on this vital aspect of the project.

I am indebted to the generosity of a number of scholars in the field of post-war British culture and cultural history who shared their expertise and knowledge with me. In particular, I wish to thank Stephen Bann, Joseph Bristow, Matt Cook, David Gilbert, Tom Gretton (for his tutorial on printing techniques!), Josephine McDonagh, Carol Jacobi, Frank Mort, Duncan Petrie, Daniel Pick, Chris Stephenson, Jennifer Tucker, Sarah V. Turner, Judith Walkowitz and Chris Waters. One of the great pleasures of this project was becoming absorbed in post-war British film and my thanks to Barry Curtis and John Wyver for many conversations on this subject; especial thanks to Sally Alexander for being my regular film companion during this time.

I would also like to acknowledge the support of Gillian Malpass, who commissioned this book and understood it so well, and Emily Lees at the Paul Mellon Centre for her calm and attentive editing of the final product.

Final thanks must go to Steve, Sam and Joe Connor for sharing and indulging my obsession with the 1950s during the development and completion of *The Tiger in the Smoke*.

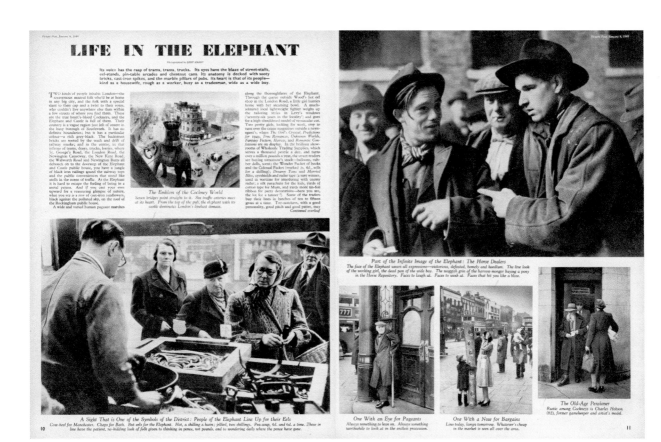

1 Bert Hardy, 'Life in the Elephant', *Picture Post*, 8 January 1949, pp. 10–11.

Introduction

In January 1949, the weekly illustrated magazine *Picture Post* published a six-page photo story on everyday life in the Elephant and Castle, a poor and then bomb-damaged neighbourhood of south London.[1] With words by the journalist Albert Lloyd and original photographs by the *Post*'s chief photographer, Bert Hardy, the article powerfully captures the look and feel of life in the run-down, terraced streets and homes of post-war Britain (fig. 1). The piece belongs firmly, decisively, in the present, with the shortages and aspirations that characterized the years immediately following the end of the war; it is a present, however, that continues to be defined through the tones of the past: by wartime, the years between the wars, the early twentieth century, and by living conditions in the Victorian city.

Hardy's images have an immense depth, both materially and symbolically, which conveys the layers of time and accumulated meanings of this moment and the unique ability of post-war press photography to capture a particular historical atmosphere embodied in the faces, clothes, shops and streets of Britain. What exactly constitutes the atmosphere, which, for me, is almost tangible, on these pages? It is, of course, to do with page design; the relationship of

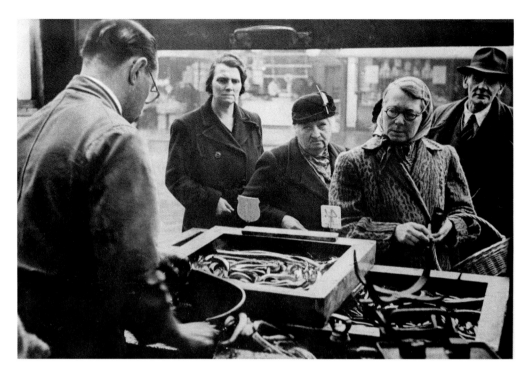

2 Bert Hardy, 'People of the Elephant Line Up for the Eels' (detail of fig. 1).

the strapline, captions and columns of text with the images, but above all it is *in* the photographs. In the figures in their sturdy overcoats and hats, queuing for warm eels – the woman at the head of the queue, with her headscarf resolutely knotted under her chin, her basket and National Health spectacle frames (fig. 2). It is in their resigned and no-nonsense expressions: a mixture of patience, greed and hunger that makes them ogle the eels and scrutinize the weighing scales. This is the distinctive world of post-war austerity: of the first benefits of the new welfare system and of ongoing shortages, clothing and food on the ration, cold, mouths turned down at the corners, tired eyes, lack of glamour.

It is an atmosphere generated through the material textures of the page, by the white highlights on the lithe, slippery bodies of the fish and the subtle range of grey tones that reveals the street and shops in the background. Life in post-war Elephant and Castle, a place that the article tells us has a particular colour: 'a rich grey-black. The backstreet bricks are sooted by the wash and drift of railway smoke; and in the centre . . . a jungle of black iron railings.' There is a perfect synergy between the tone and chromatic range of text and image – a shared cele-

bration of the rich greyness and of the community of housewives, workers, local fighters and wide boys who make up the 'human pageant' of cockney life. The article turns ordinary life into a symbol of the nation in the years immediately following the war, poised on the brink of recovery and faced with the enormous challenges of reconstruction.

The power of the photographic image arises from its staging and composition, the light and shadow, the figures and setting, but it is also something more than the form and the content, something in excess of what it shows and what it is about. There is an ambiance, a richness in the image, and in the sheer physical presence of these people and their survival. It would be easy enough to fill the image with its contexts: to talk of the extent of wartime bombing in this part of south London, to provide statistics and studies of poverty levels, and describe the eel trade in the second half of the twentieth century. This would address a significant element of the meaning of the image but it would miss something central; it would neglect its distinctive visual atmosphere. One of the aims of this study is to work with the tones of post-war visual culture, to address its atmosphere and understand how images work with and on their viewers to create powerful effects and affects, which came to define the nation during the decade or so following the end of the war and until the 1960s. There is no denying that atmosphere is, necessarily, elusive and fragile; this does not mean, however, that it is unimportant or ineffective. Atmosphere may be staged and manipulated, it is culturally highly expressive and addresses collective emotional, political and social aspirations. To overlook atmosphere is to discount a key element and defining and compelling characteristic of life in post-war Britain and of post-war British art and culture.

Take, for example, another of Hardy's photographs from 'Life in the Elephant'. It is a picture of the horse dealers in the area – of faces, clothes and hands (fig. 3). The two men in the foreground bargain, tussle, over the price of horses. Heavy overcoats faded and worn at the seams, a trilby pushed back on the head at an angle, a stray lock of hair, a neckerchief and a quizzical expression begin to construct this world of street trading, of humour that could at any moment switch to aggression. The caption instructs the viewer how to look: 'The face of the Elephant wears all expressions – victorious, defeated, homely and hoodlum. The live look of the working girl, the dead pan of the wide boy. The waggish grin of the barrow-monger buying a pony in the Horse Repository. Faces to laugh at. Faces to wink at. Faces that hit you like a blow.'[2] It is a scene that is immersed equally in Victorian and twentieth-century ways of seeing; the expressive faces and gestures invite the viewer to read the image like a nineteenth-century

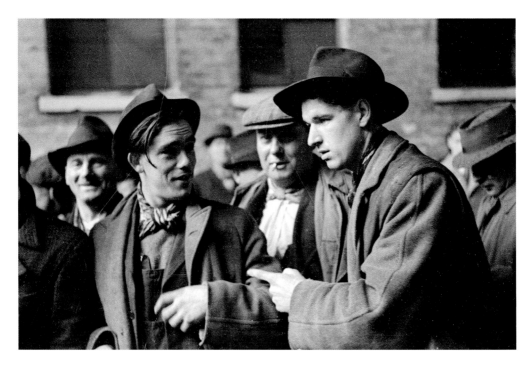

3 Bert Hardy, 'The Horse Dealers' (detail of fig. 1).

physiognomist, but this is neither a scientific study nor a Victorian genre scene. It draws on those visual traditions and transforms them through the gravure of twentieth-century photo-journalism and the mood of Britain in the first years of the post-war Labour government. It is a celebration of the resilience and photogenic possibilities of ordinary people and of the tactics and qualities required on the mean streets of the capital. It celebrates the residual look of those streets and, at the same time, shows just how much must be done to modernize this place. These are streets that might, in the next ten years, be pulled down or gentrified, that might become the site of clashes between the white and the black migrant communities, where greyscale becomes inflected with the toxic hostilities of the post-war colour bar. These social and political possibilities are part of the power of the image and, as *Picture Post* claims, they 'hit you like a blow'.

 These are not accidental effects. Although the impact of an image cannot be guaranteed and may be resisted or overlooked, visual artists sought atmosphere when they produced images; they knew that there was a quality, an intensity, which could be apprehended, for example, in

4

certain photographs. Hardy described his method of developing a photo story in an interview published in the *Listener* in the 1970s. The idea for the piece had come up at the weekly *Picture Post* editorial conference. Both Hardy and Lloyd were Londoners, born not far from the Elephant and Castle, and they went there together to flesh out the story: 'We walked around, and I did a few shots – nothing that meant anything, but sort of using the camera.' They drift round the streets in search of something ill-defined, elusive but recognizable, and they return over the next few days until a woman asks them to take her photograph and becomes their guide to the backs of the old houses where she lives. 'After that', Hardy observes, '. . . it went so smooth, it was unbelievable.'[3] Hardy wanders in search of the atmosphere of the Elephant and Castle and its visual expression, mapping ordinary lives and relationships onto the streets of post-war London. The photographs tell stories that are a kind of history – a history of life in the streets and front rooms, the public houses and shops, a history that is imbued with memory, a sense of place and historic atmosphere.[4]

What drives Bert Hardy's navigation of the streets of the Elephant and Castle? It is far from purposeless; he may not expressly articulate what he seeks, but it is, nevertheless, what propels his daily returns and use of the camera. Bill Brandt, who also worked as a *Picture Post* photographer during these years, acknowledged atmosphere as an objective of his work and compared it to the sensation that can be experienced on entering a room: 'It may be of association with a person, with simple human emotions, with the past or some building looked at long ago, or even with a scene only imagined or dreamed of.'[5] It may be ephemeral or intangible, but Brandt was able to enhance it through the material processes of his art and wrote of intensifying these effects through the choice of film, camera and printing method. For Brandt, atmosphere is paradoxically both a weight, a mass and also barely discernible, a translucent curtain; he is certain, however, that it is a presence that may be sensed and an effect that can be conveyed by the photographer.[6] For Brandt and Hardy this vague intensity exceeds what is actually shown in the image; it is a quality that expresses the experience and feel of the period and that creates affect. What both photographers seek is a feeling and response in the viewer, an interaction between the image and its audience that is sharp and intense, 'like a blow'.

The Tiger in the Smoke is about the atmosphere of post-war Britain and its evocation in art and culture during these years. Post-war atmosphere is found in the chiaroscuro of cinematography, the grain of press photography, the patina of bombed buildings, the impasto of painting; it is found in the air, in fog and dust; and in sunlight, funfairs and colour advertisements. This

is a book about the uses and meanings of black and white media and grey tones in the years after the war and the visual impact and sensation of colour. During the last ten or fifteen years there has been what is referred to as an 'affective turn' in research across the social sciences and humanities.[7] This encompasses a number of different approaches to the common project of understanding the more fugitive and transient conditions of social life, its collective affects and relations. Rather than attending to the more obviously material conditions of life, this work has tried to grasp the indeterminate but equally defining qualities of everyday experience. The history of emotions, structures of feeling and theories of affect are all aspects of the affective turn, as it has emerged, developed and been debated across a range of disciplines. It is not my intention to align myself to any specific branch of this debate; it is, however, important to acknowledge its presence and influence as I have absorbed elements into my own study of the visual culture of post-war Britain. For me, what this work draws attention to are those aspects of meaning that are anchored in the image but are not necessarily identical with it – that exceed the obvious content and context and create an intensity or power, a way of seeing and feeling, that is specific to a given historic period. Within the broad range of concepts and vocabulary that has emerged in this field of study, I prefer atmosphere, tone (for its dual sense of feeling and chromatic hue) and 'structure of feeling'.

Raymond Williams first introduced the concept of 'structure of feeling' in the 1950s in studies such as *Culture and Society* (1958); always an elusive category within his writing, the concept changed as he went on to develop it in *The Long Revolution* (1961) and *Marxism and Literature* (1977).[8] In *The Long Revolution* Williams uses 'structure of feeling' to describe those defining and distinctive characteristics of a culture, which, he writes, are: 'as firm and definite as "structure" suggests . . . [yet operate] in the most delicate and least tangible parts of our activity . . . this structure of feeling is the culture of a period.' It is something historically precise and deeply expressive but, nevertheless, evasive and difficult to fix in a chronological sense. Perhaps it is also something to do with the historical imagination and belongs, in part, within the realm of the aesthetic. Interestingly, Williams draws on visual terms to elaborate his argument; he refers to the 'particular and characteristic colour' of a period and the 'characteristic approaches and tones in argument'.[9] Williams evokes rather than defines the concept and, in the end, it seems that it almost slips from his grasp; the fact that he identified the concept, however, and sought it as an element of cultural history is most significant. More than the characteristic style of a period, it is its deep expression, something that can be extracted from the cultural forms of

a historical period and that conveys its pervasive social conditions and concerns. He suggests: 'though [structure of feeling] can be turned to trivial account, the fact of such a characteristic is neither trivial nor marginal, *it feels quite central*' [my emphasis].

Critically for this study, 'structure of feeling' is historically specific and produced through the particular conditions of social life and experience, which, in this case includes class, gender and race relations.[10] It is a collective quality that is shared between people as it comes to shape the atmosphere, feeling and culture of a particular place and time. Through a critical dialogue with concepts of atmosphere and 'structure of feeling', it is possible to identify the shared qualities and characteristics of the years between 1945 and 1960, as they shifted and reformed in relation to changing economic, social and political priorities. They will be traced in representations of the spiv, concerns about the rebuilding of the family home, the cleanliness of the air and fears of miscegenation; or in the image of the bombsite, the figure of the housewife and the experience of a Sunday afternoon. These are some of the themes and images that formed the 'structures of feeling' of post-war Britain and that gave it its deep expression and mood, its atmosphere.

There is a fascinating and irresistible fluctuation between materiality and immateriality in the atmosphere. As cultural theorist Ben Anderson has put it: 'atmospheres are material phenomena, but their materiality is strange.'[11] It is present in the materiality of visual media in the post-war period: in the specific forms of gravure news printing, the look of three and four-colour print processes, the taste for Victorian bric-a-brac, the design of exhibitions and festivals, the growth of television broadcasting. Denis Mitchell, a BBC television documentary director, described his approach to the television essay 'Morning in the Streets' (1959) as: 'Going some place, maybe a back street . . . and sort of saying well, this is the essence of it, this is what it smells like.'[12] This no longer appears vague or arbitrary, but should be seen as a further instance of the strong, shared sense of atmosphere or feeling that drove cultural producers in the period. Atmosphere is also, literally, in the quality of the air: in the overcast climate and fatal fogs that seemed to prevail in Britain, in the visible particles of soot and in the invisible threat of radioactive dust. Atmosphere is social, aesthetic and meteorological; it courses through the chapters in this book and, in all of its manifestations, it exerts a pressure on daily life and how it is experienced, represented and remembered.

It is worth saying something also in these first pages about the chronological scope of this study. The dates 1945 to 1960 are approximate and should be treated as such. There is no single

periodization that would work for all the issues and forms that are covered in this book. Put simply, a historical period is an insulated, self-contained segment of time, defined by particular characteristics that distinguish it from other historical periods.[13] It is thus possible to refer to the post-war period in a general sense, whilst also recognizing that as an analytical category it just will not do. It might be useful to isolate a period of around fifteen years during which Britain recovered from the war and focussed on reconstruction and modernization, whilst facing a progressive decline in its world role and the loss of its imperial identity; beyond this, however, it is preferable to see the period between the end of the war and the beginning of the 1960s as a historical duration that was itself subject to periodic changes and differences.

To begin in 1945 would seem clear enough: the year of peace, a future that was itself imagined during the war years. This sense of a historical beginning is present in Humphrey Jennings's film *A Diary for Timothy*, made for the Crown Film Unit in 1945. Addressed to a baby, Timothy, it is a portrait of the nation during the last year of the war and traces the individual and collective efforts, losses and aspirations as Britain moves from war to peace. It is moving and belongs expressly to this moment; it captures the 'structure of feeling' amongst many in Britain at the end of the war. 1945: the election of a Labour government; the introduction of a universal welfare system, the continuation of rationing, austerity. Whilst the prevailing discourse was of moving forward and recovery, Britain was in thrall to the Victorian past, as Part One of this book shows. The nineteenth-century past continued to exert an immense influence on post-war Britain through the material fabric of cities and houses and the haunted imagination of novelists, artists and filmmakers. Post-war Britain, it might be said, began a long time before 1945 and remained tied to the images and atmospheres of the nineteenth century.

In his books on the period, historian Peter Hennessy divides it into two distinct parts, 1945–51 (*Never Again*) and the 'Fifties' (*Having It So Good*).[14] There is some sense to this demarcation. In 1951 Labour lost the slim majority that it had won in the 1950 general election and a Conservative government was elected and the party remained in government throughout the 1950s; there would not be another Labour government until Harold Wilson was elected prime minister in 1964. The period of Labour government from 1945 to 1951 was defined by shortages and austerity and the implementation of the welfare system devised by William Beveridge. Rationing remained in place until 1954, a year that, for many, marked the real end of the war.[15] With greater access to consumer goods and new arrangements for hire purchase, the second half of the 1950s thus begins to break with the atmosphere of the previous decade

and a different structure of feeling starts to emerge, which is consolidated when the prime minister, Harold Macmillan, declares in 1957: 'most of our people have never had it so good.'[16] 1955 also saw the arrival of commercial television and the inexorable presence of television sets in the home, replacing the hearth at the centre of family life. A 'generation of TV children' had been born.[17]

This categorization of the post-war period makes little sense for the history of migration, however. As the empire continued its steady decline after the war, the migration of citizens from the colonies to the United Kingdom shaped the identity of the post-war nation. The period could equally legitimately be framed by the years 1948 and 1962, with the passing of the British Nationality Act in 1948, which gave all British subjects, regardless of their place of birth, the right to take up residence and work in the United Kingdom, and the passing of the Commonwealth Immigrants Act in 1962, which removed those rights for many. In the intervening years, race and colour became one of the most significant discourses of social, political and cultural life, pervading high and popular culture and all aspects of lived experience. The language of the colour bar came into the foreground of British life, and the fears and attractions of racial difference were dispersed across everyday life. As the British Empire transmuted into the Commonwealth family, war and fear of invasion continued to be a material or spectral presence in British life; war in Korea in 1950, the Mau Mau revolution in Kenya from 1952 to 1956, the Suez crisis and the Soviet invasion of Hungary in 1956 meant that the peacetime imagined in 1945 looked fragile and uncertain throughout the 1950s, and the compulsory two-year National Service for men aged between seventeen and twenty-one was not abolished until 1960.[18]

As these various aspects of historical periodization are mapped out, an image begins to emerge of a series of unevenly overlapping durations rather than a single distinctive post-war period. As attention moves to gender, sexuality and domestic life, an alternative duration in twentieth-century British history emerges. The period from the 1930s to the 1950s has been described as the 'golden age' of marriage – a claim that is severely challenged by the fears concerning companionate marriage and the emphasis on setting up home in the years after the war.[19] What is clear is that the image of the family home became a central element in the reconstruction of British social life after the violence of the war and was the locus for the definition of 'normal' gender and generational relations. Whilst actual living conditions often resembled Victorian housing rather than the model homes of council flats and New Towns,

the ideal of young couples setting up home together was the aspiration of many people throughout the years considered in this book. Home should create an atmosphere of comfort and recovery from the pressures of post-war life; as front doors closed, however, many discovered that the strains were inside as well as outside and that the ideal of the stay-at-home wife in her modern stylish housecoat was, for some, as undesirable as it was unattainable.

The decade of the 1950s has undergone a significant popular revival in the last ten or fifteen years, with the publication of a number of major social histories of the period, memoirs, fictional recreations in films and television series, and a return to post-war design and styling. This general resurgence of interest in the period has also included publishing on visual media, with some thoughtful studies of post-war British film and photography, the development of television broadcasting and, more recently, of British art. Thus far, however, publications on the visual arts of the late 1940s and 1950s have taken the form of discrete studies of individual media, and there has been no attempt to consider the relationships between media in this period or their shared aesthetic and thematic concerns. The effect of this separation of media within publishing and within academic disciplines has been to limit our understanding and appreciation of the scope and depth of the art and culture of Britain in these years and the ways in which its rich forms express the social concerns and atmospheres of the time. The following chapters examine fine art and photography, film and urban planning, exhibitions and advertising; they consider individual artists, writers and theorists alongside the new audiences for culture. The study is both interdisciplinary and intermedial in its methodology, demonstrating the relationships across literature, film, television, theatre and the visual arts, which constitute the vibrant cultural landscape of post-war Britain. The aim of drawing these visual media together in *The Tiger in the Smoke* is to write a history of visual culture in its fullest sense: an attentive and critical account of the social and aesthetic practices, institutions and debates in a period of economic, social and cultural uncertainty and reconstruction.

The book is divided into three main thematic parts, which I consider to be amongst the key concerns or atmospheres of post-war Britain. The first, 'The Grain of the 1950s', looks at the powerful forms and subjects of black and white media in the period. Chapter One begins with a discussion of the Great Fog of December 1952 and the broader significance of the smoky air and grey atmosphere of the post-war nation. Mist and obscurity were manifestations of the uncanny and of the ongoing presence of the nineteenth century in twentieth-century Britain. Whilst the discourses of modernity spoke of the need to clean the air of the nation, the visual

representation of the grey environment produced an outstanding and expressive range of film, photography and painting. The second chapter in this section looks at the meaning of post-war bombsites, which continued to define the landscape of British industrial cities well into the 1970s. These bombed areas were sites of danger and fascination; impossible to reclaim as monuments to the war, they created a physical and psychic landscape that haunted the imaginations of writers, filmmakers and visual artists. The third chapter of Part One develops the analysis of greyscale media through a discussion of Dickens noir, the representation of Victorian society and art in post-war culture. Taken together, these three chapters establish the importance and richness of the language of greyscale in post-war Britain – defining the atmosphere of the nation and creating the longing to let in the sunlight and the colours of modernity.

The dialogue between black and white media and colour is a central theme of *The Tiger in the Smoke* and Part Two, 'The Question of Colour', moves on to the fraught and over determined debates concerning post-war colour. If austerity Britain was defined, in part, through a deep and expressive imagery of greyness, then modernity was understood in terms of a different field of vision and a return to colour. Colour, however, was not only modern and innovative, it was also wayward and troubling; people needed to learn how to use colour, how to control its expansive possibilities. The historical significance of colour in this period is very considerable; Chapter Four examines the attractions of colour and the ways in which the nation 'learned to think in colour'. The British climate, it was claimed, produced a distinctive chromatic look. Far from being objective or scientific, colour was national and its imperial significance was embedded in the naming and narration of colours. Above all, the language of colour in this period is the language of racial difference, of the colour bar and fears of a new generation of migrants from the colonies bringing a new and strange colour to the landscape of post-war Britain. These ideas are formed through films, photography and dress, which are the subject of Chapter Five, 'Thirty Thousand Colour Problems'. Many of these themes come together in the Festival of Britain, which is discussed in Chapter Six and which took place in various sites across Britain in 1951, in the last months of the Labour government. As the festival displays tried to capture the essence of the land and its people, they created a snapshot of a nation in a state of change and fluidity. Battersea Pleasure Gardens offered a whimsical fantasy of fun and colour in the shadow of an enormous power station and within the fallout from its consumption of coal. Post-war culture was defined equally as the rediscovery of colour and as the art of a grey nation.

Part Three, 'Kitchen Sinks and Other Domestic Dramas', moves from the external spaces of post-war Britain to its homes and kitchens. Chapter Seven, 'Bill and Betty Set Up Home', examines the importance of the home to the ambitions of post-war recovery. The ideals of modern domesticity sat uncomfortably with the realities of domestic life for many in this period, a tension which was mirrored in what became known as the 'Kitchen Sink School' of British painters and the fierce critical debates about the value and significance of 'ordinary' subjects. Chapter Eight develops the examination of post-war atmospheres by focussing on a particular temporal atmosphere, that of 'An English Sunday Afternoon'. The residual and emergent meanings of home are concentrated in the debates on the 'Lord's Day'. On Sundays, families were traditionally meant to enjoy a period of rest and restoration; more often, however, it seemed like a day of strain and ennui, during which the pressures of family life became almost intolerable. Chapter Nine concludes this study with a discussion of post-war marriage, gender and sexuality. 'Woman in a Dressing Gown' examines the changing styles of domestic femininity, embodied in the contrasting images of the dowdy but comfortable old dressing gown and the stylish and feminine new housecoats. It is my firm conviction that this kind of detailed case study and interpretation acts as a cue for an understanding of key debates concerning marriage, divorce and sexual desire in the post-war period and for a concrete understanding of the importance of atmosphere in the representation and experience of these relations.

The Tiger in the Smoke takes its title from a crime novel by Margery Allingham, first published in 1952 and adapted for a film in 1956. Set in the fog-bound streets of 1950s London, it follows the criminal activities of Jack Havoc, an ex-army sergeant and a convicted murderer, who, along with a gang of accomplices, disrupts the lives and communities around him. The fog is his milieu; it disguises and covers his tracks and allows him to pounce unpredictably and dangerously. The 'tiger' in the 'smoke' of post-war Britain took many forms: it was the attraction of the Victorian world, which threatened to pull modern Britain back into the ignorance and squalor of the nineteenth century; it was the bombsites, with their horrid empty spaces and illicit liaisons; it was colour, bright, unruly and other; it was the figure of the bored and weary housewife or the unfaithful husband. The 'tiger in the smoke' of post-war Britain formed and re-formed itself in the smoke of the nation's uneven and occluded modernity and was the subject of an immensely rich and compelling visual culture, which can be observed both in the details and in the broader languages of art at this moment. In 1951 the British writer and

sociologist Charles Madge described the role of the image in the work of Humphrey Jennings as a combination of 'effects'; he continued: 'the relations between these elements and other elements, all ordered into a larger universe of imagery ... It is not only verbal, or visual, or emotional, although it is all of these. It is not in the elements, but in their coming together at a particular moment, that the magical potency lies.'[20]

Part One

The Grain of the 1950s

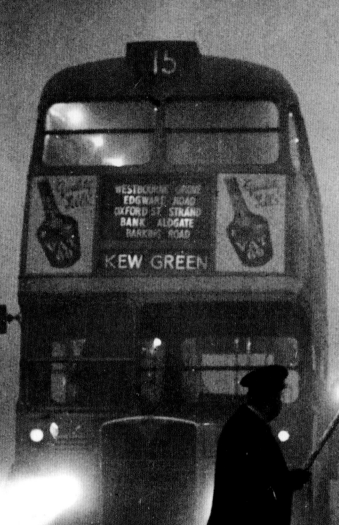

WESTBOURNE GROVE
EDGWARE ROAD
OXFORD ST STRAND
BANK ALDGATE
BARKING ROAD

KEW GREEN

1

The Tiger in the Smoke

The Smoke

December 1952: darkness but not night, gloom and obscurity, forms softened by a surrounding halo of clammy mist (fig. 4). A bus, the number 15 to Kew Green, looms out of the cloud of dirty air, the beams from its fog lights reflected on the wet tarmac and attenuated in the dense, choking vapours. Distance and distinction are eliminated by the uniform oneness of the fog. Is the bus crawling forward, or is it stationary, blinded and immobilized and requiring the guidance of the uniformed figure with his flare? It is an image of progress halted and brought nearly to a standstill, of modern life reduced to the pace of faltering footsteps. It is one of many similar photographs that were published in the British press during the winter of 1952 – their fascination, the immediate visual expression of an uncanny world, of familiar objects and places rendered unfamiliar through the phantasmagoria of the fog. The photograph reproduces a moment that belongs specifically, precisely, to the events of a few days in December 1952, but it is also an image that belongs, or should belong, to the past; to a time when linkmen with flam-beaux guided hesitant, disorientated pedestrians and drivers through the illegible, fog-bound

4 No. 15 bus to Kew Green in fog with man carrying a flare, December 1952.

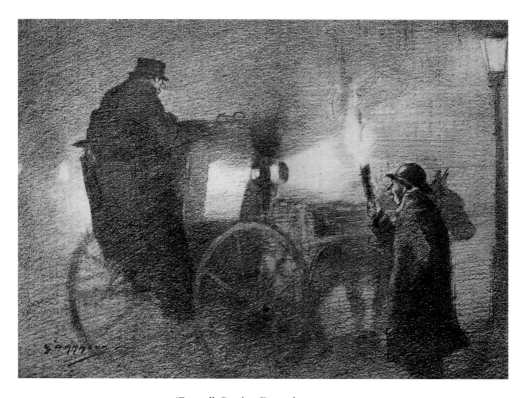

5 'Fogged', *Punch*, 7 December 1904, p. 411.

streets of the city (fig. 5). The images belong to the same grey, chiaroscuro world; they share a rhetoric of visual confusion and technological impotence. Properly, of course, they should belong to very different historical moments, but the fog is a time machine and has obliterated temporality and progress and has brought the present into direct contact with that past from which it has distanced itself.

These are the circumstances that brought about the photograph of the number 15 bus. The fog started on Friday, 5 December 1952, and continued until 9 December.[1] The weather in the days before had been marked by a period of unusual calm, and when cool air from the Continent settled over the Thames and London area it did not move. Eight million Londoners stayed indoors and huddled by their coal fires; chimneys poured smoke out into the chilled, stagnant atmosphere, where it became trapped by the canopy of cold air and settled back to ground level (fig. 6).[2] By Friday, the fog had become thicker; people began to notice the smell and dirt as sulphur dioxide levels in the air rose dramatically, and newspapers reported that filters at

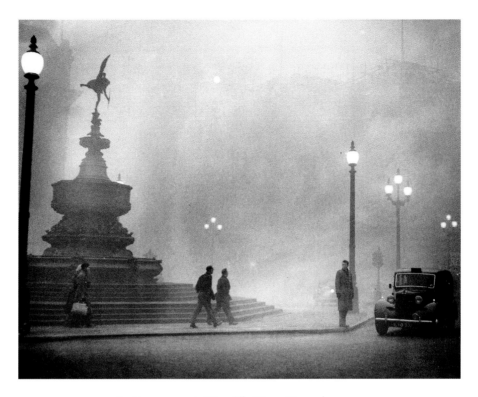

6 Heavy smog in Piccadilly Circus, December, 1952.

the National Gallery became rapidly and repeatedly clogged with poisonous particles. On the Saturday, the fog remained stuck over the city and chimneys continued to pour smoke into the air as homes tried to dispel the cold and gloom. Transport was halted and that night a performance of *La Traviata* at Sadler's Wells was abandoned at the interval as the fog seeped into the auditorium, causing incessant coughing amongst the audience and making the stage practically invisible to those seated further back in the stalls. Sunday saw no improvement as the blanket of fog continued to hang over the city and by Monday visibility had dropped to nearly zero. Finally, on Tuesday, 9 December, the air began visibly to clear and the Great Fog was over. Its effects on health, however, were not. The official report of the London fog of December 1952 was printed in 1954, although preliminary findings were published in 1953.[3] The report and related studies focussed on the two weeks immediately following the fog and estimated the numbers of deaths from bronchitis, pneumonia and from diseases of the heart and circulatory system to be approximately four thousand for Greater London. The longer term impacts on

health were not recorded and were excluded from subsequent studies.[4] Medical statisticians noted the rapidity with which deaths started and concluded that the scale of deaths from the fog was unprecedented and spectacular. In fact, they observed that the death rate had only been exceeded on a few occasions: during the great influenza epidemic of 1918 and the cholera outbreak of 1866.[5] Cholera and fog: like the Victorians, twentieth-century post-war Britain had discovered its environmental nemesis.

The events of December 1952 brought a new urgency and public awareness to ongoing debates concerning air pollution. Following pressure from MPs, a Committee of Inquiry was set up under Sir Hugh Beaver; four months later it published an interim report and its final report was published a year later in 1954. The Beaver Report stated: 'air pollution on the scale with which we are familiar in this country today is a social and economic evil...it needs to be combated with the same conviction and energy as were applied one hundred years ago in securing pure water.'[6] One hundred years on, the Chadwicks and Bazalgettes of Victorian London had become the public officials and planners of post-war Britain. Reconstruction required clean air and Victorian fogs were an obstacle in the path of recovery. Based on the Beaver Report, a private member's bill was introduced by the Conservative Member of Parliament, Gerald Nabarro, which was withdrawn when the government introduced its own bill, which became the 1956 Clean Air Act.[7] The Act became the primary legislation for the control of air pollution, limiting emissions of smoke, grit and dust from industrial furnaces and introducing smoke control areas and the adaptation of domestic fireplaces.

So the London fog of 1952 deserves a special place in the history of environmental politics for its role in speeding up the passing of the 1956 legislation and for its shaping of subsequent pollution control; its story could end there. But there is more to the fog than this; as it sat over the capital during those five December days, it assumed a metaphorical richness and significance that drew on the national past and expressed the ambiguities of the present. The fog thus becomes the motif for an interdisciplinary study of British culture during the 1950s and the object of a new kind of study of what might be called environmental or meteorological aesthetics: that is, the representation of weather and its somatic and emotional affects. What follows is an account of both the textuality and the visuality of fog in the 1950s.

In his fascinating and occasionally frustrating series of essays entitled *Heterologies*, Michel de Certeau states that Freud 'brought back sorcery in knowledge'. By this he means that Freud broke from the historiographical model that sees history as the unrolling of a straight line that

separates the past from the present and created instead a model in which past and present are imbricated: 'one in the place of the other', wrapped or folded into each other.[8] If the past is repressed, however, it may return in the present but in different or surreptitious forms, shattering the separation or apparent linearity of historical time and bringing the past and the present once again into a close and abrupt proximity. A study of the Great Fog of 1952 allows such an understanding of British culture in the 1950s. The clouds and clods of mist obscured temporal and spatial distinction and although many felt that 'such disasters were a thing of the past', the fog was an unmistakable consequence of contemporary British industrial and domestic life.[9] Fog, the air and atmosphere of Britain, defined the nation and its visual appearance in the post-war years; it was an index of its faltering historical progress towards a clean and modern future and its remaining and unbroken ties to the past.

It might appear that weather cannot have a history in the sense that culture or art can be said to have one. In French *le temps* means both time and the weather; but although weather is acknowledged to have temporality, it is not believed to have a history. As cultural theorist Steven Connor has written: 'The time of the weather is time without retention. It is pure fluctuation, without pattern, memory or history, movement without duration or direction or progression. Human affairs are historical in the sense that they are bound in potention and retention . . . weather has no history in this sense.'[10] So weather has, thus far, had no history, but it is part of and makes history, and its turbulent movements and volatile flows may be taken as an image of history. Rather than seeing weather as nature and thus incidental to or neutral within the events of history, the weather may be seen as an active mediator that draws together an array of meanings, images and values.[11] In this way, the fog of 1952 was not the hazy background to other historical events in the period but was an environment, a mediator, that expressed specific qualities and matters that were intrinsic to the developments of the 1950s. Of course, the appearance of the fog was dependent on the exact meteorological conditions of those few days in December, but as it sprawled over London, it was able to articulate a cluster of social and symbolic meanings. This is how weather becomes a kind of meteorological history.

The movement of the fog – seeping, eddying, creeping, folding over itself – is also an image of the complex overlaying of time in history, of time in the hopeful, damaged years following 1945 in Britain. Fog was a residue or return of the past; it was anti-modern, retrogressive and an obstacle in the path of reconstruction, but it also articulated many of the concerns of the

present and of the future of environmental politics. It is easy for commonplace objects and atmospheres to sink into the cultural background. The question, then, is how to return the fog to its historical expressiveness. Bruno Latour puts it this way: 'Objects, by the very nature of their connections with humans, quickly shift from being mediators to intermediaries, counting for one or nothing, no matter how internally complicated they might be. That is why specific tricks have to be invented to make them talk, that is . . . to produce scripts of what they are making others – humans or non-humans – do.'[12] Taking Latour's words as a prompt, *The Tiger in the Smoke* reassembles the layers of meaning that had accrued in the fog of 1952 and considers how it was that five days of fog could reach into the national consciousness and pervade the visual imagination of post-war Britain.

British fog has its own historiography. In very general terms it goes like this: it came; it went; and it returned. The issue of air pollution, particularly in the metropolis, had been recognized as a problem as early as the second half of the thirteenth century. Increasing use of coal, population growth and urbanization were producing an environment that was harmful to plants, buildings and people.[13] In 1661 John Evelyn presented Charles II with a treatise, which he called *Fumifugium: Or the Inconvenience of the Aer and Smoake of London Dissipated*. Evelyn argued that smoke pollution was poisoning the rain and water, killing plants and ruining human health, and he called for a new approach to urban planning that would address these issues as they had already been in continental cities. The aftermath of the Great Fire of London presented the first opportunity for planned reconstruction on a significant scale, but the rebuilding was haphazard and the pollution of the air continued unabated. By the eighteenth century, the haze of smoke and fog over the London skyline had become an iconic image of England's industrial growth. Whilst medics continued to warn about the dangers of this atmosphere to health, the visual effects of the gaseous haze began to be regarded as a distinctive national environment that expressed the power and the hubris of a great nation. It is at this historical conjuncture that it is possible to say that fog became woven into definitions of national identity, that the pall of smoke and mist that hung over the island was imbued with a spiritual, emotional and an inherited sense of Britishness. This atmosphere, with its muted colours and softened forms, was seen to produce an analogous restraint and moderation in the character of the people, which distinguished them from other nations. The fog was characterized by ambiguity: local and national; toxic and poetic; natural and man-made; at once, draining colour and full of subtle shades.

7 Anon., 'A London Fog', 1802, coloured aquatint.

The first attempts at smoke abatement legislation appeared in the early nineteenth century. In 1819 a select committee was established to consider the 'problem of smoke from steam engines and furnaces' and was followed by a sequence of select committees and smoke nuisance and public health Acts throughout the century.[14] Fogs were on the increase in the nineteenth century. Referred to as 'London particulars', people began to realize that these habitual fogs were not just the products of natural circumstances but were related to air quality and that high levels of smoke pollution contributed significantly to the formation of fogs (fig. 7). London-based meteorologist Luke Howard observed the different episodes of fog over a number

of years in his weather diary, *The Climate of London*, logging their variations in appearance and the impact on travel and health. On 15 December 1829 he noted: 'Yesterday morning the metropolis and its environs were enveloped with a dense fog . . . About five o'clock in the evening the fog . . . assumed a very dense appearance, and increased in thickness during the evening . . . *Flambeaux* and *link-boys* were equally in requisition: the most brilliant gas-light could scarcely penetrate the gloom.'[15] The experience of fog is registered equally through its visual effects and its impact on vision. It also interfered with the other senses, however; people referred to its smell, even to its taste. The fog created an acoustic impenetrability and a spatial distortion that made the judgement of distance and touch unreliable. This is the special nature of fog; it has somatic and emotional power. It interferes with time and space and feeling; when it appears, it seems to bring with it all the fogs of the past.[16]

By the middle decades of the nineteenth century, it seemed that the fogs were getting thicker and more frequent and had taken on a murky, yellow hue. They were a feature of modern life, but also brought modernity to a halt. In a double-page engraving, published in 1867 in the *Illustrated London News*, shadowy figures pick their way across a London street (fig. 8). The faint forms of pedestrians, dogs and carriages loom out of the grey fog, moving without any apparent sense of direction or spatial uniformity and threatening, at any moment, to collide with each other. The ruled lines of the engraving create a perfect screen that seems both to cover the surface of the image and to create its misty depths; the denser the lines, the thicker and more impenetrable the fog. The only whites are the uncertain flames from the torches, brazier and gaslight that barely penetrate the enveloping atmosphere. As the Victorian fogs got thicker, so they also accumulated poetic and symbolic significance; for Charles Dickens, especially in his astounding descriptions at the beginning of *Bleak House* (published in serial form 1852–3) and in *Our Mutual Friend* (1864–5), fog represents an undoing of time and place, a regression to an undifferentiated atmosphere full of infection:

It was a foggy day in London; and the fog was heavy and dark. Animate London, with smarting eyes and irritated lungs, was blinking, wheezing, and choking; inanimate London was a sooty spectre, divided in purpose between being visible and invisible, and so being wholly neither . . . Even in the surrounding countryside it was a foggy day, but there the fog was grey, whereas in London it was, at about the boundary line, dark yellow, and a little within it brown, and then browner, until at the heart of the City – which call Saint Mary Axe – it

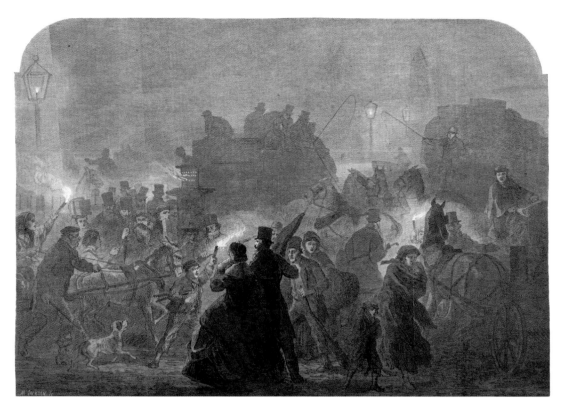

8 'A Fog in the Streets of London', *Illustrated London News*, 12 January 1867, p. 48.

was rusty black. From any point of the high ridge of land northward, it might have been discerned that the loftiest buildings made an occasional struggle to get their heads above the foggy sea, and especially that the great dome of Saint Paul's seemed to die hard; but that was not perceivable at their feet, where the whole metropolis was a heap of vapour charged with the muffled sound of wheels and enfolding a gigantic catarrah.[17]

The fog was Dickens's element, allowing him to use his thickest descriptions to explore its metaphorical presence. It lies like a poisonous cloud over the City and its environs, becoming murkier and more toxic at its centre, at which point only the dome of St Paul's can be seen emerging from its vapours. These are images, visions perhaps, that would return in the mid-twentieth century in the context of war and its aftermath. Victorian fogs even made artists out of jobbing journalists, such as the German writer Max Schlesinger:

The winter-fogs of London are, indeed, awful . . . they affect the minds and tempers of men . . . In a fog, the air is hardly fit for breathing; it is grey-yellow, of a deep orange, and even black; at the same time, it is moist, thick, full of bad smells and choking. The fog appears, now and then, slowly, like a melodramatic ghost, and sometimes it sweeps over the town as the simoom over the desert.[18]

The descriptive elements of these great Victorian fogs were quickly established: gaslight and darkness by day, the fog at once heavy and amorphous, the air thick and spectral. The fog of 1873 was a particularly notorious and destructive event, killing cattle at the Islington Great Show and bringing about a rise in deaths from bronchitis, resulting in the introduction of a smoke clause in the Public Health Act of 1875. These episodes entered into the national consciousness; they became part of fog's story. By the end of the century meteorologists were using data to demonstrate that not only had the frequency of fogs increased generally since the beginning of the nineteenth century, but also there had been a particular acceleration between 1870 and 1890.[19] Although there were some who contested this fog narrative, what was irrefutable was that by the end of the century, London had become synonymous with fog. Referred to as 'the big smoke', or simply 'the smoke', the fogs had achieved a kind of cultural and meteorological celebrity.[20]

By 1890 proto-environmentalists such as F. A. R. (Rollo) Russell were forecasting catastrophic consequences as the result of a combination of endemic fogs and poor living conditions in the inner cities. Russell described the economic, social and moral impact of London fog and also exposed the aesthetic deprivation caused by smoke fog, which differentiated its peculiar harm from the evil effects of poor urban conditions more generally. He stated: 'Beyond these bodily hurts, the presence of an overshadowing cloud of smoke produces moral evils . . . They lose, too, all distant prospects, urban or rural, and the pleasant variations of cloud-shadows which delight us in the views of great continental cities, which are not blurred or blotted out by smoke. These things are sermons from nature which humanity has need of.' The loss of a clear horizon, a view, was specific to the evils of a smoke fog and created an analogous lack of brightness and clarity in the working population: 'the prevailing expression is one of pallor, discontent, and ill-health, especially among women. Smoke and bad air by no means effect all of this; they only contribute to it, with strong drink, overwork, and artificial habits. Natural gaiety can hardly be expected in courts and alleys steeped in grime.'[21] The fog had drained the light and colour from the late Victorian city and its inhabitants had acquired a

similarly grey, lifeless demeanour. The fabric of the city was rusting and crumbling; everything was being corroded by the fog vapours.

While meteorologists and social reformers were estimating the financial costs of the fog at nearly two million pounds a year, fog was also at the zenith of its literary potential.[22] For writers such as Arthur Conan Doyle and Robert Louis Stevenson, the fog provided an accent of urban glamour to their stories of crime and detection. The fog in Sherlock Holmes stories is 'a greasy, heavy brown swirl . . . condensing in oily drops', creating in the detective 'a fever of suppressed energy'. The fog is also the nightmare environment of Mr Hyde and the cover for his murderous violence.[23] It was Henry James, however, who most precisely defined the aesthetic qualities of the fog: '[the atmosphere] with its magnificent mystifications, which flatters and superfuses, makes everything brown, rich, dim, vague, magnifies distances and minimises details, confirms the inference of vastness by suggesting that as the great city makes everything, it makes its own system of weather and its own optical laws.'[24] Rather than a loss of prospect and picturesque composition, James finds in the fog an atmospheric beauty that stimulates the imagination and induces a wistful reflectiveness. For James, the fog creates a delicious frisson of anxiety, which he describes as 'a phantasmagoria of homesickness', that summons the ghost of Dickens and coaxes images of the past.[25] Less than twenty years after his death, the London fog had already become 'Dickensian', denoting a way of seeing that is locked in the mid-Victorian period. The story of the fog is self-referential, an accumulation of texts and images, that are carried along in its swirling vapours. The expressive capacity of fog to disturb history and to draw the past and the present into immediate and troubling contact with the present was thus clearly understood by the end of the nineteenth century.

The matter of Victorian fog was deeply ambiguous; created at once by natural and artificial processes, it was described as both immaterial and vaporous and as greasy and slimy. For Conan Doyle and many other writers, the fog condenses in the form of slime, leaving a residue of grime and grease. Its weight bears down and muffles, but it also creeps and flows. Fog gets everywhere, insinuating itself into shops and homes, morphing like ectoplasm into streets and crevices, contaminating everything with its sameness.[26]

As London's air quality reached its nadir at the turn of the twentieth century, the physician and treasurer of the Coal Smoke Abatement Society, H. A. Des Voeux, wrote to *The Times* on Christmas Day 1904 to explain that the fogs of London were in fact a combination of two things: smoke and fog. Whereas a true fog was simply 'condensation of moisture in the atmo-

sphere' and a thing of nature, a 'London particular' consisted mostly of smoke produced by the combustion of coal from private homes. Although the distinction between smoke and fog was well understood, the significance of Des Voeux's letter was its introduction of a new term that captured in its formation the fatal atmospheric combination within modern fogs. This 'smog', as he named it, could be eradicated by the use of smokeless methods of cooking and heating, by the regulation of domestic as well as industrial combustion.[27] And it appears that Des Voeux was right, that the smogs were curable, because they went. This is the dramatic turn in the historiography of fog. Just as the London Fog Inquiry (1902–4) was getting under way, the fogs began to disappear.[28] Although the air of London was still scarcely pure and each winter brought its own episodes of fog, the really dense fogs of Victoria's reign stopped. The growing adoption of gas instead of coal, alongside the suburban expansion of the metropolis, lessened the density of the population and dispersed its smoke emission. Although the precise role of these different factors is not certain, what is evident is that the air of London seemed better. As the meteorologist L. W. Bonacina, identifying himself as 'a late Victorian born in 1882', wrote in 1950: 'there has been a vast improvement in the character of smoke fogs and hazes during the last thirty or forty years. In fact, brown pea-soup "London particulars" in the Victorian sense are things of the past.'[29]

But, then, in December 1952, the fog returned. Now, it is certainly an exaggeration to say that the fogs disappeared entirely in the early years of the twentieth century and it is clear that there were periodic episodes of bad fog in the intervening years; the point that should be made emphatically, however, is that when the fog came back in 1952, it was firmly established within the cultural imaginary of the post-war period as Victorian.

There is an essay by Michel de Certeau about the meaning of the *ancien régime* to the society of post-1848 France. The old regime, he suggests, represented the past, that which the new order had done away with, but it was also recent enough to be disquietingly familiar. This, I believe, is the relationship between late Victorian society and post-war Britain. I want to quote de Certeau, but change some of his terms to fit the historical period of *The Tiger in the Smoke*:

[*the nineteenth century*] was the world from which [*post-war Britain*] had broken away and rejected as 'old', so its own birth could belong to a different history. This break is both the condition of possibility and the effect of a beginning. But the 'old' returns. It forbids one to feel at home in the new age. The actual remains engaged in a 'fantasy' debate with this phantom, which continues to haunt it.[30]

The end of the war presented the opportunity to recover and start afresh, to look to the future and to a new society that would be a break with the inequalities and stasis of pre-war Britain. It was the moment finally to get rid of the slums, the poverty and the dirt of the Victorian cities, but the fog returned and reminded post-war Britain that it remained closely connected to its nineteenth-century past. As much as it might prefer to forget this national past, as hard as it might try to reject and break from this history, it will return and haunt the present. C. J. Jung describes psychological regression as a process that 'brings to the surface . . . slime from the depths'.[31] This return of the repressed is something atavistic and uncanny; it is intensely experienced both physically and emotionally but eventually enables the individual to adjust to the future. The fog, with its oily traces and dark clouds, was a reminder of the long reach of the past and the ways in which it continued to shape the realities of the present. It also defined the project of modernity in terms of the liberation from the crepuscular world of the Victorians into the clean, clear and colourful environment of the post-war future.

The Day That Never Broke

The fogs of the 1950s were different, however, from the fogs of Conan Doyle and Henry James. They drew on the accumulated meanings of the Victorian fogs, but they were also distinctively modern. Britain in 1952 had recently rejected its post-war Labour government and voted in a new Conservative government; rationing was still in place, along with National Service, and the landscape remained scarred with bombed ruins and gaping spaces where shattered buildings and streets had been cleared but not rebuilt.[32] In 1947 the Labour government had nationalized the coal industry and established the National Coal Board, and ordinary coal remained subject to rationing until 1958. On 1 December 1952, however, as a way of stretching the fuel supply, the Board announced that 'nutty slack' would be exempt from rationing (fig. 9). In a full-page advertisement, consumers were encouraged to 'Order as much as you like'; by mixing the slack with their ordinary house coal, they could 'keep the home fires burning however cold and long the winter.'[33] Keep the home fires burning; it was a phrase that evoked the spirit of the nation in wartime and the image of home. Off-the-ration coal dust would keep the hearths of Britain alight: 'It is perfect for banking up your fire at night or when you are going out.' Nutty slack was made up of small lumps of coal that amounted to little more than 'big

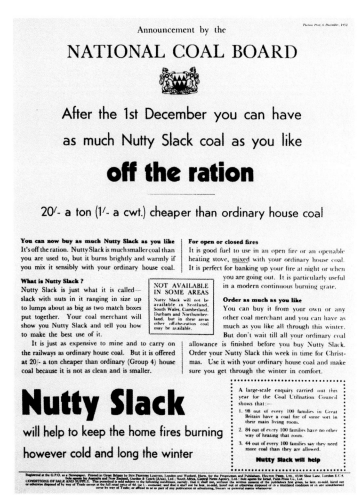

Announcement by the

NATIONAL COAL BOARD

Picture Post, 6 December, 1952

After the 1st December you can have as much Nutty Slack coal as you like

off the ration

20/- a ton (1/- a cwt.) cheaper than ordinary house coal

You can now buy as much Nutty Slack as you like
It's off the ration. Nutty Slack is much smaller coal than you are used to, but it burns brightly and warmly if you mix it sensibly with your ordinary house coal.

What is Nutty Slack?
Nutty Slack is just what it is called—slack with nuts in it ranging in size up to lumps about as big as two match boxes put together. Your coal merchant will show you Nutty Slack and tell you how to make the best use of it.

It is just as expensive to mine and to carry on the railways as ordinary house coal. But it is offered at 20/- a ton cheaper than ordinary (Group 4) house coal because it is not as clean and is smaller.

NOT AVAILABLE IN SOME AREAS
Nutty Slack will not be available in Scotland, South Wales, Cumberland, Durham and Northumberland, but in these areas other off-the-ration coal may be available.

For open or closed fires
It is good fuel to use in an open fire or an openable heating stove, <u>mixed</u> with your ordinary house coal. It is perfect for banking up your fire at night or when you are going out. It is particularly useful in a modern continuous burning grate.

Order as much as you like
You can buy it from your own or any other coal merchant and you can have as much as you like all through this winter. But don't wait till all your ordinary coal allowance is finished before you buy Nutty Slack. Order your Nutty Slack this week in time for Christmas. Use it with your ordinary house coal and make sure you get through the winter in comfort.

Nutty Slack
will help to keep the home fires burning
however cold and long the winter

A large-scale enquiry carried out this year for the Coal Utilisation Council shows that:—
1. 98 out of every 100 families in Great Britain have a coal fire of some sort in their main living room.
2. 84 out of every 100 families have no other way of heating that room.
3. 44 out of every 100 families say they need more coal than they are allowed.

Nutty Slack will help

9 'Announcement by the National Coal Board', *Picture Post*, 6 December 1952, p. 51.

dust'; it was cheap, low quality, dirty and smoky. The effect was almost immediate; within days the London Great Fog had been created by the burning of the low-grade, filthy fuel.

Photographs of the fog filled the newspapers; images of spectral figures enveloped in a vague, fog-shrouded landscape returned to post-war Britain. There is something paradoxical about a photograph of fog. Photography is, of course, dependent on light; the word itself means 'light-writing'. From the earliest attempts to fix an image through optical and chemical phenomena, the fundamental importance of capturing the sunlight was acknowledged.[34] Joseph Nicéphore Niépce, who first fixed a photographic image, called his picture a 'heliograph', or 'sun writing'. And it was during the brilliant sunny summer of 1835 that William Henry Fox

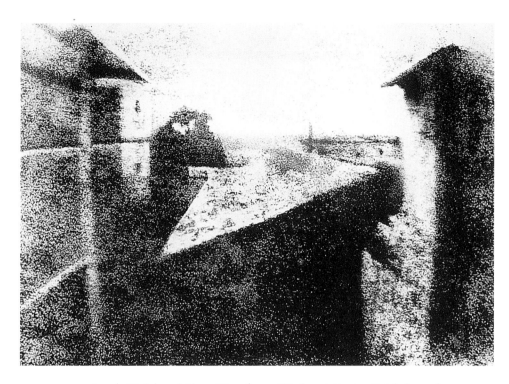

10 Joseph Nicéphore Niépce, 'View from a Window at Gras', *c.*1826, heliograph.
Gernsheim Collection, Harry Ransom Center, Austin, Texas.

Talbot developed his method of using sensitized paper, exposed to light, in order to capture the silhouettes of objects. As the chemical and mechanical aspects of photography were enhanced during the intense years of experimentation in the late 1830s and 1840s, its origins in sunlight were not forgotten and Fox Talbot continued to refer to his photographic studies as 'sun pictures' throughout the 1840s.[35] The history of photography is thus a history of sunlight; it is equally, however, a history of shadow. Niépce's heliograph of a view from a window (*c.*1826, fig. 10) lacks clarity; the edges of forms are blurred, the horizon is vague and the grain of the photographic process spreads a veil, or perhaps a mist, of fine dots over the image. Fox Talbot's first negatives also have a ghostly, ill-defined presence, and the idea itself of the development of positive prints from a negative paper or plate conjures the emergence of objects and figures from a foggy nothingness into recognizable distinction. Photography is more properly, therefore, an art of light and shadow, in which the image of the fog may be understood as the most exquisite expression of the dark side of this technology of representation.

A photograph of fog thus represents compromised visibility, where clarity and the transparency of the photographic medium succumb to the shadows and layers of mist. Where sunshine is absent, the photograph takes on a different mimetic role, representing the grain of the atmosphere and the poetics of form in the foggy environment. Fog obscures the clarity and sharp focus of sunlight and produces a space of reflective, even depressive nostalgia. Perhaps the greatest photographer of the veiled chiaroscuro of the British fog was Bill Brandt. In January 1947, *Picture Post* published Brandt's photo-essay called 'The Day That Never Broke', which begins in a graveyard and ends with a suicide. The short accompanying text tells the story of a London fog and a man who wants to be alone in the city. He cycles through the abandoned city streets to the Thames where he understands that he has nothing more to live for: 'Fog is the misanthrope's medium.'[36] Brandt's four full-page photographs revel in this melancholy urban environment (fig. 11). A London square appears like an early heliograph: uncertain, caught as it comes into or, perhaps, loses visibility, fading back into its negative form. The image seems to contain layers and layers of grey tones, perfectly photographed and developed, which convey the anxious spaces created by the fog-mist. Like the mid-nineteenth century engraving, light is eradicated and the only remnant is a weak and ineffective sun above the guilty chimneys, barely enough to fix a photographic image.

This study of environmental atmosphere plays with shadows and invokes a timeless national landscape. In his BBC Reith Lectures, broadcast in 1955, the German-born historian of art and architecture, Nikolaus Pevsner, also addressed these issues in his lectures on 'The Englishness of English Art'.[37] Pevsner had moved to England in 1933, after he was dismissed from his post at the University of Göttingen due to Nazi race laws. During the next fifty years, until his death in 1983, Pevsner undertook an extraordinary study of the history of English art, architecture and design. In the summer of 1930 when he had visited England from Göttingen in order to prepare a series of lectures on English art, he explained: 'Englishness of course is the purpose of my journey'; but Englishness was, in a sense, the purpose of his entire life and work in England.[38] Pevsner described his Reith Lectures as the creation of 'a geography of art', an examination of the ways in which English art expresses national character. For Pevsner, climate is one of the key determining factors of national character; this is a question not just of weather but of the atmosphere, the mists and fogs created by coal mining and domestic heating that create the *genius loci*, the spirit of the place and the visual character of the nation. At the beginning of the nineteenth century, Pevsner argues, artists such as Girtin, Turner, Crome and Con-

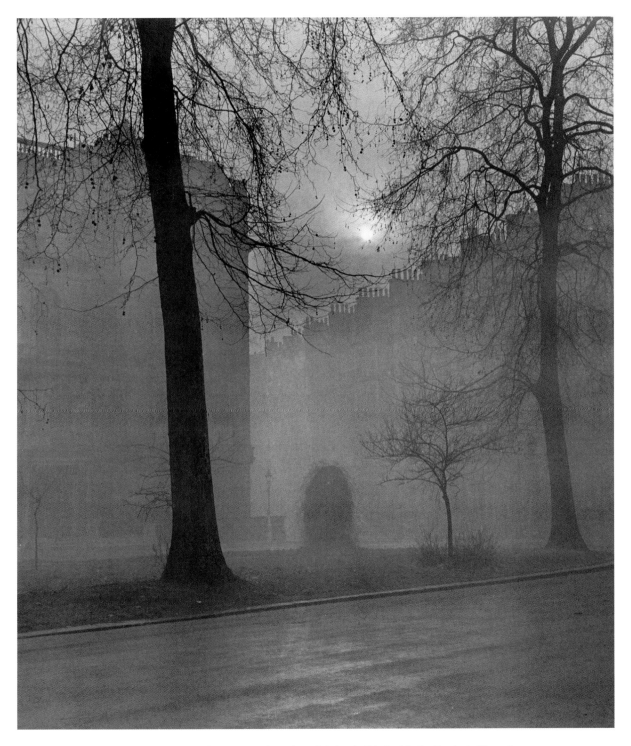

11 Bill Brandt, 'The Square Where the Nightingale Died with the Fog in its Throat',
Picture Post, 18 January 1947, p. 32.

stable turned to the study of atmosphere and developed an open, sketchy technique to convey the environment; they were painters of air who shared an 'anti-corporeal attitude' and a feel for the 'atmospheric landscape' of England.[39] Pevsner drew on his definition of English visuality to promote an approach to post-war reconstruction based on informal picturesque principles and planning. A founding member and, later, chairman of the Victorian Society, Pevsner was tireless in his advocacy of a national vernacular tradition that expressed the idiosyncrasies of English character. Pevsner and Brandt (who also moved to England from continental Europe in 1933) shared a taste for the visuality of the fog. In a walk through the Inns of Court, Pevsner observed: 'A slightly misty day shows it at its best'.[40]

Photographs of the fog touch on all of these visual vocabularies: they belong to the past as much as to the present and its environmental contingencies; they express an essential national character that is anti-corporeal, even melancholic; and they speak to the specificity of the medium of photography and its investigation of the relationship of light and art. In December 1952 the sensory and spatial dislocations of the fog were experienced directly in the streets of the city, and then again through the evocation of press photography. In these distillations of those foggy days, there is still a sense of place and time but they have lost their moorings; they cannot be connected to nearby locations and moments and have become unstable and confusing. In their recollections of the fog, people remember being unable to see beyond the hands in front of their faces – no edges, no boundaries, all that is solid melts into air. The life of a city is reduced to clouds of smoke and fog and an atmosphere that, drawing on the words of Gilles Deleuze, has become 'pure quality ... pure power ... an affect.'[41]

Khaki Fogs and Guilty Chimneys

The past returned in December 1952 in the form of the fog, but it was not the same. It had turned from brown to khaki. Of the many crime novels set in the fog in the years around 1952, one of the most unsettling in its use of atmospheric confusion and insinuation of the threat and criminality enveloped in the fog is Margery Allingham's *The Tiger in the Smoke*, which was first published in 1952 and adapted for a film in 1956.[42] In 'The Adventure of the Bruce-Partington Plans' (1908), Sherlock Holmes looks out of his window into the foggy London street below and tells Watson: 'See how the figures loom up, are dimly seen, and then blend once

more into the cloud-bank. The thief or murderer could roam London on such a day as the tiger does in the jungle, unseen until he pounces, and then evident only to his victim.'[43] The 'tiger' in Allingham's novel is Jack Havoc, an ex-army sergeant and a violent convicted murderer who has escaped from prison and is now hiding in and prowling the fog-bound streets of 1950s London. Havoc is searching for a hoard of treasure that he believes his now dead army commander has hidden in a house in Brittany. With a motley and macabre band of accomplices made up of ex-soldiers and former comrades, the novel pursues the gang through the faded alleys, terraced houses and abandoned cellars of the city, until the chase climaxes with the death of Havoc in France.

The fog is as active an actor in the novel as its hero, the amateur detective Albert Campion. In the opening scene, set in a London railway station, the fog has hung over London all day like a sooty blanket, smothering the lamps and beacons that have been lit, muffling sound, and making distances and colours deceptive. It oozes and creeps and contaminates the city and its inhabitants and it turns the world . . . khaki. For Allingham, the heart of the fog, the location of Havoc's murderous violence, is khaki-coloured and its optical effect is to render the world through a filter of army surplus:

> It was as though the war years had peeped out at them suddenly and the coloured clothes all round them in the fog had been washed over briefly with khaki. To add to the illusion, the dreary thumping of a street band away out in Crumb Street behind them reached them faintly through the station noises. It was only the ghost of a tune, not recognizable yet evocative and faintly alarming, like a half-remembered threat [p. 18].[44]

The demobilization of the British armed forces began its slow progress in the summer of 1945, but the band of ex-soldiers that Jack Havoc leads still wear their old uniforms, as they carve out a living as menacing street musicians, busking and begging from passers-by. The fog is a fitting environment for their spectral and alarming existence; even their perfunctory music sounds like a threat in the distorted acoustic world that the fog creates.[45] The band shamble along the street, half-hidden in the clouds of fog, pushing an old perambulator and rattling collection boxes at passers-by. Campion observes: 'I remember after the First World War those bands were pretty shocking . . . but I thought the Welfare State had rather seen to that sort of thing. They are ex-Service, I suppose' (p. 26). But the welfare state has not eradicated these figures from the past; they have returned, with the fog, and are now a ghastly and phantasmal parody of the

marching military bands of war time. Their existence is an extraordinary blend of post-war shortages of food, clothing and housing and a criminal underworld of streets and markets that belongs comfortably to the imagery of Dickens and Henry Mayhew. The languages of Victorianism and post-war peace come together in Allingham's description of the district where the menacing buskers live:

> The fog stopped over its low houses like a bucketful of cold soup over a row of dirty stoves. The shops had been mean when they had been built and were designed for small and occasional trade, but since the days of victory, when a million demobilized men had passed through the terminus, each one armed with a parcel of Government-presented garments of varying usefulness, half the establishments had been taken over by opportunists specializing in the purchase and sale of second hand clothes. Every other window was darkened with festoons of semi-respectable rags based by bundles of grey household linen, soiled suitcases, and an occasional collection of surplus war stores, green, khaki, and air-force blue [p. 25].

The fog and the shop windows are the same shades of grey and dun. These are the Victorian streets that have survived the slum clearances of the 1930s and the devastation of the Blitz and where the fog collects in a dull pool over the market stalls: 'their merchandise, which ranged from whelks to underwear, was open to the sooty air, while behind them tottering shops, open-fronted and ill lit, cowered odorously.' The fog thickens and a murder is committed; newspapers carry the headline: 'KILLER ROAMING LONDON FOG ... MURDERER IN THE FOG' (pp. 127, 163). In the uncanny world created by the fog, there is no reconstruction and post-war modernization; there is only a regression into the past, nervous anxiety and apprehension: 'Children were hurried home from school. Doors which were never locked in daytime were fastened by lunch, and men were glad to seek company in club and pub' (p. 163).

Roy Ward Baker's film *Tiger in the Smoke* makes a number of changes to the plot of Allingham's novel, but sticks closely to the menacing visual and psychological atmosphere of the foggy city (UK, 1956; fig. 12). Shot in black and white, it draws on the qualities of film noir cinematography, combining high contrast, shadow and the ambiguities of the fog. The gang of street musicians are a leitmotif in the foggy exteriors, linking the different locations through their shadowy silhouettes and the thumping bray of their music in a way that the fog makes otherwise impossible. The opening film credits appear over a foggy view of Tower Bridge and traffic by St Paul's Cathedral (fig. 13). The scene then changes to a foggy outdoor market and a

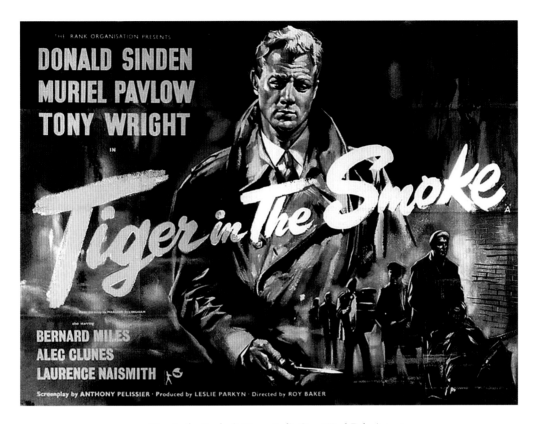

THE RANK ORGANISATION PRESENTS

DONALD SINDEN
MURIEL PAVLOW
TONY WRIGHT

IN

Tiger in The Smoke

BERNARD MILES
ALEC CLUNES
LAURENCE NAISMITH

Screenplay by ANTHONY PELISSIER · Produced by LESLIE PARKYN · Directed by ROY BAKER

12 *Tiger in the Smoke* (UK, 1956; dir. Roy Ward Baker), poster.

close-up of the shuffling figures of the street band, who move in single file through the murky
street (fig. 14). As the violence escalates, a criminal is murdered by the band and his body left
in what appears to be a corner of a bombed-out building, indicated by a jagged and broken
wall. The effect of the fog is so dense in these exterior scenes that the viewer is left in the same
uncertain state as the pedestrians in the filmic locations: unable to distinguish between solid
form and gaseous air, between pavement and gutter, between familiar and unfamiliar faces
and places. This disorientation is intensified in a scene where one of the men investigating
the mystery is kidnapped by the gang; he is tied into the metal pram and pushed through the
streets, the camera showing his point of view in an expressionist sequence of disconnected
faces and neon street signs (fig. 15). The band makes its way towards the cellar where they
live, in a journey in which urban space becomes illegible and irrational. To the sound of their
discordant music, they pass through a street, an outdoor market, an alley or doorway, into a

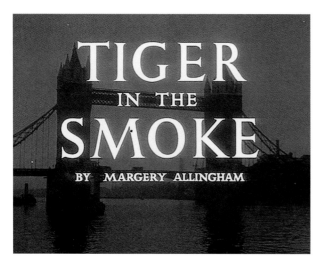
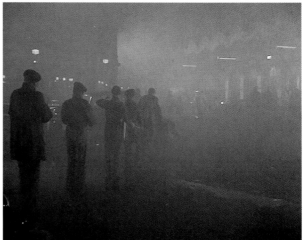

13 Opening credits over a foggy view of Tower Bridge, *Tiger in the Smoke*, 1956, frame still.

14 The street band shuffling through the foggy streets, *Tiger in the Smoke*, 1956, frame still.

hallway and down some stairs into their dilapidated cellar (fig. 16). Only the outcasts and fugitives of post-war society could make their home in this disquieting space; without warmth or stability, this shelter has none of the properties of home and is instead *unheimlich*, a place of anxiety and dread.[46]

The fog in *Tiger in the Smoke* does not stay outside but seeps into houses and interiors; it can be seen being pumped into the set when the gang returns to the cellar and it penetrates the boundaries and thresholds of respectable homes and pubs, turning them into dreamlike spaces. The fog chokes and strangles people in their homes; in Barbara Beauchamp's 1958 novel, *The Girl in the Fog*, the fog 'clamps' itself over the city and houses, creating a constant, irritating phlegm: 'In the morning his throat felt rough from the fog which had seeped into the room all night.'[47] Fog was also a problem for cinema proprietors and in February 1953 *Kinematograph Weekly*, the trade paper for film professionals, carried an article on the best methods for keeping auditoria clear of fog.[48] Fog dissolved the spectator's vision both inside the cinema and within the filmic *mise en scène*; as Oswald Morris, one of Britain's most successful cinematographers in this period, commented: 'If we were doing a fog scene you'd use much more fog in colour than you did in black and white. Colour cuts through fog unbelievably; it's quite uncanny . . . In black and white it's different, you have to be very careful and go very easy, it's very sensitive

15 Sequence of disconnected faces and neon street signs, *Tiger in the Smoke*, 1956, frame still.

16 Stairs down to dilapidated cellar, *Tiger in the Smoke*, 1956, frame still.

to fog.'[49] Fog was an essential quality of black and white film in the 1950s; it created its atmo-sphere and provided its subjects; it imprinted itself on the matter of British film.

Fog, mist and smoke are repeated motifs in the lexicon of uncanny space. Freud compared his experience of losing his way in the red light district of a provincial town to being lost in the mist of a mountain forest. In both settings, there is a loss of familiar bodily and locational references that triggers a disturbing ambiguity and insecurity. In Freud's writing the uncanny is not a property of space but a mental projection: a psychological or aesthetic response to the trauma and shock of the modern. The uncanny elides and confuses the real and the imagined, the familiar and the strange, the clear and the obscure. It is the moment when the homely becomes disturbing; as Freud summarized it: 'the uncanny would always be something one does not know one's way about in.'[50] The Great Fog of 1952 and its many visual iterations are an emphatic expression of the spatial uncanny. The loss of the sense of place and the blurring of boundaries between interiors and exteriors are amongst the conditions of the uncanny and make possible the murderous settings and marginal social types that characterize *Tiger in the Smoke*.

Freud's essay on the uncanny was first published in 1919 and, as Anthony Vidler has shown in his study *The Architectural Uncanny*, with its themes of dread and shock, it was part of Freud's

39

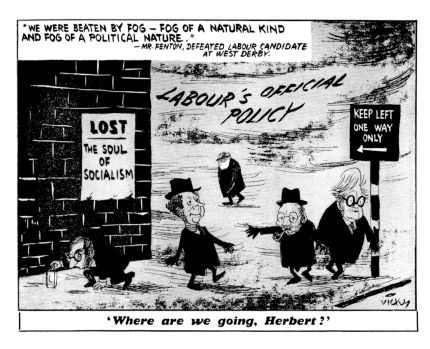

17　Vicky [Victor Weisz], 'Where are we going, Herbert?', *Daily Mirror*,
22 November 1954, p. 3.

attempts to comprehend the trauma of the First World War. The battlefields of 1914–18 were a site of the uncanny, but so, too, were the ruins left in cities throughout Europe after the bombardments of the Second World War. Fog and war share an aesthetic of ruin and pollution. In 1889, the periodical *Nineteenth Century* published an article entitled 'In Praise of London Fogs', which instructed the reader: 'When you see at the end of a long interminable street a thick volume of fog settling down and rolling onwards in triumph, fancy that it is the plague-cloud, conveying deadly germs into every household that it reaches; or imagine that London is burning, and that the fog-signals are the detonation of shells from hostile batteries.'[51] There is something remarkably prescient about this elision of fog, plague-clouds and artillery fire. In 1952, the fog was a choking khaki blanket laid over the traumatized landscape of post-war Britain. It is worth trying to remember or grasp the embodied experience of such a place and the form of cultural imagination that emerges from it. There is here a doubling of the effect of the uncanny in the bombed-out ruins and squalid Victorian slums of the inner city smothered in the corrupting fog. Familiar landmarks destroyed, everyday routes obscured and the

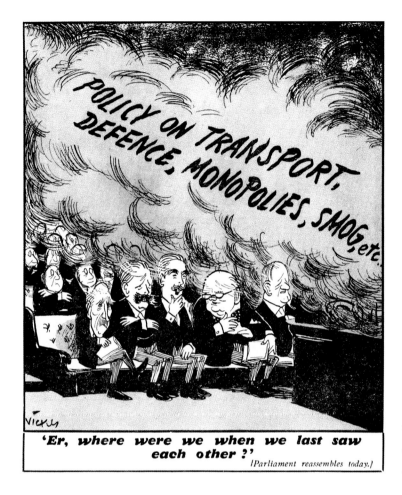

'Er, where were we when we last saw each other?'
[Parliament reassembles today.]

VICKY

18 Vicky [Victor Weisz], 'Er, where were we when we last saw each other?', *Daily Mirror*, 25 January 1955, p. 3.

world made strange to those who venture out in its thickened air. When it was proposed that another fog episode like that of 1952 might require the use and distribution of 'smog-masks', the association of the fog with the bombing raids of the war and the shortcomings of the post-war settlement was complete.[52] In the mid-1950s the *Daily Mirror's* political cartoonist, Victor Weisz ('Vicky'), suggested that both the 'soul of socialism' and the policies of the Conservative government had been lost in the fog (figs 17 and 18).

And, at this moment, there was one further meaning generated in the smoke fog. In August 1945 the United States dropped two nuclear weapons on the Japanese cities of Hiroshima and Nagasaki, creating images of unprecedented destruction that continue to haunt the contemporary imagination. Within days of the attacks, images of the atomic bomb mushroom cloud

DAWN—OR DUSK?

HULTON'S NATIONAL WEEKLY

MAN ENTERS THE

ATOM AGE

4D

AUGUST 25, 1945 Vol. 28. No. 8

19 'Man Enters the Atom Age', *Picture Post*, 25 August 1945, cover page.

The caption and labels within the figure include:

Within 80 miles buildings would be destroyed by one hydrogen bomb

COLCHESTER CLACTON-ON-SEA BURNHAM-ON-CROUCH SOUTHEND

CHELMSFORD BRENTWOOD TILBURY

Within 16 miles ... by ... hydrogen bomb ERITH MARSHES

Within 8 miles destruction by one hydrogen bomb would be complete

This circle of 2½ miles radius represents the limit of destruction of one uranium bomb

REGENT'S PARK GREENWICH

HYDE PARK CLAPHAM COMMON

WORMWOOD SCRUBBS

W. MIDDLESEX RESERVOIRS BARNES COMMON

KEW GARDENS

THIS IS WHAT WOULD HAPPEN IF A HYDROGEN BOMB WERE DROPPED ON THE BRITISH HOUSES OF PARLIAMENT

The Range of the Bomb
The central circle indicates the area within which everything would be destroyed. A bomb 35 times as big as that planned would have a spread of 1,500 miles. This could be carried by sea and blow up the whole continent of Australia.

20 'This is What Would Happen if a Hydrogen Bomb Were Dropped on the British Houses of Parliament', *Picture Post*, 18 February 1950, pp. 32–3.

were published by the world press, an iconic shorthand for the destructive power of nuclear weaponry; in the image of the radioactive cloud, the fog had propagated into a sign of indeterminate terror and mass extinction. Shortly after the surrender of Japan, the cover of *Picture Post* imagined another day that never broke, in the small silhouetted figure of a child looking out to a dark horizon; as 'Man Enters the Atom Age', it is again unclear whether it is dawn or dusk (fig. 19). By the beginning of 1950, atomic power was being considered for use in industry and the home, at the same time that *The Times* was reporting hydrogen bombs one thousand times more powerful than the atomic bombs used at Hiroshima and Nagasaki. In an extended article, *Picture Post* considered the possibility of warfare conducted with lethal radioactive dusts and speculated about its impact if used on London (fig. 20). At the centre of an aerial view of south-east England, a mushroom cloud plume of smoke rises into the sky, whilst concentric circles indicate the levels of destruction in the surrounding area. What is most fearful, however, is the possible use of invisible radioactive isotopes: 'If these substances could be scattered in

large quantities in the atmosphere over a large city, nearly the whole population would be killed . . . the result may be equally macabre, if not so immediately spectacular, as warfare conducted with super hydrogen atom bombs.'[53]

This marks a highly significant shift in the perception of the potential harm of air pollution, from a tradition of viewing it in primarily visual terms (the visible density of the fog) to the recognition that the air could be toxic and polluted even when the visible signs had faded from sight. In 1957 the National Smoke Abatement Society dissolved itself and re-formed as the National Society for Clean Air; its general review of that year referred to international concern about new forms of pollution, such as: 'fumes and dust from heavy industrial processes, and fumes from road vehicles . . . [the] worldwide problem of air polluted by radio-active matter'.[54] In this shift from the visible density and corporeality of sooty smoke fog to the invisible chemical products of combustion and radioactivity, the fogs of the past turned into the lethal atmospheres of the future, and began slowly to lose the symbolic and historical expressiveness that they possessed in the early 1950s.

The 1950s were a transitional period in the visualization of the atmosphere, from a discourse of visible pollution to one of invisible contamination. Although the apprehension of invisible threats increased throughout the decade, the image of smoking chimneys and grey smog continued to have a considerable hold on the cultural imagination. The nation perceived itself and was perceived through a filter of greyscale, a nuanced register of shades of grey and varying shadow, which defined the land and its people in the post-war years. Grey seemed inescapable; in 1951 the new edition of the British Colour Council *Dictionary of Colour Standards* announced the introduction of twenty new colours, of which a quarter were grey tones; in 1955 the Robbialac paint company advertised: 'hundreds of the grey-toned shades now so much in vogue', and the clothing trade paper, *Tailor and Cutter*, reported a new colour for 1950: 'Fog blue which is especially flattering to the older woman'. It is inaccurate to call this colour world monochrome; it is in fact a multiplicity of shades of grey – charcoal grey, dove grey, battleship grey, gull grey, elephant grey – that is as expressive and beautiful as the colours of the rainbow.[55]

Even the General Secretary of the NSAS, Arnold Marsh, could not resist the varied abundance of a grey environment. In his influential book, *Smoke: The Problem of Coal and the Atmosphere* (1947), Marsh evoked a world washed in leaden tints and described the most immediate and striking impact of air pollution as visual deprivation, leading to psychological and moral

degradation. Recalling the discourse of the late nineteenth-century environmentalists, Marsh argued: 'Life in a drab, dingy environment, with a continuous invasion of dirt, and a lack of brightness, colour, and sparkle, has a profound psychological effect on the individual . . . The very word 'gloom' describes both darkness and obscurity, such as results from a smoke pall, and a state of melancholy and mental depression.' In the absence of colour and light, compensation is sought in false luminosity, in the 'garish and the tawdry'. Marsh's smog-filled world is not simply monotone, however; it is a nuanced environment of grey-infused hues and shades of black and white. He observes: 'Red brickwork, stucco and white stone alike are grey, soot-black, or with some stones disagreeably marred with streaks and patches of black on white.' And in a conflation of earth and sky, he describes the fog as 'an aerial slum'.[56] With its highly organized campaign of posters and exhibitions, the NSAS condensed this discourse into simple, effective visual forms (fig. 21). In one of its campaign posters a hand reaches out to a graphic sun: 'Away with Smoke Let in the Light'. Liberation for post-war environmental politics meant freedom from smoke as much as it meant freedom from warmongering dictatorships.

War was declared on smoke fogs. In a sustained campaign for clean air legislation *Picture Post* described smoke as a 'mass murderer' and, elsewhere, as a 'mass killer'.[57] Clean air was covered in articles not only on smoke but also on fuel, on the state of British cities and on national reconstruction; the paper was relentless in its attack on the condition of the nation's air, which was visually symbolized in the image of smoking chimneys (fig. 22). The towers of industrial Britain that had once represented the economic power of the nation were now redefined as the wasteful relic of a pre-war world of industrial production, a historic evil that would be defeated by modern fuels and planning.

It was a world that seemed always to be on the brink of disappearing in the second half of the twentieth century but that remained nonetheless firmly rooted in the present, part of the national industrial landscape. Between 1937 and his death in 1950, the English documentary filmmaker Humphrey Jennings compiled what might be best described as a bricolage of sources, drawn from the seventeenth century to the end of the nineteenth century, describing responses to the industrial age. Although Jennings died before the book, called *Pandaemonium*, could be completed, it has subsequently been published, along with some of the notes left by Jennings relating to the project.[58] In his notes, Jennings refers to the book as an 'imaginative history', in which each extract is like a frame within a roll of film, recording the ongoing mental and emotional experiences of industrialization. Jennings defines the nature of the extracts in

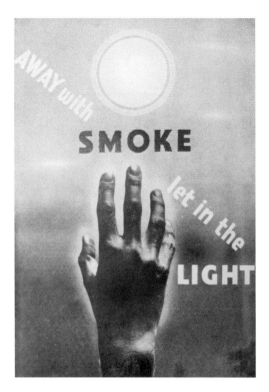 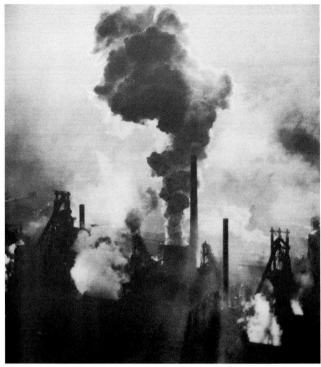

21 'Away with Smoke Let in the Light', smoke abatement poster, as reproduced in Arnold Marsh, *Smoke: The Problem of Coal and the Atmosphere* (London: Faber and Faber, 1947), facing p. 261.

22 'Smoke a Mass Murderer', *Picture Post*, 31 October 1953, p. 17.

visual terms: they are 'images' rather than texts, instants within the history of the Industrial Revolution when social and political conflicts show themselves most clearly; they are 'illuminations . . . moments of vision' when experience is *'turned into an image'*.[59] It is an inspiring piece of work that speaks directly to the concerns of the post-war years, but which continues to address the twenty-first century. Before the outbreak of war in 1939, Jennings had worked with the GPO Film Unit on documentary films; he was also involved with the British Surrealist movement and was one of the founders in 1936 of Mass Observation. Between 1939 and 1950 Jennings continued making films for the Crown Film Unit, including some of the most moving evocations of the nation in wartime. *Pandaemonium* is a poetic history of the nation through the changing imagery of industrialization; it is a paean to the smoking chimneys that transformed forever the landscape and its people. Coal, smoke, fog, storm-clouds and plague-

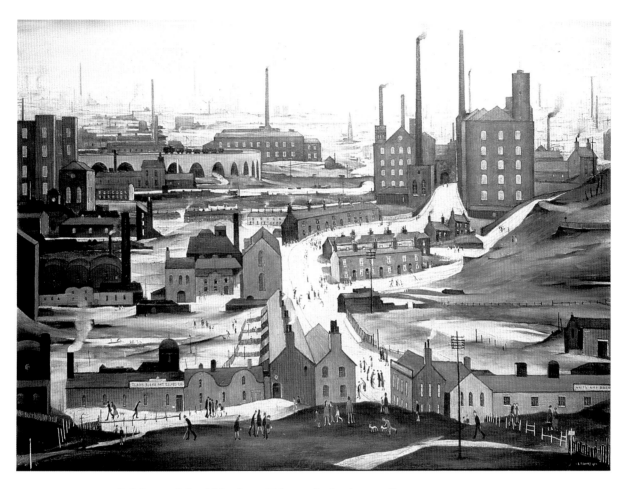

23 L. S. Lowry, *Industrial Landscape (Ashton under Lyne)*, 1952, oil on canvas, 115 × 152.5 cm.
Bradford Museums & Galleries.

winds; light and darkness are drawn together in a volume that can be read from beginning
to end or selected from at random. For Jennings and others in this period, the great smoking
chimneys of industry were part of this unfolding history: an image, a moment of illumination,
when the contradictions of progress were suddenly and terribly visible.

 Like fog, chimneys were the source of obscurity and the loss of a clear and distant prospect.
This is, in part, their function in the great imaginary industrial landscapes painted by L. S.
Lowry between 1950 and 1955 (fig. 23). The first of these panoramas was commissioned for the
1951 Festival of Britain and was followed by four further paintings on the same scale. In *Indus-*

trial Landscape (Ashton under Lyne), 1952, fragments of terraced housing, factories and smoking chimneys are isolated and distributed haphazardly in a vague urban landscape. Areas that are not built on are incoherent and empty: grey mounds or cleared bomb sites where nothing grows and no one lives. The clarity of Lowry's characteristic figures in the foreground dissolves in the middle and distance; smoke hangs like a curtain over this despondent industrial scene, dissolving and obscuring a landscape that would otherwise be too clear, too disturbing. As T. J. Clark and Anne M. Wagner have argued, this is indeed a painting of modern life in the post-war north of England, but equally it is an image of a present that remains in thrall to the forms and images of the industrial past. In an article published in *The Saturday Book* on the industrial landscapes, written by Lowry's friend, the novelist Howard Spring, Lowry is compared to Charles Dickens and described as 'the most romantic of contemporary painters'. Lowry is romantic and modern, Victorian and contemporary, for these concepts were all present in the industrial landscapes and smoking chimneys of the 1950s.[60] Always on the verge of extinction, they remained a material reality of post-war Britain: a sign of what had been achieved and what still needed to be done.

The long-established campaigners of the NSAS, with its mix of voluntary organizations and the British Medical Association, were fortified by the interests of the so-called 'smokeless fuel' providers such as the Gas Council, the British Electrical Association and the manufacturers of boilers and radiators, all of whom stood to profit from a move away from coal and open fires. In 1954 the Gas Council commissioned a documentary about air pollution, which was produced by the Pathé Documentary Unit and distributed through the NSAS. The film begins with shots of a picturesque rural landscape and then cuts to scenes in a dense urban fog (fig. 24); a camera follows an ambulance through the smoggy night as it brings a casualty of the pea-souper to a hospital. There are close-ups of medical staff examining x-rays on a light box, with a doctor pointing to the diseased area of a patient's lungs (fig. 25). The medical consequences of fog are traced through footage of children who are deprived of natural sunlight being given sunglasses so that they can play in the light of an artificial sun lamp.[61] The offscreen narrator states: 'Where the sun enters the doctor doesn't', and the scene changes to various shots of dingy terraced streets with smoking chimneys and slum housing shrouded in grey mists (figs 26 and 27). This is the landscape of pre-war, pre-welfare, Victorian provision, of unregulated industry creating illness and pollution that could drag Britain back into the nineteenth century; its cure, according to the film, is to be found in a combination of official planning

and clean fuel. The last third of the film takes the form of a lecture given at a public meeting by Mr R. E. Lawson, the 'well-known' fuel technologist. Using diagrams on a flip chart, he shows how smokeless zones can gradually clean the air of cities (fig. 28). Modern industry and technology will together put an end to smoking chimneys, and new forms of domestic heating and cooking will eliminate the use of coal and open grates (fig. 29). The film ends with the rousing call: 'Out of the gloom and darkness let us strive towards the light.'

Guilty Chimneys draws on all the visual vocabulary of darkness, smoke and slum housing that had become associated with fog and the clean air movement by the middle of the twentieth century. Fog and the concatenation of ideas that was folded into it concerning the past and post-war redevelopment were articulated through a spectrum of grey tones that reflected the classification of smoke itself. In the years leading up to the passing of the Clean Air Act in 1956, the concept of air quality remained based on visual perception and the use of standardized scales to measure the darkness, the greyness, of the smoke. 'Intensity' is one of the three attributes of colour that also includes 'hue' and 'tone'. As defined by the British Colour Council, an intense colour is one that contains very little grey and is relatively 'pure': 'because of its relative freedom from mixture with any degrading factor . . . a colour may vary according to . . . whether it is pure or greyed.' This is the language of air classification and its visual range from white/pure to black/degraded; it is also the moral language of post-war colour definition.[62]

Existing legislation regulated smoke emissions in terms of prescribed degrees of grey density and controls concentrated on the production of 'black smoke'.[63] The Clean Air Act extended this method of regulation, prohibiting the emission of 'dark smoke', the visible product of industrial processes. In its concentration on visible manifestations of air pollution, the Act represented a resurgence of an 'older optical epistemology' that had been created by the discourse of centuries of smoke fog and that trusted to the power of the eye.[64] The terms of the Act were thus produced and formulated through the appearance and cumulative history of the Great Fog; they were concerned with the abatement of visible air pollution rather than the emission of harmful but invisible gases. The 1956 Act turned the indeterminacy of fog and smoke into an optical discourse of discernible knowledge.

Dark smoke was defined in the Clean Air Act as: 'dark or darker than shade 2 on the [Ringelmann] chart.' The charts, which had been introduced in the late nineteenth century, have six levels of density represented in the form of a grid of black lines on a white surface, which, if viewed at the correct distance, converge into shades of grey. 0 is represented by a

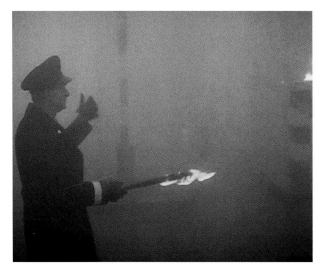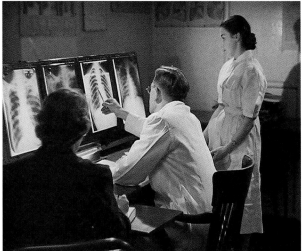

Six frame stills from *Guilty Chimneys* (UK, *c.*1954; dir. Gerard Bryant):
24 Man with a flare; 25 Medical staff examining x-rays

white sheet and 5 is solid black; the grades in between consist of increasingly thick black lines that merge into progressively dark grey shades. 0 denotes no smoke and 5 is dense black smoke; 2 indicates the presence of darker grey smoke. The method of measurement is observation from a distance of approximately fifty feet from the chimney (fig. 30). The regulations of the 1956 Act were thus a paean to the leaden, gritty air of foggy Victorianism. With charts engraved or photographed in varying densities of grey, it was a way of seeing and assessing the world through observers, witnesses and grids of black and white. And in its adherence to the control of visible pollutants, the impact of the Act was always going to be limited; as legal commentators concluded, the law should more accurately have been called the 'Cleaner Air Act'.[65]

The Act consolidated a view of post-war Britain divided between white and black, pure and polluted. It was the most basic visual language, easy to understand and limitless in its connotations. Advertisers did not need colour printing to convey their messages; their point was literally made in black and white (fig. 31). Ringelmann charts in the form of an arrow recede from a clean, white foreground into a distant, smoggy industrial landscape, as the Gas Council's brand mascot, Mr Therm, assures readers: 'I'm Ringelmann Zero!' (fig. 32). By the end of the 1950s, fog and smoke had created a visual world in which progress was defined in shades of black and white.

26 Urban industrial landscape; 27 Urban industrial landscape;
(below) 28 Smokeless zone chart; 29 Woman cooking with new appliances

The Great Fog of December 1952 was an environmental disaster; it was also an event of
immense symbolic significance. It plunged the post-war, post-Festival of Britain nation back
into a black, white and grey world of Victorian slums and urban neglect, into a world of
uncanny time and space. The uncanny is produced through the return of an idea or thought

30 '"Smoke Sleuths" Work Constantly to Combat a Pittsburgh Nuisance',
in 'Pittsburgh: Workshop of the Titans', *National Geographic Magazine*, July 1949, p. 129.

31 'Guiltless Chimneys Demand Smokeless Fuels', advert for Woodall-Duckham Construction
Company Ltd, in National Smoke Abatement Society, *Year Book*, 1956, p. 63.

that has been consigned to the past; it is linked with repression, returns and repetitions. The fog was an unambiguous reappearance of a not too distant past that the post-war settlement had tried to repress but that kept on returning. It stressed the fragility of the political consensus and post-war reconstruction and threatened to undo the new order of things. A man with a flare stands before a bus in dense fog. This was the world from which the 1950s had distanced itself, the world through which the project of redevelopment had been defined; but in 1952 it

32 'I'm Ringelmann
Zero', advert for the
Gas Council, in National
Society for Clean Air,
Clean Air Year Book, 1959,
p. 65.

returned with its ghostly mists and dark, oily deposits, a symbol of a past model of organization that threatened to colonize the progressive projects of the new age. While there were many who believed that the fog extinguished the visuality of the modern world, it can also be seen to have generated a rich and expressive visual culture that captured the atmosphere and the grain of Britain in the 1950s.

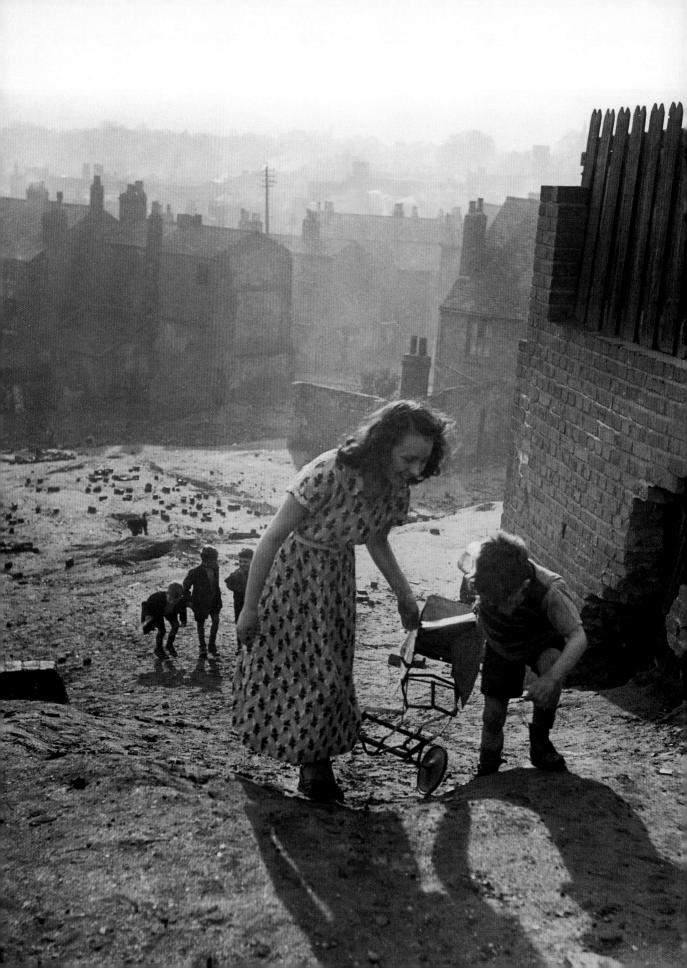

2

Broken Buildings and 'Horrid Empty Spaces'

The Atmosphere of Ruins

Six years of war had drained the colour from Britain. Or so it seemed to those arriving in the country at its ports and railway stations from overseas and to those living in its faded, battered streets and amongst the broken buildings and bombsites. The aftermath of war was perceived and later remembered through a register of greys: the colour of bombed ruins and rubble, the hue of fatigue and austerity, of ongoing rationing and uncertainty. To many, even the air, the atmosphere, was gloomy and muted, with fogs making the landscape strangely and relentlessly colourless, spreading a pall of smoke-saturated particles over streets, buildings and trees.

Why is the ruined landscape grey? What do the shadows and lights, the charred and scarred surfaces tell us about the meaning of ruination? If, as writers and philosophers such as Georg Simmel have argued, architecture is the supreme human expression of form and spirit, then ruins signify a return to nature and matter, a gradual erosion or an abrupt compression of

time that reverses the narrative of progress and brings the present into sudden and inescapable contact with the past and with forebodings and uncertainties about the future.[1] The world of peacetime is the world of colour; the desolation and violence of war are expressed through grey tones. There is a long history of the representation of ruin in which the process of laying waste is visualized in terms of the elimination of colour and an entry into the poetics of chiaroscuro and the sombre leaden shades of dust and rubble. In recent years a number of writers have also observed that photography is the foremost medium of ruins, that it captures and conveys the meanings of ruin better than any other visual medium, tracing a history that extends from photographs of the American Civil War to the wreckage of the World Trade Center and the wastelands of contemporary industrial decline.[2] If this claim is true, however, it remains curiously underexamined and surely deserves more detailed historical consideration. Why has photography emerged as the medium that can render ruin, and why does it continue to be its black and white expression that is understood to convey most forcefully the layers of symbolic meaning? This chapter addresses these questions through an exploration of a specific type of ruin and a particular photographic genre; it argues that the post-war landscape of bombsites found a perfect synergy in the forms of British photographic journalism produced and printed immediately after the end of the Second World War.

In the years between 1945 and 1955 the topography of bombsites haunted the physical landscape, cultural imagination and psyche of Britain, and found its complete expression through the specific technologies of taking and printing press photographs. There is an important difference between ruins and bombsites; whereas ruins may be said to retain form and to possess silhouettes or picturesque outlines, bombsites are wasteland: mounds and masses of debris that are the colour of cement, or as W. G. Sebald puts it: 'a grey scree'.[3] Bombsites perhaps constitute the kind of landscape that Walter Benjamin's 'Angel of History' looks back at as it is propelled onwards by the energy of progress whilst being forced to look at the devastation that is accumulating behind: 'His face is turned towards the past . . . The angel would like to stay, awaken the dead, and make whole what has been smashed. But a storm is blowing from Paradise . . . This storm irresistibly propels him into the future to which his back is turned, while the pile of debris before him grows skyward.'[4] This passage, written early in 1940, predicts the vast flattened landscapes and rubble mountains of post-war Europe and the language of fragmentation and reparation that would afterward dominate these cultures. Images of these sites, cleared of ruined buildings but suspended in time and awaiting future

reconstruction, appeared in *Picture Post* throughout the late 1940s and early 1950s, summoning through their inky shadows and grainy highlights a space full not only of loss and emptiness but also of fantasy and play and the possibilities of reparation and making whole. The images have an immense depth, a distinctive quality, which evokes not only the spatial particularities of the ruined and expectant landscape, but also conjures the complexities of time at this historical moment. Through a unique ability to exploit its conditions of production, press photography in this period captured a specific historical atmosphere and evoked the complex relationships of past, present and uncertain future that were embodied in broken buildings and horrid empty spaces.

The condition of Manchester in 1954 is caught in the inky puddles and crepuscular barren terrain in the foreground and the subtle range of grey tones and veils of mist and smoke behind (fig. 33). Framed by the black outlines of leafless trees, the only remaining signs of nature, three children stroll towards the camera and the desolate landscape of water-filled craters and abandoned, broken matter. There is an extraordinary and unexpected power in the grainy depths of this photograph that opens up an entire world and reveals the quality of everyday life in the industrial north of England nearly ten years after the end of the war. Although many writers and artists in these years regarded grey as the tone of austerity and the colour of hardship, there was clearly also a nuanced register of greys, of blackness and whiteness, which photographers, etchers and printers exploited in order to convey the feel and experience of post-war Britain.[5]

Many press photographers and picture editors were aware that pictorial atmosphere formed the basis of an essential, if allusive, visual quality of post-war photojournalism (fig. 34). Bill Brandt, who was regarded as one of the most 'contrasty' photographers on *Picture Post*'s staff, described atmosphere as 'the spell that charged the commonplace with beauty. And still I am not sure what atmosphere is. I should be hard put to define it. I only know it is a combination of elements, perhaps most simply and yet most inadequately described in terms of lighting and viewpoint, which reveals the subject as familiar and yet strange.'[6] Brandt gropes towards defining atmosphere, suggesting that it arises from a combination of technical choices that create an overall aesthetic effect that borders on the uncanny. The claim that the visual qualities of black and white photography were uniquely able to create this kind of photographic atmosphere was made more emphatically by Wilson Hicks, executive editor of *Life* magazine. In his introduction to photojournalism published in 1952, he wrote:

Picture Post, 16 January, 1954

33 Slim Hewitt, 'The Old Industrial Scene that is a Scar on the City's Face',
Picture Post, 16 January 1954, p. 41.

[The black and white] picture, in losing the realism which color provides, gains in its ability to interpret emotion and mood . . . this world of black and white photography is, in a very particular sense, a different world, and the difference serves to give a particular emphasis to what it portrays . . . It imparts a special meaning to everyday life, a shock of recognition to the too familiar.

34 Bill Brandt, 'Things We Have Left Undone', *Picture Post*, 5 December 1953, p. 17.

. . . the color picture does not contain, within itself, an interpretive capacity comparable to that which accrues to black and white through its translation into the gray scale.[7]

Hicks was one of many working in the visual media in the post-war years who understood that what was called 'black and white' was in fact a multiplicity and accumulation of shades of grey.

Black and white news photography may be less realistic than colour, but this uncoupling of 'grey scale interpretation' from verisimilitude provides a space for the creation of much greater effect and a more poetic treatment of everyday life. Both Brandt and Hicks are aware of the particular look and feel of post-war black and white photojournalism and, to some degree, are able to articulate what it is about the light, the point of view and the tonal reproduction that creates these effects. Visual effect in this context is created through a dialogue between colour and black and white film and between the narrative and temporal qualities of still and moving images; it is through these relationships that the effects of post-war photography are produced.[8]

Six years of war damaged both the physical and psychic fabric of Britain. The worst air raids on Britain were carried out in the early years of the war and were concentrated on a relatively small number of cities and towns. The impact of the air attacks was devastating, with houses and whole streets destroyed and hundreds of thousands of people made homeless. In the nine months between September 1940 and May 1941, the main period of the Blitz, London took the brunt of the bombing and was the target of over half the night raids on Britain at this time. Retaliatory raids were ordered on German cities, and on 28 March 1942 the historic old town of Lübeck suffered massive destruction. Hitler ordered reprisal raids against historic British towns such as Exeter, Bath and York in a series of bombings that became known as the Baedeker raids, in reference to the Nazi claim that they would work their way through the famous Baedeker German tourist guides to Britain. From 1944 flying bombs and V2 rockets unleashed another ferocious wave of attacks that destroyed or damaged large numbers of dwellings, particularly in the south-east of England. By the end of the war, bomb damage was concentrated in London and a relatively small number of British cities; it was most visible in urban and industrial centres, where wrecked buildings or cleared sites were the inevitable scars of six years of aerial bombardment. From as early as 1941 there were governmental plans to reconstruct the bombed areas of the country, and it was quickly appreciated that the destruction could be utilized to expedite the process that had been started in the interwar period of clearing and rebuilding old slum areas. Plans were produced and legislation such as the 1944 Town and Country Planning Act (known as the 'Blitz and Blight' Act) was put in place to prepare for the reconstruction of the nation in peacetime. Housing was the immediate priority for the post-war government, and the nation returned to peace amongst a shattered landscape of broken buildings and empty spaces that was to be a key factor in the historical experience of the post-war period.[9]

The social, historical and cultural significance of certain kinds of ruins was fully understood during the war years. Photographs of bomb-damaged buildings were reproduced throughout the war in the daily and weekly newspapers. The traditional page layout of the *Illustrated London News*, with its decorative frames and mosaic of images, tended to draw out the pictorial qualities of the images through techniques such as the repetition of broken arches and shattered Gothic columns (fig. 35). Alongside the illustrated press a number of photo books were also published recording the ruins of historically significant buildings, and it is clear that the bombing produced a new and, perhaps surprisingly, acute appreciation of the beauty of ruins during the war years.[10] There appeared to be little discomfort in acknowledging the pictorial effects of bomb damage; they were vivid, spectacular, picturesque and even surreal, and they needed to be recorded before they were cleared away or robbed of their visual appeal. Photographers such as Cecil Beaton drew on a small range of formal devices, such as distant buildings seen through a wrecked arch or foreground damage and smoke leading the eye into the middle distance, to turn blasted churches into picturesque ruins (fig. 36). Architectural historian J. M. Richards, author of *The Bombed Buildings of Britain*, which was published by the Architectural Press in 1942 and in a second edition in 1947, described the romantic beauty in the bomb ruins:

> The architecture of destruction not only possesses an aesthetic peculiar to itself, it contrives its effects out of its own range of raw materials. Among the most familiar are the scarified surfaces of blasted walls, the chalky substance of calcined masonry, the surprising sagging contours of once rigid girders and the clear siena colouring of burnt-out brick buildings, their rugged cross-walls receding plane by plane, on sunny mornings in the city.[11]

These tottering structures still existed as powerful architectural forms that were monuments to the past and reminders of the end of an era; Richards praised their 'intensely evocative atmosphere', which recalled 'the dissolution of our pre-war civilisation'.[12] Richards and other architectural writers found something still and restful in these ruins, a quality that whilst created by destruction was paradoxically complete. The granular forms of this 'architecture of destruction' and their re-presentation through the formal strategies of black and white photography were easily assimilated into the vocabulary of the romantic ruin. More than any other medium photography was seen both during and after the war to have achieved the transformation of sudden destruction into reposeful beauty; as one journalist writing in 1951, the year of the

FAMOUS LONDON BUILDINGS DAMAGED IN RECENT RAIDS.

WANTON DESTRUCTION : ST. BRIDE STREET, FORMER HOME OF "THE ILLUSTRATED LONDON NEWS," AFTER A RECENT HEAVY RAID. (Central Press.)

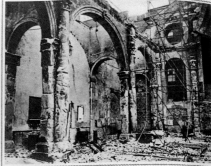

ALL THAT REMAINS OF THE HISTORIC CHURCH OF ST. MARY-LE-BOW, CHEAPSIDE, HOME OF THE FAMOUS BOW BELLS. (Central Press.)

CHARTERHOUSE BADLY DAMAGED : THE GREAT HALL, WITH ITS HAMMER ROOF AND MINSTRELS' GALLERY DESTROYED BY FIRE. (A.P.)

REPAIR WORK AT THE ABBEY. THE LANTERN, RECENTLY DESTROYED, WILL BE REPLACED TEMPORARILY BY A "LID" OF STEEL AND CONCRETE. (Keystone.)

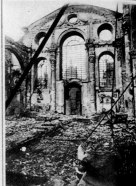

ANOTHER "VISTA" OPENED TO ST. PAUL'S : A VIEW OF THE CATHEDRAL, SEEN THROUGH A BROKEN WINDOW-FRAME IN ST. MARY-LE-BOW.

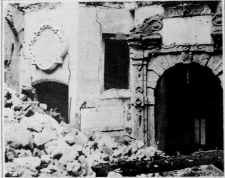

FOURTEENTH-CENTURY BUILDINGS DESTROYED : MEMORIAL TABLET, IN CHARTERHOUSE CLOISTERS, TO ROGER WILLIAMS, SCHOLAR, 1624, FOUNDER OF RHODE ISLAND. (A.P.)

SORRY REMAINS OF A FAMOUS LIBRARY : THE CHARTERHOUSE LIBRARY, BUILT BY THE DUKE OF NORFOLK TOWARDS THE END OF THE 16TH CENTURY. (A.P.)

Further bomb damage to famous London buildings has now been revealed, and many landmarks have succumbed to German ruthlessness. In St. Bride Street the gutted home of "The Illustrated London News," happily removed in time, can be seen, whilst further east the church of St. Mary-le-Bow may have to be demolished. This church takes its name from the fact that it was the first church built in England upon arches, or bows, of stone, and Wren rebuilt it at greater cost than most of his others. The famous bells are fortunately safe, having been previously dismantled. Most of the beautiful old Tudor buildings of Charterhouse have been demolished, but the ancient chapel of the Carthusian monastery, in which the famous Charterhouse School had its origin, escaped. The fine Elizabethan ceiling in the great hall is destroyed, but fortunately the screen and much of the panelling are undamaged. The library, less valuable books, was burnt out.

35 'Famous London Buildings Damaged in Recent Raids', *Illustrated London News*, 14 June 1941, p. 776.

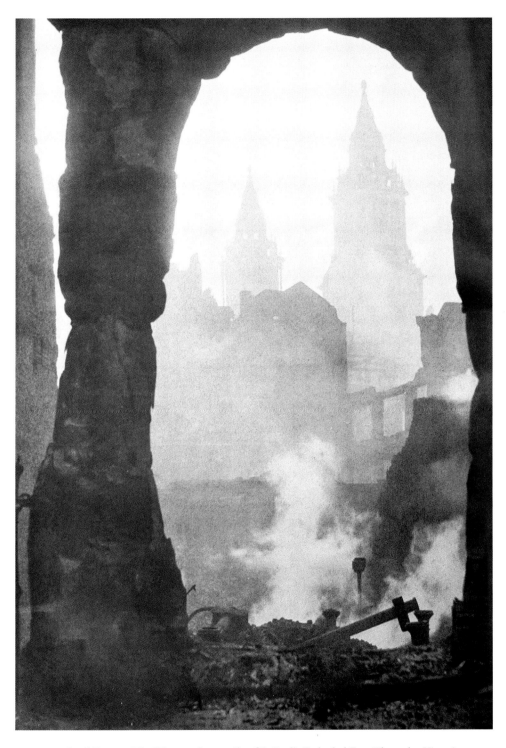

36 Cecil Beaton, 'The Western Campanile of St Paul's Cathedral Seen Through a Victorian
Shop Front', as reproduced in J. M. Richards, *The Bombed Buildings of Britain*, 2nd edn
(London: Architectural Press, 1947), p. 2.

Festival of Britain, put it: 'The camera . . . has done better work than the pen, and we turn to Cecil Beaton's photographs of ruins for an eerie beauty in destruction.'[13]

By August 1944 the appreciation of ruins was so thoroughly installed in the national way of seeing that a number of key figures in British political and cultural life, including Kenneth Clark, John Maynard Keynes and T. S. Eliot, sent a letter to *The Times* calling for the preservation of certain ruined City of London churches as commemorations of the past. This proposal had already been outlined in the *Architectural Review* and, following the letter to *The Times*, a book was published by the Architectural Press in 1945 with designs for gardens and seated sanctuaries and the integration of bomb-damaged churches within new buildings and developments.[14] During and immediately after the war certain ruined monuments were interpreted through the enduring and traditional aesthetics and values of the Romantic movement. Although created suddenly and traumatically by warfare, the remains were pleasing and moving; they had introduced a new and unexpected beauty into the city landscape and were a fitting way to commemorate the war. The post-war picturesque ruin was a historical palimpsest that conjured many different moments and memories; it was an evocative trace of the past within the present and a poignant reminder of the frailty of the future.

To see the ruins of war in these terms is, necessarily, to see them through a filter of art and aesthetics and to block out the violent or fatal conditions of their making. During these years of ruin lust, there were some who were not yet able to eliminate these associations and for whom the past was too recent to transform into architectural fantasy. Amongst this group was the writer and novelist Rose Macaulay, who made the ruins the setting for her fiction and her non-fiction work. In her scholarly study *Pleasure of Ruins* (1953), which ran from the Roman world to the present day, she saw a disjuncture between the aesthetic and associational pleasures of ancient ruins and the bomb ruins of recent years. Modern ruins are no longer playful, intellectual or mystical; they are too recent, too raw and have 'no pleasure . . . no dignity'. Until time engulfs them in ivy and nature recolonizes the broken stone, the only emotion they arouse is anger: 'stark and bare, vegetationless and creatureless; blackened and torn, they smell of fire and mortality.'[15]

There were material traces of the war, however, that not even time could mellow or soften and which spoke only of desolation and of a fearful age. For those who appreciated the beauty of ruins, there was a keen sense that if they were not preserved, both physically and through photography, the remains would soon be cleared and forgotten, that their disappearance would

be as sudden as their creation.[16] It turned out, however, that things did not move as quickly as was originally anticipated and that the traces of war that seared themselves into the cultural imagination were not the picturesque structures of ruined monuments but the cleared sites where unsafe buildings had been flattened and where only outlines of foundations and debris remained.

To write about the bombsites of post-war Britain is also, necessarily, to write about reconstruction; they were two sides of the same sets of issues and concerns. Devastation and development, destruction and planning, horrid empty spaces and modern friendly habitations were equal and connected aspects of the post-war urban landscape. As one of many similar articles in *Picture Post* made clear: 'German bombs demolished in a few moments the properties which had been condemned as insanitary for years.'[17] The war was regarded by many central and local government officials as an opportunity to complete the process, started in the 1930s, of clearing the Dickensian slums that still covered large areas of London and other major industrial cities, and reconstruction became the mantra of Britain's imagined post-war future. But, as *Picture Post* observed, aerial bombardment had been haphazard; it had created not ruinous beauty but a landscape that was an irregular mix of old slum properties, modern flats and 'derelict open spaces'. This is the unresolved topography depicted on page 9 of the issue of 22 January 1949 (fig. 37). Modern low rise housing abuts the broken walls of Victorian terraces; empty window boxes await new tenants to fill them with prize-winning horticulture; and in a devastated corner shabby reeling houses terminate abruptly in walls that are shadows of former existences and silhouettes of past lives – domestic life torn open for all to see. And then . . . nothing, flatness, plots where houses once stood and that are now marked out in rubble and wilderness.

Bombsites are very different spaces from ruins; there were no plans to preserve them as sites of official memorialization. They were ugly, desolate and empty. They did not arouse the pleasures associated with contemplating ruins, or reflections on time and natural decay. The bombsite only offered stump-ends of buildings and meaningless rubble that were tenuously attached to the fabric of a shabby past and suspended in an irregular and dysfunctional present. In 1949, when *Picture Post* published its article on the future of London housing, it might have seemed that bombsites would soon become a thing of the past, but in many cities, including London, they persisted well into the 1950s and 1960s. Their presence is palpable and compelling in novels, paintings and films throughout this period, and they find their preeminent visual expression on the pages of *Picture Post*.

WHERE OLD MEETS NEW: *Rents Are Low in These Model Council Homes*
The south side of the new Limehouse Fields area, looking through old property which will soon be rebuilt. Rents range from 7s. 8d. a week inclusive, for one-room flats for old people, to 22s. 9d., for a five-room family flat, and 27s. 3d., for a five-room two-storeyed cottage with a garden.

Where Lifts Carry Tenants to Their Flats
There are window-boxes on the public front balcony. Competitions for their cultivation will be run.

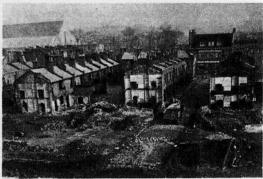

Scope for To-morrow's Big Developments
A corner of the Limehouse that is mercifully passing. The derelict open spaces it enjoys are there only because bombs destroyed the buildings around them.

9

37 'Housing: London Shows How', *Picture Post*, 22 January 1949, p. 9.

THE ARCHITECTURAL REVIEW VOLUME CII NUMBER 609 SEPTEMBER 1947 THREE & ...

38 John Piper, 'Detail of a Stone Wall of Hamsey Church',
Architectural Review, September 1947, cover photograph.

Bombsites create an aesthetic that prioritizes texture and reduces colour to a subtle range of dust and broken brick tones. Although the British artist John Piper had a picturesque and romantic sensibility, he believed that bomb damage had also created the setting for the modernist exploration of texture seen in the work of Picasso, Ernst and Mirô.[18] In September 1947 the *Architectural Review* used a photograph by Piper as its cover image; it is a detail of a stone wall of Hamsey church in Sussex, and it is an image of pure surface texture and of visual effects created by the lights and shadows of the patina of the stone (fig. 38).[19] It is an image that demands to be touched as much as seen. Like the ancient wall of the stone church, bombsites

also could not be smooth or polished; they were spaces that created tactile surfaces: stray shards and chunks of stone; crumbling grounds; broken, crunching matter that needed deep shadows or thick impasto. This is the painted surface of Frank Auerbach's series of pictures of London building sites, made between 1952 and 1962. Auerbach was born in Berlin to Jewish parents. In 1939 he was evacuated to England; his parents remained in Germany and were both killed in concentration camps during the war. In 1947 Auerbach moved to London and in the following year attended St Martin's School of Art.[20] In a later interview, Auerbach recalled the craggy topography of post-war London: '[London] was pitted with bombsites gradually turning into building sites because people were rebuilding what had been destroyed. And there was . . . a sense of survivors scurrying among a ruined city . . . London after the War was a marvellous landscape with precipice and mountain and crags, full of drama formally.'[21]

In his 1950s canvases of the building sites in Oxford Street, Earl's Court and around St Paul's Cathedral, the paint surface is thick, heavy, folded, wrinkled and carved (fig. 39). It is worked and reworked, creating successive layers of paint that stand out in relief, often an inch or more in depth. And then, when these masses of impasto are created, Auerbach gouges the surface with his finger or the end of his paintbrush. There is an extraordinary symbiosis between the muddy facture of Auerbach's subjects and the thick grey matter on his canvases; as one critic put it in 1959: '[Auerbach] bulldozes his thick, glutinous pigment across the canvas to convey an exact sense of the intractable mounds of clay.'[22] The paintings capture the transitional condition of post-war Britain; neither entirely destroyed nor yet properly remade, they oscillate between these two states, suspended between the formlessness of the bombsite and the emergent forms of scaffolding and building.

Auerbach's work on the post-war construction sites might be described as painted tactilities, images that fully respond to the sensory experience of the landscape. The bombsites exposed the archaeological layers of the city, but without logic or purpose: layers of peeling paint, discoloured and broken brick and wood, mould and wildlife that constituted a strange and often perilous context for modern life. In Rose Macaulay's 1950 novel, *The World My Wilderness*, seventeen-year-old Barbary Deniston is sent to London by her mother, having spent the war in Provence, where she was involved with the French resistance (fig. 40). Leaving her bohemian mother and her independence behind her, she goes to live with her respectable father and his conventional new young wife. Barbary finds this life stifling, and it is only wandering in the bombed wastelands around the City of London that she is able to recapture her former

39 Frank Auerbach, *Oxford Street Building Site I*, 1959–60,
oil on board, 198.1 × 153.7 cm, Tate, London.

spirit and imagination. The plot provides the framework for extended passages describing the bombed landscape, and the novel is a paean to its danger and fantasy. It is a world haunted by ghosts of the past and shadowy existences lived in the semi-shelter of the ruins. Barbary and her brother Raoul find a parallel city in the ruins, a wilderness of caves and cellars, grown over with ragwort, willow herb and bracken, where they live out a dream world as the London resistance movement:

all this scarred and haunted green and stone and brambled wilderness lying under the August sun, a-hum with insects and astir with secret, darting, burrowing life, received the

40 Barbara Jones, cover image for Rose Macaulay, *The World My Wilderness* (London: Collins, 1950).

returned traveller into its dwellings with a wrecked, indifferent calm. Here, its cliffs and chasms and caves seemed to say, is your home; here you belong; you cannot get away, you do not wish to get away, for this is the maquis that lies about the margins of the wrecked world, and here your feet are set; here you find the irremediable barbarism that comes up from the depth of the earth, and that you have known elsewhere.[23]

Ultimately, the ruins are a place of judgement and reconciliation for Barbary, when she suffers a terrible fall running from the police and is reunited with her mother and gradually comes to understand her past.

Bombed ruins are everywhere in British film during these years; much more than a backdrop, they create the *mise en scène* and often drive the narrative. A number focus on the lives of children in the ruins, a blend of excitement and danger, in which they are brought into direct contact with criminal gangs, fugitives and murderers. In *Hue and Cry*, a 1947 Ealing Studios film, directed by Charles Crichton, a gang of young boys (and one girl!) play in the bombsites of east London and Docklands (fig. 41). When they come across a group of robbers they team up with other gangs of children and, in the film's most well-known scene, hundreds of boys converge on a bombed out location to defeat and capture the criminals. The ruins are the boys' environment, a dangerous playground where things can easily get out of control. *The Yellow Balloon* (UK, 1953; dir. J. Lee Thompson) begins with a young boy, Frankie Palmer, losing the money that his father has given him to buy a glorious balloon from a street seller. Instead, he snatches his friend's balloon and is chased into the bombed out ruin of a house (fig. 42). They run across precarious walls and slender, broken beams, and Frankie's friend falls to his death. This is witnessed by a criminal, Len Turner, who is on the run from the police and hiding in the ruined house. Len convinces Frankie that the police will charge him with the murder of his friend and coerces him into stealing money from his parents and helping him with a robbery. During the robbery Frankie sees Len committing a murder, and as Len realizes that Frankie is the only witness he chases the boy through a bombed and terrifyingly dangerous abandoned Underground station (fig. 43).

Bombed ruins are dark, secret places, on the fringes of normal society, where people can hide and be hidden. In Edward Dmytryk's 1949 film *Obsession*, a doctor exacts revenge on his wife's adultery by kidnapping her lover and imprisoning him in a bombed house, where he prepares to kill him and dispose of the body in an acid bath. In children's thrillers, crime films and in comedies the bombsites turn the world upside down, creating a space that is, for a moment at least, beyond the law and morality. Location shooting meant filming in and around the bombsites and exploring their imaginative spaces. *Passport to Pimlico* (UK, 1948; dir. Henry Cornelius) opens with children playing during a heatwave in the middle of great swathes of bomb ruins and residents and local councillors debating whether they should sell the plot to developers or turn it into a playground. When an unexploded bomb is accidentally detonated,

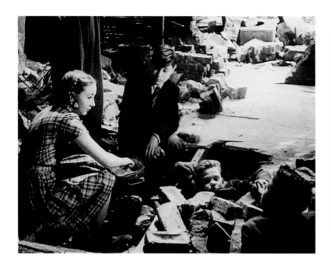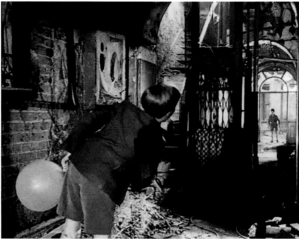

41 Gang of children in the bomb ruins, *Hue and Cry* (UK, 1947; dir. Charles Crichton), frame still.

42 Frankie and his friend in the bomb ruins, *The Yellow Balloon* (UK, 1953; dir. J. Lee Thompson), frame still.

an ancient document is discovered that seems to prove that Pimlico is, in fact, part of Burgundy and the residents declare independence from the rest of Britain, exempting themselves from rationing and other forms of post-war bureaucracy (fig. 44). Cut off from electricity, food and water, the 'Burgundians' hold out against government officials until a compromise is negotiated and a torrential downpour proves that they are once again part of Britain.

There was no getting away from the real and imagined experience of being amongst the bombsites of post-war Britain. Their strange spaces imposed themselves on the culture of the period and left their traces well into the 1960s.[24] Reconstruction simply took much longer than first envisaged; continued rationing, shortages of materials and financial constraints severely impeded the realization of rebuilding plans, and as a result some city centres retained cleared but empty bombsites throughout the 1950s. Moreover, conflicts between planners and local commercial interests and between local councils and central government also prolonged the rebuilding process. As a Member of Parliament for Southampton observed in 1953: '[one] sees a large number of bare and desolate patches of ground which are covered by . . . willow herb and other wild flowers.'[25] Whilst some welcomed the way that bombsites over the years returned to nature, they were nonetheless empty, troubling and economically unproductive spaces that confounded the modernization of Britain (fig. 45).[26] Even the lifting of building

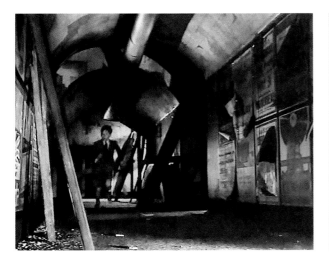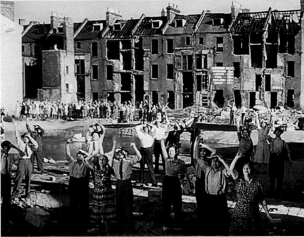

43 Frankie chased by Len into the abandoned Underground station, *The Yellow Balloon*, 1953, frame still.

44 Residents of Pimlico gathered in the bombsite, *Passport to Pimlico* (UK, 1948; dir. Henry Cornelius), frame still.

restrictions in 1954 did little to accelerate reconstruction, and complicated claims and payments for war damage compensation continued to be reported in Parliament until 1961, when it was acknowledged: 'There is a vast volume of files far too large for examination by a normal sized staff . . . claims are likely to trickle in for a great many years.'[27]

In *Picture Post*'s series on 'The Best and Worst of Britain', inaugurated in 1953 by its owner, Edward Hulton, and with photographs by Bill Brandt, the nation's failure to address the problem of bombsites was foremost among 'Things We Have Left Undone' (see fig. 34). The following year, a new series on 'The Best and Worst of British Cities' recorded the continued existence of decaying bombsites throughout Britain. Although 1954 had seen the end of rationing and in that sense marked a new beginning, the persistence of these spaces meant that the hopes of peacetime were still, to a large degree, unfulfilled.

Bombsites were ruined physically and morally; they were spaces that had been severed from their former functions and had instead become the locus of transgressive and subversive behaviour. In a series on 'Sex and the Citizen', *Picture Post* selected an expert panel to discuss sexual attitudes in modern Britain. Lella Florence, who was chair of the Birmingham Family Planning Association, observed: 'My impression is that a good deal of the illicit love-making that goes on in dark streets or in vacant open spaces is between very young people.' And in

THE WILD FLOWERS OF CANNON STREET: A WAYSIDE BOUQUET FROM THE CITY OF LONDON.

The Cannon Street district of the City of London would seem the least likely place for gathering a bunch of wild flowers ; but, as Miss Winifred Walker, F.L.S., the artist who drew the plate above, writes : "These are the flowers, many and varied, which were gathered one sunny morning in mid-June. The search for them began in Lower Thames Street, near to Cannon Street Station, in some of the worst-bombed sites in London. Here, with the dome of St. Paul's looming in the near distance, were found a strange assortment of blooms. A tall, bright toadflax (3. *Linaria purpurea*) stood in a spike of orchid-mauve, to the height of 4 ft. It is a native of Italy, now naturalised in this country. Masses of the willowherb, Codlins-and-cream (7. *Epilobium hirsutum*), grew near. Shorter flowers had, for self-preservation, to choose a fairly open site, and there, on a natural rockery of builder's rubble, was a pale rose snapdragon (12. *Antirrhinum sp.*). The garden marigold

(13. *Calendula arvensis*) glowed brightly in company with the white clover (10. *Trifolium repens*). The common persicaria (15. *Polygonum persicaria*) rambled along the earth and held its pink heads high. The yarrow (9. *Achillea millefolium*) made a sharp contrast with the deep wine colour of the hedge woundwort (8. *Stachys sylvatica*). A tall spear thistle (5. *Cirsium vulgare*) flaunted its royal rose head ; and a little way off grew nipplewort (2. *Lapsana communis*). A lovely grey-mauve poppy (4. *Papaver somniferum*) grew by itself, as though aware it was different—it provides the narcotic opium. Far down in the cellars could be seen a tiny larkspur (14. *Delphinium sp.*) of pure sapphire. Near it was the tall mullein (1. *Verbascum sp.*). A very delicate type of golden rod (11. *Solidago sp.*) was also at home in this company. The common sowthistle (6. *Sonchus oleraceus*) grew in abundance."

45 'The Wild Flowers of Cannon Street: A Wayside Bouquet from the City of London',

Illustrated London News, supplement, 19 June 1954, p. ii.

46 'Bomb-site in London', in 'The Best and Worst of Britain (5)',
Picture Post, 2 January 1954, p. 33.

Lewis Gilbert's controversial 1953 film, *Cosh Boy*, the young and violent juvenile delinquent,
Roy, forces his respectable girlfriend to have sex with him in a bombsite. Bombsites were
where 'spivs' made their deals and carried out their crimes: crepuscular, broken places that
were breeding a corrupt and depraved population (fig. 46).[28] They seemed to draw suspicion,
violence and discontent; in 1955 the race relations writer Michael Banton observed that white
hostility to the colonial immigrant population was, in part, because 'Indecent behaviour in
the alleys and bombed buildings was frequent.' This was the world of bombsites as opposed
to picturesque ruins: murder, rape, prostitution, spivs, homosexuals and black immigrants, the
nightmare antithesis of the ideal new Britain of the planners and improvers.[29]

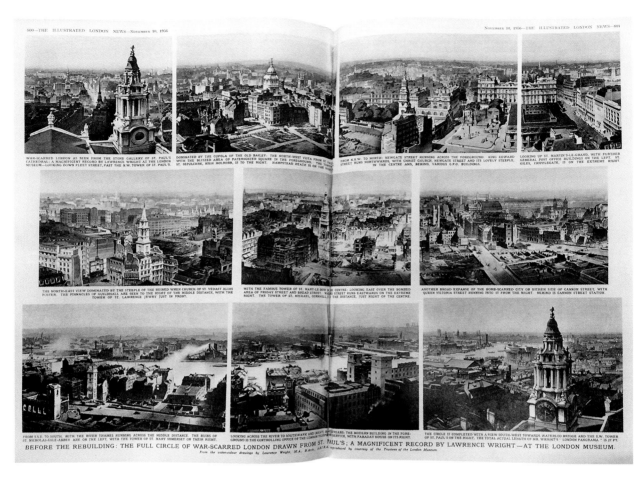

47 'Before the Rebuilding: The Full Circle of War-Scarred London Drawn from St Paul's;
A Magnificent Record by Lawrence Wright – At the London Museum', *Illustrated London News*,
10 November 1956, pp. 800–1.

It is important to capture the potency and texture of these bombsites in the decade follow-
ing the end of the war. They were much more difficult to deal with than ruined monuments.
Ruins had integrity; they could be framed and aestheticized and were places steeped in cultural
memory. The bombsites were wastelands and wildernesses; they were car parks and playgrounds,
places of crime and quick sex. In the years following 9/11 and in the further context of industrial
decline in the late twentieth century, there has been a lot of writing about ruins and wastelands,
and new terms have been formulated to describe their rich suggestiveness. In his work on the

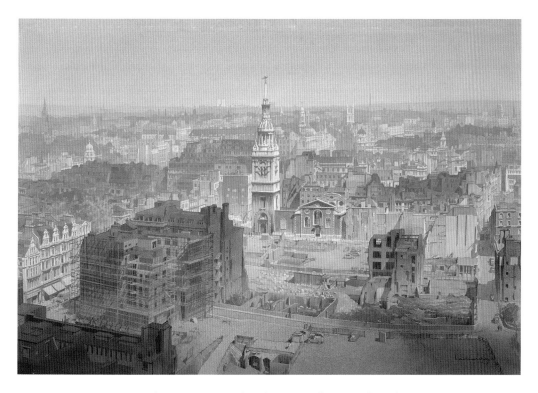

48 Lawrence Wright, *Panorama: View from the Stone Gallery, St Paul's Looking East*, 1948–52,
watercolour on paper, 63.8 × 89.2 cm, Museum of London.

aesthetics of decay, Dylan Trigg has chosen 'site' as a way of embodying the idea of non-place: levelled-out, fragmented and estranged. Elsewhere the category of *terrain vague* has been used to describe 'strange places that exist outside the city's effective circuits and productive structures . . . [the city's] negative image'.[30] They are spaces that elude the projects of reconstruction and into which we can project our fears and desires. Bombsites have lost their sense of purpose and have become sites of gritty and granular shadows, pitted surfaces and reflective puddles.

Between 1948 and 1952, the perspective artist Lawrence Wright produced an extraordinary panoramic sequence of ten large coloured wash drawings drawn from the top of St Paul's Cathedral and showing a 360-degree view of the bomb-damaged city (fig. 47).[31] The colours are muted and delicate, as though a fine mist or dust still hangs over the City (fig. 48). Taken individually and as a sequence, the drawings show the buildings that survived the bombing and the empty gaps where destruction was total. This is a different kind of urban panoramic

view from any that had come before; it is a view within which the spaces and gaps between are as expressive and significant as the built environment. The city has become senseless, disconnected, a place of plots and rubble. The disappearance of familiar buildings and the comprehension of urban space through gaps and absences created a new spatial practice. In a series of two-hour walks published by William Kent in 1947, the author points out gaps as if they are landmarks and plots that are concealed by corrugated iron fences.[32] This new city was compelling and astonishing; shop and road signs now stood next to empty sites and signified nothing.[33] In contrast to the rational space of the planners, the city was now a place of drift and disorientation and dreams (fig. 49). The war had recreated London as a Surrealist space: a cityscape of absences, fragments and relics.[34] This is the nature of the bombsites; just like the fog they undo space and delight in obscurity.

Photo Noir

If Britain's post-war bombsites became spaces of affect and quality, then the medium that gave them their full expression was *Picture Post*. Launched on 1 October 1938, its circulation peaked in the summer of 1939, when it reached 1.7 million copies; its final issue was sold on 1 June 1957. It is important to remember that copies sold are not the same as numbers of readers; issues were shared, kept in waiting rooms and stored at home. As Grace Robertson, a photographer on the *Picture Post* staff recalled: 'I hurried home and dragged copies . . . from a cupboard. I spread them over the floor. Everywhere faces stared back at me . . . the faces of ordinary men and women . . . I said to myself, this is what I want to do. I want to take pictures like these.' For a number of years, during and after the war, *Picture Post* captured the experience and appearance of everyday life in Britain; it shaped and was part of the national consciousness.[35]

Its creator and first editor, Stephan Lorant, was a Hungarian Jew who came to England in the 1930s as a refugee from Hitler's Germany, where he had produced silent films and had been chief editor of the *Müncher Illustrierte Presse*. Lorant brought with him the German photographers who shared his own experience of the new layout and style of continental photojournalism that became a part of the look of *Picture Post* from the beginning. Lorant did not stay long in England; in 1940 he went to the USA and was replaced as editor by Tom Hopkinson, who had been working on the staff of the paper as a contributor and assistant editor.

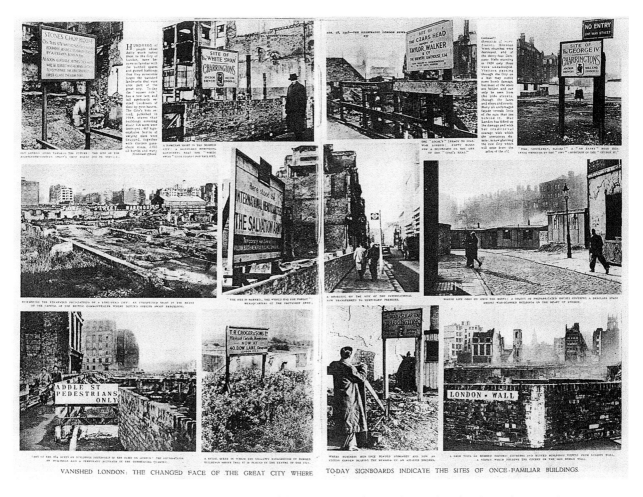

VANISHED LONDON: THE CHANGED FACE OF THE GREAT CITY WHERE TO-DAY SIGNBOARDS INDICATE THE SITES OF ONCE-FAMILIAR BUILDINGS.

49 'Vanished London: The Changed Face of the Great City Where Today Signboards Indicate the Sites of
Once-Familiar Buildings', *Illustrated London News*, 28 February 1948, pp. 236–7.

Stuart Hall has described the distinctive quality of *Picture Post* as a result of the combination
of two 'distinct journalistic traditions': a tradition of documentary reportage that came from
England in the inter-war period and a revolutionary visual style that came from avant-garde
circles on the Continent.[36] Certainly, *Picture Post*, with its simple direct layouts and its emphasis
on a varied use of horizontal and vertical images and bold captions, looked different from its
rival British papers. Photographs dictated the look of the stories; they were frequently bled off
the edge of the pages and printed across the centrefold; the layout was varied and dynamic,

recreating everyday lives and drawing out their power and beauty. Bert Hardy, who was appointed by Hopkinson, claimed that the format had been based on the proportions of a Leica 35mm negative, and although this is unsubstantiated it is certainly true that advances in lightweight roll-film cameras alongside better quality printing papers and developments in printing technologies were central to how the paper looked and the impact of its stories.[37]

Hopkinson remained as editor until 1950 when he was sacked by the publisher, Edward G. Hulton. Hulton had never taken a back seat with his paper. Although, in general terms, the politics of *Picture Post* were left wing, they also reflected the changing party political affiliations of its owner. It supported the 1942 Beveridge Report for a national welfare scheme and the election of the Labour government in 1945; during the second half of the 1940s, however, Hulton began to switch allegiance away from Labour and in 1950 he re-joined the Conservative party. In June 1950 North Korean troops, armed with Soviet equipment, invaded South Korea. With the world apparently on the brink of another war, Hopkinson sent Bert Hardy and journalist James Cameron to report on the conflict, and they returned a powerful story about the treatment by United Nations troops of political prisoners of the South Korean government. In spite of Hulton's objections, Hopkinson published the controversial piece and shortly after was fired from his post. Recalling the telephone conversation in which he told Hopkinson to withdraw the piece, Hulton stated: 'I hold the view . . . that, if a capitalist puts money into a newspaper, as we did, not only has he the right, I think he has the moral duty to oversee the social and political line it takes. I think he has the duty to do so, or he should sell it. This is my view – a rather old-fashioned view, but it is my view.'[38] Although *Picture Post* continued to publish creative stories and photographs that captured the drama and distinctive qualities of everyday life in Britain in the 1950s, circulation figures gradually declined, particularly after 1956. Most blamed the demise of the weekly paper on the growth of television and the resulting decrease in advertising revenue. Hopkinson, however, simply observed: 'I think it just lost its sense of direction and wandered off into the fog.'[39]

For most commentators the golden years of *Picture Post* were between 1940 and 1950, during the editorship of Hopkinson, when the paper, as Stuart Hall remarks, 'offered in print and picture, a staggering visual record of the imprint of mass warfare and its aftermath on a civilian population . . . [stories] in which the character of everyday life in Britain, is strikingly evoked'. *Picture Post* captured not only the appearance but also the experience and feel of ordinary lives in Britain. It was a decade during which social democracy emerged as a form of popular

politics and found its expression on the pages of *Picture Post*, when a set of social circumstances was transformed into a visual language. With the change in Hulton's political support and the sacking of Hopkinson, however, Hall suggests the distinctive 'structure of feeling' changed and *Picture Post* lost its place as the voice of the post-war democracy.[40]

Whilst there is a remarkable synergy between the grey tones of *Picture Post* and the collective national sentiment between 1940 and 1950, a shared commitment to and exploration of human values and the experiences of ordinary people, it did not come to an end as promptly as Hall suggests. Although some of the staff resigned following the sacking of Hopkinson, there was also a significant degree of continuity, and many of the most important journalists and photographers carried on working for the paper. Immediately after Hopkinson's dismissal, his Assistant Editor, Ted Castle, took over and most of the editorial staff stayed on. After six months, Castle left and was replaced by Frank Dowling, a man who had come up through advertising, and in 1953 Edward Hulton temporarily took over the editorship. Through these years of change, writers such as Kenneth Allsop, Trevor Philpot and Hilde Marchant continued to contribute articles with strong social content, accompanied by photographs by Bert Hardy, Haywood Magee and 'Slim' Hewitt. Edith Kay remained in charge of the *Picture Post* darkroom, and the high quality of the magazine's look and layout was still a feature of issues in the first half of the 1950s.[41] Whilst it is true that there was a growing dependency on advertising features and more coverage of Hollywood, royalty and sport, its social commitment did not disappear in 1950.

The end of *Picture Post* was also blamed on the rise of colour illustrated periodicals. Perhaps this is the case; what is certain, however, is that in those years between 1945 and 1955 it published some of the most accomplished black and white press photographs in the history of the medium and took the visual and haptic qualities of the form to new heights. These qualities found a particular reciprocity in images of the battered surfaces of bombsites, and as a result of outstanding etching and printing, these images contain and express the time of post-war Britain in a unique manner.

At the start of 1951 Britain was still experiencing power cuts in peak hours, and readers of *Picture Post* were being warned by British Electricity to cut their use during times of highest demand. Rationing was still in place on meat, eggs, sugar, tea and other staple products. Housing remained the most pressing issue facing planners and politicians. This was the time, the world of *Picture Post*, as it entered the sixth year of peace. 'Millions Like Her' was a six-page article, photographed by Bert Hardy and published in January 1951, on the life of an ordinary

seventeen-year-old girl in Birmingham, living in the overcrowded 'backs' and 'broken streets' of the city, working as a hairdresser and enjoying a happy, if modest, family home. The piece was written by Hilde Marchant, one of a number of women who worked on the paper as journalists and in other key roles; she took over the article from another journalist, Albert Lloyd, who had resigned over the dismissal of Tom Hopkinson. The title drew on a well-known film, made in 1943 by Sidney Gilliat, called *Millions Like Us*, which told the story of a girl's wartime experience working in a munitions factory; it was a celebration of the values and importance of ordinary people during the war. The article in *Picture Post* brought this story up to date: the life of an ordinary girl in peacetime. The look of the first double-page spread is typical of the design of the paper in the Hopkinson years, with its simple direct layout and emphasis on the overall look of the pages with strong vertical and horizontal stress (fig. 50). Photographs are printed up to the edge of the page and across the gutter; they draw the eye and turn readers into viewers.

Bombsites are the landscape in which people like this girl live their lives. Turn the page and there is a large photograph of her playing with younger children in a desolate environment of flattened earth, rubble and smoking terraces: 'The Background of Decay Where Youth Has to Bloom' (fig. 51). This is the bombsite as playground, as a site for the projection of fantasy, where broken stone becomes the surface of Mars or a field hospital. This is a fine photograph; the subtlety of the grey tones is remarkable, ranging from the whites on the girl's back and the shattered hillside to the range of greys that pick out the broken bricks and stumps of walls, and then the deep dark greys of the smoky sky and the blacks of the grimy housing in the background. How well black and white press photographs render the grain of this landscape, the materiality of this world; it is as though the dots of ink have become the particles of stone and brick that litter the hillside. Three years later the paper chose this image for its subscriptions promotion: 'Pictures That Count'. The editorial knew that this was what drew its readers: 'pictures that excite, amuse, inform and divert' (fig. 52). The photograph offers more than distraction, however; the patina of the landscape holds layers of memory and transforms an image of ordinary life into something far more extraordinary.

Time is complex in these images of bombsites. Take, for example, a photograph of 'The Birmingham of Yesterday', where children clamber over the troughs and mounds of cleared space, extemporizing a playground from this ragged, incoherent landscape and turning desolation into play (fig. 53). The caption quotes the Lord Mayor: 'we can transform the city in

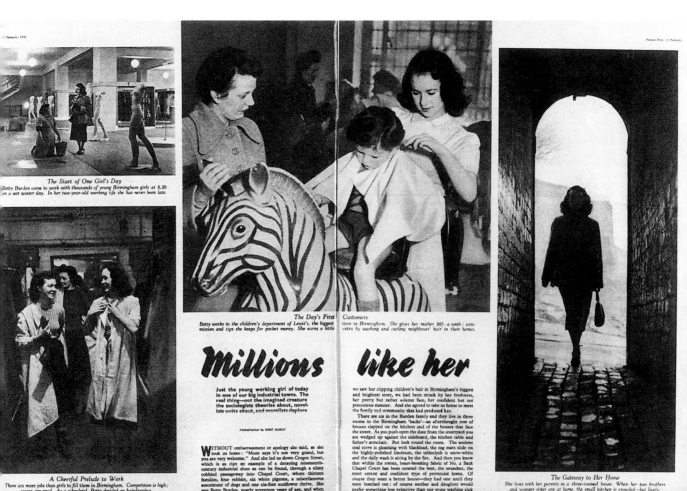

The Start of One Girl's Day
Betty Burden came to work with thousands of young Birmingham girls at 8.30 on a wet winter day. In her two-year-old working life she has never been late.

A Cheerful Prelude to Work
There are more jobs than girls to fill them in Birmingham. Competition is high; wages are good. As a schoolgirl, Betty decided on hairdressing.

The Day's First Customers
Betty works in the children's department of Lewis's, the biggest store in Birmingham. She gives her mother 30/- a week : commission and tips she keeps for pocket money. She earns a little extra by washing and curling neighbours' hair in their homes.

Millions like her

Just the young working girl of today in one of our big industrial towns. The real thing—not the imagined creature the sociologists theorise about, novelists write about, and moralists deplore

Photographed by BERT HARDY

WITHOUT embarrassment or apology she said, as she took us home : "Mum says it's not very grand, but you are very welcome." And she led us down Cregoe Street, which is as ripe an example of a decaying nineteenth-century industrial slum as can be found, through a slimy cobbled passageway into Chapel Court, where thirteen families, four rabbits, six white pigeons, a miscellaneous assortment of dogs and one six-foot sunflower thrive. She was Betty Burden, nearly seventeen years of age, and when

we saw her clipping children's hair in Birmingham's biggest and brightest store, we had been struck by her freshness, her pretty but rather solemn face, her confident but not precocious manner. And she agreed to take us home to meet the family and community that had produced her.

There are six in the Burden family and they live in three rooms in the Birmingham 'backs'—an afterthought row of houses slapped on the kitchen end of the houses that face the street. As you push open the door from the courtyard you are wedged up against the sideboard, the kitchen table and father's armchair. But look round the room. The ancient coal stove is gleaming with blacklead, the rag mats slide on the highly-polished linoleum, the tablecloth is snow-white and the daily wash is airing by the fire. And then you know that within the rotten, heart-breaking fabric of No. 2 Back Chapel Court has been created the best, the soundest, the most serene and confident type of provincial home. Of course they want a better house—they had one until they were bombed out : of course mother and daughter would prefer something less primitive than one stone washing sink
Continued overleaf

The Gateway to Her Home
She lives with her parents in a three-roomed house. When her two brothers and younger sister are at home, the small kitchen is crowded—but lively.

50 Hilde Marchant, 'Millions Like Her', photographs by Bert Hardy, *Picture Post*, 13 January 1951, pp. 10–11.

twenty years'; this is an image not of the past but of a present that should rightly belong in the past and that is suspended in time as it awaits a better future.[42] Shades of grey hang like veils between the foreground and the background, between the sharp shadows of the wasteland and the smoky outlines of the houses and chimneys. In 1952 Wilson Hicks, former editor of *Life* magazine, made the following terse but highly penetrating observation: 'Photojournalism makes space do the work of time.'[43] This is precisely what happens in *Picture Post*; the photographs have a grainy shadowy depth that conveys time as it depicts distance.

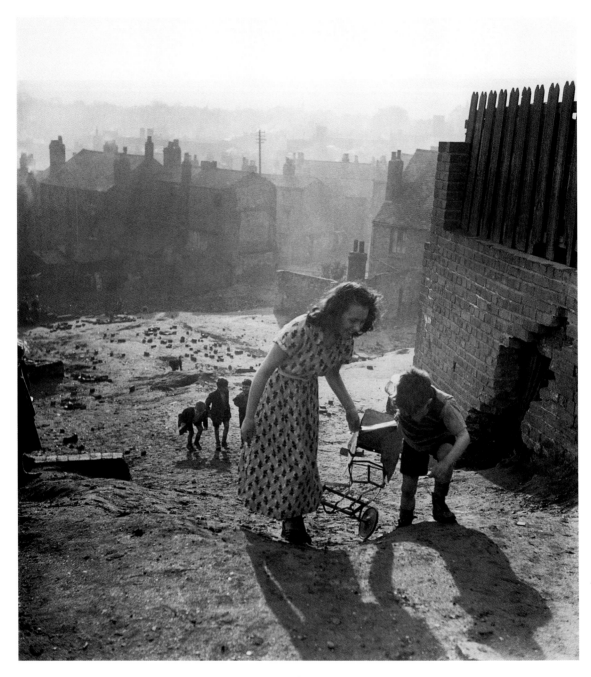

51　Bert Hardy, 'The Background of Decay Where Youth Has to Bloom',
Picture Post, 13 January 1951, pp. 12–13.

(*Facing page*) 52　Bert Hardy, 'Pictures That Count', *Picture Post*, 13 February 1954, p. 46.

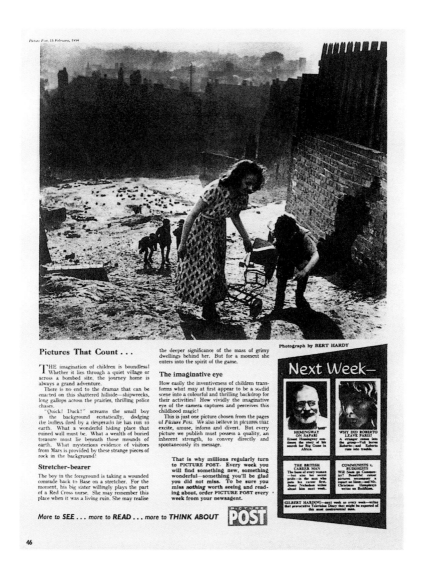

Picture Post, 13 February, 1954

Pictures That Count . . .

Photograph by BERT HARDY

THE imagination of children is boundless! Whether it lies through a quiet village or across a bombed site, the journey home is always a grand adventure.

There is no end to the dramas that can be enacted on this shattered hillside—shipwrecks, long gallops across the prairies, thrilling police chases.

"Quick! Duck!" screams the small boy in the background ecstatically, dodging the bullets fired by a desperado he has run to earth. What a wonderful hiding place that ruined wall must be. What a wealth of buried treasure must lie beneath those mounds of earth. What mysterious evidence of visitors from Mars is provided by these strange pieces of rock in the background!

Stretcher-bearer

The boy in the foreground is taking a wounded comrade back to Base on a stretcher. For the moment, his big sister willingly plays the part of a Red Cross nurse. She may remember this place when it was a living ruin. She may realise

the deeper significance of the mass of grimy dwellings behind her. But for a moment she enters into the spirit of the game.

The imaginative eye

How easily the inventiveness of children transforms what may at first appear to be a sordid scene into a colourful and thrilling backdrop for their activities! How vividly the imaginative eye of the camera captures and perceives this childhood magic!

This is just one picture chosen from the pages of *Picture Post*. We also believe in pictures that excite, amuse, inform and divert. But every picture we publish must possess a quality, an inherent strength, to convey directly and spontaneously its message.

That is why millions regularly turn to PICTURE POST. Every week you will find something new, something wonderful—something you'll be glad you did not miss. To be sure you miss *nothing* worth seeing and reading about, order PICTURE POST every week from your newsagent.

More to SEE . . . more to READ . . . more to THINK ABOUT **POST**

Next Week—

HEMINGWAY ON SAFARI
Ernest Hemingway continues the story of his search for Big Game in Africa.

WHY DID ROBERTO LEAVE PARIS?
A stranger comes into the group—Vali leaves Roberto—and Roberto runs into trouble.

THE BRITISH CAREER MAN
The boss of every woman —but also her secret pride—is the man who puts his career first. Jenny Nicholson writes about him next week.

COMMUNISTS v. BUDDHISTS
Will Siam go Communist? Beautiful colour pictures accompany a report on Siam—and Mr. Christmas Humphreys writes on Buddhism.

GILBERT HARDING—next week as every week—writes that provocative Television Diary that might be expected of this most controversial man.

46

The aesthetics of the black and white tonal range and its register of values were highly regarded by photographers, journalists and editors both in the 1950s and more recently. The British journalist and former editor of *The Times* and *Sunday Times*, Harold Evans, referred in 1978 to 'the capacity of the black and white photograph for subtlety, rich sensitivity of detail and graphic urgency'. Its potency lies in its urgent presence and its sense of historicity, its sooty gravure surface seeming to convey past and present in a single layered image.[44] The term 'film noir' was first used in the 1950s by French film critics to label a cycle of American crime

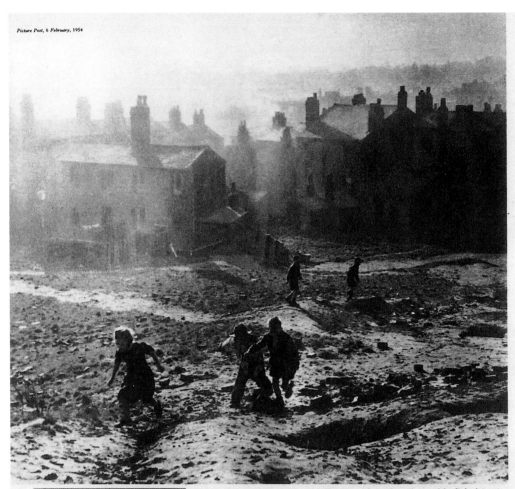

THE BIRMINGHAM OF YESTERDAY *Children play above the cramped 'back-to-back' houses of Cregoe Street, in one of five Redevelopment Areas. "If nothing hinders us," said the Lord Mayor, "we can transform the city in twenty years."*

THE BEST, AND THE WORST, OF BRITISH CITIES: 4

BIRMINGHAM

A thriving city. A city with work for all; industrial, and industrious. Yet, overall, a drab, dull city, bursting at the seams. BRIAN DOWLING and BERT HARDY, the photographer, show the price which Birmingham paid for greatness; and the energy with which her citizens have turned to make her once again a worthy capital of the Midlands

BIRMINGHAM, nearly enough, is the geographical centre of England; and when you get there you go round in circles. Her city centre boasts the most complicated system of one-way streets anywhere in the world. Eighteen months ago, a business man from Bristol drove round the centre for an hour and ten minutes in a growing fury, and flung a £5 note at the Birmingham citizen who eventually got him out of it. The man didn't know how lucky he was. Before the first one-way scheme was introduced in 1933—the best of forty that were considered—he wouldn't have been able to move at all.

For the heart of Birmingham just happened. On the site, and plan, of a small mediaeval hamlet, worth 20s. in the Domesday Book, Britain's second city grew just as fast as the Industrial Revolution, and Birmingham, today, is caught in the net of her own prosperity. Her basic problem is a physical one.

Placed on the edge of the great South Stafford-shire coalfield, half way between London and

30

53 Bert Hardy, 'The Birmingham of Yesterday', *Picture Post*, 6 February 1954, p. 30.

films that were characterized by moral ambivalence, dark urban settings and a particular visual style. In a recent study, Andrew Spicer defined these visual qualities as 'high contrast (chiaroscuro) lighting, where deep, enveloping shadows are fractured by shafts of light from a single source . . . decentred, unstable compositions . . . fog or mist'.[45] Exterior locations are often anonymous and transient: hotels, unlit alleys, and abandoned and disused spaces that become threatening and confusing. Without simplifying the complex cultural influences that marked out the development of film noir, its arresting visual style, with its emphasis on deep shadows and fascination with the dark, wet streets and desolate spaces of the city, can also be seen in post-war photojournalism: what might be termed British photo noir, with its deep exploration of the lights and shadows of black and white film. The years between 1945 and 1955 were the zenith of the visual language of black and white. People saw the world in its terms and sought a language to express its potency. They saw it on the pitted and scarred buildings, the weathered and

THE LAUNDRY'S GAIN, OUR LOSS
A sample of dust pollution emitted from a North London laundry chimney. The photograph shows 3.3 grammes of filth and is a random sample taken from 1 sq. ft. after 24 hours. The modest gardens in the neighbourhood are about 250 sq. ft., so that each gets 825 grammes (over 1¾ lb.) a day. In a year each garden will be contaminated with 301,125 grammes, i.e., 5¼ cwt.

54 'The Laundry's Gain, Our Loss', *Picture Post*, 31 October 1953, p. 16, detail.

soot-stained brick; they saw it in the sky and they even noticed it in the air. In the autumn of 1953, following the Great Fog of December 1952, *Picture Post* started its campaign for clean air that included a photograph of dust pollution emitted from a north London chimney (fig. 54). This image of filth could so easily be a patch of bombed land or a close-up of a gravured photograph. Post-war Britain excelled in the optical textures of blackness and whiteness; it was what gave it its intensity and atmosphere and was captured in the photo noir of *Picture Post*.

The history of twentieth-century press photography is invariably told through the revolution in camera technology: the development in the late 1920s and early 1930s of small, compact, versatile cameras, with built-in range-finders and interchangeable lenses, using roll-film rather than plates, which allowed exposures to be made in quick succession. Whilst it is undeniable that these changes transformed the work of the news photographer, I have come increasingly to feel that other histories are of equal importance in understanding the visual culture of the news in the post-war years. When Bert Hardy published his autobiography in 1985 he specifically thanked in the acknowledgements the printers who worked on the book. Hardy knew how important they were in achieving the look of his photographs – the highly skilled and appropriately unionized etchers and printers who translated the photographic image into

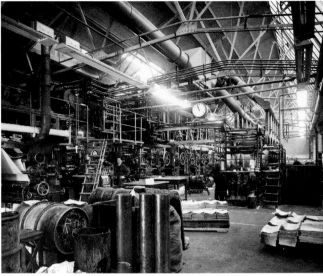

55 'Loading *Picture Post*', *c.*1951. Sun archives.

56 'View of the Gravure Pressroom', 1954. Sun archives.

layers of ink, who retouched the shadows and sharpened the highlights, who judged the dur-
ation of etching, and who ensured and enhanced the drama of the image. Without them, the
photograph was not a news image.

Throughout its life, *Picture Post* was printed at the Sun Printers Ltd in Watford, north of
London (fig. 55).[46] The company had specialized in photoengraving since the early twentieth
century and continued developing new techniques of rotary gravure printing and researching
new types of inks throughout the century (fig. 56). *Picture Post* was produced through an in-
taglio printing method, which means that the ink that makes up the image sits in hollows in a
metal plate, before being transferred to paper, rather than covering the surfaces of raised areas,
as in relief printing.[47] After the war rotogravure, which printed the pages from large cylinders,
became available on a new mass scale and was the method used at Sun for newspapers and
magazines. By the end of the 1950s gravure was being driven out of use by new offset lithog-
raphy techniques, and so the decade after 1945 constituted a distinctive generation of illus-
trated news weeklies produced through photogravure.

Photogravure is particularly good at producing rich effects from dark, contrasty subjects.
Whereas in relief printing the dark areas and the light areas are produced through the same

thickness of ink, in intaglio the darker tones are made up of thicker layers of ink than the light tones; the highlights are very sharp and the strongest darks are deep and well defined. Moreover, the matt surface of the paper used for news magazines also tends to soften the shadows and give the tonal transition greater subtlety.[48] When the photograph is passed on to the printers, it is split up into an enormous number of square cells that are then etched on to a plate (fig. 57). The dark areas of the original image will be etched for longest and will be 'bitten the deepest'; the etching solution will attack the plate for a period of time varying from the longest time for the darkest tones to the shortest time for the lightest tones.[49] The result on the plate will be a multitude of square pits of differing depth according to the tone of the original. The shadows produced through this process are, therefore, not only deeper but also longer; they have a greater duration. Time is, indeed, *in the image*, in its very materiality and making (see fig. 53).

Fig. 122. ROTARY PHOTOGRAVURE *printed on good gravure paper. This shows the square dots of ink of the same size. The variation of tone is produced by the varying thicknesses of ink.*

57 'Rotary Photogravure', in J. R. Biggs, *Illustration and Reproduction* (London: Blandford Press, 1950), p. 141, fig. 122.

It is through an understanding of the materiality of the photographs in *Picture Post* that we grasp the empathy between form and subject. The corrosive pressure that time exerts on the bombsite is re-enacted in the chemical solution as it corrodes and etches into the copper photogravure plate. The tactilities of the ruined space of the bombsite, the stray chunks and particles of building matter, the cracks and peelings, the patina of mould and smoke pollution find their perfect expression in the etched and granular photogravure image. To touch the surface of the post-war photogravure press photograph is to imaginatively experience the somatic sensation of the bombsite.

Psychic Landscapes

The title of this chapter is drawn in part from an essay published in 1955 in the *International Journal of Psycho-Analysis* by the British analyst Michael Balint. He called his article, which he worked on over a period of two years, 'Friendly Expanses – Horrid Empty Spaces', and the ideas that he set out there marked what might be described as a 'spatial turn' in British Object Relations.[50] There is a fascinating relationship to be explored between the image of the bomb-site and the language of British psychoanalysis during this period, which adds an important

dimension to the temporal and atmospheric qualities of the photographic images. It involves imagining what it was like to live amongst the bombsites after the war. Writing about the very different cityscapes of post-war Berlin, historian Jennifer Evans has described them as 'highly charged emotional spaces of transition between what had come before and what lay ahead, between life and death, and between collapse and reconstruction'.[51] The physical landscape of post-war Britain may also be conceived in terms of the topography of the mind, intensely related to spatial anxiety and broken identities, of objects and subjects shattered and in need of reconstruction and reparation.

It is well known that Freud conceived of the unconscious as a ruined landscape in need of excavation and that he saw analogies between the eloquence of ruins and the procedures of psychoanalysis.[52] I am not so much interested in seeing the landscape as an alibi or metaphor for the mind, however, as in tracing the connections and shared languages between photographic images of the bombsite and the specific discourse of certain British psychoanalysts during this period. Perhaps the relationship is best defined by Jacqueline Rose, when discussing the wartime work of Melanie Klein: '[it] *takes reference from, even as it casts light on*, the conflict going on all around' [my emphasis].[53] I have no desire to use psychoanalysis as a meta-discourse with which to interpret the images, but prefer to look, instead, at the way that both may shed light on that delicate 'structure of feeling' that characterized post-war Britain.

Object Relations is a variation of psychoanalytic theory that is based on the work of Melanie Klein and the British Independent Group. It diverged from the work of Freud in its emphasis on relationships between individuals or objects and, in particular, the mother-infant relationship, which, it stressed, shaped the infant's psychic structure in the first weeks and months of life, far earlier than was suggested by Freud. Klein moved to England in 1926, bringing with her a practice based on the treatment of children and using play to explore the development of the superego. Klein's method conflicted with Freud's on a number of key issues, notably the account of infant development and its consequent move away from the Oedipal complex as the moment after which the superego is formed. In the years immediately preceding and during the Second World War, the British Psycho-Analytical Society became the site of a series of disagreements between Klein and Anna Freud, which led to a splitting of the Society and the development of distinct schools of psychoanalysis.

It is not necessary here to go into great detail about Klein's contributions, but rather to point out the elements that have greatest pertinence to the subject of broken landscapes in

the post-war period.[54] Klein described the normal process of personal development in terms of the transition from a 'paranoid-schizoid position' (during which the infant identifies only with parts of the self and fails to distinguish between itself and the external object/mother) to a 'depressive position' (in which the infant recognizes the mother – good and bad, loved and hated – as a whole object, separate from itself). As the infant reaches the 'depressive position', it fears the loss of the loved object and experiences guilt about its former violent desires to destroy the other and to tear it apart. The move from the paranoid to the depressive position, from the part to the whole object, is thus predicated on the wish to repair the lost loved object, to restore and make it whole again. The shift between these two positions is never completed and both are potentially present at any time in childhood or adult life.

During the war, Klein had begun a four-month analysis of a ten-year-old boy, Richard, whose anxiety, depression and hypochondria had been exacerbated by the outbreak of war and the experience of air raids and bombs. Excessively devoted to his mother, Richard had difficulties relating to other children and had become overwhelmed by his fears, finding it hard to go out alone or control his anxieties. During the treatment, Richard produced a number of drawings which Klein used in her interpretations; many of these were of aircraft and air raids, including one that was later recorded in Klein's publication of the analysis that showed a number of bombers and a small figure on the edge of a bomb-crater.[55] Klein suggested that the figure was Richard and the crater his mother's breast, suggesting a partial move towards separation and a wish for reparation, fluctuating with feelings of fear and guilt. The traumatized landscape created by war and its persistence in post-war Britain was a filter through which Object Relations understood its child patients; desire and destruction, fear and reparation were materialized in the world around them, and it is not surprising that children populate the images of bombsites, in play and in danger, experiencing pleasure and extreme violence.

With its emphasis on early relationships and childcare, the broken and separated families of the war years provided the British Psycho-Analytical Society with a new public role, with analysts such as Donald Winnicott made famous by his wartime and post-war broadcasts on childcare and infant development.[56] Themes of loss, fragmentation and restoration resonated with the daily experiences of post-war European societies, where the links between inner life and external events and surroundings seemed paramount. It was possible, then, to see in the physical environment a psychic landscape, one that echoed the process of separation and frag-mentation and the ongoing and necessary desire for reparation. Winnicott related the sensation

of vertigo to the security of the infant in its environment and to the earliest anxieties of being insecurely held.[57] Here was an uncertain world that required solid objects, structure and firm boundaries to hold off feelings of disintegration, a therapeutic practice that takes reference from and casts light on the environment in which analysts and patients were living.

Perhaps the most spatial psychoanalyst of the British Object Relations School in these years is Michael Balint. Balint identified two types of patients: the 'philobat', who seeks out and enjoys thrills and dangers; and the 'ocnophil', who avoids and fears uncertainty and who clings to firm, safe objects. The philobatic environment consists of friendly spaces littered with unpredictable objects; the ocnophilic world consists of objects 'separated by horrid empty spaces'.[58] Both of these worlds can be seen as the wasteland; in both the emphasis is on an unresolved relationship with objects, whether it is expressed by holding on anxiously in fear of loss, or by leaving them again and again confident that they will remain and can be replaced. While Balint seeks the origins of these types in early infancy and the baby in its mother's arms, his ideas are elaborated within a setting that is unmistakably the post-war bombsite.

Within the framework of post-war Kleinian psychoanalysis, the desire for reparation under-lies all forms of artistic creativity. For Hanna Segal, who had her own analysis with Klein and who had a particular interest in psychoanalytic theories of artistic creativity:

> all creation is really a re-creation of a once loved and once whole, but now lost and ruined object, a ruined internal world and self. It is when the world within us is destroyed, when it is dead and loveless, when our loved ones are in fragments, and we ourselves in hopeless despair – it is then that we must re-create our world anew, reassemble the pieces, infuse life into dead fragments, re-create life.[59]

The 'loved ones' are surely also loved buildings and familiar landscapes. The language of this writing assumes such prescience in the context of the anxious setting of the bombsite. And what of the reader of *Picture Post*, who has lived through the bombing and is trying to put back together the fragments of personal and social life; what does the ruinous space with its bartering, eroticism and fantasy say to them? As they look into the deep contrasts and shadows of 'The Best and Worst of British Cities', do they not also experience the desire to make whole again, to rebuild the fractured landscape? This process of reassembly and recreation is struc-tured into the viewing of these images; they cannot make whole, but they can set in motion those reparative drives.

In her memoirs of the war years, *The Days of Mars*, the novelist Winifred Bryher describes walking through the bombed streets of London in 1945: 'So, I thought, this was what the war was making of us, it was giving us hallucinations and driving us back to the blank spaces of our beginnings.'[60] The bombsites remained for many years after the end of the war a physical environment that shaped the social and cultural imaginary of post-war Britain. Although they could be seen as 'horrid empty spaces', they were also a *tabula rasa* on which both planners and players could project their fantasies. Perhaps, then, it is time to see the grey-tone images of press photography not so much as drained of colour but as suffused with rich tonalities that convey the textured nature of time and the awful proximity of destruction and creation.

3

To Let in the Sunlight

A Victorian Chaise Longue

In Marghanita Laski's supernatural novel *The Victorian Chaise-Longue* (1953), the Victorian past and the post-war present become terrifyingly and inescapably merged through the malevolent agency of a piece of Victorian bric-a-brac. Melanie Langdon is a fashionable young woman who is married to Guy, a successful barrister. They live in what was a run-down part of London, in a renovated Regency house, where Melanie is recovering from tuberculosis and the birth of their first child. Laski is specific about the district they are living in: near to the railway lines and a canal, and within sight of derelict streets and a desolate bombed wasteland. Melanie and Guy are part of a gradual gentrification of the area; although when they moved in two years ago their parents had protested that it was little more than a slum, the steady reclamation of houses by the professional classes has left only one property still belonging to a working-class family.

The terrace is part of a transformation in post-war London housing, with working-class areas being bought up and renovated for middle-class homes. The house has been restyled both

outside and inside, with light colours, fabrics and patterns, and pretty rosewood furniture and papier-mâché chairs in the bedroom where Melanie has been recuperating. In fact, the only heavy piece of furniture in the house is a Victorian chaise longue, which Melanie bought from an antique shop shortly before she was diagnosed with tuberculosis. Junk shops are Melanie and Guy's hobby and they have filled their reclaimed house with 'pretty sparkles . . . [to] embellish and cement their nest'.[1] The chaise longue is different, however. It is ugly, heavy and strange; elaborately carved, it is upholstered in wine-red felt, covered in cross-stitch embroidered roses. Melanie had been unable to resist the Victorian sofa, in spite of the fact that it has a brownish stain on the seat and that it induced in her a strange visceral response: a need to lie there and a memory 'of another body that painfully crushed hers into the berlin-wool' (p. 19).

As Melanie slowly regains her health, the doctor allows her to move from her bedroom to rest on the chaise longue in the drawing room. As she lies there for the first time, watching the spring sunlight through the open windows, she falls asleep and when she opens her eyes again it is dark, there is a foul odour and her soft covers feel rough and harsh. She still lies on the chaise longue; in every other way, however, the world has changed: the windows are heavily draped, the sky is a leaden grey and there is an unpleasant fog outside. It becomes apparent that Melanie has woken in another time; it is 1864 and she has become, or inhabits the body of, Milly Baines, a young Victorian woman who is also suffering from tuberculosis. She is attended by Adelaide, her sister, and a maid who offers her food that tastes acrid and rotten. Melanie remembers her life in the 1950s, but she is also haunted by incomplete recollections of this Victorian existence and is aware of both times at once. The novel becomes increasingly claustrophobic and frightening as Melanie attempts to rouse herself from what she assumes is a dream and to return to her 'real' post-war environment; she tries to sleep and reawaken, but is trapped in this other body, this other place and time. She begins to understand that Milly has committed some form of moral and sexual offence and that her illness is regarded as retribution for her behaviour; she recalls the sense of being crushed onto the sofa by another body that she had first experienced in the antique shop and of passionate love for which she is now blamed and shunned by those around her. Melanie is drawn further and further into the Victorian past. Realizing that the couch is the only thing that joins her past/future life with this terrifying moment, she tries unsuccessfully to raise herself from it, but falls back against the horsehair-filled seat as the chaise longue drags her further into its putrid and unforgiving world. Milly has had an illegitimate baby and she is dying; she coughs uncontrollably and

blood gushes from her mouth, staining the embroidered surface of the chaise longue. Mortality clings to the threads of the Victorian embroidered upholstery and in the last moments Milly's Victorian world and Melanie's post-war world are conjoined: 'and at last there was nothing but darkness, and in the darkness the ecstasy, and after the ecstasy, death and life' (p. 99).

As Melanie becomes increasingly fearful, she begins to wonder how time could have allowed these two bodies and lives to become enfolded: 'It may happen often, all the time, so that there is no continuity of time, but that continuity is the only way we are capable of imagining it. Time may not be going in a straight line but in all directions and in no direction . . . so that it is my body that lies here and no dream, or not my body and still a dream from which I shall be freed' (p. 96). The Victorian chaise longue has undone the orderly progress of time. It has ruptured Melanie and Guy's futile attempts at gentrification and their modish taste for antique collectables, and has drawn her instead into a very dark and repulsive nightmare from which she cannot awaken but can only die. There is a common texture and atmosphere in the sulphuric particles of post-war fog, the gritty wastelands of the derelict bombsites, and the suffocating darkness and smells of the Victorian past. They are all forms that can shatter the illusions of modernization and progress, putting in their place a disorientating uncertainty regarding the relation and distance between the past and the present.

Melanie's thoughts conjure up Michel de Certeau's differentiation of the two strategies of time offered by historiography and psychoanalysis. Historiography 'is based on a clean break between the past and the present. It is the product of relations of knowledge and power linking two supposedly distinct domains.'[2] Psychoanalysis, on the other hand: 'recognizes the past *in* the present . . . treats the relation as one of imbrication (one in the place of the other), of repetition (one reproduces the other in another form), of the equivocal and the *quidproquo* (What 'takes the place' of what? Everywhere, there are games of masking, reversal, and ambiguity).' The Victorian chaise longue has dissolved the separation of past and present; through it, the past has returned to trouble 'the present's feeling of being "at home" . . . it lurks – this . . . "filth" . . . within the walls of the residence, and, behind the back of the owner (the *ego*).' These texts by Laski and de Certeau provide a way of seeing the role of the Victorian past in the post-war cultural imaginary: at once quaint and attractive, destructive and obscene.

Cultural historian Frank Mort has challenged progressive histories of post-war Britain that define the period as a definitive break with the Victorian past, with an initial period of austerity and state-led social reform leading to modernization, economic growth, social prosperity

and the reshaping of personal and sexual life.[3] These narratives of progress rest on the assumption that 1945 was the moment at which Britain became post-Victorian and embarked on the road of modernization and reconstruction. Like Melanie and Guy's domestic regeneration project, however, the Victorian past is not so easily expelled, and it continues to exercise considerable power over the forms and images of post-war social life. Rather than focussing simply on the new elements of British culture in this period, therefore, it is helpful also to understand the continuities, what Mort has referred to as 'the extended cultural reach of Victorianism'.[4] Moreover, this Victorianism was not simply a deadened trace of the nineteenth century, an ossified past that was occasionally resurrected in post-war discourse; rather, as Mort suggests, it was 'an active presence', able to assume many different associations and meanings as it participated in the shaping of post-war British society.[5]

The Victorian age haunted post-war Britain in different ways; everywhere there were physical and material manifestations of homelessness and poverty that belonged to the present but recalled the nineteenth-century past. William Beveridge's 1942 Report, which set out the framework for a system of social security and health care funded by a general weekly National Insurance contribution, was upheld as an end to the nineteenth-century evils of want, disease, ignorance, squalor and idleness.[6] The future of the nation was imagined in terms of its rejection of the Victorian past; the welfare state would provide a humane, modern alternative to the cruelty of the workhouse and the indifference of Victorian Britain. The image of the light, air and space of modern progress overcoming the darkness and ignorance of the nineteenth century was repeated across the visual media in the 1940s and 1950s. In 1943 Abram Games's poster for the Finsbury Health Centre contrasted Berthold Lubetkin's modernist design for the inner London building with the bleak vision of the disease and want of the past, and in the 1951 film *Scrooge* (UK; dir. Brian Desmond Hurst), starring Alastair Sims, Ebenezer Scrooge is brought to his senses when the Spirit of Christmas Present reveals the two emaciated children at his feet and invokes Beveridge with his words: 'This boy is ignorance, this girl is want' (figs 58 and 59).[7]

Britain's built environment was also substantially Victorian; the bombed industrial cities with their terraces of soot-stained brick houses and smoking chimneys were symbols of the legacy of nineteenth-century manufacturing that would make way for new homes and modern, light towns. The cover of the National Smoke Abatement Society *Year Book* in 1955 illustrates precisely this vision of Victorian urbanism; a high viewpoint displays serried ranks of smoking

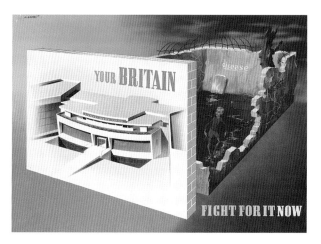
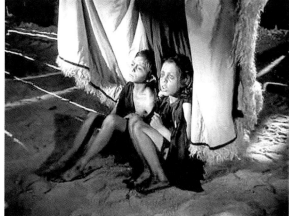

58 Abram Games, 'Your Britain: Fight For It Now', 1943, lithograph poster. Imperial War Museums, London.

59 'This boy is ignorance, this girl is want', *Scrooge* (UK, 1951; dir. Brian Desmond Hurst), frame still.

chimneys producing smoke that obscures the industrial buildings in the background (fig. 60). The cropped lamp of a gaslight in the foreground is the definitive sign that identifies this scene as Victorian, with the nearby television aerial simply emphasizing the aberration of this environment in the second half of the twentieth century. Here is the 'filth' and 'superstition' of the past that resurfaces in the present and inhibits its creation of a clean, new modern order.[8] This was not just myth, however; the fact was that after 1945 many people in Britain were still living in inadequate nineteenth-century housing that lacked the basic facilities of a modern industrial nation.[9] This had been a severe social problem before the war, but following the air raids of the war years, these streets had become even shabbier and more battered, and were now seen through a discourse of reconstruction and modernization that washed everything in the grey hues of Dickens and subsequent adaptations. In 1949 *Picture Post* reported on the new London County Council (LCC) flats that were sweeping away the old slums of east London: 'Those who have read *Oliver Twist*, or have seen the film, will recall those slum rooms described by Dickens as "so small, so filthy, so confined, that the air would seem too tainted even for the dirt and squalor which they shelter".'[10]

Post-war Britain was surrounded by traces of Victorianism, and it was the role of modern planning to erase the visible signs of this decaying past; the young meteors were the designers, architects and planners of the LCC housing and New Towns, who would let the sunlight

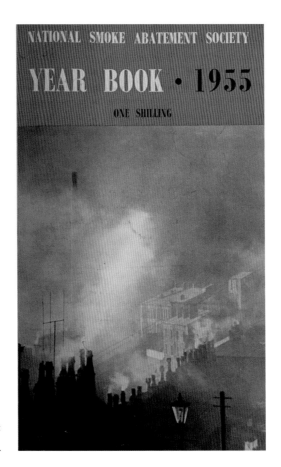

NATIONAL SMOKE ABATEMENT SOCIETY

YEAR BOOK · 1955

ONE SHILLING

60 National Smoke Abatement
Society, *Year Book*, 1955, cover.

back into the domestic and public spaces of Britain. Like the bombsites, these tenacious areas of Victorian slums bred new generations of criminalized youth. In 1954 *Picture Post* observed that crimes of violence by boys under the age of twenty-one years had increased by over 300 per cent since 1938. These were no longer the American-styled 'spivs' of the 1940s; they were 'shrewds', home grown and thoroughly English, born from the bombsites and 'the broken streets from which [they] emerge so immaculately dressed'. The 'shrewd' is described as an extraordinary blend of the Victorian and the contemporary: 'His sexual morals are almost Victorian. There is the young, tainted, street corner girl whom he will take out occasionally, and despise afterwards: and there is the girl he is going to marry at an early age. The girl he will protect with knuckle duster, or razor blade, if necessary.' 'Shrewds' are the product of the decaying fabric of old Victorian houses; they have done their National Service, which they

spent on the 'fiddle', and have spent time in prison, reading Dickens and identifying with the criminal characters. They are Bill Sikes with post-war style.[11]

Even at its most toxic, the Victorian exerted an irresistible fascination over the post-war imagination. In his 1951 literary tour of London, G. W. Stonier admired the foggy sights of the East End and reflected that following improvement: 'The London of Doré and James Thomson, of De Quincey, Dickens and Arthur Morrison, will have vanished for ever to make room for an L.C.C.-inspired vision of better homes. With everyone else I shall be approving of the new, but glad also to have caught these last dismaying glimpses of the old.'[12] It is this mythic appeal that draws the thoroughly modern Melanie Langdon to the Victorian chaise longue, in spite of its secrets and stains. It is what also drove artists, collectors and curators such as Barbara Jones in her taste for the popular arts: the toy theatres, fireworks, waxworks and shop signs of the nineteenth century, which she gathered together under the title *Unsophisticated Arts*. Jones comprehended the appeal of the dismay and disquiet generated by these things: 'a subtly unpleasant quality all their own . . . they are difficult to keep clean, and so acquire only the brown stain of dust and the promise of early destruction.'[13]

Victorian things acquired the power of fetish objects in the post-war period, possessing a supernatural power over those who desire and consume them. There is more to the Toby jugs, slipware chargers and geraniums illustrated in the annual *Saturday Book* in the 1940s and 1950s than innocent nostalgia; the bric-a-brac, *objets d'art* and curiosities had a capacity to trouble as well as to delight and threatened to bring more into the modern home than a fashionable statement from the past.[14] The antique or junk shop was a place of diversion and possible danger; Melanie and Guy Langdon pass their time looking for second-hand bargains and thereby introduce the deadly chaise longue into their home. In *The Old Dealer (The Old Curiosity Shop)* (1925), the British academic painter Charles Spencelayh captures the ambiguity in the figure of the antique collector in the inter-war years (fig. 61). The old man looks up smilingly at the viewer; there is something menacing, however, behind his friendly demeanour. He is a necromancer and we do not know what spells he has cast on those strange, colourful objects: the stuffed animals and framed prints, the glazed pots and carved furniture that can be either the finishing touch to a carefully-styled interior or the beginning of a living nightmare.

Spencelayh continued painting these subjects after the war, after David Lean had galvanized the appetite for the Victorian in the late 1940s with his films of *Great Expectations* and *Oliver Twist*.[15] The end of war and the atmosphere of post-war Britain intensified the taste

61 Charles Spencelayh, *The Old Dealer (The Old Curiosity Shop)*, 1925, oil on canvas,
51 × 61 cm. Private collection.

for the Victorian past; at the same moment that the national narrative declared a break with the nineteenth century, culture seemed more in thrall to this past than ever. Bill Brandt was born in Hamburg and came to London in 1931, after a period in Paris where he worked in the studio of Man Ray. In London he worked as a photojournalist for titles such as *Lilliput*, *Harper's Bazaar* and *Picture Post* and produced work that he brought together in a series of photo books.[16] Brandt worked up his photographs, cropping and retouching them, heightening the shadows and intensifying their haunting qualities. *Camera in London* (1948) includes soft, foggy views of London alongside carefully composed images of Shoreditch slums (fig. 62) and an interior of 'The Antique Shop' (fig. 63). This image, which might be described as a genre subject, stands out from the rest of the collection; although it shares the high contrasting values of his other work, it has a subject, a narrative, which is told through the objects in the old man's shop. The key lit marble bust in the foreground could almost be a study in itself, but here it leads the eye to the figure working in the middle ground and to

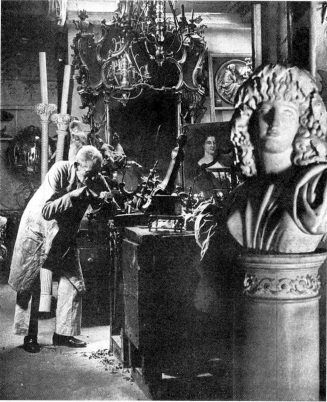

62 Bill Brandt, 'Lasting Bleakness in Shoreditch Backyards', as reproduced in *Camera in London*
(London and New York: Focal Press, 1948), p. 41.

63 Bill Brandt, 'The Antique Shop', as reproduced in *Camera in London*, p. 50.

the carved candelabra and frames, the staring portrait and the skull-like form reflected in the oval mirror on the wall behind him. The image conveys the obsession of the collector: the shop owner, the bargain hunter and Brandt himself, who during these years began to develop a taste for Victorian furnishing and objects. In 1949, in a note on its contributors, *Lilliput* observed: '[Brandt's] two passions are: Victorian furniture – he'll travel long distances to see a really unspoilt Victorian room – and hiking in London.'[17] Brandt, the peripatetic photographer, who will go out of his way to find Victorian bric-a-brac and landscape views: a sensibility born in the imagination of the immigrant and from a deep longing for an essential national heritage and identity. The contrast and shadows, the depth of field and composition

in Brandt's photographs are concerned as much with the evocation of the past as they are with capturing a particular place.

From 1941 Brandt worked for the National Buildings Record, documenting in his photographs the ancient buildings of England, the relics and remains that were threatened by war. As historian of photography David Mellor has incisively observed: 'Over and over again, it was the "fantastic" which attracted him to the English landscape as an object of desire … the cherished, surviving objects, fetishes of the body of Britain.'[18] There is a psychic labour in the representation of the past, as there is in the representation of ruin – an ongoing project to repair and make whole again, in order to move on to the new and the modern. At the end of the war, Brandt worked on subjects drawn from the British landscape and specifically from sites related to the nation's literary heritage. In *Literary Britain*, published in 1951, Brandt reproduced a series of outstanding landscape photographs with accompanying literary texts. 'In Haworth Parsonage' is an atmospheric interior of a room in the Brontë family home, where they moved in 1820 when Patrick Brontë was made curate of Haworth church (fig. 64). The image is almost cinematic in its creation of the melancholy setting, with the candles in the foreground casting a grainy, veiled light on the discarded boots and clothes and the unwavering gazes of the portraits in the background. It is as though the occupant has just left the room, and the accompanying text points out: 'In the background is the sofa on which Emily [Brontë] died.'[19] Or is it where Melanie or Milly has just died? The common 'structure of feeling' in Laski's novel and Brandt's photograph is overwhelming: an absorption in the uncanny elements of the nineteenth-century past and the knowledge of their power to disturb the equanimity of the present.

The corruption of Victorian material culture was vividly conveyed in British films of the 1940s and 1950s. In Thorold Dickinson's 1940 film of the play *Gaslight*, set in the late nineteenth century, a newlywed couple move into a grand house because the husband, Paul, believes that there are rubies hidden there. As he searches the upper floors at night, the gas lamps in the rest of the house dim and noises can be heard from the floorboards above; when his wife, Bella, asks him about these phenomena he deliberately makes her think she is imagining them and that she is losing her sanity. As the plot unfolds, it emerges that Paul had murdered the previous owner of the house and has returned to look for the jewels that he was unable to find immediately after the crime. The elaborately decorated interior of the Victorian house is central to the sense of growing claustrophobia and fear as Bella believes she is going mad.

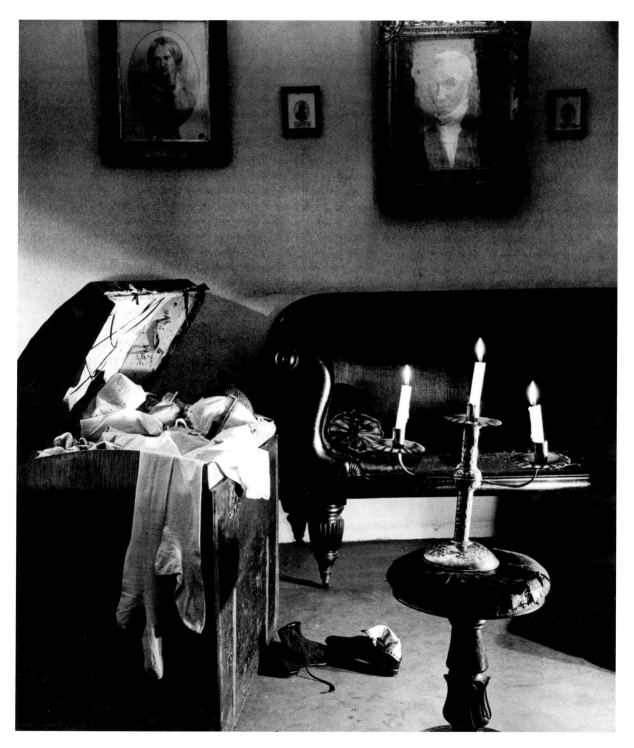

64　Bill Brandt, 'In Haworth Parsonage', as reproduced in *Literary Britain* (London: Cassell, 1951), plate no. 7.

65 | The young couple in front of the antique carved mirror, *The Dead of Night*
(UK, 1945; dir. Robert Hamer), frame still.

66 The past reflected in the mirror, *The Dead of Night*, 1945, frame still.

As one review observed: 'The poor little wife is being frightened into madness not only by her husband's cruelty, but by the heavy conservatory atmosphere in which she is doomed to dwell. The potted palms, the betasselled draperies, the ornament-loaded piano, the wax flowers in glass cases, the festoons of miniatures on the walls, all stand as barriers to sanity and freedom. She is stifled under bric-a-brac.'[20]

It was not only costume dramas that developed the visual register of menacing Victorianism; films with contemporary settings also drew on these images. In 'The Haunted Mirror', directed by Robert Hamer and part of the 1945 portmanteau horror film, *The Dead of Night*, a fashionable young woman (not unlike Melanie Langdon) buys her fiancé an ornate, antique carved mirror as a wedding present (fig. 65). Her husband begins to see visions reflected in the glass; rather than their fashionable modern home, he sees a room with a four-poster bed and an open fire (fig. 66).[21] Gradually the mirror world begins to take over his life and to change his character. It emerges that in the 1830s the mirror had 'witnessed' a previous owner murder his wife and commit suicide, and just as history is about to repeat itself, the young wife smashes the mirror, breaking its spell over her husband. The reflected world of the nineteenth-century past is a place of libido and violence, which threatens to infiltrate the order of the modern world through enchanted objects and the traces of ignorance, disease and want.

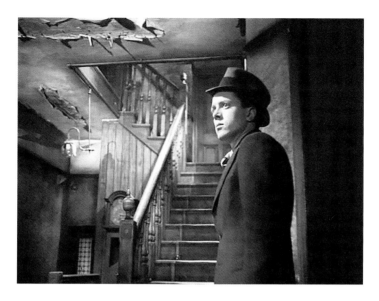

67 Pinkie in the lodging house, *Brighton Rock* (UK, 1947; dir. John Boulting), frame still.

'The extended cultural reach of Victorianism' is everywhere in post-war British film culture and provides the *mise en scène* for one of its best-known film noir crime films, *Brighton Rock* (UK, 1947; dir. John Boulting), from the novel by Graham Greene.[22] Set in the seedy under-world of the Sussex seaside resort, it traces the violent criminal career of a psychopathic teenager, Pinkie Brown (played by Richard Attenborough). Pinkie leads a gang that operates a protection racket at a nearby racetrack. Following the murder of a newspaper journalist, a clue is left incriminating Pinkie; it is discovered by a young waitress, Rose, whom Pinkie marries so that she cannot testify against him. Much of the emotional power of the film derives from the contrast between the innocence and affection of Rose and the increasingly psychotic behaviour of Pinkie. The locations in *Brighton Rock* are more than a backdrop for the drama; they are remarkably vivid and provide the social and psychological background for Pinkie and his henchmen. The gang shares a lodging house in the back streets of Brighton; the moody shadows in these interiors evoke the sordid living conditions of Victorian housing. The house, like its occupants, is decrepit and degraded; the rooms are shabby and the dark landings and creaking staircases are threatening and dangerous, realized when Pinkie pushes one of the gang over the banisters and he falls to his death (fig. 67).[23] In many ways, *Brighton Rock* is a noir gangster film, but in its visceral representation of Victorianism it is thoroughly British.

At the same that the Victorian period was feeding the Gothic noir imagination of post-war British filmmakers, it was also undergoing an intellectual reassessment and reinvention. The 1951 Festival of Britain was planned to mark the centenary of the Great Exhibition of 1851, and reflections on the changes that had taken place in the intervening one hundred years were encouraged and built into the design of the displays. It was an opportunity to indulge nostalgia and heritage alongside modernist narratives of progress and improvement. The festival mobilized a number of different versions of Victorianism, depending on which element of the nation's story of the land and its people it was telling.[24] Alongside the displays at the South Bank in London, there were exhibitions that brought Victorian culture to a new public. The Whitechapel Art Gallery programme included an exhibition on the 'East End 1851' and 'An Exhibition of Paintings by William Powell Frith, R.A. 1819–1909'. In its annual report for 1951–2, the gallery acknowledged that attendances at the Frith exhibition were small but explained: 'it was worth bringing here [from Harrogate] because Frith is perhaps the type of successful Victorian artist, and as such of great interest at this time when Victorian achievements and values are being re-examined.'[25] The Institute of Contemporary Arts fell into step with the general predilection for historical reflection and came up with 'Ten Decades: A Review of British Taste 1851–1951', which allowed them to include High Victorian artists such as Lawrence Alma-Tadema and John William Waterhouse alongside recent academic painters such as Charles Spencelayh and the competing contemporary styles of Graham Sutherland and Francis Bacon.[26] The following year the Victoria and Albert Museum sealed the official cultural reinstatement of Victorian art with its exhibition 'Victorian and Edwardian Decorative Arts'. This exhibition history was motivated in part by the belief that there was public interest in Victorian art, that it addressed a form of popular taste that still existed within the nation. In 1947 *Picture Post* had devoted one of its first colour double-page spreads to reproductions of Frith's panoramic modern-life paintings *Ramsgate Sands* (1854) and *The Railway Station* (1862). Later that year it printed a Christmas piece on Victorian leisure, and in 1948 it carried a colour spread on the Pre-Raphaelites with an article by the poet and writer Geoffrey Grigson.[27] This was the pliability of the Victorian in post-war Britain; it could be dark, Gothic, dangerous – and, equally, it could be made to metamorphose into a comfortable, colourful image of a friendly nineteenth-century past. It could be the shadows of *The Victorian Chaise-Longue* and *Brighton Rock* – or it could be the theme-park fantasies of The Far Tottering and Oyster Creek miniature steam railway at Battersea Pleasure Gardens, and the fancy-dress variety audience

and master of ceremonies in the BBC's light entertainment television programme *The Good Old Days*, which began broadcasting in 1953.[28]

Ambiguity does not sit comfortably with popular diversion and entertainment; it belongs more properly in the grain of shadows and decaying surfaces and is surely also the defining feeling of post-war Victorianism. Whilst the architect and writer Hugh Casson admired 'this truly fabulous age', he described the task of writing an introduction to Victorian architecture as having to 'pick over the troubled debris of this vast quarry, and select at random a few stones'. Casson wrote this in 1948, the same year that he was appointed to the role of Director of Architecture at the Festival of Britain, which was to be built on the plot of a massive bombsite on the South Bank of the Thames. To write about the Victorians is as bewildering as picking over the rubble of a bombsite; the metaphors become confused, ambiguous, as Casson describes Victorian society as a facade that is as 'fragile and treacherous as stucco'.[29]

Whilst post-war Britain admired the industrial energy and expansion of the Victorians, the social costs had been too high and the confidence and security of the period were an illusion, a fabrication that was seen also in its arts, design and architecture. For Nikolaus Pevsner, a path could be found through the 'rank growth' of Victorian manufacture to the clean, modern design of the twentieth century.[30] With William Morris and the Arts and Crafts movement, English modernism found its roots in the aesthetics of simplicity and economy. It was a narrative that Pevsner was to repeat and rework from the mid-1930s and the publication of the first edition of *Pioneers of Modern Design* through to the founding in 1958, with John Betjeman and others, of the Victorian Society.[31] Whilst the aim of the Victorian Society and other bodies, such as the Advisory Committee on Buildings of Special or Historic Interest, was the preservation and conservation of particular examples of Victorian architecture, the view prevailed that the poor aesthetic values of Victorian industrial design were a reflection of a prudish and hypocritical age. Post-war reconstruction could selectively draw on the nineteenth century, but it had to focus on the values of light and honesty as opposed to the 'wasteful confusion' that it saw in so much of the Victorian world.[32]

The Victorian age was portrayed as a period of sexual hypocrisy and gender inequality, and in 1953, the year of Elizabeth II's coronation, Vera Brittain traced the changes in women's social position in the mid-twentieth century and the gradual move towards equality in terms of the rejection of Victorian standards and values. Although married women still faced conflicts between child rearing and independence, birth control had freed women from the fear of preg-

nancy and the fearful consequences of sexual relationships outside of marriage. Simpler homes allow women more time to realize their ambitions in public life; they are no longer occupied 'covering sofas, cushions and piano-backs with wool embroidery . . . Far from being a pathetic family incubus she has become an economic and social asset, self-supporting, happy and free.'[33] The title of Brittain's book, *Lady Into Woman: A History of Women From Victoria to Elizabeth II*, encapsulates her argument: women in the 1950s are no longer dominated by domesticity and personal relationships; the 'invalid woman is a phantom of the Victorian past.' It is a story of progress, albeit incomplete, towards gender equality and liberation; as Brittain writes: 'human society has gone forward since it stepped into daylight from the foetid atmosphere of Victorian hypocrisy.'[34] And yet, in 1953 women were still being defined in terms of their domestic roles, and the post-war companionate marriage (discussed in detail in Part Three) was in many cases an impossible aspiration. Birth control was unreliable, and young, middle-class women like Melanie Langdon could still find themselves invalids lying on embroidered sofas. The Victorians provided post-war Britain with the opening to a narrative of progress, but it was a precarious one and could easily unravel in the fog and smoke or among the shadows and on the bombsites. These were the surfaces and atmospheres that spoke of interiority and the spectral imagination and that created nervous dreamers rather than modern consumers.

Dickens Noir

In his discussion of British film noir, Andrew Spicer introduces the subcategory of Gothic noir.[35] These are films that draw on the visual style of film noir – the expressionist lighting, the deep shadows and distorted, claustrophobic interiors – as well as the psychological complexity and moral ambiguity of the characters, but are Gothic costume melodramas, often set within gloomy nineteenth-century houses and frequently involving adultery, deception and murder. *Great Expectations*, directed by David Lean in 1946, was the first of two films that he directed in the second half of the 1940s based on novels by Dickens; the second was his 1948 film of *Oliver Twist*. *Great Expectations* is one of the most outstanding film adaptations of Dickens; it can be read through the aesthetics of film noir, but justifies its own generic category: Dickens noir.

During the war years, Lean had collaborated with Noël Coward on patriotic dramas such as *In Which We Serve* (UK, 1942; dir. David Lean) and *This Happy Breed* (UK, 1944; dir. David

Lean) and had also made the extraordinary romantic melodrama, *Brief Encounter* (UK, 1945; dir. David Lean), in which the visual language of black and white cinematography was expanded to convey the emotional restraint and sexual tension of a love affair between two married strangers (a housewife and a doctor) who meet accidentally at a railway station. On its release in 1946, *Great Expectations* received enormous critical acclaim and was seen as spearheading a resurgence of British film-making that would at last be able to compete with the films exported from America from which it had been protected during the war.[36] Lean envisaged a cycle of Dickens films, which would provide the material for the emergence of a distinctive British style of filmmaking.[37] It was nominated for five Academy Awards in 1947 and it won two: for Best Art Direction (John Bryan and Wilfred Shingleton) and for Best Cinematography, Black and White (Guy Green).[38]

The triumph of *Great Expectations* lies in its mastery of the aesthetic possibilities of black and white film and its powerful blending of German visual style and Gothic. The look of the film is dictated by its lighting and use of shadows, with an extensive tonal range from deep blacks to bright highlights and with a distorted expressionist perspective.[39] John Bryan's sketches demonstrate how these elements were part of the visual design of the film from the beginning, providing the basis for set designs, lighting and the painted matte backgrounds (figs 68 and 69).[40] Both Guy Green and John Bryan had been trained in the 1930s, when a number of German and other European refugees were working in the British studios, and there is a strong and clear aesthetic link from *Great Expectations* back to Weimar cinema (fig. 70).[41] The depth of tone in Lean's film was also a product of new black and white film stocks that had been introduced by the Kodak Company in the 1930s. More light sensitive than earlier stock, they produced higher quality images that could incorporate a wider range of tones at a high level of resolution. This style of high-contrast, low-key lighting, in which the majority of the scene is in deep shadow, was an aesthetic shared with film noir but which, in Dickens noir, is given an additional Gothic dimension.

Black is more than simply black in *Great Expectations*; it has remarkable depth, texture and materiality. The most evocative accounts of the photographic style of the film come from those involved in its making. Explaining why he had sacked his first cameraman, Robert Krasker, who had worked so successfully with him on *Brief Encounter*, David Lean stated: 'because the photography hadn't got the guts I wanted for Dickens. It's no good having those outsize characters, convicts and crooks and God knows who, in polite lighting. It doesn't work. If you're

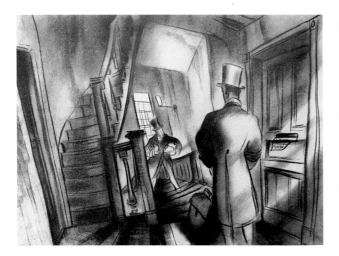

68 John Bryan, pastel design for *Great Expectations* (UK, 1946; dir. David Lean), as reproduced in Edward Carrick, *Art and Design in the British Film: A Pictorial Directory of British Art Directors and their Work*, compiled by Edward Carrick, with an Introduction by Roger Manvell (London: Dennis Dobson, 1948), not paginated.

69 John Bryan, pastel design for *Great Expectations*, 1946, as reproduced in Carrick, *Art and Design in the British Film*.

going to do Dickens you have to use very strong photography, black shadows and brilliant highlights. Bob's rushes were flat and uninteresting.'[42] Lean wanted something 'daring' and 'over the top'; he imagined something gutsy and impolite, and he knew that Dickens could take this filmic look. There is an even stronger sense of the way in which black and white photography was being used in the making of the film from Guy Green, the cinematographer:

> It was a bit like painting, except that you start with a black piece of paper instead of white. What was exciting for me about black and white photography was making the actors come out of it – stereoscopically. I played the dark against the light all the time. Whenever the actors moved, the downside would always be silhouetted a bit. It got to be plastic somehow.
> . . . I evolved the idea of using very little light and from very few directions. And I insisted that they developed the negative to the proper gamma, so I got this rich black and white feeling.[43]

The medium is used to make the figures emerge from the darkness, *repoussoir* forms against the thick, dark tones of the background that make the shadows solid and three dimensional,

70 Pip with Miss Havisham in the shadows of Satis House, *Great Expectations*, 1946, frame still.

as though sculpting in light. It is surely also significant that Green refers to a 'black and white *feeling*' [my emphasis], for the tonal contrast in the film is more than an appearance – it is an evocation and an atmosphere.

The story of Dickens's novel is reasonably familiar and although Lean retained the main structure of the narrative, he also made a number of alterations. The film opens with the pages of the book and the beginning of Pip's first-person narrative and the story of his unhappy childhood. Pip is an orphan and lives with his unkind older sister and her good-hearted husband, the blacksmith, Joe Gargery. In a powerful opening scene Pip is seen on the stormy marshland near his home, where he is visiting the graves of his parents. There, he meets the menacing escaped convict Magwitch, whom he agrees to help by bringing him a pie and a file stolen from the forge (fig. 71). Shortly after, Magwitch is caught on the marshes fighting another escaped convict, and both are taken back to the prison ship, to be deported to Australia. The landscape is dark, threatening and violent, full of anthropomorphic shadows and swirling mists. A review in the *Monthly Film Bulletin* described these scenes as 'some of the finest cinema yet made in Britain'.[44]

Sometime later, Pip is taken to Satis House, where a wealthy old widow, Miss Havisham, lives with her beautiful young ward, Estella. Miss Havisham was deserted on her wedding day and her house now remains as a shrine, unaltered from that moment. A grand wedding banquet lies covered in cobwebs and eaten by mice; the house is shuttered and gloomy and, like its owner,

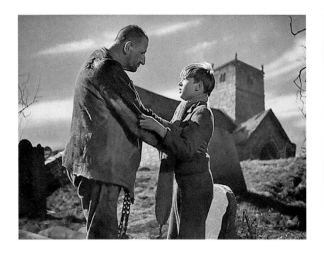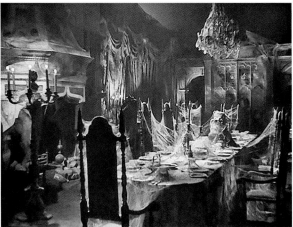

71 Pip with Magwitch on the marshes, *Great Expectations*, 1946, frame still.

72 The ruins of the wedding banquet, *Great Expectations*, 1946, frame still.

is a thing of shadows (fig. 72). Pip has been introduced to Satis House in order to play with Estella, who has been brought up by Miss Havisham to break men's hearts; Estella mocks Pip's coarse manners, but he quickly falls in love with her. When Pip reaches the age of fourteen he becomes an apprentice to Joe Gargery and his visits to Satis House end. Some years later, he discovers that he has been left a substantial amount of money from an anonymous benefactor, whom he assumes to be Miss Havisham. He goes to live in London, with great 'expectations', and it is as he assumes the identity of a gentleman that he becomes indifferent to and ashamed of his humble past and of the loyal Joe Gargery. He later acknowledges: 'in trying to become a gentleman, I had succeeded in becoming a snob'. Pip's assumptions and values are overturned when he receives a visit one night from the convict, Magwitch, who has left Australia illegally and who reveals that he is the source of Pip's wealth and social improvement. Pip returns to Satis House to confront Miss Havisham, and as he leaves a log from the fire is dislodged and ignites the ragged wedding dress, killing its wearer.

Pip now focusses on trying to help Magwitch escape; however, he is unsuccessful and Magwitch is caught and dies in prison. Pip sits at his bedside and reveals to the dying convict that Estella is his daughter and that Pip loves her. In a final dramatic scene, Pip returns to Satis House and finds Estella, where she is assuming the role of Miss Havisham; he tears down the curtains and together they leave the terrible house and the corrupting influence of its owner.

The aesthetic vision of David Lean and Guy Green is most fully realized in the sequences inside Miss Havisham's home, Satis House. Pip visits Miss Havisham as a child and as an adult, and these episodes were shot differently in order to convey the changing experience of the house. As Bob Huke, the camera operator, disclosed, the scenes with the children were shot with wider lenses so the set around them would be more imposing; in the adult sequences a longer lens was used, so that 'it was exactly the same set, but it was a vast, cavernous, shadowy place when they were kids, and it was a dreary, dirty run-down house when they were adults.'[45] Satis House is a Gothic bombsite; its effects are those of the London ruins in which Barbary Deniston plays in Rose Macaulay's novel *The World My Wilderness*: dark, cavernous, incoherent, a place of danger and fantasy. And as Pip grows up and returns, the house loses some of this power and is reduced to one of those persistent, nagging Victorian spaces that need to be swept away and replaced by the light of planning and improvement.

When Pip first goes to play in Satis House, the camera moves from the sunlit doorway into the black darkness of the interior; only Estella is key lit as they walk through the dark corridors, illuminated by the simulated light of her candle. When Estella leaves, the light goes with her, and although Miss Havisham is more brightly lit than her surroundings, there is never any luminosity to her figure (fig. 73). The windows are sealed with shutters and draped with heavy curtains that prevent any rays of natural light entering into the neglected room. Everything – mirrors, jewels, candelabra – has lost its lustre and brilliance and is part of the gloomy decay.[46] The shadows in the scenes in Satis House are thick and visceral; they seem to wrap themselves around objects and people, layer after layer, as though the darkness emerges from Miss Havisham herself. In a very different context, the Japanese novelist Junichirō Tanizaki describes the light created by a candle in a teahouse: 'the darkness seemed to fall from the ceiling, lofty, intense, monolithic, the fragile light of the candle unable to pierce its thickness, turned back as from a black wall . . . It was different in quality from darkness on the road at night. It was a repletion, a pregnancy of tiny particles like fine ashes'.[47] This is the texture of light and shadow in Lean's *Great Expectations*, producing a space of memories and loss, the world of Miss Havisham.

Of course, the interiors of Miss Havisham's house are vividly described in Dickens's novel, but it is impossible now to strip *Great Expectations* of its visual imagining in David Lean's film; it is part of the novel's accumulated meaning. What would be the point of listing the differences between the novel and the film, of describing the liberties that the film director

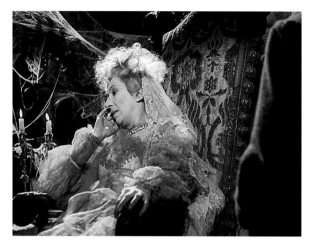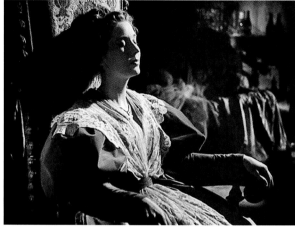

73 Miss Havisham in the shadows of Satis House, *Great Expectations*, 1946, frame still.

74 Estella as an adult returned to Satis House, *Great Expectations*, 1946, frame still.

has taken with the text in the name of visual effect? They are now part of a shared genealogy and amount to something greater than the sum of their parts; as John Glavin has argued in his study, *Dickens on Screen*: 'The Dickens film now shapes Dickens's fiction. Of course, Dickens's books came *first* (in time). They just don't come first (in meaning) anymore.'[48] Lean's own take on the relationship between text and film was: '[A writer] gives me the material and I give it visual interpretation.'[49] Although Lean was referring here to a script, his words might also be taken to describe his relationship to the novel. His was a visual medium; his role was to give words a visual imagination.

Undoubtedly, the film trades on its source text for its appeal; the title credits make this explicit, along with the opening images of the first pages of the novel being read by the voice of the narrator; but the result is not simply one of translation from one medium to another. As argued by the film theorist André Bazin in a number of articles written around 1948, adaptation should be seen as a form of creative transformation. In 'Pour un cinéma impur', he suggested that adaptation is a specific form of productivity that creates a 'new dimension'. Rather than being an additive process – novel, theatre, film, for example – the move is one of division and multiplication that communicates meaning across a range of media and forms.[50] This provides a model for how to understand the Dickens novel and its post-war 'act of creation': not simply an accumulation of interpretations, but rather an act that breaks open

the text and expands its content. Historical precedence, as Bazin has argued, cannot be an aesthetic criterion.

The ending of the film was devised by Lean's wife, Kay Walsh, which, with the possible exception of the opening episode when Pip meets Magwitch on the marshes, is probably the most discussed scene in both the film and the novel. As is well known to Dickens scholars, Bulwer Lytton persuaded Dickens to rewrite the original bleak ending in which a middle-aged Pip bumps into a divorced Estella in the London streets, and in the rewrite a younger Pip revisits Satis House and encounters the still beautiful Estella; they leave together and Pip states that he sees 'no shadow of a future parting'.[51] This conclusion, with its end to shadows, provides the starting point for the last scene of the film. Pip returns to Satis House and finds Estella there (fig. 74). She has taken up Miss Havisham's place in the chair by the fire and seems in danger of assuming the same ossified life. Pip challenges the past and defies Miss Havisham's power: he tears down the rotting curtains, pulls open the shutters and, as the light floods in through the motes of dust, he tells Estella that he has returned 'to let in the sunlight' and that she must leave with him (fig. 75). Together they run out of the house and through the ruined garden, as the words 'GREAT EXPECTATIONS' are superimposed over the final shot.

There is more to the closing sequence than this summary. The film is a visual discourse: an act of post-war visual imagination and a masterpiece of shadow composition. The play of light and shadow that runs through the film's visual language is concentrated in the closing episode. As the rays of light enter the dismal room after Pip's heroic act, the decay becomes visible in all of its morbid opulence and the reality of Miss Havisham's life and the possible future of Estella are made manifest. Natural light replaces artificial illumination and light breaks the darkness of Satis House.[52] The meaning of this final scene is commonly read by film historians in terms of the film's post-war context. For Catherine Moraitis, it is a piece of 'intelligent escapism' that took its audiences away from the drabness and tragedy of the war years and the problems of peacetime.[53] However, for Joss Marsh, Pip's return 'has more than a dash of the heroic service-man of 1945–6, home from the front to tear down the blackout curtains and claim his bride, who (as in the fantasies of *film noir*) can be put back in her proper, submissive feminine place now that her war work is over.[54]

Nearly all of these readings see the end of Lean's film as some kind of return to order and a 'restoration of balance'.[55] The scene has also been interpreted as an expression of the ethic of welfarism and a critique of the hypocrisy of the Victorian class structure: 'a metaphoric letting

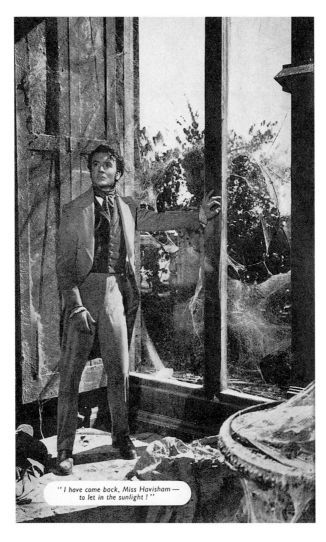

"I have come back, Miss Havisham —
to let in the sunlight!"

75 'I have come back, Miss
Havisham – to let in the
sunlight', publicity frame,
as reproduced in Cineguild's
*Great Expectations: The Book of
the Film* (London: World Film
Publications, 1946),
not paginated.

in of light on British life at large', as Brian McFarlane puts it, the film is 'very much a product of its time and place'.[56] All of these interpretations are undoubtedly correct, but it is worth paying further attention to the visual language of Lean's *Great Expectations* and the ways in which it, too, is a product of its time and place. Lean stated that the look he wanted for his film was 'daring, huge great black shadows, great big highlights – over the top'.[57] So what did this fabulous cinematography mean to post-war audiences and how did it relate to the greyscale aesthetics of the fog and the bombsites?

Post-War Shadows and Ruins

David Lean's *Great Expectations* can be understood in terms of the visual language of chiaroscuro. The most visually arresting aspect of Lean's film is its rich, thick, dense use of shadow, and the meaning of this film style is more subtle than darkness to illumination, obscurity to revelation. Chiaroscuro can be defined as the 'aesthetic of shadows'; but as Michael Baxandall has shown in his study of Enlightenment shadows, the French word *ombre* includes many other senses that reveal the uncanny associations of shadows, such as ghost, unreal appearance and concealment.[58] Shadows are not simply the negative of light; rather they are an active element of illumination and its visual experience and are able to register the smallest shift in tone and shape.

Chiaroscuro is the cinematographer's language: the modelling of space and form through light and shadow. Black and white film of the 1940s represents the absolute mastery of chiaroscuro. At a moment when technology had introduced better film stock and developing processes and when cinematographers could draw on a long expressive tradition of the medium, films were able to explore the structural interconnections between light and shadow, between manifestation and seeming. Shadows represent ambiguity and metaphor; they belong to the world of crime, subterfuge and desire and to certain orders of space: passages, doorways, ruins. 1940s chiaroscuro is the moment in Carol Reed's *The Third Man* (UK, 1949) when the camera cuts to a cat rubbing against a man's shoes on the cobbled streets of Vienna and an apartment light momentarily reveals the face of Harry Lime. It is the world of fleeting shadows and of the recognition that truth appears in the relationship between lights and shadows and not through absolute illumination. This interpretation is drawn from Hegel; in *The Science of Logic* he argues that we imagine being-in-the-world in terms of pure light and undimmed seeing and nothingness as absolute darkness. In fact, there is as little seeing in absolute light as there is in complete darkness: 'pure light and pure darkness are two voids,' he writes. Things can only be distinguished in 'darkened light' or 'illuminated darkness': 'For there to be perception at all and for determinable things to emerge in their distinctiveness, there need to be . . . gradations of light, flickerings . . . outlines and silhouettes . . . there is darkened light; there is illuminated darkness. A shadow is an index of the worlding of the world, for there will be thing, surface, angled light, and consciousness for a shadow, like a spell to be cast.'[59] Shadows are like spells; they are rich, nuanced, expressive and symbolic. This makes the final invented scene of Lean's film more uncertain and disturbing. What really happens when Pip lets in the sunlight? Do

76 Pip as a child in the garden of Satis House, *Great Expectations*, 1946, frame still.

77 Estella at a window of Satis House, *Great Expectations*, 1946, frame still.

he and Estella really achieve being-in-the-world and run from Satis House into the sunshine and a model home in a post-war New Town, or must they remain in the broken terraces and bombsites, tied to veiled expectations?

This reading of chiaroscuro in Lean's film becomes more persuasive when it is put in the context of post-war shadow. The language of light and shadow was ubiquitous in the Victorian period; titles such as the *Lights and Shadows of London Life* (1849) or George Godwin's *London Shadows* (1854) drew on a dualistic Christian iconography of good and evil and had limited expressive range.[60] In the post-war period the symbolic richness of chiaroscuro was fully real-ized through a national landscape of ruin and decay. When I visualize Satis House as filmed by David Lean, I imagine I see the whole of the exterior of the building. On viewing the film again, however, I recognize that the outside of the house is shown only in parts and never in its entirety. We see the gate and the ruined garden and we see the window from which Estella first calls down to Pip and which he later looks up at when he returns there for the final time, but there is no full exterior shot of Miss Havisham's home (figs 76 and 77). And yet, the shadows and mists of the interior are so evocative that the viewer is given a strong sense of the ruinous decay of the exterior. Ruins provided a new beauty for post-war Britain. In 1947 John Piper's article 'Pleasing Decay' was published in the *Architectural Review*, in which he claimed: 'Bomb damage has revealed new beauties in unexpected appositions.'[61] During the war, Piper was

78 John Piper, *All Saints Chapel, Bath*, 1942, ink, chalk, gouache and watercolour on paper,
42.5 × 74.5 cm, Tate, London.

one of a number of artists sent by the War Artists Advisory Committee to depict bomb ruins. The agonizing juxtaposition of beauty and destruction is palpable in Piper's watercolour of *All Saints Chapel, Bath* (1942, fig. 78), giving visual form to Kenneth Clark's words at the height of the Blitz: 'Bomb damage is in itself Picturesque.'[62]

British visual culture during the war was driven by two imperatives: to record and to preserve. As well as the project to depict the ruins, another scheme was set up to document the nation's landscape and architectural heritage. 'Recording Britain' was the brainchild of Kenneth Clark and commissioned artists such as Barbara Jones, Kenneth Rowntree and Piper to produce watercolours of subjects that were threatened not only by bomb damage but also by urbanism and ribbon development.[63] As Patrick Wright has argued, these wartime projects provided an opportunity for the regeneration of older meanings of the nation and its people; they favoured a Neo-romantic sensibility, a mild, melancholic defence of rural and vernacular

ways of life in the face of the encroaching threats of war and modernity.[64] This way of seeing could be seen as part of a rejection of European modernism and a return to a native tradition of British landscape art, with precedents in the work of William Blake and Samuel Palmer. Whilst this aesthetic language was developed in the context of wartime, it established a way of seeing the national landscape that persisted in the immediate post-war years. Although planning for the future was a priority during the 1940s and 1950s, this was mediated by a strong emotional commitment to tradition and continuity with the past.

The legacy of Neo-romantic culture informs the look and feel of *Great Expectations* and is everywhere in the film's design and locations. During the war years, when John Piper was not depicting war damage, he was painting older historic ruins (fig. 79). Seaton Delaval was a country house in Northumbria that had been built in the 1720s to designs by Sir John Vanbrugh. It had been gutted by fire in the 1820s and in 1945 Piper described its present appearance:

> Ochre and flame-licked red, pock-marked and stained in purplish umber and black, the colour is extremely up-to-date: very much of our times. And not the colour only. House and landscape are seared by the east wind, and riven with fretting industrialism, but they still withstand the noise and neglect, the fires and hauntings of twentieth-century life . . . so it largely remains to-day, patched and empty, with rakish, rusted staircases hanging above boarded-up, floorless saloons.[65]

In his painting, the ruined remains of the great house emerge from the thick impasto of their surroundings. Black lines trace the shapes of former grandeur that are stained by thick red layers of paint and the 'magnificent modern ruin' stands against a dark, stormy sky. This is my Satis House, burned, age-worn and beautiful: a relic of the past that speaks to the temperament of the present.

Ruins and shadows are the visual language of post-war Britain; they created the grain of the 1940s and 1950s, the texture and atmosphere of everyday life in the period. One of the key moments in *Great Expectations* is Pip's move to London, where he will become a gentleman (fig. 80). In Lean's film, Pip is excited and overwhelmed by the metropolis, and the dome of St Paul's Cathedral, that icon of the City of London, is repeatedly shown in the exterior shots.[66] To a post-war audience, however, the symbolism of St Paul's was especially resonant. Herbert Mason's extraordinary photograph of the dome of St Paul's, standing intact amongst the smoke

79 John Piper, *Seaton Delaval*, 1941, oil on canvas and wood, 71.1 × 88.3 cm, Tate, London.

and destruction of the Blitz, had been published on the front page of the *Daily Mail* in 1940 and had become a symbol of British survival and resilience (fig. 81). The bombing created a vast landscape of ruination around the cathedral, and after the war the reconstruction of this site became one of the most debated issues in the rebuilding of London. Photographs record the extent of the devastation in this area and the persistence of those horrid empty spaces throughout the 1950s (figs 82 and 83). Many plans were submitted for the redevelopment of the land around the cathedral, with Nikolaus Pevsner and the *Architectural Review*, in particular, supporting William Holford's scheme in the mid-1950s, which was seen to bring together traditional English picturesque principles and modern urban planning.[67]

When Pip arrives in London in Lean's film, it is a landscape of ruin. A production shot of Pip on the London coach strips away the mask of Victorianism and the illusion of a clever camera angle and reveals the bomb-shattered City of London, the buildings opposite St Paul's

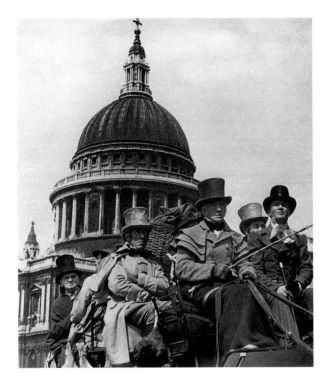

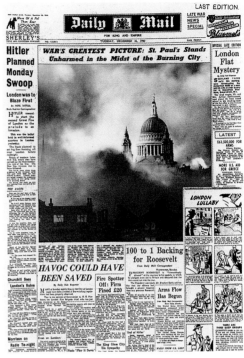

80 Pip on the coach in London, *Great Expectations*, 1946.

81 Herbert Mason, 'St Paul's Survives', *Daily Mail*, 31 December 1940, p. 1.

82 'Aerial View of St Paul's and Surrounding Damage', 1950. London Metropolitan Archives.

83 'St Paul's Cathedral with Surrounding Bombites', 1952. London Metropolitan Archives.

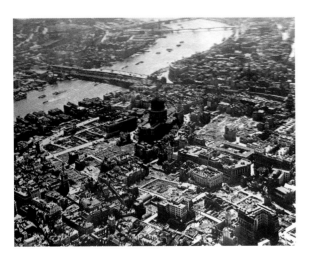

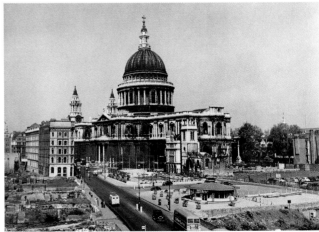

84　Filming Pip on the coach
in the City of London,
Great Expectations, 1946.

razed to the ground (fig. 84). A Victorian horse-drawn coach drives through the bombsites of post-war London; a perfect and literal visual expression of Michel de Certeau's discussion of displaced history and the theatre of Alexandre Dumas: 'Ladies and gentlemen, come this way and you will see the history for one, for all, a history recounting both the proximity of the past and the foreignness of your private life, or the present as a metaphor for a somewhere else.' The Victorian period played the part of the origin for post-war Britain: the past that would be 'redone, rewritten and re-presented' in the modern, reconstructed world.[68] The shadows of the nineteenth century would not go away, however; they were as persistent as the fog and the ruins and remained part of post-war visual culture, threatening to undo the steady progress of modernity and, like the Victorian chaise longue, draw the nation back into the murk and grain of the past. When Pip tears down the curtains in 1946 to let the sunlight into Satis House, perhaps all that is outside is the fog.

125

Part Two

The Question of Colour

85 'Colour Again', *Picture Post*, 9 November 1946, cover.

4

Learning to Think in Colour

Colour Again

Loss of colour was a metaphor for all that was wrong with the post-war settlement; rather than celebrating the poetics of chiaroscuro and atmospheric contrast, grey became the symbol of stasis: of a ruined society, a government that was failing to modernize and a country that was bogged down in the past. For British painter and writer Wyndham Lewis, the grey rot of London was a visual expression of the debt-laden over-regulation of the Labour government, and writing in 1951, the year of the Festival of Britain, it became the focus for one late 'blast': 'a monstrous derelict of a city, built upon a bog and cursed with world-famous fogs: every house in it has a crack from the blast of a bomb and dies at last of chronic dry rot.'[1]

Memories of the late 1940s and 1950s are monochrome; people recall these years through veils of mist and shades of grey, conjuring images of black and white photography or newsreel. Perhaps the starkest and most traumatic recollection of British grey was that experienced by migrants in their first sight of the country. Coming from the colonies and dominions, their hopes and dreams of the mother country were dashed by the sight of the colourless land.

Where mists and rain had, during the war years, been mobilized as part of a mythic image of timeless national identity and character, for migrants in the post-war years the grey climate represented the loss of home and community and their arrival in a strange and frequently hostile environment.[2]

One of the most powerful and resonant images of the decade following the end of the war was that of the arrival of the ship laden with colonial migrants, caught at the moment of disembarkation, as the travellers set foot on British soil. It is this moment of emergence that signals their cultural difference and the shock of the new – the moment at which grey and colour become signifiers of racial identity and part of a social, moral and political discourse. For the generation of writers who came from the Caribbean to Britain in the 1950s and who described this experience in their prose, the impact of arrival is expressed in terms of the pervasive and unremitting monochrome of the land, the chill that penetrates and the cheerless sights.[3] The title of George Lamming's *The Emigrants*, first published in 1954, emphasizes that the subjects of the novel are not just 'immigrants' or strangers arriving in a new country, they are also, and just as importantly, leaving a place and a life. The division of the text into three parts reflects this point of view: 'Part One – A Voyage', 'Part Two – Rooms and Residents', 'Part Three – Another Time'. It is a book about the uncertainty of going away from home, of journeys and fears and the repeated reason for leaving: for work and education and some vague sense of a 'better break'.

Following a long account of the journey itself, the emigrants are drawn on deck by the first sight of England and the lights of Plymouth: 'Beyond the first mild rising of the land a straight narrow spate of red brick buildings covered the hills, and further on an anonymous greyness that held within it neither hills nor houses.'[4] The indistinct greyness of the distant landscape reflects their apprehension and unease, which is exacerbated on the train journey to London and their arrival in the cold, dark and smoky station at Paddington. The rhythmic pattern of the indirect dialogue powerfully evokes the accumulation of images and the growing anxiety of the emigrants as they arrive in the metropolis:

> Where all that smoke comin' from?
> I see the smoke. But no fire. What happen now?
> We stop ol' man. We stop dead.
> Look a train next door.

Maybe they collide. The smoke thick.

We stop sudden as hell.

That smoke Tornado. It ain't look real.

It got a colour like the cold of yuh chest.

We got to wait till that smoke clear up.

That ain't smoke ol' man.

It cold Tornado. It get cold sudden as hell.

There is no relief or escape from the smoke and drab cold and the speech breaks up into frantic, disconnected thoughts:

Weak. Frightened. They said it wouldn't

be so cold. So cold . . . so frightened . . .

so frightened . . . home . . . go . . . to

go back . . . home . . . only because . . .

this like . . . no . . . home . . .

. . .

thick . . . sick . . . thick . . . sick . . .

up . . . cold . . . so . . . frightened . . .[5]

For Tornado and his fellow emigrants grey is the colour of a place that is not home and the resigned acceptance of a situation that cannot be reversed; they must get on, they must keep searching for that 'break'.

George Lamming arrived in England from Barbados in 1950, on the same boat as his fellow writer Sam Selvon, who was travelling from Trinidad. In Selvon's 1956 novel, *The Lonely Londoners*, the fog is used to evoke the strangeness and unreality of London. Drawing on a long literary tradition of the representation of the city, including Charles Dickens and T. S. Eliot, Selvon reworks this canon through the sounds and patterns of Caribbean street talk, Trinidadian calypso and an episodic modernist structure. The novel follows a group of West Indian migrants in London and begins as Moses Aloetta, who has been in London some years, goes to meet Sir Galahad, a man who is arriving from the Trinidad boat-train at Waterloo. It is a foggy day and Moses jumps on a bus in west London to go to the station: 'When Moses sit down and pay his fare he take out a white handkerchief and blow his nose. The handkerchief turn black

and Moses watch it and curse the fog. He wasn't in a good mood and the fog wasn't doing anything to help it.'[6] I like to think of Moses as one of the passengers stuck on those buses guided by the flare of a 1950s linkman, becoming increasingly impatient as the bus crawls at snail's pace through the fog; it humanizes those otherwise anonymous newspaper photographs discussed in Chapter One. Moses is there on the number 15 bus to west London, and he sees the fog and greyness through the weary eyes of an experienced traveller, of someone who has made the transformation from emigrant to immigrant.

Doris Lessing arrived in London from South Africa in 1949 and recalled in her writing the experience of home-hunting in the city in these years: 'interminable streets of tall, grey, narrow houses that became half-effaced with fog at a distance of a hundred yards . . . railings too grimy to touch, dirty flights of steps – above-all an atmosphere of stale weariness'.[7] Why are all these accounts colourless? Where was the colour of post-war Britain, or, more exactly, how was the meaning of colour articulated in British society in this period? In the later, second volume of her autobiography, Lessing observed that it was not just the physical land-scape at this time that was dull, grey and dismal: 'The war still lingered . . . in people's minds and behaviour . . . There was a wariness, a weariness.'[8] Grey is also in the mind; it is a way of seeing the landscape that is shaped by war and anxiety and that can only and perhaps will only see the world through greyscale.

Grey is like the fog; it is a heavy colour, it smothers life and kills off the light. It is the hue of post-war reminiscences. Grey is suited to the work of remembering for, as David Batchelor has shown in his brilliant discussion of *The Luminous and the Grey*, grey is a slow colour, the colour of protracted reflection and recollection: 'If luminous colours are the most fleeting, the most ephemeral and the most fugitive, then grey is the sloth and the slug of colours. Whatever looks luminous does not look grey, and perhaps it comes down to a question of velocity.'[9] It is through this suggestion that colours have a temporality and velocity that we begin to get close to an important aspect of the symbolic discourse of post-war colour. To be modern is, in part, to be 'in colour', on the spectrum, where grey is to be held back, absorbed in the past, in memory. It is to be out of time, an endless 'day that never broke', as Bill Brandt's melancholy 1947 black and white photo-essay of a foggy day in London was titled.[10]

Greyscale does a lot of work in post-war Britain; it creates a way of seeing contemporary life and acts as a filter for the landscape. It classifies the density of smoke and defines the quality of the air; it touches every surface and face with its different shades. It is the colour of the

'uprooted self', as Salman Rushdie has described it.[11] It is a subtle colour but it cannot do all this on its own. Grey needs colour to create these meanings; it needs chromatic purity and luminosity to give it its drab, semantic richness. Batchelor describes the relationship of the luminous and the grey as one of mutual dependence: 'the luminous is almost always accompanied by the grey: they cohabit and sustain one another in an often unacknowledged relationship of interdependence. The grey makes the luminous more luminous and the luminous makes the grey so much greyer . . . whatever looks luminous looks luminous because of the grey that surrounds and threatens to extinguish it.'[12] Greyness can only be the colour of the past and of bleak resignation through its relationships with colour, which take on a very specific significance in the context of post-war Britain. It turns out that grey is not just the hue of sober limitation and frustrated desire; it is also the colour of possibility, the springboard for narratives of modernization and post-war reconstruction that tell the story of the emergence of the nation from grey into a brightly coloured future. How better to tell the tale of post-war progress than in the chromatic terms of greyness and the scree of the past transformed into the clear, sharp, unimpeded colours of the future?

For the young graduates and designers who worked on the Festival of Britain, the greatest achievement of the South Bank site was its infusion of colour into a gloomy and shabby landscape. Over and over again, they describe the festival as a 'flash of colour' in an otherwise grey and threadbare country.[13] The festival needed grey to tell its story of sparkling rejuvenation as much as it needed the red, blue and yellow spheres that decorated its boundary screen.[14] Built on a bombsite on the south side of the Thames, the Festival of Britain was presented as a condensed version of the bigger story of national reconstruction that circulated in the years immediately following the end of the war. At the beginning of May 1951, just days after the official opening, *Picture Post* carried a five-page article called 'From Mud to Festival', telling the story of the South Bank.[15] With 'before' and 'after' photographs of the site, the article describes the grimy plot where the exhibition has been built: 'one of . . . London's most dispiriting no-man's lands, an abandonment of slum and confusion, dust and decay: a hopeless place'.[16] The entire lexicon of greyscale was mobilized for the festival story and the details could not have fitted better, even down to the fact that the land had been reclaimed and the foundations built from Blitz rubble. The morning of the Royal Opening was wet and misty, but out of this greyness the nation emerged into the modern world, into colour and light and gaiety.

Writing in the *Listener* in the autumn of 1951, shortly after the South Bank had closed, Harold Nicolson recalled that the festival had been organized 'to dissipate the gloom that hung like a pea-soup fog above the heads of the generation of 1951' and had transformed the area, which had been 'coloured emerald, orange, purple, pink, and scarlet'.[17] With the defeat of the Labour government, however, and a new Conservative government elected just weeks after the closure of the South Bank, festival colour was far from guaranteed. Reconstruction had barely started, and the vivid colours of the South Bank might so easily fade back into grey. By the summer of 1952 Marghanita Laski was asking readers of the *Observer* whether they remembered the colour, optimism and gaiety of the festival: 'Do you remember the colours that glared across the river, olive and scarlet and yellow and blue, balls and windmills and walls and doors, dabs of pure colour such as we didn't know we had always hungered for until at last they were there?[18] The need for colour is basic and physical; it is a hunger for something that, like food and clothes, had been rationed during the war years, and now that people had tasted it again, the fear is that it could disappear as swiftly as it had reappeared in the summer of 1951. For Laski, one year on, the festival seemed like 'a fragile bubble of hope', and memories of the magic and colour now carried a poignant sense of loss: 'It was the nicest thing that happened in England in the whole of my life.'

In the years immediately following the end of the Second World War, Britain's hold on colour was uncertain; the yearning, the appetite, for colour was expressed over and over again, but its social impact was less clear. Colour was the language of the project of modernization, but it was as though the knowledge of colour had been forgotten and needed to be reintroduced into the national fabric and psyche. Moreover, like other drives or appetites, the taste for colour was not without its tensions and problems. It was ambiguous and overdetermined, and might require restraint as much as indulgence. In November 1946, with paper rationing still in place but with small increases in the ration enabling increased newspaper sizes, *Picture Post* introduced a colour middle section in a bid to maintain wartime circulation figures. The piece was a photographic look at the Royal Rooms at Windsor Castle, and to this extent the paper conformed to what would become a convention of depicting royalty in colour. To promote this important issue the *Post* ran a cover announcing in bold white lettering against a red ground: 'Colour Again', with a photograph of a black woman in a décolleté top, against a dark background, apparently modelling for a sketch (fig. 85).[19] 'Colour Again'... the colour of royal Windsor or the colour of the skin of the woman on the cover? It would be fascinating

to be able to reconstruct the editorial discussion that led to the selection of this cover and the overlaying of the colourful interiors of Windsor with the colour of race. This choice, however, pinpoints the question of colour in post-war Britain. Colour was never just colour; it was also always something else, something more than simple hue or shade. Colour again – it was not so much a question of the return of colour, however, for colour had always been there, as the emergence of a new and different colour world in the late 1940s and the 1950s, in which colour took on greater meaning than it had ever had before.

Colour in post-war Britain: it was the language of progress and modernity; it was the new Jerusalem and the old empire staking its colour claim in the motherland. It was the world of paints and advertising, of coordinated and clashing combinations and of educated and extremely unregulated desire. It was the world of Technicolor and Eastmancolor as opposed to film and photo noir. Colour leapt off the page and the screen rather than drew its viewers into its grainy, gravure depth. Colour in Britain after the war: bright, gay, the future, dangerous, wayward, citrus yellow, 'Nigger Brown', 'Kenya Red', colour range, colour bar.

Colour Attracts

In 1953 *Kinematograph Weekly*, a trade newspaper for the British film industry, was carrying a colour advertisement for Technicolor with the slogan 'colour attracts . . .' (fig. 86).[20] At a time when other colour film companies such as Kodachrome were still advertising their products 'Supreme for Colour' in black and white, the full-page Technicolor image shows a spiky cactus on a desert floor with a large pink flower and a butterfly heading for its pollen-laden stamen.[21] The message is a clear one and was evidently liked and reused by the well-organized Technicolor company: colour is irresistible. And yet, as the poor insect risks being pierced by one of the threatening spines, perhaps it inadvertently suggests that the attraction of colour is so great that the consumer may be harmed if they get too close. We have to assume that Technicolor would not want to promote its products in quite these terms, but the advert seems to suggest once again that the meaning of colour is always in excess of the people who are using it.

Technicolor dominated the colour film industry in the years after the war, in spite of the fact it was a cumbersome technical process and that the company exercised strict centralized control over the use of its film stock and the look of the films on which it was used. The

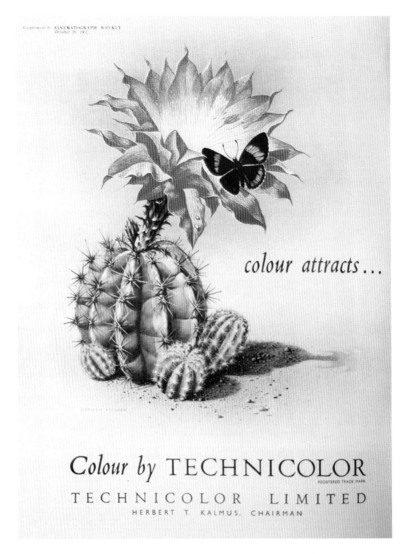


Supplement to KINEMATOGRAPH WEEKLY
October 29, 1953

colour attracts...

Colour by TECHNICOLOR
REGISTERED TRADE MARK

TECHNICOLOR LIMITED
HERBERT T. KALMUS, CHAIRMAN


86 'Colour Attracts', advertisement for Technicolor, supplement to
Kinematograph Weekly, 29 October 1953, p. 32.

three-strip Technicolor system was introduced in 1932 and became the most widely used and commercially successful colour film process in Britain until it was superseded in the mid-1950s by the much simpler Eastmancolor system.[22] The Technicolor process was based on a prism behind the lens of the camera that split the light source through three filters that produced red, blue and green negatives, which were then cemented together onto a blank film coated with

gelatine. It was expensive and involved the use of a heavy and bulky camera. The advantages of the Eastmancolor process, which was introduced by the Eastman Kodak Company in the early 1950s, were obvious. All three colours were printed onto a single strip of film, enabling the use of much lighter cameras and faster film processing.

The look of a Technicolor film was distinctive; the colour was deep, vibrant and saturated, even though the directors and cinematographers only saw black and white rushes while they were shooting the film. In a recent interview, Oswald Morris, a Director of Photography in this period, recalled the experience of working with Technicolor: 'And what a shock it is when you see it all in colour because it suddenly becomes much more powerful. The colours sort of leap out at you because Technicolor were the greatest ones in the world for piling on the colour . . . They were all out to sell colour . . . The whole system was like a Sherman tank.'[23] In the post-war world Technicolor stood for colour at its boldest and brashest, even when its position as the leading colour system had been relinquished to other processes. One of the reasons that Technicolor films had such a distinctive look was that the company retained control over the use of colour in its films, offering a Color Advisory Service, which, until 1949 was headed by Natalie Kalmus, wife of the chairman, Herbert T. Kalmus. This service supplied a colour consultant and guidelines on how to use colour to enhance the film's story and mood. Drawing on academic theories of colour in fine art, Kalmus and her advisors designed a colour chart for each film that was the equivalent of its musical score. The colours of sets, costumes and furnishings were all coordinated, with the aim of making the Technicolor motion picture a work of art. Kalmus advised: 'In order to apply the laws of art properly in relation to color, we must first develop a color sense – in other words, we must become "color conscious". We must study color harmony, the appropriateness of color to certain situations, the appeal of color to the emotions.'[24] Although she recommended using neutrals as a foil for colour, she had little time for grey: 'Gray suggests gray skies and rain. It is gloomy, dreary, and represents solemnity and maturity . . . it represents mediocrity, indecisiveness, inaction, vagueness.'[25]

Drawing on a combination of existing colour theories, Technicolor created a look that became synonymous with the idea of colour itself. In *A Matter of Life and Death*, an inventive fantasy film directed by Michael Powell and Emeric Pressburger in 1946, a British Royal Air Force pilot, Peter, bails out of his plane after being hit during a mission over Germany.[26] He should have died but escapes because the heavenly guide, Conductor 71, who has been sent to take him back to the afterlife, misses him in a thick fog over the English Channel. The film's

plot concerns the pilot's efforts to remain alive on earth and to escape the claims of the 'Other World'. The most striking visual device is the differentiation of the heavenly and the earthly worlds through black and white and colour. The scenes in the afterlife were shot on three-strip Technicolor with the colour drained out, giving a pearly monochrome effect and enabling a smooth transition when the narrative moves between heavenly and earthly zones. One of the most memorable scenes is when Conductor 71, who in life had been an eighteenth-century French aristocrat, comes to earth to reclaim Peter and the rose in his lapel changes from the bleached out monochrome to gorgeous colour. 'One is starved for Technicolor up there,' he quips and stands surrounded by colour-saturated flowers. The line is an in-joke, a jibe at the over-regulated Technicolor company by two directors and their cinematographer, Jack Cardiff, who experimented with Technicolor processes and took the system far beyond its conventional and expected forms.[27] It is a line that also belongs squarely in the world of post-war Britain, where colour is a physical need, a hunger, which the nation is finally able to satisfy. Technicolor was the colour of the 1950s, celebrated in the 1955 musical *Silk Stockings*, with music and lyrics by Cole Porter. Even when it was adapted for film in 1957 (USA; dir. Rouben Mamoulian), starring Fred Astaire and Cyd Charisse, and shot in Metrocolor and Cinemascope, the lyrics of the song 'Stereophonic Sound' remained the same:

> If you want to get the crowds to come around
> You've gotta have glorious Technicolor,
> Breathtaking Cinemascope and
> Stereophonic sound.[28]

In spite of the fact that it had been dethroned and films were being shot on other systems, Technicolor remained shorthand for the colour world of modern consumer culture. It is not surprising, therefore, that artist Richard Hamilton's 1959 lecture on the fascination of new technologies and the entertainment industry was titled 'Glorious Technicolor, Breathtaking Cinemascope and Stereophonic Sound'.[29]

Throughout the 1950s new types of colour film were constantly developed and introduced to the film industry. Alfacolor and Kodachrome were amongst the many rivals to Technicolor in this period, and although the *Kinematograph Weekly* claimed that colour was now indispensable to attract audiences, it remained more expensive than black and white film and also retained the connotation of being aesthetically inferior.[30] Colour was regarded by

some as superficial and a distraction from the essential forms of black and white photography, but its commercial momentum was irresistible. If Oswald Morris believed that Technicolor was out to sell colour, then elsewhere advertisers were persuading companies to use colour to sell. In the mid-1950s black and white and colour adverts coexisted and drew on their distinctive associations and effects to sell products. In December 1953, a year that had already suffered fatal floods and freezing temperatures, the hot drink product 'Ovaltine' pictured a wet and foggy street and a man hurrying home to a fire and a cup of the warming beverage (fig. 87). Although we can imagine the fireside in colour (and Ovaltine later used colour adverts and the slogan 'Ovaltine Families Are Happy Families' to show the family hearth – see fig. 160), the street and the smog and the journey home are best represented in shades and veils of grey.[31] It was getting close to Christmas, however, and a few pages later a full-page colour advert showed brightly coloured sparkling 'Spangles' creating the musical score for a Christmas jingle (fig. 88).[32] Spangles were introduced by Mars Limited in 1950; they were fruit flavoured boiled sweets that required only one point from a ration book and were perfectly designed for the world of colour advertising. Each little semi-transparent, cellophane-wrapped sweet is a coloured jewel that shines and glows, a tempting note to be plucked from the staff paper and popped in a Christmas stocking. Fruit sweets and jelly were frequently advertised in colour, cementing the association of colour with flavour and appetite. In the summer of 1951 an advert for Rowntree's 'Fruit Gums' showed a tube of sweets, alongside a pair of sunglasses, in deep perspective projecting into the foreground towards the viewer (fig. 89).[33] Set against an intense yellow background, the suggestion is that the luminosity of both the sweets and the coloured background requires the use of sunglasses.

As the 1950s progressed, colour printing became the convention for representing royalty and confectionary. By July 1954, when restrictions on the purchase of meat and bacon were

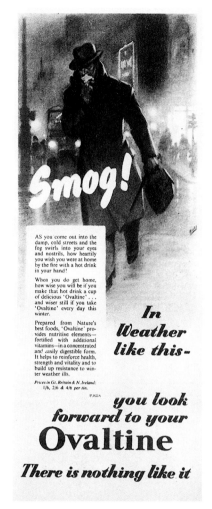

87 'Smog!', advertisement for Ovaltine, *Picture Post*, 12 December 1953, p. 30.

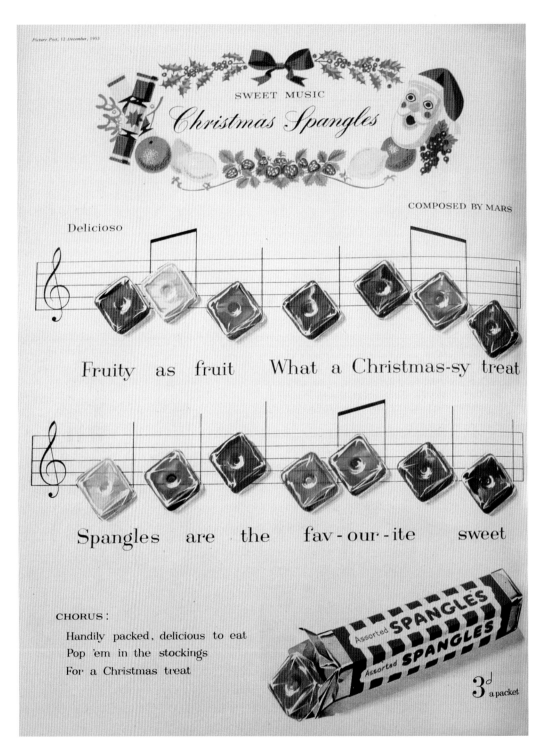

88 'Sweet Music Christmas Spangles', advertisement for Spangles, *Picture Post*, 12 December 1953, p. 34.

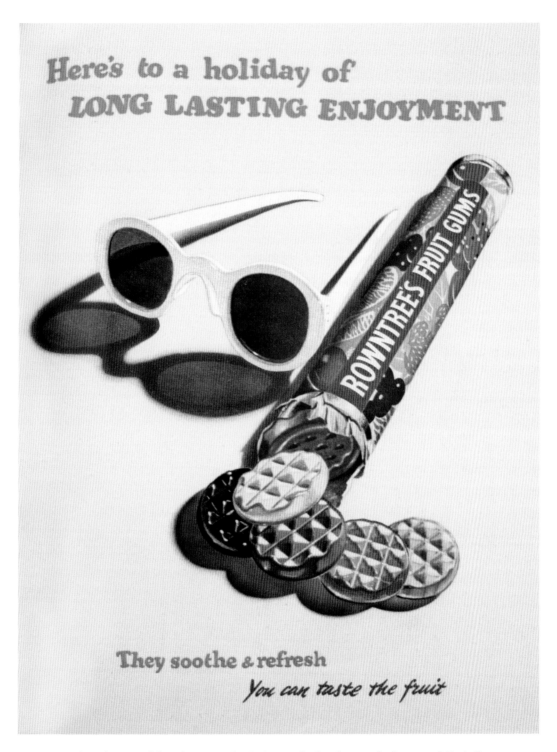

89 'Here's to a Holiday of Long Lasting Enjoyment', advertisement for Rowntree's Fruit Gums,
Picture Post, 4 August 1951, p. 9.

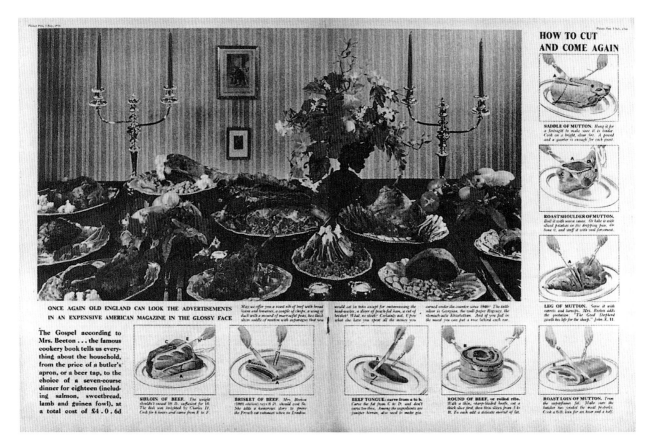

The text within the figure image:

HOW TO CUT
AND COME AGAIN

SADDLE OF MUTTON.

ROAST SHOULDER OF MUTTON.

LEG OF MUTTON.

ONCE AGAIN OLD ENGLAND CAN LOOK THE ADVERTISEMENTS
IN AN EXPENSIVE AMERICAN MAGAZINE IN THE GLOSSY FACE

The Gospel according to
Mrs. Beeton . . . the famous
cookery book tells us every-
thing about the household,
from the price of a butler's
apron, or a beer tap, to the
choice of a seven-course
dinner for eighteen (includ-
ing salmon, sweetbread,
lamb and guinea fowl), at
a total cost of £4.0.6d

SIRLOIN OF BEEF.

BRISKET OF BEEF.

BEEF TONGUE: carve from a to b.

ROUND OF BEEF, or rolled ribs.

ROAST LOIN OF MUTTON.

90 'Once Again Old England Can Look the Advertisements in an Expensive American Magazine in the
Glossy Face', *Picture Post*, 3 July 1954, pp. 26–7.

lifted and fourteen years of food rationing ended, food and colour became, in equal measure, symbols of abundance and of the end of austerity and self-denial. In celebration of the lifting of restrictions, *Picture Post* printed a double-page colour spread of a table groaning with food and joints of meat, along with diagrams reminding readers how to carve different cuts (fig. 90).[34] It was as if colour, as much as food, had come off the ration and advertisers and editors were tearing up the rules of colour restraint along with their ration books. What more appetising way to advertise the flavour of Guinness than by setting it alongside a plate of steak, beans, chips and tomatoes in shiny, moist colour: 'Natural colour . . . natural taste'.[35]

The look of colour advertisements in the 1950s was a result of the way that the image was printed on three- and four-colour blocks. The picture had to be exposed three (or four) times

142

using a different colour filter for each exposure, thus building up the picture in layers as each of the negatives is printed on to a block. If the colours in these adverts for Fruit Gums, jelly and Spangles seem to 'jump' off the page, it is an effect that reflects the printing of layers of magenta, yellow and cyan (and black) one on top of the other.[36] Throughout the 1950s the *Penrose Annual*, a professional review of the graphic arts, reported on the constant new developments in colour photography and printing and, by the end of the decade, was describing the introduction of automatic colour correction processes and electronic scanners. In its 'Editorial Notes' for 1959 it advised: 'With more British magazines offering four-colour printing to advertisers at low rates, and other magazines going over to full use of multi-colour printing for editorial features as well as for advertisements, and with experiments in colour television showing increasing promise, the advice . . . to "think in colour" – is being emphasized in the most practical way.'[37]

Professional advertising companies had adopted the advice to 'think in colour' even before the end of the war. *Selling With Color* by Faber Birren, who ran the research organization 'American Color Trends', offered pseudo-scientific guidelines on how to 'gain greater control' of colour.[38] Asserting that 'color sells' and 'this is an age of color', Birren drew on theories of colour symbolism and expression to draw the conclusion that colour preferences were corporeal and instinctive and those of the masses were 'simple . . . elemental . . . primary . . . primitive . . . obvious . . . bright'. Addressing the question of whether colour preferences are determined by gender and race, Birren suggested that colour research was inconclusive but that amongst American Indians, Filipinos, Negroes and the insane, 'white, red and blue are always predominant.' This is just one of many instances in which the psychology of colour was recruited in this period for the purpose of defining racial difference; it was a discourse that would racialize colour in the post-war world.

Other, more academic, writers, were equally convinced that the modern world was, or would be, an age of colour. The American sociologist and historian of technology, Lewis Mumford, formulated a history of western culture through the progress of industrialization and the development of the machine. In a series of studies first published in the 1930s and revised and reprinted in the 1950s, Mumford traces the origins of modern technological society, which he argues is currently in its third stage and at a point where the machine needs to be directed towards the service of society and not the destruction of the environment. According to Mumford's historiography, the Paleotechnic period, which was the age of iron

and coal, had produced a characteristic and dominant tone: 'grey, dirty brown, black'.[39] In language that is strikingly close to that of the National Smoke Abatement Society and the clean air campaigners, Mumford speaks of 'atmospheric sewage' and 'the smoking factory chimney, which polluted the air and wasted energy, whose pall of smoke increased the number and thickness of natural fogs and shut off still more sunlight'.[40] This was a crude and murky world that sought aesthetic compensation in a poetics of fog and twilight and that would ultimately lead to world war. Although Mumford concedes that the Paleotechnic order still dominates the contemporary world, he identifies a new phase, the Neotechnic period, which is driven by the economy of electricity, rather than coal, and of synthetic materials such as celluloid and plastics. If this new development is directed with intelligence and social cooperation, he writes, a new clear, sharp and penetrative vision would emerge: 'Light shines on every part of the Neotechnic world: it filters through solid objects, it penetrates fog, it glances back from the polished surfaces of mirrors and electrodes. And with light, color comes back and the shape of things, once hidden in fog and smoke, becomes sharp as crystal.'[41] Colour would be the language of the Neotechnic age as the world moved from the brown smut of iron and coal to the brilliance of a new industrial age governed by social and political justice: 'The fog lifted: the blind saw: color returned.'[42]

As Mumford celebrated, in frankly religious terms, the return of colour in the Neotechnic period, others in the post-war years continued to suspect its aesthetic and moral values and to extol the superior artistic qualities of black and white media – a residual distaste for colour that is part of a much longer history within western culture of what David Batchelor has called 'chromophobia'.[43] This prejudice is conventionally expressed in terms of either the danger of colour or its triviality, its alien qualities or its superficiality. Either way, colour is removed from the world of the intellect and the higher values of culture and is relegated to the concerns of the body and specifically to the domain of the primitive or the feminine. Batchelor traces these ideas to Pliny and the division of the Occident and the Orient within classical philosophy and, later, to eighteenth-century aesthetics and Kant, for whom colour was merely charming, an obstruction to the pure contemplation of beauty: 'As far back as Pliny, [colour] was placed at the "wrong" end of the opposition between the occidental and the oriental, the Attic and the Asian . . . In later times, the Academies of the West continued and consolidated this opposition.'[44] Academic theories of art also drew on the classical terms of rhetoric in which *colore* (colour) was subordinate to *disegno* (drawing) and could only ever be the embellishment of, or

decorative flourish to, the essential structure of the argument or design. Within these traditions of western culture, therefore, colour was exotic and foreign; it was a source of sensual delight but could not elevate or ennoble the viewer.

Whilst these theoretical and historical debates about colour were not exactly a living tradition in post-war Britain, they remained a significant part of the intellectual legacy of art criticism and provided some of the terms in which writers in these years struggled to accommodate and account for colour in the visual arts. Furthermore, the historical association of colour with sensuality and the body was revitalized by migration from the West Indies and former colonies in this period and, as will be shown in Chapter Five, became an indispensable language for defining racial chromophobia.

In the same years that Lewis Mumford was developing his history of culture and technology, Adrian Stokes was working with the psychoanalytic theories of Melanie Klein to formulate an account of the nature of aesthetic pleasure. Stokes's primary interest was in the reparative function of art and the evolution of an aesthetic based on restoring and healing that which has been torn apart or destroyed in fantasy. Beauty, he wrote, 'is a sense of wholeness'.[45] Colour plays an uneasy role in Stokes's aesthetic thought and is dependent on his sense of texture and surface, particularly in his writing on buildings and the landscape. If colour is properly subdued it is able to create rather than simply to embellish form; it becomes a type of 'visual resistance' that defines the nature and vitality of the object.[46] The concepts of the rough and the smooth create the key dichotomy in Stokes's work on architecture; they express the oral and the tactile effects that underlie visual experience and that should be held in a balanced reciprocity. Texture draws Stokes into an appreciation of shadow and light: the dark openings of doorways; the smooth, light wall-face; textured projections. Colour is an aspect of illuminated surface, but it must not be too forceful and should gradually unfold through the rhythms of light and dark: 'any form that discloses rapid change of light and shade, suggests roughness; whereas the unfluted shaft is smooth ... Owing to shadow, shallow stairs are often roughnesses with a smooth intent ... colours complicate and emphasize.'[47] In the concluding section of *Smooth and Rough*, written 1947–8, Stokes extends his reading of the surface world to a comparison of mining and quarrying. Drawing on Lewis Mumford's *Technics and Civilization*, he describes mining (Paleotechnic) as a form of wasteful violence, compared to the considered forms of quarried stone and the outstanding beauty of European architecture. Stokes's image of a post-war world would not embrace colour with the conviction of Mumford's and would

remain equivocal about the role of colour in the act of repairing both psychic damage and the destruction of war.

Colour complicates art theory and criticism in the post-war years. In a study completed during the war and then revised in 1947 (though not published until 1950), an elderly Bernard Berenson extolled a self-contained history of western art based on the ideal forms of classical antiquity and removed from the actuality and materiality of everyday life. Art was the extension of mental life; colour, however 'belongs to the world of immediately present and not merely imagined sensations, and is only less material than tasting, smelling, or touching, because it is perceived by one of the two signalling, reporting senses, and not by the three more cannibal ones.'[48] Colour for Berenson is attractive and troubling; it is devoured by the eyes and its pleasures are exotic and infantile, and he imagines an oriental prince running his fingers through piles of precious stones: 'for the touch, and perhaps chiefly for the gaiety and sparkle of colour, [he] will scarcely be credited with enjoying them as works of art.' The conclusion is a familiar one: colour must be subservient in the visual arts, used to enhance form, and limited in painting to 'a polychrome chiaroscuro'.[49]

Form is intellectual; colour is instinctive and physical. This was the language of advertisers and art theorists in the post-war period; although colour signified modernity and progress, there was something disturbing about it. Always more than hue, tone or intensity, it was wayward and overwhelming and needed to be subordinated. Post-war colour is a complex set of interconnecting discourses that cannot and should not be placed within neat categories of positive or negative meanings. What is clear, however, is that after the war there was a sense – shared by filmmakers, advertisers, and theorists of art – that colour had returned with a vengeance and that people would need educating in how to live in a post-war chromatic world.

British Colour: An 'Unruly Child'

By the middle of the 1950s, the choice of colour seemed boundless. Paint companies were advertising 'unlimited colour choice', 'a choice of upwards of 999 colours' and 'any shade you like' mixed to individual specification.[50] This superabundance was a sign of affluence and a society that was young, attractive and modern. If colour was youthful, however, there was also a perception that it was delinquent and risked becoming out of control. In an article

on Technicolor, the cinematographer, writer and director Ronald Neame began with the acknowledgement: 'Let's face it, colour has come to stay' and concluded: 'colour has been born . . . this healthy and sometimes unruly child is growing rapidly every day.'[51] The image of colour photography as an ungainly and troublesome child was repeated in the professional press; in a review of recent aesthetic developments in the field, another writer observed: 'the photographic print in colour . . . is a naughty child. It won't do what we want it to do.'[52] Too much contrast or discord was dangerous and needed to be handled with 'the utmost discretion'; good manners and restraint were as important in controlling colour as they were in other areas of modern life. Once properly managed and planned, colour could be used in the home and in industry to create cheerful and harmonious environments; when the population was properly colour educated and understood the meaning of colours, productivity, health and comfort would improve.[53]

Colour was not a universal language, however. There was a distinctive quality to British colour as well as a particularly British way of dealing with it. For many professional photographers and cinematographers there was a look to British colour that differentiated it from European and American. It was as though the weather, the rain, had infiltrated the film stock and dyes and had diluted the intensity of the hues; British colour was infused with a nationalist ideology that defined it in terms of the weather: misty, restrained and subtle.[54] Commenting on the different look of British Technicolor films, cinematographer Christopher Challis observed: 'there is a different quality of light. I mean the soft sunlight that you get here a lot of the year where there's a lot of moisture in the atmosphere is quite different from anywhere else.'[55] This was not simply a question of the wet weather, however; it was also a question of a national character or outlook. In a 1951 study of *Colour Cinematography* that includes a study of the British public, it was concluded that: 'There does seem to be a marked antipathy to excessive use of vivid colour – apparently popular in Hollywood – which may be due to a national liking for the restrained and rather sad tones typical of the British sentiment for colour during the last hundred years.'[56] Colour was gradually and steadily being harnessed to ideologies of race and nation, according to which British colour was polite, rain-soaked and deferential. In fact, British colour was grey.[57]

The British Colour Council was established in 1930 and was responsible for the standardization, naming and coding of colour in the British Empire, or, as it was put in 1949: 'The placing of colour determination for the British Empire in British hands'.[58] The first *Dictionary of Colour*

Standards was issued in 1934 and new editions were produced regularly as colours were added to the ranges. Standard colours were produced for use in interior design, horticulture, bunting, factories and offices; colour charts were created showing colour samples, initially on pure silk ribbon and later on matt, gloss and pile fabric surfaces. Each colour was named, numbered and colour coded. As the Belgian theorist of contemporary art Thierry de Duve has argued, the colour spectrum in nature is continuous and undifferentiated, and it is only through language and the act of naming that it is cut up into different symbolic elements.[59] The names of colours, therefore, are always metaphorical and cultural. Colour in the empire was not arbitrary, whimsical or self-determined; it was the subject of centralized regulation and authority.

In the second edition, published in 1951, twenty additional colours were added, including five new grey tones that took their place alongside the other swatches, such as 'Kenya Red' – BCC 237 – a colour that had been introduced in 1935 on the occasion of the marriage of the Duke and Duchess of Gloucester and so named because it reminded them of the soil of Kenya (fig. 91a). Also listed was 'Nigger Brown' – BCC 20 (fig. 91b)– a colour that continued to be included in the *Dictionary* into the 1950s, in spite of the introduction in 1934 of 'African Brown' – BCC 351 – which, it was conceded, was 'a more desirable name for the colour standardised in 1934 as "Nigger Black"; it is often to be preferred to a "dead black".'[60] This is the world of colour as it is given meaning in the historical conjuncture of post-war Britain. The British Colour Council stated that its colour names were derived in three ways: from sensations in nature, for example, cherry red; from colours associated with period styles, for example, Wedgwood blue; and from the names of the original pigments, for example, yellow ochre. So how is 'Nigger Brown' named? How is it comprehended? What did it mean to purchase the latest Whipcord coat in 'Nigger', as advertised in *Woman's Friend and Glamour* in 1951?[61] Colour is a discourse of race, skin tone and empire; it is a part of the colonial project, and like the fog and the atmosphere it has an affective history that is woven into the more familiar stories of post-war recovery and reconstruction. And it is best to be aware of how deeply British colour is embedded in this project; it is not a neutral carrier of ideological meanings but is profoundly racialized and politicized and the active creator of meaning and of power and discrimination.

So it is no surprise when, after months of trying to settle into the metropolis, Sir Galahad in *The Lonely Londoners* experiences another instance of racism, he blames the colour black for the hostility of the white population; it is colour rather than people that is the problem:

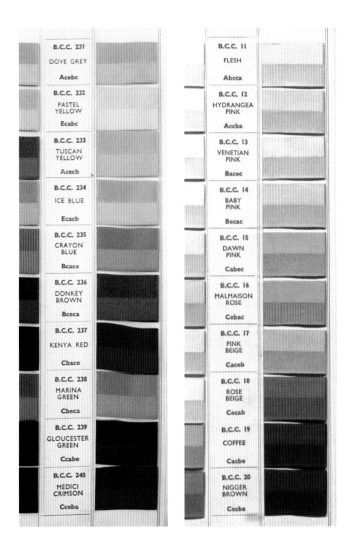

91a and b Details from colour chart (including 'Kenya Red' and 'Nigger Brown'), in The British Colour Council *Dictionary of Colour Standards: A List of Colour Names Referring to the Colours Shown in the Companion Volume,* volume 2, 2nd edn. (London: British Colour Council, 1951).

And Galahad watch the colour of his hand, and talk to it, saying 'Colour, is you that causing all this, you know. Why the hell you can't be blue, or red or green? If you can't be white? You know is you that cause a lot of misery in the world. Is not me, is you! I ain't do anything to infuriate the people and them, is you! Look at you, you so black and innocent, and this time so you causing misery all over the world!'

So Galahad talk to the colour Black, as if is a person, telling it that is not *he* who causing botheration in the place, but Black, who is a worthless thing for making trouble all about … 'Why the hell you can't change colour?'[62]

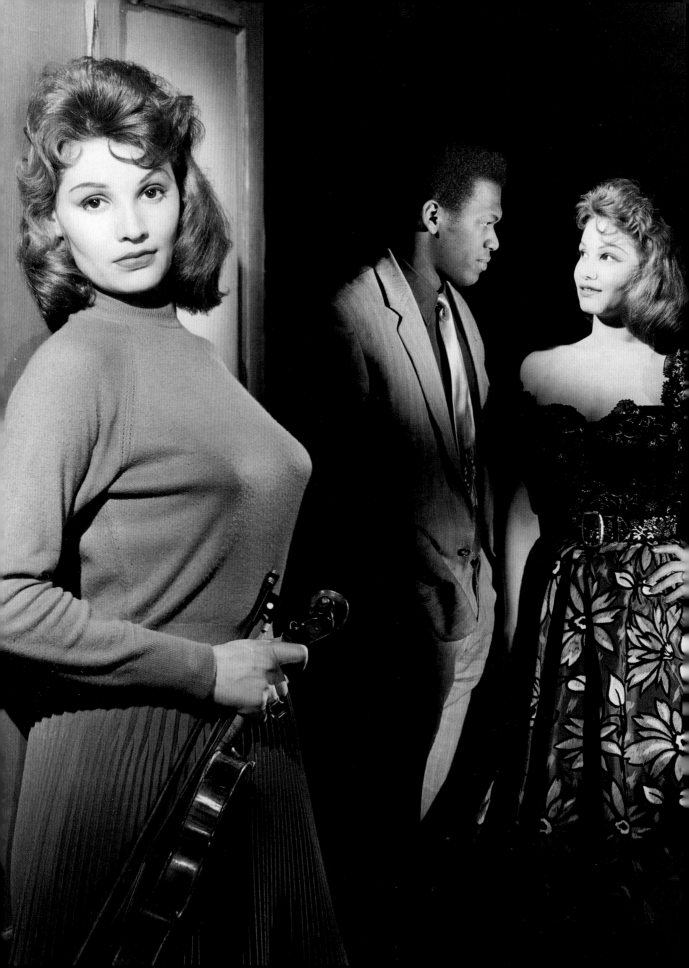

5

'Thirty Thousand Colour Problems'

The Colour of Empire

The 1948 British Nationality Act was passed by Clement Attlee's Labour government, in the immediate and pressing contexts of decolonization and national labour shortages. One year after Indian independence and the declaration of an Irish Republic, and in the same year as the United Nations General Assembly adopted the Universal Declaration of Human Rights, it was an attempt to preserve the British Empire and Commonwealth as an economic entity and as a unified grouping within post-war international politics.[1] The Act introduced an extremely expansive definition of British citizenship, providing that all residents of the British Empire and Commonwealth should be recognized as British citizens, enjoying equal rights and privileges. The government made no distinction between its own citizens born within the United Kingdom and those born in Australia, New Zealand or the West Indies; all were equally entitled to live and work in Britain. The Act also marked a shift in the ways in which colonial relations were experienced and represented, and a growing perception within white Britain of colour as a social, political and cultural problem, which ultimately led to the passing of

the 1962 Commonwealth Immigrants Act. The 1962 legislation was a response to mounting concern throughout the 1950s regarding Commonwealth migration and introduced restrictions on migrant entry into the United Kingdom through employment regulation. Only those with jobs to go to or skills that were considered necessary to the United Kingdom economy were considered eligible; unskilled labourers, who were assumed to be colonial migrants, were subjected to numerical control. The period from 1948 to 1962 is thus a distinct and key period within post-war history, and it is one that continues to have relevance within contemporary Britain.

Histories of the 1948 British Nationality Act generally acknowledge the significance of the Canadian government's announcement in 1945 of a bill to make Canadian citizenship their primary nationality and British subjecthood a secondary, or fringe, identity. By introducing a common British nationality throughout the empire, regardless of different national citizenships, the 1948 Act was a pragmatic way of ensuring the continued existence of a strong and united Empire/Commonwealth. The Act was also an entirely rational response to the threats of decolonization and colonial independence that had been growing since the 1930s. The years following the war had seen a British retreat from a number of territories, including India, Pakistan, Burma and Palestine, and the perception of a seriously shrunken and compromised empire was exacerbated by concerns regarding population decline and an economic crisis.[2] With labour shortages in heavy industry, matters came to a head in the freezing winter of 1947, when the entire country came to a standstill. The 1948 Act would, it was believed, preserve Britain's imperial status and bring badly needed workers to reinvigorate British manufacturing and export industry.

There was already a significant and established colonial community in Britain before the outbreak of the Second World War. Although the greatest numbers of immigrants at the beginning of the twentieth century and before 1939 were Jews from Eastern Europe, for centuries migrants from the British colonial territories had settled in seaports such as Cardiff and Liverpool and in major cities such as Manchester and London.[3] During the inter-war period concern had been expressed about anti-social behaviour in some of these communities, the lack of family life and the growing numbers of mixed race children. With the outbreak of war, however, these eugenicist arguments were eclipsed by the need to recruit soldiers from the colonies, and although most chose to return to their homes in 1945, a number of West Indian ex-servicemen used their demobilization payments to settle in Britain.[4] So by the passing

of the 1948 Act, there was both a historical and a recent black colonial community in Great Britain; they were part of the economic and social life of the nation, and although the numbers may not have been substantial, their presence was part of the fabric of the country and had already triggered some of the debates concerning racial difference and the purity of the white nation that were to cohere in the language of the 'colour bar' in post-war Britain.[5]

The arrival of the *Empire Windrush* at Tilbury docks from the West Indies on 22 June 1948 plays a pivotal role in both mainstream and subaltern histories of multi-racial Britain.[6] The provisions of the British Nationality Act did not come into effect until 1 January 1949, and thus by defining the 492 *Windrush* migrants as 'Jamaican unemployed', the Labour Cabinet immediately placed them outside the prevailing legal categories of UK citizenship. Temporary housing was provided in a disused air raid shelter in south London, basic comforts that were intended to discourage further colonial migration. The arrival of the *Windrush* was given extensive coverage in the British newspapers and on newsreels, and there was clearly also concern within the government about the possible scale of colonial immigration. On the day that *Windrush* docked eleven Labour Members of Parliament signed a letter to the prime minister voicing their concerns: 'This country may become an open reception centre for immigrants not selected in respect to health, education, training, character, customs and above all, whether assimilation is possible or not.'[7] The question of assimilation was central to immigration debates in Britain after 1948; whilst the preservation of an imperial identity had been provisionally ensured, the new post-war Commonwealth immigrants had introduced a problem and it was a problem of colour. The letter from the Labour MPs refers to a range of selection criteria other than race, and yet race and skin colour were at the heart of their concerns. As historian Kathleen Paul has expressed it: '"The British people" were not "coloured" and conversely, "coloured" people were not British . . . the colonial workers on the *Empire Windrush* and the colonial citizens waiting to be recruited may have had British passports, may have served in the Allied Forces during the war, may have been citizens of the United Kingdom and Colonies but because they were black, they were not and never could be, British.'[8]

By the time a third ship arrived in England in December 1948 no further support or welcome was being offered. Colonial migrants were forced to accept low-paid, unskilled jobs and faced discrimination from landlords and landladies when trying to find accommodation. As Sir Galahad had discovered, people can be assimilated but colour cannot. Black stands out and insists on being itself. And there was one even more horrifying possibility than lack of

assimilation and that was total assimilation: relationships between black men and white women and the creation of a mixed race solution to the population crisis. In 1948 the Ministry of Labour expressed concern that 'coloured colonials' would be 'brought in for a permanent absorption into our own population'.[9] Within a few years of the end of the war, the nation was being imagined as white and unified – 'our own' – and the colonial migrant as a dangerous intruder. Immigration addressed the problems of labour shortages and the empty bombed landscapes of post-war Britain, but it filled those vacancies with the problem of colour.

By 1950, the government was facing pressures both to restrict right of entry to British subjects and to introduce legislation against discrimination. The report of the Royal Commission on Population of 1949 had concluded that large-scale migration was only acceptable if the individuals were from 'good human stock and were not prevented by their religion or race from intermarrying with the host population and becoming merged in it'.[10] Although figures on colonial immigration were often inaccurate, the rate of migration gradually increased during the late 1940s and early 1950s, reaching approximately 5,000 new arrivals by 1950–1.[11] A Cabinet committee, established in the summer of 1950, reported that migration levels needed to be kept under review, and with the Conservative governments of the 1950s race took centre stage in political life; the ground had been well prepared, however, by the previous Labour administration.[12]

In the terms introduced by the 1948 British Nationality Act, the passengers who made their journeys from the Caribbean and who disembarked at British ports were not aliens; they were citizens of the United Kingdom and Colonies, with identical legal rights and a common citizenship with white British subjects. This status was constantly renegotiated in the terminology used to describe the colonial passengers; writing in the late 1950s, the Jamaican diplomat Ivo de Souza stressed that they were 'migrants' not 'immigrants', since the latter term referred to 'aliens moving across political boundaries which would involve a possible change of citizenship'.[13] These were British citizens who were travelling to another part of the Commonwealth to which they already legally belonged; and yet, as the historian Bill Schwarz has pointed out, the moment the West Indian emigrant stepped foot in Britain they were defined by the home nation as an immigrant, a foreigner and outsider who was transforming the nature and look of British society.[14]

West Indians who migrated to Britain after 1948 also recalled feeling that they knew about British society and that, in the traditional terms of late imperialism, they were travelling to the

Mother Country. As one emigrant later remembered: 'I knew a lot about England, although I never saw it ... because we had a radio in the shop and all the programmes in Barbados coming through was basically English ... there was always the English news ... you hear about Regent Street and Charing Cross, those things you knew ... the Festival of Britain ... the Coronation ... Everest.'[15] This England, imagined in the West Indies, was immediately challenged by the trauma of arrival and the experience of race in the Mother Country. In 1949 an article in *Picture Post* asked: 'Is There a British Colour Bar?' (fig. 92). Examining communities across England, illustrated with Bert Hardy's photographs, the journalist Robert Kee concluded that the colour bar may not always be tangible but its covert existence could not be denied, and racial segregation would inevitably lead to social grievances and conflict.[16] What is evident during these years is the chronic mismatch between legal definitions and social perceptions of citizenship, and between the imaginary anticipation of the Mother Country and the traumatic experience of trying to 'get a break'. Increasingly, throughout the 1950s, British identity was defined as white; citizenship was understood in terms of skin colour, and as the borders of the empire progressively shrank, the imperial frontier and the colonial encounter were reconfigured within the nation and at the edges of the black migrant communities in British towns and cities.[17]

Although figures for black migration remained relatively low and consistent in the first years of the 1950s, at the end of 1952 the Conservative Cabinet appointed an inquiry into whether controls on colonial migration should be introduced. The report did not lead to the introduction of legal restrictions, but was notable for the concerns it expressed about the impact of black migration on the image of the white nation. Questioning the relevance of the concept of the Mother Country within the modern Commonwealth, and running a wedge between the members of the older white Dominions and the new black colonies, it commented: 'a large coloured community as a noticeable feature of our social life would weaken the sentimental attachment of the older self-governing countries to the United Kingdom. Such a community is certainly no part of the concept of England or Britain to which people of British stock throughout the Commonwealth are attached.'[18] Increasingly, migration figures were monitored, and in 1954 they showed an abrupt rise from around one or two thousand people per year to ten thousand and they continued to climb. Official concern grew in proportion to the statistics, which were also reported extensively in the daily newspapers. At a moment when London Transport, amongst other British companies, was actively recruiting in the West Indies,

IS THERE A BRITISH COLOUR BAR?

Photographed by BERT HARDY

Britain stages Colonial Month—a campaign to stimulate popular interest in the life and people of the Colonies. The King attends the opening ceremony. But there are more than 20,000 Colonial people who live among us. What do we know of them—of their work, of their living conditions, their hopes and grievances? Picture Post conducts a survey into this dangerous and important question.

IT is not possible to find out the exact number of colonial coloured people in Great Britain. There is no registry of people with black skin, any more than there is a registry of people with black hair. And there you discover the first important fact about the colour bar in Britain : officially it does not exist. For the purpose of the law and the administration of Britain there is no distinction whatsoever made between white and coloured British subjects—they are all just British subjects. And the same official lack of discrimination is echoed categorically by all government departments, professional organisations and trade unions. But offices and organisations are run by human beings, and inside the minds of human beings, both in and outside offices, strange fogs of ignorance and prejudice can be at work.

Although there are no official figures, the coloured population of Great Britain is estimated by both the Colonial Office and the League of Coloured People at about 25,000, including students. This total is distributed over the whole of Britain, but there are two large concentrated communities : one of about 7,000 in the dock area of Cardiff round Loudoun Square, popularly known as 'Tiger Bay', and the other of about 8,000 in the shabby mid-nineteenth century residential South End of Liverpool. These came into existence largely as a result of the immigration of colonial coloured people to work as seamen, soldiers and factory hands in the First World War. They were supplemented during the Second. Smaller coloured communities are found in all the main ports including London (there is one of about 2,000 in North and South Shields), in Manchester and the industrial areas of the Midlands. The prosperity of these different communities varies.

The term 'colonial coloured people' is, of course,
Continued overleaf

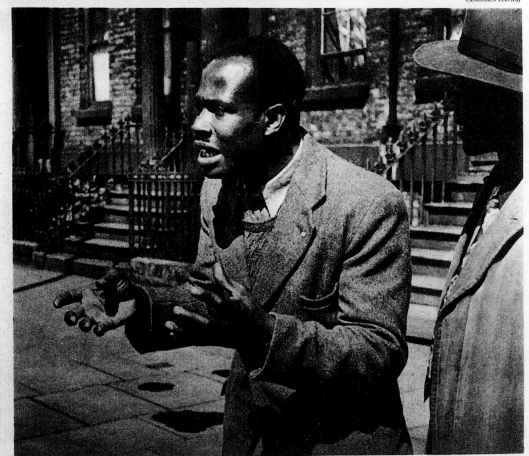

On the Curb of a Liverpool Pavement a Coloured British Subject Expresses the Indignation of His People
Officially there is no colour bar in Britain. But from restaurant-keepers and landladies, employers and employees, even from the man in the street, says Nathaniel Ajayi, he and his people meet with considerable colour prejudice. Ajayi has lived in five European countries, was a British Prisoner-of-War in Germany, but says he knows of no European country where the coloured man is treated with more unofficial contempt than in Britain.

a ministerial committee was considering the possibility of a 'coloured invasion of Britain'.[19] As statistics failed to convey the fears of white Britain, the amorphous and terrifying image of invasion was invoked and remained the language of advocates of immigration control well into the 1960s.

By the second half of the 1950s, the belief that colonial immigration had introduced a problem into the heart of the old empire was fully installed. In *City of Spades* (1957), the first of his three London novels, Colin MacInnes describes the friendship between Montgomery Pew, a newly appointed Assistant Welfare Officer of the Colonial Department, and Johnny Fortune, a new immigrant from Lagos. Pew is told by his senior colleague: 'Thousands, you see, have come here in the last few years from Africa and the Caribbean, and given us what we never had before – a colour problem.'[20] Like many white characters in MacInnes's writing, Pew and his friend Theodora are deeply attracted to and fascinated by black London, and its apparent regeneration of traditional British culture. The contradictory pulls of attraction and repulsion, of admiration and disgust, and of fear and dismissal were constantly displayed in the official and fictional texts of white Britain in the 1950s. As outbreaks of violence were reported in Nottingham and the Notting Hill area of west London in 1958, it seemed that the fears of national destabilization had been realized and the introduction of the Commonwealth Immigrants Bill in 1961 by Harold Macmillan's Conservative government was the culmination of political and social debates since 1948, as well as a much longer tradition of hostility towards the colonial population. This is not a simple history; its post-war chapter, however, is absolutely central to understanding British culture *c.*1945–60. By summarizing the key debates concerning race and migration in these years, it is possible to trace how the concept of colour, already so worrying and intransigent, was mapped on to the discourses of racism and national identity. The problem of colour, or the colour problem: the phrase was reformulated and repeated by art critics, cinematographers, politicians, novelists and journalists as chromatic hue and skin colour became utterly imbricated. Colour was the 'tiger in the smoke', which threatened to tear apart the atmospheric unity of the nation.

The dissolution of the empire after 1945 was ragged and violent; in the mid-1950s, Britain was involved in colonial wars in Cyprus, Malaya and Kenya, and reports of these conflicts fed into beliefs and assumptions about migrants from the empire who were now living in Britain. In particular, the conflicts in Kenya between 1952 and 1956, involving the Mau Mau, seemed to feed into long-established imperial fantasies of superstitious and violent natives, violating

and murdering English women and bringing on themselves violent reprisals.[21] Kenya was the focus of British imperial ambitions in Africa in the 1950s; a favourite with the royal family (the new queen received news of her father's death in 1952 while she was on an official visit there) and a lucrative possession, Kenya's Mau Mau rebellion was one of the most traumatic and violent colonial wars of the twentieth century. Although reporting of the war in Britain suggested that it was motivated by a barbaric and primitive sect that opposed the modernization of Kenya and focussed on attacks on the white homesteads, it was in fact a build-up of popular discontent relating to land ownership and use. From the beginning of the twentieth century, European settlers had taken land belonging to Kenyans and had created a dispossessed and impoverished population both in the countryside and in urban centres such as Nairobi. A loose coalition of Kikuyu people and trade unionists was held together by the swearing of traditional secret oaths, and fighting broke out between this radical resistance and Kenyan supporters of colonial policies. A state of emergency was declared in October 1952, and the British army was ordered to coordinate the response to the revolt. What was in many respects a revolutionary nationalistic movement against colonial oppression was redefined as atavistic and barbaric native violence spurred by superstitious oaths.

In November 1952 a British woman could sit in her living room, its walls painted in 'Kenya Red', and whilst symbolically renewing her bond with the Duchess of Gloucester, she could read in *Picture Post* that Mau Mau actually meant 'Get Out Get Out' (fig. 93).[22] She could look, with growing horror, at photographs of the hanging corpses of sacrificed animals and the detritus of initiation ceremonies, and wonder about the growing numbers of African and West Indian citizens with whom she now shared her homeland. Perhaps she would then feel a frisson of vengeful pleasure as she read about the punishments meted out by heavily armed British troops and the consequent rehabilitation and re-education of the Mau Mau men. By the end of 1955, over 70,000 Kenyans were held in detention camps and prisons, and reprisals were so severe that concern was expressed in Britain about the levels of official violence and public executions.[23] As programmes were devised to 'Wash the Soul of Mau Mau', male Kikuyu were screened and classified as 'black', 'grey' or 'white', according to the degree of their involvement with Mau Mau activities.[24] Those designated black and grey were placed in special camps for re-education that involved European dancing and lectures. At the same time that the density of smoke in Britain was being classified on the Ringelmann chart in shades of grey, from white to black, Kenyan rebels were defined using the same language.

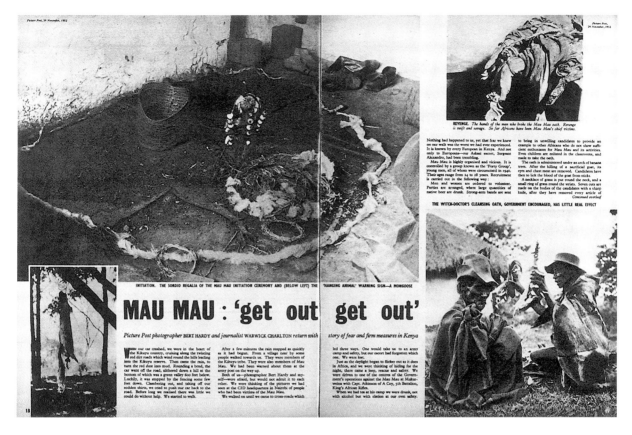

93 'Mau Mau: "Get Out Get Out"', *Picture Post*, 29 November 1952, pp. 18–19.

For a time, the colour of Africa was drained and rendered grey; these were the terms of the reimposition of colonial order.

If the reader of *Picture Post* got tired of her four walls, she could meet some friends and see Mau Mau in the cinema.[25] In 1955 J. Arthur Rank Film had released *Simba: Mark of Mau Mau* (UK; dir. Brian Desmond Hurst). Shot on location in Kenya in Eastmancolor, the story revolves around the ransacking and ultimate destruction of a white settlement and the individual heroism of the British men and women in the face of Mau Mau atrocities. And if empire films were to their taste, in the following year they could go to see the Technicolor vision of Kenya in another British production, *Safari*, starring the Bermudan actor Earl Cameron as Jeroge, the Mau Mau leader, and the burly American actor Victor Mature as the professional hunter who revenges the Mau Mau killing of his son (UK, 1956; dir. Terence Young).

159

Although these were mediocre films by most standards, they were significant for their work of racial imagining and ethnic fantasy. As film historian Sarah Street has shown, colour films were conventionally associated with specific genres that emphasized fantasy and the exotic, using colour to 'highlight questions of racial difference and exoticism within generic contexts which favoured the foregrounding of colour: the outdoor melodrama and empire film'.[26] Cinema audiences could relish the clichéd narratives and stereotypical characters in the saturated colour locations of Kenya, but they did not necessarily leave these fantasies in the cinema. The effect of these films remained with them as they returned to the streets of Britain, and perhaps, as they walked home, they shared the vision of Montgomery Pew when he observed: 'Another coloured man was lurking at the next corner: haunting the city thoroughfare as if poised with a spear in the deep bush.'[27]

On 28 January 1956, *Picture Post* printed a special colour supplement to commemorate the Queen's current tour of Nigeria.[28] By now the paper was on its last legs; with drastically reduced circulation figures and a far more anodyne journalistic tone, a colour cover of the enthroned Queen against a rich (Kenyan?) red background might be expected to boost sales, temporarily at least. Other monarchs were pictured in the issue: a Benin queen, 'one of the seven wives of the king . . . of Benin' (fig. 94), and a Nigerian king, who was shown surrounded by his collection of ninety-two crowns (fig. 95). The issue reproduces the two most important worlds of colour in the 1950s, royalty and empire, whilst reminding us how different and distinct these worlds are. In Cecil Beaton's official portrait of the Queen in Buckingham Palace, there is one distant queen, one crown, one throne (fig. 96). Elizabeth II is 'Queen of the Commonwealth' rather than 'The King with a Carpet of Crowns'. The shift from the notion of empire to that of Commonwealth was part of the troubled and protracted process of decolonization in the post-war years and the attempt to salvage a form of 'family' of nations, reconfigured and rejuvenated. This was the message of Elizabeth II's Christmas Day broadcasts, and in 1953, speaking from New Zealand where she was visiting as part of a Commonwealth tour, she reminded her listeners: 'the Commonwealth bears no resemblance to the Empires of the past. It is an entirely new conception – built on the highest qualities of the spirit of man; friendship, loyalty, and the desire for freedom and peace.'[29] The Commonwealth, she observed was 'an equal partnership'. The Commonwealth had evolved; it was no longer authoritarian and was like a companionate marriage, a concept, which, as will be seen in Part Three, was being as severely tested in these years as the bonds of empire.

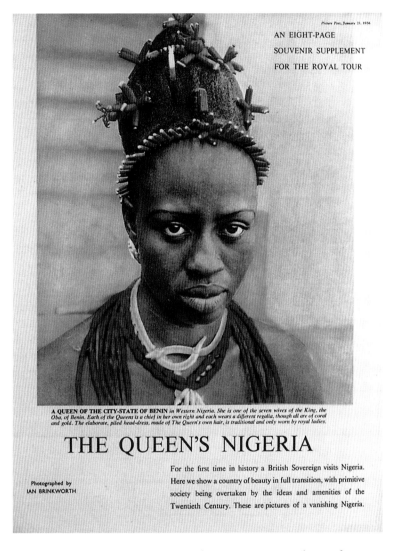

AN EIGHT-PAGE
SOUVENIR SUPPLEMENT
FOR THE ROYAL TOUR

A QUEEN OF THE CITY-STATE OF BENIN *in Western Nigeria. She is one of the seven wives of the King, the Oba, of Benin. Each of the Queens is a chief in her own right and each wears a different regalia, though all are of coral and gold. The elaborate, piled head-dress, made of The Queen's own hair, is traditional and only worn by royal ladies.*

THE QUEEN'S NIGERIA

Photographed by
IAN BRINKWORTH

For the first time in history a British Sovereign visits Nigeria. Here we show a country of beauty in full transition, with primitive society being overtaken by the ideas and amenities of the Twentieth Century. These are pictures of a vanishing Nigeria.

94 'The Queen's Nigeria', in eight-page souvenir supplement for
the royal tour, *Picture Post*, 28 January 1956, p. 17.

As the frontiers of empire were either shored up or relinquished and the Queen celebrated the character of the Commonwealth, the racial frontiers within Britain became the new site for what Bill Schwarz has described as 'the primal colonial encounter'.[30] As soon as the 1948 British Nationality Act was passed, journalists and broadcasters began to consider whether there was a colour bar in Britain. As first reports of the Mau Mau revolts were reaching

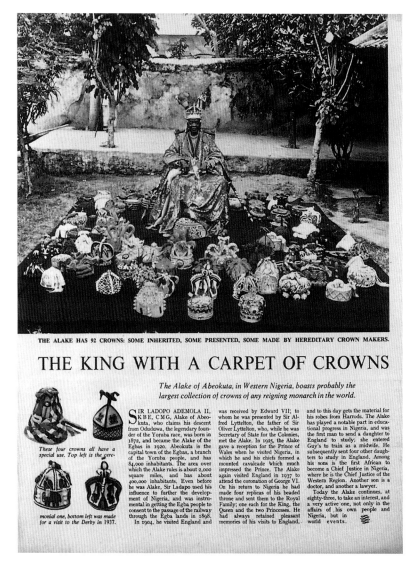

THE ALAKE HAS 92 CROWNS: SOME INHERITED, SOME PRESENTED, SOME MADE BY HEREDITARY CROWN MAKERS.

THE KING WITH A CARPET OF CROWNS

The Alake of Abeokuta, in Western Nigeria, boasts probably the largest collection of crowns of any reigning monarch in the world.

These four crowns all have a special use. Top left is the cere-monial one, bottom left was made for a visit to the Derby in 1937.

SIR LADOPO ADEMOLA II, KBE, CMG, Alake of Abeo-kuta, who claims his descent from Oduduwa, the legendary foun-der of the Yoruba race, was born in 1872, and became the Alake of the Egbas in 1920. Abeokuta is the capital town of the Egbas, a branch of the Yoruba people, and has 84,000 inhabitants. The area over which the Alake rules is about 2,000 square miles, and has about 400,000 inhabitants. Even before he was Alake, Sir Ladopo used his influence to further the develop-ment of Nigeria, and was instru-mental in getting the Egba people to consent to the passage of the railway through the Egba lands in 1898.

In 1904, he visited England and was received by Edward VII; to whom he was presented by Sir Al-fred Lyttelton, the father of Sir Oliver Lyttelton, who, while he was Secretary of State for the Colonies, met the Alake. In 1925, the Alake gave a reception for the Prince of Wales when he visited Nigeria, in which he and his chiefs formed a mounted cavalcade which much impressed the Prince. The Alake again visited England in 1937 to attend the coronation of George VI. On his return to Nigeria he had made four replicas of his beaded throne and sent them to the Royal Family; one each for the King, the Queen and the two Princesses. He had always retained pleasant memories of his visits to England,

and to this day gets the material for his robes from Harrods. The Alake has played a notable part in educa-tional progress in Nigeria, and was the first man to send a daughter to England to study; she entered Guy's to train as a midwife. He subsequently sent four other daugh-ters to study in England. Among his sons is the first African to become a Chief Justice in Nigeria, where he is the Chief Justice of the Western Region. Another son is a doctor, and another a lawyer.

Today the Alake continues, at eighty-three, to take an interest, and a very active one, not only in the affairs of his own people and Nigeria, but in world events.

95 'The King with a Carpet of Crowns', *Picture Post*, 28 January 1956, p. 24.

Britain, *Picture Post* followed up its earlier inquiry into the colour bar with an investigation of whether Britain was 'Breeding a Colour Bar?', written by their staff reporter Hilde Marchant and photographed by Charles 'Slim' Hewitt (fig. 97).[31] In its reporting of immigration and race in the 1950s, *Picture Post* oscillated between humanitarianism and sensationalism. Always explicitly opposed to discrimination, the paper nevertheless consistently presented the issues

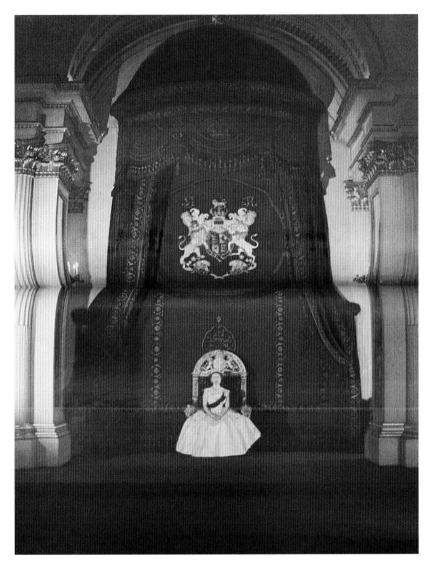

96 Cecil Beaton, 'The Queen of the Commonwealth', *Picture Post*, 28 January 1956, pp. 20–1.

in terms of the scale of migration and impending problems: 'Five hundred West Indians are coming to Britain every month. They have every right to do so – but they need training, work, housing. It is an urgent problem, and may become ugly if a solution is not found quickly.' This point was reinforced by Hewitt's photograph on the same page of graffiti in Brixton: 'K.B.W.' (Keep Britain White). The article warned that housing shortages and local

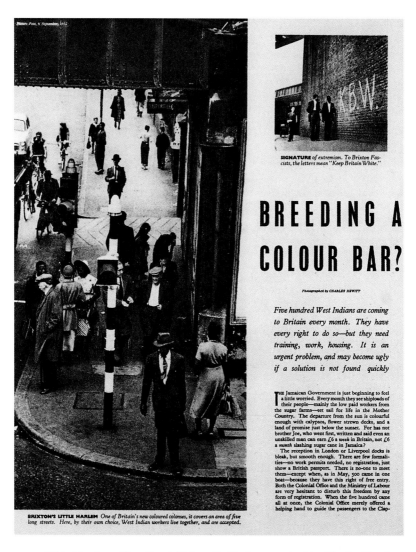

Picture Post, 6 September, 1952.

SIGNATURE of extremism. To Brixton Fascists, the letters mean "Keep Britain White."

BREEDING A
COLOUR BAR?

Photographed by CHARLES HEWITT

Five hundred West Indians are coming to Britain every month. They have every right to do so—but they need training, work, housing. It is an urgent problem, and may become ugly if a solution is not found quickly

THE Jamaican Government is just beginning to feel a little worried. Every month they see shiploads of their people—mainly the low paid workers from the sugar farms—set sail for life in the Mother Country. The departure from the sun is colourful enough with calypsos, flower strewn decks, and a land of promise just below the sunset. For has not brother Joe, who went first, written and said even an unskilled man can earn £6 a *week* in Britain, not £6 a *month* slashing sugar cane in Jamaica?

The reception in London or Liverpool docks is bleak, but smooth enough. There are few formalities—no work permits needed, no registration, just show a British passport. There is no-one to meet them—except when, as in May, 500 came in one boat—because they have this right of free entry. Both the Colonial Office and the Ministry of Labour are very hesitant to disturb this freedom by any form of registration. When the five hundred came all at once, the Colonial Office merely offered a helping hand to guide the passengers to the Clap-

BRIXTON'S LITTLE HARLEM *One of Britain's new coloured colonies, it covers an area of five long streets. Here, by their own choice, West Indian workers live together, and are accepted.*

97 Hilde Marchant, 'Breeding A Colour Bar?', photographed by Charles Hewitt,
Picture Post, 6 September 1952, p. 28.

unemployment would lead to colour conflict in Brixton's 'Little Harlem' and Britain's other 'coloured colonies'.

The article provoked a substantial response from its readers, and in subsequent issues a number of letters were printed from those claiming that a colour bar was already in operation in Britain. One correspondent informed the editor of a recent petition in central London

asking the local council to stop renting homes to coloured people. The author was Learie Constantine, the West Indian cricketer and political activist.[32] Born in Trinidad, Constantine came to England in the late 1920s to become a professional cricketer, although he continued to play as a member of the West Indies national team. During the war he worked for the government as a welfare officer for West Indians employed in English industry, and it was during this time that he and his family were turned away from the Imperial Hotel in London. Constantine took legal action against the hotel for breach of contract and won the case; he later qualified as a barrister in 1954, and continued to campaign against racial discrimination throughout the 1960s until his death in 1971. Constantine also had a career as a writer and broadcaster and in 1954 published his book *Colour Bar*, the first sentence of which states: 'I am black.' Describing his own experiences of racial prejudice, he concludes that, in general terms: 'almost the entire population of Britain really expect the coloured man to live in an inferior area devoted to coloured people.'[33] As newspapers continued to report racial conflicts in cities throughout Britain and television programmes joined the debate, the question mark at the end of the 1955 *Picture Post* article, 'Are We Building Up to a British Colour Conflict?', looked purely rhetorical.[34]

'Would You Let Your Daughter?'

Black migrant communities in the post-war period were concentrated in particular areas of cities such as Cardiff, Birmingham, Liverpool and London, which, increasingly, were referred to as 'Little Harlems' and even 'The Jungle'.[35] With white landlords and landladies more or less openly operating a colour bar, migrants were forced to move to the poorest accommodation: the broken, grey Victorian terraces with their neighbouring bombsites that were anathema to the project of reconstruction and modernization. There is, then, a particular geography of post-war migration – certain kinds of places and spaces that were explored by anthropologists and sociologists and became the subject of what historian Chris Waters has described as the 'new science of race relations'.[36]

Drawing on the well-established practices of Victorian social investigators and their explorations of 'darkest' England, post-war race relations academics and their teams of researchers made close studies of the styles and customs of local black communities and their relations with

other local groups. As Waters has observed, the race relations writers in these years were generally highly critical of racist stereotypes and white hostility to migrant communities; nevertheless, their language and narratives also exposed the ways in which they perpetuated some of those popular beliefs. Amongst the first of these British sociological works was Kenneth Little's 1947 study of Bute Town, the dockland area of Cardiff that included the historic black community of Tiger Bay.[37] Using a paradigm drawn from the Chicago Sociological School and their inter-war studies of urban communities, Little considered the Bute Town community as a distinct and homogenous social group, thus allowing him to explore not only what was distinctive about their customs but also the structure of relations with other British cultural and social communities and how they could be improved.

As the discipline developed in the 1950s, writers developed their work through case studies of specific local areas and communities. Michael Banton, a social scientist at Edinburgh University whose early work had been supervised by Kenneth Little, studied the African and West Indian community in Stepney, east London. This was also an area of long-standing migrant settlement and included Cable Street, which had been the scene in 1936 of violent clashes between local Jewish and anarchist groups and the Metropolitan Police over a planned fascist march. By the end of the war it was blitzed and poor with squalid and inadequate housing. In *The Coloured Quarter*, published in 1955, Banton describes, in text and photographs, the bomb-damaged landscape and its community, detailing the multi-occupancy dwellings with their single-let rooms and the housing shortages that frequently led to migrants sleeping in bombed buildings and complaints of 'indecent behaviour' in the alleys and bombsites (fig. 98).[38] Colonial migrants were being forced into areas of historical poverty in parts of cities that were already in decline, and this geography exacerbated the popular white association of immigration and urban degeneration. Banton observed two patterns of behaviour in these communities: a 'centrifugal effect' as immigrants move away from local areas, and a 'centripetal effect' as an area becomes a social meeting place for immigrants who have moved elsewhere. He confirms that most 'coloured people' believe that there is a colour bar in Britain, which he defines in straightforward terms as racial discrimination.[39]

The reader comes away from Banton's work with an irrefutable sense of the difference and separation of migrant communities in Britain at this time; in later writing this becomes even more emphatic as Banton defines the black migrant as an outsider in British society. In 1958, in an essay for the *Listener* entitled "'Beware of Strangers!'", he argued that 'in our culture, the

top left: Cable Street on a Sunday afternoon.

top right: Cottage dwellings, some uninhabitable, some still occupied. This row has been due for demolition for several years and it is worth no one's while to keep the houses in good repair.

bottom: Notice the row of small dwelling houses at the back of the row next to the street, and approached only by a narrow alley. Air raid damage has exposed them to view from the road.

98 Photographs of Cable Street area of London with air raid damage, as reproduced in Michael Banton, *The Coloured Quarter: Negro Immigrants in an English City* (London: Jonathan Cape, 1955), facing p. 97.

coloured man is the archetypal stranger'; and in an italicized passage in a section subtitled 'The Meaning of Colour' in his 1959 book, *White and Coloured*, he stated: '*Strangers are people who are unaware of . . . norms of conduct. The coloured man is considered the most distant of all strangers.*' Although Banton blamed group influence within white British society and the imperial past for the persistence of these beliefs, to a degree his own writing contributed to, and certainly fails to dislodge, the image of the colonial migrant as always a newcomer, a stranger, and indifferent to the 'British way of life'.[40]

Sheila Patterson was another race relations writer who, like Banton, began her research with Kenneth Little; focussed on the West Indian community of Brixton, in south London, two themes emerge in her writing: 'colour shock' and 'strangeness'. Although skin colour, she suggests, is not the only defining factor in immigrant–host relations, it is the one which most defines the discourse of race relations and which constitutes the greatest social problem. In a fascinating passage, she describes one of her first visits to Brixton in May 1955; it is worth quoting at length because of its vivid evocation of her initial encounter with the geography of the black migrant community:

> As I turned off the main shopping street, I was immediately overcome with a sense of strangeness, almost of shock. The street was a fairly typical south London side-street, grubby and narrow, lined with cheap cafés, shabby pubs, and flashy clothing-shops. All this was normal enough. But what struck one so forcefully was that, apart from shopping housewives and a posse of teddy boys in tight jeans outside the billiards hall, almost everyone in sight had a coloured skin. Waiting near the employment exchange were about two dozen black men, most in the flimsy suits of exaggerated cut that, as I was later to learn, denoted their recent arrival. At least half of the exuberant infants were *café noir* or *café au lait* in colouring. And there were coloured men and women wherever I looked, shopping, strolling, or gossiping on the sunny street-corners . . .[41]

What differentiates this everyday scene from others in post-war Britain is the visibility of race and colour, and the power and strangeness of this experience pours from Patterson's sentences, as her sociological gaze moves around the street and its occupants. Finally, she understands: 'I experienced a profound reaction of something unexpected and alien . . . "colour shock".' Patterson recovers her professional composure; for a moment, however, she assumes the position of a white woman registering her shock at the primal encounter, on the streets of Britain, with the black newcomer. Inappropriate and unusual clothing register the strangeness of these new citizens and mixed race children represent the most terrifying spectacle of all: miscegenation.

In July 1956 the *Daily Express* ran a series of articles carrying the strapline: 'Would You Let Your Daughter Marry a Black Man?' It was a question that was asked, with increasing frequency, throughout the 1950s and that became the litmus test of British racism. You (the assumed white male addressee) may not approve of race discrimination and the colour bar, but would you let your daughter . . . ? In the second half of the 1950s as debates in Parliament

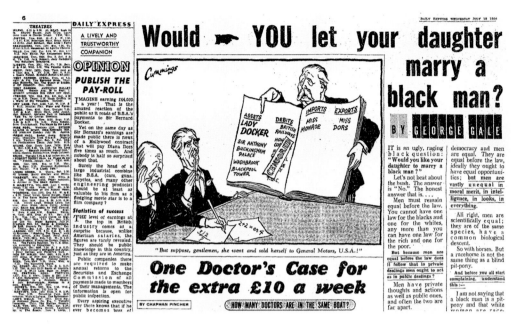

99 George Gale, 'Would YOU Let Your Daughter Marry a Black Man?', *Daily Express*,
18 July 1956, p. 6 (detail).

alternated between race discrimination bills and immigration controls, the question was the bottom line for just how tolerant British society was prepared to be. In 1954 Learie Constantine asked his readers to consider a sequence of encounters with a black man: 'do you feel, with the United Nations, that there is no distinction? That you would shake hands with a Negro, make him your friend in similar circumstances as you would a white man, a guest in your house, perhaps see him marry your daughter?'[42] The degrees of intimacy gradually increase: would you touch a black man? Would you entertain him in your home? Would you let your daughter have sex with him? The fear and fantasy of miscegenation dominated white Britain; as the white population retrenched in the face of the loss of empire, and the new colonial presence made itself felt on the streets of the Mother Country, the imperial nightmare of black men with white women and of mixed race children came back to haunt it.

There is something stark and uncompromising about the black letters printed on the white page of the *Daily Express* that has a synergy with the unadorned directness of the question posed (fig. 99).[43] There is a stress in the sentence: 'Would YOU let . . .', with the silhouette of a hand pointing to the capitalized letters. And almost inescapably, the journalist, George Gale,

begins the article: 'It is an ugly, raging black question.' Gale differentiates public views and private actions; publicly we may advocate equality, but privately we may feel that there are profound racial differences that make men unequal, so probably, he suggests, the honest answer to the headline question is: no. The following day the *Express* continued its inquiry with another strapline: 'Think …! Every Day – Week In, Week Out, 150 Coloured People Come Here to Stay.' After justifying the inquiry because 'There will be 100,000 coloured people in this country at the end of the year,' Gale reports his visit to Manchester to interview mixed race couples and to London where he speaks to Rudolph Dunbar, the orchestral conductor, and he gets in a tangle. It cannot be wrong for a black man to marry a white woman, but neither is it wrong to answer 'no' to that most intractable question. In the third and final instalment, Gale reports two further interviews and comes to what is, perhaps, a surprising conclusion: 'The most constructive thing I can write is that these marriages were normal and happy … Well … ? Was my "no" just prejudice?' It is another question he fails to answer.

The erotics of racial difference and the fear of miscegenation are adjuncts of empire. Nineteenth-century racial theories worked to classify and separate races, to demonstrate white superiority and to justify the authority of Britain over its subject peoples. The fear of miscegenation, of interracial sex, struck at the heart of Victorian racial theory. Sexual mixing with inferior subjects might bring about a disastrous dilution of British racial strength and destabilize the foundations of the empire; racial scientists pointed to the sterility of the mule as an instance of the dangers of intermixture and the inevitability of degeneration. The repulsion from the idea of interracial sex was continually transmuted in this period into expressions of attraction towards other races, and nineteenth-century representations of race were defined across what Robert Young has called an 'ambivalent axis of desire and aversion'. He describes a 'structure of attraction, where people and cultures intermix and merge, transforming themselves as a result, and a structure of repulsion, where the different elements remain distinct and are set against each other dialogically'.[44]

Post-war images of the colonial other remained poised on this axis of attraction and aversion, between maintaining a sense of essential racial difference and expressing a desirability that threatens to undo the entire construct of racial distinction. Within every forensic account of black urban areas, in each description of items of dress, behaviour and deportment, there was also the possibility of an erotic consumption of these sights, of a gaze that desired as well as delineated. As advertisers well knew, 'colour attracts', and John Barron

Mays, Professor of Sociology at the University of Liverpool, confirmed that white women were drawn to that city's 'Harlem' by 'the lure of colour'.[45] In 1949 Mass Observation sent out its trained observers to London dance halls as part of a study of juvenile delinquency; there they saw 'Six black males in Air Force uniform . . . dancing with white girls . . . there seems to be great competition to dance with the Blacks, the reason being, I should imagine, their superb sense of rhythm and their natural ease of keeping time with music.'[46] Many experts also propagated the belief that white women who were attracted to black men had a high or abnormal sex drive, which matched the voracious sexuality of black men. Michael Banton observed: 'the women attracted to coloured men appear to be nymphomaniacs', whilst Eustace Chesser, Director of the Research Council into Marriage and Human Relationships, cited the case of an educated white woman who 'married a coarse Negro "because having once in a foolish moment had intercourse with him, she thereafter became a slave to his sexual powers"'.[47]

It is difficult to overstate the degree to which the fantasized fear of miscegenation struck at the heart of white British society in the years after the war. Both black and white citizens tried to account for the level of anxiety that mixed relationships provoked. Interviewed by George Gale in the *Daily Express*, Rudolph Dunbar suggested: 'It's part economics, this thing . . . part sex. Sex, it's blood. The Englishman is afraid of mixing blood. It's a myth, this blood business. The blood's the same.' And in his psychoanalytic account of the processes that contribute to Negrophilia and Negrophobia, first published in 1952, Frantz Fanon suggested that the racism in the question, 'Would you let your daughter marry a black man?', masked an incestuous desire between the white father and daughter: 'the father revolts because in his opinion the Negro will introduce his daughter into a sexual universe for which the father does not have the key, the weapons or the attributes.'[48] Behind all the images of Mau Mau attacking white homesteads, mixed race children in British cities, black men and white women dancing in clubs, there is the image of sex and the power of desire that can change the colour of the nation.

It is hardly surprising, then, that during these years young white women in love with black men sought advice from magazine agony aunts. For example, 'Unhappy Gwen' from Cardiff wrote to Marion Dark's 'Between Friends' column in the *Woman's Friend and Glamour*. With the subhead 'Loves A Negro', Gwen explained that she loves her boyfriend but it would break her parents' hearts if she married him. Marion was fair but firm:

It *is* true that coloured men are often kind, gentle and considerate, and there have been happy marriages between people of different colour, but as long as there is a colour bar, it is most unwise for people of black and white races to marry . . . children of such marriages *do* suffer from a handicap . . . Remember, too, that you and your boy come from different civilisations, with different backgrounds, so be cautious.[49]

This view that although individual relationships might work, they were powerless in the face of social prejudice and cultural difference, became the fallback position for popular writers in the period. It allowed them to sound liberal *and* to represent the voice of realism. Blame could be placed on institutions and systems rather than on individuals; they could, at the same time, disown the colour bar whilst acquiescing to its values.

1954: the end of rationing, the year that the war really ended and peace began, the year that the annual migration figures jumped, probably in response to the United States McCarren-Walter Immigration Act, which limited West Indian migration to the USA[50] – and the year that *Picture Post* decided to run an article on attitudes to and experiences of mixed marriages, with the inevitable title: 'Would You Let Your Daughter Marry a Negro?' (fig. 100). Couched in the familiar terms of the numbers of black migrants arriving in Britain, the equivocal tone that had characterized the paper's previous pieces on race relations also defines this article, written by the distinguished journalist Trevor Philpott and illustrated by one of its star photographers, Slim Hewitt. Fonts and graphic design are used to sensationalize the story; the largest words on the page are 'MARRY A NEGRO?' By now, the question was so familiar it could be abbreviated; readers knew well what they were referring to. Hewitt's arresting photographs of the young white mother and her child shift genres from portraiture on the first page to social investigation on the two following pages (fig. 101). In the first half-page image there is no background detail; all the focus is on the faces, which are lit from the right and half in deep shadow. They are a post-war mixed race Madonna and Child. On the following pages, the two figures are contextualized, in the home (a room in Brixton with the black husband/father) and in the street (where they are stared at by passers-by), and the timeless ideal of the young mother and child is shattered by the social realities of contemporary Britain. The woman is confined by prejudice, by cramped living conditions and a bleak, urban street. In the third photograph a slight smile softens her long, thin face and the child seems to be pointing to the camera; the image was probably a *Picture*

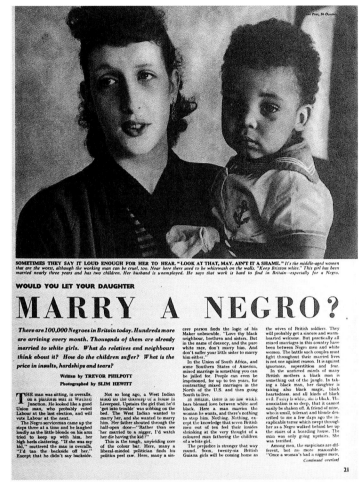

SOMETIMES THEY SAY IT LOUD ENOUGH FOR HER TO HEAR. "LOOK AT THAT, MAY. AIN'T IT A SHAME." *It's the middle-aged women that are the worst, although the working man can be cruel, too. Near here there used to be whitewash on the walls. "Keep Brixton white." This girl has been married nearly three years and has two children. Her husband is unemployed. He says that work is hard to find in Britain—especially for a Negro.*

WOULD YOU LET YOUR DAUGHTER

MARRY A NEGRO?

There are 100,000 Negroes in Britain today. Hundreds more are arriving every month. Thousands of them are already married to white girls. What do relatives and neighbours think about it? How do the children suffer? What is the price in insults, hardships and tears?

Written by TREVOR PHILPOTT
Photographed by SLIM HEWITT

THE man was sitting, in overalls, on a platform seat at Watford Junction. He looked like a good Union man, who probably voted Labour at the last election, and will vote Labour at the next.

The Negro serviceman came up the steps three at a time and he laughed loudly as the little blonde on his arm tried to keep up with him, her high heels clattering. "If she was my kid," muttered the man in overalls, "I'd tan the backside off her." Except that he didn't say backside.

Not so long ago, a West Indian stood on the doorstep of a house in Liverpool. Upstairs the girl that he'd 'got into trouble' was sobbing on the bed. The West Indian wanted to marry her, and she wanted to marry him. Her father shouted through the half-open door—"Rather than see her married to a nigger, I'd watch her die having the kid!"

This is the tough, unyielding core of the colour bar. Here, many a liberal-minded politician finds his politics peel raw. Here, many a sin-

cere parson finds the logic of his Maker unbearable. "Love thy black neighbour, brethren and sisters. But in the name of decency, and the pure white race, don't, marry him. And don't suffer your little sister to marry him either."

In the Union of South Africa, and some Southern States of America, mixed marriage is something you can be jailed for. People can even be imprisoned, for up to ten years, for contracting mixed marriages in the North of the U.S. and then going South to live.

In Britain, there is no law which bars blessed love between white and black. Here a man marries the woman he wants, and there's nothing to stop him. Nothing. Nothing, except the knowledge that seven British men out of ten feel their insides shrinking at the very thought of a coloured man fathering the children of a white girl.

The prejudice is stronger that way round. Soon, twenty-six British Guiana girls will be coming home as

the wives of British soldiers. They will probably get a sincere and warm-hearted welcome. But practically all mixed marriages in this country have been between Negro men and white women. The battle such couples must fight throughout their married lives is not one against reason. It is against ignorance, superstition and fear.

In the unstirred minds of many British mothers a black man is something out of the jungle. In taking a black man, her daughter is taking also black magic, black heartedness, and all kinds of black evil. Fury is white, sin is black. The association is so deep, that it cannot easily be shaken off. A friend of mine, who is small, tolerant and blonde described to me a few days ago the inexplicable terror which swept through her as a Negro walked behind her up the stairs of a boarding house. The man was only going upstairs. She was terrified.

Among men, the suspicions are different, but no more reasonable. "Once a woman's had a nigger mate,
Continued overleaf

21

100 Trevor Philpott, 'Would You Let Your Daughter Marry a Negro?',
photographed by Slim Hewitt, *Picture Post*, 30 October 1954, p. 21.

Post set-up, telling a photographic colour bar story for readers already familiar with the *mise en scène* and its inevitable conclusions.

Stuart Hall has summed up, with great acuity, the strains and limitations on the *Picture Post* social documentary style of realism; he suggests that the paper was unable to reveal 'the forces at work creating these situations because it had no understanding of social contradiction, no language for stripping away the surface "naturalism" in which the problem appeared to present itself, no way of revealing the contradictory and oppositional forces creating it, or the conflicts

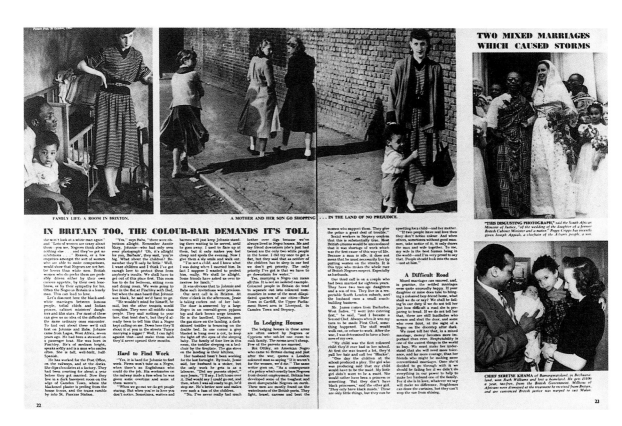

101 Trevor Philpott, 'Would You Let Your Daughter Marry a Negro?', photographed by Slim Hewitt, *Picture Post*, 30 October 1954, pp. 22–3.

out of which radical change or transformation might be generated.'[51] No matter how gifted the journalists and photographers working on *Picture Post*, even following the sacking of editor Tom Hopkinson, its world view made it impossible to look beyond the conventions of the 'human story' and identify the greater and systemic forces that were creating the experiences and attitudes of its subjects. It could not connect the stories of two high profile controversial mixed marriages, which it covered on the same pages, with the ordinary woman and her son in Brixton; it could only place them side by side.[52] And perhaps the compromised and restricted understanding of *Picture Post* was even greater than Hall has supposed. On the page immediately following the article on mixed marriages, the paper printed a photographic portrait of '15 Views of a Happy Marriage' (fig. 102) – fifteen small head and shoulder portraits of Richard Attenborough and his wife, Sheila Sim, their white faces displaying a range of emotions and

102 'Richard Attenborough and Sheila Sim: 15 Views of a Happy Marriage', *Picture Post*, 30 October 1954, p. 24.

expressions. Readers are invited to choose six in order of appeal, with a prize of £200 for the 'correct' reply. It is sobering to consider this page with a mixed race couple photographed fifteen times, fifteen versions of a happy marriage. It is an impossibility. Mixed marriages were not happy marriages; they were difficult and challenging because in post-war Britain colour was a problem. I do not know who won the competition, or the preferred order of the photographs; the paper did not publish these details. I do, however, like to imagine another audience for *Picture Post*, not perhaps the one projected by the paper's editorial, reading 'Would You Let Your Daughter?' and choosing the most appealing pictures of Richard and Sheila. It is Tornado and his friends from George Lamming's *The Emigrants*, in a barber's shop in a London basement, 'reading the *Manchester Guardian* while the others looked at the old *Picture Post* magazines with which the room was partially furnished'.[53] This was the afterlife of papers in the 1950s; they were kept in waiting-rooms and stored in cupboards, they were read and reread and their audiences changed. So Tornado, in the social environment of the migrant's barber shop, would discuss the article with his friends, choose his favourite photographs and discuss the troubled times . . . and perhaps he would shake his head and laugh.

'Red Taffeta under a Tweed Skirt'

A young white woman's body is thrown roughly onto a bed of dry brown leaves; the camera zooms in on her face and shoulders as the title of the film appears on the screen in vibrant red letters (fig. 103). These are the opening shots of a British film called *Sapphire*. Released in 1959, it was shot in Eastmancolor and directed by Basil Dearden and was voted 'Best British Film' of the year by the British Film Academy. As far as genre is concerned, *Sapphire* is a murder mystery wrapped into a 'colour bar problem picture';[54] the mystery that the film eventually unravels, however, is not simply the identity of the murderer but, more importantly, the true identity of the victim.

The corpse is discovered the following morning by children walking with their mother on Hampstead Heath. The police are called and can find only one clue to the victim's identity, a handkerchief embroidered with the letter 'S'. The victim's clothes are taken to the police station in a box, where Superintendent Hazard and his assistant, Detective Inspector Learoyd, look through them for clues to the young woman's identity: a brown pleated skirt, a warm

coat, sensible brown shoes and camel-coloured thick socks. 'Nice sensible things', Learoyd suggests. But then Hazard pulls out another item, a red petticoat, which calls into question all their previous assumptions about the murder victim: 'Don't quite go together do they?' he observes (fig. 104). The semantic disjuncture between the two styles of clothing – the sensible, tweedy outer clothes and the bright, frivolous underclothing – belongs to a social language of dress that was developed in the nineteenth century; in the post-war, colour bar years, however, this language was honed and mapped onto a language of race and colour to become a key register of racial identity and difference.[55]

The detectives discover that the girl's name was Sapphire and that she was a student at the Royal Academy of Music; they also find out that she had a boyfriend, David Harris, a talented architecture student who has recently been awarded a scholarship at a European university. They visit Sapphire's rented room; it is messy and Hazard finds a locked drawer. He breaks into it and discovers that it is full of colourful, frilly petticoats, decorated stockings and red dancing shoes (fig. 105). The importance of this moment is reinforced by Philip Green's musical score, with a 'sting' punctuating the opening of the drawer, and a slinky saxophone riff played during the discovery of the clothes. The opening of the drawer and its secrets represents the uncovering of the truth of Sapphire's identity. In its review the *Daily Express* described the film as a 'psychological striptease', and as the detectives rifle through the victim's underclothes, the voyeurism of the investigation is as uncomfortable as it is inescapable.[56] A torn photograph also found in her room shows Sapphire dancing, but the figure of her dance partner is missing.

Back at the police station the police meet Sapphire's brother, Doctor Robbins, who has arrived from Birmingham. Another musical punch prepares us for the shock that Doctor Robbins is black. He explains that their father was a white doctor and their mother was a singer, 'black as iron'. Because Sapphire looked white she was able to 'pass' for white and lived a double life, which had been implied by the discovery of her clothes and is now exposed by the identity of her brother. Meanwhile, an autopsy has revealed that Sapphire was three months' pregnant; with her identity uncovered Learoyd now assumes that the baby 'could be anybody's'. The detectives visit her boyfriend's home; he tells them that he knew she was 'coloured' and about the pregnancy. A local policeman also tells Hazard that David's father is very bigoted and that his sister, Mildred, is unhappily married to a merchant seaman who never seems to come home on leave.

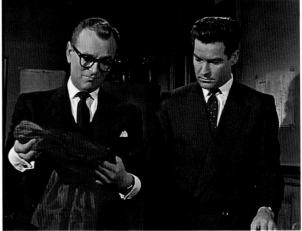

103 Title frame, *Sapphire* (UK, 1959; dir. Basil Dearden), frame still.

104 Hazard and Learoyd looking at the clothes of the murder victim, *Sapphire*, 1959, frame still.

The Harrises' home is grey. The walls, ceilings, doors, curtains and furniture are all muted shades of grey. This is the full British Colour Council grey range: dove grey, battleship grey, charcoal grey, etc. Everything in the Harris's world is grey; streets are dull and shrouded in mist, and even the tin labels in the grocery shop are black and white. This establishes the two colour worlds of the film: the reds and purples of the black Sapphire and the greys and neutrals of the white Sapphire. This colour coding was a deliberate feature of Dearden's direction. In an interview with *Kinematograph Weekly* shortly before the release of the film, he explained how the daylight location shots and sets had been designed and lit to accent sombre winter colours. 'My idea', said Dearden, 'is to throw all this into contrast with the sudden splashes of colour produced by the coloured people themselves. The things they wear, the things they carry, their whole personality . . . I hope to bring something of this contrast to the screen.'[57] The film uses colour to signify race. Sapphire's true and essential racial identity is first suggested by the colour and style of her clothing, and is reinforced by her love of dancing and music.

With their new information, Hazard looks again at the clothes found on Sapphire's body, observing: 'Red taffeta under a tweed skirt', and Learoyd confirms: 'Yes, that's the black under the white alright.' The police visit Babette's in Shaftesbury Avenue, which caters 'for girls

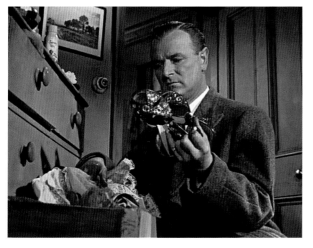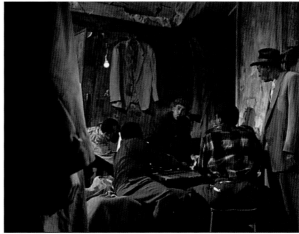

105 Hazard discovering the clothes in Sapphire's locked drawer, *Sapphire*, 1959, frame still.

106 Men gambling in a room in Johnny's lodging house, *Sapphire*, 1959, frame still.

who like flashy, pretty underwear'.[58] The interior of the lingerie shop is the first infusion of colour – pinks and reds – in the otherwise grey London landscape. An assistant remembers Sapphire, who came to the shop accompanied by 'a great big coloured chap'. For Hazard, this is all revealing 'the other side of the picture' – the black side of Sapphire's white masquerade. As the *Daily Express* review appreciated: 'Each time [Hazard] peels another layer of clothing off the body of the dead girl he stumbles upon another clue to her secret life.'

The investigation takes Hazard and Learoyd to the clubs and meeting places of black Londoners. They visit the International Club, a social club for immigrants of all nationalities, and the Tulip Club, 'a dive in Shepherds Bush'. Tulip's is a jazz club frequented by black guests and 'lilyskins', black girls who look white. Race is again installed through colour and through music. The owner of the club assures the detectives that the racial identity of the 'passing' women is revealed when they hear the sound of the bongos. At this point, the camera cuts to the tapping feet of a pale-skinned woman sitting at the bar. Learoyd looks at her feet and then his gaze moves up to her rapturous face, and there follows a frenetic sequence of shots as the camera cuts between dancers, bongos, and finally the legs and thighs exposed by a swirling skirt. The woman may appear white, but her race makes it impossible to resist tapping her feet and dancing wildly to the 'black' jazz music.

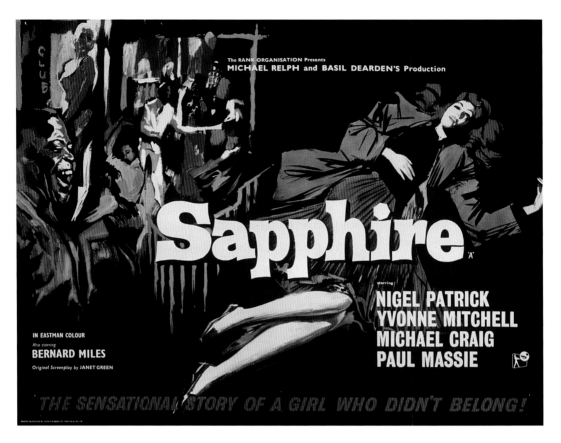

The RANK ORGANISATION Presents
MICHAEL RELPH and BASIL DEARDEN'S Production

Sapphire 'A'

starring

NIGEL PATRICK
YVONNE MITCHELL
MICHAEL CRAIG
PAUL MASSIE

IN EASTMAN COLOUR
Also starring
BERNARD MILES
Original Screenplay by JANET GREEN

THE SENSATIONAL STORY OF A GIRL WHO DIDN'T BELONG!

107 Poster advertising *Sapphire*, 1959.

At the Tulip Club they find out about Johnny Fiddle, who was Sapphire's dancing partner.
Johnny makes a run for it and is beaten up by Teddy boys and finally picked up by the police.
They visit his room, which is in a rundown area with crumbling houses, corrugated metal
hoardings and bombsites. There they find a bloodstained shirt and a knife; Johnny tells them
that he has been in a fight, and his alibi is confirmed by a group of men who are gambling in
a neighbouring room (fig. 106). Meanwhile, Hazard continues to check David's alibi, which is
beginning to crack. He visits the Harrises in their grey home and tells the family that he has
asked Dr Robbins to join them; Mildred protests that she does not want him in her house.
When Dr Robbins arrives Hazard passes him a doll; the camera cuts from the white doll in
his hands to Mildred's increasingly agonized face. Within moments she is unable to watch any
longer and cries: 'Get him out . . . [I] don't want his hands on my kids' toys.' Mildred confesses

180

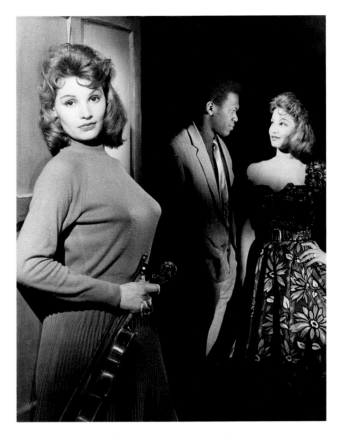

108 Publicity photograph, *Sapphire*, 1959.

that on the afternoon of the murder, Sapphire had come to her grocery shop and taunted her about the race of her baby; fuelled with a hatred of black people and, it is implied, by frustrated desire, she reveals herself to be the murderer.

Sapphire builds the criminal investigation around the clues offered by colour and clothes as signifiers of race and sexuality. The original poster and publicity shots played on the contrast between the 'two' Sapphires: white, tweedy student and scarlet, dancing black woman (figs 107 and 108).

Although the film was intended to expose the racial prejudices within the white nation, its liberal conscience is undermined by its dependence on a simplistic notion of racial difference, drawn through the visual discourses of colour, race and dress. The grey world of the racist white population is contrasted to the colour world of the black immigrant population. As the

police investigate Sapphire's murder, they follow up clues that lead to the black community in clubs, slum housing and gambling dens. Many of the black male characters are violent criminals, thieves and gamblers, and as the critic for the *Daily Worker*, Nina Hibbin, wryly observed, rather than being a critique of the colour bar, '[the film] is perilously near to becoming a justification.'[59]

Moreover, Sapphire is an absence in the film, seen only as a corpse, a figure in a photograph and through the clues offered by her clothing. There is no psychological depth or complexity to this black woman and her motivation to 'pass' as a white woman. Her decision to drain herself of colour and step into the grey world of the Harrises is simply assumed rather than explored in any depth. Why would she not prefer to escape the colour bar of white landladies and the racial prejudice of the white community? The film poses this as a statement of fact rather than a question of choice, compulsion and competing possibilities. And yet there are passages and elements in the film – overlooked, perhaps, by the filmmakers themselves – that begin to point to the complexities of this phenomenon. For example, the presence of the 'lilyskins' in the Tulip Club, the return to the black community of these women who are passing as white, suggests that something important is also lost in the act of racial passing. In a fine recent study of racial passing in American society, Allyson Hobbs has considered the complex emotional experiences of black people who choose this kind of social exile. Describing the practice as a 'risky business', she argues that adopting a clandestine racial identity brings with it advantages and disadvantages, gains and losses: 'Without a doubt, benefits accrued to these new white identities. But a more complex understanding of this practice [passing] requires a reckoning with the loss, alienation, and isolation that accompanied, and often outweighed, its rewards.'[60] For Hobbs the methodological imperative of studying the history of racial passing, of crossing the 'permeable border of black and white', is that it reveals the historically and socially constructed, the socially contingent nature of race.[61] It begins to highlight the elements other than skin colour, such as location, speech, dress and gesture, that construct racial identities and identification. Perhaps this is also what the film demonstrates. Sapphire's resourceful performance shows her understanding of the signs of white female respectability: the details of fabric, colour and design that speak to the elements of white racial identity at that time. But Sapphire's locked drawer, with its sartorial and racial secrets, unravels her racial posturing, suggesting that race identity is inescapable and that, try as she might, Sapphire cannot fully escape her 'true' racial nature.

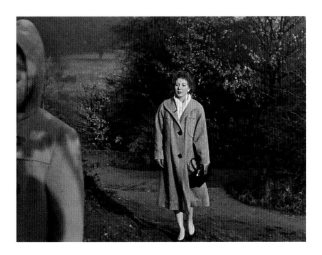

109 The mother who discovers Sapphire's body on Hampstead Heath, *Sapphire*, 1959, frame still.

Finally, within this framework, Mildred Harris's murder of Sapphire may be understood as an act that symbolically seals, at least momentarily, the porous and traversable racial boundary between black and white.

A novel of the film was published shortly after its release; although the novel closely follows the narrative of the film, it omits some scenes such as Johnny Fiddle's beating by the white gang, and also 'fills' and elaborates many of the visual signs of the film, such as the details of clothes. In the novel, when Hazard and Learoyd arrive at the murder scene on Hampstead Heath, they notice that the clothes on the body do not include gloves. This becomes an additional clue for the sharp superintendent: 'Subconsciously [Hazard] glanced round the crowd and saw that every woman there wore gloves – tan cape, black suede, cotton, nylon, plain woollen, coloured woollen – as many kinds as there were women. Only the hands of the dark-haired Unknown . . . were deprived of any protection from the chill morning air.'[62] This incident is not part of the film; however, viewers had seen these decorous clothes on Hampstead Heath in the attire of the mother accompanying the children who find Sapphire's body (fig. 109). She is wearing a well-coordinated outfit of grey overcoat, yellow woollen scarf, brown leather court shoes and matching handbag and gloves. The novel spots a clue that Hazard overlooks in the film; Sapphire may seem to be dressed properly in her brown tweed outfit but she has no gloves, and so her racial masquerade, which is so nearly perfect, is undone. In post-war Britain, clothes and colour were two aspects of a visual language of racial difference.

It marked out black men and women as strange and as strangers to the prevailing customs of dress and appearance. From the moment the migrant arrived in Britain their physical appearance became the subject of an investigative gaze, a 'psychological striptease' that peeled away the layers of dress to reveal difference.

In the experience and narration of colonial migration clothes mattered – whether handmade, purchased on vouchers, or off the ration. They mattered to the migrant and to the white population, and never more than in the initial encounter as passengers arrived at ports and railway stations and made their first impressions. There is a profound emotional power to clothes and appearance in this context; they express hopes and dreams, fears and prejudices, the intractability of difference and the possibility of assimilation. Just such a moment is represented in the *Picture Post* article 'Thirty Thousand Colour Problems', written by Hilde Marchant, with photographs by Haywood Magee and published in June 1956 (fig. 110).[63] The story traces the arrival of West Indian migrants on the Italian ship *Irpinia,* focussing on the vulnerability of the young women who are ill-informed about and inadequately prepared for Britain. Few have jobs to go to, and it is too easy in this situation for those who are pretty to end up as prostitutes. The article outlines the attempts that are being made by the British authorities to discourage West Indian migration and the work of welfare and charity groups to protect women when they arrive in Britain.

Magee's photographs tell a slightly different story; they evoke both the numbers of people arriving ('West Indian immigrants are now arriving in Britain at the rate of 3,000 a month'), and they depict the loneliness and apprehension of the individual migrant. In the largest picture on the double-page spread, the 'newest boatload' is shown in the customs hall, which is packed with people and their belongings. Men and women mill around, some women sit, and all wait. The luggage is varied: holdalls, suitcases and many decorated straw baskets, all full and, in some cases, brimming. The people are smart and formally dressed: the men in suits and ties and hats and the women in pretty dresses, tailored coats and hats. They are dressed as respectable citizens rather than passengers from a long and uncomfortable sea journey. A caption describes the women's clothes as a sign of their naive unfamiliarity with their destination: 'Many young women arrive alone, some in woollen clothes prepared for a British summer, others in cotton dresses fit only for a tropical sun.'

Stuart Hall reads the formality and respectability of the migrants' clothing as a poignant sign of their hopes and ambitions and their desire to make a good impression:

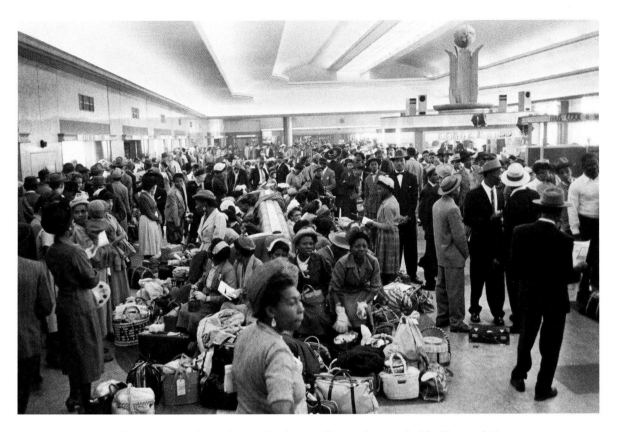

110 Hilde Marchant, 'Thirty Thousand Colour Problems', photographed by Haywood Magee,
Picture Post, 9 June 1956, pp. 28–9.

Jamaicans travelled – as they went to Church, or to visit their relatives – in their 'Sunday best'; the best things you had in the wardrobe. They were coming to a new place. The clothes are those of someone determined to make a mark, make an impression on where they are going. Their formality is a sign of their self-respect . . . The angle of the hats is universally jaunty: cocky. Already there is *style*.[64]

Hall's interpretation finds something that is in the photographs that photographer and journalist choose to overlook. Marchant sees the clothes in the terms of white Britain's stereotyped images of the migrant – a stranger and a potential problem – and cannot perceive them in any other way, least of all from the perspective of the migrant. Two further photographs focus on figures of young women; one, seated and surrounded by her bags, dressed in a summer dress

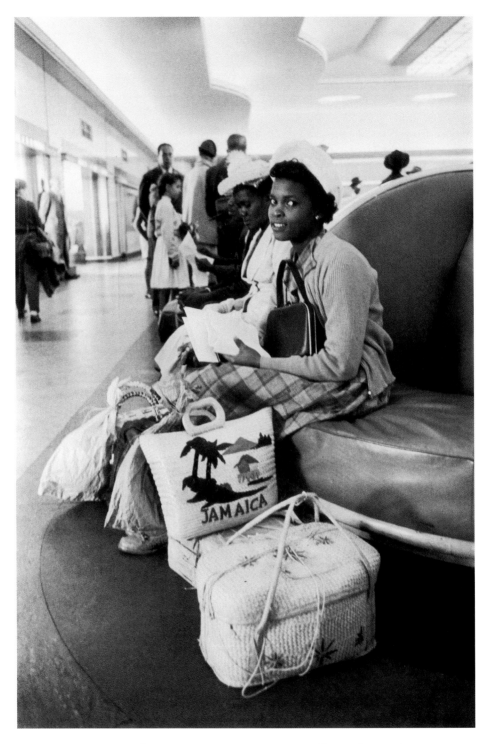

111 Haywood Magee, 'Many Young Women Arrive Alone ...', *Picture Post*,
9 June 1956, pp. 28–9.

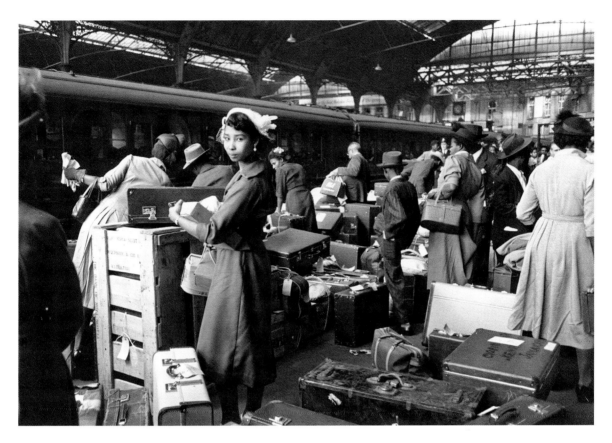

112 Haywood Magee, 'Immigrants Arriving at Victoria Station, London', May 1956.

and cardigan, and holding on firmly to her handbag and papers (fig. 111). Almost in profile, her eyes are turned towards the camera and she smiles hesitantly. Where uncertainty for Hall is a natural and inevitable response of the migrant to the moment of arrival, for Marchant and *Picture Post* it is further confirmation of their culpable and irresponsible lack of preparation.[65] Getty Images now owns the *Picture Post* archive that includes out-takes taken during the same photographic shoot but not included in the article. They are as arresting and powerful as the published photographs; some are extraordinary. A young woman with her suitcases at Victoria Station; pretty, neat, she turns to the camera. Dress historian Carol Tulloch has pointed to the creases in the back of her dark coat, the photographic *punctum* – the piercing detail – that tell the story of her long journey (fig. 112).[66] A couple, seated side by side in a train; they turn towards each other, hold each other's gaze and smile (fig. 113). It is a deeply moving interaction:

187

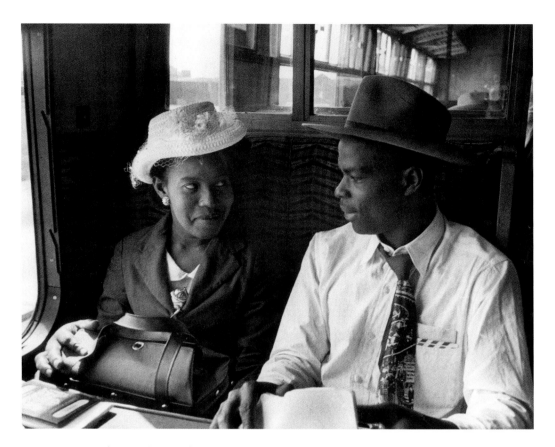

113 Haywood Magee, 'West Indian Immigrants Travel from Southampton to London Victoria', no date.

too intimate, perhaps, for publication. There are papers in his shirt pocket, an envelope, perhaps with an address, and on the table in front of them the familiar form of a British passport. They are British citizens; they have a right to be in England, on that train. I feel for them.[67]

The importance of looking respectable and making an impression recurs frequently in the memories of those who came to Britain from the West Indies in the years following the 1948 Act. Women in the West Indies bought and made outfits, specifically for travelling:

I bought a whole outfit. I want shoes. I want to look like somebody.

When I was leaving [Barbados], I got a tailor to make a nice jacket, and I made a skirt, so I had a nice outfit. And when I came to Victoria my brother bought me a lovely red coat, fitted one. And I was this pretty young girl in this lovely red coat.

I bought a blouse . . . a nice one, with embroidery on both sides . . . and a beige hat. And gloves. I looked quite nice, I must admit. I didn't show I'm poor at that time.[68]

There was clearly a stylistics of migration: a considered and concerted aim to look as good as possible for the moment of arrival that goes to the heart of migrant identity. Moreover, this was not simply a question of what you wore, but how you wore it. It was about the angle of a hat, the cut of a skirt and the colour of a coat – the panache with which you presented who you were when you stepped off the boat or train and into a new life. As one group of Caribbean women in Birmingham told cultural historian Tina Campt: '*We* taught the English how to dress! . . . Those teddy boys used to beat up our boys because they looked so sharp. It was not just about race. It was about style!'[69]

But it was about race and style and colour. What is interesting is how signs of sartorial respectability and status were turned, in the hands of journalists and academics, into signs of alien strangeness and unpredictable sexuality. How the 'lovely red coat' became a taffeta petticoat and the terrible secret of Sapphire's black identity. The first step in this process was to interpret the crisp dresses, pretty cardigans and sharp suits as visual signs of cultural outsiderness, clothes made for a tropical climate and unsuited (like their wearers) to the British climate/atmosphere. In her investigation of 'colour shock' and 'strangeness', sociologist Sheila Patterson recalled a bleak February day in 1956 and the arrival of a typical group of migrants in Folkestone: 'Almost all wore sandals or light shoes, straw hats, and pastel-coloured summer clothes, now stained and crumpled after three days of train and sea travel from Genoa. Several had wound towels round their necks or heads, or had put on two or more jackets, in a vain effort to keep out the dank chill.'[70] Gone are the sartorial signs of aspiration, respectability and style, and what is left, or what is seen, are grubby, lightweight clothes and shivering immigrants. The clothes, like the imagined colonies, are always bright and tropical; for these observers, there are never any cold nights or formal occasions in the West Indies. Clothes were the source of great unease in the colonial encounter in Britain; they signified the alien nature of these new citizens and, at its most extreme, this discomfort expressed itself in the terms of mythic racism. A group of West Indian dockers in Liverpool told race relations writer Anthony Richmond that they were frequently asked 'if they used to wear clothes at home, and did the girls in Jamaica wear grass skirts'.[71]

What emerges clearly from the extensive discourse on migration and clothing in the 1950s is how overdetermined and deeply significant dress was: it created general impressions and

reinforced or challenged preconceptions; it made you feel good; it was a personal statement; it was misinterpreted and could be recruited for a myriad of ideological purposes. Beryl Gilroy came from Guyana to England in 1951 in order to pursue her teaching career; she became the first black head teacher in London and an influential education activist and author. One of her suits from this period is now in the collection of the Victoria and Albert Museum, London (fig. 114). It is a pink, tailored piece made in Guyana and styled from American fashion magazines. Gilroy later recalled:

> Everyone was wearing grey and black and we brought bright colours. We were used to wearing bright colours. We would walk along dressed to the nines and bouncing with confidence – people had never seen the likes of us; they'd never seen black people smart . . . We really enjoyed our clothes . . . we couldn't win you know. If you were dressed up, people would think 'you are wearing our clothes', but if you were in bright colours from the [our] country, it would be 'look at those foreigners'.[72]

Gilroy's recollections illustrate how clothes were used and enjoyed in this period and also the awareness that what you wore was constantly interpreted by others. We can no more assume that all white Britons wore drab, neutral colours than we can accept that colonial migrants were always dressed in bright colours; what is indisputable is that these images and beliefs dominated popular and academic representations of racial difference and that the visual language of dress was a post-war battleground for respectability and social status.

Clothes expanded and gave a highly visible expression to the connotations of colour and race. Male and female colonial migrants were equally defined through their dress and style, with the cut of men's suits the subject of particular fascination. West Indian men's suits were 'sharp'; they were bigger and bolder than usually worn in Britain, with wider trouser legs, higher waists, bigger lapels and brighter fabrics. No sooner had the *Empire Windrush* docked in England than the trade journal *Tailor and Cutter* was reporting on the well-dressed '"Zootable" Imports!!' (fig. 115), picking out the details of trouser shape and shoulder padding that characterized the American, drape style zoot suits that the men were wearing. Two months later the paper published a longer piece on the psychology of the zoot suit and what it said about the origins of the men who wore it (fig. 116): 'It is a reflection of the Negro's connections with the tropics – where his instincts were attuned to extremes of growth and colour and heat and excitement and are now reflected in his adoption of these sartorial exaggerations.' Within

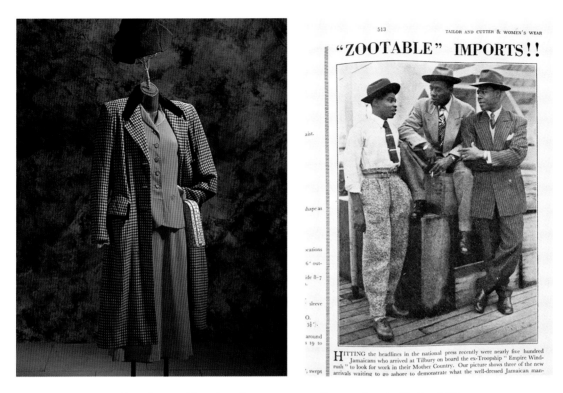

"ZOOTABLE" IMPORTS!!

HITTING the headlines in the national press recently were nearly five hundred Jamaicans who arrived at Tilbury on board the ex-Troopship "Empire Windrush" to look for work in their Mother Country. Our picture shows three of the new arrivals waiting to go ashore to demonstrate what the well-dressed Jamaican man-

114 Nat Gaynes, skirt suit, early 1950s, cotton, Guyana, given by Dr Beryl Gilroy.
Victoria and Albert Museum, London.

115 '"Zootable" Imports!!', *Tailor and Cutter & Women's Wear*, 2 July 1948, p. 513.

the discourses of post-war colonial migration, the taste for bright colours and big styling was defined as a racial predisposition, an aspect of essentialist racial characteristics. The author of the article saw something more threatening, however, in the remodelling of tailoring norms than merely bad taste. It was a *statement*: 'the symbol of a once captive, now emancipated, race thumbing its nose at the world and the world's conventions . . . an instinctive reaction embodied in a pathetic attempt to outwhiteman the white man.'[73]

Clothes not only determine how people look, they also alter the appearance of city streets and urban landscapes. The cut and colour of migrant clothes were changing the appearance of Britain and reworking its conventions of self-fashioning. For the fashion historian James Laver who was Keeper of Prints, Drawings and Paintings at the Victoria and Albert Museum throughout the 1950s, it was possible for migrants to be fully assimilated, but the black man was

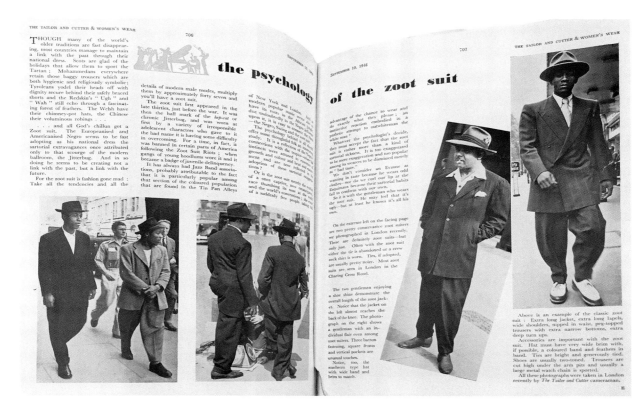

116 'The Psychology of the Zoot Suit', *Tailor and Cutter & Women's Wear*, 10 September 1948, pp. 706–7.

'unable to suppress completely his own individuality'. This view was expressed in his article 'A Touch of Colour', one of a series on 'Clothes and the Welfare State', published in *Punch* in 1953. There is an appropriate ambiguity to the title of the article; does he refer to clothes or skin, or are they now so imbricated as to be semantically inseparable? Drawing on a succession of stereotypes, Laver describes the tailoring of black men as a form of hyper-masculinity, and their clothes are more interesting than their female counterparts because 'they have, so to speak, *been through* European clothes, and come out on the other side, into a world of freedom and fantasy' [original emphasis].[74] The reader can only wonder whose fantasy it is. A full-page caricature accompanies Laver's article, a sketchy evocation of a contemporary British street corner with the defining silhouettes of the migrant bodies that were re-forming the nation (fig. 117).

Navigating the multiple and often contradictory discourses of race, colour and clothing is illuminating, shocking and moving. There is one last move in this set of representations: the pre-

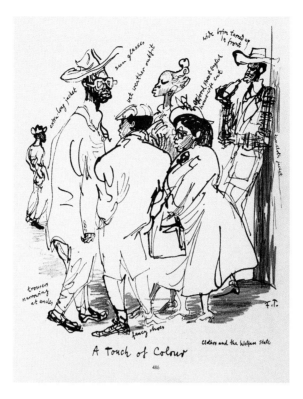

117 'A Touch of Colour', *Punch Historical Archive*,
22 April 1953, p. 486.

sentation of the migrant self to those at home in the Caribbean. There is an archive of photographs in the Birmingham Library from the local photographic studio business established by Ernest Dyche in the early twentieth century.[75] Dyche specialized in portraits, including from the 1950s the African Caribbean migrant community who came to the city in the post-war years (figs 118–24). Historians have commented on the generic conventions of these portraits: the studio props and backgrounds that recur throughout the photographs and that add a generalized touch of glamour and sophistication to the studio setting.[76] Perhaps repetition is the key to understanding these images – the painted backgrounds and vases of flowers, the forms that Roland Barthes refers to as the photographic *studium* – the generic element of a photograph – but which, in this context, is so expressive of the individual's identity.[77]

The images are clearly exercises both in *self*-imaging (the sitters are agents in their own representation) and in depicting the *other* (the photographers can determine settings, lighting,

193

Seven undated photographs:

(*facing page*) 118 Man standing by a table; 119 Man seated at a desk writing;

120 Woman seated by a table; 121 Woman standing, hand touching a table;

(*this page*) 122 Woman standing by a table; 123 Man in suit and hat in front of a backdrop;

124 Group portrait, three rows of figures. Dyche Photographic Studio Collection,

reproduced with the permission of Birmingham Archives and Heritage Photographic Collections.

etc.). Sandra Courtman has suggested that they display 'the processes involved in the shift from "colonial subjects" to "black citizens"'.[78] The portraits demonstrate the belief in dressing well and the power of clothes to show respectability and success. These are not habits and conventions learned in Britain; they also functioned in the Caribbean and could be exchanged as part of a shared language of aspiration: 'to be someone; to be proud and good-looking; respectable and upstanding; an aspiration to betterment and middle-class prosperity'.[79] Accessories are essential: wrist watches, handbags, gloves, handkerchiefs and pens are signs of success, evidence that the sitter has had that 'break' they came in search of.

'Red taffeta under a tweed skirt ... the black under the white'. Disentangling this short bite of film dialogue opens up a world of discourse and representation in which colour and clothes define racial and sexual identity. As a black woman, Sapphire is sexualized by the choice of the colour red as much as by the style of lingerie. By the 1950s the basic rules of the psychology of colours were available to everyone, and chromatic choice could be informed and mindful. In its February 1952 issue, *Everywoman* offered a colour table and a double-page spread on the psychology of colours:

> RED: 'psychology': the symbol of power, war and sex.
>> 'why you wear it': To attract men physically ... to excite the opposite sex.
>> 'men's reactions': Immediate and physical. To young men, red is the colour of sex and
>>> is meant to be.

It would take a bold woman to read this and go out and buy a red dress or petticoat – better, by far, to choose a neutral colour:

> NEUTRALS: 'psychology': These are the complex colours of civilization. Denote normal
>> adjustment to modern living. Brown for those with their feet firmly planted. Grey
>> for those content and adapted. Fawn for those achieving mind over matter.
> 'men's reactions': They like them on their married womenfolk and families.[80]

Red is physical, sexual and basic; unlike the neutral colours, it represents a less advanced form of civilization and, by implication, an abnormal adjustment to modern life. Women were being offered colour advice in relation to their walls, furniture, make-up, clothes and garden and knew that their choices might be seen as reflections of their temperament, habits and morals.

Wives wore neutrals; they wore tweeds. Clothes rationing was introduced in 1941, and Utility regulations continued to restrict availability of materials and the use of decoration until 1952. As design historian Pat Kirkham has shown, this did not rule out innovation and individuality, and dresses in the Utility period are often brightly patterned and customized.[81] Nevertheless, the prevailing respectable look for women during the 1950s was a mix of practical stylishness and provincial restraint. Overcoats and hats were key items and generated multiple adaptations, with manufacturers and press advertising overcoats, topcoats, weather wear and storm collars. In 1949, *Picture Post* reported the appointment at the Royal College of Art of Madge Garland as 'The First Professor of Fashion', a position intended to improve the standards of women's clothing in Britain. Garland's own look was 'unostentatious, yet so obviously well chosen, that for her to be well-dressed seems natural', qualities that exemplify the understated aesthetic of respectable fashionability in this period. In 1951 another young woman was sending her photograph abroad; when Carol from Nantwich wrote to the *Woman's Friend* agony aunt for advice about what to wear to have her photograph taken to send to her boyfriend overseas, she was told: 'Wear a simple dark dress, with a touch of white at the neck, and avoid anything that will . . . look too frilly or fussy.'[82]

Fabrics were preferably natural, colours were muted, and contrasts unobtrusive. The favoured colours were browns and neutrals; in 1948 the *Tailor and Cutter* described the colours being used for women's suits that year: 'There is much use being made of donkey brown (which is another name for snuff colour). Beige brown and beige fawn are amongst the most favoured tones and they are used plus rust and a pleasing light royal for heavy linen.' Later in the year its correspondent reported a new tone called 'greige', which was joined, in the spring of 1950 by 'Fog Blue'.[83] And, if you preferred something a little darker, it was still possible to order a coat in 'Nigger' (see Chapter Four). Post-war colour was, of course, never neutral. It was overladen with meanings and created the conditions through which people made sense of themselves and of each other. Red taffeta and brown tweed – a choice of colours, fabrics and races. Perhaps the greatest contrast in *Sapphire* is not between the two lives of the eponymous victim, or even between Sapphire and David's frustrated, grey sister, Mildred, but between the elegant white mother on Hampstead Heath and the black woman in her red taffeta petticoat.

6

Battersea, Whitechapel and the Colours of Culture

'Finding Something that Has Been Lost'

The Festival of Britain was opened by King George VI on 3 May 1951 with a grand ceremony at St Paul's Cathedral. What better place to stage the pageantry of the opening than in the historic building that had withstood the Blitz and that now, surrounded by bombsites, was like a phoenix symbolizing the determination of the nation to rebuild and face the post-war future. The following day the royal couple visited the festival site on the South Bank and signs were less propitious; the day was cold, wet and misty, and the elegant silk hats and court shoes of the royal entourage were little protection against the rain and puddles. Gerald Barry, the Director-General of the festival, recalled in an unpublished memoir: 'The bunting hung in the lifeless air as limp as wet dishcloths, the Thames was barely discernible in the mist, and a general air of damp languor hung over the scene.'[1]

And yet the juxtaposition of bunting and rain was not entirely inappropriate; the festival was constructed through a discourse of gaiety and colour emerging from the grey, scarred landscape

of wartime Britain, and as the sun at last came out and the public began to visit the many exhibition sites and events across the country, the festival summer and the future of the nation could begin. There were other times during the festival when meteorological conditions seemed intent on impeding the spectacle, when visitors had to put on their heavy coats to dance in the open air. This would not dampen spirits, however; there was a great deal at stake in its success, and the national stories it told and British weather would not inhibit its supporters.

The festival was a Labour government project; planned to open 100 years after the Great Exhibition of 1851, it was conceived as a morale boosting scheme that would lift the people and, just as importantly, project an image of Britain as enterprising, productive and ready to trade. In 1947 it was approved by Parliament, and Gerald Barry (who was then editor of the left-wing *News Chronicle*) was appointed Director-General of the Festival of Britain and its office in Whitehall. The Festival of Britain was conceived and described as a narrative of beginnings; whilst it would tell the story of the nation's past, its focus was the energy of the present and the potential of the future. In many ways, however, it was a story about endings. In 1947, the year of its official inception, Parliament granted self-government to India, Pakistan, Burma and Ceylon; the festival bore witness to the effective end of empire and its story is thus also that of decolonization. In February 1950, as the festival site on the South Bank of the Thames in London was reclaimed and prepared for the pavilions, restaurants and walkways, a general election saw the Labour party's overall majority cut to five, and three weeks after the festival closed on 30 September 1951, another general election ended the Labour government's post-war welfare project and returned the Conservatives to power. One of the first actions of Prime Minister Winston Churchill was to dismantle the South Bank site, which he regarded as a symbol of the profligate spending of the previous Labour regime, scrapping its symbols of the future, the Skylon and the Dome of Discovery, and getting rid of the rest at public auction.[2] And it was the end of the king; unable to take part in the closing ceremony because he was recovering from lung surgery on a malignant tumour, his health continued to worsen until his death in February 1952.

The South Bank site was always a fragile expression of optimism, a strangely vulnerable edifice in the middle of a bombed out, decrepit Victorian metropolis. In its special festival issue, *Architectural Design* commented on the striking 'Abacus Screen' of coloured balls designed by Edward Mills: 'decorative screens are used where neighbouring buildings *press too closely*' (fig. 125).[3] The South Bank was indeed a microcosm of the nation: a bright illusion, embattled and

125 'Linking the Telecinema Pavilion to the Administrative Block: A Screen of Gaily Coloured Balls', *Illustrated London News*, 12 May 1951, p. 758.

exposed at its borders. As much as designers and architects could manage the space within the site, there was always pressure from the outside, and it remained poised on an axis of inside fun and outside threat. In 1952 a black and white documentary was made about the festival buildings, produced by Patrick Massingham and supported by the *Observer* newspaper (UK; dir. Jacques Brunius, Maurice Harvey).[4] With most of the footage shot two weeks before the South Bank closed, the film's guides and narrators are Sir Hugh Casson, chair of the committee of festival architects, and Patrick O'Donovan, a senior journalist on the *Observer*. The film's

title, *Brief City*, emphazises its ephemerality, which is reinforced by a two-minute opening sequence, shot after the South Bank had closed down. The camera pans round the deserted site as the narration explains that the buildings are now awaiting demolition and the festival is 'part of London's past'. The landscape is bleak and wet, with only the discarded signs of its former purpose: the camera follows a sheet of newspaper blowing about in the wind and focuses on an abandoned notice advising 'No Readmission'. The narration recalls that 'outside the soot and smoke' had been in charge, while inside 'it blazed with bright nursery colours'. With the festival over and the control of its boundaries abandoned, it as though the grey Victorian city has infiltrated the festival fantasy and reimposed its own order on the landscape, turning the colour back to shadows and darkness.

The festival was designed as fun, with a heavy dose of didacticism; it was to be the story of 'the nation', the 'autobiography' of the people. The two key themes were 'the Land' and 'the People', which set the terms for the representation of a unified nation, bound together by a strong physical and emotional bond to the land itself. It was an image that was needed within the nation and that could be projected overseas to attract visitors and badly needed revenue. It was reported that advertising leaflets had been printed in eight different languages and distributed in thirty-four countries; four London double-decker buses had been sent on a tour of Europe, publicizing 'Britain herself'. Visitors from the United States were especially desirable.[5] For the first time since the war Britain was branding itself for home and overseas consumption; this was why the story had to be a good one. As the official guide put it: '[the Festival] will add up to one united act of national reassessment, and one corporate reaffirmation of faith in the nation's future.'[6]

Although the South Bank sold itself in terms of fun and gaiety, there was little spontaneity in the conception of the site and pavilions. From the beginning the designers planned a preferred route for visitors, a circuit that would make the story clear and unambiguous. In one of a small number of official guides to the South Bank Exhibition, published by His Majesty's Stationery Office, the route was described as 'The Way to Go Round', and the design of the site and buildings was compared to the chapters in a book that 'tell one continuous interwoven story' (p. 8). A plan of the site illustrates the 'Upstream Circuit', devoted to 'The Land', and the 'Downstream Circuit', which focussed on 'The People' (fig. 126). Arrows trace the visitor's path through the display, with occasional deviations exposing the complexities or subtexts within the overarching narrative. The South Bank site also had to tread a careful path between

THE WAY TO GO ROUND

The Exhibition, which tells a continuous story, will make most sense if the Pavilions are visited in the order shown; but each Pavilion can be visited separately if so desired.

UPSTREAM CIRCUIT - "THE LAND"

1	**The Land of Britain**	How the natural wealth of the British Isles came into being. (*Pages* 11–12.)
2	**The Natural Scene**	The rich and varied wild life that inhabits these islands. (*Pages* 13–15.)
3	**The Country**	A highly mechanised and most efficiently farmed countryside results from long experience, aided by science and engineering. (*Pages* 17–19.)
4	**Minerals of the Island**	How the British have drawn on their natural resources to produce raw materials for industry. (*Pages* 21–22.)
5	**Power and Production**	Highlights in the growth of present-day industry—the lifeline of Britain, with many examples of first-class design and production. (*Pages* 23–27.)
6	**Sea and Ships**	Shipbuilding, propelling machinery and the fisheries. (*Pages* 29–31.)
7	**Transport**	British pioneering, and contemporary achievement in design, for *Communications* and transport by *Road, Rail, Air* and *Sea.* (*Pages* 32–39.)

4

126 'The Way To Go Round', in Ian Cox, *The South Bank Exhibition: A Guide to the Story It Tells* (London: HMSO, 1951), p. 4.

orchestrating the route and appearing over-regimented or joyless; different types of visitors could thus select the sections that most interested them without departing entirely from the central circuits.[7]

In her recent book on the festival, Harriet Atkinson has pointed to some of the tensions and competing forms of identity that emerged during the planning of the exhibition and its story of Britain, between the regional and the national, the rural and the urban and between Englishness and Britishness; indeed, to pick at the threads of the festival's image of the nation is to unravel the entire myth of a unified people on which the design was constructed.[8] What is equally clear is that the designers and planners needed to orchestrate the visitor's gaze; they needed to focus attention on the festival events and sites and to prevent it wandering to the surrounding empty spaces and *terrains vagues*, where the fragility of the premise of the land and its people would collapse into disunity and ruin. 'The People of Britain' pavilion was designed to 'show how the British stock was blended' (p. 69). Of course, this language of good British stock that must be defended from racial hybridization was already part of the discourse of colonial immigration and the colour bar (see Chapter Five); in the South Bank, however, it was given a different spin. Here, the diverse origins of the British people were acknowledged – Celts, Romans, Anglo-Saxons, Vikings and Normans – ancient invaders who had been absorbed by the land and the people: 'But though the ancient dead are buried, it is the very blood they brought here that runs in us . . . They were absorbed into the life that was here before them, and themselves became islanders of a land that moulded the thoughts, the feelings, the behaviour of them all into a whole which is our British way of life and our tradition' (p. 65).

This is a fascinating piece of historical revisionism. The address to the reader/visitor as one of 'us' – part of a shared British racial inheritance – and the image of the absorption of the stranger into the indigenous community bear striking similarities to the 1949 'Royal Commission on Population' and its recommendation that migration was acceptable if those involved were not 'prevented by their religion or race from intermarrying with the host population and becoming merged with it'. It is impossible not to see the ideological work of the South Bank as part of the post-war reconfiguration of the nation as determinedly and essentially white; as Bill Schwarz has put it: 'from the ruins of the colonial empires across the globe there emerged, among the white populations themselves, a recharged, intensified self-consciousness of their existential presence as white.'[9]

As well as through blood, the British people were unified through their shared personality, which was explored in 'The Lion and the Unicorn' pavilion, with the title symbolizing the two main qualities of the national character: 'on the one hand, realism and strength, on the other fantasy, independence and imagination' (p. 67). Here was national identity through a lens of quirky eccentricity: a model of Lewis Carroll's White Knight based on the illustrations of John Tenniels, alongside a tradition of vernacular craftsmanship; things that take time to develop and that are deeply grounded in the past, things that newcomers cannot quickly assimilate or simulate and that, in the end, are 'indefinable' (p. 68). British identity was on display through the festival buildings, displays and objects; in the end, however, true identity was something impalpable, a shibboleth that would expose strangers for what they really were: aliens.[10] This was the importance of the message from 'The Lion and the Unicorn' to 'visitor[s] from overseas': how can you merge with something so deep and elusive that it cannot, ultimately, be defined?

The Festival of Britain, described so unremittingly in terms of an outburst of colour after the years of wartime and austerity grey, thus constructed an image of the British people as without colour, as unified through their whiteness. This colour blindness has been recognized by historians of the festival, who have also commented on the wilfulness of this exclusion in the light of colonial migration during the period. On the whole, these studies have suggested that the festival simply did not refer to the colonies and Commonwealth, or as Barry Turner has put it: '[they] were not just sidelined but dismissed from the field.'[11] The festival makes sense now as an act of what sociologist Paul Gilroy has referred to as 'cultural insiderism', fostering notions of national belonging and images of the nation as ethnically homogeneous.[12] As Gilroy has argued, colonial migration interferes with this neat homogeneity; it disrupts the mythic image of national life as peaceful, unified and held in common that the festival played such a large part in disseminating in post-war Britain. Perhaps, however, the colonial presence was not totally erased from the festival; perhaps if we stray from 'the way to go round' and look at the overlooked, it is possible to rediscover another version of the 'people' that acknowledges their diversity and the struggles over national identity and racial difference.

The Commonwealth was at the festival; it was there in the exhibition of 'Traditional Art from the Colonies' held at the Imperial Institute during the festival months; it was there in the performances by the Trinidadian steel orchestra at the South Bank and in the records about it made by *Windrush* musicians Lord Beginner and Lord Kitchener.[13] Look carefully enough, and the colonial presence that had been marginalized within the official narrative can be seen. The

'Dome of Discovery' was one of the most striking and popular buildings on the South Bank, with a number of different displays relating to science and technology and British initiatives in exploration and discovery. Past explorations, the narrative explained, had opened up new lands, allowing Britain to 'serve' whole continents. Moreover, this global role was not over, and British organizations such as the Commonwealth Agricultural Bureaux, continued to support engineering, medical and agricultural projects in these overseas countries. The culmination of British exploration is the Commonwealth of Nations, which is described as a flow of migration and communication: 'Our sons and daughters have left Britain and set up their own homes overseas; our adopted children are coming into their own estates' (p. 43). No mention here of those who have come from overseas and set up home in Britain.

The festival's account of the present and its projection of the future rested on a highly developed sense of the nation's past, and an older colonial iconography of nation and empire recurs in representations of the events and in the material culture surrounding them. The official guidebook carried pages of colour adverts at the front and back of the volume, adverts that often evoked the past whilst claiming a global role within future British trade and industry. 'Quality' and a history of outstanding production are the key features of well-established brand names that continue to be great national assets, such as Cussons Imperial Leather toiletries (fig. 127). Two grinning black figures dressed in eighteenth-century breeches and frock-coats, with matching feathered turbans, emerge from behind heavy red curtains bearing enormous bars of Imperial Leather soap. Anne McClintock has discussed the way in which soap advertising flourished during the late Victorian period of imperial competition and anticolonial resistance, and has described soap advertising as 'the embodiment and record of an incongruous and violent encounter'.[14] The sources for soap came from plantations in Malaya, Ceylon and Africa, many of these areas in which, by 1951, the processes of decolonization were well advanced. This is not the world of the festival advertisers, however, who draw instead on well-worn visual clichés and stereotypes, which can still work within the temporal framework of a dynamic present built upon a great past.

It seems also the imperial moment of 1901 rather than 1851 that is evoked in the cover of the *Illustrated London News* Festival of Britain special number (fig. 128): a coloured drawing of an aerial view of the South Bank site, with framing allegorical figures, a Union flag and in the bottom corner a heavily made-up Britannia resting her right hand on a globe. The imperial past was part of the cultural imaginary of the festival; it framed its displays and narratives.

127 'The Quality Toilet Soap *Everyone* Wants!', advertisement for Cussons
 Imperial Leather Soap, in Cox, *The South Bank Exhibition*, p. xvii.

Registered in the United Kingdom and published in Commonwealth House, the *Illustrated London News* spread its strangely retrogressive image of the festival throughout Britain and the remaining colonies and protectorates of the British Empire and Commonwealth, increasingly out of touch with the fragile balance of imperial politics in 1951.

The Imperial Institute in London organized two temporary exhibitions for the festival: 'Focus on Colonial Progress' and 'Traditional Art from the Colonies'. Only 'authentic trad-

128 'The Exhibition's Opening – Special Number', *Illustrated London News – Festival of Britain*,
12 May 1951, cover illustration.

129 *Traditional Sculpture from the Colonies* (London: HMSO, 1951), cover.

itional work' that did not show any modern or extraneous influences was selected for display; indeed, the catalogue instructed visitors that in order to appreciate the objects they had to divest themselves of modern values and become receptive to their 'strange forms and rhythms'.[15] If white Britain was projected as authentic and distinct, then the black colonies were also represented as primitive and untouched by modernity, as entirely other, as Mau Mau rather than disenfranchised, militant workers. An illustrated handbook was produced for the exhibition, a simple publication with an essay and a list of exhibits and a striking red cover (fig. 129). It is safe to assume that the designers did not know Frank Ormrod's article on 'Colour in Photography', published in the *Penrose Annual* in 1951, in which he claimed: 'In West Africa it seems that there are only three colour words, red, white and black – everything that is not black or white is called red'; for, as seen in Chapter Five, there was a whole discursive world of race and colour to determine their choice of red.[16]

1951 – festival year: approximately 2,200 migrants arrived in Britain that year and the overall African Caribbean population stood at approximately 27,000.[17] Immigration numbers were still relatively small; however, the discourse of racial discrimination and the practice of the colour bar were well developed. So when the organizers made overseas visitors one of their key objectives, it was Europe and the USA that they had in mind. Films and photographs of the South Bank and other sites seem to show an astonishingly homogeneous white crowd; given the black presence in London and other British cities at this period, how can we make sense of this uniformity? Did the migrant population simply not attend the festival, or did the filmmakers and photographers choose to depict a white nation, or have we not looked well enough?

Film was part of the festival at the South Bank; the site had a purpose-built cinema and there were specially commissioned films, including a feature film, *The Magic Box* (a biography of the British film pioneer William Friese-Greene, UK, 1951; dir. John Boulting) and a documentary, *Family Portrait*, made by Humphrey Jennings (UK, 1950).[18] The subtitle of Jennings's film is 'A Film on the Theme of the Festival of Britain, 1951'; through a collage of images and commentary it offers a portrait of the nation as a family, held together through tradition and hard work. The film begins with shots of pages from a family album: familiar, everyday events such as holidays, Christmas celebrations and births, and then develops into scenes of the coastline, shipping, St Paul's Cathedral, smoking chimneys. In the final seconds it returns to the pages of the album and two last photographs of Blitz bomb damage and the family; a blank page is filled with the festival logo and date. The effect is emotional and poetic, with the family (also representing the unity of both the nation and Europe) as the framing device for its message. In a later commentary, film director Lindsay Anderson admired its lyricism but described it as a 'fantasy of Empire'; it was a collective fantasy, however, one that captured the national mood and imagination.[19]

Festival in London (UK, 1951) is a nine and a half minute colour documentary made by the Crown Film Unit for the Central Office of Information and Commonwealth Relations Office. Its director was Philip Leacock, who had spent the Second World War making a range of documentaries and training films for the Army Kinematograph Service and had joined the Crown Film Unit in 1948. In 1952 he moved into feature film production, after being invited by the documentarist John Grierson to make *The Brave Don't Cry*, a drama about a mining disaster, for Group 3, an independent film unit, supported by the National Film Finance Cor-

poration.[20] Shot in colour, *Festival in London* was a prestige title that could have been seen both in Britain and overseas. It begins with a painting of the 1851 Great Exhibition and then cuts to the title over images of Big Ben and the Thames in 1951, while the London Symphony Orchestra plays the 'Festival March' by William Alwyn. The camera then pans across the South Bank site, with different shots of the crowds and displays. The commentary, written by James Cameron, states: 'It is open house on the South Bank. To those from home, and to those who come from other lands.' The film continues with shots of visitors at the Dome of Discovery and celebrates British science, industry and invention, before moving on to the Lion and the Unicorn and those more intangible values: 'We smile at our follies and our most profound beliefs. Such as tradition. Such as peace. Such as justice.' And in the spirit of Lewis Carroll and Edward Lear the film then follows the festival upstream to the gardens at Battersea: 'Lights and laughter; all the merriment of a people who build with gladness on an old inheritance.'

The film recreates the key messages of the festival, as might be expected from an official piece of work created for the Central Office of Information, an agency that coordinated information in all media for the Foreign Office, the Colonial Office and the Commonwealth Relations Office.[21] Films of the festival were an outstanding opportunity to disseminate positive images of Britain to British and international audiences and to develop the 'art of national projection' that had been advocated by Stephen Tallents since the 1930s. In *The Projection of England*, first published in 1932 and reissued in 1955, Tallents had urged that all forms of communications should be used to promote the national brand overseas, and he offered a list of suitable subjects that included gardening, tailoring and the 'national personality'.[22] Following financial cuts after the war, the Crown Film Unit closed in 1952; *Festival in London* is thus a late and distinctive piece of national projection made by an organization that had spent decades developing the image of the nation for home and overseas consumption.

It would be easy to treat the film simply as an interesting official record of the festival, with useful documentary footage of the sites on the South Bank and Battersea in daytime and at night. I want, however, to work differently with this film, drawing my method from what film historian Laura Mulvey refers to as 'delaying cinema'. I want to return to the sequence, approximately three minutes into the film, when the commentary refers to 'open house on the South Bank. To those from home, and to those from other lands.' At this point there are long shots of crowds and visitors flowing down steps and a cacophony of barely distinguishable languages and accents. Mulvey observes that delay is a fundamental methodology of film theory and

criticism, allowing selected scenes and frames to be extracted from the narrative flow and the discovery of previously unanticipated meanings.[23] She elaborates this concept, commenting:

> The process of repetition and return involves stretching out the cinematic image to allow space and time for associative thought, reflection on resonance and connotation, the identification of visual clues, the interpretation of cinematic form and style, and, ultimately, personal reverie ... key moments and meanings become visible that could not have been perceived when hidden under the narrative flow and movement of the film (pp. 146-7).

To extract a frame is to discover deferred meanings that 'have been waiting decades to be seen'. Although Mulvey is considering the genre of Hollywood melodrama, it is possible to understand the forms and conventions of the festival documentary through this critical practice. To return to the 'open house' sequence in *Festival in London*, with its endless flow of visitors and ceaseless chatter of voices and languages: there is a moment in this episode when the camera lingers, for an instant, on the head and shoulders of a well-dressed man, his face hidden by the rim of his hat, who appears to be looking down at a map or guide (fig. 130). He looks up and for that fleeting moment, as the frame is frozen, his face is withdrawn from the mêlée of the crowds and he is a black man at the Festival of Britain (fig. 131). Discussing the presence of black extras in the opening scene of Douglas Sirk's *Imitation of Life* (1959), Mulvey suggests the importance of noticing these figures through delaying cinema is that: 'With the image halted, the appearance of the black figures on the screen takes on an added power and weightiness, standing in for and conjuring up the mass of "coloured people" rendered invisible by racism and oppression' (pp. 157–8). I am content with the additional political emphasis that is added to that figure, that face, by freezing the image. It draws attention to the invisibility of race that runs through the Festival of Britain and its tireless reiteration of the entrepreneurial, quirky white nation. It disturbs the seamless white narrative of the festival nation and the inadequacy of those who argue that the crowds are white because there were not many black people in Britain at the time.[24]

Moreover, the image reveals a double blindness at work both within the film and within British society in the 1950s. The black man is positioned as one of the 'visitors' to whom the festival is 'open house'; like the Europeans and the American tourists (whose accent can be discerned on the soundtrack), he is not staying, his presence is temporary. What is unthinkable is that this man is a citizen, that he is British and is part of the nation. His presence in the film

130 and 131 Man with hat, *Festival in London* (UK, 1951; dir. Philip Leacock), frame stills.

is fleeting, but halting the film at this moment exposes the ideological work of the Festival of Britain and locates it within a set of relations and the framework of race that have otherwise been rendered invisible. In its penultimate paragraph, the official guide to the festival reflected: 'Britain will be welcoming from overseas more visitors than ever before and this year is an occasion not only for presenting an account of ourselves but also gestures of hospitality.'[25] The gestures of hospitality were needed not only for visitors, however, but also for the new citizens who in 1951 were already part of the nation: people whose presence was not contingent on the temporality of the festival and who were changing the myth of the white nation that it worked so hard to promote.

If the South Bank was an oasis within the smoky Victorian city, approximately four miles upstream there was an even brighter escape at the Festival Pleasure Gardens in Battersea. The site at Battersea was differently financed from the South Bank and the rest of the Festival of Britain, with a number of exhibits realized through commercial sponsorship and a govern- ment-sponsored limited company, Festival Gardens Ltd, responsible for managing budgets and completing the project on time.[26] The history of the construction of the Festival Pleasure Gardens makes dour and unpleasurable reading. The building work was disrupted by a series of strikes, and heavy rain during the winter months of 1950–1 turned the site into a quagmire. By April 1951, weeks before the opening, the Battersea site was behind schedule and spending

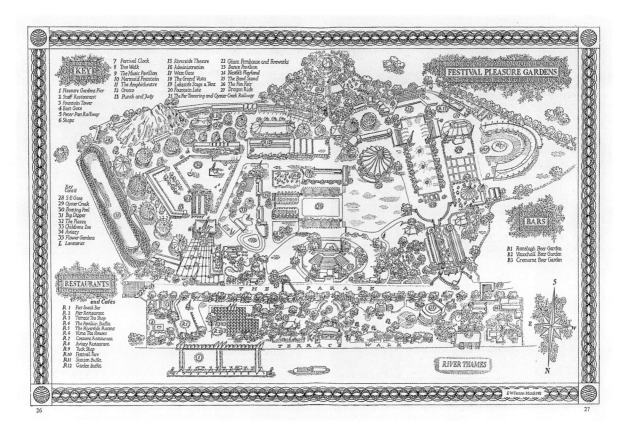

The following key text appears within the map:

KEY

7 Festival Clock
8 Tree Walk
9 The Music Pavilion
10 Mermaid Fountain
11 The Amphitheatre
12 Grotto
13 Punch and Judy

15 Riverside Theatre
16 Administration
17 West Gate
18 The Grand Vista
19 Lakeside Stage & Tent
20 Fountain Lake
21 The Far Tottering and Oyster Creek Railway

22 Giant Farmhouse and Fireworks
23 Dance Pavilion
24 Nestlé's Playland
25 The Band Stand
26 The Fun Fair
27 Dragon Ride

1 Pleasure Gardens Pier
2 Staff Restaurant
3 Fountain Tower
4 East Gate
5 Peter Pan Railway
6 Shops

FESTIVAL PLEASURE GARDENS

Key Cont'd
28 S.E Gate
29 Oyster Creek
30 Boating Pool
31 Big Dipper
32 The Piazza
33 Childrens Zoo
34 Aviary
35 Flower Gardens
L Lavatories

BARS
B1 Ranelagh Beer Garden
B2 Vauxhall Beer Garden
B3 Cremorne Beer Garden

RESTAURANTS and Cafés
R 1 Pier Snack Bar
R 2 Pier Restaurant
R 3 Terrace Tea Shop
R 4 The Pavilion Buffet
R 5 The Riverside Rooms
R 6 Vista Tea Houses
R 7 Crescent Restaurant
R 8 Aviary Restaurant
R 9 Tuck Shop
R 10 Festival Fare
R 11 Station Buffet
R 12 Garden Buffet

THE PARADE

TERRACE WALK

RIVER THAMES

132 'Festival Pleasure Gardens', in *Pleasure Gardens Guide* (London: Festival Gardens Ltd, 1951), pp. 26–7.

had gone vastly over budget; not surprisingly, the managing director of Festival Gardens Ltd resigned, the gardens opened late, and a royal visit was later cancelled. In spite of being a political and financial embarrassment, however, the gardens persisted with the creation of a certain kind of whimsical amusement, modelled on the pleasure gardens of the eighteenth century but with a distinctly modern twist.

Visitors entered the site at the Grand Vista, with fountains designed by Osbert Lancaster and decorations by John Piper. Unlike the route at the South Bank, once inside the Pleasure Gardens visitors could wander around and choose their entertainments from the range on offer: riverside rooms, tree walk and boating lake, dance pavilion, aviary, theatres, fun fair, Punch and Judy shows, etc. (fig. 132). Amongst the most whimsical and popular diversions was the Far Tottering and Oyster Creek miniature railway, designed by Rowland Emett. In a

214

period that had seen the nationalization of the railways it was an extraordinary piece of nostalgic kitsch; the guide joked: 'The directors [have] refused enormous sums in compensation offered by the Government.'[27] And so the little coloured trains took passengers back and forth between the Far Tottering and Oyster Creek stations, and more importantly into a fantasy no-time, equally detached from wartime and post-war time (fig. 133). Food in the gardens was equally amusing: jellied eels, hamburgers, popcorn, shellfish and candy floss – and history was treated in the same light-hearted manner. There were Regency shops, Good Queen Bess and, perhaps most strikingly, the Nell Gwynn orange girls who greeted visitors on their arrival (fig. 134).[28] It was as though the pages of a popular history book had been torn out and thrown in the air and now offered a scrambled repertoire of styles and entertainments. At Battersea the past was insistently nostalgic and indulgent, and after years of blackouts and power restrictions, at night it was all lit by glowing fairy lamps, multicoloured lanterns, sodium tubes and white flood lights. In September 1951 *Picture Post* reported that the gardens had already had five and a half million visitors, and the reason for its popularity was clear: 'Battersea does more than take you out of the office or factory; it takes you out of yourself.'[29]

The prevailing look at Battersea was colourful pattern and bold decoration (the Guinness clock and the lakeside stage are fine examples, figs 135 and 136): enlarged toy buildings, sham historicism and mass infantilization. It is like the moment in Victor Fleming's 1939 film *The Wizard of Oz*, when Dorothy leaves Kansas and enters the colourful world of Oz. In his fascinating study of the film, which was advertised as 'The Happiest Film Ever Made', Salman Rushdie describes the impact of the shift in visual register from the greys of Kansas to the hectic colour of Oz: 'We have reached the moment of colour . . . The makers [of the film] clearly decided to make their colour as colourful as possible.'[30] This captures perfectly the aesthetic and ethos of Battersea: the happiest and most colourful place ever made. Oz and Battersea also share a sense of hopefulness and poignancy – in the words of Dorothy, 'Somewhere Over the Rainbow', and in the guidebook, the dream of 'Finding something that has been lost' (p. 44).

The relationship between the South Bank and Battersea was also important, with the pedagogy of the national story downriver contrasted to the fun and entertainment further upstream. Historian Peter Bailey has described Victorian leisure in terms of two distinct categories: amusement and recreation. Amusement was really purposeless leisure; it was concerned with diversions and more superficial pleasures. Recreation represented the rational side of leisure and was associated with renewal and improvement.[31] There is something of this distinction between the

133 '"Neptune" on the Far Tottering and Oyster Creek Railway', in *Festival Gardens: Photo-Memories;*
A Souvenir of the Festival Pleasure Gardens, London, photographed by J. F. Lawrence
(London: Charles Skilton Ltd, 1951), fig. 26.

134 'Period Costume Orange and Lavender Sellers', in *Festival Gardens: Photo-Memories*, fig. 15.

site at the South Bank and the Pleasure Gardens at Battersea; although both were meant to be entertaining, at Battersea visitors could let off steam, its purpose was fun. Or, more precisely, as the chief designer at Battersea, James Gardner, described it: 'elegant fun', an organized and licensed excess, a momentary expansion of pleasure that was still responsible and benign.[32]

Battersea was all the fun of the fair, but it was not to be described as a fair. On a visit to Battersea Borough Council in 1950, Sir Henry French, who was then chairman of Festival Gardens Ltd, pleaded: 'Please don't call the whole scheme a funfair or it will break my heart.'[33] There was a funfair on the site complete with a Big Dipper, but the objective at Battersea was something more complex than Coney Island; it was the post-war version of Vauxhall and Cremorne. This was a lofty ambition for a very run-down part of the metropolis; if the Festival of Britain had provided 'the occasion for a national spring-cleaning', then Battersea also definitely needed a tidy-up.[34] The South Bank Festival had been built on a bombsite, but post-war Battersea was not much more. The area had seen its greatest expansion during the nineteenth century, when the railways had created a meteoric growth, and Battersea Park, opened in 1858, was an oasis in the midst of suburban streets and working-class terraces.[35] As the population outgrew available housing, the area became notorious for overcrowding, and by the 1930s had

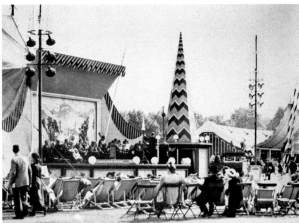

135 'The Guinness Clock', in *Festival Gardens: Photo-Memories*, fig. 10.

136 'The Lakeside Stage', in *Festival Gardens: Photo-Memories*, fig. 6.

a density of 73.8 persons per acre compared to 58.7 for the County of London as a whole. The housing shortage was massively exacerbated by significant bomb damage during the war, and by 1945 the council was faced with a serious housing problem, which it tried to address by building prefabs and gradually replacing them with permanent homes; the pace of rehousing was, however, extremely slow and the area had a large number of dreary and derelict streets. Battersea also had a long tradition of radical politics and activism, which was still part of the local council in 1951. Mayor Lane's father had been a builder and trade unionist, and the mayor himself was a local bricklayer and a Labour councillor.[36] It is in the interface between the local and the national that it is possible to see what the festival meant at ground level, what actually went into the dream of a modern pleasure garden.

In general terms the mayor supported the location of the gardens in Battersea Park; addressing a meeting of the Battersea and Wandsworth Industrial Group, however, he admitted that it was going to happen with or without his support: 'it was an accomplished fact.' He suggested that they should make the best of the situation and take the opportunity to brighten the place up with hanging baskets of flowers and window boxes, to show the visitors from home and around the world that Battersea 'is not such a bad place'. In 1950 the Borough Council Festival Committee was set up, and local papers reported that Battersea would be transformed for the festival and would become 'civilised'.[37] Days before the gates were due to open, the

217

men working on the site walked out again over bonus payments and the mayor visited them, blaming poor management for requesting last-minute alterations when the gardens were almost finished. Council archives and local newspapers reveal the impact that the gardens had on Battersea; whilst the railway executive was putting up colourful posters and the council was planting trees and converting bombsites into gardens, the official Souvenir Programme of local events conceded that there were more serious matters in Battersea than street parties. Nearly 5,000 applicants were still waiting to be found accommodation and with 'so many families remaining inadequately housed, feelings of frustration and despair are inevitable.'[38] Entire streets in the older Victorian parts of the borough needed to be demolished before reconstruction could begin.

The strain in Battersea between welcoming the Pleasure Gardens as an opportunity to improve the local environment and the far more pressing problems of housing shortages and overcrowding focusses the issues that faced the Festival of Britain at a national level. In July 1951 Battersea Borough Council voted thirty-six to thirteen in favour of the continuation of the Pleasure Gardens beyond the end of the festival; the increased volume of visitors brought new business to the area that would have a longer duration and greater benefit than a summer pleasure garden.[39] Battersea tried to look good that summer of 1951; they did everything to fit in with the mood of the festival and to avert their eyes from the lived realities of post-war London. There was a local Garden Festival and entrants were assured that each garden would be judged fairly and there would be no disadvantage to gardens affected by the 'falls of soot which occasionally decorate Battersea streets'.[40] Soot-fall was more of a problem in Battersea than in other parts of the country. There is a delightful colour drawing of an aerial view of the Battersea site by Bryan de Grineau, who made a number of drawings of the park that were published in the *Illustrated London News* Festival Number (fig. 137).[41] It shows the large crescent-shaped café, the lakes and fountains, the towers and pagodas, and in the distance the funfair with the Big Dipper. Squashed into the very top right hand corner of the image, no more than a sketchy grey silhouette, is the cause of the soot and the other reason why the area was famous: Battersea Power Station.

The power station was as much the reality of Battersea as the gardens. Built in two stages, between 1929–35 and 1937–55, construction on the power station had continued during the war and the fourth chimney was only finished in 1955 (fig. 138).[42] In 1948 electricity was nationalized and the power station came under the control of the British Electricity Authority.

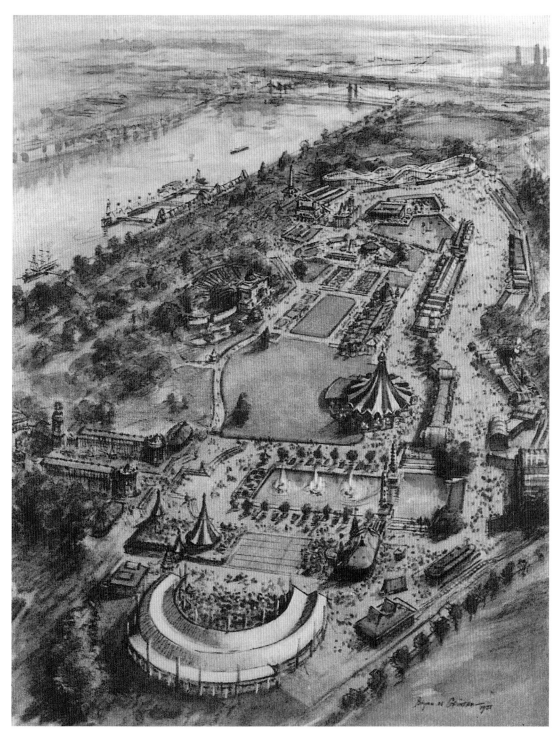

137　Bryan de Grineau, 'All the Fun of the Fair in Battersea Park', *Illustrated London News – Festival of Britain*,

12 May 1951, p. 1

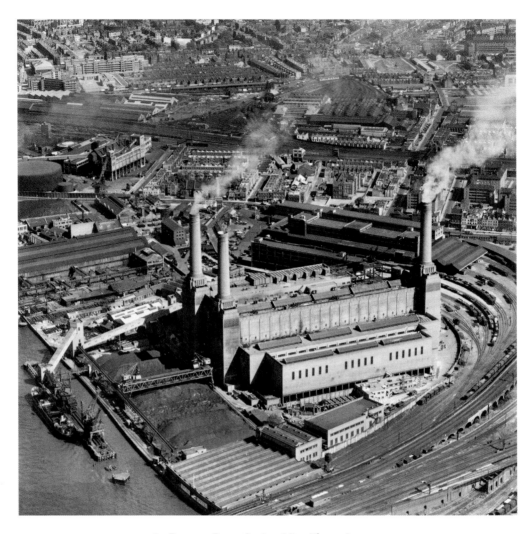

138 Battersea Power Station, Nine Elms, 5 June 1951.

In the late 1920s there had been mass objections to its central location and to the harm that would be caused to the health of the population and to surrounding nature by the smoke and fumes from the massive chimneys. Battersea Power Station is not far from the park, a fact that de Grineau is forced to acknowledge in his drawing of the site in the interests of topographical accuracy, but which the medium allows him to marginalize and transform into a matter of faint lines and shadows. The station could not be hidden, however. It was huge and filthy. The political cartoonist Joseph Lee regularly addressed the smoke damage caused by the station in

220

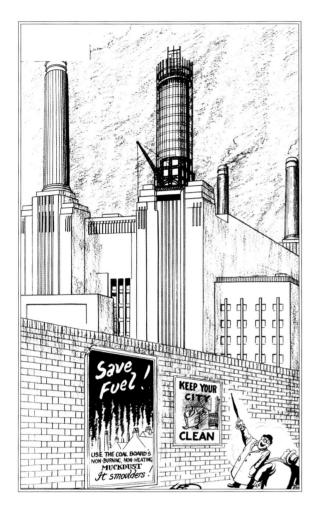

139 Joseph Lee, 'London Laughs: Battersea in Smog', *Evening News*, 7 October 1953, p. 5.

140 Joseph Lee, 'London Laughs: Legislation Promised', *Evening News*, 31 January 1955, p. 5.

his work for the London *Evening News*. In a cartoon from October 1953 as the fourth chimney was nearing completion, the huge geometric forms of the station dwarf the two men and make the nearby government posters calling on people to 'Save Fuel' and 'Keep Your City Clean' absurd (fig. 139). In January 1955 Lee celebrated the construction of the fourth chimney and the government's intention to introduce a clean air bill with a cartoon of a woman in her garden holding a newspaper with the headline, 'Anti-Smog Bill Soon – Penalties', as the chimneys pour black smoke into the air and on to her line of washing (fig. 140). Construc-

tion on the power station took place in Battersea at the same time as the gardens were built. No wonder local horticultural judges were told to ignore the soot. The gardens were bright, colourful and fun; they were an attempt to find something that had been lost; in the end, however, they disappeared back into the fog and smoke.

'Black Eyes & Lemonade': Unsophisticated, Popular and Mass

The colour of the Festival of Britain was citrus yellow; when people looked back at the summer of 1951, this was the colour that dominated their memories.[43] Perhaps the most intense expression of this festival colour was at the exhibition organized by Barbara Jones and Tom Ingram at the Whitechapel Art Gallery called 'Black Eyes & Lemonade'. As Jones explained in the guide to the exhibition, the title was derived from a poem by Thomas Moore 'which seems to express the vigour, sparkle, and colour of popular art ... "A Persian's heaven is easily made, / 'Tis but – black eyes and lemonade."'[44] With its vibrant yellow cover design, which was also used on the posters and advertising material, Jones uses colour, with all its associations of the East and the exotic, to express the vivacity of popular art (fig. 141). Yellow is a bold, strong colour, especially the hue chosen for the branding of 'Black Eyes & Lemonade'; it is eye-catching and stimulating and little wonder that the British Colour Council warned interior decorators to use Citrus Yellow with care.[45] Jones, however, did not use it with care; she used it vigorously and deliberately to make a point about vernacular culture and it seemed to work. The Director of the Whitechapel, Hugh Scrutton, reported: '[The poster] looks splendid on the Underground,' and the critic for the *Observer* commented that when the visitor enters the gallery, 'The room is a mass of strident and restless colour.'[46]

The exhibition, which ran from August to October 1951, was presented as a Festival of Britain event. It was preceded by another festival exhibition called 'East End 1851', which included models of characters drawn from Henry Mayhew and objects from Victorian homes in East London, and was followed by a display of paintings by the Victorian artist William Powell Frith. 'Black Eyes' was much more popular than its two neighbouring Victorian shows, however; it had extensive press coverage and the annual Gallery Report described it as a 'record-breaker in a big way'.[47] Barbara Jones was an artist, writer and curator. As a student in the 1930s she had studied mural painting at the Royal College of Art, and during the war she

141 Barbara Jones, *'Black Eyes & Lemonade': A Festival of Britain Exhibition of British Popular and Traditional Art* (London: Whitechapel Art Gallery, 1951), cover design.

had been part of the *Recording Britain* project, set up by Sir Kenneth Clark to celebrate national landscape and heritage. Jones had a taste for vernacular ways of life: aspects of culture such as fairground carousels, canal boat decoration, carving and knick-knacks that were neglected but significant expressions of popular sentiment and experience. She was involved in a number of elements at the Festival of Britain; she contributed murals to the 'Seaside Pavilion' at the South Bank, and she worked on the displays at Battersea alongside the chief designer, James Gardner. Jones made an important contribution to the festival look; she shared its whimsical reiteration of the quotidian, added to its colour, and extended its notion of cultural value.

The idea for the exhibition had come from the Society for Education in Art (hereafter SEA), and Barbara Jones was brought in to curate it by the Whitechapel Art Gallery. There were evidently deep and ongoing disagreements between the partners in the project, which surfaced in discussions about the title and simmered throughout the organization. The SEA had approached the Whitechapel with a proposal for an exhibition of art made by working people, to be called 'Popular Art'. Jones immediately wrote to the gallery saying that the suggested title was dull and proposing 'Black Eyes & Lemonade' to reflect the objects themselves, which were 'both bold and fizzy'. Scrutton supported Jones, sharing her aversion to the SEA's 'William Morris creed [which] is unrealistic, romantic and naif'.[48] The exhibition would not be about craft but would include machine-made contemporary objects and would be an exploration of popular taste. The disagreements continued: the gallery wished to exclude aesthetic judgement in the selection of objects, and the SEA objected to the display of a twentieth-century period room, which was withdrawn. The incompatibility of the different visions for the exhibition was openly acknowledged in the gallery's report on the show, which stated simply: 'It seems legitimate at this stage to reveal that this exhibition was attended by rather more than the usual quota of disagreement among the various organisers.'[49]

The authors of the report did not find it easy to describe the exhibition. The objects were listed under a number of categories, which, it was claimed, were arbitrarily chosen and free from 'bogus sociological implications'.[50] They included transport; toys, hobbies and pets; food; souvenirs; religion; birth, marriage and death; and so on. The exhibits were a diverse miscellany of the rural and the industrial, the historical and the contemporary, the familiar and the frankly bizarre. A model of Dunstable Church made from 3,862 (and a half) matchsticks, a St Paul's Cathedral made in icing sugar by an RAF officer, an advertising lemon (fig. 142), a tiled fireplace made in 1951 in the form of an Airedale dog (fig. 143), fireworks, Christmas

142 Idris advertising lemon, from 'Black Eyes & Lemonade'.

143 Tiled fireplace, from 'Black Eyes & Lemonade'.

crackers . . . For Jones, the exhibits represented a range of cultural value, from older objects that were beginning to accrue cultural significance to others before which 'the museum eye must be abandoned.' It was this category that unsettled and confused some of the more traditional critics; Jones, however, remained committed to their importance in setting out the history of British popular art and its compelling blend of 'vigour and humour' with 'horror and realism'.[51]

It is relatively straightforward to list the objects in 'Black Eyes & Lemonade' and obtain a sense of the gallimaufry of colourful everyday objects displayed in the Whitechapel galleries and to admire the feat of innovative curatorship involved in its creation. It is more important, however, to consider not so much what was *in it* but what it was *about*. One of the main objectives of the exhibition was to demonstrate to a nation that considered itself inexpressive and unartistic the vigour and brilliance (Jones would prefer sparkle or fizz) of its popular culture.

In these terms it is easy to see 'Black Eyes' as a Festival of Britain event; it sits well within the celebration of quirky national character on show at 'The Lion and the Unicorn' pavilion and at the Pleasure Gardens in Battersea. It is also about and part of a wider debate concerning culture, class and national identity that took shape in the interwar years and took on great political and social significance in the post-war period. Was culture an authentic expression of particular kinds of domestic identity, and, if so, did it need protection from the new, unfamiliar cultural forms that were exerting commercial pressure on the post-war generation? Had the war protected these traditional forms of culture or exposed the nation to the diluted images and objects of mass production?

The central claim of 'Black Eyes & Lemonade' was that British popular culture was a living tradition, demonstrated by its diverse and colourful idiosyncrasy rather than by its tastefulness or beauty. Many art critics were not equipped or prepared to find a way past the apparent ugliness of the objects. Writing in *Punch*, the art historian William Gaunt described the show as 'a chamber of horrors', while Marxist critic John Berger conceded that the exhibition was 'worth a visit' but could see neither aesthetic nor social value in the most recent commercial objects: 'The argument that these things are enjoyed ignores the fact that industrial capitalism has now destroyed the standards of Popular Taste and substituted for them standards of Gentility, Bogus-originality and competitive cultural Smartness.' Several reviews wrote about the Whitechapel exhibition alongside 'Ten Decades of British Taste', a fine art show organized by the Institute of Contemporary Arts. Together they challenged assumptions concerning artistic taste and popularity, and for some, like the art critic and broadcaster Eric Newton, the authenticity of vernacular culture raised it above the kind of high art that pandered to popular taste: 'The shapes, colours and rhythms they evolve are as inevitable as evolution itself. Here is no pandering to a given level of taste, for there is no question of taste . . . It is usually robust, almost always ornate, often silly, never insincere.'[52] Sincerity, authenticity, vigour substituted for artistic merit and aesthetic taste; behind all of this, however, was something else, a sense of loss, a feeling that the objects in 'Black Eyes' represented a culture that was disappearing.

Jones herself had a more nuanced appreciation of the 'popular'. In *The Unsophisticated Arts*, a book published in 1951 by the Architectural Press to coincide with the Whitechapel exhibition, she differentiated folk arts (handicrafts) from vernacular arts (machine-made) and recognized that the crude, bright forms of toy theatres, ventriloquists' dummies or shop signs shared a capacity to disturb: 'Popular arts have certain characteristics. They are complex, unsubtle,

144 Barbara Jones, *The Unsophisticated Arts* (London: Architectural Press, 1951), cover design.

145 Barbara Jones, *Mr George Burchett at Work*, 1950, as reproduced in *The Unsophisticated Arts* (London: Architectural Press, 1951), p. 111.

often impermanent, they lean to disquiet, the baroque and sometimes terror.' In the paper, cloth and dust of 'unsophisticated arts', Jones discovered a patina of age and unpleasant decay, a 'nice rich debased baroque' that was as far removed as possible from the streamlined Scandinavian modern design of the Festival of Britain.[53] The contemporary, clean, restrained South Bank style was not Barbara Jones's festival; there is an undercurrent to her work in this period that is distinctly anti-festival. The cover of *The Unsophisticated Arts* takes the form of a crudely drawn torso of a man with Jones's name and the title tattooed on his body, along with other popular designs. Jones devotes a chapter of the book to 'Tattooing', including a reproduction of her painting of the interior of George Burchett's tattoo parlour, which was demolished during the construction of the South Bank site (figs 144 and 145).[54] Items from Burchett's shop were

displayed in 'Black Eyes & Lemonade', testimony to a form of vernacular culture that had been swept away by the festival's own version of the popular.

In developing this notion of popular art and disseminating it through her writing and curating, Jones was drawing on a longer history of cultural ethnography that had emerged in Britain in the interwar years. In January 1937 Tom Harrisson, Humphrey Jennings and Charles Madge had written to the *New Statesman and Nation* announcing the creation of Mass Observation, defining their interests as 'the aspidistra cult . . . Beards, armpits, eyebrows . . . the dirty joke . . . Funerals and undertakers'.[55] It reads like a list of exhibits at 'Black Eyes & Lemonade', and if it can be called an aesthetic, then Jones and Mass Observation share the same taste. From 1941 *The Saturday Book*, an annual illustrated miscellany of life during and after the Second World War, often included items on Toby jugs, carved doors and fairground decoration in an eclectic mix of essays and images. The photographer Edwin Smith contributed work to *The Saturday Book* and was acknowledged in the credits of *The Unsophisticated Arts* (fig. 146).[56] Jones clearly comes out of this approach to everyday culture; what makes 'Black Eyes & Lemonade' so interesting and distinctive, however, is its place within the Festival of Britain moment. Whilst appearing to sit happily within the festival's celebration of national whimsy, its citrus yellow has a darker side and speaks of cultural loss and social class in ways that can be seen as anti-jazz, anti-streamline, anti-festival.

The conflicts over the original concepts of the exhibition were profound and deeply felt; it was not just a question of preferring different titles but a matter of widely divergent beliefs regarding culture and society. In the years following the war and throughout the 1950s, 'culture' was politicized and the Left 'revival' in these years was, in part, focussed on reconceptualizing culture and using it as a way of understanding and defining British class and society.[57] Publications such as E. P. Thompson's *William Morris: Romantic to Revolutionary* (1955), Richard Hoggart's *Uses of Literacy* (1957) and Raymond Williams's *Culture and Society 1780–1950* (1958), along with the recently reorganized *New Left Review*, argued for the importance of cultural politics and of cultural forms, as distinct from economic, in the formation of class and identity. The naming of this cultural formation mattered and was needed to define and encapsulate the new socialist understanding of culture and class. Where Jones's colourful jamboree had celebrated the cultural expression of a vaguely defined 'popular', the debates on the Left in the later 1950s sought to open debates about the role of culture in British society and to formulate a politics of culture.

146 Edwin Smith, 'Fairground Ride, Hampstead, London', 1937.

Richard Hoggart's anthropological account of the changes in working-class culture in the north of England since the interwar period traces the destruction of traditional cultural forms through the emergence of a new mass culture. *The Uses of Literacy* is often nostalgic, even sentimental, in its evocation of the richness of the 'old ways' and of dull, grey, working-class neighbourhoods that are nevertheless organically whole and 'for the most part, comforting'.[58] Hoggart creates a moving and detailed world of working-class culture and entertainment that draws on his own experiences and shares many of the qualities celebrated by Barbara Jones. He describes the cultural taste of these pre-war communities as 'a sprawling, highly-ornamental, rococo extravagance. It loves what might be called ... the 'baroque' ... It loves the cornucopia, all that is generous and sprawling, that suggests splendour and wealth by sheer abundance and lavishness of colour. It loves the East, because the East is exotic and elaborate.'[59] This reads like a summary of 'Black Eyes & Lemonade', although Hoggart's sense of loss and of a dying culture

is much stronger than for Jones. In the second part of *The Uses of Literacy*, Hoggart examines the aspects of contemporary life that are changing working-class culture, creating 'an empty *ersatz* experience of wonder' and a world in which style is valued over content. He describes the modern 'streamlining' of culture, which eradicates the traditional valences and expressions of working-class leisure, producing instead a 'mass' culture that is devoid of moral capital and unscrupulous. In spite of the persistence of older attitudes, traditional cultural forms are being systematically replaced by 'faceless' mass culture, and although the working classes are now 'better off' and have improved access to education and consumer goods, the changes have been detrimental to working-class culture and identity. Hoggart sees the real values of working-class culture being replaced by the superficial and glossy world of mass culture, advertising and commodification; the deep baroque colour of the old ways replaced by the plastic, candy floss world of contemporary cultural seduction.[60]

In *Culture and Society* Raymond Williams traces the history of the idea of culture from the Industrial Revolution to the present, using culture to access and interpret 'thoughts and feelings' within English society. He advocates a concept of 'common culture' as a form of collective cultural engagement in which 'the selection is freely and commonly made and re-made' and which embraces respect for the natural environment. Williams later explained that his motivation for writing *Culture and Society* 'was oppositional – to counter the appropriation of a long line of thinking about culture to what were by now decisively reactionary positions'.[61] 'Common culture' was thus distinct from 'popular culture' in terms of its socialist framing and, in Williams's case, its roots in the environmentalist politics of the Campaign for Nuclear Disarmament (hereafter CND). In April 1958 the CND protest march left Trafalgar Square for Aldermaston in Berkshire, the location of the Atomic Weapons Research Establishment. Fog was no longer the nemesis of industrial nations; a far more menacing and invisible threat was presented by nuclear weapons, and Williams compared the dominant approaches to culture and society since the eighteenth century to attempts to 'master' the natural world: 'We are learning, slowly, to attend to our environment as a whole, and to draw our values from that whole, and not from its fragmented parts, where a quick success can bring long waste.'[62]

Williams and Hoggart share the conviction that culture is a rich and varied expression of individual and class identity and that contemporary commercial culture is dissipating this relationship. Through concepts such as 'popular culture', 'mass culture' and 'common culture', post-war intellectuals opened up debates about the historical relationship of culture and society

and its present, beleaguered condition. In the same years that Hoggart and Williams were for-mulating their critiques of contemporary mass culture, a very different sensibility was taking shape in the creation of the Independent Group and their subsequent collaboration on the exhibition 'This Is Tomorrow' at the Whitechapel Art Gallery in 1956.[63] In a blatant rejection of the elegiac accounts of British popular and working-class culture, the Independent Group appropriated the forms and images of modern American mass culture, arguing that it was a product of consumer choice and was essentially democratic. In an article entitled 'The Arts and the Mass Media' published in *Architectural Design* in 1958, Lawrence Alloway described the radical nature of the new culture. Alloway was an art critic and curator and had been a leading figure in the Independent Group; in 1955 he was appointed Assistant Director of the Institute of Contemporary Arts, from where he continued to promote the Independent Group's concept of 'popular culture' and mass communication through lectures and exhibitions. In his 1958 article Alloway argued that elite aesthetic criteria were unable to respond to the new forms of mass culture: 'It is impossible to see them clearly within a code of aesthetics associated with minori-ties with pastoral and upper-class ideas because mass art is urban and democratic.'[64] Technology was bringing about changes in the forms of popular art that were sudden and revolution-ary: 'Colour TV, the improvements in colour printing . . . all are part of the constant technical improvements in the channels of mass communication'; even so, the icons of contemporary culture – film stars, advertisements, pin-ups – were really nothing more than a 'mass-produced folk art' addressed to a great global audience.[65] Gone was the understanding of popular culture as an expression of national identity; for Alloway the power of mass culture was its relationship to and expression of a new multinational audience. These were consumers who did not need to be educated by the British Colour Council and trained in the unruly ways of colour because they were already discerning and powerful; in a world of Cinemascope and Vista Vision, in the era of electronics and an 'expanding frame' of culture, the popular arts had become 'pop art'.

An Art of a Grey Climate

In *The Black Atlantic* (1993), Paul Gilroy proposes a new approach to cultural history and modernity based on the movement of people, objects and ideas across the spaces between Europe, America, Africa and the Caribbean.[66] Rather than studying the creation and cultures

of homogeneous nation states, he argues, powerfully and convincingly, that modernity can be traced differently through a study of the middle passage, through a history of the migrations and journeys made by the African diaspora into the western hemisphere. An account of post-war British visual culture needs to pay attention to Gilroy's thesis. For too long, the period from the end of the war to the beginning of the 1960s has been seen in terms of the gradual and uneven modernization of the nation, a fragile period of economic growth, social prosperity and consensus politics that is mirrored in its faltering attempts at cultural expression. Neo-romanticism gives way to a moment of realism and hesitant attempts at abstraction that, in turn, are eclipsed by the brash interventions of Pop Art. No matter how this art history is moderated or revised, its conclusions will essentially be the same unless the impact of these transnational movements of people and intercultural relations are made a formative part of the narrative. Whilst Britain, in this period, fostered the vision of a stable national identity and belonging that extended to the Commonwealth as a benign 'family of nations', it was undergoing significant social and cultural transformation through the growing movements of people between nations and across the 'Black Atlantic'. This provides a way of seeing and making sense of the discussions in the post-war years of cultural atmosphere and the tone of national colour. The discourses of greyscale and colour represent one kind of response to the specific conditions of migration and modernity in post-imperial Britain.

In late 1950 the painter and illustrator John Minton became part of the post-war movement of people across the Black Atlantic; travelling in the opposite direction from the *Windrush* migrants, Minton, an outsider within mainstream British society, left England and made the two-week boat trip to Kingston, Jamaica. During the war Minton's artistic roots in the realist aesthetics of Neo-romanticism provided him with an effective visual language for representing the ruined urban landscape.[67] Unlike other Neo-romantic painters such as John Piper and Graham Sutherland, Minton served in the armed forces for two years until he was invalided out of the army in 1943. In 1941, shortly after he lost his claim to be a conscientious objector and was on the point of being conscripted, he produced a suite of paintings and drawings of blitzed landscapes that combine elements of realism and fantasy and provide the setting for Minton to explore his homosexual identity and desire. In paintings such as *Blitzed City with Self-Portrait*, he uses a limited palette of greys and blues to create a dream-like cityscape of bombed buildings and ruined streets (fig. 147). In the foreground a young man leans against a broken pillar of bricks; his clothes and appearance are unkempt, his shirt is unbuttoned and his

147 John Minton, *Blitzed City with Self-Portrait*, 1941, oil on board, 30.5 × 40 cm.
Imperial War Museums, London.

belt roughly fastened. His expression is melancholic and dreamlike as he stands and waits. As previously seen, bombsites were associated both during and after the war with a wide range of illicit practices from the black market dealings of spivs to casual sexual encounters, crime and murder; in the years of housing shortages following the war, bombsites were also believed to provide shelter for migrants from Africa and the Caribbean. Minton evidently found in the shattered and desocialized zone of the bombsite a space for sexual fantasy and liberation; his

biographer, Frances Spalding, quotes a letter from 1 June 1943 in which he refers to his wish to stop being seen as 'a nice boy' and his desire to have sex with 'anyone that would have me'.[68] The grey, shadowy wartime world of the blackout, bomb ruins and docks offered Minton the perfect setting for both the physical realities and psychic fantasies of art and sex.

Perhaps Minton felt less free and less hidden in the bombsites of the post-war city and the new Labour ethics of reform, rationing and recovery because in 1950 he left and went in search of the colour of Jamaica. Just as migrants had described their first visual impressions of the coastline of England, so Minton was later to write in an article published in *Vogue* about his first sight of Jamaica: 'The colour of Jamaican landscape is that of coloured inks, of over-ripe fruit, acid lemon yellows, magentas, viridians, sharp like a discord.'[69] Minton discovered a peculiar palette of strident, putrid colours; harsh hues, the colours of rotting nature. Caribbean colour, he declared, was inflected by economic, social and political conditions; Minton, the tourist, was unravelling the tourist fantasy through a combination of realism and melancholy. First impressions of Kingston were: 'The town stretch[ing] back from the waterfront in char-acterless disorder, steamy and depressing, symptomatic of the worst aspects of the island. Here seethe the conflicts of race and politics.' Beauty and colour could be found inland and on the north coast; Minton, however, could not, would not, allow himself to be seduced by a tropical fantasy and saw instead an island suffering unemployment and poverty, the consequences of 'the crumbling of a way of colonial life which is forever past'. So Minton returned to England from where he continued to represent the Jamaican landscape and could indulge a more soothing and nostalgic vision of the island; he concluded his article with a Jamaican picture seen through the filter of a different 'structure of feeling': 'remembering in the icy January London snow, the kindness and hospitality, the warm golden days of the seashore, the strange haunting landscape and the island's sadness.'[70]

In 1951, as part of the Festival of Britain, the Arts Council organized an exhibition of specially commissioned contemporary art, 'Sixty Paintings for '51', which included Minton's *Jamaican Landscape*, a painting of a banana plantation with four figures (fig. 148).[71] On the left, stylized branches and leaves create an overlapping pattern of shapes and colours that provides the setting for the figures who are, perhaps, plantation workers. Is it fanciful to observe a mood of restraint in this canvas – something subdued that resists assimilation into the British fantasy of exotic Caribbean colour that prevailed in this period and that found its way into television variety programmes such as 'Port Calypso'?[72] Minton existed on the margins of mainstream

148 John Minton, *Jamaican Landscape*, 1951, oil on canvas, as reproduced in Arts Council, *Sixty Paintings for '51* (London: Arts Council, 1951), fig. 5.

British culture; he made the journey to Jamaica, where he penetrated the myth of a happy, sunny island and discovered a different kind of landscape, a different range of colours. And when he returned to London and the bombsites, he made equivocal images of the Jamaican scene that do not sit easily with the fantasy of a distant land untouched either by history or by modernity. The Arts Council exhibition toured a number of regional galleries and finally came to London in June 1951; of the fifty-four paintings included, only Minton contributed an image of the new Commonwealth and brought the colonies home to the festival. Also in the exhibition was a *Portrait Group* of the teaching staff at the Royal College of Art by Rodrigo Moynihan, who was Professor of Painting at the College (fig. 149). Minton is the figure seated on the far left; with his distinctive thin face and shock of dark hair, he is detached from the group and, distracted from the book on his lap, he stares into the distance. In his reminiscences of Jamaica he recalled 'a disquiet that is potent and nameless'; with greater political insight, it might have been possible to name this disquiet; in the group portrait, however, he remains haunted by its unsettling and unsettled images.

149 Rodrigo Moynihan, *Portrait Group*, 1951, oil on canvas, 213.4 × 334.6 cm. Tate, London.

Intercultural relations and the movements and journeys of artists in the post-war years disrupt the conservative narrative of the white nation elaborated by the visual arts during and after the Festival of Britain. Amongst the migrants from Africa, Asia and the Caribbean in the years following 1948 were artists such as Francis Newton Souza, who came to London from India in 1949, and Aubrey Williams, who travelled to Britain from Guyana in 1952 (fig. 150).[73] Both men had been involved in independence movements in their countries of birth and brought these political and cultural dimensions with them as they sought to develop their careers, exhibit their work and 'get a break' within the European art world. Some had already completed their art education; others studied in Britain, such as Frank Bowling, who came to London from Guyana in 1950 at the age of fifteen and later attended Chelsea School of Art and the Royal College of Art. These artists of African and Asian heritage joined an existing community of artists such as Denis Bowen, who came to Britain from South Africa in the 1920s, and Uzo Egonu, who moved from Nigeria to England in 1945 when he was thirteen and enrolled at Camberwell School of Arts in his late teens.[74] As individuals and as networked

150 Aubrey Williams, *Death and the Conquistador*, 1959, oil on canvas, 83.5 × 133.8 cm. Tate, London.

artists, they were part of the post-war art world in Britain and had a significant and subversive impact on what Stuart Hall has referred to as 'our island story'.[75]

For many, although not all, of the post-colonial artists in Britain, the artistic language of modernism seemed to offer a transnational aesthetic and a global sensibility that echoed the progressive politics of independence and decolonization with which they had been or continued to be involved. Where figurative art might be seen within the contours of a narrow nationalist or even regionalist practice, abstraction and the formal experimentation associated with modernism in the 1950s allowed a more expansive and varied engagement by artists from a range of cultural backgrounds. One of the key exhibition spaces for international modernist artists was created by the New Vision Group, established by Denis Bowen in 1951.[76] Dedicated to the promotion of non-figurative and international artists, the group hosted exhibitions that included a number of artists from Commonwealth countries in their main gallery, the New Vision Centre Gallery, and in galleries around west London. Other organizations such as the Caribbean Artists Movement also provided a platform for artists such as Aubrey Williams to

exchange ideas and offer support. Whilst London in the 1950s clearly offered opportunities for black and Asian diaspora artists, historians such as Eddie Chambers and Leon Wainwright have also considered the ways in which British art critics tried to define their work in terms of a common aesthetic derived from their 'exotic origins' and how they were subsequently marginalized by the art world. It is a history that is still being addressed by Caribbean, African and Asian artists today. Commonwealth artists coming to Britain in the 1940s and 1950s gradually transformed the culture of the metropolis; this was not the outcome of a unified artistic movement or a common artistic language, but was simply because they were there and wanted to be successful artists.[77]

For artists in the 1950s who were engaged with international and modernist art, the display of Abstract Expressionism in the 'Modern Art in the United States' exhibition at the Tate Gallery in 1956 was a clear demonstration of the power of this new form of abstraction. Rather than being seen as a national style, Abstract Expressionism was regarded as bold, expansive and global, as a way of breaking with the restrained colour range and melancholic aesthetics that had come to characterize British art in the culturally isolated wartime years. For supporters of abstraction, Neo-romanticism was the artistic whipping-post, the dreary monochrome figuration of a tiny island. In his introduction to an exhibition of the work of 'Nine Abstract Artists' in 1954, Lawrence Alloway positioned British abstraction in relation to the international movement of the interwar period, which had been smothered by figurative art during the war: 'Both the loyal men and the dreamy boys developed an imagery of landscape which implied a kind of dark, meditative patriotism. The sceptred isle became an armoured womb.' The revival of the principles of the international movement in the 1950s would liberate the colour and forms that had 'disappeared under the foliage and chiaroscuro of the romantics'.[78] Within the terms of post-war British modernism, Neo-romanticism was dark, shadowy, claustrophobic and moribund; the lessons of colour needed to be relearned by art students as well as citizens, and new experimental chromatic curricula were developed and taught by Richard Hamilton during his time at Newcastle University and by Tom Hudson at Cardiff College of Art.

For the painter, writer and curator Patrick Heron, colour was the fundamental language of abstraction, creating the distinctive physical reality of painting and its spatial organization. From the late 1940s, Heron was a passionate advocate of colour painting and waged war, in print and on canvas, on the dull poetic and literary atmosphere of British artists associated with Neo-romanticism and the Euston Road School. One of the earliest accounts of his under-

151 Patrick Heron, *Scarlet, Lemon and Ultramarine: March 1957*, 1957, oil on canvas, 61 × 182.9 cm. Tate, London.

standing of the spatial qualities of colour was in his catalogue introduction to the exhibition 'Space in Colour', which he organized at the Hanover Gallery, London, in 1953: 'Colour is the utterly indispensable means for realising the various species of pictorial space. Mere perspectival drawing, mere chiaroscuro of monochromatic tone – these may render illusionistic verisimilitude of reality: but it is a dead version; they cannot produce that fully created thing . . . which I call pictorial space.'[79] From the middle of the 1950s Heron worked on abstract canvases in which he was able to explore the materiality of the paint surface and the formal properties of colour using increasingly simplified shapes, little more than horizontal and vertical bands, which allowed even greater concentration on the matter of colour. In *Scarlet, Lemon and Ultramarine: March 1957*, bands of vertical colour of varying flatness and density are arranged across a horizontal canvas (fig. 151). Of course, it is logical that Heron should explore these ideas on the canvas through the three primary colours, condensing pictorial form into the most rudimentary language of colour; as we have seen, however, colour is never pure or simple and is seldom restrained within a single discursive field. Red taffeta under a tweed skirt: Heron may be seen as the hidden face of international colour below the tweedy insularity of Neo-romanticism; art, pictorial form, is drawn into the post-war discourse of colour and nation.

Throughout his artistic career, Heron maintained a sustained critique of the 'prevailing pictorial climate' of British art. Never in the language of art criticism had pictorial climate and meteorological climate been brought more closely together; take, for example, his bruising dis-

missal of the work of Paul Nash: 'Colour was, of course, by far his weakest point . . . If a master of oil paint wants to communicate a certain grey-blue – the wistful no-colour of an English November tea-time – he will know how to express the wan, grey tone without resorting literally to wan, grey paint . . . there should never be *actual* greyness, actual dullness of colour as in Nash's biscuit landscapes, with their opaque mud.'[80] For Heron it is as though Nash has dipped his brushes in the national weather, the national atmosphere, and spread its insular greyness over his canvases. Elsewhere, Heron criticized Ben Nicholson for his diluted 'English' use of colour. True chromatic art is luminous and vibrant; it can be discovered in Cornwall, where Heron painted his later abstract canvases, but it appears impossible to realize in the industrial and urban landscapes of 1950s Britain.[81]

British colour was prim and tweedy; for Heron the lack of colour consciousness was nothing less than a failure of national character. A reluctance or inability to talk about the palpable reality of an art work had led to a national obsession with meaning and mood and a preference for two styles of art: 'the "realist" (however drab, repetitive or retrogressive); and the romantic-illustrational (however expressionist, surrealist, or whimsical)'.[82] The commitment to an ideal of pure, vivid colour was shared across many forms of visual media in the post-war period; it guided the advertisers and fed the dreams of painters and yet it seemed antithetical to British taste, as Adrian Cornwell-Clyne observed in his survey of colour cinematography: 'There does seem to be a marked antipathy to excessive use of vivid colour . . . which may be due to a national liking for the restrained and rather sad tones typical of the British sentiment for colour during the last hundred years.'[83]

Aesthetic debates about colour can be understood alongside and as part of the social and political debates on race and nation in the post-war period; they share a language and, frequently, a set of concerns, a way of seeing the world in terms of greyscale and brilliance of hue that can be tracked across ideas, practices, events and movements. This is not to reduce the arts to a reflection of these other social elements, but to understand the striking convergence of expression at this particular moment in the history of post-war Britain. By the early 1960s the pressure to introduce restrictions on immigration had become irresistible. The race riots in Nottingham and Notting Hill in 1958 had led to renewed calls for changes to the 1948 Act, claiming that the existing regulations were inadequate and obsolete and that the 'British public' supported greater controls on immigration. At the beginning of the 1960s, news media continued to report the uncontrollable numbers, the unstoppable flow, the flood of immigrants

into Britain, and in 1962 the Commonwealth Immigrants Act was passed with a majority of eighty-four votes.[84] The expansive definition of citizenship introduced in 1948 was curtailed, and only citizens with British-based passports could enjoy full rights of citizenship; all British citizens outside the United Kingdom had to apply for employment vouchers, and limits were imposed on unskilled work permits. It was acknowledged that the permit scheme would prejudice poorer workers from the colonies; in effect, the legislation would halt immigration from Africa, the Caribbean and Asia – it was a legal enactment of the colour bar.

These were the circumstances in which Patrick Heron wrote about his latest paintings for an exhibition held in Zurich in January 1963; reiterating his commitment to colour as form he stated: 'colour is now the only direction in which painting can travel. Painting still has a continent left to explore in the direction of colour.'[85] One can wonder at the choice of metaphor, the sense that colour is still a continent, 'Kenya Red' perhaps, and at the credibility or probity in celebrating the endless possibilities of colour at the moment when epidermal colour was being used as the basis for curbing immigration. At the same time, however, the '1st Commonwealth Biennale of Abstract Art' was held at the Commonwealth Institute in London. Including work by artists from all over the Commonwealth, including Africa, Asia and the Caribbean, as the catalogue claimed, it demonstrated that abstract art offered a common aesthetic language across 'widely different cultural backgrounds ... [and] religious and racial origins'.[86] Colour in the 1950s, the apparently irresistible convergence of visual culture, race, nation and post-colonialism; any attempt to separate these elements and to maintain them as discrete fields of practice is thwarted by the inevitable overlapping and interlocking of themes, images and language. Colour in the 1950s was determined by the weather; it was restrained and strangely diluted; it was joyful and vivid; it was global and expansive; it was attractive and seductive; it was political and lived in every sense of the word.

Part Three

Kitchen Sinks and Other Domestic Dramas

7

Bill and Betty Set Up Home

————————————

The Tones of Post-War Domestic Life

In June 1952, Bill and Betty returned from honeymoon and went to the Whitechapel Art Gallery. Bill and Betty were the names given to a fictional couple in the form of two manne-quins, dressed in their 'coming-home-from-honeymoon clothes', who stood at the entrance to an exhibition called 'For Bill and Betty; Or Setting Up Home'.[1] The gallery had considered other titles, including 'Moneysworth', 'Double or Quits', 'Good Buy Mr Chippendale', 'For Mary and John' and 'Home's Best'; in the end, however, the plain, alliterative names had seemed best, along with the subtitle explaining the theme of the display.[2] The exhibition was organized by the gallery, with the assistance of the Council of Industrial Design, and in collaboration with Oxford House in Bethnal Green, which was established in 1822 for religious, social and educa-tional work in the East End of London. By the 1950s colour education and home decoration had become part of its social mission and its programme of community service.

'For Bill and Betty' was arranged as a sequence of eight domestic interiors, furnished with objects that could be bought in local shops in the Whitechapel area. It was addressed to 'Bill and

Betty' and to all newly married couples trying to set up home on a limited budget, showing them how they could use colour and design principles to set up their home and begin their lives together in the best and most tasteful way possible. As a form of display, furnished rooms had been popularized through their use in the *Daily Mail* 'Ideal Home Exhibitions', which had been held in London since 1908. Although they did not take place between 1940 and 1946, they resumed in 1947, with their show houses and room sets offering visitors entertainment and spectacle as well as an education in home improvement and post-war recovery. In September 1946 the 'Britain Can Make It' exhibition at the Victoria and Albert Museum, organized to promote British industrial design and manufacture, also included twenty-four furnished rooms, representing a range of room types for a variety of families ranging from coal miners to company directors. The room sets gave visitors the opportunity to project a desired lifestyle and a voyeuristic peak into the domestic lives of those above and below their own economic and social class. According to a Mass Observation survey, the furnished rooms had been the most popular element of the 'Britain Can Make It' display, with visitors comparing the rooms to film sets and showrooms.[3]

'For Bill and Betty' drew on this successful display format, beginning with an exterior view of an East End terraced house and continuing with a series of small furnished and decorated rooms, including a kitchen, a sitting-dining room and bedrooms (fig. 152). What differentiated the Whitechapel display from its precursors, however – what made it look and feel different – was its specific address to young working-class couples, with a local newspaper, the *Hackney Gazette*, describing it as a 'Show for Newly-Weds' and 'East London's Ideal Homes Exhibition'.[4] The exhibition was designed to be didactic and practical, with visitors invited to try out the exhibits, compare the prices and plan their homes on that basis. Moreover, the immediate post-war context of the exhibition was made explicit through the backdrop of an East End bombsite, installed at the end of the series of model rooms and providing the setting for a modest garden (fig. 153). *Country Life* described the backcloth as an 'authentic replica of any vacant lot, either bombed or just forgotten from which not all the random debris has been cleared away. Yet mostly by pot-planting and a few other ingenious devices, this bit of East London is made to bloom in a peculiarly lovely way.'[5] This was no ideal home exhibition; it was an ordinary home exhibition, a display that made do and drew on design principles to create a good enough East End home. The shift from the promotion of an ideal of domestic life to the support of the satisfactory and the everyday characterized post-war debates on many

152 Installation shot, 'For Bill and Betty', 1952.

aspects of the family home. It is a language that recurs in the following chapters and that was brought to bear in discussions of domestic space, motherhood and marriage.

The exhibition was opened by Britain's favourite young married couple, Richard and Sheila (Sim) Attenborough, whose happy marriage would later be celebrated in 1954 in the photo-graphic competition in *Picture Post*.[6] In his opening speech Richard Attenborough commented that the exhibition offered just the kind of help to newly-weds that he and his wife had needed when they had started life together. Bill and Betty, Richard and Sheila: the exhibition would help all newly-weds avoid what the catalogue described as 'the tragedy of the bad first-buy'.[7]

153 Installation shot, including bombed backdrop, 'For Bill and Betty', 1952.

This may sound now like laughable hyperbole; in the early 1950s, however, 'setting up home' was a serious business. There was more at stake than finding somewhere to live and moving in, nor was it simply a question of good taste and value for money. It was about a new start, and it carried the weight of the future of the nation. The economic, social and aesthetic project of reconstruction would be built on Bills and Bettys being able to create homes for a new post-war Britain that would be different and better than the past.

The catalogue essay was written in the form of a letter to Bill and Betty from the head of Oxford House, Alan Jarvis. Recommending good contemporary design, 'soundly constructed,

efficient and . . . cheap', he advised against furniture with 'ribbons and bows, the corsets and petticoats of our ancestors'. Furniture design could both secure the future happiness of a couple and it could break up a home; so Bill had been given 'a good big easy chair to relax in after work, and Betty, you got an easy chair without arms so you could sew in comfort.'[8] Jarvis had previously been a director of the Council of Industrial Design (hereafter COID), and the insistent and paternalistic tone of 'Bill and Betty', along with its belief in the power of design to transform all aspects of social life, were also features of the council in these years. The COID was established in 1944 to promote better design in British industry and to educate consumers; through exhibitions, guidebooks and manuals it would play a central role in the reconstruction of social and domestic life. It seems, moreover, that people did want to be shown how to make good design choices; the *Hackney Gazette* reported that attendance records at the gallery had been broken and that, due to public demand, the gallery would be holding late night openings on Thursdays. Jarvis also arranged visits for three groups of 100 school children each as part of Housing Week for Schools. The domestic interior was the starting point for a new post-war social world; 'For Bill and Betty' promoted taste as part of a broader discourse of civic and social responsibility, as a language that could be taught, learned and exercised in everyday life.[9]

Interior decoration was a prescribed combination of contemporary furniture and the correct use of colour. The catalogue for 'Bill and Betty' offered a range of guidelines regarding colour in the home: neither too many colours in one room nor too much of a single colour; go for 'safe' colours but avoid dullness. Colour was generally acknowledged to be the trickiest element of a domestic interior. Consumers seemed inhibited; all they needed, however, was knowledge and education, beginning with the housewife. In Margaret Llewellyn's *Colour and Pattern in your Home*, published in 1955 for the COID, the author observed: 'To-day we are indeed living in a new age – an age of colour and pattern, which is available to every one of us. Colour in the world to-day, in advertising, in shop windows, in display, and in textiles, is far brighter and gayer than that which our parents and grandparents knew.'[10] It was not surprising, therefore, that people did not yet know how to create colour schemes, and Llewellyn provided a number of uncoloured line drawings of rooms for the reader to colour in, as well as a list for further reading.

A break with the past and new beginnings were recurrent themes in post-war design manuals and guidebooks. In *Ideas for Your Home*, published in 1950, the council imagined an ideal context in which 'we can start clean, with a new house and money to furnish it.' Failing that, however, it advised: 'We must clear our minds of a clutter of ideas about interior decor-

ation that are not our own; they have come to us from the past, and put into practice today, they would suit neither the habits nor the fashion of our own time.'[11] The desire to start from scratch was not just an ambition for designing the home, it was also an aspiration for the modern family; the domestic life of the pre-war years needed to be remodelled, covered in new fabric and wallpapers, and reconfigured for the post-war world. Whilst the reality for many newly married couples in the years after the war was living with their parents and other relatives, or in rented rooms, the fantasy of 'setting up home' continued to be disseminated by the design experts and educators.

Bill and Betty, and Richard and Sheila, and Tony and Anne, the protagonists in the 1954 film *For Better For Worse*, directed by J. Lee Thompson. Tony is twenty-three and Anne is nineteen, and when she accepts his proposal of marriage it is expected that they will have to live with Anne's middle-class parents until Tony is able to secure a good living. Fiercely independent, however, they decide to set up home, renting a tiny, one-room flat. Returning after their honeymoon, the space becomes jam-packed with the old bulky pieces of furniture that Anne has brought from her family home. While Anne gives up her job and stays at home, she listens to radio programmes about furnishing rooms and making money at home, and in spite of a leaking ceiling and a blocked sink, they manage to survive and enjoy their first year of married life. Clearly not coming up to the standards of the COID, or even those of Bill and Betty, Tony and Anne represent the ordinary devoted couple who do the best they can, work with what they have got, and turn a rented room into a home.

Housing, Homes and Coal Fires

Housing was the first great problem of peacetime.[12] Neglect during the interwar years and wartime bomb damage had led to serious shortages in the housing stock, and the provision of new housing and the improvement of existing dwellings was an urgent economic, social and political issue. Buildings in cities were run down and decrepit and lacked the basic facilities required of a modern industrial nation; housing thus concentrated the debate between the squalor and inequalities of the Victorian past and the clean, modern homes of the future, between laissez-faire slums and planned New Towns. Its significance went far beyond the provision of dwellings, however. War had shattered families, physically, emotionally and psycho-

logically, and the home was necessarily the foundation of post-war social reconstruction and the restoration of family life. Home would repair the damage of war.

Planning for reconstruction began immediately after the major bombing attacks in 1941. Plans and legislation were produced throughout the 1940s, including John Forshaw and Patrick Abercrombie's 1943 *County of London Plan* and the 1944 Town and Country Planning Act, which became known as the 'Blitz and Blight' Act.[13] It was evident even during the war that any post-war government would have to address the provision of housing. The post-1945 Labour government aimed to provide a home for any family that needed one, and although impeded by shortages of labour and materials and the balance of payments crisis, in the years up to 1951 it built more than one million houses. Many of these buildings were erected on the outskirts of towns and villages and constructed from non-traditional materials, with steel frames and prefabricated parts. While the Ministry of Health had overall responsibility for housing until 1951, when it was replaced by the Ministry of Housing and Local Government, many local governments did not have planning departments and had to commission the work of designing and building post-war housing developments from private surveyors and architects, working from government handbooks with advice on the design and layout of estates.

Plans for housing that started out as radical visions of a new, modern society were frequently compromised by squeezed resources and political realities; the need for accommodation was so severe that larger scale ambitions had to take a back seat to the basic provision of shelter for families. There remained a strong sense, however, that housing was not enough, that it did not necessarily create the homes and families that were at the heart of social reconstruction. Within weeks of the end of the war and the surrender of Japan, British newspapers were lampooning the jerry-built, prefabricated houses that were being constructed by planning departments. Giles, cartoonist for the *Daily Express*, showed an aristocrat visiting a 'Prefabricated Housing Office', itself little more than a rough wooden shell, to be told by the designer: 'we haven't got around to designing a prefabricated castle yet.' In the background three identical, lightweight houses are carried off the assembly line (fig. 154).[14] Where housing suggested a kind of anonymous mass, home was particular and individualized; it was the object of emotional and psychic desire and was associated with memory and the past as much as with the modern and the new.[15] Whilst housing was a basic need, rebuilding the home was a priority for recovering social stability.

154 Giles [Ronald Carl], 'Sorry, Your Lordship – But We Haven't Got Round to Designing a Prefabricated Castle Yet', *Sunday Express*, 14 October 1945, p. 3.

In the years immediately following the war social workers and psychiatrists were agreed that British society was in a transitional stage and that the housing shortage was having a destructive effect on the lives of a generation. In a survey of 200 soldiers and their wives carried out between 1943 and 1946, Eliot Slater and Moya Woodside examined attitudes to marriage and concluded that the desire for a home was the most common reason for marriage and was of key importance to individual happiness. They found a huge disparity, however, between the fantasies of home and the material realities of post-war accommodation. Many couples were living with relations, or were renting rooms and flats in houses:

> We found attics, top floors and basements; rooms over shops, pubs and off-licences; bomb-damaged houses still unrepaired or partly repaired; unpainted cracking walls and ceilings; damp, draughts, and black-out arrangements permanently in position. The families who live in these homes had inadequate storage . . . inadequate washing facilities . . . Many had no furniture of their own . . . Others had to make do with bare half-furnished rooms, decked out with the few pathetic bits and pieces they had been able to collect.

These were the forms of post-war domestic life; while exhibitions created furnished room sets and manuals set out the 'rules' for good interior design, many were living in surroundings that belonged more to wartime than to peace and that were more suited to life in a Victorian city than the planned towns of the post-war world. With little privacy and shared facilities,

155 B. S. Townroe, 'Housing: London Shows How', photographed by Chris Ware, *Picture Post*, 22 January 1949, p. 7.

multi-occupancy houses were the reality for many who were 'setting up home', a situation that Slater and Woodside described as the 'tragedy of our era'.[16]

By the late 1940s a number of new council developments had been completed, which offered more space and better facilities. In January 1949 *Picture Post*, which reported regularly on the progress of reconstruction and the condition of British cities in the decade following the end of the war, carried an article titled 'Housing: London Shows How' about the new housing developments in Stepney in the East End (fig. 155). Comparing the old housing in the area to scenes from *Oliver Twist*, it assured its readers: 'The flats of 1949 are not the ugly tenements of Victorian days. They will be surrounded by playgrounds and railed-in gardens.'[17] It lists the facilities offered inside the accommodation, including a boiler in the kitchen, a

sun balcony, and living rooms with open fires. This was the shape of the future, with flats and communities that would not only address the chronic housing problems of the nineteenth century, but would also create functional, modern living and, most importantly, homes that would restore and renew.

Homes were also part of the Festival of Britain; they were an important chapter in its story of the nation. After leaving 'The Lion and the Unicorn' display, the recommended route continued to the 'Homes and Gardens' pavilion; here, history was jettisoned as the visitor followed 'the British people straight into their homes – the homes of the present time'.[18] Six groups of designers had been commissioned to work on six problems of design in the contemporary home, including the kitchen, the bed-sitting room, home entertainment and the parlour. Using furnished room sets, the pavilion reconstructed the lives of typical family members and, with a festival eye to practicality, 'Nowhere in this section are there any displays of non-existent "homes of the future" . . . for the moment, we are content to show how we are trying to solve [the problems] that face us here and now.'[19] Solutions to the problem of town planning were also on display at the festival 'Exhibition of Architecture' at Poplar: a living display of contemporary planning and architecture in the redevelopment of a bombed area of London. Houses, flats, a shopping centre and schools told the story of Britain's new towns which would rise 'from blitzed ruins and from the slums and chaotic planning of the past'.[20]

The importance to the Labour government of showcasing successes in housing and town planning at the Festival of Britain cannot be overstated. The election in 1945 had been won, in part, on the back of a promise to provide homes for all, and housing continued to be a key political platform in the General Election of 1951. With a narrow victory and a pledge to build 300,000 homes a year – an increase on the numbers achieved by Labour – it was clear to the new Conservative government that there would have to be a significant reallocation of resources and regulations if it was to meet this key target. As Minister of Housing, Harold Macmillan expanded private sector building and renting and reduced local authority housing targets, which he mediated through a new rhetoric of a 'property-owning democracy'. In 1954 building licence restrictions were lifted, and by the General Election of 1955 the Conservative party manifesto confirmed that it had exceeded its original 1951 pledge on housing.[21] As the locus of economic and political power, the foundation of social reconstruction and the bedrock of emotional and psychic well-being, the home permeated all aspects of public and private life in the post-war period. It defined the aspirations of peacetime Britain

and was the distinctive discourse of the period. Although housing was about material realities, it also existed through more abstract and intangible forms, in cultural expression and individual longing; it created the tones of post-war Britain. Whilst political parties struggled over quantities and numbers of homes built, the home was not about statistics; it was about the qualitative life of the period and its deep expression, what Raymond Williams has called its 'structure of feeling'.[22]

The Census of 1951 had introduced new questions relating to housing conditions, asking households whether they 'had exclusive use of, or shared with another household, or lacked entirely, piped water supply within the house, cooking stove or range, kitchen sink, water-closet, fixed bath'. In the General Report, published in 1958, it showed that just over half of the households of England and Wales had exclusive use of all of these facilities, and that there were significant regional differences.[23] It also recorded that between 1931 and 1951 the number of multi-occupancy households had decreased and that in 1951 only 14 per cent of households were sharing a dwelling with one or more households, although numbers were higher in Greater London.[24] With a rise in owner-occupation from 29 per cent to 43 per cent of households between 1951 and 1961, it seemed that the dream of a private domestic life was increasingly becoming a reality for people in Britain.[25] At the same time, however, the disjuncture between the social vision of nuclear families living in their own comfortable and well-equipped homes and the continued experience of the squalor of rented accommodation continued and intensified into the 1960s. The sleek, modern domestic lifestyle camouflaged a scandalous world of rented rooms occupied by migrants, the poor and the elderly: a Victorian world of crime and irregular existences that would prove a stubborn and resilient element of the post-war landscape.[26]

There is a fascinating oscillation in representations of home between notions of the modern, the new and a fresh start and nostalgia and the persistence of the past, which is encapsulated in debates about the place of the coal fire in the modern home. Although the open hearth, as a symbol of home and domestic comfort, has a very long history, it took on new and different meanings in the context of the Second World War and post-war campaigns for clean air. Just as home meant so much more than housing, so the value of a coal fire was about far more than the provision of heating; it represented the heart and soul of the family home, a place of reverie and memory. It was also dirty and inefficient and was as responsible for the polluted air of Britain as smoke from industrial chimneys. Coal was the material of Lewis Mumford's

Paleotechnic period, responsible for draining the world of colour and rendering it grey, brown and black, the hues of soot and cinders.[27]

One of the foremost domestic design questions was how to provide the cosy atmosphere of the coal fire economically and without pollution. Engineering companies advertised adapted grates and boilers that would heat homes cleanly and efficiently whilst retaining an open fire (fig. 156).[28] Here was a modern fire in a modern home: still using coal or coke but heating radiators and supplying hot water at the same time as providing a centrepiece for an uncluttered and comfortable living room. Ornaments on the mantelpiece, but not too many; coal in the fire 'that warms three other rooms'. Following the Great Fog of 1952 and the findings of the Beaver Report, clean heating was a priority for modern homes, and designers reworked the image of the open domestic fire so that it was compatible with the new furniture lines, abstract forms and restrained patterns of post-war progressive living (fig. 157). With the passing of the 1956 Clean Air Act and the introduction of smokeless zones, the race was on to sell new fuels and appliances to retailers and domestic consumers. Mr Therm, the cartoon mascot of the Gas Council since the 1930s, came into his own in the 1950s. The chirpy little gas-flame figure would put an end to fog, providing 'An open fire *but* no smoke' (fig. 158); a wise little planner, Mr Therm would protect the wealth and health of the nation and preserve its open hearth (fig. 159).

It may seem too esoteric or whimsical to suggest that Mr Therm is a symbol of post-war Britain, and yet he sits at the epicentre of a series of debates concerning reconstruction, the home and the family that began before the war and continued well into the second half of the twentieth century, and that defined what it meant to be a nation that was both traditional and forward looking. Since at least the beginning of the nineteenth century, when it was still possible to overlook the relationship between smoke and pollution, the hearth had been a symbol of comfort and prosperity. The coal fire was the heart of the family home and was the source of physical and spiritual sustenance; in the context of war the coal fire also stood for the defended nation.[29] In his 1941 essay 'England Your England', George Orwell evoked the nation in terms of its essential and everyday values: 'the pub, the football match, the back garden, the fireside and the "nice cup of tea"'.[30] In a similar vein, in *The Uses of Literacy*, Richard Hoggart mourned the loss of authentic, working-class culture and community symbolized by the family hearth: 'Warmth, to be "as snug as a bug in a rug", is of the first importance . . . a fire is shared and seen.'[31]

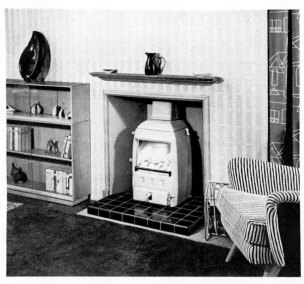

Start Getting Rid of Smog Now

The Beaver Report has indicated to all of us the urgent task of ending smog — by cutting out the black smoke that costs lives. Radiation's new smoke-consuming fire, the Parkray No. 2, will help effectively to beat the smog. It actually burns about 80% of the smoke ordinary fires discharge into the air—a big step towards cleansing the smoke polluted atmosphere of our cities.

From no more coke, coal or even nutty slack than is burnt in the ordinary open grate, the Parkray extracts enough heat to thoroughly warm quite a large room, and heat enough hot water for all the family's needs, and a towel rail or radiator.

How does it do it? Part of the secret is in the down draught fuel box. Another aid to comfort and fuel economy is the Radiation 'throat restrictor' which reduces heat wasting air changes by around ⅓. Yet another, is the constant flow towards the room of convected warm air. To these real advantages in efficiency

is added the convenience of gas ignition for trouble free fire lighting, and a shaker grate which dumps clinker and stones. The Parkray No. 2 opens up a new field for the contemporary treatment of the hearth. It offers the simplest method of convection heating.

It calls for the provision of a small recess — brick, stone, tiled or rendered in tinted cement. Why not provide it in your plans, and give the owner or tenant a *choice* of home heating appliances?

PIONEERS OF SMOKE REDUCTION

For full details, write to Radiation Group Sales Ltd., Leeds 12.

156 Advertisement for 'Ideal Neofire', in National Smoke Abatement Society, *Year Book*, 1951, p. 44.

157 'Start Getting Rid of Smog Now', advertisement for 'Radiation Parkray No. 2', *Architectural Review*, January 1955, p. lx.

These kinds of images retained a powerful hold on the post-war imagination and the desire for restorative peace; they were part of a fantasy of home, family and community that had survived the war but was still threatened by external and foreign forces. Whilst it was clearly a nostalgic and even reactionary outlook, it was nevertheless an effective ideology that defined experiences and expectations in the post-war years. Bill and Betty and other working-class couples might be taught how to furnish and decorate a room, but 'setting up home' also entailed creating an atmosphere of permanence and security that was in excess of 'taste'. In

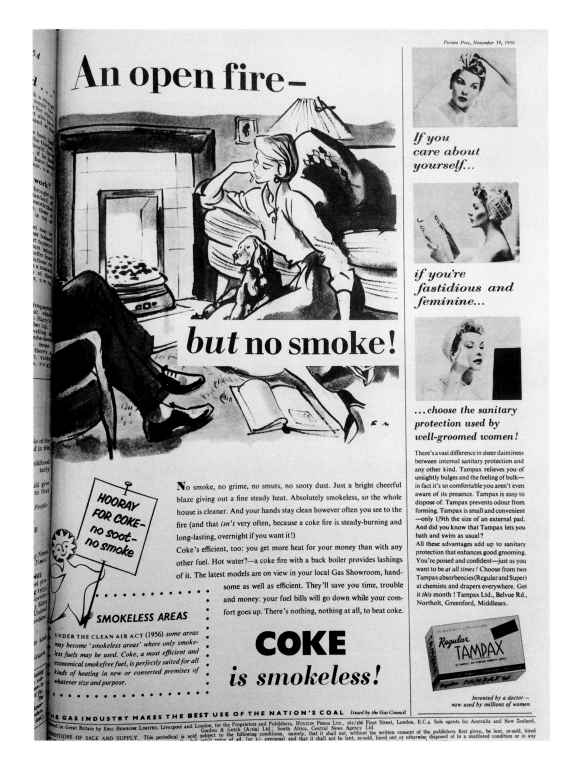

158 Gas Council advertisement, *Picture Post*, 19 November 1956, p. 57.

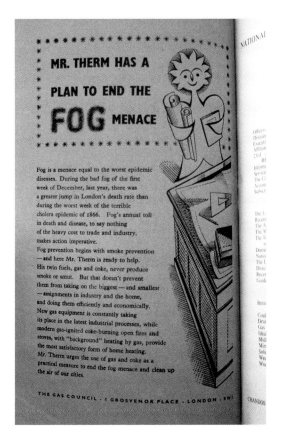

159 'Mr Therm has a Plan to end the Fog Menace', Gas Council advertisement, National Smoke Abatement Society, *Year Book*, 1953, inside front cover.

an article entitled 'No Place Like Home', published in 1957 in the self-confessed retrogressive and sentimental annual miscellany, *The Saturday Book*, Olive Cook celebrated 'the privacy, the well-curtained windows and the cosy fire of our own home'.[32] In fact, this is a very 1950s take on the open fire. It is homely, private and self-contained: owner-occupied rather than a rented room with shared facilities. Whilst marriages and families were straining to adapt to post-war domestic life, the coal fire remained a symbol of continuity and well-being, and in her second Christmas broadcast as queen, it is hardly surprising that Elizabeth II drew on its reassuring and familiar image to represent the tribulations of the Commonwealth: 'When it is night and wind and rain beat upon the window, the family is most conscious of the warmth and peacefulness that surround the pleasant fireside, so our Commonwealth hearth becomes more precious than ever before by the contrast between its homely security and the storm which sometimes seems to be brewing outside.'[33]

These almost folkloric associations made it harder in the 1950s to legislate against domestic smoke than it was to regulate the smoke from industrial chimneys. Vested interests drew on the powerful rhetoric of the coal fire to combat the smoke pollution reports of the early 1950s and the growing inevitability of legislation. In its response to the 1954 Interim Report on Air Pollution, a member of the Institute of [Coal] Fuel stated: 'I refuse to be deprived of some of the things that are dear to my heart, and one of them is the open fire'; watching the flames of a coal fire is a trigger for the romantic imagination, like 'watching waves break on the sea-shore – and who wanted to sit and look at the electric radiator or the gas fire?'[34] The National Union of Mineworkers was also a powerful lobby group in this period, and it is possible that the Conservative government's support of anti-smoke legislation was motivated, in part, by the desire to curtail the power of the miners. With royalty, industry, unions and popular culture mobilizing the myth of the coal fire, it was up to Arnold Marsh, General Secretary of the National Smoke Abatement Society, to criticise the 'viscous sentimentality that surrounds the open coal fire' and to spell out the environmental problems created by this 'grand old English custom'.[35]

The point is this: the coal fire could only assume its symbolic image as a national custom and a repository of feeling through the people seated around it, and in the 1950s those people were the happy companionable couple and their family. The coal fire was part of a post-war chain of being that started with the domestic hearth and progressed to the family, the home, the nation and the Commonwealth. This was not as straightforward as it might seem, however. Although the idea of the 'companionate marriage', as a partnership based on equality, mutual affection and complementary goals, had been the basis for William Beveridge's plans for the post-war welfare system, experts from a range of social and psychological organizations were observing the fragility of this model of the family and appreciating that it could not be taken for granted, that it needed effort – tending – for it to work. Dr Eustace Chesser, Director of the Research Council into Marriage and Human Relationships and author of guides to sex and marriage, recognized that 'Britain's greatness has been built primarily in the homes of its people, and those homes have housed not merely individuals and furniture, but families and a spirit of family unity.'[36] It was the spirit of the family home as well as houses that needed rebuilding, and this was a matter of political as well as private interest, commercial as much as personal endeavour.

Fog, smoke, coal, hearth and home; the greys of iron and the colours of modern design – this was the spectrum through which Britain rebuilt domestic life in the years after the war. Accord-

ing to Lewis Mumford, the Paleotechnic world of iron and coal would be replaced by the Neotechnic world of light, colour and synthetics, but post-war Britain existed in the interstices of both phases of development. No one made use of these images and developed them more effectively than the advertisers. What better way to evoke the consuming comforts of home than through their contrast with the chilly chiaroscuro of the city? In the winter months hot drink products such as Ovaltine and Horlicks, Bovril and Cadbury's Drinking Chocolate ran advertising campaigns linking their brands with the restorative values of home. In December 1953, Ovaltine drew on the experience of the Great Fog with an atmospheric black and white image of a man hurrying home through a damp, dark street (see fig. 87): 'Smog! As you come out into the damp, cold streets and the fog swirls into your eyes and nostrils, how heartily you wish you were at home by the fire with a hot drink in your hand!'[37] The imagined family he is rushing home to is as vivid as the choking damp air of the winter street, but a few years later Ovaltine shifted its focus and depicted the world on the other side of the front door: 'Ovaltine Families Are Happy Families' (fig. 160).[38] Well dressed, well furnished and boisterously happy, this is the world of domestic colour, the safe haven from the storms brewing outside. There was, however, a more troubling possibility that the advertisers dared not hint at: perhaps the storms were not only outside the home but also inside, creating conflict that not even Ovaltine could ease.

The Kitchen Sink School

> I just enjoyed having it nice and putting your nice tea set out and that sort of thing, you know. It was all part of the pleasure . . . This home-making thing to me was nice, you know (Jean, 1955).[39]

Home was the object of considerable public and personal investment and belief in the post-war years. In it was deposited all that had been fought for during the war and much that was desired and expected of the future. As Britain attempted to rebuild shattered homes and families, marriage was reconfigured through strongly gendered notions of the man as the breadwinner and the woman as the homemaker: attractive, devoted and house-proud, as restorative as the domestic hearth. Social workers and psychiatrists addressed the significant problem of the impact of war on the emotional development of children, with many reaching the con-

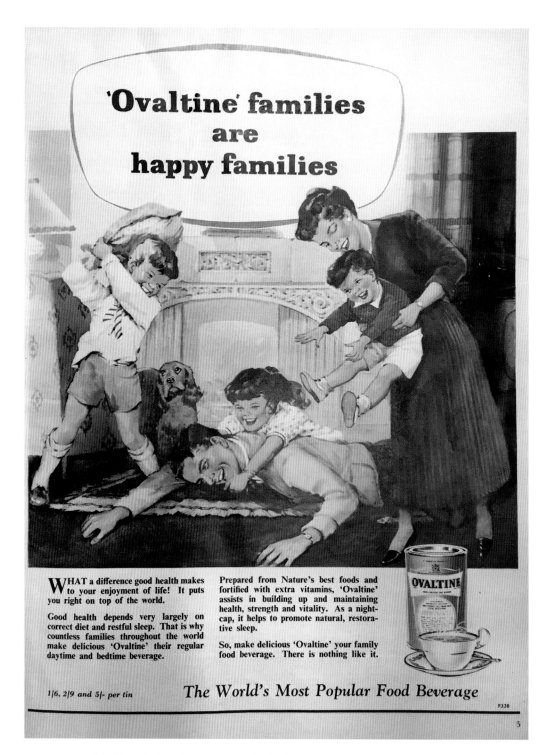

160 'Ovaltine Families Are Happy Families', advertisement, *Everywoman*, January 1958, p. 3.

clusion that mental health could only be ensured by maternal care within the family home. In his book *Child Care and the Growth of Love* (1953), based on work carried out for the World Health Organization, Dr John Bowlby, Director of Child Guidance at the Tavistock Clinic, London, set out his position that maternal care in infancy and early childhood was essential for mental health. Problems caused by evacuation and prolonged separation of children from their mothers, especially during the first five years, had led in a number of cases to the development of a psychopathic character and delinquent behaviour.[40] Problem families and delinquent teenagers picked at the fabric of the family home and corroded its image as the source of social stability. Problems later in life could be prevented, however, and a child's healthy emotional development secured by the mother's presence in the child's first years.

In April 1952, as part of a week-long series of opinion pieces on modern marriage, published in the *News Chronicle*, Bowlby did not mince his words: 'the deprived children of today are the delinquents and neurotics of tomorrow.' The paper published a range of opinions on the subject, including the author and economist Honor Croome, who suggested that part-time work by a mother made her happier and more fulfilled and offered benefits to all the family. Letters from readers supported both positions, with Mrs Evelyn Stone from Romford claiming: 'My two children attended nurseries for four years and neither of them developed phobias or ill effects of any kind. But they showed considerable ill effects while cooped up with me all day in furnished rooms.'[41] 'Cooped up': a short, sharp phrase that is an affront to all the symbolic meanings of the restorative home. How can you be cooped up in a place of sustenance and comfort? Unless things are not what they seem in the Ovaltine adverts and Bill and Betty have other, more pressing problems than the colour of their walls. And yet, for all the Evelyn Stones, there were also the women for whom setting the table with their nice things was a source of real pleasure. In the years after the end of the war, there were conflicting views about the nature of home and the roles of family members, particularly the wife and mother, that were played out on the pages of periodicals, the screens of cinemas and televisions, and on the canvases of artists.

The clean, convenient, time-saving kitchen was part of the promise of peace. New labour-saving devices would remove the drudgery from housework and provide a modern environment for the post-war housewife.[42] The kitchen was the room where modernity was most fully articulated; although the living room was updated and stripped of some of its old-fashioned clutter, the kitchen was the space where design met science and where Britain

263

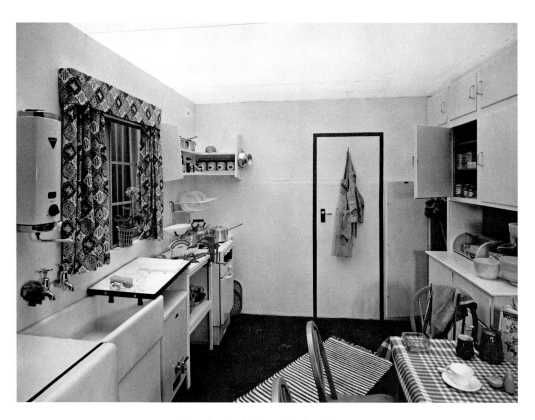

161 Kitchen, 'For Bill and Betty', 1952.

could demonstrate how far it had progressed since 1945. The kitchen room sets at the post-war 'Ideal Home Exhibitions' provided an opportunity for visitors to fantasize about the latest domestic gadgets that they probably could not afford and did not have space to accommodate. The image of the ideal kitchen was a prevalent dream during the years of reconstruction and was one of the six design problems addressed in the 'Homes and Gardens' pavilion at the Festival of Britain. Here, the designers imagined a 'two-purpose' room, which is both where food is stored and prepared and a social space where the family eat and sit: an approach that allowed the housewife to become part of the social life of the house rather than being relegated to the 'service quarters'.[43] Bill and Betty also got their own kitchen at the Whitechapel Art Gallery – a modest room with easily cleanable surfaces, a boiler and a gas cooker (fig. 161). Betty could imagine herself preparing meals and eating and chatting with Bill in this neat little kitchen with its bright gingham tablecloth and jaunty, striped rug.

In spite of the festival's emphasis on 'realistic' homes and the evident modesty of the White-chapel kitchen, for many in the early 1950s these were still fantasy spaces. As the Census of 1951 had shown, a significant number of households did not have exclusive use of a cooking stove or kitchen sink, or would also use the room where they cooked for living and sleeping. The room rented by the protagonist of Lynne Reid Banks's novel *The L-Shaped Room* (1960) offers a bleak image of the accommodation that continued to be let out to the poor, migrants and those on the margins of British society in the late 1950s. Jane Graham is pregnant and unmarried; forced by her father to leave her family home, she moves into a single room in a run-down boarding house in west London, along with other tenants including a Jewish writer, prostitutes and a black guitar player. Jane looks round her new accommodation:

> One wall – the partition – was bare; along the other ran some rudimentary cooking facil-
> ities, consisting of a wash-basin-cum-sink with a tin draining-board and a small cupboard
> with a top just large enough to hold a gas-stove, about a foot square, with a grill and
> two small elements. Under the window, with its dirty-looking brown curtains, was a small
> kitchen table scarred with ancient cigarette burns.[44]

The contrast between the modern, mechanized kitchen with its glamorous and relaxed house-wife and the squalid, cramped conditions of the rented room in a multi occupancy dwelling represented the difference between the residual world of Victorian Britain and the gleaming emergent forms of the post-war twentieth century, between those on the margins of or dis-engaged from the project of reconstruction and those who were involved in the business of setting up home and nation. At once the location of the utterly quotidian and the most basic functions of domestic life, the kitchen was also the most receptive room within the home to the display of modern technology and design innovation. It is no exaggeration to state that the post-war kitchen was an index of the state of contemporary Britain, and that to choose it as the setting for art, fiction or film was to enter into this world of divided opinions and lives.

The label 'Kitchen Sink School' was first applied to the group of young, male, realist painters including John Bratby, Jack Smith, Edward Middleditch and Derrick Greaves in an essay by the art critic David Sylvester, published in the literary journal *Encounter*, in December 1954. Referring to a tradition of still-life and interior painting drawn from the domestic interior and the artist's studio, Sylvester considered the most recent manifestation of this tendency in the work of some British post-war artists:

The post-war generation takes us back from the studio to the kitchen . . . an inventory which includes every kind of food and drink, every kind of utensil and implement, the usual plain furniture, and even the baby's nappies on the line. Everything but the kitchen sink? The kitchen sink too. The point is that it is a very ordinary kitchen, lived in by a very ordinary family. There is nothing to hint that the man about the house is an artist or anything but a very ordinary bloke. It may have the air of . . . a proletarian kitchen, as with Jack Smith, or, as with John Bratby, it may not suggest a particular social background so much as a compelling sense of modern life, because of its profusion of packaged groceries. But in every case it is clearly a kitchen in which ordinary people cook their ordinary food, and doubtless live their ordinary lives.[45]

Sylvester uses the word 'ordinary' six times in this extract, pressing home the everyday and unexceptional nature of the subjects that these artists depict. Kitchens, nappies, utensils, groceries: the scraps and clutter of daily life that are turned by the canvases into signs of culture. Sylvester is clear, however, that the artists have not chosen these subjects because they have particular associations or 'social implications'; they are simply general, ordinary, if you like, a pretext for an exploration of realism. The significance of their subject matter and the politics of realism became topics of hostile disagreement in writing about the 'Kitchen Sink' painters in the first half of the 1950s; did they intend to make a political statement or were they just developing an artistic language? Whether or not they wanted to engage with public and political discourse, however, their kitchen sink subjects were already expressive elements of a public discourse on the state of British society; and whether or not they wished it, the depiction of ordinary lives was far from neutral or general and came replete with 'social implications'.

The trigger for Sylvester's review had been an exhibition of the artists' work at Helen Lessore's Beaux Arts Gallery in London, which included paintings such as John Bratby's *Still Life with Chip Frier* of 1954 (fig. 162). The vertical format of the canvas is emphasized by the composition in which part of a kitchen table juts at a steep angle into the left background. You would, indeed, feel cooped up in such a compressed space. Details such as three wooden chairs, a doorway and floorboards are dwarfed by the vertiginous table top, which is covered with kitchen utensils – a whisk, scissors, the basket of a chip frier – crockery, bottles and packs of food.[46] There is too much stuff on this table; objects balance precariously on their sides; bottles and glasses teeter on the edge, threatening to roll off and smash on the floor. Forms and

162 John Bratby, *Still Life with Chip Frier*, 1954, oil on hardboard, 131.4 × 92.1 cm. Tate, London.

outlines overlap; a small pair of scissors bisects a skewer, a tea strainer butts against a can opener, and the edges of the canvas only just succeed in holding back the teeming pile of objects, exerting a physical and aesthetic pressure that enables the viewer to read the brand labels on the packs of salt and mustard in the bottom right-hand corner. Bratby's painting is an emphatic and ostentatious rejection of conventional notions of still-life composition; everything about it suggests that kitchen things have been tipped out of a cupboard onto the table and that is it. It is a picture about mess and clutter, and as such it is an artistic assault on the clean, streamlined kitchens of post-war domestic reconstruction.

163 Jack Smith, *Mother Bathing Child*, 1953, oil on board, 182.9 × 121.9 cm. Tate, London.

This approach to domestic subject matter appears in the work of other artists associated with the 'Kitchen Sink' group. In Jack Smith's *Mother Bathing Child* (1953), there is no clutter; everything is stripped back to the raw, roughly painted, colourless surfaces and the two heavily out-lined figures of the woman washing the baby (fig. 163). There is no clutter in this place because these two grim, thin figures seem to have nothing. The baby stands in a sink with water up to its calves, its arm bent to avoid the tap from the water heater on the wall. It is, nevertheless, a chilly image. In the years immediately following the war, a stable family life was regarded as the only lasting foundation for a secure national life, and yet, as David Mace, General Secretary of

the National Marriage Guidance Council, stated in 1948: 'Today [family life] is threatened as never before.'[47] Husbands and wives, parents and children: identities and relationships that had been torn apart during the war were now being reassembled, but it was not a straightforward process and everyday emotional life could be messy and conflicted. Messy emotions, cluttered and untidy rooms, agitated paint surfaces. They all speak to the unresolved nature of the domestic in this period and to the tensions that characterized so many aspects of ordinary life.

So it is hard not to see these images as interventions, of some kind, in the debates during this period about the post-war home and family. But the artists were adamant, both at the time and subsequently, that there was no shared aesthetic, no 'Kitchen Sink School', and certainly no political agenda to their art. Jack Smith claimed simply to have painted the war-damaged house in Kensington that he shared with other artists at the time: 'I just painted the objects around me. I lived in that kind of house. A house that I suppose many would consider rather squalid, surrounded by social realist objects.' Similarly, John Bratby later explained: 'The painting of [the 1950s] was an expression of its *Zeitgeist* – introvert, grim, khaki in colour often, opposed to prettiness, and dedicated to portraying a stark, raw, ugly reality.'[48] Both are clear that the paintings are realist in the sense that they reflect the look of the society at that time; but there is no critical eye, and they are social realist only to the extent that the objects they depict may be labelled in this way.

A lot of effort went into denying left-wing political content in the paintings of the 'Kitchen Sink School'; the artists themselves and a number of influential critics dismissed the suggestion that the work was social realist or that there was any shared platform amongst the painters beyond having been to the same art school, the Royal College of Art, shared accommodation and exhibited at the same art galleries. Perhaps they were right, but this is neither the question nor the answer. The issue is that for a time they adopted subjects and a style of painting that had social and cultural significance and were already part of political and public discourse, and whether or not they intended to, by making these choices they were drawn into an intense and highly motivated debate in the 1950s on the political role of art.

The artists first came to public attention in 1952, when their work was included in the exhibition of 'Young Contemporaries' at the Royal Society of British Artists Galleries. Although they had all studied at the Royal College of Art, they did not have a unified 'group' style, they never issued a manifesto, and their work developed in distinct and different directions. In the following two years Bratby, Smith, Greaves and Middleditch were all given solo shows

at Helen Lessore's Beaux Arts Gallery in London and were subsequently referred to as 'the Beaux Arts quartet'.[49] In 1955 they were given a group exhibition at Heffer's Art Gallery in Cambridge, and in 1956 they were the 'Four Young Painters' representing Britain at the Venice Biennale. If it is possible, therefore, to refer to a 'Kitchen Sink School' of art, then its duration was brief but vigorous, from 1952 to 1956. And although it is clear that, in significant ways, their work was quite different, there were enough shared interests for their pictures to be placed loosely together and to represent a 'tendency' in British art of the period. They shared a rough handling and a preference for awkward compositions; they rejected both abstraction and earlier forms of realism; they were young, provocative, evasive and tapping into a contemporary interest in the most ordinary aspects of post-war British life. There was enough in their art for it to become the focus of a critical and political battle over the meaning of realism in the broader global context of the Cold War.[50] Political ideologies were an integral part of art critical debates in the 1950s, and the 'Kitchen Sink' painters were absorbed into this cultural battle as it played out on the pages of journals such as the *New Statesman and Nation* and the *Spectator*.

Painter, writer, curator and critic John Berger played a key role in positioning Kitchen Sink realism through a prism of left-wing politics. Although he did not join the Communist Party of Great Britain, he was closely associated with it and presented contemporary realist painting as popular, dissident and socially engaged, a challenge to the idealism and increasing hegemony of abstract art. In his *New Statesman* review of the 1952 'Young Contemporaries' exhibition, he suggested that a new, common approach could be detected amongst young British artists:

> Slowly but quite certainly something is happening to British painting . . . This attitude is based on a deliberate acceptance of the importance of the everyday and the ordinary. It is not pedestrian because, just as their comparatively representational pictures imply an acceptance of the revolutionary theories of the last forty years, their way of looking at the back garden, the railway, the wharf, the street, the herring fisheries, the deck-chairs on the pier, implies a fresh intention: an intention to discover and express the reality, the sharper meaning, given to such apparently unremarkable subjects by the habits and lives of the people they concern.[51]

These artists would produce a new tradition of art that would reject the excessive subjectivity and formalism of modern abstract art and prioritize communication and identification with their proletarian subjects. Berger associated the new British realism with the work of

the Italian Social Realists whose work was represented at the 1952 Venice Biennale; in the following months and years, however, he would have to make use of all his critical skills to persuade the art public that the British realists shared any of the political aims and attitudes of their Italian counterparts. In the autumn of 1952, Berger organized an exhibition of contemporary British art for the Whitechapel Art Gallery that he called 'Looking Forward' and which included industrial and urban subjects by L. S. Lowry and Ruskin Spear, as well as the younger, Royal College artists such as Greaves and Smith.[52] The record-breaking 'Bill and Betty' had recently vacated the gallery spaces, but Berger's attendance figures were only a fraction of those of the earlier exhibition, which the gallery's Annual Report put down to 'the sombre nature of most of the realist pictures . . . combined with a general low keyed palette, [which] disconcerted many visitors; and in general the reaction to the exhibition was mixed.'[53]

Following its closure at the Whitechapel, some of the works from 'Looking Forward' were selected for an Arts Council touring exhibition. In his 'Forward' to the accompanying list of works, Berger reiterated that realism was an attitude rather than a method, and that realist works of art present images to the spectator 'that will make him more aware of the meaning and significance of familiar, ordinary experiences'.[54] From the outset, therefore, Berger made the ordinary political, the central component of a longer-term goal for art to communicate with the people and engage with the problems of society. During the early 1950s, Patrick Heron was also a regular contributor to the *New Statesman* and used his reviews to attack Berger's notion of realism as illustrative and ideological. 'To study and grasp the nature of appearances is the student's job,' he noted: 'true abstraction is a slow process demanding long experience.'[55] The disagreements between Heron and Berger deepened following the international sculptural competition, organized by the Institute of Contemporary Arts, for a public monument to the 'Unknown Political Prisoner' and spread to involve writers such as Herbert Read. With the finalists exhibited at the Tate Gallery in 1953, the overall winner was a British sculptor, Reg Butler, with his design for a large metal abstract monument.[56] Berger launched a ferocious attack in his *New Statesman* review of the works displayed at the Tate: 'They are tolerant, uncommitted, remote, anaesthetised, harmless and therefore, in the end, impertinent.' Accusing them of sentimentality and evasion he concluded: 'the "official" modern art of the West is now bankrupt.'[57] The following week, Herbert Read, who as President of the ICA and a member of the selection jury for the competition had considerable vested interests, responded. Berger conflated realism with a commitment to 'local, urgently everyday issues';

rather than seeking 'beauty and dignity', Read declared, Berger advocated the clichés of academic realism. It was time to 'tear aside Mr Berger's camouflage, and we find him saying quite bluntly, like his colleagues in Russia, that art must be illustrative (because only illustrations appeal to the mass of the people).'[58] Although Heron was equivocal about Butler's winning model, the conflicts over art and politics and the politics of realism continued, and it was into this maelstrom that the 'Kitchen Sink' painters were drawn. There was no recourse in the supposed neutrality of the ordinary and the everyday, because they had already been rendered ideological by the critical discourse of the period.

John Berger was a tireless advocate of socially engaged realist art throughout the 1950s. In spite of the reticence of the Beaux Arts painters to endorse his reading of their work, Berger continued to write about the social implications of their paintings, whilst modifying his interpretation of their aims. In a review of a 1955 exhibition of realist painting at the Leicester Galleries that included Greaves, Middleditch and Smith, Berger restated his understanding of social realism:

> They paint or sculpt the under-privileged because they have found their reactions more direct, more vital, less cluttered up with considerations of Style. Actions take place in a scullery kitchen, pregnant women are shoeless, children are snotty ... If the content of a realist work has clear social implications, it can be said to be Social Realist ... The fact that the young artists I am discussing find human motives and values revealed most spontaneously and vividly in a working-class environment has a clear social implication. Whether they themselves are very concerned or not with this implication is unimportant.[59]

The social implication is unavoidable and present whether or not the artists wish it. It is there in the representation of the messy, shabby existences played out in a scullery kitchen, a phrase that, in itself, calls to mind the Victorian terraces that continued to populate the landscapes of post-war Britain. Berger appreciated the political implications of ordinary, down-at-heel, domestic life as a subject for art, and so the motives of the artists did not matter; he did not claim that they were Socialist Realists, merely that 'the fact that they can find heroic inspiration only in the lives of those denied security, reveals the frustration of spirit behind the apathy and comparative comfort of the Welfare State.'[60]

For the critic Albert Garrett, however, writing in *Studio* magazine in 1954, it was precisely the comfort of the welfare state that prevented the English realists from being innovatory or radical.

In a long article in which he proposed four different types of realist art, Garrett was emphatic that the English realists, unlike their counterparts in Russia, Mexico, Italy and France, were not political artists: 'The background of the English painters is less political, and, therefore, not so violently propagandistic. Being far removed from peasant stock, they are living in a Welfare State, which surely is the realisation of Courbet's, Proudhon's and Zola's dream . . . Because of this, the English painters' Realist art is an insular affair.'[61] The 'Kitchen Sink' realists lack passion and urgency in their environment and are therefore unable to create innovative art; as a result, they emphasize content for its own sake and their formal language is reactionary.

Whether they were exposing the underlying hardships of life within the welfare state or were cosseted by its support, the critical debates surrounding their art and the idea that they might constitute a 'Kitchen Sink School' brought them to public attention and undoubtedly helped their careers during the 1950s. Interviewed in 1968, the gallery owner Helen Lessore, who had shown their work regularly throughout the decade, confirmed that the label 'certainly helped the careers of the painters'; and in an article published in *Ark* in 1955, the artist John Minton, who taught them at the Royal College, suggested that the debates about the English realist painters not only promoted the artists, but also helped the art critics: 'Here are presented three young painters; self-aware, ambitious. Doom being in, and Hope being out, the search among the cosmic dustbins is on, the atomic theme is unravelled . . . *Is it valid? Is it socially significant?* The critics cry, and in answering themselves fill their columns.'[62]

In the end, evasion probably best suited the purposes of the artists. In 1956 Smith, Middleditch, Greaves and Bratby represented Britain at the Venice Biennale. Presented as 'Four Young Painters', each was given their own wall space, and in the accompanying catalogue text the realist label was, once more, rejected: 'it is convenient rather than strictly accurate to call these artists realists . . . they have neither produced a manifesto nor formed a group.'[63] Their selection for the British display represents both the official highpoint and the end of the idea of the 'Kitchen Sink School' of art. In the same Biennale, Jackson Pollock represented the United States, and in London that year Abstract Expressionism continued its onslaught on European art in the 'American Abstract Painting' exhibition shown at the Tate Gallery, whilst the Whitechapel showcased the new interest in American mass culture in 'This Is Tomorrow'. In his review of the 1956 Biennale, published in the *Observer*, the art historian Alan Bowness commented: 'The description of "social realist" has been wisely dropped – it might be used for Greaves, but can only damage the others, whose interests, I should have thought, are far

164 Richard Hamilton, *Just what is it that makes today's homes so different, so appealing?*, 1956, collage, paper, 26 × 25 cm. Kunsthalle Tübingen, collection Zundel.

removed from the political.' It was left to John Berger to continue to bang the drum for a political realism: 'What is this movement? The kitchen-sink school? Social Realism? The name, deprecating or proud, doesn't matter. It is a movement of protest . . . a protest against the squalor of indulgent dishonesty and self-deception.'[64]

The debates concerning the political significance of post-war realist art were, in the end, in excess of the paintings that stimulated them. Perhaps David Sylvester's insistence on the 'ordinary' in his 1954 article in *Encounter* holds the key to what generated such interest in the idea of the 'Kitchen Sink School'. The ordinary and the everyday are inevitably local conditions; they speak to the here and now, to the issues that surround the appearance and experience of social and domestic life at any given time. In the 1950s the kitchen was the barometer of British modernization; it was the locus both of aspiration and frustration, emotions that flowed into the pictures of the 'Kitchen Sink' painters. They were, in essence, deeply British pictures that spoke to the particular conditions of national life in the post-war years: national pots and pans, national canvases. As a review in *The Times* at the time of the Biennale concluded:

> There is a recurrent emphasis in their work on the shoddy character of domestic life as most of us in this country are compelled to live it, and their pictures are redolent of the variety of functions now inappositely performed in the kitchens of those who are lucky enough to have them. According to Mr Bratby, they simply paint their environment, with no social criticism; but their environment being what it is, the mere choice of the subject contains a germ of protest, and . . . this expression of protest . . . justifies and invigorates their subject matter.[65]

This is a judicious assessment that acknowledges the importance and contemporaneity of the domestic as a subject for art and culture. While Richard Hamilton examined the commodification of domestic life in his 1956 collage *Just what is it that makes today's homes so different, so appealing?*, Bratby, Smith and others were also addressing the nature of the contemporary English home but coming up with different social and aesthetic answers (fig. 164).[66] Rather than domestic appliances and the impact of modern media, the 'Kitchen Sink School' found a post-war home that, in many ways, still resembled that of the pre-war nation.

8

An English Sunday Afternoon

Sunday at Home

Atmospheres are indeterminate and elusive; difficult to grasp or define, they are also expressive and affective. Whilst an atmosphere cannot necessarily be represented, it comes into existence through the relationship between, for example, a place or image and a perceiving subject. Atmosphere describes neither the look nor necessarily the experience of post-war Britain, but it begins to capture the distinctive feel of the period as it settled into the gradual and uneven processes of peacetime. The fascination of atmosphere is that at the same time that it appears vague and ill-defined, it is also almost palpable or physical. Take, for example, Bill Brandt's description of the air in London in the late 1940s: 'You are always conscious of masses of air between yourself and the distant prospect . . . a series of barely translucent curtains ranging away towards the horizon . . . The air can be sensed.'[1]

Atmosphere is not only environmental and spatial, however, it is also temporal. Atmospheres change in relation to broader historical moments and also, more sharply, relative to the different days of the week, or times of the day. Most people living in post-war Britain would have

agreed that the atmosphere of Sundays was tangible and distinctive and was expressive of a 'structure of feeling', a collection of concerns that were specific to the historical conditions of the nation in these years. In 'England Your England' (1941), George Orwell included 'solid breakfasts and gloomy Sundays' in his list of the elements that went into creating the distinct 'flavour' of English identity.[2] After the end of the war, the gloomy Sundays continued but, like the fog and the bombsites, they began to seem like the residue of an older, old-fashioned nation and an obstacle in the path of recovery and modernization.

According to the panel of observers working on the Mass Observation study of national attitudes to and habits on Sundays, the day had become one of general aimlessness, often pleasant but also frequently boring and depressing. People tended to stay at home and the streets were empty and closed. The study, which was published in 1949, commented: 'the Sunday atmosphere is so pervasive that it affects even those to whom the religious and holiday values of the day are nothing.'[3] Sunday was a day for Christian worship, but as these religious values came under increasing assault during the 1950s and Sunday became progressively stripped of its religious significance, what was left other than a gloomy, characterless day of ennui and emptiness? Representing the views of the Methodist Church, Kenneth Greet suggested that non-Christians could still derive some benefits from a quiet Sunday: 'It is hard for men to hear in a noisy world; it is harder still if Sunday becomes as noisy as every other day. Atmosphere counts. There is still something different in the atmosphere of Sunday.'[4] Slow and aimless or peaceful and quiet? Sunday atmosphere forced the nation back into the world of the home, where they ate, read the newspapers and waited until the pubs opened.

The origins of Sunday as the Lord's Day lie in the Jewish week, with its seven-day cycle, with one day devoted to the worship of God. As Craig Harline describes in his recent history of *Sunday*, in the first century AD the Romans adopted the structure of a seven-day week and a weekly rest day, which fell on the Sabbath, the seventh day.[5] By around AD 100 the Jewish and Roman weeks had become aligned: the Jewish Sabbath and the Roman Saturn Day both fell on the seventh day, with the first day in both calendars falling on the Sun Day. For early Christianity the first day was the Lord's Day and a day of worship, and as Christianity moved increasingly away from other religions, the emphasis grew on the Lord's Day as a day of rest. As Harline shows, by the beginning of the thirteenth century the basic expectations of Sunday as a day of worship and rest had been established. From the seventeenth century, however, the requirements of the English Sunday began to take on a different character from those on the

European continent. Through the influence of the Puritans, English Sundays became stricter, devoted to scripture reading and charitable acts; sport, leisure activities and entertainment were prohibited. The distinctions between the strict English Sunday and the moderate continental Sunday continued into the nineteenth and twentieth centuries, particularly in urban centres. While Parisians could visit restaurants, cafés, horse races and shops, their British counterparts were faced with limited opening hours and resistance to the expansion of sport, television broadcasting and other forms of commercial leisure. This was the state of the English Sunday after the war; indeed, it was the state of the British Sunday, but the image of the gloomy Sunday became condensed in the hegemonic notion of Englishness, and it was through this version of national identity that the battle for Sunday was fought.[6]

The 1949 Mass Observation publication, *Meet Yourself on Sunday*, offers a fascinating sampling of national Sunday habits in the years immediately after the Second World War. Mass Observation had been established in 1937 to produce an 'anthropology of everyday life', using a range of investigative methods including observational research and a national panel of volunteers (or 'mass-observers') who kept diaries and responded to monthly directives and questionnaires.[7] Key to the Mass Observation Sunday project was the use of anonymous investigators who, unseen, would record people's activities in their gardens or around the home, watching them 'whilst they are unaware that they are observed' (p. 7). Other empirical investigations of Sunday customs were also conducted in the early 1950s; in their 1952 study of *English Life and Leisure*, B. Seebohm Rowntree and G. R. Lavers based their findings on indirect interviewing and the development of acquaintances between subjects and investigators so that people did not realize they were being interviewed.[8] Social investigation and spying might, thus, be numbered amongst the customary activities of the English on post-war Sundays.

The principal conclusion of the Mass Observation investigation was that Sunday meant staying in: 'most people, do, in fact, spend not only Sunday morning but the entire day either in or around the home' (p. 5). Although a rest from the weekly routine was appreciated, people also complained of dullness and of 'more or less forcible confinement' (p. 55); with little to do and nowhere to go, the strains and frustrations of domestic life were quickly exposed. Considerable time was spent preparing and eating meals and cleaning up afterwards. The customary Sunday was spent 'in a mildly pleasant, aimless sort of way . . . The Sunday output of effort is often largely confined to . . . cooking and eating the Sunday dinner. Food is a big item in Sunday at home' (p. 10). Many families kept their best rations for the Sunday roast joint of meat

165 Ronald Searle, 'Sunday at Home', in Mass Observation, *Meet Yourself on Sunday* (London: The Naldrett Press, 1949), p. 13.

and accessories; getting up late, eating a solid breakfast and reading the *News of the World* before an afternoon meal, it was a day for 'solid stuffing' (p. 12; fig.165). Although Sunday seemed aimless to many respondents, the day of stuffing did not come without effort, and for many women who were questioned, Sunday at home meant extra work. The forty-year-old wife of a taxi-driver declared: 'I simply can't bear Sundays; it's a day which everyone regards as a rest day except for me . . . my man sleeps in a chair; and I'm left with a load of dishes to wash up. I hate Sundays. I dread to see it coming' (pp. 57–8). The slow tempo of Sundays was exacerbated by the customary nap and punctuated by endless church bells; whereas the rigid Victorian Sunday seemed to have some purpose, the post-war Sunday was merely dull and slow. The thirty-four-year-old wife of a metal worker complained: 'Sunday is a dreary day. Everywhere is dead. The children aren't allowed to play in the street . . . Father wants to sleep in the afternoon, why I don't know . . . my little boy doesn't go to Sunday School, it's so dreary' (p. 57).

It was almost enough, but not quite enough, to drive the nation to church. Although few families included Bible reading amongst their Sunday activities, R. C. Churchill suggested that novel reading or listening to adaptations of Victorian classics on the radio could be understood in relation to this Protestant tradition. Churchill's study, *The English Sunday*, published in 1954, was an examination of Christian observation in contemporary England. Drawing

on recent press reports and articles, he concluded that church attendance was declining; although churches were full on special occasions, he endorsed the Mass Observation findings that only 10–15 per cent of British people attended church regularly and only one in four adults was a 'real believer'. Sunday newspapers comprised the new secular literature of the Lord's Day, with around 90 per cent of the population reading a Sunday paper. The *News of the World*, established in 1843, was the nation's favourite, with its regular menu of sex, crime, sport and royalty, but for Churchill this 'Sunday interest in crime' was not necessarily irreconcilable with churchgoing: 'Many a pious Christian in Edwardian times must have gone to church or chapel in the morning and then settled down with "the Sunday Murder" in the afternoon.'[9] Girls' legs, beauty queens, cartoons, film news, What the Stars Foretell, and sport filled the quiet Sunday afternoons at home. Rather than seeing these subjects as un-Christian, however, Churchill regarded them as the extreme development of Protestantism and 'a degraded form of religious ritual'.[10]

Although Churchill was willing to condone the habits of the English Sunday as a social form of religion, the fervent supporters of the Lord's Day Observation Society (hereafter LDOS) were more inclined to see the Sunday newspapers as symptomatic of a corrupt and pagan nation. The Sunday morning experience of Arthur Seaton, in Alan Sillitoe's novel *Saturday Night and Sunday Morning* (1958), epitomized the betrayal of the Sabbath that the LDOS campaigned to change. After staying overnight with his married lover, Brenda, Arthur wakes to '[newspapers] bearing crossword puzzles, sports news and forecasts, and interesting scandal that would be struggled through with a curious and salacious indolence over plates of bacon and tomatoes and mugs of strong sweet tea'.[11] The LDOS knew that illicit sex in print meant illicit sex in reality, describing the introduction of Sunday newspapers into the home as 'an invasion of the everyday things of news, sport, finance, fashions, police court reports etc [a] secular intrusion into the sacred hours'.[12] It would be easy enough to dismiss the LDOS as a fanatical and outdated group that had no place in post-war British society. Founded in 1831, in the context of the early nineteenth-century Evangelical revival, the society experienced a resurgence of support in the uncertain circumstances of social and personal life after the war. They were an effective lobbying group and knew how to organize political campaigns and galvanize support across specific interest groups. They were conservative, racist and stubborn, and their voice needs to be acknowledged within the post-war debates in Britain on the conduct of modern life and culture.

Restrictions on Sunday trading and commercial entertainment were frequently described by their opponents in the 1950s as 'Victorian'; in fact, the laws relating to Sunday activities were much older and had been introduced during the seventeenth and eighteenth centuries, resulting by the mid-twentieth century in a confusing and inconsistent patchwork of contradictory regulations. Although certain kinds of shops were allowed to trade, others were not; some kinds of public entertainment were permitted, but others were prohibited. The laws seemed to lack any kind of logic and many were simply ignored. Moreover, the new forms and styles of post-war social life militated against the strict observation of the Lord's Day. As media and entertainments proliferated and became increasingly available, the gloomy Sunday with its outdated legal scaffolding seemed more and more irrelevant, and the LDOS found itself with a pressing new campaign on its hands, defending Sundays from the encroachment of modern life. The 1950s witnessed a series of attempts to revise the law relating to Sundays and to extend the provision of commercial entertainments and leisure. The 1950 Shops Act had been passed to consolidate a range of legislation introduced between 1912 and 1938 relating to shop opening hours and Sunday trading.[13] Apparently aimed at rationalizing regulations, the Act was peppered with arbitrary and eccentric exceptions and incongruities – you could, if you wished, purchase cooked or partly cooked tripe, but not fish and chips; you could, during hours of opening, buy fresh but not tinned fruit and vegetables; books and stationery could be purchased, but only in railway stations and aerodromes. Not surprisingly, there were widespread breaches, particularly by larger retailers and businesses.

The secularization of post-war British society and official support of the nation's desire to get away from home and be entertained on Sundays were demonstrated by the opening of the Festival of Britain on Sundays; over 900,000 people had visited the South Bank display on Sundays and, even more disturbing, many thousands had enjoyed the far less edifying entertainments at the Pleasure Gardens in Battersea Park, although a special Sunday programme included 'A Service of Hymns'. Following a debate in the House of Commons, the funfair remained closed on Sundays.[14]

By 1952 there were calls in Parliament for further revisions to the laws relating to Sundays and increased provision of commercial entertainment. The Labour MP for Dagenham, John Parker, introduced a private member's bill to repeal the 1780 Sunday Observance Act and end prohibitions on Sunday entertainments; in an interview published in *Today's Cinema* he stated: 'I think all the laws ought to go and people should be able to do what they like on a Sunday.'[15]

This was evidently too radical for the majority of MPs, who acceded to the pressure of the LDOS and Parker's bill fell. Like most of the popular press, *Picture Post* opposed Sunday restrictions and represented the LDOS as a group of dangerous, old-fashioned killjoys. In an article published in February 1953, shortly after the failure of the bill, they described the methods of the LDOS and how they mobilized support and exerted pressure on MPs. Since the vote was an issue of individual conscience and was not subject to a party whip, MPs were vulnerable to pressure from their constituents: 'When a campaign such as the recent one is promoted, the letters and postcards from sabbatarians outnumber the others by as many as a hundred to one.'[16]

The LDOS celebrated the Victorian Sunday because it was a 'family day': a day when parents and children spent the day together in the home. A simple line drawing, reproduced in *Joy and Light*, the society's magazine, depicted the stark choice: Broadway or the Narrow Way; Sunday shops, cinemas and dirt track races or worship and home joy (fig. 166).[17] The battles over the English Sunday represented two entirely different views of post-war society: between those who advocated the traditional values of home and family and those who supported a modern world of choice, consumption and entertainment. By the middle of the 1950s, with the expansion of television broadcasting, the debate was not simply about remaining within the home or going out, but had also become concerned with the nature of home itself and the character of modern domestic leisure. The steady and inexorable rise of television ownership in the 1950s is a mainstay of histories of the medium; whereas there were around 400,000 television licences issued in 1950, in 1953, the year of the great televisual event of the coronation of Elizabeth II, there were over one million. The escalation in television ownership after 1953 was also boosted by the end of rationing and the easing of restrictions on hire purchase, which allowed households to put down a deposit and pay for their sets in weekly instalments.[18] In 1954 the Television Act approved the introduction of commercial television, and by the middle of the decade, the hours of broadcasting by each channel had increased and the service had spread to more parts of England, Wales, Scotland and Northern Ireland.

Sunday broadcasting was a controversial issue for both radio and television, with supporters of Sunday entertainment continually clashing with the protectionist attitudes of the Sabbatarians. During the 1930s Sunday broadcasting on BBC radio was different in character and structure from programmes on weekdays, with careful monitoring of the balance between religious and 'lighter' programmes. As Asa Briggs puts it in his excellent history of British broadcasting: 'There was more controversy about this [Sunday broadcasting] aspect of BBC

166 Illustration in *Joy and Light: The Lord's Day Magazine*, no. 2018 (July–September 1953) p. 115.

policy during the 1930s than about anything else.'[19] Pressure to extend the nature and hours of Sunday broadcasting reached a peak between 1953 and 1955 with the creation of independent television. The BBC closed period between 6 p.m. and 7 p.m. during weekdays (known as the 'toddlers' truce') was extended to the commercial companies. On Sundays programmes were

permitted between 2 p.m. and 11 p.m., but were subject to a longer closed period between 6.15 p.m. and 7.30 p.m.; children's programmes were only allowed after 4 p.m., so that children would not be tempted away from Sunday school by television.[20] The weekday break in broadcasting was abolished on 16 February 1957, although the period on Sundays remained closed to general broadcasting for a further twenty years.[21]

Television companies were attentive to the interests of traditional communities and to the accusations that broadcasting was destroying and commercializing the home, replacing the flickering fire in the hearth with the flickering black and white images of Sunday night light entertainment. The LDOS reserved its greatest efforts for its campaigns against Sunday television. Never hesitant to attack the bastions of official British life (it criticized the Duke of Edinburgh for playing polo on Sundays at Windsor), it pointed to the BBC's 'disgraceful record' in relation to Sunday broadcasting and the fact that in June 1954 it had shown horse-racing from Longchamp (racing was not allowed in England on Sundays).[22] The BBC and the LDOS took up deeply entrenched and embattled positions, and in the same month the BBC aired a documentary programme on 'The English Sunday', which attacked both the dull atmosphere of Sundays and the lobbying of groups such as the LDOS.[23]

Even more worrying was the introduction of independent commercial television and the broadcasting of advertisements on Sundays, which the LDOS described as a 'betrayal of sabbath'.[24] What did it matter if the shops were closed, if the appetite for buying was still being fed by television sets within the home? Commercial television specifically addressed a female audience with *Going Shopping with Elizabeth Allan*, a directly sponsored 'advertising magazine' programme, scheduled at 4 p.m. on Sundays, in which 'Miss Allan will take you out of the home and into the shops to show you yet another range of wonderful new household goods you dare not leave unbought.'[25] Television, it was argued, would kill the British Sunday and make it the same as Sundays on the Continent; even the LDOS could not resist the challenge of independent television and the beginning of the nation's love affair with their television sets. Independent television introduced the Sunday light entertainment schedule, with the variety show *Sunday Night at the London Palladium* as its highpoint in the slot from 8 p.m. to 9 p.m. *Picture Post* imagined Sundays spent watching sport that you could not pay to see live, drama that you could not pay for in the theatre and huge audiences that could not be created by any other medium: 'the coming of competitive TV will see the end of the British Sunday as a day of rest, church-going and good works' and the beginning, it might have added, of a day of

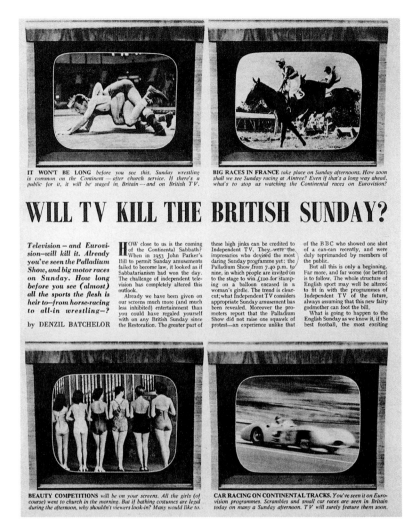

167　Denzil Batchelor, 'Will TV Kill the British Sunday?', *Picture Post*,
3 December 1955, p. 34.

amusement, light entertainment and fun in the home (fig. 167).[26] The LDOS confirmed that commercial television was the greatest threat to the Lord's Day and that: '[Sunday] is openly advertised by the ITV authorities as one of the best-paying days for the advertisers because the largest audiences are obtainable.'[27] Paradoxically, the resistance to shop opening and live entertainment had provided exactly the right conditions for the cultivation of domestic entertainment for those struck by the torpor of an English Sunday at home.

The Day of Rust

The English Sunday was dying and it seemed that there was little that could be done to revive it. It was not so much that religion no longer mattered in the 1950s; the Christian faith continued to be deeply ingrained within British society, but it was being reconfigured in relation to the new forms and styles of the post-war nation. People continued to send their children to Sunday school and attend services at Easter and Christmas and to celebrate church baptisms and weddings, but the strains and cracks in traditional organized religion were beginning to show in the mid-1950s and the conduct of Sundays was a strong index of this change.[28] Bills to extend commercial and recreational activities were presented with regularity to Parliament throughout the 1950s, and each time the LDOS had to rally its supporters to sign petitions and lobby their MPs. It is clear from debates in Parliament on these occasions that MPs believed they were voting on a subject that went to the heart of national identity and that cut across conventional political differences.

During the second reading of John Parker's 'Sunday Observance Bill' in the House of Commons in 1953, the Labour member for Cardiff West opposed the bill, reminding the House: 'it is essential that we, as custodians of the British heritage, shall move cautiously in legislation that would radically transform the way of life of this nation . . . Sunday is not just another day, it is an institution in the country. It is one of our typically British institutions.' He also emphasized the importance of Sunday to the preservation of family life: 'Family life . . . is one of the buttresses of our civilisation, and Sunday has been a potent factor in building up the quality of our family life. It is the only day when father can be assured of the company of his children; the only day, too, in millions of working-class homes in this country, when the children can be assured that they will be able to spend their time with their father and mother.'[29] Rather than defending the traditional Christian Sunday in religious terms, therefore, it was represented as the bulwark of the home and family, the last defence against the 'decay and degeneration' of post-war life. For supporters of reform, the traditional Sunday and the life that it represented had already disappeared; its advocates were trying to hang on to a fantasy that no longer had any substance. As Woodrow Wyatt, MP for Birmingham Aston, concluded: '[The Bill] would give a much more cheerful atmosphere to our Sunday.'[30] On this occasion, however, tradition prevailed and the bill was defeated by 281 votes to 57. As supporters of the traditional British Sunday lined up against advocates of Sunday freedom, new alliances and

oppositions were forged. Regional differences were reinforced as Labour representatives of Nonconformist and Methodist constituencies in Wales were pitted against MPs from urban centres such as Birmingham and London, often from the same party. Commercial interests were advocated and shop workers' conditions of employment were defended; the quiet family Sunday was set against the pleasures of modern entertainment and consumption.

Magazines and newspapers kept the debate alive; *Picture Post* asked its readers 'What Should We Do With Sundays?' and they wrote back, with the majority of the published letters disagreeing with the recent vote. Reverend Marcus Morris hit out at the 'power of vociferous pressure-groups and the ability of cranks and fanatics to influence large numbers of sensible people', while another correspondent insisted that neither politicians nor the LDOS had a 'right to tell a free people what to do on a Sunday'.[31] Sunday was a gloomy day and *Picture Post* readers had had enough of it. The matter was brought back to Parliament in 1957 through the Shops Bill, which was later withdrawn, and again in 1958 with a private member's bill calling for an inquiry to be set up into Sunday laws, introduced by the Labour MP for Birmingham All Saints, Denis Howell. This time, the popular daily newspapers did not hold back in their campaign against 'Gloomy Sunday'. During the days that the bill was debated in the House of Commons, the *Daily Mirror* ran a series of articles, beginning with a punchy piece by Keith Waterhouse, with the headline: '"No-Can-Do" Day!' Using a range of typefaces and a dynamic page layout, the newspaper asked: 'How long must Sunday, the Day of Rest, remain the Day of RUST?' Referring to some of the most outlandish anomalies within the existing laws, Waterhouse stated: 'It is now time to lift the glass case off the English Sunday.'[32] The paper kept up the pressure on the following two days, including a cartoon by 'Vicky' showing Puritans arresting a young boy because 'he bought ice-cream on a beach on a Sunday' (fig. 168).[33]

During the days surrounding the House of Commons debate other newspapers also supported an inquiry and attacked the hypocrisy that surrounded Sundays in Britain. The *Daily Herald* began its coverage with the question: 'What d'you do, Sundays? How do you get through those twenty-four hours of semi-suspended animation that are forced on us once a week?' No shops, no theatres, no sport, limited drinking hours: 'Chaos, Hypocrisy, and Nonsense.' The following day, the *Herald* continued with a personal attack on 'Happy' Harold Legerton, general secretary of the LDOS, which the paper described as 'this strangely powerful society'.[34] Howell's bill did not win a majority vote and the inquiry was abandoned; the *Herald* reported that more than two-thirds of readers were in favour of removing Sunday restrictions,

168 Vicky [Victor Weisz], 'He Bought Ice-Cream on a Beach on a Sunday',
Daily Mirror, 15 March 1958, p. 3.

but it seemed that the £175,000 spent by the LDOS on its campaign had once again effectively influenced the parliamentary debate.

The LDOS hit back at the newspapers and at television broadcasters, reporting on a BBC *Panorama* documentary on the subject, which it accused of being biased against the society: 'It opened – and closed – with a picture of London streets on a rainy day, thus rather naively suggesting that every Sunday is wet! Actually it was quite a nice change to see the quiet deserted streets.'[35] If anything, the irresistible growth of television and the increasing visibility of the Sunday Freedom Association and its supporters made the LDOS even more resolute and uncompromising and more dogmatic in its allocation of blame for the threats to the Lord's Day. In the last few years of the 1950s, the LDOS identified the real enemies of the Christian Sunday; it was not so much the sporting, catering and entertainment worlds – it was foreigners. It had started with concessions given to Jews, which were now at risk of being extended to Muslims: 'we have seen, for example, Jews opening furniture stores in cities such as London and Manchester on Sundays – something which a Gentile is not allowed to do – as well as other types of shops. The new [1957] bill grants these concessions to Muslims in addition.' In its ongoing

campaign to consolidate support for their campaign, the LDOS tapped into the growing public concerns about immigration and race, and represented the preservation of the Christian Sunday as a matter of national identity and the protection of traditional British values. In 1958 it declared: 'Sunday is becoming more and more a day for the purchase of goods . . . Much of this is due to the concessions granted to Jews in England, Italians in Scotland and other aliens in most of the Kingdom . . . Sunday meaning nothing to them.'[36] The battles in the 1950s over the conduct of Sundays extended beyond the ostensible issue of keeping the Lord's Day and permeated nearly every aspect of the social and cultural landscape of Britain in the post-war period. It was about the elaboration of commercial life and the growth of modern entertainment; it was about the management of family life and the role of the home within the welfare state. When traditionalists and Sabbatarians lamented the death of the traditional British Sunday, they were, in truth, mourning the disintegration of a mythic pre-war family home and nation.

Atmosphere is persistent; it hangs around and lingers in time and memory where it becomes deeply ingrained in national culture. Sunday atmosphere remained part of the experience of post-war Britain and, for some, aimlessness and tedium could become depression and loneliness. In 1956 *Picture Post* ran a story on 'Big City Loneliness' with photographs by Bert Hardy. The pictures stage the arrival in London of a young woman from the country as she tries to find accommodation and work; the article quotes the woman's own account: 'Saturdays and Sundays were the worst. I stayed in my one room, smoking. Often, I buried by face in the pillow and cried.' The accompanying photograph, which is captioned: 'The Picture That Tells the Whole Story', shows the woman (modelled by Katharine Whitehorn, a journalist who went on to work for *Picture Post*) sitting in a bedsit, smoking and staring at the gas fire (fig. 169).[37] It is a room straight out of the 'Kitchen Sink School'; the table looks like a Bratby interior, and the rack of drying clothes comes out of a Jack Smith painting. This is modern urban life, removed from the support of community and family and adrift in the atmosphere of an anonymous Sunday. The loneliness of the stranger was heightened on Sundays, the family's day. For Moses Aloetta and the other lonely migrant Londoners in Sam Selvon's novel, Sunday is when they feel most homesick and pessimistic, and when they come together to chat and keep each other company in Moses's room:

> Nearly every Sunday morning, like if they going to church, the boys liming in Moses room, coming together for a oldtalk, to find out the latest gen, what happening . . .

169 Bert Hardy, 'The Picture That Tells the Whole Story', in Victor Anant, 'Big City Loneliness',
Picture Post, 3 March 1956, p. 14.

Always every Sunday morning they coming to Moses, like if is confession, sitting down
on the bed, on the floor, on the chairs, everybody asking what happening but nobody like
they know what happening . . .

Sometimes, listening to them, he look in each face, and he feel a great compassion for
every one of them, as if he live each of their lives . . . Some Sunday mornings he hardly say
a word, he only lay there on the bed listening to them talk . . .

How many Sunday mornings gone like that? It look to him as if life composed of Sunday
morning get-togethers in the room: he must make a joke of it during the week and say: 'You
coming to church Sunday?' Lock up in that small room, with London life on the outside, he
used to lay there on the bed, thinking how to stop all the crap . . . [38]

In a strange simulation of the Sabbatarian Sunday of church and home, the pathos of the migrant experience is intensely conveyed through the group of men gathered in the single room and the empathy that Moses feels for them. Confined to the bedsit, life, even on a Sunday, is happening elsewhere and the men can only seek solace in each other.

Sunday torpor saturated British life and came to represent a kind of complacent conservatism that needed to be aroused and offended. In an essay on writing and commitment, another post-war migrant, Doris Lessing, evoked the profoundly parochial world of the British establishment: 'We are soaked in the grandeur of suffering; and can imagine happiness only as the yawn of a suburban Sunday afternoon.'[39] Time slows down and stretches out on Sunday, emphasized by what Mass Observation described as the endless chiming of church bells. During the war bell-ringing was stopped, but was reintroduced by Winston Churchill in 1942 because he missed the 'familiar sound of an English Sunday'.[40] Rather than a sound of reassurance, however, church bells are also like the steady, repetitive drone of the rain, exacerbating the ennui of the Lord's Day.

John Osborne's *Look Back in Anger* was first performed at the Royal Court Theatre on 8 May 1956. The play is set in a Midlands town, in the cramped attic flat belonging to a young married couple, Jimmy and Alison Porter. The stage directions are detailed and describe the appearance of the room, which is furnished with pieces of heavy wooden furniture: 'dark oak dressing table . . . heavy chest of drawers . . . two deep, shabby leather armchairs'.[41] This is the social realist style of home decoration rather than the modest reworking of festival modernism favoured by Bill and Betty, and it soon emerges that Jimmy and Alison are the dark and troubled antithesis of Bill and Betty. The first scene opens with Jimmy and his friend, Cliff, reading the newspapers while Alison irons. Jimmy throws down his paper and his opening lines are: 'Why do I do this every Sunday? Even the book reviews seem to be the same as last week's.' From the very beginning it is established that the drama takes place during the limbo of an English Sunday afternoon: the day of rust, the no-can-do day. For Jimmy Porter the rituals of Sunday represent all the frustrations and limitations of contemporary life and relations. He continues: 'God, how I hate Sundays! It's always so depressing, always the same. We never seem to get any further, do we? Always the same ritual . . . A few more hours, and another week gone. Our youth is slipping away.' The atmosphere of Sunday is central to establishing Jimmy's antagonism and resentment; it represents the general malaise of post-war society: 'Nobody thinks, nobody cares. No beliefs, no convictions and no enthusiasm. Just another Sunday evening.' And at this

point, it starts to rain. Jimmy proceeds to vent his outrage on his wife, Alison, who is pregnant but has not yet told him. In a vitriolic and sexist attack that still shocks, he says: 'She has the passion of a python. She just devours me whole every time, as if I were some over-large rabbit. That's me. That bulge around her navel – if you're wondering what it is – it's me. Me, buried alive down there and going mad, smothered in that peaceful looking coil . . . She'll go on sleeping and devouring until there's nothing left of me.'

Acts Two and Three also take place on a Sunday evening, two weeks and several months later, respectively. In all three acts church bells are heard ringing, and in the third act Jimmy exclaims: 'Oh, those bells!' Sunday is central to the structure and unease of *Look Back in Anger*, creating the cultural environment for Osborne's exploration of the frustrations of post-war class and masculine identity: 'There aren't any good, brave causes left . . . No there's nothing left, me boy, but to let yourself be butchered by the women.'[42]

Many critics in 1956 underlined the similarities between the fictional 'Angry Young Man', Jimmy Porter, and his creator, John Osborne. Both sought controversy and seemed to be waging a war of words on the complacency of 1950s Britain; as *Picture Post* put it: 'H-Bombs, British Sundays, J. B. Priestley, the entire English middle-class and its prejudices, American evangelists, homosexuals, Church bells and anything remotely "posh" or "phoney"'[43] (fig. 170). To this list might have been added: women, the ideal home, the cosy fireplace and all the aspirations of Bill and Betty.

Perhaps the Sunday of all post-war Sundays belongs to the British comedian and actor Tony Hancock in 'Sunday Afternoon at Home', broadcast on BBC radio in April 1958, in the fifth series of the popular *Hancock's Half Hour*, written by Ray Galton and Alan Simpson.[44] Hancock shares his down-at-heel suburban home at 23 Railway Cuttings, East Cheam, with an odd assortment of friends (including characters acted by Sidney James, Bill Kerr and Hattie Jacques) who make up his bizarre and dysfunctional household. Unlike Jimmy Porter, however, Hancock's ire is tinged with a weary and depressive self-irony that is in complete accord with Galton and Simpson's narrative of the aimless Sunday in East Cheam. The episode opens with a yawn:

Tony H.: 'Oh dear! Oh dear, oh dear! Oh dear me! [sighs] Stone me what a life! What's the time?'

Sid J.: 'Two o'clock.'

Tony H.: 'Is that all? [sighs] Dear oh dear! Ah dear me! I don't know [yawns]. Oh I'm fed up.'

Sid J.: 'Oy! Why don't you shut up moaning and let me get on with the paper?'

Tony H.: 'Well I'm fed up.'

Sid J.: 'So you just said and so am I fed up and so is Bill fed up, we're all fed up, so shut up moaning and make the best of it.'

Tony H.: 'You sure it's only two o'clock?'

Bill K.: 'No it's one minute past two now.'

Tony H.: 'One minute past two? Doesn't the time drag? Oh, I do hate Sundays. I'll be glad when it's over. It drives me up the wall, just sitting here looking at you lot. Every Sunday it's the same, nowhere to go, nothing to do. Just sit here waiting for the next lot of grub to come up.'

The monotony of the afternoon is conveyed in the protracted, repetitive dialogue, which, like the day, goes nowhere but circles round itself, minute by minute. The tedium is momentarily broken by the observation that it is raining; time drags on as they try to entertain themselves by staring at the wallpaper and seeing faces in the patterns and filling in the o's, d's, p's and g's in the newspaper. Unlike on the continent, everything is shut up; they cannot play *Monopoly* because they have lost the board . . . and it is only twenty past two. Time passes so slowly that it almost seems to go backwards, until they realize that the clocks have gone forward one hour for British Summer Time, it is twenty past three and a whole hour has passed. The piano is locked up, but no one can play it anyway, the television is broken, then the next door neighbour knocks on the door (Kenneth Williams); he is also bored. Following an interval in the narrative, filled with sombre cords of music, the audience learns that the neighbour has been doing animal impressions for seven hours. And finally, achingly and inexorably, midnight comes:

Sid J.: 'Monday at last. That must be the most miserable day I've ever spent in my life.' . . .

Tony H.: 'I'll see you next Sunday.' [They all agree.]

Hancock's Half Hour was innovative comedy. Driven by the laconic personality of Tony Hancock, it moved British comedy away from its music hall formats through its use of a single

The caption text within the image reads:

SUNDAY AFTERNOON AT THE PORTERS. FRIENDS ALAN BATES AND HELENA HUGHES WATCH AS JIMMY BULLIES HIS WIFE (MARY URE).

Moments in the bitter life of Jimmy Porter

THE PORTERS IN LOVE. *The only time Jimmy and Alison are happy together is when they relapse into a childish fantasy life. He becomes a 'jolly scooooper marvellous bear', she 'a beautiful, great-eyed squirrel'.*

Photographed by SLIM HEWITT

"I'M IN THE MUD AT LAST! I'M GROVELLING! I'M CRAWLING!" *Alison Porter returns, broken, to resume a life of torture with her husband. 'Look Back In Anger' vindicates the 'writer's theatre' policy of the English Stage Company, and confirms the first-rate acting talents of Mary Ure and Kenneth Halgh.*

34 35

170 Slim Hewitt, 'Moments in the Bitter Life of Jimmy Porter', in Robert Muller, 'Angry Young Men', *Picture Post*, 23 June 1956, pp. 34–5.

narrative storyline and situation comedy based on the everyday life of Hancock and his associates. And like all good situation comedy it was current and tapped into contemporary social issues. Just weeks after Denis Howell's private member's bill requesting an inquiry into Sunday laws had been debated in all the national papers, Tony Hancock spent a miserable Sunday afternoon at home, which was broadcast to the nation. The final nail had been hammered into the terminal day of rust.

'It Always Rains on Sunday'

NOTES TO ALL DEPARTMENTS: The indication (RAIN) in heading of scene means rain certainly required; (?RAIN) means rain may be required, depending on set-up . . . In all non-rain sequences where exteriors are seen (even through windows and doors) some

degree of post-rain wetness will probably be required. (*It Always Rains on Sunday*, shooting script, 1947)[45]

The opening shots of the Ealing studios film *It Always Rains on Sunday*, made in 1947 (UK; dir. Robert Hamer), establish the weather, the location and the time: rain, a shabby terrace in the East End of London, daybreak on a Sunday morning. As the directions in the shooting script clearly show, rain was an essential element in creating the mood of the film and, throughout, the weather almost functions as a character within the narrative. Meteorological and temporal atmosphere intensify each other and combine with the chiaroscuro of the black and white cinematography and the orchestration of the musical score to create an inescapable sense of imminent threat on this rainy Sunday. As the press release pointed out: 'a prime consideration in the making of the film has been to try and capture the atmosphere in which these characters live';[46] the film achieved this aim superbly, creating a paean to the English Sunday and the dark desires and crimes that lurk just below the surface of the rituals of post-war family life.

It Always Rains on Sunday is the story, taken from a novel by Arthur La Bern, of one Sunday in the lives of a group of people living in the East End.[47] Although the novel is set in the pre-war period, the film brings the story up to date, to the immediate post-war years, in an East End that is still pitted with bombsites and homes that continue to keep blackout material in their disused garden air-raid shelters. In most respects, the film starts as an ordinary Sunday, the kind described by Mass Observation in 1949 – getting up late, a cup of tea in bed, breakfast and the *News of the World* – but external events begin to disturb the apparent ordinariness of the day, bringing physical and emotional violence to Coronet Grove. The family at the centre of the plot, who live at 26 Coronet Grove, are the Sandigates. Rose Sandigate (played by Googie Withers) is a former barmaid and is married to George (Edward Chapman), a dull but decent middle-aged man, who has two teenage daughters, Vi and Doris, from a previous marriage.[48] In the early hours of Sunday morning, George is wakened by the noise of the rain and watches from his bedroom window as Vi returns from a night out with Morry, a married band leader who also runs a music shop in Petticoat Lane. The rain also soaks a gang of petty criminals who shelter at a nearby coffee stall where the owner is reading a news story about the escape of a convict, a local man called Tommy Swann (played by John McCallum, who later married Withers), from Dartmoor prison.

In the morning Rose wakes up and knocks insistently on the bedroom wall, shouting at Doris to bring her a cup of tea. This is the first sign of the many tensions within the Sandigate family and of the aggressive frustration of Rose herself. In the bedroom the ordinary Sunday routine begins; Rose brushes her hair in the mirror and George reads his paper and tells his wife about the escape of Tommy Swann. Rose is startled by the name and tells her husband that there used to be someone with that name who went to the local pub, the Dolphin, when she worked there as a barmaid. At this point, the tone of the film changes; as Rose looks at her reflection in the mirror, the screen fades into a vision of an earlier time, a younger Rose, and a love affair with Tommy Swann. An engagement ring, a promise of marriage, and then, on the morning they are to go away together, Tommy is arrested and Rose's dreams are shattered. Rose is roused from her memories by George asking what is for breakfast: 'haddock'; her reply tells us everything we need to know about Rose's subsequent marital compromise.

The family continue with their usual Sunday activities: Alfie, George and Rose's son, asks for pocket money; Doris washes up and Vi goes out to see Morry in his shop. Everything is as normal, although Rose remains abrasive and short-tempered. When Rose goes out to the old air-raid shelter to get some blackout material to mend a broken pane of glass, she discovers that Tommy is hiding there and wants her to shelter him until nightfall (fig. 171). Rose goes back inside the house, but now the normal Sunday routines are unsettled, familiarity becomes threatening and monotony is dangerous. George takes a bath in a tub in front of the kitchen range and prepares himself for his weekly rounds of darts in the pub (fig. 172); Rose begins to prepare the Sunday meal. Eventually, she is able to smuggle Tommy inside the house, where she dries his clothes and gives him some food. She takes him up to her bedroom and reassures him that George always takes his Sunday nap in the front room downstairs and will not find him. The normality and predictability of the Sandigate Sunday allow Rose to shelter Tommy but create immense tension in the fabric of the day. From this point on, there are two worlds in Coronet Grove: upstairs where Rose's lover, Tommy, lies in her marital bed; and downstairs, where George and the family go about their normal Sunday business, oblivious to the drama that is unfolding in their home. When Rose goes up to the bedroom to take Tommy a plate of food from the family Sunday meal, she sees him lying in the bed, in George's clothes, covered in their shiny, quilted eiderdown. The sexual physicality of Tommy seems incongruous in that bedroom, with its patterned wallpaper, heavy mahogany furniture and iron bedstead, normally occupied by the stolid and unassuming George (figs 173 and 174). It is evident that Rose still

Four frame stills from *It Always Rains on Sunday* (UK, 1947; dir. Robert Hamer):
171 Rose and Tommy in the air-raid shelter; 172 George in the bathtub in the kitchen parlour

loves Tommy, and as the day progresses, with its risks of discovery, the strain becomes almost intolerable.

Meanwhile the police and the press are trying to track down Tommy; that night, when George has gone off to the pub, a local reporter calls at the house and discovers Tommy as he is attempting to leave. After attacking the reporter and pushing Rose to the ground, Tommy runs off, and after a chase through the wet streets and a marshalling yard he is caught by the police. In her home, Rose, frightened and exhausted, goes into the kitchen, turns on the gas stove and tries to kill herself. As the central plot and its peripheral narratives are resolved, there is a scene in the London Hospital, where Rose is recovering. George, loyal and patient, is by her bedside, and the couple are reconciled. George goes back out into the dark, wet and deserted streets, and the camera pans up to the rain-filled clouds.

A number of film historians have observed that *It Always Rains on Sunday* does not belong within any single category of film genre but is generically mixed. Charlotte Brunsdon describes it as 'East End Noir'; a blend of 'traditions of British realism, melodrama and film noir'.[49] The moment that Tommy Swann is discovered by Rose in the Anderson shelter, these genres collide, just as the normality of an ordinary Sunday is unravelled by crime and desire. Mirrors play an important role in creating the world of sexual fantasy, away from the mundane realities of life in Coronet Grove. Rose remembers her love affair with Tommy as she looks in

173 Rose and George in the bedroom; 174 Rose and Tommy in the bedroom;

the mirror in her bedroom, and as a barmaid her first sight of Tommy is his reflection in the mirror at the back of the bar. Rose's emotional turmoil is contrasted with the realist treatment of the everyday: the haddocks for Sunday breakfast, the clotheshorse in the kitchen parlour, and the steam produced by hot baths and boiling vegetables. The details are vivid and intense and give a sense not only of what Sundays looked like in the post-war period, but of how they *felt* for those who lived them.[50]

So many of the elements of Sunday routine that are mentioned in the Mass Observation study are also present in *It Always Rains on Sunday* and go towards making up the unbearable predictability of Rose's life: the endless preparing and eating of meals in the draughty kitchen, the husband's afternoon nap, the drudgery of women's work, the visit to the pub with the wife on a Sunday night. 'I hate Sundays. I dread to see it coming.' Those could be the words of Rose Sandigate, Jimmy Porter or Tony Hancock; they are, in fact, the words of the woman responding to the questions of the Mass Observation investigation. Life in Bethnal Green on Sunday is not entirely dull and lifeless, however. The studio press release emphasized that 'actual locations have been used', a fact that was repeated by those involved with the filming.[51] When the action in *It Always Rains on Sunday* moves away from the Rose/Tommy plot and gets out of the Sandigate home, it takes place in the bustling market and Jewish community in Petticoat Lane. The diverse nature of East End Jewish cultural life is treated with considerable subtlety in

La Bern's novel, which differentiates the religious observance of an older generation of Jewish inhabitants from the more assimilated identities of their children. The novel also examines the political life of the working classes, specifically through the character of Bessie Hyams, a second generation Jewish woman who is a socialist and an active trade unionist. Although the film cuts some of this material, the Hyams family and the market are nevertheless treated in some detail, and the diversity and vibrancy of the Jewish East End on a Sunday are powerfully conveyed, through details such as the use of Yiddish and the presence of herring stalls.[52]

The ducking and diving of the crooks around the market, the tradesmen and the crowds intensify the dull uniformity and growing tension in the scenes in the Sandigate home. This contrast between the customary Christian Sunday, with its closed and empty streets, and the raucous cacophony of Petticoat Lane was also described by Mass Observation investigators: 'Traders are mostly Jewish. Those holding the attention of the largest crowds are generally men in their early thirties, quite pleasant to look at, and with a non-stop flow of racy, smutty talk, which keeps the crowd laughing uproariously. The selling technique is all the same – a racy and glib tongue, saucy insinuations.'[53] The shouts and banter of the market traders mix with the sounds of a busking band and radio music, creating a confusing and animated backdrop to the sale of food, clothes, nylons and puppies. Where Mass Observation described Petticoat Lane as a 'bright spot' in the general 'lethargy and aimlessness' of Sundays, the LDOS saw the concessions given to Jewish traders as the beginning of the corruption of the Christian Sunday, which was spreading through the harmful influences of modern life.[54] *It Always Rains on Sunday* captures the transitional state of Sunday, stripped of its religious significance and caught between customary domestic routines and the attractions of public commercial life.

Rose Sandigate is equally a character caught between two worlds. Rose's choice between desire and duty is structured through the opposition of the mirror world of dreams and the realist world of the post-war East End, and the men who inhabit these worlds, Tommy and George. The tension created by this type of female dilemma, between settling for the steady man rather than the glamorous but dangerous one, is a theme that was explored in a number of Ealing films during the late 1940s and 1950s, including *Dance Hall* (UK, 1950; dir. Charles Crichton) and *The Cage of Gold* (UK, 1950; dir. Basil Dearden).[55] Googie Withers described the part of Rose as 'meaty', and although she is definitely more attractive than the woman depicted in La Bern's novel, her plain appearance is clearly contrasted in the film to her younger, remembered self.[56] Rose is now a middle-aged woman with three children and married to respectable

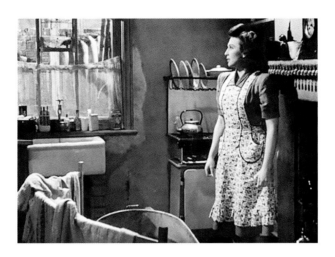

175 Rose in dress and apron, *It Always Rains on Sunday*, 1947, frame still.

George; she wears a sensible dressing gown or an ordinary dress and apron, all of which were acquired within the clothing coupon allocation of the Ealing Studios wardrobe department (fig. 175).[57] This is the black and white world of Rose's Sunday until Tommy comes back, hides in her bedroom and brings disorder to the ordinary home, the ordinary wife, the ordinary Sunday.

The style of *It Always Rains on Sunday* has been described by film historian Charles Barr as 'a "classically" restrained British style'. With unobtrusive camera movement that responds to the characters and reinforces the emotional narrative, Barr suggests that the look is not exactly 'cinematic', but is 'appropriate' to the mood of the film and its values. When Ealing Studios was sold in 1955, Michael Balcon, who was Head of Production, composed a plaque that read: 'Here during a quarter of a century many films were made projecting Britain and the British character.'[58] This quality, or atmosphere perhaps, was the result of a skilful combination of elements that was carefully developed at all levels of production including cinematography, wardrobe, set furnishing and publicity. The poster for *It Always Rains on Sunday* and additional artwork such as the background for the title and credits were the work of James Boswell (fig. 176). Ealing was distinctive in its use of British artists, such as Boswell, John Minton and John Piper, to design its publicity materials, and Michael Balcon owned works by these and other artists, such as Graham Sutherland.[59] The director of press and publicity until 1948 was Monja Danischewsky, a former art student from Russia; thereafter, the role was taken on by John Woods, a designer and art critic who was acquainted with British artists and sculptors such

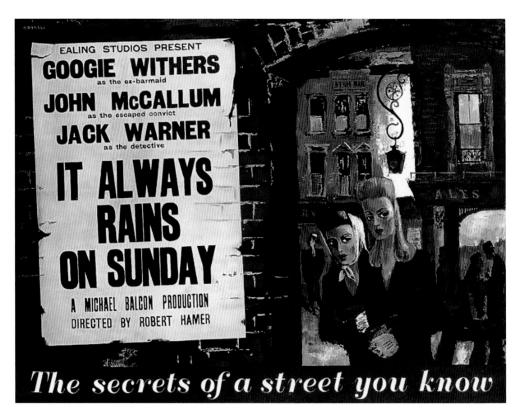

176 Poster advertising, *It Always Rains on Sunday*, 1947, artwork by James Boswell.

as Henry Moore and Barbara Hepworth and had a strong sense of how he wanted the artwork to look. Boswell's poster is striking in that it does not represent a scene or specific characters from the film, but evokes a more general sense of place and type. In 1944, Ealing entered a ten-year deal with the Rank Organization, which agreed to provide financial backing and to release Ealing films in their chain of cinemas that included Gaumont and Odeon. Nathalie Morris has discussed the tension between Ealing and Rank over publicity styles; the Rank approach was described in 1948 as 'a large Kodachrome reproduction of the star or stars, stressing the sex appeal if possible'.[60] Rank evidently objected strongly to Boswell's poster design for *It Always Rains on Sunday*, complaining that it did not represent anything in the film.

Framed by a brick arch, two women walk arm in arm past a street corner lit by a large pub lamp. In the background there are a few silhouetted characters, including the distinctive outline of a spiv. The edginess of the night-time scene is emphasized by the women's uneasy

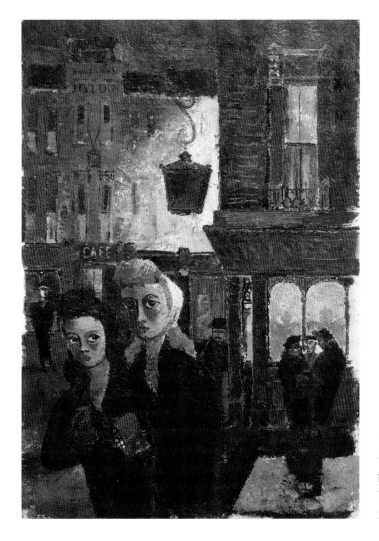

expressions, looking to their left, at something just beyond the frame of the image. The poster was taken from an oil sketch by Boswell called *Saturday Night*, which was also reproduced as an illustration for an article entitled 'Portrait of a Neighbourhood', written by Eric Hobsbawm and published in 1947 in *Lilliput* magazine (fig. 177).[61] The article was about Camden Town, an area in north London described by Hobsbawm as dominated by poor Victorian housing and with a population including Irish and 'coloured seamen', and reproduced in colour inserts four pictures by Boswell (fig. 178). The painting is oil on paper, with details of the pub exterior incised with pencil; it has an illustrative quality showing the influence of Georg Grosz

178 James Boswell, *Little Gold Mine*,
as reproduced in Eric Hobsbawm,
'Portrait of a Neighbourhood', *Lilliput*,
20:4 (April 1947), facing p. 320.

and other visual artists from the Weimar period. Boswell had studied in the 1920s at the Royal College of Art; in 1932 he joined the Communist party and remained a member until 1946.[62] He was a founding member and later chairman of the Artists International Association, which had strong links to the Communist Party of Great Britain. After demobilization, Boswell became Art Editor of *Lilliput*, a monthly magazine founded by Stefan Lorant and, following its sale to Edward Hulton, part of the stable that included *Picture Post*. Boswell belonged to a tradition of British realism that traced its roots to William Hogarth and satirical prints; he moved in the same artistic circles as John Berger and shared his critical engagement with the ordinary and his commitment to the creation of an aesthetics of the everyday.

Boswell's artwork suits the brooding, rain-soaked world of *It Always Rains on Sunday*. As well as poster designs, Boswell also produced drawings for the studio press campaign books which were put together by the publicity department to promote the film and to help cinemas boost ticket sales. A double-page drawing of the crowds at Petticoat Lane market is overlaid with framed vignettes of some of the main characters of the film – the petty crooks, the Sandigates

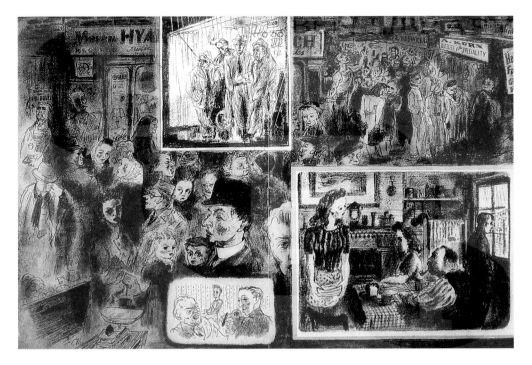

179 James Boswell, artwork for *It Always Rains on Sunday*, 1947. BFI Archive Pressbooks Collection.

and the Hyams (fig. 179).[63] The raw graphic style, which borders on caricature, and the deep shadows of the black and white medium capture both the rough multitude of existences in the post-war East End and the strained claustrophobia of Coronet Grove. The press books also included plot summaries, anecdotes about the making of the film, texts for foyer publicity, and suggestions for competitions and tie-ins with local companies. Cinemas opened later on Sundays, but the publicity suggested that the film offered excellent opportunities for boosting attendances and recommended using showcards reading: 'What Do *You* Do When It Rains on Sundays? Why Not Go to the Pictures? . . . It's Always Fine Inside.' It also suggested a letter competition under the heading: 'What Do You Do When It Rains on Sunday?'; there was clearly also potential for tie-ins with umbrella shops and the National Savings Campaign ('"It Always Rains on Sunday" But Have *You* Saved Up for a Rainy Day?'). Ealing's promotional tools wring all the commercial possibilities from the image of a rainy Sunday; and while the film played on all the connotations of an English Sunday, it was also itself part of the disintegration of the customary Lord's Day and the traditional notion of national identity that it embodied.

Tempestuous, tender, warmhearted
and impossible to live with
she was her own worst enemy...

ASSOCIATED BRITISH PRESENTS

YVONNE MITCHELL
in her prize winning performance

SYLVIA SYMS
ANTHONY QUAYLE

*Woman in
a Dressing Gown*

Also starring
ANDREW RAY CAROLE LESLEY A Godwin-Willis / Lee-Thompson Production Original Story and Screenplay by TED WILLIS

Produced by FRANK GODWIN and J. LEE-THOMPSON Directed by J. LEE-THOMPSON Distributed by Associated British-Pathe Limited

The prize winning BERLIN FESTIVAL FILM

4" d/c W.I.D.G. No. 2 Price 11/6

Tempestuous, tender, warmhearted
and impossible to live with she was her own
worst enemy...

ASSOCIATED BRITISH PRESENTS

YVONNE MITCHELL
in her prize winning performance

SYLVIA SYMS
ANTHONY QUAYLE

*Woman in a
Dressing Gown*

Also starring
ANDREW RAY CAROLE LESLEY

The prize winning BERLIN FESTIVAL

3" d/c W.I.D.G. No. 3

ADVERTISING BLOCKS

If you require a specific size advertising block
not illustrated here, A.B.-Pathe will make it
for you at standard rates. Contact Advertising
Manager, Film House, Wardour Street, Lon. W.I

Tempestuous, tender, warmhearted and impossible
to live with she was her own worst enemy...

*Woman in a
Dressing Gown*

o. 5 Price 8/-

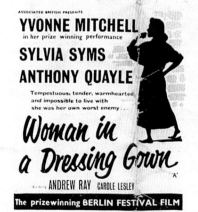

ASSOCIATED BRITISH PRESENTS

YVONNE MITCHELL
in her prize winning performance

SYLVIA SYMS

ANTHONY QUAYLE

Tempestuous, tender, warmhearted
and impossible to live with
she was her own worst enemy...

*Woman in
a Dressing Gown*

ANDREW RAY CAROLE LESLEY

The prizewinning BERLIN FESTIVAL FILM

2" s/c W.I.D.G. No. 6 8/-

Tempestuous, tender,
warmhearted and impossible
to live with she was her own
worst enemy...

ASSOCIATED BRITISH PRESENTS

YVONNE
MITCHELL
in her prize
winning performance

SYLVIA SYMS
ANTHONY
QUAYLE

*Woman in a
Dressing Gown*

ANDREW RAY CAROLE LESLEY

**The prize winning
BERLIN FESTIVAL FILM**

3" s/c W.I.D.G. No. 7 8/6

9

Woman in a Dressing Gown

Housecoats and Negligées

It is difficult to imagine Rose Sandigate in a lightweight housecoat or a lacy negligée. When Rose gets out of bed on that fateful Sunday morning, she puts a warm dressing gown over her nightdress; the house is cold and draughty, and she has to go and prepare a meal in a kitchen that has a broken pane of glass (fig. 180). When Rose is not in her dressing gown, she is in an austerity-style dress with a white print apron over it.[1] In her role as George's wife, she represents a type of femininity and domesticity in which lightweight, floaty lingerie has no place and where you are either in your dressing gown or fully dressed. Post-war but not yet reconstructed, her image of the housewife belongs as much to the mid-1930s as it does to the late 1940s: a short-tempered, East End version of Richard Hoggart's nostalgic recollections of the pre-war, northern, working-class wife and mother. If the fantasy of an ideal home pervaded plans for post-war reconstruction, then the image of the housewife had also to be reconfigured. It was no good putting a woman like Rose, dressed like Rose, in a new stream-lined home; women had to get out of their dressing gowns and become, like their kitchens,

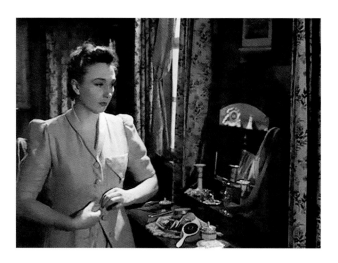

Rose Sandigate in her dressing gown, *It Always Rains on Sunday* (UK, 1947; dir. Robert Hamer), frame still.

both stylish and practical. As Elizabeth Wilson has commented: 'In the fifties the consumer boom led to an emphasis on the ways in which small electrical gadgets had solved the problem [of domestic work] – the myth became that housework was hardly housework anymore.'[2] If domestic labour was no longer physically demanding and dirty, then there was no reason for women in the home to look dowdy or unfashionable; a new kind of housewife appeared in the press and media – elegant, relaxed and dressed specifically in a new type of costume designed for life in the post-war home.

In the period between 1945 and 1960, the domestic became the focus of a concatenation of debates about women, consumption and modernity; key to these ideas was the look of women within the home. The cosy or worn dressing gown, perhaps food- or tea-stained, a little faded and fraying at the edges, yielded to the post-war housecoat, which became a leitmotif of modern domestic femininity: glamorous, convivial, surrounded by new technology and commodities, maintaining the household but sufficiently liberated from drudgery to develop her own stylish self. The woman in her housecoat, in contrast to the woman in a dressing gown, was always on top of things – ready to welcome her husband and to demonstrate her easeful command of the domestic scene.

It may seem whimsical to choose women's dressing gowns as the subject for a study of post-war British culture, but in many ways they represent a range of issues that are central to the

debates concerning reconstruction and national identity that have woven in and out of the chapters of this book. If the choice requires vindication, then I refer to the methodologies of anthropology and design history and their use of the apparently insignificant objects of everyday material culture to trigger broader areas of cultural analysis. In her article on 'Design as a Practice of Modernity', Judy Attfield takes as her case study the 1950s coffee table, in order to show 'how a "seemingly trivial" object, when contextualized within the politics of domestic consumption, can contribute a further layer to that analysis'.[3] Attfield defines the coffee table as 'a practice of modernity' that evolves within the space of the home in relation to specific revised definitions of 'utility and leisure'. The abolition of the Utility Furniture Scheme in 1952 allowed the development of new items of furniture that would previously have been regarded as non-essential within the context of wartime shortages of raw materials and regulations on consumption. The post-Festival of Britain coffee table, with its slim and stylish proportions, expressed a new sense of modern domesticity 'based on a sense of leisure as informal conviviality', as Attfield puts it. Appealing to a younger generation of consumers and homemakers, it represented a new conception of the home as the site of pleasure, consumption and entertainment.

Attfield's use of the term 'conviviality' is accurate and suggestive. Defined as 'informality in the domestic environment, and . . . leisure in terms of pleasure and enjoyment in the company of others',[4] it is absolutely germane to another domestic commodity that emerged in this period as a 'practice of modernity' – the housecoat.[5] The housecoat and the range of related domestic clothing items that also appeared in these years defined a new modern femininity; 'at home' but not involved in drudgery and therefore feminine and fashionable. The housecoat offered a relatively simple way for a woman to update her own image and that of her home, and it rendered the dressing gown obsolete, a residual form of domestic life that was out of date and out of place in the modernized interiors of post-war Britain. The housecoat and modern domestic leisure wear portrayed women as relaxed but not lazy, informal but not disorganized, in private but also always aware of being sociable and on show. It was also a sign of other forms of consumption, of labour-saving devices such as the washing machine, which meant that wives no longer had to stand at steaming kitchen sinks or spend hours scrubbing floors on their hands and knees. And they were functional as well as fashionable, with advertisers frequently pointing out that the fabrics were not only stylish but also washable and warm. The housecoat was a way of being up to date; like rearranging the furniture, painting the bedrooms or hanging new curtains, it was a means of restyling modern British identity.

Women's magazines in the early 1950s regularly advertised varieties of housecoats to their female readers; the fashion pages of *Everywoman* offered readymade as well as 'Simplicity' patterns that captured the romantic but cosy ethos of the modern wife and mother: 'Housecoats, with their neat waistlines, swirling hems and trim, high-fastened necks – perhaps, too, a piped bow trimming on a pocket – have the charm of Victorian morning dresses. Colours chosen for them should be clear and pretty; fabrics warm but washable. Here is your chance to be cosy, yet beguiling – and utterly feminine.'[6] This was not straightforward or simple dressing; it was not just a question of getting rid of your old dressing gown and slipping on an elegant housecoat. The codes symbolized by the housecoat were often ambiguous, even contradictory, and reflected the complexities of redefining femininity in these years. They are always described as romantic, but never just romantic and definitely not overtly sexual; they are also warm and cosy, somewhere between an informal dress and nightwear. The reference in the *Everywoman* article to a Victorian morning dress is perhaps surprising, but points to the social function of this kind of garment and the new elaborated forms of domestic entertainment it was intended to indulge. The housecoat is illustrated in a colour photograph alongside a double-page spread of sketches of the season's nightwear and lingerie (fig. 181). Made from a pale, grey-blue fabric, the style is full-length with a fitted waist and flared skirt: a New Look housecoat.[7] The woman holds a delicate emerald green scarf that matches the green of her fur-trimmed slippers. Everything about this woman is posed and assured, not a finger or hair out of place, from her carefully pointed foot to her elegantly extended fingers and flawless smile. The mutability of the housecoat is also suggested in the caption, which suggests: 'Wear it as a dressing gown or as a dress with your favourite jewellery.'[8] The model is shown standing in part of a contemporary sitting room; on the wall behind her there is a framed still-life – expressive, modern, in the style of Matisse, with a roughly outlined figure in grey-blue in the left corner and a rust red background that is echoed in the fabric of the armchair by her side. The woman and her environment are in harmony: colour coordinated and matching. It is as if the post-war housewife has evolved perfectly with her new domestic setting and has become the perfect life form for the new style of home living and consumption.

The housecoat defined the modern British woman as elegant but practical, and desirable but not threatening or a femme fatale: 'cosy, yet beguiling', romantic but washable; feminine and good value. The 'Bargain of the Month' in May 1952 was 'a housecoat-dressing-gown' ideal for honeymoons and holidays: easy to pack and 'a perfect washer' (fig. 182). In November 1952,

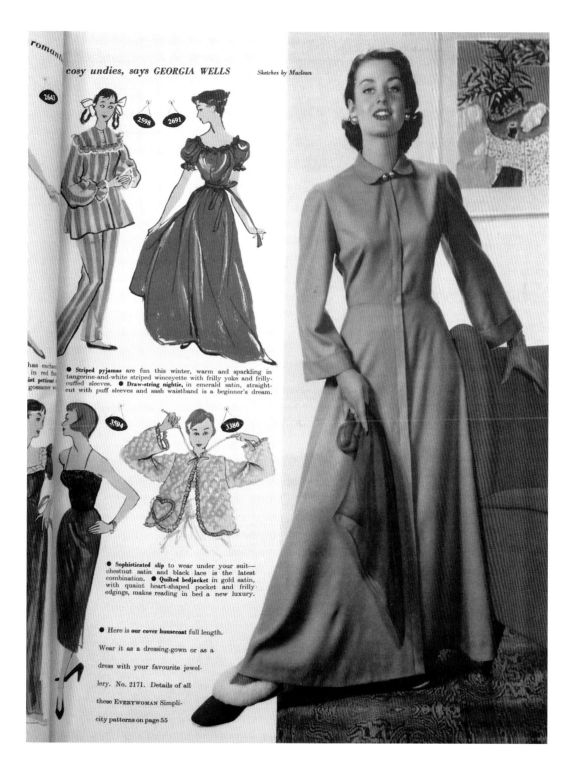

romant…

cosy undies, *says* GEORGIA WELLS

Sketches by Maclean

● **Striped pyjamas** are fun this winter, warm and sparkling in tangerine-and-white striped winceyette with frilly yoke and frilly-cuffed sleeves. ● **Draw-string nightie**, in emerald satin, straight-cut with puff sleeves and sash waistband is a beginner's dream.

has encha…
in red fla…
…st petticoat …
gossamer w…

● **Sophisticated slip** to wear under your suit— chestnut satin and black lace is the latest combination. ● **Quilted bedjacket** in gold satin, with quaint heart-shaped pocket and frilly edgings, makes reading in bed a new luxury.

● Here is **our cover housecoat** full length.

Wear it as a dressing-gown or as a

dress with your favourite jewel-

lery. No. 2171. Details of all

these EVERYWOMAN Simpli-

city patterns on page 55

181 Housecoat, *Everywoman*, January 1952, p. 49.

Bargain of the Month

To Buy: For honeymoons and holidays a housecoat-dressing-gown in a romantic carnation scattered print. It's silk-finished rayon and couldn't be easier to pack. Because it has push-up melon sleeves, the new dropped shoulderline and a full skirt, it's a fashion scoop. Because it's a perfect washer it's completely practical. Estrava model in five shades, 35s. 6d. Turn to page 87 for where to buy.

GEORGIA WELLS

Continued from page 26

keep quiet, for a change, shall we?" said their father. Alex looked up with dignity. "I am *always* quiet!" "He's not," Josie said. "But I've simply learned to concentrate. You should try. Noise is Life, after all. And after all, Life is copy——" "Precocious brat!" Charles returned. "Stop quoting your mother."

Charles. "At last. In time to pour coffee. But only just. By a hairbreadth——"
In the same split second: "Your coffee, M'sieur?" Ani said. And stood, holding the coffee-pot.
"Yes, pour out, will you, Ani, please?" Madame sat down, and didn't notice, or didn't care, that this wifely ritual—what should be a loving duty, to perform with charming feminine tender care—

182 'Bargain of the Month', *Everywoman,* May 1952, p. 28.

Everywoman's fashion editor, Georgia Wells, asked readers: 'Are You a Smart Housewife?...Do You Look the Part?' (fig. 183).[9] The accompanying outfits explored all the nuances of post-war domestic life and women's roles as caterer, mother, wife and hostess: 'You are taking care of your looks, and even if you are your own charwoman, you see no reason to look like one.' With an efficient and pretty overall for housework, there are also outfits for every eventuality, including a pinafore to go over your party dress for when 'your guests refuse to go until they have helped you clear up', and a brocade housecoat for relaxing and welcoming your husband

183 'Are You a Smart Housewife?', *Everywoman*, November 1952, pp. 72–3.

home. There is always a considerable degree of reservation in describing these garments as exclusively or excessively glamorous or exotic. Undoubtedly this was, in part, the ongoing influence of years of wartime austerity, of 'Make Do and Mend' and a morality of clothing consumption that was only gradually being abandoned with the end, in 1952, of the Utility Clothing Scheme.[10] But it was about something else also; the modern housewife was not just decorative, she had a vital role in the reconstruction of the family and the reparation of familial relationships. Beautiful clothes and homes were the outward display of something that had to go much deeper and that had a far more profound impact on British social life.

The housecoat was the perfect modern commodity, combining fashion and necessity and offering new variants depending on weather, function and look. In 1954 Georgia Wells recommended the latest style of 'ballet-length housecoat':

The new short housecoat, or 'brunch coat', is ideal for wearing around the house, particularly if you are nervous of tripping on the stairs with a baby or a tray. I've chosen one in candy-striped cotton plissé . . . The fabric . . . is a dream to launder and to pack because it washes in a minute, never needs ironing and is crease resistant. What's more, it is not in the least transparent and is as soft as thistledown.[11]

'As soft as thistledown', as soft as the feathery plumed seeds of a thistle, blown in the wind through a British landscape. In an instant, Wells has turned an icon of modern domesticity, with its connotations of 'brunch' and American labour-saving gadgetry, into something essentially British and suited to the tastes of British women.

There was, however, no denying that the housecoat and many of the other forms of postwar domesticity were derived from America and that the look of the modern home drew on ideals of commercial and domestic life as they were being coupled and developed in the United States. It is surely no coincidence that the first meetings of the artists, designers and critics associated with the Independent Group took place in 1952, the year in which the Utility Scheme ended. As restrictions were being lifted on many aspects of consumption, the Independent Group began its reassessment of how mass production and consumption were changing British society and culture. In its second phase of meetings and talks, held in 1954–5, the Independent Group developed its theory of 'The Expendable Aesthetic', which analysed the ways in which Americanized mass culture and styles of consumption were creating a world in which traditional forms of cultural criticism and timeless ideals of beauty were obsolete.[12] For art critic and curator Lawrence Alloway, mass popular art and media provided training in how to be a modern consumer and a modern citizen: 'The mass media give perpetual lessons in assimilation, instruction in role-taking, the use of new objects, the definition of changing relationships.'[13] The figure of the modern British housewife, liberated from the old-fashioned drudgery of housework and free to entertain in her stylish housecoat, fits seamlessly into the 'expanding frame of culture' imagined by the Independent Group. As historian Anne Massey has shown, modern domestic life was a significant theme within Independent Group activities from the beginning, and specifically the conjuncture of women, consumption and domestic technologies.[14] It was also the subject of Richard Hamilton's collage *Just what is it that makes today's homes so different, so appealing?*, made for the catalogue of the exhibition 'This Is Tomorrow', held at the Whitechapel Art Gallery in 1956 (see fig. 164). Hamilton depicts a modern

interior populated with new technologies such as a vacuum cleaner and television. Although the hyper-sexualized female pin-up would have no place in the pages of *Everywoman* and similar women's magazines, the elegant woman effortlessly vacuuming at the top of the stairs on the left, and the smiling face on the television screen, belong comfortably within the aesthetic coding of housecoat femininity. Hamilton recognized that the discrete floral housecoat had become a contemporary uniform for women in the home that defined their roles and identities. Writing in 1962 about his oil painting and collage *$he* (1958–61), Hamilton developed his critique of the use of sexualized images of women in adverts for domestic goods: 'The worst thing that can happen to a girl, according to the ads, is that she should fail to be exquisitely at ease in her appliance setting.'[15]

In a letter to the architects Peter and Alison Smithson in 1957, Hamilton listed the 'characteristics of Pop Art', which included: 'Low cost, Mass produced . . . Sexy . . . Glamorous'. Now taken as one of the defining statements of Pop Art, it is also a clear testimony to the importance of the home and domestic femininity within critical and progressive forms of post-war British culture. Alongside the realist painters and critics, Hamilton and those involved with the Independent Group, such as the Smithsons, understood that in certain key ways modern life was being defined through the visual imagery of the home and the look of those women whose identities were defined by it. The Smithsons were able to develop these ideas when they were commissioned by the *Daily Mail* to design a 'House of the Future' for the Jubilee 'Ideal Home Exhibition' in 1956.[16] Invited to imagine a house twenty-five years in the future, the Smithsons created a prototype made from plastic and plywood. Each room was designed as an independent unit and was moulded from a continuous piece of plastic. The visual dynamic of the design is towards the centre; with no exterior windows, a visitor to the home would enter through an airlock in which they were first decontaminated before passing into the air-conditioned house. The latest domestic appliances – colour television, dishwasher, cooking equipment, etc. – are integrated within the walls, and at the centre there is an interior garden. Architectural historian Beatriz Colomina has described the Smithson design as a bunker, 'a kind of bomb shelter', insulated from the outside world, sealed off from what is imagined as a hostile environment. The air of the 'House of the Future' is smokeless, dustless, germless, a haven from the toxins of a nuclear world and, displayed in the year that the Clean Air Act was passed, it is also clearly a space where inhabitants can escape the smog pollution of modern urban life. As most imaginings of the future, therefore, the Smithsons' house was shaped by

184 Clothes for the inhabitants of the House of the Future, designed by
Teddy Tinling, *Ideal Home Exhibition 1956 Olympia, London*, 1956, frame still.

the anxieties of the present. Visitors to the 'Ideal Home Exhibition' looked into the house
from elevated walkways through apertures in an external casing; from there they could watch
models living in the home of the future. Teddy Tinling explained his designs for the clothing
of the men and women in the 'House of the Future'; while the clothes worn by men are plain
and undecorated, women 'will wear ultra-feminine clothes in the home. Out-of-doors their
clothes will have to be almost as severe as men's. A woman's space suit, for instance, will be
much the same as a man's. As a reaction to this, I feel sure she will want light, pretty clothes
to wear in her well-heated home. Through history women have emphasised their femininity
by décolleté necklines, and our woman of the future will be no exception.'[17] Newsreels and
photographs show figures in the Smithson bedroom holding a semi-transparent black lace
nightgown, trimmed on the neckline and hem with ribbon (fig. 184). In the warm, controlled
atmosphere of the future home, it turns out that the woman will wear a black negligée – more
transparent, perhaps, than *Everywoman* might have liked, but entirely in keeping with its ethos
of elegant conviviality.

In 1962 John Braine published *Life at the Top*, the sequel to *Room at the Top*, published in 1957. In the second novel, Joe Lampton has realized his ambitions and married the boss's daughter; he has a good job, two cars and is living in a modern home. Joe compares his social and economic struggles as a young man with the comfort of his married life:

> I went back into the bedroom to fetch my own slippers and the fuzzy dressing-gown . . . its thickness had been welcome enough in the draughty corridors and icy bathroom of the house in Pudney Lane; it wasn't really necessary now. The oil-fired central heating, in fact, kept the house so warm that we hardly needed clothes at all; I didn't object to this, but there were times when, perversely, no doubt, I missed the comfort the dressing-gown had given me on winter mornings, just as I missed the open fire in the big kitchen.[18]

By the end of the 1950s the dressing gown was an expressive sign of the national past: a wartime, austerity world of cold rooms and warm fires, of baths in the kitchen and aimless Sundays. As Joe Lampton acknowledged, there was no place for dressing gowns in the modern world or in the house of the future. As the home was enveloped in the images and values of advertising, the housewife – dressed in her wardrobe of housecoats, slacks and pinafores – was the clearest index of this domestic transformation. It was a radical change in the conduct of domestic life and spoke of shifts in the nature of marriage and the family that were also taking place in these years. A woman in a dressing gown flouted these new social, cultural and emotional identities; she was a problem, an intrusion of a sloppy past in the sleek, modern consumer world of 1950s domesticity.

Jim and Amy … and Georgie

In the same year that the Smithsons designed their 'House of the Future' and a few weeks after *Look Back in Anger* premiered at the Royal Court Theatre, the Independent Television network (hereafter ITV) broadcast Ted Willis's play *Woman in a Dressing Gown* as part of its regular drama series 'Television Playhouse'.[19] Telecast live, the programme no longer exists in audiovisual form, although Willis's original published screenplay and reviews of the broadcast give a vivid sense of the production. The *TV Times* listed the play by posing a series of questions: 'What is the true day-to-day "story" of an ordinary family? And what happens when an

ordinary woman finds her happiness is suddenly threatened? How does she fight back? What happens to an ordinary family when faced with such a moment of crisis?'[20] The repetition of the word 'ordinary' recalls David Sylvester's description of post-war 'kitchen sink' painting: 'ordinary kitchen ... ordinary family ... ordinary lives', or John Berger's advocacy of a politically engaged social realism: 'the importance of the everyday and the ordinary'.[21] At the same time that manufacturers and advertisers were promoting an ideal image of modern domesticity, the world of the ordinary, the everyday and the good enough continued to exert considerable influence on the visual and performing arts, on film and television.

If the nation had been constructed during wartime as a community of radio listeners, then in the post-war period it became a community of television viewers. By the middle of the 1950s, television had consolidated its place at the heart of domestic entertainment: more people owned televisions; there were new ways of purchasing or renting sets; national network coverage had grown; and there were longer hours of broadcasting. Steadily and inexorably, television usurped the open fire at the heart of family life.[22] BBC Television was launched in 1936 but closed down during the war and did not resume broadcasting until June 1946; the first commercial network launched nearly a decade later in 1955. From the restoration of transmission in 1946, television drama had a significant presence within post-war broadcasting; in the context of the magazine format of programming, the stand-alone play or drama series had a cultural gravitas and importance that distinguished serious drama from other genres in the schedules and fulfilled the public service remit of both the BBC and ITV.[23] Until the second half of the 1950s, most television drama was transmitted live and was not recorded; with the arrival of commercial television the recording of television programmes on film or tape increased but continued to coexist with live transmissions. The live performance of television plays in the first years of the 1950s gave them an immediacy and directness that became the defining aesthetic qualities of this kind of broadcast; a 'repeat' literally entailed the cast and crew reassembling in the studio and creating the work again in its entirety in a second performance.

Following the passing of the Television Act in 1954, which gave approval to the introduction of commercial television, Associated Rediffusion began broadcasting in London in 1955, expanding through separate franchises into other parts of the United Kingdom during the second half of the 1950s. Amongst the new features introduced by independent television were imported American drama series, home produced soap operas, and greater use of specially commissioned original material for television plays. The new dramas worked with the aes-

thetic qualities of the American programmes and drew on the interest in working-class realism and ordinary lives that was emerging in 'kitchen sink' subjects in the visual arts and theatre. The 'ITV Television Playhouse' series ran from 1955 to 1967 and was a prominent and popular part of Associated Rediffusion's programming, as well as being an important originator of contemporary drama throughout this period.[24] This was the context and the moment for Ted Willis's television play *Woman in a Dressing Gown*, with its focus on the emotional life of an ordinary wife and mother.

Willis had spent the war writing for the Army Bureau of Current Affairs; after 1945 he wrote plays for the theatre, as well as writing for BBC radio and television and screenplays for feature films. Willis was committed to the exploration of contemporary working-class subjects and to a dramatic style that emphasized authenticity and surface realism.[25] Willis had co-written the story for the Ealing film *The Blue Lamp* (UK, 1950; dir. Basil Dearden), which had introduced the fictional policeman George Dixon, played by Jack Warner. In a powerful narrative that pits a new violent form of post-war criminality against the dependable morality of the experienced policeman, Dixon is murdered by the young hoodlum in the film but was resurrected to become the anchor for Willis's hugely successful BBC police series, *Dixon of Dock Green* (1955–76). In 1956 Associated Rediffusion offered Willis a three-year contract to write a number of television dramas, which would have a limited number of actors and would be shot in the studios. In his autobiography, titled *Evening All*, Willis states that at the time of the contract he was heavily influenced by the American author Paddy Chayefsky, who had written 'golden age' American television plays such as *Marty* and *The Mother*. At this point Willis quotes Chayefsky: '[Both plays] deal with the mundane, the ordinary, and the untheatrical. The main characters are typical rather than exceptional . . . I am just now becoming aware of this area, this marvellous world of the ordinary.'[26] This became the mantra for Willis's own television dramas. Invited in 1958 to reflect on the previous decade of television, Willis nailed his colours to the mast of 'absolute realism': 'The nature of the medium [television] is such that realism is the only road . . . The finest television is that which is concentrated in time and space and character, which takes one or at most two characters and makes their true nature known . . . We select a moment of crisis in the lives of our people, and against this moment we show them as they are.'[27]

Woman in a Dressing Gown is the story of Amy and Jim Preston, a middle-aged couple, living with their teenage son in a London council flat. Amy is good-hearted but completely disorga-

nized. Doting on her husband and son, she is domestically incompetent: the flat is a mess, meals are burned and the ironing piles up. Although daily life seems pleasant and regular enough to Amy, she is unaware that Jim is having an affair with a pretty young secretary from work called Georgie and has promised her that he will leave his wife. From the point at which the viewer becomes aware of Jim's affair, Amy's hapless attempts at domesticity become increasingly painful and poignant. Sensing that her husband is distracted, she prepares a special dinner for him; the stage directions describe the scene: 'THE PRESTON FLAT. Amy is now wearing an old dressing gown. She is laying a meal on a tray and taking great pains to arrange it nicely. She wipes the edge of the plate on the corner of her gown. She takes a chip from the plate and tests it between her fingers, then puts it back.'[28] Fish and chips; apple tart and cream; a bottle of brown ale and Tchaikovsky's Sixth Symphony, the *Pathétique*, playing on the radio in the background: it should all be perfect. While Jim eats the meal, Amy sits anxiously at his feet and describes the new way that she has found to cook chips: 'Cook 'em for a minute or so and then take 'em out. Leave them for another minute and then back to brown ... Makes them crisp' (p. 37). They chat about neighbours and his work, and Amy continues to lavish attention on her husband, explaining: 'I've got a good husband and a good son, and a nice home. Sometimes I like to show that I appreciate my good fortune' (p. 38). At this Jim gets up abruptly and the tension of the evening surfaces. Amy regularly enters a fashion competition in the daily newspaper, hoping to win a prize of £1,000 if she puts a number of photographed outfits in the correct order. Like her method of cooking chips, Amy's life derives from the world of adverts and domestic perfection that she can never attain. Jim tells her she will never win her competition and then angrily criticizes her housework: 'It would make a change to come home once – just once – and find the place tidy. Have you finished your ironing?' (p. 39). He then storms into the bedroom and slams the door. Amy follows him, apologizing for the state of their home and suggesting that it might be because she has a mineral deficiency or a lack of iron, and at last Jim tells her he wants a divorce. As Amy begins gradually to comprehend what is going on, her hand instinctively 'twitches at her robe' (p. 42).

Georgie is young and beautiful and stands for everything that Amy in her dressing gown is not. The next morning Amy gets up early to clean the flat and prepare breakfast, and follows Jim round the flat desperately trying to reassure him that they will be alright. She asks Jim to bring Georgie back to the flat after work that evening so they can all talk about the situation. Amy plans to look her best and to tidy up the flat; borrowing some money from her son and

pawning her engagement ring to raise some cash, she goes to the hairdresser to get her hair done and then buys a bottle of whisky for the evening. Suddenly it begins to rain heavily, Amy gets soaked, and by the time she arrives home her hair is ruined.[29] The day gets even worse; with her hair wrapped in a towel, she tries on her best dress, which is now too tight and rips as she tries to do up the zip. Interrupted by Hilda, her next door neighbour, Amy tells her everything and they start drinking the whisky. By the time Jim arrives home with Georgie, Amy is drunk and has had to be put to bed; when she gets up she confronts Georgie, accuses her of stealing her husband, and reveals that there had been another child who had died shortly after birth. After telling her about their marriage, Amy finally loses patience and tells them both to leave immediately: 'I don't need you any more, Jimbo. I can work. I can find a job . . . Maybe – maybe this is the best thing that could happen to me . . . For twenty years I haven't thought of myself, only of you. Now – it's changed. You go tonight. This is my home' (p. 76). This is the moment of greatest strength for Amy, as she packs Jim's suitcase and realizes there are other possibilities for her than housewife and mother. As they come out of the bedroom they discover that Georgie has already left, and, after some hesitation, Jim chooses not to follow her but to stay with Amy and Brian in the flat. In the final moments of the play, Amy reassures her husband:

'It's all right, Jimbo. Everything is going to be all right. You'll see. You know what? I'm going to scrap this old dressing gown – honestly, I didn't realize until tonight how shabby it is . . . Anyway, a woman should dress . . . she shouldn't slouch all day in an old gown . . .'

JIM: '[With a smile] Place won't seem the same without it' (p. 83).

The family is restored but wounded, and the viewer is left with the contradictory sense that Amy has both won the battle for her marriage and lost the opportunity to be something other than a failed housewife. Amy knows that her dressing gown is the sign of her inability to live up to the image of the ideal domestic woman, but as they settle back into their relationship, both husband and wife realize that she can never get rid of it and never be anything other than a woman in a dressing gown.

Originally Willis had called the play 'Amy' after the central character; halfway through, however, he changed it: 'as so often happens, a better title flashed into my mind and it ended up as *Woman in a Dressing Gown*.'[30] Willis was right, it is a better title; by shifting the focus from

an individual to a generic type of femininity, Willis activates all the meanings that had accrued in the mid-1950s to the image of a woman in a dressing gown. Much of the emotional power of the play comes from the gap between the ideal of an easeful domestic glamour, which Amy absorbs through newspapers and adverts, and her own amiable, dishevelled incompetence. Willis recognized this divergence within the format of commercial television broadcasting: 'after you have built mood and tension in your first act, there is a "natural break" occupied by seven or eight advertisements half of which are competing with each other to prove that it is possible to wash whiter than white.'[31] Just as Amy struggles to look attractive, to prepare the perfect meal and to maintain a clean and tidy home, the commercial breaks reiterate those very images of domestic perfection that bring about the dramatic crisis in her ordinary life. The play received positive reviews in the press, where it was admired for its realism and described as a 'heart-rending' and 'adult' drama that offered a 'true, complete and wholly convincing portrait of a woman'. It topped that week's television ratings and, shortly after, Willis was approached by the English film director, J. Lee Thompson, about the film rights.[32]

The film adaption of *Woman in a Dressing Gown* (UK, 1957; dir. J. Lee Thompson) was even more successful than the television version, winning the Best Film Award at the Berlin Film Festival and thirteen further international prizes.[33] In many respects the film remains very close to the television script, including the opening shots of the exterior of the modern block of council flats where the Prestons live.[34] The dressing of the interior of the flat also follows the set directions of the television play; it is cluttered and untidy and strewn with bundles of clothes for ironing and repair. Every surface is covered with papers, dishes and objects that are not in their right place, and the camera style enhances the mess and claustrophobia of the rooms (fig. 185).[35] In other ways, however, the film version changes and elaborates the emotional drama of Jim and Amy . . . and Georgie. During the title sequence, as the camera pans over the landscape of council flat blocks, there is a sound track of church bells, and as the location changes to the stairwell outside the Preston flat, a newspaper boy is seen delivering the *News of the World*. The film thus sets the important first scenes of *Woman in a Dressing Gown* – those that establish the character of the marriage and the adulterous relationship, the wife and the mistress – on a Sunday.[36] The audience first sees Amy seated at a table, working on the fashion competition; she is interrupted by the smell of the burning Sunday breakfast that she is preparing for her husband. In every way the Preston family performs a typical Mass Observation domestic Sunday of food, newspapers and pub . . . and fails. Jim explains that he has to go to work, but

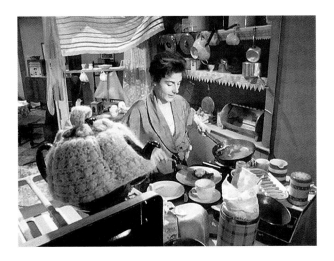

185 Mess and clutter in Amy's kitchen, *Woman in a Dressing Gown* (UK, 1957; dir. J. Lee Thompson), frame still.

placates Amy by promising to take her to the pub in the evening.[37] Amy attempts to carry out wifely tasks such as sewing on Jim's missing shirt button and straightening his tie, and as soon as he is out in the street he goes to a phone box and phones his mistress, Georgie. It is in Georgie's neat basement flat that Jim eats his Sunday lunch and enacts a leisurely and loving Lord's Day. Georgie observes that she loves Sundays, and to the soundtrack of more church bells the camera shows the view through a rain-soaked window of Jim carving a joint of meat and the couple eating their lunch. They are to all intents and purposes the happy married couple. That evening Jim and Amy go to the pub with some neighbours, and as Amy joins in with the pub sing-song Jim's discomfort is palpable. The decision to set these sequences on a Sunday – the Sunday at home – underlines the aberrant nature of both domestic settings: the Preston flat cannot recreate the ideal family setting for breakfast and newspapers, and Georgie cooks the perfect Sunday lunch but it is, equally, a fabrication. In neither is Jim fully 'at home'.

In the film, the parts of Amy and Georgie are played by Yvonne Mitchell and Sylvia Sims. Willis describes Amy as 'thirty-five to forty, a genial, good-natured, untidy slummock. Her clothes, her hair, her manner – all suggest that she doesn't bother about things. For all of this, she has a sympathetic personality: one takes to her at once' (pp. 24–5; fig. 186).[38] Yvonne Mitchell was a 'serious' actress; with an established reputation as a stage actress, she was keen to differentiate herself from 'film starlets, T.V. parlour-game personalities, or pin-up girls'.[39] She created

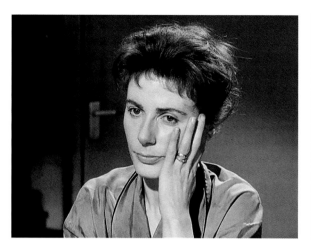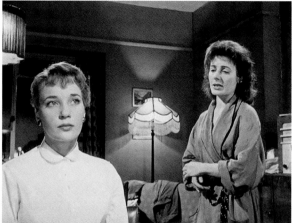

186 Amy, *Woman in a Dressing Gown*, 1957, frame still.

187 Amy and Georgie, *Woman in a Dressing Gown*, 1957, frame still.

a moving portrayal of the wronged wife, Amy, and won the Silver Bear for Best Actress at the Berlin Film Festival for her performance. Georgie is described briefly in the stage directions: 'an attractive efficient girl of about twenty-five or thirty' (p. 33). In the film, however, the contrasts between the two women are enhanced; Georgie, as played by Sylvia Sims, is clearly considerably younger than Amy, and her trim, pretty appearance makes Amy look even more shabby and out of date (fig. 187). Sims was twenty-three when she was given the role; a young actress at the beginning of her career, she had just signed a seven-year contract with Associated British Pictures Corporation, the production company for *Woman in a Dressing Gown*. Sims later recalled a strange mirroring of her own life at the time of shooting the film and that of Georgie:

> When I was playing the part, hero-worshipping Anthony Quayle [Jim] as I did, it seemed to me absurd that any wife could behave as Yvonne Mitchell's character did in the film. The part was very close to me, because one of my problems was that, as well as being a gifted actress, I thought it was my bounden duty to be a gifted housewife – to the detriment of my work, because I was always in conflict.[40]

Sims describes her personal experience in terms of the female characters in *Woman in a Dressing Gown*. Devoted to Jim, Georgie is disgusted by Amy's domestic ineptitude, and tells him: 'I want to see you with a crease in your trousers, and some joy in your face' (p. 35). Equally,

188 'Advertising Blocks', *Woman in a Dressing Gown*, 1957. BFI Archive Pressbooks Collection.

however, Sims acknowledges that this would never have been enough for her and that, as a young woman in the mid-1950s, she also wanted a successful career; she was, therefore, 'always in conflict'. In spite of the film's attempts to create two totally contrasting female characters, it appears that they had more in common than the film and the realist style of kitchen sink drama could accommodate.

The promotional materials created by the film company drew on the disparate characters of Amy and Georgie for tie-ins. Georgie could be shown decorating her flat with 'Starline' paint, and there was even more potential for commercial exploitation of Amy's character.[41] A silhouette of Amy in her dressing gown was used as the film logo, for use on posters and as stickers as well as mounted in cinema foyers (fig. 188). The campaign also suggested a makeover tie-in with local stores and created six stills of Yvonne Mitchell in elegant modern gowns, housecoats

and negligées that ranged from 'sophisticated' to 'demure' (fig. 189). Unlike her own frustrated attempts to become the perfect housewife, cinema proprietors and audiences could create a new, improved Amy: 'fashion stills can also be used for a foyer display – one angle could be to create a contrast approach. Have as a central feature a still of Yvonne Mitchell wearing the old dressing gown which establishes the title of the film and display the fashion stills around it. Head the display "Yvonne Mitchell, the WOMAN IN A DRESSING GOWN – displays an old with the new."' The publicity department fully understood what Amy's dressing gown represented and distilled the image into a number of promotional stunts. The dressing gown belonged to an old, sloppy form of domestic femininity and a wife 'who is so disorganised that she . . . never has a moment to look after her appearance or wonder whether she is the sort of wife a man wants to come home to'. The dressing gown was not simply a sign of an outmoded style of femininity, it was also part of a much larger, post-war debate on the nature of modern marriage.

Pictures of a Post-War Marriage

Rose Sandigate and Amy Preston are both essentially ordinary women in whose lives something extraordinary happens to interrupt the routine of everyday domestic life. At the same time that the post-war family home was becoming the focus of new forms of modern consumption and aspiration, kitchen sink realism was also transforming ordinary and working-class homes and marriages into a 'structure of feeling' that captured the web of conflicting desires within women's lives in the 1950s. Rose, Amy and Georgie are all, in their different ways, waiting and wanting, trapped by their dreams of something better, something perfect. In her study of contemporary women's roles, feminist sociologist Ann Oakley has drawn attention to 'the curiously impressive image of women as always waiting for someone or something . . . in hope of love or freedom or re-employment, waiting for the future to liberate or burden them and the past to catch up with them'.[42] Rose dreams of her ex-lover; Amy fantasizes about winning a fashion competition and being an ideal housewife; and Georgie longs and waits for the middle-aged Jim.

All of these fictional women are unfulfilled by their lives and roles in post-war Britain, and yet they should have been satisfied, they should have been happy. By the 1950s improved housing and greater availability of household appliances had contributed to a new image of

marriage and the family home, and the concept of the 'companion-ate marriage', first used in the 1920s, had been reworked to evoke the modern partnership of post-war married life.[43] Marriage and the family home were the two pillars of reconstruction following the war; with the return of men and women from the armed services and the restoration of domestic life, marriage was redefined as a modern partnership, sexually fulfilling and emotionally stable. This new form of post-war marital relationship was continually reinforced, often in blunt and practical terms. In a series on 'Human Problems Today', published in *Everywoman* magazine, the 'leading London psychiatrist', Mayo Wingate, addressed the question 'Is Your Marriage a Partnership?' He advised: 'No matter how deeply a husband and wife may be in love, or how well matched their two personalities may be, their marriage will founder unless it has those underlying elements of responsibility, of fair exchange, and of loyalty which they would expect to bring to a business partnership.'[44]

The image of 'an equal partnership' was also drawn on as an image for the Commonwealth, which the Queen described in her 1953 Christmas broadcast as a 'new conception – built on the highest qualities of the spirit of man; friendship, loyalty, and the desire for freedom and peace'.[45] It was a companionate empire, a shared partnership, built on and mirroring the married couples of the home nation. There were, however, stark differences between prevailing ideologies of the companionate marriage and lived experiences. Individual emotional lives were inevitably messy and difficult, and the cracks in the edifice of post-war companionate marriage were exposed by growing contemporary concerns regarding anti-social families, juvenile delinquency and divorce, and the continually expanding literature of marriage guidance manuals and advice columns.

189 'Dressing Gown Fashion Stills', *Woman in a Dressing Gown*, 1957. BFI Archive Pressbooks Collection.

DRESSING GOWN FASHION STILLS

Illustrated here is a set of six stills showing Yvonne Mitchell wearing a range of modern dressing gowns which give wide scope for fashion tie-ups around the title of the film.

Still No. E.57.3. EXP 35
(For prices see summary)
Seen here wearing a pale yellow dressing gown with a black design is actress Yvonne Mitchell.
Still No. E.57.3. EXP 26
(For prices see summary)
Featured here is an exquisite pale pink négligé, fitted at the waist, with white lace overlay and a very deep collar. It is being modelled by Yvonne Mitchell.

Still No. E.57.3. EXP 32
(For prices see summary)
Versatile and warm is this red corduroy dressing gown which has a zip front and wide collar. Yvonne Mitchell is the model.
Still No. E.57.3. EXP 22
Yvonne Mitchell wearing a lightweight pale pink floral cotton dressing gown.

Still No. E.57.3. EXP 36
(For prices see summary)
A very sophisticated négligé is featured here by Yvonne Mitchell. It consists of a very delicate shade of pale coral lace with matching lace and pleating.
Still No. E.57.3. EXP 28
(For prices see summary)
A demure style nightgown, here worn by Yvonne Mitchell, is made up in a soft yellow cotton with contrasting trimmings in white nylon.

As social historians of the period have shown, William Beveridge's plan for a state welfare system, introduced by the post-war Labour government, was based on a strongly gendered notion of marriage and the different contributions of men and women to the home and the state. Men were workers and women were home-based wives and mothers, roles which were reflected in the system of social insurance, health and welfare and education.[46] Within this model, marriage was a partnership built on harmony, affection and shared interests; it also remained, for most women, the most accessible and privileged route to social status and security.[47] The modern companionate marriage, with its emphasis on equality, intimacy and mutual respect, actually sustained a system in which women were still defined in terms of their domestic roles and continued to be economically dependent on their husbands.

Sex in marriage was the subject of particular interest, and mutual satisfaction was considered an essential part of a successful relationship. Throughout the 1950s a number of studies, written by psychiatrists and social workers, considered whether standards of sexual morality had changed as a result of the war; in statements that range in register from Victorian moralist to 1960s liberal, experts grappled with the problem of female desire. In a survey of 200 soldiers and their wives, published in 1951, it was concluded that society was in a transitional phase. The authors of the study, Eliot Slater, a psychiatrist, and Moya Woodside, a psychiatric social worker, observed that in spite of an expansion of opportunities for women, the double standard of morality prevailed, and respondents to their survey continued to condone male sexual desire whilst they regarded female sexuality with concern. In spite of the rhetoric of companionate marriage, few women expected pleasure from sex and were satisfied if their husband was 'very good; he doesn't bother me much'.[48] Other experts offered practical advice; in the third revised edition of his guide to successful marriage, *Love and Marriage*, published in 1957, Dr Eustace Chesser, Director of the Research Council into Marriage and Human Relationships and a Harley Street psychiatrist and gynaecologist, suggested pragmatism rather than romance, with the couple 'pulling together' and making an 'effort'.[49] In 1942 Chesser had been prosecuted under the Obscene Publications Act for his book *Love Without Fear: A Plain Guide to Sex Technique for Every Married Adult* and had been found not guilty. Immediately after the war, he returned to the subject, advocating a combination of the 'old morality, with its regard for the home and family' and a new awareness of the sexual aspects of modern marriage. Chesser's message is definitely mixed, arguing both that the modern woman is her husband's equal and that she should study her husband's faults and virtues and adapt herself to him 'at every stage'.

Chesser also dismisses demands from 'extreme feminism' for complete sexual equality, which he describes as childish and misguided; better for men to aspire to standards of female sexual morality than for women to claim the right to absolute sexual equality with men.[50] In a survey of 6,500 women and 1,498 doctors, published by Chesser in 1956, he reported that 71 per cent of married women surveyed described themselves as 'exceptionally happy' or 'very happy'; only 2 per cent said they were 'very unhappy'.[51]

Modern marriage was a key topic for social research in the years following the war and throughout the 1950s. It had been one of the foundations for national recovery and was the setting for reproduction and maternal care. The Royal Commission on Population had been established in response to concerns regarding falling birth rates; reporting in 1949, it made a number of recommendations including higher family allowances and improved advice on fertility.[52] Marriage was buffeted between conflicting and changing notions of sexual morality and behaviour; it was modern and adaptable, but it had to negotiate a barrage of social changes that included a decline in religious observation, more sexual relationships before marriage, higher standards of living, and greater hopes and expectations that conflicted with everyday life. It is hardly surprising that post-war marriage became one of the most prevalent and pressing contemporary subjects for popular debate; with an irresistible blend of individual relevance and titillation, it covered the pages of the popular press and filled hours of broadcasting. In September 1951, *Picture Post* launched an eleven-week series called 'Sex and the Citizen', with a panel of six experts discussing a different issue each week to 'clear the air' and ease the tensions of modern sex and marriage.[53]

In 1955 the anthropologist and author Geoffrey Gorer published the findings of a survey commissioned by the *People* newspaper concerning the lives and attitudes of the English. Volunteers were requested from readers of the paper and over 10,000 completed questionnaires were received, from which half were used in the subsequent publication, *Exploring English Character*. Respondents were asked about their attitudes to sex both within and outside of marriage; Gorer reported that a single standard of premarital chastity was the most common attitude, with a slightly larger percentage against any premarital sexual experience for women. Furthermore: 'Among the young, the unmarried and the more prosperous . . . there is a belief, held more strongly by men than women, that women's sexual feelings are as strong as, or stronger than, men's.'[54] Gorer devoted two chapters to marriage – one looking at 'Hopes and Fears', the second at 'Experience'. In response to a question to husbands about what they most valued

in their wives, Gorer reported that most men looked for 'the possession of appropriate femi-
nine skills' and seldom mentioned good looks or a good figure.[55] Glamour was a problematic
quality that was regarded as fleeting and inauthentic; like the adverts for Technicolor, glamour
attracts and that was not what men – even modern, post-war men – wanted in their wives.

By the middle of the 1950s there was a substantial discourse on the nature of modern
marriage. Social scientists and psychiatrists drew on the growing stature of their disciplines to
carry out field work, which was then disseminated in a wide range of specialist and popular
publications. The public were asked about their views, questioned about their experiences and
encouraged to seek advice. Rather than being a natural evolution, it seemed that the habits of
modern marriage had to be taught; like the rules of colour and interior decoration, poor Bill
and Betty also needed to learn how to be a companionate couple. In a book written for young
couples who 'are experiencing difficulties', the magistrate and doctor Mary Macaulay agreed
that 'living the married life is an art which has to be learnt with patience and practised with
care.'[56] For every instance of a stable, contented marriage, there appeared also to be evidence
of breakdown and conflict, as couples struggled to restore and establish domestic life after the
experiences of the war. In 1946 the National Marriage Guidance Council was created and
was followed in 1948 by the Family Discussion Bureau and by the Tavistock Clinic's Marital
Unit in 1949. The creation of and state support for these counselling organizations, along with
the proliferation of popular advice columns, suggest that rather than being the 'golden age' of
marriage, something was rotten in the state of post-war marriage.[57]

The war was over, but the nation was now engaged in a new 'battle of the family', as David
Mace, the first General Secretary of the National Marriage Guidance Council, expressed it
in 1948.[58] As divorce rates began to rise following the end of the war, marriage breakdown
seemed to threaten the entire project of post-war reconstruction and social modernization.
In 1951 the Royal Commission on Marriage and Divorce (hereafter RCMD) was set up to
consider 'the large number of marriages which each year are ending in the divorce court'.[59]
The commission had been established in response to a private member's bill, introduced in
1951, which proposed to enable either spouse to dissolve a marriage if they had lived apart for
seven years, regardless of 'guilt'. Whilst it was clear that the existing laws were out of date and
could not embrace the current landscape of marriage breakdown, there were anxieties that if
divorce became too available it would undermine social stability more generally. The RCMD
produced its report in 1955; while it conceded that higher rates of divorce were natural and

inevitable after the dislocations and separations of wartime, it also submitted that divorce was becoming more socially acceptable and that the greater expectations of companionate marriage were creating increased levels of tension and dissatisfaction, with the result that 'marriages are now breaking up which in the past would have held together' (8:42). The members of the commission could not reach agreement on all of the issues, and particularly on the grounds for dissolution of a marriage. Although some members supported the introduction of 'irretrievable breakdown' as a new ground, it was finally agreed that the principle of 'matrimonial offence' should be retained (13:65). Opinions within the commission ranged from those who advocated divorce 'by consent' and those who felt that it would be better to abolish divorce altogether and accept 'the inevitable hardships that this would entail' (11:54). It is difficult not to see the anxieties regarding divorce in these years other than in terms of a 'moral panic'; statistics provided in the RCMD report showed a dropping away in the numbers of divorces after 1948. Whilst it was true that there had been a significant increase in the divorce rate between 1937 and 1950, the figures between 1950 and 1953 appeared remarkably stable and consistent.[60]

Amongst its recommendations, the report called for greater support for marriage guidance agencies and for those involved in matrimonial reconciliation. The Family Discussion Bureau (hereafter FDB) was a therapeutic social casework organization that introduced object relations psychoanalytic methods to the support of marriage welfare.[61] As one of its leading caseworkers, Lily Pincus, explained: 'For a young couple marriage represents a further stage in the evolution of their relationships with their own parents . . . the emotional conflicts of childhood relationships with the original love objects can be resolved, or may be re-staged in marriage, and . . . the original phantasies may be re-embodied or dispelled.'[62] Established by Enid Balint and her husband, Michael Balint of the Tavistock Clinic, the FDB focussed on the unconscious motives underlying marital conflicts, and unlike the Marriage Guidance Council, it aimed to help couples understand their behaviour as much as save their marriages. In the early 1950s, Michael Balint addressed the psychological topography of post-war ruin, examining both the drives behind fears of 'horrid, empty spaces' and the corroded landscape of marital breakdown.[63] With Balint leading weekly meetings of the FDB caseworkers, the two institutions became increasingly close until, in 1956, the FDB separated from the Family Welfare Association and became part of the Tavistock Clinic.

In a book published in 1955, six of the FDB caseworkers described the first five years of their work, a period during which they were publicly funded. Recording actual case reports

and discussions, the study introduced a range of couples and marital problems, including Mrs Milton and Mrs Carter. Mrs Milton is described as being 'tall, ungainly, bespectacled . . . [a] clumsy appearance . . . emphasized by her clothes – a drab raincoat, heavy black over-boots'. Mrs Carter 'looked like a drab, untidy schoolgirl'. As the two cases are worked through, the reader is shown how the women's neglected appearance reflects underlying difficulties that they have in fulfilling their feminine roles of wife and mother. Although not all cases could be successfully resolved, Pincus reflected: 'Often each partner has been enabled to carry out his particular role in the family more effectually and with greater enjoyment: Mrs Milton and Mrs Carter, for instance, became better housewives.'[64]

So let us imagine, then, that rather than just patching up their problems, ignoring Jim's adultery, and muddling along with their marriage, Jim and Amy Preston decide to turn to the FDB – what would the caseworker make of this 'woman in a dressing gown'? They would visit the FDB offices in the West End of London, fitted with 'teak Knoll chairs and polished wooden floors' – smooth, professional, uncluttered, so different from the Preston family home.[65] Painfully, haltingly, they would tell their story; perhaps the death of their second child would be mentioned, or Jim would tell the caseworker about Amy's lack of organization, the endless mess, the newspaper competitions. And he would have to talk about Georgie. The case of Mr and Mrs P: at the next weekly conference, the caseworker might suggest that Jimbo's attraction to Georgie is a result of his highly idealized fantasy picture of his own mother and his continuing experience of his emotional life through the abiding image of this 'good' mother. Perhaps one of the other caseworkers, Kathleen Bannister or Alison Lyons, would suggest that he is irritated by Amy's untidiness and lack of organization because they continually frustrate his expectations, as he seeks a relationship that will fit with the figure staged in his unconscious fantasy. After two or three interviews, the caseworker would attempt to enable Jim to bridge and accept the gap between fantasy and reality, between the child's idealized image of the good mother/Georgie and the affable and loving, the good enough Amy.

And they would certainly note Amy's drab, untidy appearance and her fears that her husband finds her unattractive, and would wonder why she is conflicted about, or even defiant, in her refusal to identify with and accept the feminine position. Gradually, as Jim and Amy begin to recognize the unconscious causes of their marital problems, they would start to build a more secure and mature relationship. Amy might begin to move towards a more satisfactory sexual identification; she would go to the hairdresser more regularly and perhaps make a housecoat

from one of the patterns in *Everywoman*. And Jim might buy some new furniture for their flat, praise his wife and make more plans for a shared future, knowing that the breach in their relationship was being repaired and healed. Would Amy ever wonder, though, what might have happened if Jim had gone off with Georgie, if she had got that job and acquired greater freedom and financial independence, instead of holding on to her life with Jim and Brian and the meals and the ironing and the sad melody of the *Pathétique*?

By the middle of the 1950s the split between men's labour in the workplace and women's labour in the home was firmly established; a number of factors, however, began to draw attention to the experiences of women later in life, when their child-rearing years were over. Richard Titmuss, who held the founding chair in Social Administration at the London School of Economics, suggested that as a result of greater life expectancy, people getting married earlier in life and having fewer children, women would have more years when their child-rearing was fulfilled and they could return to the workforce.[66] Although he pointed to a growth in the employment of married women over thirty, and more specifically of forty to fifty year olds, there were still not enough educational and training opportunities for women in this age group.

This question was also addressed by feminist sociologists Alva Myrdal and Viola Klein, in their 1956 publication *Women's Two Roles*, in which they advocated a model of combining family and professional life over the period of a woman's life cycle. With current patterns of marriage and reproduction women had 'two adult lives', with up to fifty years of life ahead after marriage.[67] They calculated that a mother was needed at home, to provide full-time supervision for children, for approximately fifteen years. This meant that if a woman married at around twenty-five, then at forty or forty-five she could resume outside work for a number of years. With better urban planning that placed housing, schools and nurseries in close proximity, provision of day nurseries and rationalization of housework, women could be freed from the conflict of career and family that they currently faced and that 'continues as a psychological problem which may assume many different variations and shades . . . [this] pull in two directions goes on practically throughout a woman's life.'[68] This is surely Amy Preston's conflict; her son is eighteen and independent, but rather than entering a new phase of her life, she continues to go through the motions of domestic work, with greater frustration and irrelevance for all concerned.

Middle-aged women were also the subject of new attention amongst authors of marriage guidance manuals. In the second enlarged edition of *The Art of Marriage*, published in 1956,

Mary Macaulay added a chapter on 'Middle Age', where she warned that lack of appreciation from a husband or wife made middle-aged couples highly susceptible to any admiration offered outside of the marriage. Moreover, if, after years of marriage, a woman became uninterested in sex, 'what they offer their husbands is an apathetic acquiescence. This is not what a man wants, but women blame their husbands bitterly when they leave them for someone younger and more responsive.'[69] Although Macaulay describes the husband and wife as equally responsible for the success of a 'modern, democratic marriage', there is a strong inference that the woman is always partly to blame if her husband is unfaithful:

> It is difficult for a wife, with all her cares and the responsibilities of housekeeping, to be as amusing and stimulating a companion as the single woman friend has time to be; but she should try to remember it is often partly her own fault when her husband is attracted by other women. This is no excuse for the husband who allows his affection to wander, but it may help the wife to deal more understandingly with the situation if it arises.[70]

If Amy had read these lines, she would undoubtedly have identified with these circumstances and internalized the blame.

It is unlikely that Jim and Amy would have been comfortable discussing their marriage at the FDB; they would probably prefer just to get on with things, whilst Amy would read, with particular interest, the advice columns in the newspapers and magazines. The idea that wives were ultimately to blame for their husbands' adultery was a common and widely held perception of marital breakdown. In his survey of *English Character*, Geoffrey Gorer included 'letting herself go, slovenly, dress badly, etc.' amongst the faults that men found in their wives. In addition he noted: 'women tend to assume that the reason for their husband straying is that they have lost their physical attractions, and that they can win him back by smartening themselves up . . . a new hair-do and smarter clothes.' This was confirmed by female respondents to the question of how women should react to their husband's infidelity; a thirty-eight-year-old woman from Sunderland wrote: 'I suggest she stands in front of the mirror and examines her reflection in detail, then she should examine her conscience carefully, and finally review her attitude towards her husband. Inevitably she will find that the fault lies within herself and as soon as she remedies it, her husband's affair will cease.' A thirty-three-year-old wife from Shepperton also advised: 'New clothes, undies, hair styles . . . Try not to show grief, or discuss the other woman.' Another woman recommended: 'make herself and home attractive enough

to compete with and beat the other one.'[71] Although good looks were seldom mentioned by husbands as important, as soon as he had an affair, women looked in the mirror and found themselves lacking.

Amy would have found the same views repeated in the agony columns of magazines such as *Woman*, which was described by its long-standing editor, Mary Grieve, as a 'trade paper for mothering'.[72] *Woman* offered a regular menu of home subjects, fiction and items on cooking and marriage; it showed women how to make themselves and their homes attractive, and if problems arose, it offered the expertise of its agony aunt, Evelyn Home. On 20 January 1951, the magazine published a letter from a woman whose husband, after twenty years of marriage, had been unfaithful; Home described how this 'sensible and valiant' woman had decided to 'fight' for her marriage: 'she made a new rule – never to forget how she looked. "Nowadays", she says, "if we need a saucepan or I need a pair of stockings – the stockings win. It used always to be the saucepan; that was the mistake. In being selfish, dressing up, having an occasional hair-set and buying a spot of make-up, I have won back my husband, and made our home happy."'[73] Wives fought for their marriages by being good consumers and getting a makeover: 'money spent on your own appearance is almost always well spent.'[74] When Amy takes on Georgie – the neat, slim, well-groomed, young career woman – she does the rational thing, what all the marriage guidance counsellors and manuals, advice columns and women themselves say she should do: she goes out and gets her hair done.

Of course, in Amy's case the pain is exacerbated by her failure, the impossibility of getting out of her dressing gown appearance and frame of mind. In 1960 *Woman* published an apocryphal tale called 'Girl with the Dressing-Gown Mind', in its regular opinion page on personal and family matters, written by John Deane Porter. Porter described how he had recently met up again, after seven years, with a woman who had worked for him and who was now a thirty-two-year-old wife and mother of two children. Whereas in the past she had been neat, smartly dressed and witty, now her clothes were creased and ill-fitting and she looked and sounded dull:

I realized suddenly what she had become – a girl in a grey dressing-gown.

I could visualize her wandering about the house in the early morning with her hair flopping into her eyes, and that warm, serviceable garment roped around her.

It was not the image of the garment that shocked me. It was the grey dressing-gown mind she had draped around herself.[75]

Not simply grey, this dressing gown, like the foggy air and the blighted, undeveloped bomb-sites, is 'a rather dull, dreary grey'. Porter wonders what has brought about this terrible transformation: 'Was it secret frustration that had made her contract out of life? ... what had made her unloosen her mental corsets so that she now seemed completely brainless?' For Porter and so many others in post-war Britain, a woman in a dressing gown was a figure who had opted out of modern femininity; enveloped in its loose, unstructured threads, her dowdiness was a symbol of an old, colourless style of living that belonged in the past and an affront to the fantasy of domestic life on which the nation was being reconstructed.

At the end of the 1940s the English paediatrician and psychoanalyst Donald Winnicott broadcast nine talks on BBC radio on Wednesdays at 9.30 p.m.[76] Winnicott was an excellent and engaging broadcaster; his style was intimate, personal and direct, and his audience and subject was 'the ordinary devoted mother'. Week after week he reassured women that they were doing well, that they did not need to be perfect mothers, and that it was better for the emotional development of their babies to be 'good enough'. In the final programme he concluded: 'Enough then if I have enabled some mothers who were already doing ordinarily well to feel more confident in themselves and their natural instincts.'[77] Here the 'ordinary' – the mantra of post-war realism – is invoked in order to bring psychoanalytic insights into the mother–infant relationship to an audience of radio listeners. It is a term of reassurance and aspiration: ordinary is good enough. Is Amy Preston an ordinary devoted wife and mother, or a woman with a dressing gown mind? Is she to blame for her husband's adultery and for 'letting herself go'; should she get a hairdo or a job? Women's lives in post-war Britain were shaped by conflicting definitions and images at all phases of their lives. A young actress, Sylvia Sims, is caught between her desire to be a good wife and to have a successful career; the poor little mannequin, 'Betty', must be shown how to set up home and, as she grows older, must stay attractive and attentive and make sure that 'Bill' does not find a younger woman. On Sundays they must cook the dinner while masking their own desires or listening to the rants of Jimmy Porter. And Amy Preston must hope that being ordinary *is* good enough.

History may be found in the everyday and the ordinary: in dressing gowns and Sunday afternoons that open up a dimension of historical atmosphere – a fine network of meanings, images and relationships – that can be said to constitute the period's 'structure of feeling'. This study begins and ends in grey, with fogs and dressing gowns. In between it has traced the expressive

visual languages of black and white media and the diverse attempts within Britain in the post-war period to take on colour. Colour was compelling and modern. It was the world of commodities and entertainment; it was also the world of empire and migration and the encounter of the black and the white on the streets of Britain. At the heart of it all are housing and homes. Homes and nation are inextricably linked within the period: companionate marriages, a stable nation and a Commonwealth based on equal partnership. These beliefs and values were set out in texts, but they were defined most vividly and forcibly in the visual media of the period. Considered collectively rather than as separate histories, films, newsreels, television plays, paintings, press photographs and advertisements constitute a unique and unmatched archive of Britain as it recovered from war and positioned itself as a modern nation. In Margery Allingham's 1952 detective novel, *The Tiger in the Smoke*, the ex-army sergeant and murderer, Jack Havoc, lurks in the fog bank that covers the metropolis, waiting to destroy the peace and order of the lives around him. This image has been a constant presence in the conception and writing of this book; instead of Jack Havoc, however, the tigers in the smoke of British post-war modernity were colour and migration and the threats of the past – bombsites and Victorianism, broken homes, kitchen sinks and women in dressing gowns.

Notes

Introduction

1 'Life in the Elephant', *Picture Post*, 8 January 1949, pp. 10–16. Hardy's photographs for this article won him his second Encyclopaedia Britannica award. For discussion of the article, see Ben Campkin, 'Down and Out in London? Photography and the Politics of Representing "Life in the Elephant", 1948–2005', in Mark Swenarton, Igea Troiani and Helena Webster, eds, *The Politics of Making* (Oxford and New York: Routledge, 2007), pp. 230–43. The political and cultural identity of *Picture Post* is discussed again in Parts One and Two of this book.

2 'Life in the Elephant', p. 11.

3 Hardy's interview was published in 'How Hulton and the Hungarian Made Picture History', *Listener* (1 September 1977), p. 262. The interviews were conducted by the journalist René Cutworth and were published to accompany a BBC One documentary on *Picture Post*, written and produced by John Ormond. In the interview Hardy describes their guide to the Elephant as a West End prostitute.

4 The Situationist notion of atmospheric effects and the urban environment is beautifully considered in Guiliana Bruno, *Atlas of Emotion: Journeys in Art, Architecture, and Film* (New York: Verso, 2002).

5 Bill Brandt, *Camera in London* (London and New York: Focal Press, 1948), p. 12.

6 Ibid., pp. 20, 22. For a suggestive discussion of Marx's concept of a revolutionary atmosphere, see Ben Anderson, 'Affective Atmospheres', *Emotion, Space and Society*, 2 (2009): 77–81.

7 There is a very substantial body of work in this field and a particularly energetic debate within philosophy, geography and architectural studies. For indicative publications see Teresa Brennan, *The Transmission of Affect* (Ithaca and London: Cornell University Press, 2004); Kathleen Stewart, 'Atmospheric Attunements',

Environment and Planning D: Society and Space, special issue, 29:3 (June 2011): 445–53; Nigel Thrift, *Non-Representational Theory: Space, Politics, Affect* (London and New York: Routledge, 2008); Tonino Griffero, *Atmospheres: Aesthetics of Emotional Spaces*, trans. Sarah de Sanctis (Farnham: Ashgate, 2014); Christian Borch, ed., *Architectural Atmospheres: On the Experience and Politics of Architecture* (Basel: Birkhäuser Verlag, 2014). See also articles in the academic journal *Emotion, Space and Society*. For a particularly intelligent and perceptive discussion, see Ben Anderson, *Encountering Affect: Capacities, Apparatuses, Conditions* (Farnham: Ashgate, 2014). The Centre for the History of the Emotions at Queen Mary University of London has also generated a lot of innovative historical research in the field, see http://projects.history.qmul.ac.uk/emotions.

8 Raymond Williams, *Culture and Society 1780–1950* (London: Chatto and Windus, 1958), *The Long Revolution* (London: Chatto and Windus, 1961), *Marxism and Literature* (Oxford: Oxford University Press, 1977). For a useful discussion of 'structure of feeling' in Williams's work, see Anderson, *Encountering Affect*, pp. 105–35.

9 Williams, *Long Revolution*, p. 48.

10 Significantly, 'structure of feeling' has been used in two outstanding cultural histories of post-war migration; see Mary Chamberlain, *Narratives of Exile and Return,* rev. edn (New Brunswick, N.J.: Transaction Publishers, 2005), p. 32, and Tina M. Campt, *Image Matters: Archive, Photography, and the African Diaspora in Europe* (Durham and London: Duke University Press, 2012), p. 150.

11 Anderson, *Encountering Affect*, p. 140.

12 'Morning in the Streets' was set in the terraced streets of Liverpool; it was directed by Denis Mitchell and Roy Harris and broadcast on BBC television on 25 March 1959. Mitchell as cited in Stuart Laing, *Representations of Working-Class Life 1957–1964* (Basingstoke: Macmillan, 1986), p. 162.

13 For an interesting debate on post-war periodization, see Richard Rose, 'Periodisation in Post-War Britain', *Contemporary Record*, 6:2 (Autumn 1992): 326–40, and contributions also by Ben Pimlott and Dennis Kavanagh.

14 Peter Hennessy, *Never Again: Britain 1945–51* (London: Jonathan Cape, 1992) and *Having It So Good: Britain in the Fifties* (London: Allen Lane, 2006).

15 See, for example, '1955 – Will It Be The First Year of Peace?', *Picture Post*, 1 January 1955, pp. 3–5.

16 Macmillan's phrase is also used in the title of Dominic Sandbrook, *Never Had It So Good: A History of Britain from Suez to the Beatles* (London: Little, Brown, 2005), which the author describes as a book about the 'long sixties' that begins in 1956, p. xx. David Kynaston's detailed, multi-volume history of post-war Britain is divided into *Austerity Britain, 1945–51*, *Family Britain, 1951–57* and *Modernity Britain, 1959–62*, all published by Bloomsbury Press 2007–13. Elsewhere film historian Melanie Bell refers to the 'long 1950s', from 1945 to the early 1960s, and which she divides between 1945 and 1953 (the coronation of Queen Elizabeth II) and the 'new Elizabethan period' under the Conservative government; see her *Femininity in the Frame: Women and 1950s British Popular Cinema* (London and New York: I. B. Tauris, 2010), p. 13.

17 An observation made at the time, see 'Commercial TV: This Is It', *Picture Post*, 30 April 1955, p. 44.

18 The last conscripted servicemen left the armed forces in 1963.

19 See Pat Thane, 'Family Life and "Normality" in Postwar Britain', in Richard Bessel and Dirk Schumann, eds, *Life After Death: Approaches to a Cultural and Social History of Europe during the 1940s and 1950s* (Cambridge: Cambridge University Press, 2003), pp. 193–210.

20 Charles Madge, 'A Note on Images', first published 1951, reprinted in Mary-Lou Jennings, ed., *Humphrey Jennings: Film-Maker, Painter, Poet* (London: British Film Institute in association with Riverside Studios, 1982), p. 47.

1 The Tiger in the Smoke

1 For recent accounts of the fog of 1952, see Peter Brimblecombe, *The Big Smoke: A History of Air Pollution since Medieval Times* (London and New York: Routledge, 1988), pp. 165–6; Devra Davis, *When Smoke Ran Like Water: Tales of Environmental Deception and the*

Battle Against Pollution (Oxford: Perseus Press, 2002), pp. 49–52, and 'The Great Smog', *History Today*, 52:12 (December 2002): 2–3; *50 Years On: The Struggle for Air Quality in London since the Great Smog of December 1952* (London: Greater London Authority, 2002); Peter Thorsheim, *Inventing Pollution: Coal, Smoke, and Culture in Britain since 1800* (Athens: Ohio University Press, 2006), pp. 161–80; Christine Corton, *London Fog: The Biography* (Boston, Mass.: Harvard University Press, 2015). See also http://www.nickelinthemachine.com/2008/11/a-proper-pea-souper-the-terrible-london-smog-of-1952, accessed 28 January 2013.

2 For a discussion of the prevailing weather conditions leading up to the Great Fog, see L. C. W. Bonacina, 'An Estimation of the Great London Fog of 5–8 December 1952', *Weather: Journal of the Royal Meteorological Society*, 8 (1953): 333–4.

3 Ministry of Health, 'Mortality and Morbidity during the London Fog of December 1952', *Reports on Public Health and Medical Subjects*, 95 (London: HMSO, 1954). See also Medical Officer of Health, 'Fog and Frost in December 1952 and Subsequent Deaths in London', *Report to the Health Committee* (London: London County Council, 19 January 1953); W. P. D. Logan, 'Mortality in the London Fog Incident, 1952', *Lancet* (14 February 1953): 336–8; National Smoke Abatement Society (hereafter NSAS), *Year Book* (London: NSAS, 1953 and 1954).

4 Devra Davis suggests that mortality rates remained elevated for some time after the December episode; see *When Smoke Ran Like Water*, pp. 49, 52.

5 See 'The London Smoke Fog, December, 1952', NSAS, *Year Book* (1953), p. 29; and 'Smoke: A Mass Murderer', *Picture Post*, 31 October 1953, p. 18: 'A doctor has said that smoke is more devastating to health than cholera ever was.'

6 Ministry of Housing and Local Government, *Committee on Air Pollution, Interim Report*, Cmd 9011 (London: HMSO, 1953) and *Committee on Air Pollution, Final Report*, Cmd 9322 (London: HMSO, 1954). The Beaver Report. Para. 6 of the Beaver Report, as cited in NSAS, *Year Book* (1955), p. 35.

7 Clean Air Act, 1956. 4 & 5 Eliz II, c. 52. See J. G. Garner and R. S. Offord, *The Law on the Pollution of the Air and the Practice of its Prevention* (London: Shaw and Sons, 1957); *50 Years On*, pp. 14–15.

8 Michel de Certeau, *Heterologies: Discourse on the Other*, trans. Brian Massumi, foreword Wlad Godzich (Minneapolis and London: University of Minnesota Press, 1986) p. 8.

9 'The London Smoke-Fog', NSAS, *Year Book* (1953), p. 6.

10 Steven Connor, *The Matter of Air: Science and the Art of the Ethereal* (London: Reaktion Books, 2010), p. 176. Connor has many insightful observations on the materiality of air and its cultural meanings, to which I am indebted.

11 Bruno Latour has differentiated between *intermediaries* and *mediators*. An intermediary is an agent that carries meaning but effects no transformations. A mediator transforms, translates and modifies the elements with which it associates. See *Reassembling the Social: An Introduction to Actor-Network Theory* (Oxford: Oxford University Press, 2005), p. 39. The distinction between intermediary and mediator is also made by Latour in *We Have Never Been Modern*, trans. Catherine Porter (Cambridge, Mass.: Harvard University Press, 1993), p. 78.

12 Latour, *Reassembling the Social*, p. 79.

13 See Brimblecombe, *The Big Smoke* and *50 Years On*.

14 See Arthur C. Stern, ed., *Air Pollution: Volume 1, Air Pollution and its Effects* (London and New York: Academic Press, 1968), p. 5.

15 Luke Howard, *The Climate of London, Deduced from Meteorological Observations, Made in the Metropolis, and at Various Places Around It*, vol. 3 (London: Harvey and Darton, 1833), p. 341 [original emphasis].

16 This quality of fog is captured in John Carpenter's 1980 film, *The Fog*, in which a sea fog brings with it the vengeful ghosts from a shipwreck one hundred years earlier.

17 Charles Dickens, *Our Mutual Friend*, http://www.gutenberg.org/files/883/883-h/883-h.htm#link2HCH0034, accessed 9 October 2015.

18 Max Schlesinger, *Saunterings In and About London* (London: Nathaniel Cooke, 1853), p. 84.

19 'The Fog in London', *Lancet*, 3 January 1874, p. 28; F. J. Brodie, 'On the Prevalence of Fog in London

during the Years 1871–1890', *Quarterly Journal of the Royal Meteorological Society*, 18 (1892): 40–5; Bill Luckin, '"The Heart and the Home of Horror": The Great London Fogs of the Late-Nineteenth Century', *Social History*, 28:1 (January 2003): 31–48; Thorsheim, *Inventing Pollution*, 20–30.

20 See G. Hartwig, *The Aerial World: A Popular Account of the Phenomena and Life of the Atmosphere* (London: Longman and Green, 1877), pp. 135–41.

21 Rollo Russell, *Smoke in Relation to Fogs in London: A Lecture Delivered under the Auspices of the National Smoke Abatement Institution* (London: National Smoke Abatement Institution, 1888), pp. 31–2 and 21–2.

22 Russell, *Smoke*, p. 37.

23 Arthur Conan Doyle, 'The Adventure of the Bruce-Partington Plans' (1908), www.gutenberg.org/files/2346/2346-h/2346-h.htm, accessed 27 October 2011. See also Arthur Conan Doyle, 'The Sign of the Four' (1890), www.gutenberg.org/files/2097/2097-h/2097-h.htm. Robert Louis Stevenson, *Strange Case of Dr. Jekyll and Mr. Hyde* (1886), esp. ch. 4 'The Carew Murder Case', www.gutenberg.org/cache/epub/42/pg42.html. See also J. Jackson Wray, *Will It Lift? The Story of a London Fog* (London: James Nisbet and Co.: 1888) and J. J. Sheppard, *The Romance of a London Fog* (London: Simpkin Marshall and Co., 1898).

24 Henry James, 'London' (1888), in *English Hours* (London: William Heinemann, 1905), p. 16.

25 Ibid., p. 32.

26 On the ambiguity of fog, see Craig Martin, 'Fog-Bound: Aerial Space and the Elemental Entanglements of Body-*With*-World', *Environment and Planning D: Society and Space*, 29:3 (June 2011): 454–68.

27 H. A. Des Voeux, 'London Fogs', letter to *The Times*, 27 December 1904, p. 11.

28 See Henry T. Bernstein, 'The Mysterious Disappearance of Edwardian London Fog', *London Journal: A Review of Metropolitan Society Past and Present*, 1:2 (1975): 189–206; Brimblecombe, *The Big Smoke*, pp. 110–12; Thorsheim, *Inventing Pollution*, pp. 128–30. See also F. J. Brodie, 'Decrease in London Fog in Recent Years', *Quarterly Journal of the Royal Meteorological Society*, 31 (1905): 15–28.

29 L. C. Bonacina, 'London Fogs – Then and Now', *Weather: A Monthly Magazine for All Interested in Meteorology*, 5 (1950): 91. See also NSAS, *Smoke Prevention in Relation to Initial Post-War Reconstruction* (London: NSAS, n.d. [*c.*1942]), p. 2.

30 Michel de Certeau, 'The Theater of the *Quidproquo*', in *Heterologies*, p. 67. The altered phrases are italicized and in parentheses.

31 C. J. Jung, *The Structure and Dynamics of the Psyche*, vol. 8 of *The Collected Works*, as cited in Valdine Clemens, *The Return of the Repressed: Gothic Horror from 'The Castle of Otranto' to 'Alien'* (Albany: State University of New York, 1999), p. 2.

32 For a general history of the post-1945 period, see Arthur Marwick, *British Society since 1945* (London: Pelican, 1982).

33 Announcement by the National Coal Board, *Picture Post*, 6 December 1952, p. 51. By the time *Picture Post* carried the announcement that after 1 December nutty slack was off the ration, London was already in the middle of the smog that it had created. See also 'Worst Fog in Memory', *Picture Post*, 3 January 1953, p. 34, and Thorsheim, *Inventing Pollution*, p. 161.

34 There are many histories and critiques of the 'origins' of photography; my interest here is not to engage with this debate but to emphasize the importance of sunlight within that historiography. See Graham Clarke, *The Photograph* (Oxford and New York: Oxford University Press, 1997) for a clear introduction. For a longer history of optical illusion and screen practice that includes early photography, see Laurent Mannoni, *The Great Art of Light and Shadow: Archaeology of the Cinema*, trans. and ed. Richard Crangle (Exeter: Exeter University Press, 2000). My thanks to Noam Gal, Curator of Photography at the Israel Museum, for his comments on photography and the physical conditions of visibility and for his paper, 'Photography Heliocritically', at 'Topics in Modern and Contemporary Art and Visual Culture', Ben-Gurion University of the Negev, 22–23 May 2013.

35 See William Henry Fox Talbot, *Sun Pictures in Scotland* (London: n.p., 1845).

36 'The Day That Never Broke', photographed by Bill Brandt, *Picture Post*, 18 January 1947, p. 31. For

an excellent essay on Brandt's melancholy aesthetics in the second half of the 1940s, see David Mellor, 'Brandt's Phantasms', in Bill Brandt, *Behind the Camera*, intro. Mark Haworth-Booth (New York: Aperture, Philadelphia Museum of Art, 1985), pp. 71–97.

37 The Reith Lectures is an annual series of radio lectures broadcast by the BBC. Named after the BBC's first director-general, Sir John Reith, the series was inaugurated in 1948. Pevsner's lectures were broadcast weekly between 16 October and 27 November 1955. For an excellent biography of Pevsner, see Susie Harries, *Nikolaus Pevsner: The Life* (London: Chatto and Windus, 2011) and for a useful discussion of key aspects of his work, see Peter Draper, ed., *Reassessing Nikolaus Pevsner* (Aldershot: Ashgate, 2004).

38 As cited in Harries, *Pevsner*, p. 97.

39 Nikolaus Pevsner, *The Englishness of English Art* (London: Architectural Press, 1956), pp. 13, 14, 152, 168. Pevsner's Reith Lectures were first published by the BBC in 1955; the Architectural Press was the parent company of the *Architectural Review*, to which Pevsner was a frequent contributor and editor 1943–5. The 1956 publication was an expanded and annotated version of the lectures, the work for which was begun in 1941–2 as a course of lectures for Birkbeck College, where he taught.

40 Nikolaus Pevsner, *Visual Planning and the Picturesque*, ed. Mathew Aitchison (Los Angeles: Getty Research Institute, 2010), p. 85. He also admired the coarse granularity of the cloister of Corpus Christi, Oxford, p. 61.

41 Gilles Deleuze, *Cinema I: The Movement Image*, trans. Hugh Tomlinson and Barbara Habberjam (London: Athlone Press, 1986), 111. Deleuze associates these qualities with the shadows of expressionist cinema, which, he argues, creates disconnected and emptied spaces, or 'any-space-whatever'.

42 Margery Allingham, *The Tiger in the Smoke*, first published London: Chatto and Windus, 1952 (London: Penguin Books, 1957 – page references are to this edition). For other crime novels set in the fog around 1952, see Arthur Gask, *Night and Fog* (London: Herbert Jenkins, 1951); John Newton Chance, *Screaming Fog* (London: Macdonald and Co., 1952); Christi-anna Brand, *London Particular* (London: Hodder and Stoughton, 1958). Films include *Lady in the Fog* (UK, 1952; dir. Sam Newfield); *Footsteps in the Fog* (UK, 1955; dir. Arthur Lubin); *23 Paces to Baker Street* (USA, 1956; dir. Henry Hathaway).

43 Arthur Conan Doyle, 'The Adventures of the Bruce-Partington Plans', p. 2.

44 The description of the fog as khaki-coloured and uncanny appears in other crime novels of the period; see, for example, Brand, *London Particular*, p. 1: 'The dank grey fog was like an army blanket, held pressed against the windows of the car . . . A bus crept by, a ghost bus, a-glimmer with eerie lights.' See also John Bude, *The Night the Fog Came Down* (London: Macdonald, 1958), p. 123.

45 The ex-servicemen's band was a feature of postwar street life; in the Mass Observation description of a Sunday in Petticoat Lane market, the band is part of the cacophony of sound, along with the shouts of the street traders, the sound of radios and the crowds; see Mass Observation, *Meet Yourself On Sunday* (London: Naldrett Press, 1949), p. 41. This report is discussed in detail in Chapter Eight. For a discussion of the street band as 'a troupe of almost Victorian street beggars', see Charlotte Brunsdon, *London in Cinema: The Cinematic City since 1945* (London: British Film Institute, 2007), pp. 46–7.

46 On Freud's notion of the *unheimlich* in relation to the spatial uncanny, see Anthony Vidler, *The Architectural Uncanny: Essays in the Modern Unhomely* (Cambridge, Mass. and London: MIT Press, 1992).

47 Barbara Beauchamp, *The Girl in the Fog* (London: Hodder and Stoughton, 1958), p. 51.

48 'Fug Preferable to Fog', *Kinematograph Weekly*, 12 February 1953, p. 10.

49 Interview with Oswald Morris in Simon Brown, Sarah Street and Liz Watkins, eds., *British Colour Cinema: Practices and Theories* (Basingstoke: Palgrave Macmillan, 2013), p. 74.

50 Sigmund Freud, 'The Uncanny' (1919), as cited in Vidler, *Architectural Uncanny*, p. 23.

51 M. H. Dziewicki, 'In Praise of London Fogs', *Nineteenth Century*, 26 (December 1889): 1054–5.

52 NSAS, *Year Book* (1954), p. 7.

53 Derek Wragge Morley, 'Can Man Survive the Hydrogen Bomb?', *Picture Post*, 18 February 1950, p. 36. See also John Stobbs, 'Civil Defence: Do We Need It?', *Picture Post*, 4 October 1952, pp. 27–9, including a model of the ruins of an English town following an atomic attack.

54 'Clean Air', NSAS, *Year Book* (1958), p. 36.

55 British Colour Council, *Dictionary of Colour Standards*, 2nd edn, vol. 1 (London: British Colour Council, 1951), passim. Advertisement for Robbialac paints in *Architectural Review* (January 1955), p. xxxix; 'The Collections', *Tailor and Cutter & Women's Wear*, 10 February 1950, p. 165.

56 Arnold Marsh, *Smoke: The Problem of Coal and the Atmosphere* (London: Faber and Faber, 1947), pp. 77, 111, 109. The phrase 'aerial slum' is quoted from the *Manchester Guardian*.

57 'Smoke: A Mass Murderer', *Picture Post*, 31 October 1953, p. 16, and 5 December 1953, p. 19.

58 *Pandaemonium* was first published by André Deutsch; the new edition, with a foreword by Frank Cottrell Boyce, is cited here. Humphrey Jennings, *Pandaemonium 1660–1886: The Coming of the Machine as Seen by Contemporary Observers*, ed. Marie-Lou Jennings and Charles Madge (London: Icon Books, 2012). See the essay by Marie-Lou Jennings, 'Humphrey Jennings and this Book', pp. xx–xxviii, on which the following short biographical notes are based. Attention was drawn to Jennings's book when film director Danny Boyle cited it as the source for the Opening Ceremony of the 2012 London Olympics, for which he was the artistic director. One of the most memorable sequences in the ceremony was the depiction of the industrial revolution and the erection of four tall industrial chimneys in the Olympic stadium. For a reading of Jennings's work through the filter of the 2012 Olympics Ceremony, see Jennifer Tucker, 'Picturing Modernization: Vision, Modernity and the Technological Image in Humphrey Jennings's *Pandaemonium*', lecture given at Birkbeck, University of London, 9 March 2016. My thanks to Jennifer Tucker for discussion about *Pandaemonium* and the history of industrialization.

59 Jennings, *Pandaemonium*, pp. xiii–xiv [original emphasis].

60 See 'Lowry and the Painting of Modern Life', Tate Britain, London, 26 June – 20 October 2013; also T. J. Clark and Anne M. Wagner, *Lowry and the Painting of Modern Life* (London: Tate Publishing, 2013). Howard Spring, 'The World of L. S. Lowry', *The Saturday Book*, 17 (1957), p. 228. On the particular aesthetic of English romantic modernism, see Alexandra Harris, *Romantic Moderns: English Writers, Artists and the Imagination from Virginia Woolf to John Piper* (London: Thames and Hudson, 2010).

61 The benefits of winter 'sunbathing' and domestic use of sunlamps were advertised throughout the period; see, for example, advertisement for 'Homesun' lamps, *Picture Post*, 15 February 1947, p. 2.

62 British Colour Council, *Dictionary of Colours for Interior Decoration: Including a List of Names and the History of Colours Illustrated in the Two Companion Volumes*, vol. 3 (London: British Colour Council, 1949), p. xv. The racialized discourse of colour in the post-war period is discussed at length in Part Two.

63 On the Public Health Act of 1936, see J. F. Garner and R. S. Offord, *The Law on the Pollution of the Air and the Practice of its Prevention* (London: Shaw and Sons, 1957), pp. 5–6.

64 The phrase 'optical epistemology' is taken from de Certeau's critique of Foucault's theory of power as figured in the panopticon in 'Micro-Techniques and Panoptic Discourse', de Certeau, *Heterologies*, p. 187.

65 Ibid., p. 20.

2 Broken Buildings and 'Horrid Empty Spaces'

1 Georg Simmel, 'The Ruin' (1911), in Kurt H. Wolff, ed., *Essays on Sociology, Philosophy and Aesthetics* (New York: Harper and Row, 1965), pp. 259–66. On the ruin as liberating matter from its subservience to form, see also Robert Ginsberg, *The Aesthetics of Ruins* (Amsterdam and New York: Rodopi, 2004).

2 On photography as the pre-eminent medium of ruins, see, for example, Alan Trachtenberg, 'Albums of War: On Reading Civil War Photographs', *Representations*, 9 (Winter 1985): 1–32; Charles Merewether, 'Traces of Loss', in Michael S. Roth with Claire

Lyons and Charles Merewether, *Irresistible Decay: Ruins Reclaimed* (Los Angeles: Getty Research Institute, 1997), pp. 25–40; Julia Hell and Andreas Schönle, 'Introduction', in Hell and Schönle, eds., *Ruins of Modernity* (Durham and London: Duke University Press, 2010), pp. 1–14.

3 W. G. Sebald, 'Air War and Literature: Zürich Lectures', in *On the Natural History of Destruction*, trans. Anthea Bell (London: Hamish Hamilton, 2003), p. 37.

4 Walter Benjamin, 'Theses on the Philosophy of History', in *Illuminations*, ed. and with an introduction by Hannah Arendt, trans. Harry Zohn (London: Fontana/Collins, 1973), pp. 259–60.

5 On the use of greyscale by artists such as Alberto Giacometti and Isabel Rawsthorne as an 'anti-ideal' aesthetic, see the excellent essay by Carol Jacobi, '"A Kind of Cold War Feeling" in British Art, 1945–52', in Catherine Jolivette, ed., *British Art in the Nuclear Age* (Farnham: Ashgate, 2014), pp. 19–50.

6 Bill Brandt, *Camera in London* (London and New York: Focal Press, 1948), p. 11. Bert Hardy was one of a number of *Picture Post* staff who thought Brandt's work high in contrast; see Bert Hardy, *Bert Hardy: My Life* (London and Bedford: Gordon Fraser, 1985), p. 104.

7 Wilson Hicks, *Words and Pictures: An Introduction to Photojournalism* (New York: Harper & Bros, 1952), p. 140.

8 Alan Trachtenberg describes black and white news photography as the 'most formative process' of the 1950s in 'Picturing History in the Morgue', in Douglas Dreishpoon and Alan Trachtenberg, eds, *The Tumultuous Fifties: A View from the 'New York Times' Photo Archives* (New Haven and London: Yale University Press, 2001), p. 22.

9 The literature on post-war reconstruction is extensive; the following have been particularly helpful in the context of rebuilding bombed areas: Jumichi Hasegawa, *Replanning the Blitzed City Centre: A Comparative Study of Bristol, Coventry and Southampton 1941–1950* (Buckingham and Philadelphia: Open University Press, 1992); Nick Tiratsoo, 'The Reconstruction of Blitzed British Cities 1945–55: Myths and Reality', *Contemporary British History*, Special Issue: Planning, Politics and Housing in Britain, 14:1

(Spring 2000): 27–44; Nicholas Bullock, *Building the Post-War World: Modern Architecture and Reconstruction in Britain* (London and New York: Routledge, 2002); Peter J. Larkham and Joe Nasr, eds., *The Rebuilding of British Cities: Exploring the Post-Second World War Reconstruction*, proceedings of a workshop sponsored by the Faculty of the Built Environment and the International Planning History Society (Birmingham: University of Central England and School of Planning and Housing, 2004). The destruction of German cities by British Bomber Command has also been the subject of many recent studies; see, for example, Sebald, 'Air War'; Robert G. Moeller, 'On the History of Man-Made Destruction: Loss, Death, Memory and Germany in the Bombing War', *History Workshop Journal*, 61 (Spring 2006): 103–34. The question of housing in Britain after the war is discussed in further detail in Chapter Seven.

10 On the interest in ruins during the war years, see Mark B. Pohlad, 'The Appreciation of War Ruins in Blitz-Era London', *London Journal*, 30:2 (2005): 2–24; Neil Matheson, 'National Identity and the "Melancholy of Ruins": Cecil Beaton's Photographs of the London Blitz', *Journal of War and Cultural Studies*, 1:3 (2008): 261–74.

11 J. M. Richards, ed., *The Bombed Buildings of Britain: A Record of Architectural Casualties: 1940–1*, with notes by John Summerson (Cheam: Architectural Press, 1942), p. 3; second edition *The Bombed Buildings of Britain: Recording the Architectural Casualties Suffered during the Whole Period of Air Bombardment* (London: Architectural Press, 1947), p. 7.

12 Richards, *Bombed Buildings*, 1942, p. 2; 1947, p. 7.

13 G. W. Stonier, *Round London with the Unicorn* (London: Turnstile Press, 1951), p. 41.

14 Hugh Casson, *Bombed Churches as War Memorials* (Cheam: Architectural Press, 1945). See also Bill Brandt's photographs of the churches in 'Ruins for Remembrance', *Picture Post*, 22 June 1946, p. 23. The artist and writer John Piper was a great advocate of the aesthetics of ruin and the incorporation of ruined buildings in post-war development schemes; see 'Pleasing Decay', *Architectural Review* (September 1947): 85. On the movement for the preservation of bomb-

ruined churches, see Christopher Woodward, *In Ruins* (London: Chatto and Windus, 2001), pp. 205–26, and Robert Bevan, *The Destruction of Memory: Architecture at War* (London: Reaktion, 2006), p. 191; Kitty Hauser, *Shadow Sites: Photography, Archaeology and the British Landscape 1927–1955* (Oxford: Oxford University Press, 2007), pp. 231–54. Coventry Cathedral is perhaps the most well-known post-war example of bombed ruins being integrated into the new design.

15 Rose Macaulay, *Pleasure of Ruins* (London: Weidenfeld and Nicolson, 1953), pp. 370, 453. The phrase 'Ruin Lust' (from the German *Ruinelust*) was recently used by Tate Britain as the title for its exhibition on the history of ruination in art, 4 March – 18 May 2014.

16 In the second edition of *Bombed Buildings* (1947) J. M. Richards adds: 'as the appearance of the ruins that once occupied so many cleared or rebuilt sites fades from memory, the documentary interest of these pictures may increase, and one day we may even need reminding of the intensely romantic character that the manner of their destruction brought to bomb ruins, and of their poignancy, which was of a kind not possessed by ruins that have undergone a slower, more merciful process of dismemberment and decay'. (p. 5)

17 'Housing: London Shows How', *Picture Post*, 22 January 1949, p. 7.

18 John Piper, 'Pleasing Decay', p. 93.

19 This issue included Piper's essay 'Pleasing Decay' (September 1947): 85–94, which was reprinted in his collection of essays, *Buildings and Prospects* (London: Architectural Press, 1948), pp. 89–116. In the December 1947 issue, *Architectural Review* published a photo-essay on 'Time, Weather and Sculpture', pp. 206–7.

20 For a recent examination of Auerbach's career, see *Frank Auerbach*, Tate Britain, London, 9 October 2015 – 13 March 2016. For an excellent discussion of his building site paintings, see Barnaby Wright, 'Creative Destruction: Frank Auerbach and the Rebuilding of London', in Barnaby Wright, ed., *Frank Auerbach: London Building Sites 1952–62*, Courtauld Gallery, London, 16 October 2009 – 17 January 2010 (London: Courtauld Gallery in association with Paul Holberton Publishing,

2009). John Minton's wartime paintings of bomb ruins with young men are discussed in Chapter Six.

21 Interview with Barnaby Wright, 2009, in Wright, 'Creative Destruction', p. 14.

22 Neville Wallis reviewing Auerbach's 1959 exhibition at the Beaux Arts Gallery, as cited in Wright, 'Creative Destruction', p. 22.

23 Rose Macaulay, *The World My Wilderness*, first published 1950 (London: Virago, 1983), pp. 128–9.

24 For example, David Bailey's photographic study of the *East End* in 1961 shows children playing in rubble sites; see *Bailey's Stardust*, National Portrait Gallery, London, 6 February – 1 June 2014, and Don McCullin's photo-essay 'East of Aldgate', *Man About Town*, 2:2 (February 1961): 16–25, also gives a dramatic glimpse of the bombed sites that remained in these years. On the slow progress of rebuilding in this period, see Tiratsoo, 'Reconstruction', pp. 27–44; Peter J. Larkham, 'The Reconstruction Plans', in Larkham and Nesr, *Rebuilding*, pp. 1–14; Catherine Flinn, 'Reconstruction Constraints: Political and Economic Realities', in Mark Clapson and Peter J. Larkham, eds., *The Blitz and its Legacy: Wartime Destruction to Post-War Reconstruction* (Farnham: Ashgate, 2013), pp. 87–97.

25 Cited in Tiratsoo, 'Reconstruction', p. 30.

26 The *Illustrated London News* celebrated the wild flowers of the City of London in a special colour supplement 19 June 1954, pp. II, III.

27 HM Treasury, Final Settlement of War Damage Payments, Cmnd 1583 (London: HMSO, 1961), pp. 5, 3. In the year 1960–1 there were still outstanding claims amounting to £8,500,000 and provision for 'clearance payments' (for clearing remains from 'total loss' sites) was continued.

28 Lella Secor Florence, in 'Environment: Sex and the Citizen', *Picture Post*, 6 October 1951, p. 43. *Cosh Boy* was one of the first British films to receive an 'X' certificate. The film was criticized for glamourizing violence and *Picture Post* debated whether it could affect the behaviour of its adolescent audiences, 28 February 1953, pp. 15–17, 18. 'The Best and Worst of Britain (5)', *Picture Post*, 2 January 1954, p. 33. Graham Greene's short story 'The Destructors' was serialized in *Picture Post* in the summer of 1954 (24 July, pp. 36–8; 31

July, pp. 29, 45). It tells the story of the Wormsley Gang, who spend their days in a makeshift car park created on the site of the 'last bomb of the blitz' and who systematically destroy the last remaining dwelling, a historic bomb-damaged house occupied by an old man, until it is no more than the rubble that surrounds it. For an excellent discussion of the subversive and nonconformist forms of life in this landscape, see Jennifer V. Evans, *Life Among the Ruins: Cityscape and Sexuality in Cold War Berlin* (New York: Palgrave Macmillan, 2011).

29 Michael Banton, *The Coloured Quarter: Negro Immigrants in an English City* (London: Jonathan Cape, 1955), p. 81. Banton's work is discussed in detail in Chapter Six. Henry Bond discusses the shocking 1955 police scene of crime photographs of a murder victim in south London in the 'abject environment' of a bombsite in *Lacan at the Scene* (Cambridge, Mass., and London: MIT Press, 2009), p. 65. For the opposition of the spiv and the planner in relation to spatial order and disorder, see Richard Hornsey, *The Spiv and the Architect: Unruly Life in Postwar London* (Minneapolis and London: University of Minnesota Press, 2010).

30 See Dylan Trigg, *The Aesthetics of Decay: Nothingness, Nostalgia and the Absence of Reason* (New York: Peter Lang, 2006) and *The Memory of Place: A Phenomenology of the Uncanny* (Athens: Ohio University Press, 2012). *Terrain vague* is defined by Ignasi de Solà-Morales, 'Terrain Vague', in Manuela Mariani and Patrick Barron, eds, *Terrain Vague: Interstices at the Edge of the Pale* (London and New York: Routledge, 2014), p. 26.

31 The Museum of London now has seven of the original ten watercolours in their collection. The double-page engraving suggests how the sequence might have been intended, although it does not fully work as a continuous 360-degree view. See 'Before the Rebuilding: The Full Circle of War-Scarred London Drawn from St. Paul's; a Magnificent Record by Lawrence Wright – At the London Museum', *Illustrated London News*, 10 November 1956, pp. 800–1. My thanks to Dr Pat Hardy, Curator of Paintings, Prints and Drawings at the Museum of London, for showing and discussing with me the seven works in the collection. See also *Devastated London: The Bombed City as Seen from a Barrage Balloon*, drawn by Cecil Brown,

with notes by Ralph Hyde (London: Topographical Society, 1990). Brown's aerial view was completed in 1945 and was widely reproduced, including in the *Builder* (1947) and in the *Illustrated London News* (1949).

32 William Kent, *The Lost Treasures of London* (London: Phoenix House, 1947), p. 32 and passim.

33 'Vanished London: The Changed Face of the Great City Where Today Signboards Indicate the Sites of Once-Familiar Buildings', *Illustrated London News*, 28 February 1948, pp. 236–7; this double-page piece was one of other, similar photo-spreads published by the paper during these years and depicting bombed ruins throughout Europe and Japan.

34 There is a substantial literature on the Surrealist and Situationist city; I have found the following most helpful: Simon Sadler, *The Situationist City* (Cambridge, Mass.: MIT Press, 1998); Raymond Spiteri, 'Surrealism and the Irrational Embellishment of Paris', in Thomas Mical, ed., *Surrealism and Architecture* (London and New York: Routledge, 2005), pp. 191–208; M. Stone-Richards, 'Latencies and Imago: Blanchot and the Shadow City of Surrealism', in Mical, *Surrealism*, pp. 249–72; Leo Mellor, *Reading the Ruins: Modernism, Bombsites and British Culture* (Cambridge and New York: Cambridge University Press, 2011).

35 Grace Robertson as cited in Juliet Gardiner, *Picture Post Women* (London: Collins and Brown, 1993), p. 128; George Lamming's reference to old copies in a basement barber shop is discussed in Chapter Six. In 1952 B. Seebohm Rowntree and G. R. Lavers suggested that *Picture Post* had 9,560,000 readers per week: *English Life and Leisure: A Social Study* (London, New York and Toronto: Longmans, Green and Co., 1952), p. 297. There are a number of histories of *Picture Post*; see, for example, Tom Hopkinson, 'Introduction', in Hardy, *Bert Hardy*, pp. 7–13; Michael Hallett, '*Picture Post*: An Essentially English Aroma', *Photographic Journal* (October 1998): 380–2; David Joseph Marcou, *All the Best: Britain's 'Picture Post' Magazine; Best Mirror and Old Friend to Many, 1938–57* (LaCrosse, Wis.: Digi-COPY, 2013).

36 Stuart Hall, 'The Social Eye of *Picture Post*', *Working Papers in Cultural Studies*, 2 (Spring 1972): 72. See also Stuart Hall, 'Media and Message: The Life and

Death of *Picture Post*', *Cambridge Review*, 91/92 (19 February 1971): 140–4.

37 Hardy, *Bert Hardy*, p. 25.

38 As cited in René Cutworth, 'How Hulton and the Hungarian Made Picture History', *Listener* (1 September 1977), p. 263.

39 As cited in Hallett, '*Picture Post*', p. 382; on the impact on photo-news weeklies of competition from television, see 'Editorial Notes', *Penrose Annual: A Review of the Graphic Arts*, 53 (1959): xxx.

40 Hall, 'Social Eye', p. 74.

41 Details of the editors and staff at *Picture Post* are given in Marcou, *All the Best*, ch. 26; ebook accessed 15 January 2015.

42 Brian Dowling, 'The Best, and the Worst, of British Cities: 4 Birmingham', *Picture Post*, 6 February 1954, p. 30. This photograph resembles the landscape and groups of children in Hardy's images for 'Millions Like Her', and it is possible that the art editor was reusing photographs from the earlier shoot for this later article.

43 Hicks, *Words and Pictures*, p. 6.

44 Harold Evans, *Pictures on a Page: Photo-journalism, Graphics and Picture Editing*, Book IV in the series on Editing and Design, published under the auspices of the National Council for the Training of Journalists (London: Heinemann, 1978), p. 13. Stuart Hall suggests that the 'historicity' of *Picture Post*'s black and white photography 'may have been present to the contemporary reader': 'Social Eye', p. 86.

45 Andrew Spicer, *Film Noir* (Harlow: Pearson, 2002), p. 4; on exterior city locations see p. 67. The British film *It Always Rains on Sunday* (1947) is usually described as a British film noir and is discussed in Chapter Eight. The first extended study of film noir was Raymond Borde and Etienne Chaumeton's *Panorama du film noir américain 1941–1953* (1955), trans. Paul Hammond, *A Panorama of American Film Noir 1941–1953* (San Francisco: City Lights Books, 2002).

46 The company changed its name as it underwent different mergers throughout the twentieth century; its history is given in its excellent website www.sun-printershistory.com/history.html, accessed 11 March 2014. See also Peter Greenhill and Brian Reynolds,

The Way of the Sun: The Story of Sun Engraving and Sun Printers (Claremont, Ont.: True to Type Books, 2010).

47 The best source on printing techniques in this period is the excellent J. R. Biggs, *Illustration and Reproduction* (London: Blandford Press, 1950). See also Frederick A. Horn, 'The Picture and Press Advertising', *Penrose Annual*, 49 (1955): 62–4; Richard Benson, *The Printed Picture* (New York: Museum of Modern Art, 2008). My thanks to Dr Tom Gretton for his immensely helpful and enjoyable tutorial on post-war magazine printing.

48 See V. G. W. Harrison, 'The "Finish" of Printing Papers', *Penrose Annual*, 44 (1950): 134–40. Paper rationing in Britain was introduced in 1940 and continued until 1949. Immediately after the end of the war there was a small increase in paper ration to periodicals, which was reported in *Picture Post*, along with enlarged issues due to planning the ration and a further increase in the ration in November 1948. The quality of the paper remained poor compared to pre-war papers.

49 Biggs, *Illustration*, p. 128.

50 Michael Balint, 'Friendly Expanses – Horrid Empty Spaces', *International Journal of Psycho-Analysis*, 36 (1955): 225–41. I am most grateful to the following research paper that introduced me to Balint's essay, Shaur Bar-Haim, 'Regressive States as Social Indicators in 1950s Britain', Psychoanalysis and History Seminar, Institute of Historical Research, London, 29 February 2012. On British Object Relations from the 1930s to the 1980s, see Jill Savage Scharff, 'The British Object Relations Theorists: Fairbairn, Winnicott, Balint, Guntrip, Sutherland and Bowlby', in Martin S. Bergmann, ed., *Understanding Dissidence and Controversy in the History of Psychoanalysis* (New York: Other Press, 2004), pp. 175-200. Balint's involvement in the Family Discussion Bureau is discussed in Chapter Nine.

51 Evans, *Life Among the Ruins*, p. 59. For an excellent exploration of post-war writing and visual culture in relation to topography and anxiety, see Lyndsey Stonebridge, *The Writing of Anxiety: Imagining Wartime in Mid-Century British Culture* (Basingstoke and New York: Palgrave Macmillan, 2007).

52 See Charles Merewether, 'Traces of Loss', in Roth, Lyons and Merewether, *Irresistible Decay*, pp. 25–40.

53 Jacqueline Rose, *Why War? Psychoanalysis, Politics and the Return to Melanie Klein* (Oxford: Blackwell, 1993), p. 170.

54 A helpful source on Klein's work is Lyndsey Stonebridge and John Phillips, eds., *Reading Melanie Klein* (London and New York: Routledge, 1998). Also Melanie Klein, Paula Heimann and R. E. Money-Kyrle, eds., *New Directions in Psycho-Analysis: The Significance of Infant Conflict in the Pattern of Adult Behaviour* (London: Tavistock, 1955), and Hanna Segal, *Introduction to the Work of Melanie Klein* (London: Hogarth Press, 1973).

55 Melanie Klein, *Narrative of a Child Analysis: The Conduct of the Psycho-Analysis of Children as Seen in the Treatment of a Ten-year-old Boy*, with a Foreword by Elliott Jacques, first published 1961 (London: Vintage, 1998), p. 74. My thanks to Professor Daniel Pick and Dr Lesley Hall for correspondence about this material.

56 See Donald Winnicott, *The Ordinary Devoted Mother and her Baby: Nine Broadcast Talks (Autumn 1949)* (London: 'Pamphlet', 1950). The implications of this material for the image of the 'ordinary . . . good enough' mother are discussed in Chapter Nine.

57 Donald Winnicott, 'Anxiety Associated with Insecurity' (1952), in *Collected Papers: Through Paediatrics to Psycho-Analysis* (London: Tavistock, 1958), pp. 97–100.

58 Balint, 'Friendly Expanses', p. 228 and passim.

59 In this passage Segal is writing about Proust, 'A Psycho-Analytical Approach to Aesthetics', in Klein, Heimann and Money-Kyrle, *New Directions*, p. 390. The British writer and art critic Adrian Stokes also drew on Klein's work in these post-war years to account for the pleasures of art, architecture and urban space; see, for example, *Inside Out: An Essay in the Psychology and Aesthetic Appeal of Space* (London: Faber and Faber, 1947) and *Smooth and Rough* (London: Faber and Faber, 1951), which are discussed in Chapter Four.

60 Winifred Bryher, *The Days of Mars: A Memoir 1940–1946* (London: Calder and Boyars, 1972), p. 150.

3 To Let in the Sunlight

1 Marghanita Laski, *The Victorian Chaise-Longue*, first published 1953 (London: Persephone Books,

1999), p. 16 (page references hereafter given in parentheses within the text).

2 All quotes in this paragraph are from Michel de Certeau, 'Psychoanalysis and its History', in *Heterologies: Discourse on the Other*, trans. Brian Massumi, foreword Wlad Godzich (Minneapolis and London: University of Minnesota Press, 1986), p. 4.

3 See Frank Mort's excellent article 'Scandalous Events: Metropolitan Culture and Moral Change in Post-Second World War London', *Representations*, 93 (Winter 2006): 106–37; Mort's discussion of Victorianism in this article in relation to the John Christie murders is elaborated in *Capital Affairs: London and the Making of the Permissive Society* (New Haven and London: Yale University Press, 2010).

4 Frank Mort, 'Modernity and Gaslight: Victorian London in the 1950s and 1960s', in Gary Bridge and Sophie Watson, eds., *The New Blackwell Companion to the City* (Chichester: Wiley-Blackwell, 2011), p. 432. On the continuities between the nineteenth century and the second half of the twentieth century, see Mica Nava and Alan O'Shea, 'Introduction', in Nava and O'Shea, eds., *Modern Times: Reflections on a Century of English Modernity* (London and New York: Routledge, 1996), pp. 1–6, and Peter Mandler and Susan Pedersen, eds., *After the Victorians: Private Conscience and Public Duty in Modern Britain* (London and New York: Routledge, 1994).

5 Mort, 'Scandalous Events', p. 123.

6 Beveridge referred to these as the 'five giants on the road of reconstruction'; see http://www.beveridgefoundation.org/sir-william-beveridge/1942-report, accessed 13 November 2015. On the wartime debate on social reconstruction, see Nicholas Bullock, *Building the Post-War World: Modern Architecture and Reconstruction in Britain* (London and New York: Routledge, 2002).

7 On *Scrooge* (UK, 1951; dir. Brian Desmond Hurst) see Jeffrey Richards, *Films and British National Identity: From Dickens to Dad's Army* (Manchester and New York: Manchester University Press, 1997), p. 341.

8 De Certeau, 'Psychoanalysis and History', p. 4.

9 For reports on post-war housing conditions, see General Register Office, *Census 1951: England and*

Wales; General Report (London: HMSO, 1958); passim. Housing and homes are discussed in greater detail in Part Three.

10 'Housing: London Shows How', *Picture Post*, 22 January 1949, p. 7. On the spatial management of post-war public space, see Richard Hornsey, *The Spiv and the Architect: Unruly Life in Postwar London* (Minneapolis and London: University of Minnesota Press, 2010).

11 'Best and Worst of Britain – 5: Heroes and Spivs', *Picture Post*, 2 January 1954, pp. 34–5.

12 G. W. Stonier, *Round London with the Unicorn* (London: Turnstile Press, 1951), p. 18.

13 Barbara Jones, *The Unsophisticated Arts* (London: Architectural Press, 1951), p. 10. Jones's interest in mass-produced popular arts is discussed further in Chapter Six.

14 John Hadfield, 'Introduction', *The Saturday Book*, 17 (1957), p. 5.

15 See Charles Spencelayh, *A Lover of Dickens*, 1947 (Oldham Gallery). Lean's film adaptations of Dickens are discussed in the following section.

16 For a useful summary of Brandt's life and work, see Mark Haworth-Booth, 'Introduction', in Bill Brandt, *Behind the Camera*, essay David Mellor (New York: Aperture, 1985) pp. 9–71.

17 'Our Contributors', *Lilliput* (February 1949), p. 124.

18 David Mellor, 'Brandt's Phantasms', in Brandt, *Behind the Camera*, p. 89. I am indebted to Mellor's evocative reading of Brandt's work in the post-war period.

19 Bill Brandt, *Literary Britain*, photographed by Bill Brandt, with an introduction by John Hayward (London: Cassell, 1951), no. 7. See also no. 35, 'Cooling Graveyard' in Kent, a site that is widely believed to have been the inspiration for the graveyard scene in Charles Dickens, *Great Expectations*.

20 Review from the *Eastern Daily Press*, 14 June 1940, as cited in programme notes and credits, compiled by the BFI Documentation Unit. For other Victorian costume dramas, see, for example, *Pink String and Sealing Wax* (UK, 1945; dir. Robert Hamer) and *Footsteps in the Fog* (UK, 1955; dir. Arthur Lubin).

21 On 'The Haunted Mirror' episode, see Charles Barr, *Ealing Studios*, 3rd edn (Berkeley, Los Angeles and London: University of California Press, 1998), pp. 55–7, and Mick Conefrey, dir., John Wyver and Michael Jackson, prod., 'Flames of Passion: The Other Side of British Cinema', *Arena*, 2007, a film which offers a fascinating study of the aesthetics and themes of British film in the period.

22 The screenplay was written by Graham Greene and Terence Rattigan.

23 The persistence of Victorianism is given a far more benign treatment in *The Ladykillers* (UK, 1955; dir. Alexander Mackendrick) in the presentation of the character of the 'little old lady' Mrs Wilberforce and her Victorian house in St Pancras, which the gang uses as a cover for its van robbery at King's Cross station. See Charlotte Brunsdon, *London in Cinema: The Cinematic City since 1945* (London: British Film Institute, 2007), p. 2.

24 The Festival of Britain and the Festival Pleasure Gardens at Battersea are discussed in detail in Chapter Six.

25 'Whitechapel Art Gallery: Report 1951–52', p. 10, WAG/PUB/5/1 Guardbook 4/49 – 9/51, Whitechapel Gallery Archives. In the 'Foreword' to the Frith exhibition catalogue, the art and design historian James Laver wrote: 'now that the Victorian Period has outlived the indifference of the Edwardians and the contempt of the nineteen-twenties, we find ourselves looking at his [Frith's] pictures with a new interest.' *An Exhibition of Paintings by William Powell Frith, R.A. 1819–1901*, in co-operation with the Harrogate Arts Collection Society, 25 October – 1 December 1951, n.p.

26 https://www.ica.org.uk/sites/default/files/downloads/ICA%20Exhibitions%20List%201948%20-%20Present.pdf, accessed 16 November 2015.

27 Heidi Heimann, 'The Life-Story of W. P. Frith', *Picture Post*, 2 August 1947, pp. 18–20; A. L. Lloyd, 'Do We Have Such Fun?', 20 December 1947, pp. 22–5; Geoffrey Grigson, 'The Pre-Raphaelite Rebellion', 11 September 1948, pp. 15–18. Grigson was a founder member of the Institute of Contemporary Arts, and along with a love of the English countryside he also wrote about British artists such as Samuel Palmer and published an anthology of Victorian poetry, *The Victorians* (London: Faber and Faber, 1950).

28 *The Good Old Days* was a mêlée of Victorian and Edwardian elements broadcast from Leeds City of Varieties Music Hall; see *Picture Post*, 20 July 1953, p. 36.

29 Hugh Casson, *An Introduction to Victorian Architecture* (London: Art and Technics, 1948), pp. 5, 38.

30 Nikolaus Pevsner, *Pioneers of Modern Design: From William Morris to Walter Gropius*, first published 1936, 2nd edn (New York: Museum of Modern Art, 1949), p. 24.

31 Pevsner was chairman of the Victorian Society; on his involvement see Susie Harries, *Nikolaus Pevsner: The Life* (London: Chatto and Windus, 2011), pp. 567–79; Hugh Casson was also a member. On the 1950s conservation movement see Gavin Stamp, 'The Art of Keeping One Jump Ahead: Conservation Societies in the Twentieth Century', in Michael Hunter, ed., *Preserving the Past: The Rise of Heritage in Modern Britain* (Stroud: Alan Sutton, 1996), pp. 77–98. Pevsner's publications on Victorian design also included *High Victorian Design* (London: Architectural Press, 1951); for a suggestive reading of Pevsner's portrayal of Victorian architecture, see Lynne Walker, '"The Greatest Century": Pevsner, Victorian Architecture and the Lay Public', in Peter Draper, ed., *Reassessing Nikolaus Pevsner* (Aldershot: Ashgate, 2004), pp. 129–47.

32 Pevsner, *Pioneers*, p. 28.

33 Vera Brittain, *Lady Into Woman: A History of Women From Victoria to Elizabeth II* (London: Andrew Dakers, 1953), pp. 232, 234.

34 Ibid., pp. 236, 160.

35 Andrew Spicer, *Film Noir* (Harlow: Pearson, 2002), pp. 183–4.

36 On the regulation of American films within the post-war British film economy, see Sue Harper and Vincent Porter, *British Cinema of the 1950s: The Decline of Deference* (Oxford: Oxford University Press, 2003), pp. 5–6.

37 On the development by Lean of the Dickens films, see Joss Marsh, 'Dickens and Film', in John O. Jordan, ed., *The Cambridge Companion to Charles Dickens* (Cambridge: Cambridge University Press, 2001), pp. 211–12.

38 From the mid-1930s and the introduction of colour film, Academy of Motion Picture Arts and Sciences awards for cinematography were divided into black and white and colour; in 1947 the winner of Best Colour Cinematography was also a British cinematographer, Jack Cardiff, for his hallucinogenic work on *Black Narcissus* (UK, 1947; dir. Michael Powell and Emeric Pressburger).

39 On the visual style of *Great Expectations*, see Duncan Petrie, *The British Cinematographer* (London: BFI, 1996), pp. 14–33; Catherine Moraitis, *The Art of David Lean: A Texual Analysis of Audio-Visual Structure* (Bloomington, Ind.: AuthorHouse, 2004), pp. 196–7.

40 Matte shots use backgrounds that are painted directly on glass; see Richard L. Stromgren and Martin F. Norden, *Movies: A Language in Light* (Englewood Cliffs, N.J.: Prentice-Hall, 1984), p. 106.

41 My thanks to Duncan Petrie for his advice on this aspect of Lean's film; see also Duncan Petrie, 'Neo-Expressionism and British Cinematography: The Work of Robert Krasker and Jack Cardiff', in John Orr and Olga Taxidou, eds., *Post-War Cinema and Modernity* (Edinburgh: Edinburgh University Press, 2000), pp. 223–33. On Bryan's set designs see Edward Carrick, *Art and Design in the British Film: A Pictorial Directory of British Art Directors and their Work*, intro. Roger Manvell (London: Dennis Dobson, 1948), pp. 42–3.

42 As cited in Kevin Brownlow, *David Lean: A Biography* (London: Richard Cohen Books, 1996), p. 213.

43 Ibid., p. 214.

44 *Monthly Film Bulletin*, 13:156 (December 1946): 166, at http://www.screenonline.org.uk/media/mfb/1002584/index.html, accessed 17 November 2015.

45 As cited in Brownlow, *David Lean*, p. 214. On Rose Macaulay, *The World My Wilderness*, see Chapter Two.

46 For discussion of the lighting in *Great Expectations*, see Alain Silver, 'The Untranquil Light: David Lean's *Great Expectations*', *Literature/Film Quarterly*, 2:2 (Spring 1974): 140–52.

47 Junichirō Tanizaki, *In Praise of Shadows*, trans. Thomas J. Harper and Edward G. Seidensticker (London: Vintage, 2001), p. 52.

48 John Glavin, 'Introduction', in John Glavin, ed., *Dickens on Screen* (Cambridge: Cambridge University Press, 2003), p. 5.

49 As cited in A. L. Zambrano, 'Great Expectations: Dickens and David Lean', Literature/Film Quarterly, 2:2 (Spring 1974): 155.

50 André Bazin, 'Pour un cinema impur', as cited and discussed in Colin MacCabe, 'Bazinian Adaptation: The Butcher Boy as Example', in Colin MacCabe, Kathleen Murray and Rick Warner, eds., True to the Spirit: Film Adaptation and the Question of Fidelity (Oxford and New York: Oxford University Press, 2011), pp. 6–7.

51 On the ending of the novel, see Regina Barreca, 'David Lean's Great Expectations', in Glavin, ed., Dickens on Screen, pp. 43–4, and Brian McFarlane, Novel to Film: An Introduction to the Theory of Adaptation (Oxford: Clarendon Press, 1996), pp. 108–11.

52 A complete shot by shot log of this scene is given in the Post Production Script, Great Expectations, SCR 8980, Unpublished Scripts Collection, BFI National Archive.

53 Moraitis, Art of David Lean, p. 192.

54 Marsh, 'Dickens and Film', p. 217.

55 Guerric DeBona, 'Doing Time, Undoing Time: Plot Mutation in David Lean's Great Expectations', Literature/Film Quarterly, 20:1 (1992): 85.

56 McFarlane, Novel to Film, p. 111; McFarlane also makes this argument in Screen Adaptations: Charles Dickens' 'Great Expectations'; The Relationship Between Text and Film (London: Methuen, 2008), pp. 151–2; see also Richards, Films and British Identity, p. 341.

57 As cited in Brownlow, David Lean, p. 213.

58 Michael Baxandall, Shadows and Enlightenment (New Haven and London: Yale University Press, 1995), p. 144.

59 G. W. F. Hegel, The Science of Logic, trans. A. V. Miller (London, 1969), Book 1, first section, ch. 1, remark 2, as cited in Gray Hochhar-Lindgren, Philosophy, Art and the Specters of Jacques Derrida (Amherst, N.Y.: Cambria Press, 2011), p. 185. See also Victor I. Stoichita, A Short History of the Shadow (London: Reaktion Books, 1997).

60 Thomas Miller, The Mysteries of London: Lights and Shadows of London Life (London: Vickers, 1849) and George Godwin, London Shadows: A Glance at the 'Homes' of the Thousands (London: G. Routledge, 1854).

61 John Piper, 'Pleasing Decay', Architectural Review (September 1947), p. 93.

62 As cited in Christopher Woodward, In Ruins (London: Chatto and Windus, 2001), p. 212.

63 On 'Recording Britain' see Gill Saunders, ed., Recording Britain (London: V&A, 2011). The surviving pictures are now in the collection of the Prints and Drawings Department at the V&A.

64 Patrick Wright, paper delivered at the 'Recording Britain' conference at the V&A, 20 April 2012. On Neo-romanticism see also Robin Ironside, Painting since 1939 (London and New York: Longmans, Green and Co., 1947); David Mellor, A Paradise Lost: The Neo-Romantic Imagination in Britain 1935–1955 (London: Lund Humphries, in association with the Barbican Art Gallery, 1987); Virginia Button, 'The Aesthetic of Decline: English Neo-Romanticism c.1935-1956', PhD thesis, University of London, 1992.

65 John Piper, 'Seaton Delaval' (1945), in Buildings and Prospects (London: Architectural Press, 1948), p. 88. Geoffrey Beard described Seaton Delaval as 'the noblest ruin of them all', 'Romantic Ruins, with drawings by Michael Felmingham', The Saturday Book, 17 (1957), p. 153. See also 'Ruins of Houghton Hall, Bedfordshire', in Brandt, Literary Britain, no. 13.

66 On Lean's representation of London in Great Expectations, see Joachim Frenk, 'Great Expectations: David Lean's Visualizations of Dickensian Spaces', in Ewald Mengel, Hans-Jörg Schmid and Michael Steppat, eds., Anglistentag 2002 Bayreuth Proceedings (Trier: Wissenschaftlicher Verlag Trier, 2003), p. 313.

67 The post-war literature on the reconstruction of the land around St Paul's is extensive; for examples from across the post-war period, see Architect and Building News, 12 July 1946, p. 24; Architectural Review, June 1956, special issue devoted to Holford's scheme; Nikolaus Pevsner, 'A Setting for St Paul's Cathedral', Listener, 10 May 1956, pp. 594–6. Photographs of the site are now in the collections at the London Metropolitan Archives and the Museum of London.

68 Michel de Certeau, 'The Theater of the Quid-proquo: Alexandre Dumas', in Heterologies, p. 151.

4 Learning to Think in Colour

1 Wyndham Lewis, *Rotting Hill* (London: Methuen & Co., 1951), p. 91.

2 On the role of British weather in defining national identity, see Homi K. Bhabha, 'Dissemi-Nation: Time, Narrative, and the Margins of the Modern Nation', in Homi K. Bhabha, ed., *Nation and Narration* (London and New York: Routledge, 1990), pp. 291–322 and esp. p. 319, where he discusses Salman Rushdie's *Satanic Verses*. A number of the Caribbean immigrants interviewed by Mike Phillips and Trevor Phillips describe the shock of their first sight of the smoking chimneys and bombsites of England; see *Windrush: The Irresistible Rise of Multi-Racial Britain* (London: Harper Collins, 1998).

3 On the Caribbean writers who came to Britain in the 1950s, see Caryl Phillips, 'Following On: The Legacy of Lamming and Selvon', *Wasifiri*, 14:29 (1999): 34–6, and Nick Bentley, 'Black London: The Politics of Representation in Sam Selvon's *The Lonely Londoners*', *Wasafiri*, 18:39 (2003): 41–5. For discussion of postcolonial immigration in post-war fiction, see Mica Nava, 'Thinking Internationally: Gender and Racial Others in Postwar Britain', *Third Text*, 20:6 (2006): 671–82.

4 George Lamming, *The Emigrants*, first published 1954 (London: Allison and Busby, 1980), p. 99.

5 Ibid., pp. 121–2, 123.

6 Sam Selvon, *The Lonely Londoners*, first published 1956 (London: Penguin, 2006), p. 1.

7 Doris Lessing, *In Pursuit of the English: A Documentary* (London: MacGibbon and Kee, 1960), p. 41.

8 Doris Lessing, *Walking in the Shade: Volume Two of My Autobiography 1949–1962* (New York: Harper Collins, 1997), p. 5.

9 David Batchelor, *The Luminous and the Grey* (London: Reaktion Books, 2014), p. 66.

10 'The Day That Never Broke', photographed by Bill Brandt, *Picture Post*, 18 January 1947, pp. 30–3, discussed in Chapter One.

11 Salman Rushdie, *The Wizard of Oz*, 2nd edn (London: Palgrave Macmillan on behalf of the British Film Institute, 2012), p. 24.

12 Batchelor, *Luminous*, pp. 60–1.

13 See, for example, the interviews with Charles Plouviez, who worked in the Festival of Britain organizing offices; Clifford Hatts, a Royal College of Art graduate and a festival designer; and Gordon Bowyer, who also worked as a designer, in 'The 1951 Festival of Britain: A Brave New World', BBC2, broadcast 24 September 2011.

14 Cecil Beaton described the festival abacus screen as 'Miró-like coloured balls against the distant chimney pots of the city', *Vogue*, July 1951, p. 59.

15 'From Mud to Festival', *Picture Post*, 5 May 1951, pp. 11–15.

16 Ibid., p. 11. Although the South Bank was nearly always described as a bombsite, the construction of the festival site inevitably also involved the displacement of the population who lived in the area. The 1952 British comedy film, *The Happy Family* (London Independent Producers), directed by Muriel Box, tells the story of the Lord family, who have a grocery shop (the House of Lords) close to the construction site of the Festival Hall, and their campaign to stop their home and business being demolished by the builders. After a prolonged siege the planners give in, the shop is saved and the Lords are shown enjoying a day out at the festival.

17 Harold Nicolson, 'After the Festival: A Note for Posterity', *Listener*, 1 November 1951, p. 733.

18 Marghanita Laski, 'You Remember the Festival?', *Observer*, 6 July 1952, p. 4.

19 Cover page, *Picture Post*, 9 November 1946. 'The Royal Rooms at Windsor', pp. 20–1. The coupling of colour photography printing with women of colour as subjects was repeated in the colour section on 7 December 1946, in which a nude study by Erwin Blumenfeld of a black woman behind a multicoloured Venetian blind, titled 'The Sliced Girl in the House Across the Way', was printed on p. 21.

20 The advert was carried regularly throughout the autumn months of 1953, see *Kinematograph Weekly*, 29 October 1953, p. 32; 19 November 1953, p. 17; 17 December 1953, p. 45.

21 'Supreme for Colour', advertisement for Kodachrome, *Kinematograph Weekly*, 20 August 1953, p. 32.

22 The best sources on colour film technology are Sarah Street, *Colour Films in Britain: The Negotiation of*

Innovation (Basingstoke: Palgrave Macmillan, 2012) and Simon Brown, Sarah Street and Liz Watkins, eds, *British Colour Cinema: Practices and Theories* (Basingstoke: Palgrave Macmillan, 2013). See also John Huntley, *British Technicolor Films* (London: Skelton Robinson, 1949); Robert T. Ryan, *A History of Motion Picture Color Technology* (London: Focal Press, 1977) and Angela dalle Vacche and Brian Price, eds, *Color: The Film Reader* (New York and London: Routledge, 2006). On Eastmancolor see G. J. Craig, 'Eastman Colour Films for Professional Motion Picture Work', *British Kinematography*, 22:5 (1953): 146–58.

23 Interview with Oswald Morris, as cited in Brown, Street and Watkins, *British Colour Cinema*, p. 66.

24 Natalie M. Kalmus, 'Color Consciousness' (1935), in dalle Vacche and Price, eds. *Color*, p. 25.

25 Ibid., p. 27.

26 For a detailed and informative reading of *A Matter of Life and Death*, see Ian Christie, *A Matter of Life and Death* (London: Palgrave Macmillan, 2000). See also Street, *Colour Films in Britain*, pp. 112–18.

27 The film was admired for its use of colour, especially in the trade reviews; see Christie, *A Matter*, p. 59. Powell and Pressburger worked again with Jack Cardiff on the equally creative Technicolor film, *The Red Shoes* (UK, 1948).

28 The 1955 Broadway musical had been based on the 1939 Metro-Goldwyn-Mayer film *Ninotchka*, directed by Ernst Lubitsch and written by Billy Wilder. Lyrics for 'Stereophonic Sound' at www.lyricszoo.com, accessed 12 February 2014.

29 Richard Hamilton, 'Glorious Technicolor, Breathtaking Cinemascope and Stereophonic Sound', unpublished typescript of lecture (1959), in *Collected Words 1953–1982* (London: Thames and Hudson, 1982), pp. 112–31.

30 On developments in colour technologies, see Peter G. Baker, 'The Focus on Colour', 'Studio Review Supplement', *Kinematograph Weekly*, 30 March 1950, pp. 4–13.

31 Ovaltine advertisement in *Picture Post*, 12 December 1953, p. 30. For discussion of the Ovaltine colour advertising campaign in the context of the family home, see Chapter Seven.

32 'Christmas Spangles', advertisement in *Picture Post*, 12 December 1953, p. 34. On Spangles see Nicholas Whittaker, *Sweet Talk* (London: Orion, 1998), pp. 136–7 (which suggests that Spangles were introduced in 1948) and http://en.wikipedia.org/wiki/Spangles_(sweets), accessed 29 May 2015.

33 Rowntree's 'Fruit Gums' advertisement in *Picture Post*, 4 August 1951, p. 9. For further examples see 'Mars are Marvellous', the first full-page colour advert in *Picture Post*, 15 February 1947, p. 37, and Rowntree's 'Sunripe Jelly', 31 March 1951, p. 27, and 16 January 1954, p. 31.

34 *Picture Post*, 3 July 1954, pp. 26–7.

35 Guinness advertisement in *Picture Post*, 19 March 1955, p. 29.

36 The process is described in J. R. Biggs, *Illustration and Reproduction* (London: Blandford Press, 1950), pp. 105–16.

37 'Editorial Notes', *Penrose Annual: A Review of the Graphic Arts*, 53 (1959), p. xxviii.

38 Faber Birren, *Selling With Color* (New York and London: McGraw Hill, 1945), p. vii. Subsequent quotes on pp. 104, 109, 12–13 and 21. Birren developed his ideas on the emotional significance of colour in the workplace in *New Horizons in Color* (New York: Reinhold Publishing, 1955). The emotional properties of colour in relation to advertising were explored by other publications in this period; see, for example, H. D. Murray, ed., *Colour in Theory and Practice* (London: Chapman and Hall, 1952).

39 Lewis Mumford, *Technics and Civilization*, first published 1934 (London: Routledge & Kegan Paul, 1955), p. 163. See also *Art and Technics* (London: Oxford University Press, 1952) and *Brown Decades: A Study of the Arts in America 1865–1895*, first published 1931, 2nd rev. edn (New York: Dover, 1955).

40 Mumford, *Technics and Civilization*, pp. 169, 168. The images and ideas in Mumford's work are strongly reminiscent of the extracts relating to the impact of the Industrial Revolution collected by Humphrey Jennings between 1937 and 1950 and discussed in Chapter One; see Humphrey Jennings, ed. Marie-Lou Jennings and Charles Madge, *Pandaemonium, 1660–1886: The Coming of the Machine as Seen by Contemporary*

Observers (London: Icon Books, 2012). Director Danny Boyle acknowledged the influence of Jennings's work in the creation of the 'Pandemonium' section of the Opening Ceremony of the 2012 Summer Olympic Games, which was in almost every way also a reimagining of Mumford's Paleotechnic period.

41 Mumford, *Technics and Civilization*, p. 245.

42 Ibid., p. 201.

43 David Batchelor, *Chromophobia* (London: Reaktion Books, 2000). On the fear and dislike of colour in western culture, see also John Gage, *Colour and Culture: Practice and Meaning from Antiquity to Abstraction* (London: Thames and Hudson, 1993) and dalle Vacche and Price, *Color*, on which the following brief summary of western debates about colour is drawn.

44 Batchelor, *Chromophobia*, p. 29.

45 Adrian Stokes, *Smooth and Rough* (London: Faber and Faber, 1951), p. 62. See also *Inside Out: An Essay in the Psychology and Aesthetic Appeal of Space* (London: Faber and Faber, 1947) for Stokes's autobiographical account of the development of his aesthetic ideas.

46 Adrian Stokes, *Colour and Form* (London: Faber and Faber, 1951), p. 35 and passim.

47 Stokes, *Smooth and* Rough, p. 65. For Stokes, Venice was the outstanding example of spatial effects of blackness and whiteness, from which colour was allowed to emerge; see Stephen Kite, '"A Deep and Necessary Commerce": Venice and the "Architecture of Colour-Form"', in Stephen Bann, ed., *The Coral Mind: Adrian Stokes's Engagement with Architecture, Art History, Criticism and Psychoanalysis* (University Park: Pennsylvania State University Press, 2007), pp. 37–58. The essays collected in this volume are the best survey of Stokes's theories of art.

48 Bernard Berenson, *Aesthetics and History* (London: Constable, 1950), p. 75.

49 Ibid., p. 77.

50 'Robbialac Colorizer Paints', advertisement in the *Architectural Review*, January 1955, p. xxxix, and 'Joseph Mason Paints', advertisement, May 1955, p. xlvi.

51 Ronald Neame, 'A Talk on Technicolor', *Cine-Technician* (May–June 1944), pp. 36, 44.

52 Frank Ormrod, 'Some Aspects of Colour in Photography', *Penrose Annual*, 45 (1951), p. 71.

53 On the role of colour in the home and workplace and the need for colour education, see 'Ex Cathedra', *British Journal of Photography*, XCV:4584 (26 March 1948), p. 119, and British Colour Council, *Colour Schemes for the Interior Decoration of Factories and Offices*, 2nd edn (London: British Colour Council, 1956), p. 16 and passim.

54 The nationalist reading of British colour is mentioned in Street, *Colour Films*, p. 2.

55 Interview with Christopher Challis, as cited in Brown, Street and Watkins, *British Colour Cinema*, p. 28. See also the interview with Oswald Morris in which he also says that there is a distinctive national approach to colour, p. 80.

56 Adrian Cornwell-Clyne, *Colour Cinematography*, 3rd edn (London: Chapman and Hall, 1951), p. 663.

57 The British Colour Council defined colour intensity: 'An intense colour is one which contains very little or no grey.' See British Colour Council, *Dictionary of Colours for Interior Decoration: Including a List of Names and the History of Colours Illustrated in the Two Companion Volumes*, vol. 3 (London: British Colour Council, 1949), p. xv.

58 Ibid., p. xi.

59 Thierry de Duve, extracts from *Nominalisme pictural: Marcel Duchamp* (Paris, 1984), as reproduced in David Batchelor, ed., *Colour*, Documents of Contemporary Art (London and Cambridge, Mass.: Whitechapel Gallery and MIT Press, 2008), pp. 175–8.

60 British Colour Council, *Dictionary of Colours*, p. 1; see British Colour Council, *Dictionary of Colour Standards: A List of Colour Names Referring to the Colours Shown in the Companion Volume*, vol. 1, 2nd edn (London: British Colour Council, 1951), p. 40.

61 Advertisement in *Woman's Friend and Glamour*, 2 January 1951, p. 20.

62 Selvon, *Lonely Londoners*, p. 77. Nick Bentley argues that Selvon's novel relies on 'stereotypical representations of black identity' that clash with the experimental form: see 'Black London', p. 45.

5 'Thirty Thousand Colour Problems'

1 British Nationality Act, 1948, 11 & 12 Geo.VI, c. 56. There are a number of important studies of British migration following the 1948 Act; the most helpful and those which I have drawn on for the following summary are by Kathleen Paul, '"British Subjects" and "British Stock": Labour's Postwar Imperialism', *Journal of British Studies*, 34:2 (April 1995): 233–76; *White-washing Britain: Race and Citizenship in the Postwar Era* (Ithaca and London: Cornell University Press, 1997); 'Communities of Britishness: Migration in the Last Gasp of Empire', in Stuart Ward, ed., *British Culture and the End of Empire* (Manchester and New York: Manchester University Press, 2001), pp. 180–99. See also Randall Hansen, *Citizenship and Immigration in Post-War Britain: The Institutional Origins of a Multicultural Nation* (Oxford: Oxford University Press, 2000); Bill Schwarz, 'Reveries of Race: The Closing of the Imperial Moment', in Becky Conekin, Frank Mort and Chris Waters, eds, *Moments of Modernity: Reconstructing Britain 1945–1964* (London and New York: Rivers Oram Press, 1999), pp. 189–207.

2 On population debates during this period, see Pat Thane, 'Population Politics in Post-War British Culture', in Conekin, Mort and Waters, *Moments of Modernity*, pp. 114–33.

3 On colonial communities in Britain before the war, see D. W. Dean, 'Coping with Colonial Immigration, the Cold War and Colonial Policy: The Labour Government and Black Communities in Great Britain 1945–51', *Immigrants and Minorities*, 6:3 (November 1987), esp. pp. 305–10.

4 Estimates of 'coloured residents' in the United Kingdom in 1945 varied between 10,000 and 30,000; see Paul, *Whitewashing*, p. 113.

5 The transmutation of these pre-1948 debates into the discursive world of debates on miscegenation and the culture of the colour bar in the 1950s is powerfully described by Bill Schwarz in a number of publications, including '"The Only White Man In There": The Re-Racialisation of England, 1956–68', *Race & Class*, 38 (July–September 1996): 65–78; 'Black Metropolis, White England', in Mica Nava and Alan O'Shea, eds, *Modern Times: Reflections on a Century of English Modernity* (London and New York: Routledge, 1996), pp. 176–207; 'Reveries of Race'.

6 I use 'subaltern' in the sense used within post-colonial studies for those histories told from below and from marginalized positions, as opposed to the per-spectives of mainstream and official discourse.

7 As cited in Clive Harris, 'Post-War Migration and the Industrial Reserve Army', in Winston James and Clive Harris, eds, *Inside Babylon: The Caribbean Diaspora in Britain* (London: Verso, 1993), p. 24.

8 Kathleen Paul, 'The Politics of Citizenship in Post-War Britain', *Contemporary Record*, special issue 'Ending the Empire', 6:3 (Winter 1992): 464.

9 As cited in Paul, *Whitewashing*, p. 125.

10 Royal Commission on Population, Report, Cmd 7695 (1949), p. 124, as cited in Colin Holmes, *John Bull's Island: Immigration and British Society 1871–1971* (Basingstoke: Macmillan, 1988), p. 210.

11 The figures for annual colonial immigration 1948–51 are given in Hansen, *Citizenship*, p. 57, and in Peter Hennessy, *Never Again: Britain 1945–51* (London: Jonathan Cape, 1992), p. 442.

12 On the politics of race under the Conservative government, see Bob Carter, Clive Harris and Shirley Joshi, 'The 1951–55 Conservative Government and the Racialization of Black Immigration', in James and Harris, *Inside Babylon*, pp. 55–71.

13 Ivo de Souza, 'Arrival', in S. K. Ruck, ed., *The West Indian Comes to England*: A Report Prepared for the Trustees of the London Parochial Charities by the Family Welfare Association (London: Routledge & Kegan Paul, 1960) p. 51. De Souza also founded the British Caribbean Welfare Service.

14 Bill Schwarz, '"Claudia Jones and the *West Indian Gazette*": Reflections on the Emergence of Post-Colonial Britain', *Twentieth Century British History*, 14:3 (2003): 268.

15 As cited in Mary Chamberlain, *Narratives of Exile and Return*, first published 1997, rev. edn (New Brunswick, N.J.: Transaction Publishers, 2005), p. 71. Chamberlain draws on the archive 'National Life Story Collection' of the National Sound Archive at the British Library.

16 Robert Kee, 'Is There a British Colour Bar?', *Picture Post*, 2 July 1949, pp. 23–8.

17 This important point concerning the restaging of the colonial encounter in England itself is made in Schwarz, '"The Only White Man"', p. 66 and passim.

18 As cited in Hansen, *Citizenship and Immigration*, p. 67.

19 'Cabinet Colonial Immigrants: Report of the Committee of Ministers', 22 June 1956, as cited in Hansen, *Citizenship and Immigration*, p. 78. Migration figures are given in General Register Office, *Census 1961: England and Wales: Preliminary Report* (London: HMSO, 1961), which observed an excess of immigration over emigration for the first time in 1954–5, p. 6. See also 'Not for Publication before Noon 12th March 1963. 1961 Census: England and Wales: London County Report', p. 2: 'a noticeable increase . . . in those born in the colonies and Commonwealth countries'. British Library BS34/34.

20 Colin MacInnes, *City of Spades*, first published 1957 (London: Allison & Busby, 2012), p. 13. Later in the novel Pew asserts that the black migrants 'bring an element of joy and fantasy and violence into our cautious, ordered lives' (p. 93). For discussion of MacInnes's fascination with Caribbean male culture, see Alan Sinfield, *Literature, Politics and Culture in Postwar Britain* (Berkeley and Los Angeles: University of California Press, 1989), pp. 127–9.

21 On the colonial war in Kenya, see John D. Hargreaves, *Decolonization in Africa* (London and New York: Longman, 1988), and on the Mau Mau within the white imaginary of Africa, see Schwarz, '"The Only White Man"', pp. 70–3. The common view that Mau Mau was motivated by pagan superstition was challenged by Professor of Social Anthropology Max Gluckman, who argued instead that it was a response to colonization; see 'The Mau Mau Rituals: Tribal Religion and Witchcraft', *Manchester Guardian*, 19 March 1954, p. 8.

22 'Mau Mau: "Get Out Get Out', *Picture Post*, 29 November 1952, pp. 18–22. It was suggested that this was a translation of Uma Uma. See also 'Campaign of Murder', 3 January 1953, p. 33, and 19 December 1953, p. 18.

23 There was a notorious case where a British army officer was acquitted by a court martial of shooting two Africans in the back; evidence in the trial suggested that monetary rewards were being offered to British soldiers for the numbers of Mau Mau suspects that were killed. The case was reported in newspapers and discussed in the House of Commons. See Learie Constantine, *Colour Bar* (London: Stanley Paul, 1954), p. 181.

24 'Washing the Soul of Mau Mau', *Picture Post*, 22 October 1956, pp. 5–8. The article was printed on the occasion of the visit of Princess Margaret to Kenya. On the 'screening' of Kikuyu and a critique of British interrogation practices, see Anthony H. Richmond, *The Colour Problem: A Study of Racial Relations*, first published 1955, rev. edn (Harmondsworth: Penguin, 1961), pp. 188–206. See also 'What is Mau Mau?', *Picture Post*, 27 March 1954, pp. 18–20.

25 *Simba: Mark of Mau Mau* (1955, UK); *Safari* (1956, USA). See also 'Safari: In the Elstree Jungle', *Picture Post*, 10 September 1955, pp. 16–17. For discussion of these films, see Richard Dyer, 'White', *Screen*, 29:4 (1988): 44–55; Wendy Webster, '"There'll Always Be An England": Representations of Colonial Wars and Immigration 1948–1968', *Journal of British Studies*, special issue 'At Home in the Empire', 40:4 (October 2001): 557–84, and Webster, *Englishness and Empire 1939–1965* (Oxford: Oxford University Press, 2005), pp. 119–36; David Anderson, 'Mau Mau at the Movies: Contemporary Representations of an Anti-Colonial War', *South African Historical Journal*, 48:1 (2003): 71–89.

26 Street, *Colour Films*, p. 58.

27 MacInnes, *City of Spades*, p. 84. The association of Mau Mau with terrifying violence and superstition continued beyond the 1950s; in 1970 Tom Wolfe used it to describe a style of intimidating black militancy; see *Radical Chic / Mau-Mauing the Flak Catchers*, first published 1970 (London: Michael Joseph, 1971).

28 'Nigeria: Special Supplement for the Royal Tour', *Picture Post*, 28 January 1956, pp. 17–24. A full-page colour advertisement for Brooke Bond tea on the back page of this issue reproduced a painting of the Rift Valley, Kenya, above a caption that read: 'Africa is not so dark nowadays.'

29 As cited in Tom Fleming, intro., *Voices Out of the Air: The Royal Christmas Broadcasts 1932–1981* (London: Heinemann, 1981), p. 74. The Commonwealth and empire was regularly referred to as the 'family of nations' in broadcasts by George VI and Elizabeth II.

30 Schwarz, '"The Only White Man"', p. 66.

31 'Breeding a Colour Bar?', *Picture Post*, 6 September 1952, pp. 28, 30–1.

32 Constantine's letter was published, along with other correspondence, on 20 September 1952, p. 4. The issue continued to appear in articles and correspondence; see 'Readers' Letters', *Picture Post*, 30 January 1954, p. 5.

33 Constantine, *Colour Bar*, p. 67. In 1953 Parliament had opposed the 'Colour Bar Bill'; see 'Debate: House of Commons May 1953', *Hansard Parliamentary Debates*, vol. 514, no. 100.

34 'Are We Building Up to a British Colour Conflict?', *Picture Post*, 22 January 1955, p. 29.

35 See, for example, 'The Best and Worst of British Cities: Our New Series: Liverpool', *Picture Post*, 3 April 1954, p. 41.

36 Chris Waters, '"Dark Strangers" in Our Midst: Discourses of Race and Nation in Britain, 1947–1963', *Journal of British Studies*, 36:2 (April 1997): 209 – the article offers an excellent discussion of these writers to which I am indebted. On nineteenth-century social investigators, see Seth Koven, *Slumming: Sexual and Social Politics in Victorian London* (Princeton, N.J.: Princeton University Press, 2004).

37 K. L. Little, *Negroes in Britain: A Study of Racial Relations in English Society* (London: Kegan Paul, Trench, Trubner and Co., 1947).

38 Michael Banton, *The Coloured Quarter: Negro Immigrants in an English City* (London: Jonathan Cape, 1955), pp. 72, 81 and passim. A similar landscape of overcrowding and poor physical amenities is described by Ruth Glass in *Newcomers: The West Indians in London* (London: Centre for Urban Studies and George Allen & Unwin, 1960). Based on research carried out in the late 1950s on West Indian communities in London, Glass compared the living conditions in west London to those described by Charles Booth at the end of the nineteenth century, pp. 50–2.

39 Banton, *The Coloured Quarter*, pp. 94, 119.

40 Michael Banton, '"Beware of Strangers!"', *Listener*, 3 April 1958, p. 567; Banton, *White and Coloured: The Behaviour of British People towards Coloured Immigrants* (London: Jonathan Cape, 1959), pp. 178, 184.

41 Sheila Patterson, *Dark Strangers: A Sociological Study of the Absorption of a Recent West Indian Migrant Group in Brixton, South London* (London: Tavistock Publications, 1963), p. 3.

42 Constantine, *Colour Bar*, p. 25.

43 George Gale, 'Would YOU Let Your Daughter Marry a Black Man?', *Daily Express*, 18 July 1956, p. 6; the subsequent articles were published on 19 July 1956, p. 4, and 20 July 1956, p. 4.

44 Robert J. C. Young, *Colonial Desire: Hybridity in Theory, Culture and Race* (London: Routledge, 1995), p. 19. For discussion of nineteenth-century racial theories in relation to William Mulready's painting, *The Toyseller* (1857–63), see Lynda Nead, 'The Secret of England's Greatness', *Journal of Victorian Culture*, 19:2 (2014): 161–82.

45 See Chapter Four for a discussion of colour and advertising. John Barron Mays, *Growing Up in the City: A Study of Juvenile Delinquency in an Urban Neighbourhood* (Liverpool: University Press of Liverpool, 1954), p. 44.

46 H. D. Wilcox, *Mass Observation Report on Juvenile Delinquency* (London: Falcon Press, 1949), p. 48. For an account of Mass Observation methodologies, see Liz Stanley, *Sex Surveyed, 1949–1994: From Mass Observation's 'Little Kinsey' to the National Survey and the Hite Reports* (London: Taylor and Francis, 1995), pp. 3–10. For Mass Observation surveys on British family life, see Part Three.

47 Banton, *Coloured Quarter*, p. 153; Eustace Chesser, quoting Professor Ray E. Baber, *Love and Marriage*, rev. edn (London: Pan Books, 1957), p. 92.

48 *Daily Express*, 19 July 1956, p. 4. Frantz Fanon, *Black Skin, White Masks*, first published 1952, first published in English 1968, trans. Charles Lam Markmann (London: Pluto Press, 1986), p. 165. This section is cited by Lola Young in her discussion of the film *Flame in the Streets* (UK, 1959; dir. Roy Ward Baker), which follows the relationship between a young white woman,

Kathie, and a black teacher, Peter. See *Fear of the Dark: 'Race', Gender and Sexuality in the Cinema* (London and New York: Routledge, 1996), pp. 101–14.

49 'Between Friends', *Woman's Friend and Glamour*, 23 January 1951, p. 19. On 20 November 1951 'Liz from Cardiff' wrote using very similar words and phrases; on this occasion Marion reminded her: 'scientists do not yet know if it is wise for two such very different races as white and black to marry for sometimes the children of mixed marriages seem to inherit the worst characteristics of each race,' p. 15. In 1951 the British film *Pool of London* also depicted a mixed race friendship between a white girl and a black sailor (Earl Cameron). A Gallup poll taken in 1958 showed that only 13 per cent of people questioned approved of mixed marriages; see Claire Langhamer, *The English in Love: The Intimate Story of an English Revolution* (Oxford: Oxford University Press, 2013), p. 74.

50 See Paul, 'Communities of Britishness', p. 189.

51 Stuart Hall, 'Reconstruction Work: Images of Post-war Black Settlement', *Ten.8*, 16 (1984): 7.

52 'Two Mixed Marriages Which Caused A Storm', *Picture Post*, 30 October 1954, p. 23. The two marriages concerned were first, that of Peggy Cripps, daughter of a former British cabinet minister, to Joseph Appiah from the Gold Coast. A newspaper photograph of their wedding was held up in the South African Parliament by the Minister of Justice and described as 'disgusting'. The second marriage was that of Seretse Khama, the hereditary ruler of the Bamangwato people in Bechuanaland (later Botswana), to Ruth Williams in 1949. The marriage was the alibi for the South African government to depose Khama, who was exiled in Britain as the British capitulated to South African racism. Both cases were clearly related to British colonial ambitions and as much an aspect of post-war decolonization as colonial migration. The cases were widely discussed at the time; see, for example, Learie, *Colour Bar*, pp. 90–1 and 183–6.

53 Lamming, *Emigrants*, p. 135.

54 The term 'colour bar problem picture' was used in the British Film Institute's *Monthly Film Bulletin*, 26:305 (June 1959): 69. The film is discussed in a number of film histories; especially interesting are

John Hill, 'The British "Social Problem" Film: *Violent Playground* and *Sapphire*', *Screen*, 26:1 (1985): 34–48; Hill, *Sex, Class and Realism: British Cinema 1956–1963* (London: BFI, 1986), pp. 83–9; Carrie Tarr, '*Sapphire*, *Darling* and the Boundaries of Permitted Pleasure', *Screen*, 26:1 (1985): 50–65; Young, *Fear of the Dark*, pp. 84–101. The use of the African-American name 'Sapphire' in US films and television is discussed in bell hooks, 'The Oppositional Gaze: Black Female Spectators', in *Black Looks: Race and Representation* (Boston, Mass.: South End Press, 1992), pp. 115–31.

55 For a discussion of the social and moral language of clothes in the nineteenth century, see Lynda Nead, 'Fashion and Visual Culture in the Mid-Nineteenth Century: Women in Red', Museum of London for Gresham College, 4 March 2014, http://www.gresham.ac.uk/lectures-and-events/women-in-red.

56 Leonard Mosley, 'The Psychological Striptease', *Daily Express*, 8 May 1959, p. 10.

57 As quoted in 'Reality and Colour Is Dearden's Aim', *Kinematograph Weekly*, 25 December 1958, p. 15.

58 The underwear shops of Shaftesbury Avenue were part of the shopping landscape of the West End in the 1950s. See Toni del Renzio, *After a Fashion . . .* (London: ICA Publications, 1956), p. 1: 'psychological accounts of clothing elaborate the attractions for men of the windows of Shaftesbury Avenue underwear shops'. See also the shots of Shaftesbury Avenue in the British Pathé film, 'This Was Yesterday', 1955, http://www.Britishpathe.com/video/this-was-yesterday-title, accessed 29 December 2014.

59 As cited in Stephen Bourne, *Black in the British Frame: The Black Experience in British Film and Television* (London: Continuum, 2001), p. 195.

60 Allyson Hobbs, *A Chosen Exile: A History of Racial Passing in American Life* (Cambridge, Mass.: Harvard University Press, 2014), pp. 5, 6. See also Shompa Lahiri, 'Performing Identity: Colonial Migrants, Passing and Mimicry between the Wars', *Cultural Geographies*, 10:4 (2003): 408–23; Renee Romano, 'The Pain of Passing', *Reviews in American History*, 44:2 (2016): 264–9.

61 Hobbs, *A Chosen Exile*, p. 8.

62 E. G. Cousins, *Sapphire* (London: Hamilton & Co., 1959), p. 11.

63 Hilde Marchant, 'Thirty Thousand Colour Problems', *Picture Post*, 9 June 1956, pp. 28–9, 38.

64 Hall, 'Reconstruction Work', p. 4.

65 George Lamming also describes the experience of the first sight of England in these terms: 'that feeling of uncertainty crawled over them and for a moment they were still, sympathetic, together.' *Emigrants*, p. 96.

66 Carol Tulloch, 'Strawberries and Cream: Dress, Migration and the Quintessence of Englishness', in Christopher Breward, Becky Conekin and Caroline Cox, eds, *The Englishness of English Dress* (Oxford and New York: Berg, 2002), p. 68.

67 Referring to Magee's photographs Hall identifies the distinctive quality or 'structure of feeling': 'I personally feel an astonishing fullness or plenitude in the sheer "presence" of those photographs.' 'Reconstruction Work', p. 6. On the photographic *punctum*, see Roland Barthes, *Camera Lucida: Reflections on Photography*, trans. Richard Howard (London: Vintage Books, 2000), pp. 25–8.

68 All quotes are taken from the National Life Story Collection, as cited in Chamberlain, *Narratives*, pp. 98, 108. See also Carole Tulloch, 'There's No Place Like Home: Home Dressmaking and Creativity in the Jamaican Community of the 1940s to the 1960s', in Glenn Adamson, ed., *The Craft Reader* (Oxford and New York: Berg, 2010), pp. 508–10.

69 As cited in Tina M. Campt, *Image Matters: Archive, Photography, and the African Diaspora in Europe* (Durham, N.C., and London: Duke University Press, 2012), p. 163. See also Campt, 'Imaging Diaspora: Race, Photography, and the Ernest Dyche Archive', *Letters*, Newsletter of the Robert Penn Warren Center for the Humanities, Vanderbilt University, 16:2 (Spring 2008): 1–7.

70 Patterson, *Dark Strangers*, p. 4. See also Glass, *Newcomers*, p. 9. In Selvon's *The Lonely Londoners*, Sir Galahad arrives in a lightweight suit but insists that he does not feel the cold to demonstrate his 'acclimatization' in the city, p. 4.

71 Anthony H. Richmond, *Colour Prejudice in Britain: A Study of West Indian Workers in Liverpool 1941–1951* (London: Routledge & Kegan Paul, 1954), p. 59.

72 Beryl Gilroy, 1994, as cited in 'Object history note', http://collections.vam.ac.uk/item/O138168/skirt-suit-gaynes-nat/ accessed 10 July 2014. The suit's museum number is T.134, 135-1995. It is also included in Amy de la Haye and Cathie Dingwall, *Surfers, Soulies, Skinheads and Skaters* (London: V&A, 1996), not paginated. Gilroy refers to clothing in *Black Teacher* (London: Cassell and Company, 1976). See also Sandra Courtman, 'A Journey through the Imperial Gaze: Birmingham's Photographic Collections and its Caribbean Nexus', in Simon Faulkner and Anandi Ramamurthy, eds, *Culture and Decolonisation in Britain* (Aldershot: Ashgate, 2006), pp. 127–52. For an outstanding recent study of how black style articulates the different aspects of the experience of migration, see Carol Tulloch, *The Birth of Cool: Style Narratives of the African Diaspora* (London: Bloomsbury, 2015), in which she draws on her personal archive to expand her notion of style narratives and black identity.

73 '"Zootable" Imports!!', *Tailor and Cutter & Women's Wear*, 2 July 1948, p. 513; 'The Psychology of the Zoot Suit', 10 September 1948, pp. 706–7. On male immigrant clothes, see also Banton, *Coloured Quarter*, pp. 202–3, and James Wickenden, *Colour in Britain* (London, New York and Toronto: Oxford University Press, 1958), p. 25. On the zoot suit, see Steve Chibnall, 'Whistle and Zoot: The Changing Meaning of a Suit of Clothes', *History Workshop: A Journal of Socialist and Feminist Historians*, 20 (Autumn 1985): 56–81.

74 James Laver, 'A Touch of Colour', *Punch*, 22 April 1953, p. 487; the caricature is printed on p. 486.

75 The Dyche Studio Collection is part of Birmingham Archive, Heritage and Photography Collections. My thanks to Jim Ranahan, Archivist (Photographic Collections), for his assistance during my work on this collection and to the librarians in the Wolfson Centre during my visit. The similar work of a Brixton photographer, Harry Jacobs, was shown at The Photographer's Gallery, London, October–November, 2002.

76 There are excellent studies of the Dyche Collection; see Courtman, 'A Journey'; Campt, *Image Matters*, and Gen Doy, *Black Visual Culture: Modernity and Postmodernity* (London and New York: I. B. Tauris, 2000), pp. 127–36.

77 On the *studium* see Barthes, *Camera Lucida*, p. 26.

78 Courtman, 'A Journey', p. 129.

79 Campt, *Image Matters*, p. 150.

80 Eileen Winnicroft, 'Colour in Your Life', *Everywoman*, February 1952, pp. 52–3. See also October 1954, p. 44: 'The women who wear striking reds crave attention. They are exhibitionists and want the spotlight.' For advice on cultivating a sense of colour, see 'The Art of Being a Beautiful Woman', March 1955, 10-page section, and the cover of January 1956: 'Join Our Colour Crusade for Your Looks, Your Home, Your Party Tables.'

81 Fashion during the Second World War is explored in the exhibition 'Fashion on the Ration: 1940s Street Style', Imperial War Museum, London, 5 March – 31 August 2015, which included brightly coloured and patterned Utility dresses in modern fabrics such as rayon. On the colourful and 'witty' prints of women's clothing in wartime, see Pat Kirkham, 'Fashioning the Feminine: Dress, Appearance and Femininity in Wartime Britain', in Christine Gledhill and Gillian Swanson, eds, *Nationalising Femininity: Culture, Sexuality and British Cinema in the Second World War* (Manchester and New York: Manchester University Press, 1996), pp. 152–74.

82 Marjorie Beckett, 'The First Professor of Fashion', *Picture Post*, 19 February 1949, pp. 24–5. 'Between Friends', *Woman's Friend and Glamour*, 3 April 1951, p. 15. On conventional 'English' dress in the period, see Christopher Breward, Becky Conekin and Caroline Cox, 'Introduction: "Dyed in the Wool English?"', in Breward, Conekin and Cox, *The Englishness of English Dress*, pp. 1–12.

83 *Tailor and Cutter & Women's Wear*, 14 May 1948, p. 375; 9 July 1948, p. 544; 10 February 1950, p. 165.

6 Battersea, Whitechapel and the Colours of Culture

1 Gerald Barry, 'unpublished memoir', as cited in Barry Turner, *Beacon for Change: How the 1951 Festival of Britain Helped to Shape a New Age* (London: Aurum, 2011), p. 124; see also 'The Royal Opening to Britain's Festival', *Picture Post*, 19 May 1951, p. 15. There is a substantial secondary literature on the Festival of Britain; the following are particularly interesting: Mary Banham and Bevis Hillier, eds, *A Tonic to the Nation: The Festival of Britain 1951* (London: Thames and Hudson, 1976); Becky Conekin, *The Autobiography of a Nation: The 1951 Festival of Britain* (Manchester: Manchester University Press, 2003); Harriet Atkinson, *The Festival of Britain: A Land and its People* (London and New York: I. B. Tauris, 2012). In 2011, on the sixtieth anniversary of the festival, the Southbank hosted a series of events and displays, 'Southbank Centre Celebrates the Festival of Britain', Southbank, London, 4 May – 4 September 2011.

2 On the political attacks on the festival by the Conservative party, see Peter Hennessy, *Never Again: Britain 1945–51* (London: Jonathan Cape, 1992), pp. 425–7; David Kynaston, *Family Britain 1951–57* (London: Bloomsbury Press, 2010), pp. 7–12, and Turner, *Beacon*, pp. 208–42.

3 'Leader', *Architectural Design*, Special Festival Number, 21: 7 (July 1951), p. 186 (my emphasis). See also p. 191: 'A screen of coloured balls hides the buildings of Waterloo Road.' The design of the screen was based on atoms and molecules and reflected the relationship between science and the arts that was developed at the Festival.

4 *Brief City* is discussed by Sarah Street in her excellent article 'Cinema, Colour and the Festival of Britain, 1951', *Visual Culture in Britain*, 13:1 (2012): 83–99.

5 The figures on the overseas publicity campaign are reported in Paul Wright, 'Projecting the Festival of Britain', *Penrose Annual*, 45 (1951): 60–1.

6 Ian H. Cox, *The South Bank Exhibition: A Guide to the Story It Tells* (London: HMSO, 1951), p. 6. Hereafter page references to this publication will be given in parentheses within the text.

7 An idea of how this might work is given by an article describing a family visit to the festival and how each member builds their visit around their individual interests, 'A Day at the South Bank', *Everywoman*, Festival Number (May 1951), p. 36.

8 See Atkinson, *Festival*, p. 28. On the pedagogic aspects of the festival narrative and its reconciliation of national differences, see Barry Curtis, 'One Continu-

ous Interwoven Story (The Festival of Britain)', *Block*, 11 (Winter 1985–6): 48–52.

9 See Royal Commission on Population, Report, Cmd 7695 (1949), p. 124, as discussed in Chapter Five. Bill Schwarz, '"The Only White Man In There": The Re-Racialisation of England, 1956–68', *Race & Class*, 38:1 (July–September 1996): 65.

10 I am reminded of the use of this notion of national identity in propaganda produced during the Second World War, in which German fifth columnists and spies are exposed because of their inability to master the smallest and apparently least significant inflections of British custom and pronunciation. See *Miss Grant Goes to the Door* (UK, 1940; dir. Brian Desmond Hurst), made by the Ministry of Information in 1940, in which the German spy gives himself away by pronouncing a 'J' as a 'Y', and *Went The Day Well?* (UK, 1942; dir. Alberto Cavalcanti), in which the invasion of a village by a group of German paratroopers dressed as British soldiers is exposed in part by the continental style of writing the number '7'.

11 Turner, *Beacon*, p. 44. On the white nation in the festival narrative, see Conekin, *Autobiography*, pp. 100–4; Atkinson, *Festival*, p. 64.

12 Paul Gilroy, 'The Black Atlantic as a Counterculture', in *The Black Atlantic: Modernity and the Double Consciousness* (London: Verso, 1993), esp. pp. 3–7.

13 For an excellent initial discussion of Commonwealth participation through steel bands and the Imperial Institute, see Jo Littler, '"Festering Britain": The 1951 Festival of Britain, Decolonisation and the Representation of the Commonwealth', in Simon Faulkner and Anandi Ramamurthy, eds, *Visual Culture and Decolonisation in Britain* (Aldershot: Ashgate, 2006), pp. 21–42. On Caribbean music in this period, see John Cowley, 'London Is the Place: Caribbean Music in the Context of Empire 1900–1960', in Paul Oliver, ed., *Black Music in Britain: Essays on the Afro Asian Contribution to Popular Music* (Milton Keynes: Open University Press, 1990), pp. 57–76.

14 Anne McClintock, *Imperial Leather: Race, Gender and Sexuality in the Colonial Contest* (New York and London: Routledge, 1995), p. 231.

15 [Colonial Office], *Traditional Art from the Colonies,* An Exhibition in the Art Gallery of the Imperial Institute, London, 28 May–30 September 1951 (London: HMSO, 1951), p. 5. See also [Colonial Office], *Traditional Sculpture from the Colonies* (London: HMSO, 1951).

16 Frank Ormrod, 'Some Aspects of Colour in Photography', *Penrose Annual*, 45 (1951), p. 71.

17 Figures as cited in Hennessy, *Never Again*, p. 442.

18 For a detailed discussion of the role of film at the Festival of Britain, see Sarah Easen, 'Film and the Festival of Britain', in Ian Mackillop and Neil Sinyard, eds, *British Cinema of the 1950s: A Celebration* (Manchester and New York: Manchester University Press, 2003), pp. 51–63.

19 On *Family Portrait* see Charles Madge, 'A Note on Images (1951)', reprinted in Mary-Lou Jennings, ed., *Humphrey Jennings: Film-Maker, Painter, Poet* (London: British Film Institute in association with the Riverside Studios, 1982), pp. 47–9, and Lindsay Anderson, 'Postscript: October 1981', p. 59.

20 For Leacock's biography see http://www. screenonline.org.uk/people/id/513363/, accessed 22 June 2015. *Festival in London* is available, along with a transcript, at http://nationalarchives.gov.uk/films/ 1945to1951/filmpage_fil.htm, accessed 18 June 2014.

I am most grateful to Dr Luke McKernan, Lead Curator, News and Moving Image at the British Library, for his advice during my research on the film.

21 On the Central Office of Information, see Emily Crosby and Linda Kaye, eds, *Projecting Britain: The Guide to British Cinemagazines* (London: British Universities Film & Video Council, 2008), and, in particular, Luke McKernan, 'Cinemagazines: The Lost Genre', pp. ix–xiv, and Linda Kaye, 'Reconciling Policy and Propaganda: The British Overseas Television Service 1954–1964', pp. 69–96.

22 Stephen Tallents, *The Projection of England*, first published 1932 (London: Olen Press for Film Centre Ltd, 1955), pp. 11, 14. Before the war Tallents had been the secretary of the Empire Marketing Board; their film unit provided a template for wartime film information.

23 Laura Mulvey, *Death 24 × a Second: Stillness and the Moving Image* (London: Reaktion Books, 2006), p. 144. Hereafter page references will be given in paren

theses within the text. I am greatly indebted to Mulvey's argument, which enabled me to develop my own reading of *Festival in London*.

24 I was surprised during research on this material how many academic colleagues were content to see this question of the whiteness of the festival crowds as a more or less accurate expression of the numbers of African Caribbean migrants in Britain at this time. This approach to delaying cinema, which as Mulvey describes has been so enhanced by digital viewing platforms, also allows us to capture the presence of two black men and a woman carrying a small child, who briefly inhabit a crowd scene in the 'Dome of Discovery' in *Brief City* (1952). I am extremely grateful to Professor Barry Curtis for all his help and encyclopaedic knowledge in working on these details and, indeed, on all the film elements of this book.

25 [Basil Taylor], *The Festival of Britain: The Official Book of the Festival of Britain* (London: HMSO, 1951), p. 70.

26 On the organization and construction of the Festival Pleasure Gardens, see Michael Frayn, 'Festival', in Michael Sissons and Philip French, eds, *Age of Austerity* (London: Hodder and Stoughton, 1963), pp. 331–38; Turner, *Beacon*, pp. 87–105. Unlike the South Bank site, the site at Battersea Park stayed open until the 1970s.

27 *Pleasure Gardens Guide* (London: Festival Gardens Ltd, 1951), p. 23. 'The Guide' section, pp. 13–34, describes the different entertainments in detail. See also *Festival Gardens: Photo-Memories; A Souvenir of the Festival Pleasure Gardens, London* (London: Charles Skilton, 1951). The gardens were reported and illustrated in the press throughout the summer; see, for example, the coverage in *Picture Post*: 'Fair Fun', 16 June 1951, pp. 22–4; the colour feature 'Has All This Come To Stay?', 15 September 1951, pp. 25–7; and a 3-D special, 'The Fun of the Fair in 3-D', 20 June 1953, pp. 25–7. 'The Festival Gardens Open to the Public: Some of their Beauty, Fun, Thrills and Entertainment', *Illustrated London News*, 9 June 1951, pp. 937–9.

28 On 'retro chic' as embodied in the Nell Gwynn girls, see Raphael Samuel, *Theatres of Memory: Volume 1:*

Past and Present in Contemporary Culture (London and New York: Verso, 1994), pp. 92–3.

29 *Picture Post*, 15 September 1951, p. 27.

30 Salman Rushdie, *The Wizard of Oz*, 2nd edn (London: Palgrave Macmillan on behalf of the British Film Institute, 2012), pp. 32, 36. The poster advertising 'The Happiest Film Ever Made!' is reprinted on p. 2.

31 Peter Bailey, *Leisure and Class in Victorian England: Rational Recreation and the Contest for Control, 1830–1885* (London: Routledge & Kegan Paul, 1978), p. 56.

32 Interview with James Gardner, in Banham and Hillier, *Tonic*, p. 118. For a reading of the festival in terms of Bataille's theory of excess within rational social economies, see Owen Gavin and Andy Lowe, 'Designing Desire – Planning, Power and the Festival of Britain', *Block*, 11 (Winter 1985–6): 53–69.

33 Borough of Battersea, 'The Activities of the Mayor and Mayoress of Battersea: J. F. Lane Junr. J.P. and Mrs Lane,' 1950–1, not paginated, D116/4 [Scrap Book]. My thanks to Ruth MacLeod, Heritage Officer, Wandsworth Heritage Service, for her assistance during my research in the Battersea Library Archives.

34 [Taylor], *Festival*, p. 65.

35 For a history of Battersea see Colin Thom, ed., *Survey of London, Volume 50: Battersea. Part 2: Houses and Housing* (New Haven and London: Published for English Heritage by Yale University Press on behalf of Paul Mellon Centre for Studies in British Art, 2013), from which the following summary is drawn. See also Andrew Saint, ed., *Survey of London, Volume 49: Battersea. Part 1: Public, Commercial and Cultural* (2013).

36 Mayor Lane's family and political background is drawn from a variety of sources in the archives of the Wandsworth Heritage Service.

37 Borough of Battersea, 'Activities of the Mayor', not paginated. This archive is a scrap book of the mayor and mayoress's activities during 1950–1 and includes invitations, speeches and newspaper cuttings. I am reminded of the 'cleaning up' of the streets on the route to the Olympic site in Stratford in preparation for the London Olympics in 2012.

38 *The Metropolitan Borough of Battersea: Festival of Britain 1951; Official Souvenir Programme of Local Events*

(London: Century Press, 1951), p. 61, Festival of Britain 1951 and Battersea Park Misc., Battersea Library Archives.

39 Reported in the *South Western Star*, 20 July 1951, Cuttings, Battersea Library Archives.

40 *Festival 1951: A Festival Magazine for Battersea* (London: Paramount Press, 1951), p. 12, Battersea Library Archives.

41 See 'Bryan de Grineau's Drawings for the *Illustrated London News*, *Friends of Battersea Park Review*, 22 (Autumn–Winter 1993): 14–15. Cuttings, Battersea Library Archives.

42 On Battersea Power Station, see Saint, ed., *Survey of London, Volume 49*, pp. 369–87.

43 See 'Recollections' in Banham and Hillier, *Tonic*, p. 170.

44 *Black Eyes & Lemonade: A Festival of Britain Exhibition of Popular and Traditional Art Arranged in Association with the Society for Education in Art and the Arts Council Organised by Barbara Jones and Tom Ingram Catalogued by Douglas Newton* (London: Whitechapel Art Gallery, 1951), p. 5. I am grateful to Gary Haines and to Pamela Sepúlveda, Archivist, Whitechapel Gallery, for their help during my research on the exhibition. 'Drawing, Writing and Curating: Barbara Jones and the Art of Arrangement. An Essay by Catherine Moriarty to Accompany the Exhibition Black Eyes & Lemonade: Curating Popular Art', Whitechapel Gallery, 9 March – 1 September 2013, is an invaluable source.

45 British Colour Council, *Colour Schemes for the Interior Decoration of Factories and Offices*, 2nd edn (London: British Colour Council, 1956), p. 17.

46 Letter from Hugh Scrutton to Barbara Jones, 15 August 1951, WAG/EXH/2/17/1, Whitechapel Gallery Archives. Patrick O'Donovan, 'Black Eyes and Lemonade', *Observer*, 16 September 1951, Press Cuttings, Black Eyes & Lemonade, 1951, Whitechapel Gallery Archives.

47 'Whitechapel Art Gallery: Report 1951–52', p. 9, WAG/PUB/5/1, Whitechapel Gallery Archives. On the Victorian exhibitions of 1951, see Chapter Three.

48 Letter from Barbara Jones to Hugh Scrutton, dated 'Whit Monday'; Scrutton letter to Wendy Koop (SEA), dated 12 July 1950, WAG/EXH/2/17/1, Whitechapel Gallery Archives.

49 'Whitechapel Art Gallery: Report 1951–52', p. 10.

50 Barbara Jones, 'Introduction', in *Black Eyes*, p. 7.

51 Ibid., pp. 5, 7.

52 William Gaunt, 'Popular Art', *Punch*, 31 October 1951; John Berger, *New Statesman and Nation*, 1 September 1951; Eric Newton, 'Art of the People', *Time and Tide*, 25 August 1951. Press Cuttings, Black Eyes & Lemonade, 1951, Whitechapel Gallery Archives. There is an extensive collection of press cuttings in the Archive, on which this section is based.

53 Barbara Jones, *The Unsophisticated Arts* (London: Architectural Press, 1951), pp. 9, 10.

54 George Burchett's tattoo shop belongs to the same world as the grocery shop in the film *The Happy Family* (UK, 1952; dir. Muriel Box), which is also threatened with demolition by the Festival of Britain; see Chapter Four.

55 As cited in Jennings, *Humphrey Jennings*, p. 17.

56 On Edwin Smith's work for *The Saturday Book* and more generally, see 'Ordinary Beauty: The Photography of Edwin Smith', RIBA, London, 10 September – 6 December 2014.

57 On culture and the left 'revival' of the 1950s, see Perry Anderson, 'Components of the National Culture', *New Left Review*, 50 (July–August 1968): 3–57; Lisa Jardine and Julia Swindells, 'Homage to Orwell: The Dream of a Common Culture, and Other Minefields', in Terry Eagleton, ed., *Raymond Williams. Critical Perspectives* (Cambridge: Polity Press, 1989), pp. 108–29. See also Daniel Horowitz, *Consuming Pleasures: Intellectuals and Popular Culture in the Postwar World* (Philadelphia: University of Pennsylvania Press, 2012).

58 Richard Hoggart, *The Uses of Literacy: Aspects of Working Class Life with Special Reference to Publications and Entertainments*, 1st published 1957 (Harmondsworth: Pelican, 1958), p. 49.

59 Ibid., p. 114.

60 Post-war debates about popular culture, taste and Americanization are brilliantly discussed in Dick Hebdige, 'Towards a Cartography of Taste 1935–1962',

in *Hiding in the Light* (London and New York: Routledge, 1988), pp. 44–76.

61 Raymond Williams, *Culture and Society 1780–1950* (London: Chatto and Windus, 1958), p. 337; Raymond Williams, *Politics and Letters: Interviews with 'New Left Review'* (London: New Left Books, 1979), p. 97.

62 Williams, *Culture and Society*, p. 336.

63 There is a very extensive literature on the Independent Group; I have found the following most helpful: David Robbins, ed., *The Independent Group: Postwar Britain and the Aesthetics of Plenty* (Cambridge, Mass., and London: MIT Press, 1991); Anne Massey, *The Independent Group: Modernism and Mass Culture in Britain 1945–59* (Manchester and New York: Manchester University Press, 1995), and *Out of the Ivory Tower: The Independent Group and Popular Culture* (Manchester and New York: Manchester University Press, 2013).

64 Lawrence Alloway, 'The Arts and the Mass Media', *Architectural Design*, 28 (February 1958), p. 84.

65 Ibid., p. 85.

66 Gilroy, *Black Atlantic*.

67 On Neo-romanticism see Virginia Button, 'The Aesthetics of Decline: English Neo-Romanticism *c.*1935–1956', PhD thesis, University of London, 1992. See also Frances Spalding, *Dance Till the Stars Come Down: A Biography of John Minton* (London: Hodder and Stoughton, 1991).

68 Letter from John Minton to Michael Middleton, 1 June 1943, as cited in Spalding, *Dance*, pp. 37, 48.

69 John Minton, 'Jamaican Pictures', *Vogue*, November 1951, p. 132.

70 All quotes ibid., p. 134.

71 Arts Council – Festival of Britain, *Sixty Paintings for '51* (London: Arts Council, 1951), no. 37, ill. no. 5. On the organization of the exhibition, see Massey, *Independent Group*, pp. 13–14.

72 On Minton's Jamaican landscapes, see Simon Faulkner, 'Late Colonial Exoticism: John Minton's Pictures of Jamaica, 1950–1952', in Faulkner and Ramamurthy, *Visual Culture*, pp. 71–100; although Faulkner sees these paintings as constructing an image of the 'exotic', he also suggests that they offer a more complex representation of Jamaica than seen in other forms of contemporary visual culture. See also Simon Faulkner, 'Homo-Exoticism: John Minton in London and Jamaica, 1950–1', in Tim Barringer, Geoff Quilley and Douglas Fordham, eds, *Art and the British Empire* (Manchester: Manchester University Press, 2007), pp. 169–88. 'Port Calypso' was a weekly musical show broadcast on ITV in the mid-1950s that 'takes viewers to this Caribbean paradise to join the friendly inhabitants in a fiesta of music, song and romance', *TV Times*, 22 June 1956, p. 10.

73 See Rasheed Araeen, 'A Conversation with Aubrey Williams', *Third Text*, 2 (1987), reprinted in Kwesi Owusu, ed., *Black British Culture and Society: A Text Reader* (London and New York: Routledge, 2000), pp. 465–88, in which the date of his arrival is given as 1952; on the Institute of International Visual Arts (INIVA) website it states that he settled in London in 1954: http://www.iniva.org/library/archive/people/w/williams_aubrey, accessed 13 May 2015.

74 There is a growing literature on the post-war diaspora artists; amongst the sources that I have found helpful are Rasheed Araeen, *The Other Story: Afro-Asian Artists in Post-War Britain* (London: Hayward Gallery, 1989); Araeen, 'A Conversation', pp. 465–88; Olu Oguibe, 'Footprints of a Mountaineer: Uzo Egonu and the Black Redefinition of Modernism', in Owusu, *Black British Culture*, pp. 499–518; Leon Wainwright, 'Francis Newton Souza and Aubrey Williams: Entwined Art Histories at the End of Empire', in Faulkner and Ramamurthy, *Visual Culture*, pp. 101–26; Kobena Mercer, 'Black Atlantic Abstraction: Aubrey Williams and Frank Bowling', in *Discrepant Abstraction* (Cambridge, Mass., and London: MIT Press and the Institute of International Visual Arts, 2006), pp. 182–205; Eddie Chambers, *Black Artists in British Art: A History since the 1950s* (London and New York: I. B. Tauris, 2014). On the interwar years see the Tate Britain display 'Spaces of Black Modernism: London 1919–39', 13 October 2014 – 4 October 2015. A small number of these artists were included in 'Artist and Empire', Tate Britain, 21 November 2015 – 10 April 2016.

75 Stuart Hall, 'Black Diaspora Artists in Britain: Three "Moments" in Post-War History', *History Workshop Journal*, 61 (Spring 2006): 2.

76 See Margaret Garlake, *New Vision 56–66* (Jarrow, Tyne and Wear: Bede Gallery, 1984).

77 For an important survey of black British art, see 'No Colour Bar: Black British Art in Action 1960–1990', Guildhall Art Gallery, London, 10 July 2015 – 24 January 2016, which includes items from Eric and Jessica Huntley's archive and a recreation of their west London bookshop. The range of political and cultural positions represented by migrant artists is demonstrated by Frank Bowling, who describes the trauma of having the identity of 'black British artist' thrust upon him when he was a student at the Royal College of Art; see Frank Bowling, 'In Conversation', Tate Britain, 24 November 2015.

78 Lawrence Alloway, *Nine Abstract Artists: Their Work and Theory* (London: Alec Tiranti, 1954), pp. 2–3.

79 Patrick Heron, *Space in Colour* (London: Hanover Gallery, July–August 1953), as reproduced in Mel Gooding, ed., *Painter as Critic: Patrick Heron; Selected Writings* (London: Tate Gallery, 1998), p. 87. Also on Heron see Alan Gouk, 'Patrick Heron I', *Artscribe*, no. 34 (March 1982): 40–54, 'Patrick Heron II', *Artscribe*, no. 35 (June 1982): 32–43; Vivien Knight, ed., *Patrick Heron* (London: John Taylor in association with Lund Humphries, 1988); Vivien Knight, 'The Pursuit of Colour', in *Patrick Heron* (London: Hayward Gallery, July–September 1985), pp. 5–12; Andrew Wilson, 'Between Tradition and Modernity: Patrick Heron and British Abstract Painting 1945–1965', PhD thesis, University of London, 2000; *Patrick Heron Early Paintings 1945–1955* (London: Waddington Galleries, October–November 2000).

80 Patrick Heron, 'Paul Nash 1889–1946', *New English Weekly* (18 February and 6 March 1947), as reproduced in Gooding, *Painter as Critic*, p. 26 (original emphasis). See also Patrick Heron, 'Paul Nash', in *The Changing Forms of Art* (London: Routledge & Kegan Paul, 1955), p. 181.

81 Patrick Heron, 'Five Types of Abstraction: Ben Nicholson, Victor Pasmore, William Scott, Roger Hilton, John Wells', in Gooding, *Painter as Critic*, p. 189.

82 Patrick Heron, *Ivon Hitchens*, Penguin Modern Painters (Harmondsworth: Penguin, 1955), p. 3.

83 Adrian Cornwell-Clyne, *Colour Cinematography*, 3rd edn (London: Chapman and Hall, 1951), p. 663.

84 On the Commonwealth Immigrants Act, 1962, see Randall Hansen, *Citizenship and Immigration in Post-War Britain: The Institutional Origins of a Multicultural Nation* (Oxford: Oxford University Press, 2000), pp. 100–11; Kathleen Paul, 'Communities of Britishness: Migration in the Last Gasp of Empire', in Stuart Ward, ed., *British Culture and the End of Empire* (Manchester and New York: Manchester University Press, 2001), p. 193; David Kynaston, *Modernity Britain, Book Two: A Shake of the Dice, 1959–62* (London: Bloomsbury, 2014), pp. 346–53.

85 Patrick Heron, 'A Note on my Painting: 1962', catalogue of exhibition at Galerie Charles Lienhard, Zurich, January 1963, as cited in Michael McNay, *Patrick Heron* (London: Tate Publishing, 2002), p. 49.

86 As cited in Chambers, *Black Artists*, p. 19.

7 Bill and Betty Set Up Home

1 *Setting Up Home for Bill and Betty*, Whitechapel Art Gallery, in association with Oxford House, 5 June – 24 July 1952, p. 7.

2 The alternative titles are reported in WAG/EXH/2/20/1, Bill & Betty, Whitechapel Gallery Archives.

3 On the *Daily Mail* 'Ideal Home Exhibitions', see Deborah S. Ryan, *'Daily Mail' Ideal Home Exhibition: The Ideal Home through the Twentieth Century* (London: Hazar, 1997). On 'Britain Can Make It', see Penny Sparke, ed., *Did Britain Make It? British Design in Context 1946–86* (London: Design Council, 1986). The Mass Observation survey is referred to in Lucy Bullivant, '"Design for Better Living" and the Public Response to Britain Can Make It', in Sparke, *Did Britain Make It?*, pp. 148–9.

4 *Hackney Gazette*, 2 April 1952. Whitechapel Press Cuttings, Bill and Betty, 1952, Whitechapel Gallery Archives.

5 Robert Lutyens, 'Furnishing for Bill and Betty', *Country Life*, 18 July 1952, p. 197.

6 *Picture Post*, 30 October 1954, p. 24, discussed in Chapter Five (see fig. 102).

7 Attenborough's speech was reported in the *East London Advertiser*, 13 June 1952, Whitechapel Press

Cuttings, Bill and Betty, 1952. The exhibition cata-logue 'letter' to Bill and Betty has no page numbers.

8 *Setting Up Home* (the catalogue essay was not paginated though the catalogue itself was).

9 Attendances reported in the *Hackney Gazette*, 9 July 1952, Whitechapel Press Cuttings, Bill and Betty, 1952. Total attendance figures are given by the Gallery as 21,154 in 'Whitechapel Art Gallery: 52nd Annual Report, 1952–3', p. 10, WAG/PUB/5/2, Guardbook 10/51-7/57. The school visits are reported in a letter from Alan Jarvis, WAG/EXH/2/20/1, Bill & Betty. On the COID see Lesley Whitworth, 'Anticipating Afflu-ence: Skill, Judgement and the Problems of Aesthetic Tutelage', in Lawrence Black and Hugh Pemberton, eds, *An Affluent Society? Britain's Post-War 'Golden Age' Revisited* (Aldershot: Ashgate, 2004), pp. 167–83. On the role of the Council of Industrial Design in creating a new moral economy, see Richard Hornsey, *The Spiv and the Architect: Unruly Life in Postwar London* (Min-neapolis and London: University of Minnesota Press, 2010).

10 Margaret Llewellyn, *Colour and Pattern in your Home* (Loughborough and London: Co-Operative Union Ltd and the Council of Industrial Design, 1955), p. 1.

11 Council of Industrial Design, *Ideas for your Home* (London: HMSO, 1950), p. 2.

12 The phrase was used in '"Blitz" and "Blight"', *Picture Post*, 14 July 1945, p. 26. There is an extensive literature on housing and planning in the post-war period; amongst the most helpful and detailed are Junichi Hasegawa, *Replanning the Blitzed City Centre: A Comparative Study of Bristol, Coventry and Southamp-ton 1941–1950* (Buckingham and Philadelphia: Open University Press, 1992); Nick Tiratsoo, 'The Recon-struction of Blitzed British Cities, 1945–55: Myths and Reality', *Contemporary British History*, special issue: Planning, Politics and Housing in Britain, 14:1 (Spring 2000): 27–44; Nicholas Bullock, *Building the Post-War World: Modern Architecture and Reconstruction in Britain* (London and New York: Routledge, 2002); Peter J. Larkham and Joe Nasr, eds, *The Rebuilding of British Cities: Exploring the Post-Second World War Recon-struction*, Proceedings of a workshop sponsored by the

Faculty of the Built Environment and the Interna-tional Planning History Society (Birmingham: Uni-versity of Central England School of Planning and Housing, 2004); Catherine Flinn, '"The City of our Dreams"? The Political and Economic Realities of Rebuilding Britain's Blitzed Cities, 1945–54', *Twenti-eth Century British History*, 23:2 (2012): 221–45; Mark Clapson and Peter J. Larkham, eds, *The Blitz and its Legacy: Wartime Destruction to Post-War Reconstruction* (Farnham: Ashgate, 2013).

13 On Forshaw and Abercrombie's planning vision in the context of 1950s London, see Frank Mort, *Capital Affairs: London and the Making of the Per-missive Society* (New Haven and London: Yale Univer-sity Press, 2010), pp. 91–104.

14 The cartoon was published in the *Daily Express*, 13 October 1945, and was reprinted in the *Architect and Building News*, 27 December 1946, p. 240, in an article on how cartoonists had depicted the housing crisis. The British Cartoon Archive, University of Kent, ref-erence number GA0056.

15 For this definition of 'housing' and the 'home', see Marion Roberts, 'Designing the Home: Domes-tic Architecture and Domestic Life', in Graham Allan and Graham Crow, eds, *Home and Family: Creating the Domestic Sphere* (Basingstoke: Macmillan, 1989), p. 33.

16 Eliot Slater and Moya Woodside, *Patterns of Marriage: A Study of Marriage Relationships in the Urban Working Classes* (London: Cassell, 1951), pp. 217, 125.

17 B. S. Townroe, 'Housing: London Shows How', photographed by Chris Ware, *Picture Post*, 22 January 1949, p. 33. See also Chapters Two and Three.

18 Ian H. Cox, *The South Bank Exhibition: A Guide to the Story It Tells* (London: HMSO, 1951), p. 69.

19 Ibid., p. 72.

20 Basil Taylor, *The Festival of Britain: The Official Book of the Festival of Britain* (London: HMSO, 1951), p. 13. The Lansbury Estate was already occupied when it became the festival's Living Architecture Exhibition.

21 On the politics of housing 1945–55, see Graham Crow, 'The Post-War Development of the Modern Domestic Ideal', in Allan and Crow, *Home and Family*, pp. 14–32; Catherine Flinn, 'Reconstruc-tion Restraints: Political and Economic Realities', in

Clapson and Larkham, *The Blitz and its Legacy*, pp. 87–97.

22 Williams's term recurs throughout this study and is considered in detail in the Introduction.

23 General Register Office, *Census 1951: England and Wales; General Report* (London: HMSO, 1958), pp. 2, 123.

24 Figures given in the General Register Office, *Census 1951: England and Wales; Housing Report* (London: HMSO, 1956), pp. lxxx, lxxxiii.

25 Crow, 'Post-War Development', p. 21.

26 This Victorian housing landscape is vividly described by Frank Mort in the context of the murders committed by John Christie at 10 Rillington Place in north Kensington, an area of rented housing and Caribbean occupation; see *Capital Affairs*, pp. 104–25. Overcrowded and crumbling Victorian houses are the setting for the representation of migrant communities in the films and novels of this period, such as *Sapphire* (UK, 1959; dir. Basil Dearden, 1959); *Flame in the Streets* (UK, 1961; dir. Roy Ward Barker, 1961); and Lynne Reid Banks, *The L-Shaped Room* (London: Chatto and Windus, 1960) and film adaptation *The L-Shaped Room* (UK, 1962; dir. Bryan Forbes).

27 Lewis Mumford, *Technics and Civilization* (London: Routledge & Kegan Paul, 1955), p. 163. See also Chapter Four for discussion of Mumford's Paleo-technic and Neotechnic periods.

28 Boiler and radiator manufacturers advertised new designs in both specialist and general press; see, for example, the National Smoke Abatement Society, *Year Book* (London: NSAS, 1951), p. 44; (1952), p. 38; (1959), p. 7; *Architectural Review* (April 1955): lx. See also 'Fuel: Save and Be Warmer', *Picture Post*, 12 January 1952, pp. 14–15, 35; 'How to Save Ten Million Tons of Coal Each Year', 15 March 1952, pp. 15–17; 'Let's Keep the Home Fires Burning Without Wasting Heat and Fuel', 12 March 1955, pp. 36–7.

29 On domestic coal fires and smoke in the nineteenth century, see Peter Brimblecombe, *The Big Smoke: A History of Air Pollution since Medieval Times* (London and New York: Routledge, 1988), pp. 91–3, and Stephen Mosley, 'Fresh Air and Foul: The Role of the Open Fireplace in Ventilating the British Home

1837–1901', *Planning Perspectives*, 18:1 (January 2003): 1–21. On the home as a metaphor for the nation in wartime, see Antonia Lant, 'Prologue: Mobile Femininity', in Christine Gledhill and Gillian Swanson, eds, *Nationalising Femininity: Culture, Sexuality and British Cinema in the Second World War* (Manchester and New York: Manchester University Press, 1996), p. 17.

30 http://orwell.ru/library/essays/lion/english/e_eye, accessed 3 August 2015.

31 Richard Hoggart, *The Uses of Literacy: Aspects of Working Class Life with Special Reference to Publications and Entertainments*, first published 1957 (Harmondsworth: Pelican, 1958), p. 22.

32 Olive Cook and Edwin Smith, 'No Place Like Home', *The Saturday Book*, 17 (1957), p. 15. Cook goes on to express the hope that the idea of modern houses as '"machines for living in" may yet learn to speak English' (p. 17). *The Saturday Book* was launched in 1941; it was edited by Leonard Russell, who described the view of the annual: 'it looks backward, and nostalgia for small pre-war pleasures emerges from the pages...a tranquil book.' *The Saturday Book 1941–2: A New Miscellany* (London: Hutchinson, 1941), p. 6.

33 Christmas broadcast, 1954, in Tom Fleming, intro., *Voices Out of the Air: The Royal Christmas Broadcasts 1932–1981* (London: Heinemann, 1981), p. 75.

34 'Discussion on the Beaver Report', *Journal of the Institute of Fuel*, 28 (April 1955), p. 193, as cited in Peter Thorsheim, *Inventing Pollution: Coal, Smoke, and Culture in Britain since 1800* (Athens: Ohio University Press, 2006), p. 180. The argument that the gas fire could never stimulate the visual imagination was also put in 'Focal Point', *The Times*, 24 January 1946, p. 5.

35 The suggestion that the Conservative government agreed to a committee to inquire into air pollution as a way of curbing the power of the National Union of Mineworkers is made, for example, by Roy Parker, Centre of Social Policy, University of Bristol, in 'The Big Smoke: Fifty Years after the 1952 London Smog', seminar held 10 December 2002, Brunei Gallery, SOAS, London (London: Centre for History in Public Health, 2005, http://www.kcl.ac.uk/sspp/departments/icbh/witness/PDFfiles/BigSmoke.pdf),

p. 18. Arnold Marsh, *Smoke: The Problem of Coal and the Atmosphere* (London: Faber and Faber, 1947), p. 216.

36 Eustace Chesser, *Love and Marriage*, first published 1946, rev. edn 1952 (London: Pan Books, 1957), p. 182. On companionate marriage within Beveridge's welfare model, see Elizabeth Wilson, *Women and the Welfare State* (London: Tavistock, 1977), and Jane Lewis, *The End of Marriage? Individualism and Intimate Relations* (Cheltenham: Edward Elgar, 2001). See also Chapter Nine.

37 *Picture Post*, 12 December 1953, p. 30. Ovaltine is a milk-based drink containing barley, malt and cocoa. In 1953 the brand had been boosted when Sir Edmund Hillary had drunk Ovaltine during his Everest climb.

38 *Everywoman* (January 1958), p. 3.

39 As cited in Claire Langhamer, 'The Meanings of Home in Postwar Britain', *Journal of Contemporary History*, 40:2 (April 2005): 358.

40 John Bowlby, *Child Care and the Growth of Love* (London: Pelican, 1953). Based on Bowlby's report *Maternal Care and Mental Health*, produced for the World Health Organization and published in 1951. For an excellent discussion of psychological debates about the mother and child in this period, see Denise Riley, *War in the Nursery: Theories of the Child and Mother* (London: Virago, 1983). See also A. F. Philp, *The Problem of 'The Problem Family': A Critical Review of the Literature Concerning the 'Problem Family' and its Treatment* (London: Family Service Units, 1957).

41 John Bowlby, 'The Mother Who Stays at Home Gives Her Children a Better Chance', *News Chronicle*, 23 April 1952, p. 4. The series, 'For Better, For Worse . . .', ran for a week from 21 to 25 April 1952. Evelyn Stone's letter was published 25 April 1952, p. 2.

42 On the peacetime kitchen, see Sigfried Giedion, 'The Kitchen Becomes Mechanised', *Picture Post*, 18 March 1950, pp. 48–55. *Picture Post* carried regular advertising features on trends in kitchen design and equipment; see 'The Modern Kitchen', 27 February 1954, pp. 43–51, and 25 February 1956, pp. 29–32.

43 Cox, *South Bank Exhibition*, p. 71.

44 Lynne Reid Banks, *The L-Shaped Room*, first published 1960 (London: Vintage, 2004), p. 41.

45 David Sylvester, 'The Kitchen Sink', *Encounter* (December 1954), p. 62. On the 'Kitchen Sink' painters, see Deborah Cherry and Juliet Steyn, 'The Moment of Realism: 1952–1956', *Artscribe*, 35 (June 1982): 44–9; Graves Art Gallery, *The Forgotten Fifties*, Graves Art Gallery, Sheffield, 31 March – 13 May 1984; Dawn Ades, 'Figure and Place: A Context for Five Post-War Artists', in Susan Compton, ed., *British Art in the 20th Century: The Modern Movement*, Royal Academy of Arts, London, 15 January – 5 April 1987 (Munich: Prestel-Verlag, 1987), pp. 73-81; Mayor Gallery, *The Kitchen Sink Painters: John Bratby, Peter Coker, Derrick Greaves, Edward Middleditch, Jack Smith*, Mayor Gallery, London, in association with Julian Hartness, 20 March – 26 April 1991; James Hyman, *The Battle for Realism: Figurative Art in Britain during the Cold War 1945–60* (New Haven and London: Yale University Press, 2001); Juliet Steyn, 'Realism versus Realism in British Art of the 1950s', *Third Text*, 22:2 (March 2008): 145–56.

46 For a fascinating discussion of this painting in terms of the home as a shelter or bunker and the packed kitchen table as a nuclear survival kit, see Gregory Salter, 'Cold War at Home: John Bratby, the Self and the Nuclear Threat', in Catherine Jolivette, ed., *British Art in the Nuclear Age* (Farnham: Ashgate, 2014), pp. 151–69. Salter also offers a psychoanalytic reading of the cramped space and Bratby's fraught and occasionally violent domestic life.

47 As cited in Claire Langhamer, *The English in Love: The Intimate Story of an Emotional Revolution* (Oxford: Oxford University Press, 2013), p. 10.

48 Jack Smith in the Royal College of Art student magazine, *Ark*, 1960, as cited in Lynda Morris, 'The Beaux Arts Years, 1948–57', in Paul Huxley, ed., *Exhibition Road: Painters at the Royal College of Art* (Oxford: Phaidon, Christie's and the Royal College of Art, 1988), p. 34; John Bratby interviewed in 1984 for Graves Art Gallery, *Forgotten Fifties*, p. 46. In an interview for the same exhibition catalogue Smith emphasized: 'it was a misrepresentation of my attitude and intention to consider it social realist . . . I remember a critic of the time saying, "these artists identify with the working class". I don't identify with any class. The artist is classless and any identification of that kind is creative death' (p. 49).

49 For a clear summary of the group's work 1952–6, see Frances Spalding, 'Introduction', in Mayor

Gallery, *Kitchen Sink Painters*, pp. 7–13. On the role of the Beaux Arts Gallery in exhibiting the Kitchen Sink painters, see 'The Beaux Arts Gallery and Some Young British Artists', *Studio*, 154:775 (October 1957), pp. 110–13, and Andrew Forge, 'Helen Lessore and the Beaux Arts Gallery', in Marlborough Fine Art, *Helen Lessore and the Beaux Arts Gallery* (London: Marlborough Fine Art, 1968), pp. 5–12.

50 The Cold War context and political polarization of art criticism in this period is argued in Cherry and Steyn, 'Moment of Realism', and Steyn, 'Realism versus Realism'. The approach is picked up and developed by Hyman in *Battle for Realism*.

51 John Berger, 'For the Future', *New Statesman and Nation* (hereafter *New Statesman*), 19 January 1952, p. 64.

52 See Robert Hewison, *In Anger: Culture in the Cold War 1945–60* (London: Weidenfeld and Nicolson, 1981), pp. 110–12.

53 Total attendance at 'Looking Forward' was 9,724; see 'Whitechapel Art Gallery: 52nd Annual Report, 1952–3', p. 11.

54 John Berger, 'Forward', in Arts Council, *Looking Forward: An Exhibition of Realist Paintings and Drawings by Contemporary British Artists* (London: Arts Council, 1953), p. 2.

55 Patrick Heron, 'Three Exhibitions', *New Statesman*, 7 March 1953, p. 261.

56 For an excellent discussion of Butler's winning model and the political and cultural contexts of the 'Unknown Political Prisoner' competition, see Robert Burstow, 'Butler's Competition Project for a Monument to "The Unknown Political Prisoner": Abstraction and Cold War Politics', *Art History*, 12:4 (December 1989): 472–96. Burstow argues that the competition was supported by the CIA (Central Intelligence Agency), which, along with the anti-Communist Congress for Cultural Freedom, also backed the journal *Encounter*; see Hyman, *Battle for Realism*, pp. 158–65.

57 John Berger, 'The Unknown Political Prisoner', *New Statesman*, 21 March 1953, p. 338.

58 Herbert Read, 'Tragic Art', *New Statesman*, 28 March 1953, p. 366.

59 John Berger, 'Social Realism and the Young', *New Statesman*, 30 July 1955, p. 133.

60 Ibid., p. 134.

61 Albert Garrett, 'The New Realism in English Art', *Studio*, 147:735 (June 1954), p. 162.

62 Helen Lessore interviewed in 1968, as cited in Andrew Brighton and Lynda Morris, eds, *Towards Another Picture: An Anthology of Writings by Artists Working in Britain 1945–1977* (Nottingham: Midland Group, 1977), p. 69. John Minton, 'Three Young Contemporaries', *Ark*, 13 (1955): 12.

63 As cited in Hyman, *Battle for Realism*, p. 179. See Sophie Bowness and Clive Phillpot, eds, *Britain at the Venice Biennale 1895–1995* (London: British Council, 1995), pp. 106–7.

64 Alan Bowness, 'The Venice Biennale', *Observer*, 24 June 1956, p. 9. John Berger, 'The Battle', *New Statesman*, 21 January 1956, p. 70.

65 'Degrees of Realism in Painting', *The Times*, 17 July 1956, p. 5.

66 On Hamilton's contributions to Group 2's installation at 'This Is Tomorrow', 1956, see most recently Victoria Walsh, 'Seahorses, Grids and Calypso: Richard Hamilton's Exhibition-Making in the 1950s', in Mark Godfrey, Paul Schimmel and Vincente Todoli, eds, *Richard Hamilton* (London: Tate Publishing, 2014), pp. 73–4.

8 An English Sunday Afternoon

1 Bill Brandt, *Camera in London* (London and New York: Focal Press, 1948), pp. 20, 22.

2 http://orwell.ru/library/essays/lion/english/e_eye, accessed 27 August 2015.

3 Mass Observation, *Meet Yourself on Sunday*, drawings by Ronald Searle (London: Naldrett Press, 1949), p. 15. The notion of Sunday 'atmosphere' is repeated frequently throughout the investigation. (Hereafter quotes from this publication will be given in parentheses within the text.)

4 Kenneth G. Greet, *Enjoying Sunday* (London: Epworth Press, 1954), p. 10.

5 See Craig Harline, *Sunday: A History of the First Day from Babylonia to the Super Bowl* (New Haven and London: Yale University Press, 2011), from which my

summary of the history of Sunday is drawn. See also Stephen Miller, *The Peculiar Life of Sundays* (Cambridge, Mass., and London: Harvard University Press, 2008).

6 Although public debates about the nature of Sundays related to Britain in the period, they also exposed differences between its constituent parts, between, for example, the stricter religious commitments of some Welsh Members of Parliament and English MPs who proposed a relaxation of regulations on Sunday trading. In most cases, however, the issue was referred to as the 'English Sunday', as national identity was hegemonically defined as English rather than British.

7 For a useful account of Mass Observation research, see Liz Stanley, *Sex Surveyed, 1949–1994: From Mass Observation's 'Little Kinsey' to the National Survey and the Hite Reports* (London: Taylor & Francis, 1995), pp. 3–10.

8 B. Seebohm Rowntree and G. R. Lavers, *English Life and Leisure: A Social Study* (London, New York and Toronto: Longmans, Green & Co., 1952), p. xii.

9 R. C. Churchill, *The English Sunday* (London: Watts and Co., 1954), pp. 95–6. Rowntree and Lavers also discussed Sunday newspapers, comparing readerships of the popular press with those of 'serious' titles such as the *Observer* and the *Sunday Times*, pp. 289–92. Using figures from the Hulton Readership Survey of 1947, they confirmed that the *News of the World* had the biggest readership and also cited the statistic that 89.9 per cent of men and women read one or more Sunday newspapers (*English Life*, p. 295).

10 Churchill, *English Sunday*, p. 136.

11 Alan Sillitoe, *Saturday Night and Sunday Morning*, first published 1958 (London: Harper Perennial, 2008), p. 19. Sillitoe's novel is divided into 'Part One: Saturday Night' and 'Part Two: Sunday Morning'; Seaton's life is a rhythm of explosive Saturday nights ('a violent preamble to a prostrate Sabbath', p. 9) and Sunday morning repurcussions. The novel was adapted into a film in 1960, directed by Karel Reisz.

12 *Joy and Light: The Lord's Day Magazine*, no. 203 (April–June 1952), p. 10.

13 Shops Act 1950. 14 Geo. VI, c. 28.

14 Visitor numbers are reported in *121st Annual Report of the Lord's Day Observation Society*, 1951, p. ii. The Sunday programme at the Festival Pleasure Gardens was included in the regular 'What's On Today' official programmes.

15 As cited in *Joy and Light*, no. 206 (January–March 1953), p. 51.

16 'How the Pressure Works', *Picture Post*, 7 February 1953, p. 10. On 3 December 1955 *Picture Post* reported that the LDOS collected half a million signatures against Parker's bill, p. 37.

17 *Joy and Light*, no. 208 (July–September 1953), p. 115.

18 Similar figures are given in a number of histories, see, for example, Joe Moran, *Armchair Nation: An Intimate History of Britain in Front of the TV* (London: Profile Books, 2013), p. 73; on post-Coronation patterns of ownership, p. 81; and on Sunday broadcasting, pp. 107–8. See also Lez Cooke, *British Television Drama: A History* (London: BFI, 2003), and Asa Briggs, *The History of Broadcasting in the United Kingdom* (Oxford: Oxford University Press, 1995), esp. *Volume 4, Sound and Vision*, pp. 696–733.

19 Briggs, *History of Broadcasting, Volume 2, The Golden Age of the Wireless*, p. 211.

20 On the toddlers' truce and its abolition, see Bernard Sendall, *Independent Television in Britain: Volume 1, Origin and Foundation 1946–62* (London and Basingstoke: Macmillan, 1982), pp. 95, 243–6.

21 Ibid., p. 244. The introduction of religious broadcasting in this Sunday slot is described on pp. 279–83.

22 Reporting on the royal Sunday *Joy and Light*, no. 219 (April–June 1956), p. 182, and no. 220 (July–September 1956), pp. 201–4; on the BBC, 'TV and Sunday', no. 210 (January–March 1954), p. 192, and the broadcasting of Longchamp, no. 213 (October–December 1954), p. 256.

23 'The English Sunday' was broadcast on Friday 4 June 1954. *Joy and Light* reported that the programme amounted to 'an attack on the LDOS', no. 212 (July–September 1954), p. 227.

24 'Betrayal of Sabbath', *Joy and Light*, no. 212 (July–September 1954), p. 202. The prohibition of

broadcasting adverts was put forward as an amendment to the government-sponsored television bill, but was rejected and withdrawn when it was presented to the House of Lords.

25 Peter Eadie, 'Plenty in Store for Women', *Picture Post*, 27 August 1955, p. 44. This kind of advertising programme was abolished in 1961 by the Pilkington Committee report; see Sendall, *Independent Television*, p. 100. An example of Elizabeth Allan's programme can be seen at http://player.bfi.org.uk/film/watch-going-shopping-with-elizabeth-allan-1955/, accessed 18 July 2016.

26 Denzil Batchelor, 'Will TV Kill the British Sunday?', *Picture Post*, 3 December 1955, p. 37.

27 *127th Annual Report of the LDOS*, 1957, pp. 2–3. It was also reported that on a typical Sunday in 1957 out of seven and a half hours of programmes only forty minutes were religious.

28 See Callum G. Brown, *The Death of Christian Britain: Understanding Secularisation 1800–2000* (London and New York: Routledge, 2001). Brown revises the narrative of religious decline in the post-war period and suggests that signs of 'popular religiosity' continued to be strong until the early 1960s. Rowntree and Lavers suggested that although there was not necessarily a loss of a Christian ethic in public and private life, the nation was 'living on the spiritual capital of the past', *English Life*, p. 371.

29 Second Reading of Sunday Observance Bill, *HC Deb*, 30 January 1953, vol. 510, cc. 1401, 1403.

30 Ibid., c. 1427.

31 'Readers' Letters', *Picture Post*, 14 February 1953, p. 4.

32 Keith Waterhouse, '"No-Can-Do" Day', *Daily Mirror*, 13 March 1958, pp. 12–13.

33 'Saturday Satire by Vicky', *Daily Mirror*, 15 March 1958, p. 3. See also Peter Wilson, 'No-Can-Do-Day', *Daily Mirror*, 14 March 1958, p. 23.

34 Douglas Warth, 'Gloomy Sunday', *Daily Herald*, 13 March 1958, p. 4; Douglas Warth, 'Beware the Smile of Happy Harold', 14 March 1958, p. 4; 'Readers' Letters', 19 March 1958, p. 4. See also 'Should SUNDAY be GLOOMDAY?', *Daily Mail*, 24 April 1958, p. 5.

35 'In Debate and on T.V.', *Joy and Light*, no. 226 (January–March 1958), p. 12. The documentary series *Special Enquiry* also broadcast a programme in which people spoke about 'The English Sunday'; see Stuart Laing, *Representations of Working-Class Life 1957–1964* (Basingstoke: Macmillan, 1986), pp. 161–2.

36 'Increased Sunday Trading', *Joy and Light*, no. 222 (January–March 1957), p. 228; 'Threats to the Lord's Day', no. 227 (April–June 1958), p. 4.

37 Victor Anant, 'Big City Loneliness', photographed by Bert Hardy, *Picture Post*, 3 March 1956, p. 14; a number of letters in response to the article were published 24 March 1956, p. 5. On Katharine Whitehorn and *Picture Post*, see Juliet Gardiner, *Picture Post Women* (London: Collins and Brown, 1993), p. 7.

38 Sam Selvon, *The Lonely Londoners*, first published 1956 (Harmondsworth: Penguin, 2006), pp. 134–6.

39 Doris Lessing, 'The Small Personal Voice', in Tom Maschler, ed., *Declaration* (London: MacGibbon and Kee, 1957), p. 19.

40 Mass Observation, *Meet Yourself*, p. 31. On wartime church bells, Harline, *Sunday*, pp. 276–7.

41 John Osborne, *Look Back in Anger and Other Plays* (London: Faber and Faber, 1993), p. 5. There is a significant literature on the figure of the 'Angry Young Man' and working-class masculinity in *Look Back in Anger* and other literature from the period; it is my intention here not to rehearse these arguments, but to emphasize the importance and meaning of Sunday to Osborne's evocation of the bland hypocrisy of the British post-war consensus. See Michelene Wandor, *Look Back in Gender: Sexuality and the Family in Post-War British Drama* (London and New York: Methuen, 1987); Lynne Segal, 'Look Back in Anger: Men in the 50s', in Rowena Chapman and Jonathan Rutherford, eds, *Male Order: Unwrapping Masculinity* (London: Lawrence and Wishart, 1988), pp. 68–96; Janet Wolff, 'Angry Young Men and Minor Female Characters', in *Resident Alien: Feminist Cultural Criticism* (Cambridge: Polity, 1995), pp. 135–52; Deborah Philips and Ian Haywood, *Brave New Causes: Women in British Postwar Fictions* (London: Leicester University Press, 1998); Stephen Brooke, 'Gender and Working Class Identity in Britain during the 1950s', *Journal of Social History*, 34:4 (Summer 2001): 773–95.

42 Osborne, *Look Back*, pp. 6, 11, 13, 34–5, 92, 83. Kenneth Allsop describes Jimmy's attack on Alison in Act One as 'grinding away like a tooth-drill at the nerve ends of all around him during that Sunday limbo in the provincial flat', in *The Angry Decade: A Survey of the Cultural Revolt of the Nineteen-Fifties*, first published 1958 (Wendover: John Goodchild, 1985), p. 20.

43 Robert Muller, 'Angry Young Men', photographed by Slim Hewitt, *Picture Post*, 23 June 1956, p. 33.

44 See 'Ray Galton's and Alan Simpson's *Hancock's Half Hour*: The Very Best Episodes; Volume 1', BBC Audio, BBC Worldwide Ltd, 2014, from which the following quotes are taken. The episode is referred to in Harline, *Sunday*, pp. 225–6. The radio show began in 1954 and, from 1956, ran concurrently with a BBC television series with the same name; it ended as a radio show in 1959.

45 *It Always Rains on Sunday*, shooting script, 24 January 1947, not paginated, SCR 10254, Unpublished Scripts Collection, BFI National Archive.

46 *It Always Rains on Sunday*, press book – small, PBS 33754. Pressbooks Collection, BFI National Archive.

47 Arthur La Bern, *It Always Rains on Sunday* (London: Nicolson and Watson, 1945).

48 A full outline of the plot and many aspects of the production of the film are given in John W. Collier, *A Film in the Making: It Always Rains on Sunday* (London: World Film Publications, 1947).

49 Charlotte Brunsdon, *London in Cinema: The Cinematic City since 1945* (London: BFI, 2007), p. 163. See also Sheila Whitaker, '*It Always Rains on Sunday*: Part (II)', *Framework*, 9 (Winter 1978): 21; Charles Barr, *Ealing Studios*, 3rd edn (Berkeley, Los Angeles and London: University of California Press, 1998), pp. 68–9; Christine Geraghty, *British Cinema in the Fifties: Gender, Genre and the 'New Look'* (London and New York: Routledge, 2000), pp. 83–8; Philip Gillett, *The British Working Class in Postwar Film* (Manchester and New York: Manchester University Press, 2003), p. 45. Gillett points to the realist treatment of the Sandigate home and suggests: 'The unheated bedrooms are hardly visited during the day, so Rose can safely let Tommy sleep in her bed' (p. 42).

50 This point is made in relation to the representation of women's experiences in the film *Dance Hall* (1950) in Geraghty, *British Cinema*, p. 89.

51 *It Always Rains on Sunday*, press book – small. See Collier, *A Film in the Making*, p. 64. Actress Googie Withers also said that director Robert Hamer wanted to shoot the film 'out in the streets where it all happens'. In Brian McFarlane, *An Autobiography of British Cinema: As Told by the Filmmakers and Actors Who Made It* (London: Methuen, 1997), p. 610. See also Barry Forshaw, *British Crime Film: Subverting the Social Order* (Basingstoke: Palgrave Macmillan, 2012), p. 20.

52 The treatment of the Hyams family is discussed in Brunsdon, *London in Cinema*, p. 164.

53 Mass Observation, *Meet Yourself*, p. 41.

54 Ibid., p. 43.

55 See Melanie Bell, *Femininity in the Frame: Women and 1950s British Popular Cinema* (London and New York: I. B. Tauris, 2010), and Geraghty, *British Cinema*, pp. 82–92.

56 Withers in McFarlane, *An Autobiography*, p. 610. The younger Rose, seen in flashback, has blonde hair, whereas in the present, the middle-aged Rose has dark hair.

57 The dress chart for Googie Withers in *It Always Rains on Sunday* is reproduced in Collier, *A Film in the Making*, p. 63. The head of the wardrobe department at Ealing from 1947 to 1956 was Anthony Mendleson, and *It Always* was his first film for the studio. See Catherine A. Surowiec, 'Anthony Mendleson: Ealing's Wardrobe Wizard', in Mark Duguid, Lee Freeman, Keith M. Johnston and Melanie Williams, eds, *Ealing Revisited* (London: BFI/Palgrave Macmillan, 2012), pp. 111–24.

58 See Barr, *Ealing Studios*, p. 89. The plaque is quoted on p. 7.

59 On Ealing press and publicity materials, see the excellent essay by Nathalie Morris, 'Selling Ealing', in Duguid et. al., *Ealing Revisited*, pp. 91–100. On Ealing posters, see David Wilson, ed., *Projecting Britain: Ealing Studios Film Posters* (London: BFI, 1982).

60 Memo from Monja Danischewsky to Michael Balcon, 5 March 1948, as cited in Morris, 'Selling Ealing', p. 99.

61 The oil sketch is in the collection of the V&A. An ink and gouache sketch by Boswell called *Café, Kentish Town* (1947), in the collection of Tate, is clearly also part of this series but is not so closely related to the poster. Eric Hobsbawm, 'Portrait of a Neighbourhood', *Lilliput*, 20:4 (April 1947), pp. 320–6. The four accompanying images by Boswell were *Little Gold Mine, Private Enterprise, Saturday Night* and *Spring Fever*.

62 On Boswell's life and career, see Paul Hogarth, *James Boswell 1906–71: Drawings, Illustrations and Paintings* (Nottingham: Nottingham University Art Gallery, 22 November – 16 December 1976); William Feaver, *Boswell's London: Drawings by James Boswell Showing Changing London from the Thirties to the Fifties* (London: Wildwood House, 1978); Hyman, *Battle for Realism*, pp. 49–50.

63 *It Always Rains on Sunday*, press book – medium, PBM 33754, Pressbooks Collection, BFI National Archive.

9 Woman in a Dressing Gown

1 See dress chart for Googie Withers as reproduced in John W. Collier, *A Film in the Making: It Always Rains on Sunday* (London: World Film Publications, 1947), p. 63.

2 Elizabeth Wilson, *Only Halfway to Paradise: Women in Postwar Britain 1945–1968* (London and New York: Tavistock, 1980), p. 30.

3 Judy Attfield, 'Design as a Practice of Modernity: A Case for the Study of the Coffee Table in the Mid-Century', *Journal of Material Culture*, 2:3 (November 1997): 270.

4 Ibid., p. 277.

5 I use 'housecoat' here as an umbrella term for the range of lightweight and stylish items of clothing that was aimed at women in the home in the postwar period and that was intended to replace the warm dressing gown of the previous years; it is not my intention here to examine terminology and the different words for these items, although they will be referred to where relevant. On the new range of domestic outfits, see Christopher Breward, Becky Conekin and Caroline Cox, 'Introduction', in Christopher Breward, Becky Conekin and Caroline Cox, eds, *The Englishness of English Dress* (Oxford and New York: Berg, 2002), pp. 4–5; Roseann Ettinger, *50s Popular Fashions for Men, Women, Boys, and Girls* (Atglen, Penn.: Schiffer, 1995), pp. 62–7.

6 *Everywoman* (January 1952), p. 48.

7 Christian Dior's 'New Look' style was launched in 1947; with its long, full skirts and careful tailoring, it was regarded as a complete break with the pared down styles of wartime clothing.

8 *Everywoman* (January 1952), p. 49.

9 'Bargain of the Month', *Everywoman* (May 1952), p. 28; 'Are You a Smart Housewife?' (November 1952), pp. 72–3.

10 These themes were fully explored in the exhibition 'Fashion on the Ration: 1940s Street Style', Imperial War Museum, London, 5 March–31 August 2015, and in papers delivered at 'The Look of Austerity' conference, held at the Museum of London, 11–12 September 2015.

11 'Bargain of the Month', *Everywoman* (August 1954), p. 77.

12 The Independent Group and 'The Expendable Aesthetic' are discussed in detail in Anne Massey, *The Independent Group: Modernism and Mass Culture in Britain 1945–59* (Manchester and New York: Manchester University Press, 1995), pp. 72–94. Here, I am less concerned with the Independent Group than with considering how the image of the modern housewife permeated British post-war culture, from mainstream commercial life to the forms of avant-garde or progressive art.

13 Lawrence Alloway, 'The Arts and the Mass Media', *Architectural Design*, 28 (February 1958), p. 85.

14 Massey, *Independent Group*, pp. 42, 44.

15 Richard Hamilton, 'An Exposition of *$he*', first published in edited form in *Architectural Design* (October 1962), as reproduced in *Collected Words 1953–1982* (London: Thames and Hudson, 1982), p. 36. On Hamilton's use of the visual languages of consumer culture, see Alice Rawsthorn, 'Richard Hamilton and Design', in Mark Godfrey, Paul Schimmel and Vincente Todoli, eds, *Richard Hamilton* (London: Tate Publishing, 2014), pp. 125–34.

16 On the 'House of the Future', see the excellent discussion in Beatriz Colomina, 'Unbreathed Air 1956', *Grey Room*, 15 (2004): 28–59. See also Dirk Van Den Heuvel and Max Risselada, eds, *Alison and Peter Smithson: From the House of the Future to a House for Today* (Rotterdam: 010 Publishers, 2004).

17 As cited in '*Daily Mail' Ideal Home Exhibition: Olympia March 6th to 31st; Catalogue and Review* (London: n.p., 1956), p. 100.

18 John Braine, *Life at the Top* (London: Eyre & Spottiswoode, 1962), as cited in Ben Highmore, *The Great Indoors: At Home in the Modern British House* (London: Profile Books, 2014), p. 168. See also John Braine, *Room at the Top* (London: Methuen, 1957).

19 *Woman in a Dressing Gown* was broadcast at 8.00 p.m. on Thursday 28 June 1956, in the regular slot for the anthology drama series, 'Television Playhouse', produced by Associated Rediffusion.

20 *TV Times*, 22 June 1956, p. 21. See also Cecile Leslie, 'Play on a Page', original short story introducing the characters of *Woman in a Dressing Gown*, p. 34. See reviews in the *Daily Mail*, 29 June 1956, *Daily Mail* Historical Archive, accessed 22 April 2015, and in the *Daily Express*, 29 June 1956, p. 5.

21 David Sylvester, 'The Kitchen Sink', *Encounter* (December 1954), p. 62; John Berger, 'For the Future', *New Statesman and Nation*, 19 January 1952, p. 64. Discussed in Chapter Seven.

22 The growth in television ownership is discussed in Chapter Eight. See also the *Daily Film Renter*, 25 January 1955, p. 1, which reported that in the first quarter of 1954 television audiences had risen from 8,400,000 to 11,000,000. As cited in Amy Sargeant, *British Cinema: A Critical History* (London: BFI, 2005), p. 205. See also Pat Thane, 'Family Life and "Normality" in Postwar Britain', in Richard Bessel and Dirk Schumann, eds, *Life After Death: Approaches to a Cultural and Social History of Europe during the 1940s and 1950s* (Cambridge: Cambridge University Press, 2003), p. 203.

23 There is a substantial literature on post-war television drama; see, in particular, John Caughie, *Television Drama: Realism, Modernism and British Culture* (Oxford: Oxford University Press, 2000); Jason Jacobs, *The Intimate Screen: Early British Television Drama* (Oxford: Clarendon Press, 2000); Lez Cooke, *British Television Drama: A History* (London: BFI, 2003) and *Style in British Television Drama* (Basingstoke: Palgrave Macmillan, 2013); Su Holmes, *Entertaining Television: The BBC and Popular Television Culture in the 1950s* (Manchester and New York: Manchester University Press, 2008).

24 The 'ITV Television Playhouse' series also included the strand 'ABC Armchair Theatre', produced by Sydney Newman, with a strong commitment to original, realist drama. Thanks to John Wyver for his observations on television programming in this period.

25 See Ted Willis, *Evening All: Fifty Years Over a Hot Typewriter* (London: Macmillan, 1991). 'Evening All' was the signature phrase of Dixon of Dock Green and opened each programme.

26 Ibid., p. 138.

27 Ted Willis, 'Look Back in Wonder', *Encore: The Voice of Vital Theatre*, 4:4 (March–April 1958): 15.

28 Ted Willis, *Woman in a Dressing Gown and Other Television Plays* (London: Barrie and Rockliff, 1959), p. 36. Hereafter page references from this publication will be given in parentheses within the text. Most commentary on Willis's story has focussed on the later film adaptation; very little has been said about the television play.

29 In a recent study of audience memories of the 1957 film of *Woman in a Dressing Gown*, this scene of the ruined hairdo stood out; see Melanie Williams, 'Remembering "the poor soul walking in the rain": Audience Responses to a Thwarted Makeover in *Woman in a Dressing Gown'*, *Journal of British Cinema and Television*, 10:4 (2013): 709–26.

30 Willis, *Evening All*, p. 139. See also Willis, *Woman in a Dressing Gown*, p. 8.

31 Willis, *Woman in a Dressing Gown*, p. 20.

32 Reviews published in the *Daily Mail* and *Daily Express* and cited by Willis in *Woman in a Dressing Gown*, p. 9. The public response to the television broadcast and the approach by J. Lee Thompson are referred to in *Evening All*, pp. 140–1.

33 Following the success of the film, Willis turned *Woman in a Dressing Gown* into a stage play, which

opened in Australia and toured South America, Japan and Europe. The Australian production cast Googie Withers in the role of Amy, who Willis stated was the best actress in that role, *Evening All*, pp. 166–7.

34 The television play opened with a film clip of the flats: '[a] large, modern block of council or L.C.C. flats'; the use of this setting in the film led historian Raymond Durgnat to describe the film as 'the *Brief Encounter* of the council houses', in *A Mirror for England: British Movies from Austerity to Affluence* (London: Faber and Faber, 1970), p. 58.

35 The camera style is described in more detail in Sue Harper and Vincent Porter, *British Cinema of the 1950s: The Decline of Deference* (Oxford: Oxford University Press, 2003), pp. 86–7, where it is also stated that the film earned nearly £1 million at the box office. Film historian Melanie Williams has written on a number of aspects of the film; see 'Women in Prison and Women in Dressing Gowns: Rediscovering the 1950s Films of J. Lee Thompson', *Journal of Gender Studies*, 11:1 (2002): 5–15; 'Housewife's Choice: *Woman in a Dressing Gown*', in Ian MacKillop and Neil Sinyard, eds, *British Cinema of the 1950s: A Celebration* (Manchester and New York: Manchester University Press, 2003), pp. 143–54; 'Remembering', pp. 709–26. See also Melanie Bell, *Femininity in the Frame: Women and 1950s British Popular Cinema* (London and New York: I. B. Tauris, 2010), esp. pp. 156–9.

36 Release script, *Woman in a Dressing Gown*, SCR 19402, Unpublished Scripts Collection, BFI National Archive.

37 Sunday evening was typically the one time of the week when men would take their wives to the pub; see Mass Observation, *Meet Yourself on Sunday* (London: Naldrett Press, 1949), p. 31. George Sandigate also expects his wife, Rose, to accompany him to the local pub in *It Always Rains on Sunday*, discussed in Chapter Eight.

38 'Slummock' is a Yiddish term for a sloppy, dowdy person.

39 Yvonne Mitchell, *Actress* (London: Routledge & Kegan Paul, 1957), p. 1. The book was published to tie in with the release of the film.

40 Sylvia Sims interviewed in Brian McFarlane, *An Autobiography of British Cinema: As Told by the Film-makers and Actors Who Made It* (London: Methuen, 1997), p. 549.

41 'EXPLOITATION! "Woman in a Dressing Gown is worth all the exploitation that a showman can give it" – *The Cinema*. TAKE THIS ADVICE SHOWMEN and GO TO IT!'. In *Woman in a Dressing Gown*, not paginated, press book – medium, PBM 51902, Pressbooks Collection, BFI National Archive. All promotions cited in the following paragraphs are taken from the press book.

42 Ann Oakley, *From Here to Maternity: Becoming a Mother* (Harmondsworth: Penguin, 1981), p. 11. This passage is memorably quoted by Carolyn Steedman in her study of twentieth-century working-class women, *Landscape for a Good Woman: A Story of Two Lives* (London: Virago, 1986), where she observes: 'The other side of waiting is wanting', p. 22.

43 There is a very substantial literature on the postwar 'companionate marriage'; amongst the texts that I have found most useful are Janet Finch and Penny Summerfield, 'Social Reconstruction and the Emergence of Companionate Marriage, 1945–59', in David Clark, ed., *Marriage, Domestic Life and Social Change: Writings for Jacqueline Burgoyne (1944–88)* (London and New York: Routledge, 1991), pp. 7–32; Thane, 'Family Life and "Normality" in Postwar Britain'; Marcus Collins, *Modern Love: An Intimate History of Men and Women in Twentieth Century Britain* (London: Atlantic, 2003); Claire Langhamer, 'Adultery in Post-War England', *History Workshop Journal*, 62 (Autumn 2006): 86–115, 'Love and Courtship in Mid-Twentieth Century England', *Historical Journal*, 50 (2007): 173–96, 'Love, Selfhood and Authenticity in Post-War Britain', *Cultural and Social History*, 9:2 (2012): 277–97 and *The English in Love: The Intimate Story of an Emotional Revolution* (Oxford: Oxford University Press, 2013).

44 Mayo Wingate, 'Is Your Marriage a Partnership?', *Everywoman* (November 1954), p. 79.

45 As cited in Tom Fleming, intro., *Voices Out of the Air: The Royal Christmas Broadcasts 1932–1981* (London: Heinemann, 1981), p. 74.

46 See Lesley A. Hall, *Sex, Gender and Social Change in Britain since 1800* (Basingstoke and London: Macmillan, 2000), p. 146, and Jane Lewis, *The End of*

Marriage? Individualism and Intimate Relations (Cheltenham: Edward Elgar, 2001), p. 172.

47 See Alison Oram, 'Love "Off the Rails" or "Over the Teacups"? Lesbian Desire and Female Sexualities in the 1950s British Popular Press', in Heike Bauer and Matt Cook, eds, *Queer 1950s: Rethinking Sexuality in the Postwar Years* (Basingstoke: Palgrave Macmillan, 2012), pp. 41–57.

48 Eliot Slater and Moya Woodside, *Patterns of Marriage: A Study of Marriage Relationships in the Urban Working Classes* (London: Cassell, 1951), p. 168. On 1950s sex and marriage manuals, see Hall, *Sex, Gender*, pp. 136–9.

49 Eustace Chesser, *Love and Marriage*, rev. edn (London: Pan Books, 1957), pp. 46, 50. The book was first published in 1946, with a revised edition in 1952. See also *Love Without Fear: A Plain Guide to Sex Technique for Every Married Adult* (London: Rich and Cowan Medical Publications, 1941).

50 Ibid., pp. 71, 87, 89.

51 Eustace Chesser, *The Sexual, Marital and Family Relationships of the English Woman* (London: Hutchinson's Medical, 1956), p. 397.

52 Finch and Summerfield, 'Social Reconstruction', pp. 8–9. See also Carol Smart, 'Law and the Control of Women's Sexuality: The Case of the 1950s', in Bridget Hunter and Gillian Williams, eds, *Controlling Women: The Normal and the Deviant* (London: Croom Helm, 1981), pp. 40–60.

53 'Sex and the Citizen', *Picture Post*, 15 September 1951, p. 37.

54 Geoffrey Gorer, *Exploring English Character* (London: Cresset Press, 1955), pp. 113, 96–7. See also his *Sex and Marriage in England Today: A Study of the Views and Experience of the Under-45s* (London: Nelson, 1971).

55 Gorer, *Exploring*, p. 125. For discussion of the Technicolor advert, see Chapter Four.

56 Mary Macaulay, *The Art of Marriage* (London: Delisle, 1952), not paginated.

57 On revisionist accounts of the 'golden age' marriage in the 1950s, see Oram, 'Love', p. 42. On counselling organizations, see Collins, *Modern Love*, p. 116.

58 David Mace, *Marriage Crisis* (1948), as cited in Martin Francis, 'A Flight from Commitment? Domes-

ticity, Adventure and the Masculine Imaginary in Britain after the Second World War', *Gender & History*, 19:1 (April 2007), p. 163.

59 *Report 1951–1955*, Cmd 9678 (London: HMSO, 1956), Royal Commission on Marriage and Divorce, p. 8, para. 39. Hereafter page and paragraph references will be given in parentheses in the text. On the RCMD, see Hall, *Sex*, pp. 150–2, and Finch and Summerfield, 'Social Reconstruction', pp. 26–7.

60 *RCMD*, pp. 357–9, Table 5.

61 The Family Discussion Bureau is now run as Tavistock Relationships; see www.tavistockrelationships.org. My thanks to Susanna Abse, former Director of the Tavistock Centre for Couple Relationships, for discussions about couple counselling in the 1950s. For an outstanding discussion of the work of the FDB, see Deborah Cohen, *Family Secrets: Shame and Privacy in Modern Britain* (Oxford and New York: Oxford University Press, 2013). The best account of the work of the FDB in its first years is Lily Pincus et al., *Social Casework in Marital Problems: The Development of a Psychodynamic Approach; A Study by a Group of Caseworkers* (London: Tavistock, 1955).

62 Pincus et al., *Social Casework*, pp. 32, 35.

63 For discussion of Balint's work in the context of bombsites and ruined landscapes see Chapter Two.

64 Pincus et al., *Social Casework*, pp. 116, 78, 166.

65 Cohen, *Family Secrets*, p. 221. The following analysis of the case of Mr and Mrs P is based on similar cases that were reported by Pincus.

66 Richard M. Titmuss, *Essays on 'The Welfare State'* (London: George Allen & Unwin, 1958), pp. 101–3.

67 Alva Myrdal and Viola Klein, *Women's Two Roles: Home and Work* (London: Routledge & Kegan Paul, 1956), p. 13. See Jane Lewis, *Women in Britain since 1945: Women, Family, Work and the State in the Post-War Years* (Oxford: Basil Blackwell, 1992), pp. 24–5, 72–4.

68 Myrdal and Klein, *Women's Two Roles*, p. 137. Lily Pincus and the FDB also acknowledged the conflict that a woman might feel between her desire to earn her living and other expectations relating to the feminine roles of wife and mother, and identified this as a reason why she might have difficulty in making a

satisfactory sexual identification; Pincus, *Social Case-work*, p. 166.

69 Macaulay, *Art of Marriage,* rev. edn (London: Delisle, 1956), p. 97.

70 Ibid., p. 78.

71 Gorer, *Exploring English Character*, pp. 128, 145, 148, 149, 150. See also the reply of a twenty-eight-year-old wife from Tiverton who wrote: 'After marriage . . . really you should try to be as attractive as the day he married you and even with children. Always have his meals *ready*, nice clean house and home, listen to all his troubles about what a horrid day he's had, even if yours has been dreadful, a housewife can stop and rest for half an hour, but a man can't. Above all, look clean and attractive yourself' (p. 143).

72 Grieve as cited in Wilson, *Only Halfway to Paradise*, p. 38. Grieve wrote about her years as editor of *Woman* in *Millions Made My Story* (London: Victor Gollancz, 1964). On women's magazines in the post-war period, see Cynthia L. White, *Women's Magazines 1693–1968* (London: Michael Joseph, 1970), pp. 130–54.

73 'Ask Evelyn Home', *Woman*, 20 January 1951, p 37

74 'Ask Evelyn Home', *Woman*, 27 January 1951, p. 37.

75 John Deane Porter, 'Girl with the Dressing-Gown Mind', *Woman*, 26 November 1960, p. 25.

76 Donald W. Winnicott, *The Ordinary Devoted Mother and her Baby: Nine Broadcast Talks (Autumn 1949)* (London: 'Pamphlet', 1950). Winnicott began his radio talks during the war and continued to publish on the mother-child relationship throughout the 1950s; see *The Child and the Family: First Relationships* (London: Tavistock, 1957) and *Collected Papers: Through Paediatrics to Psycho-Analysis* (London: Tavistock, 1958). His concept of the 'good enough' mother describes the gradual loosening of the initial bond between mother and baby, which allows the infant to gain a sense of autonomy and to adapt to external realities. In this way, the 'good enough' mother may be preferred to the 'perfect' mother who does not relinquish the connection with her baby. Though not defined as perfect, Winnicott's image of the 'good enough' mother might also be considered a maternal ideal. See 'Transitional Objects and Transitional Phenomena: A Study of the First Not-Me Possession', *International Journal of Psycho-Analysis*, 34 (1953): 93. For a recent discussion on Winnicott's work in the context of post-war Britain, see Sally Alexander, 'Primary Maternal Preoccupation: D. W. Winnicott and Social Democracy in Mid-Twentieth Century Britain', in Sally Alexander and Barbara Taylor, eds, *History and Psyche: Culture, Psychoanalysis, and the Past* (New York: Palgrave Macmillan, 2012), pp. 149–72.

77 Winnicott, *Ordinary Devoted Mother*, p. 47.

Works Cited

Archival Sources

Archives, Heritage and Photography, Library of
 Birmingham
Battersea Library Archives, Wandsworth Heritage
 Service
British Cartoon Archive, University of Kent
British Film Institute National Archive
British Library
London Metropolitan Archives
Museum of London
National Archives
National Sound Archive, British Library
Victoria and Albert Museum
Whitechapel Gallery Archives

Statutes, Parliamentary Papers and Official Publications

British Nationality Act, 1948, 11 & 12 Geo. VI, c. 56.
Clean Air Act, 1956, 4 & 5 Eliz. II, c. 52.
Commonwealth Immigrants Act, 1962, 10 & 11 Eliz.
 II, c. 21.
General Register Office. *Royal Commission on
 Population, Report*, Cmd 7695. London: HMSO,
 1949.
—. *Census 1951: England and Wales; Housing Report*.
 London: HMSO, 1956.
—. *Census 1951: England and Wales; General Report*.
 London: HMSO, 1958.
—. *Census 1961: England and Wales; Preliminary
 Report*. London: HMSO, 1961.
HM Treasury. *Final Settlement of War Damage
 Payments*, Cmnd 1583. London: HMSO, 1961.

Medical Officer of Health. 'Fog and Frost in December 1952 and Subsequent Deaths in London', *Report to the Health Committee*. London: London County Council, 19 January 1953.

Ministry of Health. 'Mortality and Morbidity during the London Fog of December 1952', *Reports on Public Health and Medical Subjects*, 95. London: HMSO, 1954.

Ministry of Housing and Local Government. *Committee on Air Pollution. Interim Report*. Cmd 9011. London: HMSO, 1953.

—. *Committee on Air Pollution: Final Report*, Cmd 9322. London: HMSO, 1954.

Parliamentary Debates (Hansard) House of Commons Official Reports, ser. London: HMSO.

Parliamentary Debates (Hansard) House of Lords Offical Reports, ser. London: HMSO.

Royal Commission on Marriage and Divorce. *Report 1951–1955*, Cmd 9678. London: HMSO, 1956.

Shops Act, 1950, 14 Geo.VI, c. 28.

Shops HL Bill, 1957–8.

Sunday Observance Act HC Bill, 1952–3.

Television Act, 1954, 2 & 3 Eliz. II, c. 55.

Newspapers and Periodicals

Architect and Building News
Architectural Design
Architectural Review
Ark
British Journal of Photography
Builder
Clean Air Society Year Book
Country Life
Daily Express
Daily Film Renter
Daily Herald
Daily Mail
Daily Mirror
Daily Telegraph
Emotion, Space and Society
Encounter
Everywoman
Festival 1951: A Festival Magazine for Battersea
Harper's Bazaar
Illustrated London News
Joy and Light: The Lord's Day Magazine
Journal of the Institute of Fuel
Kinematograph Weekly
Lancet
Lilliput
Listener
Man About Town
Manchester Guardian
Monthly Film Bulletin
New Left Review
New Statesman and Nation
News Chronicle
Observer
Penrose Annual: Review of the Graphic Arts
Picture Post
Punch
The Saturday Book
Spectator
Studio
Tailor and Cutter & Women's Wear
Time and Tide
The Times
TV Times
Vogue
Weather: Journal of the Royal Meteorological Society
Woman
Woman's Friend and Glamour
Year Book (National Smoke Abatement Society)

Unpublished Theses and Papers

Button, Virginia. 'The Aesthetic of Decline: English Neo-Romanticism *c.*1935–1956'. PhD thesis, University of London, 1992.

Wilson, Andrew. 'Between Tradition and Modernity: Patrick Heron and British Abstract Painting 1945–1965'. PhD thesis, University of London, 2000.

Online Sources

www.beveridgefoundation.org/
 sir-william-beveridge/1942-report
www.britainfromabove.org.uk
www.britishpathe.com
www.collections.vam.ac.uk
www.gettyimages.co.uk
www.gresham.ac.uk/lectures-and-events/
 women-in-red
www.gutenberg.org/files
www.ica.org.uk
www.icbh.ac.uk/witness/hygiene/smoke
www.iniva.org/library
www.lyricszoo.com
www.nationalarchives.gov.uk/films/1945to1951
www.nickelinthemachine.com/2008/11/a-proper-
 pea-souper-the-terrible-london-smog-of-1952
www.orwell.ru/library
www.player.bfi.org.uk/film/
 watch-going-shopping-with-elizabeth-allan-1955
www.projects.history.qmul.ac.uk/emotions
www.screenonline.org.uk
www.sunprintershistory.com/history
www.tccr.org.uk
Marcou, David Joseph. *All the Best: Britain's 'Picture Post' Magazine; Best Mirror and Old Friend to Many, 1938–57*. La Crosse, Wis.: DigiCOPY, 2013.

Printed Sources

50 Years On: The Struggle for Air Quality in London since the Great Smog of December 1952. London: Greater London Authority, 2002.

Ades, Dawn. 'Figure and Place: A Context for Five Post-War Artists', in Susan Compton, ed., *British Art in the 20th Century: The Modern Movement*, 73–81. Royal Academy of Arts, London, 15 January – 5 April 1987. Munich: Prestel-Verlag, 1987.

Alexander, Sally. 'Primary Maternal Preoccupation: D. W. Winnicott and Social Democracy in Mid-Twentieth Century Britain', in Sally Alexander and Barbara Taylor, eds, *History and Psyche: Culture, Psychoanalysis, and the Past*, 149–72. New York: Palgrave Macmillan, 2012.

Allingham, Margery. *The Tiger in the Smoke*. London: Chatto and Windus, 1952.

Alloway, Lawrence. *Nine Abstract Artists: Their Work and Theory*. London: Alec Tiranti, 1954.

Allsop, Kenneth. *The Angry Decade: A Survey of the Cultural Revolt of the Nineteen-Fifties* (1958). Wendover: John Goodchild, 1985.

An Exhibition of Paintings by William Powell Frith, R.A. 1819–1901. London: Whitechapel Gallery London, in co-operation with the Harrogate Arts Collection Society, 1951.

Anderson, Ben. 'Affective Atmospheres', *Emotion, Space and Society* 2 (2009): 77–81.

—. *Encountering Affect: Capacities, Apparatuses, Conditions*. Farnham: Ashgate, 2014.

Anderson, David. 'Mau Mau at the Movies: Contemporary Representations of an Anti-Colonial War', *South African Historical Journal* 48:1 (2003): 71–89.

Anderson, Perry. 'Components of the National Culture', *New Left Review* 50 (July–August 1968): 3–57.

Araeen, Rasheed. *The Other Story: Afro-Asian Artists in Post-War Britain*. London: Hayward Gallery, 1989.

Arts Council – Festival of Britain. *Sixty Paintings for '51*. London: Arts Council, 1951.

Atkinson, Harriet. *The Festival of Britain: A Land and its People*. London and New York: I. B. Tauris, 2012.

Attfield, Judy. 'Design as a Practice of Modernity: A Case for the Study of the Coffee Table in the Mid-Century', *Journal of Material Culture* 2:3 (November 1997): 267–89.

Baber, Ray E. *Love and Marriage*, rev. edn. London: Pan Books, 1957.

Bailey, Peter. *Leisure and Class in Victorian England: Rational Recreation and the Contest for Control, 1830–1885*. London: Routledge & Kegan Paul, 1978.

Balint, Michael. 'Friendly Expanses – Horrid Empty Spaces', *International Journal of Psycho-Analysis* 36 (1955): 225–41.

Banham, Mary and Bevis Hillier, eds. *A Tonic to the Nation: The Festival of Britain 1951*. London: Thames and Hudson, 1976.

Banks, Lynne Reid. *The L-Shaped Room* (1960). London: Vintage, 2004.

Bann, Stephen, ed. *The Coral Mind: Adrian Stokes's Engagement with Architecture, Art History, Criticism and Psychoanalysis*. University Park: Pennsylvania State University Press, 2007.

Banton, Michael. *The Coloured Quarter: Negro Immigrants in an English City*. London Jonathan Cape, 1955.

—. *White and Coloured: The Behaviour of British People towards Coloured Immigrants*. London: Jonathan Cape, 1959.

Barr, Charles. *Ealing Studios*, 3rd edn. Berkeley, Los Angeles and London: University of California Press, 1998.

Barreca, Regina. 'David Lean's *Great Expectations*', in John Glavin, ed., *Dickens on Screen*, 39–44. Cambridge: Cambridge University Press, 2003.

Barthes, Roland. *Camera Lucida: Reflections on Photography*, trans. Richard Howard. London: Vintage Books, 2000.

Batchelor, David. *Chromophobia*. London: Reaktion Books, 2000.

—, ed. *Colour*. Documents of Contemporary Art. London and Cambridge, Mass.: Whitechapel Gallery and MIT Press, 2008.

—. *The Luminous and the Grey*. London: Reaktion Books, 2014.

Baxandall, Michael. *Shadows and Enlightenment*. New Haven and London: Yale University Press, 1995.

Beauchamp, Barbara. *The Girl in the Fog*. London: Hodder and Stoughton, 1958.

Bell, Melanie. *Femininity in the Frame: Women and the 1950s British Popular Cinema*. London and New York: I. B. Tauris, 2010.

Benjamin, Walter. 'Theses on the Philosophy of History', in *Illuminations*, ed. and with an introduction by Hannah Arendt, trans. Harry Zohn, 255–66. London: Fontana/Collins, 1973.

Benson, Richard. *The Printed Picture*. New York: Museum of Modern Art, 2008.

Bentley, Nick. 'Black London: The Politics of Representation in Sam Selvon's *The Lonely Londoners*', *Wasafiri* 18:39 (2003): 41–5.

Berenson, Bernard. *Aesthetics and History*. London: Constable, 1950.

Berger, John. 'Forward', in Arts Council, *Looking Forward: An Exhibition of Realist Paintings and Drawings by Contemporary British Artists*, 1–3. London: Arts Council, 1953.

Bernstein, Henry T. 'The Mysterious Disappearance of Edwardian London Fog', *London Journal: A Review of Metropolitan Society Past and Present*, 1:2 (1975): 189–206.

Bevan, Robert. *The Destruction of Memory: Architecture at War*. London: Reaktion Books, 2006.

Bhabha, Homi K. ed., *Nation and Narration*. London and New York: Routledge, 1990.

Biggs, J. R. *Illustration and Reproduction*. London: Blandford Press, 1950.

Birren, Faber. *Selling With Color*. New York and London: McGraw Hill, 1945.

—. *New Horizons in Color*. New York: Reinhold Publishing, 1955.

Black Eyes & Lemonade: A Festival of Britain Exhibition of Popular and Traditional Art, Arranged in Association with the Society for Education in Art and

the Arts Council, Organised by Barbara Jones and Tom Imgram, Catalogued by Douglas Newton. London: Whitechapel Art Gallery, 1951.

Bonacina, W. 'London Fogs – Then and Now', Weather: A Monthly Magazine for All Interested in Meteorology, 5 (1950): 91.

—. 'An Estimation of the Great London Fog of 5–8 December 1952', Weather: Journal of the Royal Meteorological Society 8 (1953): 333–4.

Bond, Henry. Lacan at the Scene. Cambridge, Mass., and London: MIT Press, 2009.

Borch, Christian, ed. Architectural Atmospheres: On the Experience and Politics of Architecture. Basel: Birkhäuser Verlag, 2014.

Borde, Raymond, and Etienne Chaumeton. A Panorama of American Film Noir 1941–1953 (1955), trans. Paul Hammond. San Francisco: City Lights Books, 2002.

Bourne, Stephen. Black in the British Frame: The Black Experience in British Film and Television. London: Continuum, 2001.

Bowlby, John. Child Care and the Growth of Love. London: Pelican Books, 1953.

Bowness, Sophie and Clive Phillpot, eds. Britain at the Venice Biennale 1895–1995. London: British Council, 1995.

Braine, John. Room at the Top. London: Methuen, 1957.

—. Life at the Top. London: Eyre & Spottiswoode, 1962.

Brand, Christianna. London Particular. London: Hodder and Stoughton, 1958.

Brandt, Bill. Camera in London. London and New York: Focal Press, 1948.

—. Literary Britain, intro. John Hayward. London: Cassell, 1951.

—. Behind the Camera, intro. Mark Haworth-Booth, essay David Mellor. New York: Aperture, 1985.

Brennan, Teresa. The Transmission of Affect. Ithaca and London: Cornell University Press, 2004.

Breward, Christopher, Becky Conekin and Caroline Cox, 'Introduction', in Christopher Breward, Becky Conekin and Caroline Cox, eds, The Englishness of English Dress, 1–12. Oxford and New York: Berg, 2002.

Briggs, Asa. The History of Broadcasting in the United Kingdom, 5 vols. Oxford: Oxford University Press, 1995.

Brighton, Andrew and Lynda Morris, eds. Towards Another Picture: An Anthology of Writings by Artists Working in Britain 1945–1977. Nottingham: Midland Group, 1977.

Brimblecombe, Peter. The Big Smoke: A History of Air Pollution since Medieval Times. London and New York: Routledge, 1988.

British Colour Council. Dictionary of Colours for Interior Decoration: Including a List of Names and the History of Colours Illustrated in the Two Companion Volumes, 3 vols. London: British Colour Council, 1949.

—. Dictionary of Colour Standards: A List of Colour Names Referring to the Colours Shown in the Companion Volume, 2 vols, 2nd edn. London: British Colour Council, 1951.

—. Colour Schemes for the Interior Decoration of Factories and Offices, 2nd edn. London: British Colour Council, 1956.

Brittain, Vera. Lady into Woman: A History of Women From Victoria to Elizabeth II. London: Andrew Dakers, 1953.

Brodie, F. J. 'On the Prevalance of Fog in London during the Years 1871–1890', Quarterly Journal of the Royal Meteorological Society 18 (1892): 40–5.

—. 'Decrease in London Fog in Recent Years', Quarterly Journal of the Royal Meteorological Society 31 (1905): 15–28.

Brooke, Stephen. 'Gender and Working Class Identity in Britain during the 1950s', Journal of Social History 34:4 (Summer 2001): 773–95.

Brown, Callum G. The Death of Christian Britain: Understanding Secularisation 1800–2000. London and New York: Routledge, 2001.

Brown, Simon, Sarah Street and Liz Watkins, eds. *British Colour Cinema: Practices and Theories.* Basingstoke: Palgrave Macmillan, 2013.

Brownlow, Kevin. *David Lean: A Biography.* London: Richard Cohen Books, 1996.

Bruno, Guiliana. *Atlas of Emotion: Journeys in Art, Architecture, and Film.* New York: Verso 2002.

Brunsdon, Charlotte. *London in Cinema: The Cinematic City since 1945.* London: British Film Institute, 2007.

Bryher, Winifred. *The Days of Mars: A Memoir 1940–1946.* London: Calder and Boyars, 1972.

Bude, John. *The Night the Fog Came Down.* London: Macdonald, 1958.

Bullivant, Lucy. '"Design for Better Living" and the Public Response to Britain Can Make It', in Penny Sparke, ed., *Did Britain Make It? British Design in Context 1946–86*, 145–55. London: Design Council, 1986.

Bullock, Nicholas. *Building the Post-War World: Modern Architecture and Reconstruction in Britain.* London and New York: Routledge, 2002.

Burstow, Robert. 'Butler's Competition Project for a Monument to "The Unknown Political Prisoner": Abstraction and Cold War Politics', *Art History* 12:4 (December 1989): 472–96.

Campkin, Ben. 'Down and Out in London? Photography and the Politics of Representing "Life in the Elephant" 1948–2005', in *The Politics of Making*, ed. Mark Swenarton, Igea Troiani and Helena Webster, 230–43. Oxford and New York: Routledge, 2007.

Campt, Tina M. 'Imaging Diaspora: Race, Photography, and the Ernest Dyche Archive', *Letters*, Newsletter of the Robert Penn Warren Center for the Humanities, Vanderbilt University 16:2 (Spring 2008): 1–7.

—. *Image Matters: Archive, Photography, and the African Diaspora in Europe.* Durham, N.C., and London: Duke University Press, 2012.

Carrick, Edward. *Art and Design in the British Film: A Pictorial Directory of British Art Directors and their Work*, intro. Roger Manvell. London: Dennis Dobson, 1948.

Carter, Bob, Clive Harris and Shirley Joshi, 'The 1951–55 Conservative Government and the Racialization of Black Immigration', in Winston James and Clive Harris, eds, *Inside Babylon: The Caribbean Diaspora in Britain*, 55–71. London: Verso, 1993.

Casson, Hugh. *Bombed Churches as War Memorials.* Cheam: Architectural Press, 1945.

—. *An Introduction to Victorian Architecture.* London: Art and Technics, 1948.

Caughie, John. *Television Drama: Realism, Modernism and British Culture.* Oxford: Oxford University Press, 2000.

Chamberlain, Mary. *Narratives of Exile and Return*, rev. edn. New Brunswick, N.J.: Transaction Publishers, 2005.

Chambers, Eddie. *Black Artists in British Art: A History since the 1950s.* London and New York: I. B. Tauris, 2014.

Chance, John Newton. *Screaming Fog.* London: Macdonald and Co., 1952.

Cherry, Deborah and Juliet Steyn. 'The Moment of Realism: 1952–1956', *Artscribe* 35 (June 1982): 44–9.

Chesser, Eustace. *Love without Fear: A Plain Guide to Sex Technique for Every Married Adult.* London: Rich and Cowan Medical Publications, 1941.

—. *The Sexual, Marital and Family Relationships of the English Woman.* London: Hutchinson's Medical, 1956.

—. *Love and Marriage* (1946), rev. edn 1952. London: Pan Books, 1957.

Chibnall, Steve. 'Whistle and Zoot: The Changing Meaning of a Suit of Clothes', *History Workshop* 20 (Autumn 1985): 56–81.

Christie, Ian. *A Matter of Life and Death.* London: Palgrave Macmillan, 2000.

Churchill, R. C. *The English Sunday.* London: Watts and Co., 1954.

Clapson, Mark and Peter J. Larkham, eds. *The Blitz and its Legacy: Wartime Destruction to Post-War Reconstruction*. Farnham: Ashgate, 2013.

Clark, T. J. and Anne M. Wagner. *Lowry and the Painting of Modern Life*. London: Tate Publishing, 2013.

Clarke, Graham. *The Photograph*. Oxford and New York: Oxford University Press, 1997.

Clemens, Valdine. *The Return of the Repressed: Gothic Horror from 'The Castle of Otranto' to 'Alien'*. Albany: State University of New York, 1999.

Cohen, Deborah. *Family Secrets: Shame and Privacy in Modern Britain*. Oxford and New York: Oxford University Press, 2013.

Collier, John W. *A Film in the Making: It Always Rains on Sunday*. London: World Film Publications, 1947.

Collins, Marcus. *Modern Love: An Intimate History of Men and Women in Twentieth Century Britain*. London: Atlantic, 2003.

Colomina, Beatriz. 'Unbreathed Air 1956', *Grey Room* 15 (2004): 28–59.

[Colonial Office]. *Traditional Art from the Colonies*. An Exhibition in the Art Gallery of the Imperial Institute, London, 28 May – 30 September 1951. London: HMSO, 1951.

—. *Traditional Sculpture from the Colonies*. London: HMSO, 1951.

Conekin, Becky. *The Autobiography of a Nation: The 1951 Festival of Britain*. Manchester: Manchester University Press, 2003.

—, Frank Mort and Chris Waters, eds. *Moments of Modernity: Reconstructing Britain 1945–1964*. London and New York: Rivers Oram Press, 1999.

Connor, Steven. *The Matter of Air: Science and the Art of the Ethereal*. London: Reaktion Books, 2010.

Constantine, Learie. *Colour Bar*. London: Stanley Paul, 1954.

Cooke, Lez. *British Television Drama: A History*. London: BFI, 2003.

—. *Style in British Television Drama*. Basingstoke: Palgrave Macmillan, 2013.

Cornwell-Clyne, Adrian. *Colour Cinematography*, 3rd edn. London: Chapman and Hall, 1951.

Corton, Christine. *London Fog: The Biography*. Boston, Mass.: Harvard University Press, 2015.

Council of Industrial Design. *Ideas for your Home*. London: HMSO, 1950.

Courtman, Sandra. 'A Journey through the Imperial Gaze: Birmingham's Photographic Collections and its Caribbean Nexus', in Simon Faulkner and Anandi Ramamurthy, eds, *Culture and Decolonisation in Britain*, 127–52. Aldershot: Ashgate, 2006.

Cousins, E. G. *Sapphire*. London: Hamilton & Co., 1959.

Cowley, John. 'London Is the Place: Caribbean Music in the Context of Empire 1900–1960', in Paul Oliver, ed., *Black Music in Britain: Essays on the Afro Asian Contribution to Popular Music*, 57–76. Milton Keynes: Open University Press, 1990.

Cox, Ian H. *The South Bank Exhibition: A Guide to the Story It Tells*. London: HMSO, 1951.

Crosby, Emily and Linda Kaye, eds. *Projecting Britain: The Guide to British Cinemagazines*. London: British Universities Film and Video Council, 2008.

Crow, Graham. 'The Post-War Development of the Modern Domestic Ideal', in Graham Allan and Graham Crow, eds, *Home and Family: Creating the Domestic Sphere*, 14–32. Basingstoke: Macmillan, 1989.

Curtis, Barry. 'One Continuous Interwoven Story (The Festival of Britain)', *Block* 11 (Winter 1985–6): 48–52.

'Daily Mail' Ideal Home Exhibition: Olympia March 6th to 31st 1956; Catalogue and Review. London: n.p., 1956.

dalle Vacche, Angela and Brian Price, eds. *Color: The Film Reader*. New York and London: Routledge, 2006.

Davis, Devra. 'The Great Smog', *History Today* 52:12 (December 2002): 2–3.

—. *When Smoke Ran Like Water: Tales of Environmental Deception and the Battle Against Pollution*. Oxford: Perseus Press, 2002.

Dean, D. W. 'Coping with Colonial Immigration, the Cold War and Colonial Policy: The Labour Government and Black Communities in Great Britain 1945–51', *Immigrants and Minorities* 6:3 (November 1987): 305–34.

De Bona, Guerric. 'Doing Time, Undoing Time: Plot Mutation in David Lean's *Great Expectations*', *Literature/Film Quarterly* 20:1 (1992): 77–100.

de Certeau, Michel. *Heterologies: Discourse on the Other*, trans. Brian Massumi, foreword Wlad Godzich. Minneapolis and London: University of Minnesota Press, 1986.

de la Haye, Amy and Cathie Dingwall, *Surfers, Soulies, Skinheads and Skaters*. London: V&A, 1996.

Deleuze, Gilles. *Cinema 1: The Movement Image*, trans. Hugh Tomlinson and Barbara Habberjam. London: Athlone Press, 1986.

del Renzio, Toni. *After a Fashion…* London: ICA Publications, 1956.

de Solà-Morales, Ignasi. 'Terrain Vague', in Manuela Mariani and Patrick Barron, eds, *Terrain Vague: Interstices at the Edge of the Pale*, 24–30. London and New York: Routledge, 2014.

de Souza, Ivo. 'Arrival', in S. K. Ruck, ed., *The West Indian Comes to England*, A Report Prepared for the Trustees of the London Parochial Charities by the Family Welfare Association, 51–62. London: Routledge & Kegan Paul, 1960.

Devastated London: The Bombed City as Seen from a Barrage Balloon, drawn by Cecil Brown, with notes by Ralph Hyde. London: Topographical Society, 1990.

Doy, Gen. *Black Visual Culture: Modernity and Post-modernity*. London and New York: I. B. Tauris, 2000.

Draper, Peter, ed. *Reassessing Nikolaus Pevsner*. Aldershot: Ashgate, 2004.

Duguid, Mark, Lee Freeman, Keith M. Johnston and Melanie Williams, eds. *Ealing Revisited*. London: BFI/Palgrave Macmillan, 2012.

Durgnat, Raymond. *A Mirror for England: British Movies from Austerity to Affluence*. London: Faber and Faber, 1970.

Dyer, Richard. 'White', *Screen* 29:4 (1988): 44–55.

Dziewicki, M. H. 'In Praise of London Fogs', *Nineteenth Century*, 26 (December 1889): 1054–5.

Easen, Sarah. 'Film and the Festival of Britain', in Ian Mackillop and Neil Sinyard, eds, *British Cinema of the 1950s: A Celebration*, 51–63. Manchester and New York: Manchester University Press, 2003.

Ettinger, Roseann. *50s Popular Fashions for Men, Women, Boys and Girls*. Atglen, Penn.: Schiffer, 1995.

Evans, Harold. *Pictures on a Page: Photo-journalism, Graphics and Picture Editing*. Book IV in the series on Editing and Design, published under the auspices of the National Council for the Training of Journalists. London: Heinemann, 1978.

Evans, Jennifer, V. *Life Among the Ruins: Cityscape and Sexuality in Cold War Berlin*. New York: Palgrave Macmillan, 2011.

Fanon, Frantz. *Black Skin, White Masks* (1952), trans. Charles Lam Markmann. London: Pluto Press, 1986.

Faulkner, Simon. 'Late Colonial Exoticism: John Minton's Pictures of Jamaica, 1950–1952', in Simon Faulkner and Anandi Ramamurthy, eds, *Visual Culture and Decolonisation in Britain*, 71–100. Aldershot: Ashgate, 2006.

—. 'Homo-Exoticism: John Minton in London and Jamaica, 1950–1', in Tim Barringer, Geoff Quilley and Douglas Fordham, eds, *Art and the British Empire*, 169–88. Manchester: Manchester University Press, 2007.

Feaver, William. *Boswell's London: Drawings by James Boswell Showing Changing London from the Thirties to the Fifties*. London: Wildwood House, 1978.

Festival Gardens: Photo-Memories; A Souvenir of the Festival Pleasure Gardens, London. London: Charles Skilton, 1951.

Finch, Janet and Penny Summerfield, 'Social Reconstruction and the Emergence of Companionate Marriage, 1945–59', in David Clark, ed., *Marriage, Domestic Life and Social Change: Writings for Jacqueline Burgoyne (1944–88)*, 7–32. London and New York: Routledge, 1991.

Fleming, Tom, intro. *Voices Out of the Air: The Royal Christmas Broadcasts 1932–1981*. London: Heinemann, 1981.

Flinn, Catherine. '"The City of our Dreams"? The Political and Economic Realities of Rebuilding Britain's Blitzed Cities, 1945–54', *Twentieth Century British History* 23:2 (2012): 221–45.

—. 'Reconstruction Constraints: Political and Economic Realities', in Mark Clapson and Peter J. Larkham eds, *The Blitz and its Legacy: Wartime Destruction to Post-War Reconstruction*, 87–97. Farnham: Ashgate, 2013.

Forge, Andrew. 'Helen Lessore and the Beaux Arts Gallery', in Marlborough Fine Art, *Helen Lessore and the Beaux Arts Gallery*, 5–12. London: Marlborough Fine Art, 1968.

Forshaw, Barry. *British Crime Film: Subverting the Social Order*. Basingstoke: Palgrave Macmillan, 2012.

Francis, Martin. 'A Flight from Commitment? Domesticity, Adventure and the Masculine Imaginary in Britain after the Second World War', *Gender & History* 19:1 (April 2007): 163–85.

Frayn, Michael. 'Festival', in Michael Sissons and Philip French, eds, *Age of Austerity*, 317–38. London: Hodder and Stoughton, 1963.

Frenk, Joachim. '*Great Expectations*: David Lean's Visualizations of Dickensian Spaces', in Ewald Mengel, Hans-Jörg Schmid and Michael Steppat, eds, *Anglistentag 2002 Bayreuth Proceedings*, 307–17. Trier: Wissenschaftlicher Verlag Trier, 2003.

Gage, John. *Colour and Culture: Practice and Meaning from Antiquity to Abstraction*. London: Thames and Hudson, 1993.

Gardiner, Juliet. *Picture Post Women*. London: Collins and Brown, 1993.

Garlake, Margaret. *New Vision 56–66*. Jarrow, Tyne and Wear: Bede Gallery, 1984.

Garner, J. G. and R. S. Offord. *The Law on the Pollution of the Air and the Practice of its Prevention*. London: Shaw and Sons, 1957.

Gask, Arthur. *Night and Fog*. London: Herbert Jenkins, 1951.

Gavin, Owen and Andy Lowe. 'Designing Desire – Planning, Power and the Festival of Britain', *Block* 11 (Winter 1985–6): 53–69.

Geraghty, Christine. *British Cinema in the Fifties: Gender, Genre and the 'New Look'*. London and New York: Routledge, 2000.

Gillett, Philip. *The British Working Class in Postwar Film*. Manchester and New York: Manchester University Press, 2003.

Gilroy, Beryl. *Black Teacher*. London: Cassell, 1976.

Gilroy, Paul. *The Black Atlantic: Modernity and the Double Consciousness*. London: Verso, 1993.

Ginsberg, Robert. *The Aesthetics of Ruins*. Amsterdam and New York: Rodopi, 2004.

Glass, Ruth. *Newcomers: The West Indians in London*. London: Centre for Urban Studies and George Allen & Unwin, 1960.

Glavin, John, ed. *Dickens on Screen*. Cambridge: Cambridge University Press, 2003.

Gledhill, Christine and Gillian Swanson, eds. *Nationalising Femininity: Culture, Sexuality and British Cinema in the Second World War*. Manchester and New York: Manchester University Press, 1996.

Godwin, George. *London Shadows: A Glance at the 'Homes' of the Thousands*. London: G. Routledge, 1854.

Gooding, Mel, ed. *Painter as Critic: Patrick Heron; Selected Writings*. London: Tate Gallery, 1998.

Gorer, Geoffrey. *Exploring English Character*. London: Cresset Press, 1955.

—. *Sex and Marriage in England Today: A Study of the Views and Experience of the Under-45s*. London: Nelson, 1971.

Gouk, Alan. 'Patrick Heron I', *Artscribe* no. 34 (March 1982): 40–54.

—. 'Patrick Heron II', *Artscribe* no. 35 (June 1982): 32-43.

Graves Art Gallery. *The Forgotten Fifties*. Sheffield: Graves Art Gallery, 31 March – 13 May 1984.

Greenhill, Peter and Brian Reynolds. *The Way of the Sun: The Story of Sun Engraving and Sun Printers*. Claremont, Ont.: True to Type Books, 2010.

Greet, Kenneth G. *Enjoying Sunday*. London: Epworth Press, 1954.

Grieve, Mary. *Millions Made My Story*. London: Victor Gollancz, 1964.

Griffero, Tonino. *Atmospheres: Aesthetics of Emotional Spaces*, trans. Sarah de Sanctis. Farnham: Ashgate, 2014.

Grigson, Geoffrey. *The Victorians*. London: Faber and Faber, 1950.

Hall, Lesley A. *Sex, Gender and Social Change in Britain since 1800*. Basingstoke and London: Macmillan, 2000.

Hall, Stuart. 'Media and Message: The Life and Death of *Picture Post*', *Cambridge Review* 91/92 (19 February 1971): 140–4.

—. 'The Social Eye of *Picture Post*', *Working Papers in Cultural Studies* 2 (Spring 1972): 71–120.

—. 'Reconstruction Work', *Ten. 8* 16 (1985): 2–9.

—. 'Black Diaspora Artists in Britain: Three "Moments" in Post-War History', *History Workshop Journal* 61 (Spring 2006): 1–24.

Hallett, Michael. '*Picture Post*: An Essentially English Aroma', *Photographic Journal* (October 1998): 380–2.

Hamilton, Richard. 'An Exposition of *$he*', in *Collected Words 1953–1982*, 34–9. London: Thames and Hudson, 1982.

—. 'Glorious Technicolor, Breathtaking Cinemascope and Stereophonic Sound', unpublished typescript of lecture 1959, in *Collected Words 1953–1982*, 112–31. London: Thames and Hudson, 1982.

Hansen, Randall. *Citizenship and Immigration in Post-War Britain: The Institutional Origins of a Multicultural Nation*. Oxford: Oxford University Press, 2000.

Hardy, Bert. *Bert Hardy: My Life*. London and Bedford: Gordon Fraser, 1985.

Hargreaves, John D. *Decolonization in Africa*. London and New York: Longman, 1988.

Harline, Craig. *Sunday: A History of the First Day from Babylonia to the Super Bowl*. New Haven and London: Yale University Press, 2011.

Harper, Sue and Vincent Porter. *British Cinema of the 1950s: The Decline of Deference*. Oxford: Oxford University Press, 2003.

Harries, Susie. *Nikolaus Pevsner: The Life*. London: Chatto and Windus, 2011.

Harris, Alexandra. *Romantic Moderns: English Writers, Artists and Imagination from Virginia Woolf to John Piper*. London: Thames and Hudson, 2010.

Harris, Clive. 'Post-War Migration and the Industrial Reserve Army', in Winston James and Clive Harris, eds, *Inside Babylon: The Caribbean Diaspora in Britain*, 9–54. London: Verso, 1993.

Hartwig, Georg. *The Aerial World: A Popular Account of the Phenomena and Life of the Atmosphere*. London: Longman and Green, 1899.

Hasegawa, Jumichi. *Replanning the Blitzed City Centre: A Comparative Study of Bristol, Coventry and Southampton 1941–1950*. Buckingham and Philadelphia: Open University Press, 1992.

Hauser, Kitty. *Shadow Sites: Photography, Archaeology and the British Landscape 1927–1955*. Oxford: Oxford University Press, 2007.

Hebdige, Dick. *Hiding in the Light*. London and New York: Routledge, 1988.

Hell, Julia and Andreas Schönle, eds. *Ruins of Modernity*. Durham and London: Duke University Press, 2010.

Hennessy, Peter. *Never Again: Britain 1945–51*. London: Jonathan Cape, 1992.

—. *Having It So Good: Britain in the Fifties*. London: Allen Lane, 2006.

Heron, Patrick. *Space in Colour*. London: Hanover Gallery, July–August 1953.

—. *The Changing Forms of Art*. London: Routledge & Kegan Paul, 1955.

—. *Ivon Hitchens*. Penguin Modern Painters. Harmondsworth: Penguin, 1955.

—. 'Five Types of Abstraction: Ben Nicholson, Victor Pasmore, William Scott, Roger Hilton, John Wells', in Mel Gooding, ed., *Painter as Critic: Patrick Heron; Selected Writings*, 183–207. London: Tate Gallery, 1998.

Hewison, Robert. *In Anger: Culture in the Cold War 1945–60*. London: Weidenfeld and Nicolson, 1981.

Hicks, Wilson. *Words and Pictures: An Introduction to Photojournalism*. New York: Harper & Bros, 1952.

Highmore, Ben. *The Great Indoors: At Home in the Modern British House*. London: Profile Books, 2014.

Hill, John. 'The British "Social Problem" Film: *Violent Playground* and *Sapphire*', *Screen* 26:1 (1985): 34–48.

—. *Sex, Class and Realism: British Cinema 1956–1963*. London: BFI, 1986.

Hobbs, Allyson. *A Chosen Exile: A History of Racial Passing in American Life*. Cambridge, Mass.; Harvard University Press, 2014.

Hochhar-Lindgren, Gray. *Philosophy, Art and the Specters of Jacques Derrida*. Amherst, N.Y.: Cambria Press, 2011.

Hogarth, Paul. *James Boswell 1906–71: Drawings, Illustrations and Paintings*. Nottingham: Nottingham University Art Gallery, 22 November – 16 December 1976.

Hoggart, Richard. *The Uses of Literacy: Aspects of Working Class Life with Special Reference to Publications and Entertainments* (1957). Harmondsworth: Pelican, 1958.

Holmes, Colin. *John Bull's Island: Immigration and British Society 1871–1971*. Basingstoke: Macmillan, 1988.

Holmes, Su. *Entertaining Television: The BBC and Popular Television Culture in the 1950s*. Manchester and New York: Manchester University Press, 2008.

hooks, bell. *Black Looks: Race and Representation*. Boston, Mass.: South End Press, 1992.

Hornsey, Richard. *The Spiv and the Architect: Unruly Life in Postwar London*. Minneapolis and London: University of Minneapolis Press, 2010.

Horowitz, Daniel. *Consuming Pleasures: Intellectuals and Popular Culture in the Postwar World*. Philadelphia: University of Pennsylvania Press, 2012.

Howard, Luke. *The Climate of London, Deduced from Meteorological Observations, Made in the Metropolis, and at Various Places Around It*, 2nd edn, 3 vols. London: Harvey and Darton, 1833.

Huntley, John. *British Technicolor Films*. London: Skelton Robinson, 1949.

Hyman, James. *The Battle for Realism: Figurative Art in Britain during the Cold War 1945–60*. New Haven and London: Yale University Press, 2001.

Ironside, Robin. *Painting since 1939*. London and New York: Longmans, Green and Co., 1947.

Jacobi, Carol. '"A Kind of Cold War Feeling" in British Art, 1945–52', in Catherine Jolivette, ed., *British Art in the Nuclear Age*, 19–50. Farnham: Ashgate, 2014.

Jacobs, Jason. *The Intimate Screen: Early British Television Drama*. Oxford: Clarendon Press, 2000.

James, Henry. *English Hours*. London: William Heinemann, 1905.

James, Winston and Clive Harris, eds. *Inside Babylon: The Caribbean Diaspora in Britain*. London: Verso, 1993.

Jardine, Lisa and Julia Swindells. 'Homage to Orwell: The Dream of a Common Culture, and Other Minefields', in Terry Eagleton, ed., *Raymond Williams: Critical Perspectives*, 108–29. Cambridge: Polity Press, 1989.

Jennings, Humphrey. *Pandaemonium 1660–1886: The Coming of the Machine as Seen by Contemporary Observers*, ed. Mary-Lou Jennings and Charles Madge. London: Icon Books, 2012.

Jennings, Mary-Lou, ed. *Humphrey Jennings: Film-Maker, Painter, Poet*. London: British Film Institute, in association with Riverside Studios, 1982.

Jones, Barbara. *The Unsophisticated Arts*. London: Architectural Press, 1951.

Kaye, Linda. 'Reconciling Policy and Propaganda: The British Overseas Television Service 1954–1964', in Emily Crosby and Linda Kaye, eds, *Projecting Britain: The Guide to British Cinemagazines*, 69–96. London: British Universities Film & Video Council, 2008.

Kent, William. *The Lost Treasures of London*. London: Phoenix House, 1947.

Kirkham, Pat. 'Fashioning the Feminine: Dress, Appearance and Femininity in Wartime Britain', in Christine Gledhill and Gillian Swanson, eds, *Nationalising Femininity: Culture, Sexuality and British Cinema in the Second World War*, 152–74. Manchester and New York: Manchester University Press, 1996.

Kite, Stephen. '"A Deep and Necessary Commerce": Venice and the "Architecture of Colour-Form"', in Stephen Bann, ed., *The Coral Mind: Adrian Stokes's Engagement with Architecture, Art History, Criticism and Psychoanalysis*, 37–58. University Park: Pennsylvania State University Press, 2007.

Klein, Melanie. *Narrative of a Child Analysis: The Conduct of the Psycho-Analysis of Children as Seen in the Treatment of a Ten-year-old Boy* (1961), foreword Elliott Jacques. London: Vintage, 1998.

—, Paula Heimann and R. E. Money-Kyrle, eds. *New Directions in Psycho-Analysis: The Significance of Infant Conflict in the Pattern of Adult Behaviour*. London: Tavistock, 1955.

Knight, Vivien. 'The Pursuit of Colour', in *Patrick Heron*, 5–12. London: Hayward Gallery, July–September 1985.

—, ed. *Patrick Heron*. London: John Taylor, in association with Lund Humphries, 1988.

Koven, Seth. *Slumming: Sexual and Social Politics in Victorian London*. Princeton, N.J.: Princeton University Press, 2004.

Kynaston, David. *Austerity Britain, 1945–51*. London: Bloomsbury Press, 2007.

—. *Family Britain, 1951–57*. London: Bloomsbury Press, 2009.

—. *Modernity Britain, Book Two: A Shake of the Dice, 1959–62*. London: Bloomsbury Press, 2014.

La Bern, Arthur. *It Always Rains on Sunday*. London: Nicolson and Watson, 1945.

Lahiri, Shompa. 'Performing Identity: Colonial Migrants, Passing and Mimicry between the Wars', *Cultural Geographies* 10:4 (2003): 408–23.

Laing, Stuart. *Representations of Working-Class Life 1957–1964*. Basingstoke: Macmillan, 1986.

Lamming, George. *The Emigrants* (1954). London: Allison and Busby, 1980.

Langhamer, Claire. 'The Meanings of Home in Postwar Britain', *Journal of Contemporary History* 40:2 (April 2005): 341–62.

—. 'Adultery in Post-War England', *History Workshop Journal* 62 (Autumn 2006): 86–115.

—. 'Love and Courtship in Mid-Twentieth Century England', *Historical Journal* 50 (2007): 173–96.

—. 'Love, Selfhood and Authenticity in Post-War Britain', *Cultural and Social History* 9:2 (2012): 277–97.

—. *The English in Love: The Intimate Story of an Emotional Revolution*. Oxford: Oxford University Press, 2013.

Lant, Antonia. 'Prologue: Mobile Femininity', in Christine Gledhill and Gillian Swanson, eds, *Nationalising Femininity: Culture, Sexuality and British Cinema in the Second World War*, 13–32. Manchester and New York: Manchester University Press, 1996.

Larkham, Peter J. and Joe Nasr, eds. *The Rebuilding of British Cities: Exploring the Post-Second World War Reconstruction*. Proceedings of a workshop sponsored by the Faculty of the Built Environment and the International Planning History Society. Birmingham: University of Central England School of Planning and Housing, 2004.

Laski, Marghanita. *The Victorian Chaise-Longue* (1953). London: Persephone Books, 1999.

Latour, Bruno. *We Have Never Been Modern*, trans. Catherine Porter. Cambridge, Mass.: Harvard University Press, 1993.

—. *Reassembling the Social: An Introduction to Actor-Network Theory*. Oxford: Oxford University Press, 2005.

Lessing, Doris. *In Pursuit of the English: A Documentary*. London: Macgibbon and Kee, 1960.

—. *Walking in the Shade: Volume Two of My Autobiography 1949–1962*. New York: Harper Collins, 1997.

Lewis, Jane. *Women in Britain since 1945: Women, Family, Work and the State in the Post-War Years*. Oxford: Basil Blackwell, 1992.

—. *The End of Marriage? Individualism and Intimate Relations*. Cheltenham: Edward Elgar, 2001.

Lewis, Wyndham. *Rotting Hill*. London: Methuen & Co., 1951.

Little, K. L. *Negroes in Britain: A Study of Racial Relations in English Society*. London: Kegan Paul, Trench, Trubner and Co., 1947.

Littler, Jo. '"Festering Britain": The 1951 Festival of Britain, Decolonisation and the Representation of the Commonwealth', in Simon Faulkner and Anandi Ramamurthy, eds, *Culture and Decolonisation in Britain*, 21–42. Aldershot: Ashgate, 2006.

Llewellyn, Margaret. *Colour and Pattern in your Home*. Loughborough and London: Co-Operative Union Ltd and the Council of Industrial Design, 1955.

Logan, W. P. D. 'Mortality in the London Fog Incident, 1952', *Lancet* (14 February 1953): 336–8.

Luckin, Bill. '"The Heart and the Home of Horror": The Great London Fogs of the Late-Nineteenth Century', *Social History* 28:1 (January 2003): 31–48.

Macaulay, Mary. *The Art of Marriage*. London: Delisle, 1952.

Macaulay, Rose. *The World My Wilderness*. London: William Collins, 1950.

—. *Pleasure of Ruins*. London: Weidenfeld and Nicolson, 1953.

MacCabe, Colin. 'Bazinian Adaptation: *The Butcher Boy* as Example', in Colin MacCabe, Kathleen Murray and Rick Warner, eds, *True to the Spirit: Film Adaptation and the Question of Fidelity*, 3–25. Oxford and New York: Oxford University Press, 2011.

McClintock, Anne. *Imperial Leather: Race, Gender and Sexuality in the Colonial Contest*. New York and London: Routledge, 1995.

McFarlane, Brian. *Novel to Film: An Introduction to the Theory of Adaptation*. Oxford: Clarendon Press, 1996.

—. *An Autobiography of British Cinema: As Told by the Filmmakers and Actors Who Made It*. London: Methuen, 1997.

—. *Screen Adaptations: Charles Dickens's 'Great Expectations'; The Relationship Between Text and Film*. London: Methuen, 2008.

MacInnes, Colin. *City of Spades* (1957). London: Allison & Busby, 2012.

McKernan, Luke. 'Cinemagazines: The Lost Genre', in Emily Crosby and Linda Kaye, eds, *Projecting Britain: The Guide to British Cinemagazines*, ix–xiv. London: British Universities Film & Video Council, 2008.

McNay, Michael. *Patrick Heron*. London: Tate Publishing, 2002.

Madge, Charles. 'A Note on Images' (1951), reprinted in *Humphrey Jennings: Film-Maker, Painter, Poet*, ed. Mary-Lou Jennings, 47–9. London: British Film Institute, in association with Riverside Studios, 1982.

Mandler, Peter and Susan Pedersen, eds. *After the Victorians: Private Conscience and Public Duty in Modern Britain*. London and New York: Routledge, 1994.

Mannoni, Laurent. *The Great Art of Light and Shadow: Archaeology of the Cinema*, trans. and ed. Richard Crangle. Exeter: Exeter University Press, 2000.

Marsh, Arnold. *Smoke: The Problem of Coal and the Atmosphere*. London: Faber and Faber, 1947.

Marsh, Joss. 'Dickens and Film', in John O. Jordan, ed., *The Cambridge Companion to Charles Dickens*,

204–23. Cambridge: Cambridge University Press, 2001.

Martin, Craig. 'Fog-Bound: Aerial Space and the Elemental Entanglements of Body-*With*-World', *Environment and Planning D.: Society and Space*, 29:3 (June 2011): 454–68.

Marwick, Arthur. *British Society since 1945*. London: Pelican, 1982.

Maschler, Tom, ed. *Declaration*. London: MacGibbon and Kee, 1957.

Mass Observation. *Meet Yourself on Sunday*. London: Naldrett Press, 1949.

Massey, Anne. *The Independent Group: Modernism and Mass Culture in Britain 1945–59*. Manchester and New York: Manchester University Press, 1995.

—. *Out of the Ivory Tower: The Independent Group and Popular Culture*. Manchester and New York: Manchester University Press, 2013.

Matheson, Neil. 'National Identity and the "Melancholy of Ruins": Cecil Beaton's Photographs of the London Blitz', *Journal of War and Cultural Studies* 1:3 (2008): 261–74.

Mayor Gallery. *The Kitchen Sink Painters: John Bratby, Peter Coker, Derrick Greaves, Edward Middleditch, Jack Smith*. London: Mayor Gallery, in association with Julian Hartness, 20 March – 26 April 1991.

Mays, John Barron. *Growing Up in the City: A Study of Juvenile Delinquency in an Urban Neighbourhood*. Liverpool: University Press of Liverpool, 1954.

Mellor, David. 'Brandt's Phantasms', in Bill Brandt, *Behind the Camera*, intro. Mark Haworth-Booth, 71–97. New York: Aperture, Philadelphia Museum of Art, 1985.

—. *A Paradise Lost: The Neo-Romantic Imagination in Britain 1935–1955*. London: Lund Humphries, in association with the Barbican Gallery, 1987.

Mellor, Leo. *Reading the Ruins: Modernism, Bombsites and British Culture*. Cambridge and New York: Cambridge University Press, 2011.

Mercer, Kobena. 'Black Atlantic Abstraction: Aubrey Williams and Frank Bowling', in *Discrepant Abstraction*, 182–205. Cambridge, Mass., and London: MIT Press and the Institute of International Visual Arts, 2006.

Merewether, Charles. 'Traces of Loss', in Michael S. Roth, with Claire Lyons and Charles Merewether, *Irresistible Decay: Ruins Reclaimed*, 25–40. Los Angeles: Getty Research Institute, 1997.

Metropolitan Borough of Battersea: Festival of Britain 1951; Official Souvenir Programme of Local Events. London: Century Press, 1951.

Miller, Stephen. *The Peculiar Life of Sundays*. Cambridge, Mass., and London: Harvard University Press, 2008.

Miller, Thomas. *The Mysteries of London: Lights and Shadows of London Life*. London: Vickers, 1849.

Mitchell, Yvonne. *Actress*. London: Routledge & Kegan Paul, 1957.

Moeller, Robert G. 'On the History of Man-Made Destruction: Loss, Death, Memory and Germany in the Bombing War', *History Workshop Journal* 61 (Spring 2006): 103–34.

Moraitis, Catherine. *The Art of David Lean: A Texual Analysis of Audio-Visual Structure*. Bloomington, Ind.: AuthorHouse, 2004.

Moran, Joe. *Armchair Nation: An Intimate History of Britain in Front of the TV*. London: Profile Books, 2013.

Moriarty, Catherine. *Drawing, Writing and Curating: Barbara Jones and the Art of Arrangement; An Essay by Catherine Moriarty to Accompany the Exhibition Black Eyes & Lemonade: Curating Popular Art*. London: Whitechapel Gallery, 2013.

Morris, Lynda. 'The Beaux Arts Years, 1948–57', in Paul Huxley, ed., *Exhibition Road: Painters at the Royal College of Art*, 30–9. Oxford: Phaidon, Christie's and the Royal College of Art, 1988.

Morris, Nathalie. 'Selling Ealing', in Mark Duguid, Lee Freeman, Keith M. Johnston and Melanie Williams, eds, *Ealing Revisited*, 91–100. London: BFI/Palgrave Macmillan, 2012.

Mort, Frank. 'Scandalous Events: Metropolitan Culture and Moral Change in Post-Second World

War London', *Representations* 93 (Winter 2006): 106–37.

—. *Capital Affairs: London and the Making of the Permissive Society*. New Haven and London: Yale University Press, 2010.

—. 'Modernity and Gaslight: Victorian London in the 1950s and 1960s', in Gary Bridge and Sophie Watson, eds, *The New Blackwell Companion to the City*, 431–41. Chichester: Wiley-Blackwell, 2011.

Mosley, Stephen. 'Fresh Air and Foul: The Role of the Open Fireplace in Ventilating the British Home 1837–1901', *Planning Perspectives* 18:1 (January 2003): 1–21.

Mulvey, Laura. *Death 24 x a Second: Stillness and the Moving Image*. London: Reaktion Books, 2006.

Mumford, Lewis. *Art and Technics*. London: Oxford University Press, 1952.

—. *Brown Decades: A Study of the Arts in America 1865–1895* (1931), 2nd edn. New York: Dover, 1955.

—. *Technics and Civlization* (1934). London: Routledge & Kegan Paul, 1955.

Murray, H. D., ed. *Colour in Theory and Practice*. London: Chapman and Hall, 1952.

Myrdal, Alva and Viola Klein. *Women's Two Roles: Home and Work*. London: Routledge & Kegan Paul, 1956.

National Smoke Abatement Society. *Smoke Prevention in Relation to Initial Post-War Reconstruction*. London: National Smoke Abatement Society, n.d. [*c.*1942].

Nava, Mica. 'Thinking Internationally: Gender and Racial Others in Postwar Britain', *Third Text* 20:6 (2006): 671–82.

— and Alan O'Shea, eds. *Modern Times: Reflections on a Century of English Modernity*. London and New York: Routledge, 1996.

Nead, Lynda. 'The Secret of England's Greatness', *Journal of Victorian Culture* 19:2 (2014): 161–82.

Neame, Ronald. 'A Talk on Technicolor', *Cine-Technician* (May–June 1944): 36–44.

Oakley, Ann. *From Here to Maternity: Becoming a Mother*. Harmondsworth: Penguin, 1981.

Oguibe, Olu. 'Footprints of a Mountaineer: Uzo Egonu and the Black Redefinition of Modernism', in Kwesi Owusu, ed., *Black British Culture and Society: A Text Reader*, 499–518. London and New York: Routledge, 2000.

Oram, Alison. 'Love "Off the Rails" or "Over the Teacups"? Lesbian Desire and Female Sexualities in the 1950s British Popular Press', in Heike Bauer and Matt Cook, eds, *Queer 1950s: Rethinking Sexuality in the Postwar Years,* 41–57. Basingstoke: Palgrave Macmillan, 2012.

Osborne, John. *Look Back in Anger and Other Plays*. London: Faber and Faber, 1993.

Owusu, Kwesi, ed. *Black British Culture and Society: A Text Reader*. London and New York: Routledge, 2000.

Patrick Heron Early Paintings 1945–1955. London: Waddington Galleries, October–November 2000.

Patterson, Sheila. *Dark Strangers: A Sociological Study of the Absorption of a Recent West Indian Migrant Group in Brixton, South London*. London: Tavistock, 1963.

Paul, Kathleen. 'The Politics of Citizenship in Post-War Britain', *Contemporary Record*, special issue 'Ending the Empire' 6:3 (Winter 1992): 452–74.

—. '"British Subjects" and "British Stock": Labour's Postwar Imperialism', *Journal of British Studies* 34:2 (April 1995): 233–76.

—. *Whitewashing Britain: Race and Citizenship in the Postwar Era*. Ithaca and London: Cornell University Press, 1997.

—. 'Communities of Britishness: Migration in the Last Gasp of Empire', in Stuart Ward, ed., *British Culture and the End of Empire*, 180–99. Manchester and New York: Manchester University Press, 2001.

Petrie, Duncan. *The British Cinematographer*. London: BFI, 1996.

—. 'Neo-Expressionism and British Cinematography: The Work of Robert Krasker and Jack Cardiff', in John Orr and Olga Taxidou, eds, *Post-War Cinema and Modernity*, 223–33. Edinburgh: Edinburgh University Press, 2000.

Pevsner, Nikolaus. *Pioneers of Modern Design: From William Morris to Walter Gropius* (1936), 2nd edn. New York: Museum of Modern Art, 1949.

—. *High Victorian Design*. London: Architectural Press, 1951.

—. *The Englishness of English Art*. London: Architectural Press, 1956.

—. *Visual Planning and the Picturesque*, ed. Mathew Aitchison. Los Angeles: Getty Research Institute, 2010.

Philips, Deborah and Ian Haywood. *Brave New Causes: Women in British Postwar Fictions*. London: Leicester University Press, 1998.

Phillips, Caryl. 'Following On: The Legacy of Lamming and Selvon', *Wasafiri* 14:29 (1999): 34–6.

Phillips, Mike and Trevor Phillips. *Windrush: The Irresistible Rise of Multi-Racial Britain*. London: Harper Collins, 1998.

Philp, A. F. *The Problem of 'The Problem Family': A Critical Review of the Literature Concerning the 'Problem Family' and its Treatment*. London: Family Service Units, 1957.

Pincus, Lily, *et al. Social Casework in Marital Problems: The Development of a Psychodynamic Approach; A Study by a Group of Caseworkers*. London: Tavistock, 1955.

Piper, John. 'Pleasing Decay', *Architectural Review* (September 1947): 85–94.

—. *Buildings and Prospects*. London: Architectural Press, 1948.

Pleasure Gardens Guide. London: Festival Gardens Ltd, 1951.

Pohlad, Mark B. 'The Appreciation of War Ruins in Blitz-Era London', *London Journal* 30:2 (2005): 2–24.

Rawsthorn, Alice. 'Richard Hamilton and Design', in Mark Godfrey, Paul Schimmel and Vincente Todoli, eds, *Richard Hamilton*, 125–34. London: Tate Publishing, 2014.

Richards, Jeffrey. *Films and British National Identity: From Dickens to Dad's Army*. Manchester and New York: Manchester University Press, 1997.

Richards, J. M., ed. *The Bombed Buildings of Britain: A Record of Architectural Casualties 1940–1*, with notes by John Summerson. Cheam: Architectural Press, 1942.

—. *The Bombed Buildings of Britain: Recording the Architectural Casualties Suffered during the Whole Period of Aerial Bombardment*, 2nd edn. London: Architectural Press, 1947.

Richmond, Anthony H. *Colour Prejudice in Britain: A Study of West Indian Workers in Liverpool 1941–1951*. London: Routledge & Kegan Paul, 1954.

—. *The Colour Problem: A Study of Racial Relations* (1955), rev. edn. Harmondsworth: Penguin, 1961.

Riley, Denise. *War in the Nursery: Theories of the Child and Mother*. London: Virago, 1983.

Robbins, David, ed. *The Independent Group: Postwar Britain and the Aesthetics of Plenty*. Cambridge, Mass., and London: MIT Press, 1991.

Roberts, Marion. 'Designing the Home: Domestic Architecture and Domestic Life', in Graham Allan and Graham Crow, eds, *Home and Family: Creating the Domestic Sphere*, 33–47. Basingstoke: Macmillan, 1989.

Romano, Renee. 'The Pain of Passing', *Reviews in American History* 44:2 (2016): 264–9.

Rose, Jacqueline. *Why War? Psychoanalysis, Politics and the Return to Melanie Klein*. Oxford: Blackwell, 1993.

Rose, Richard. 'Periodisation in Post-War Britain', *Contemporary Record* 6:2 (Autumn 1992): 326–40.

Rowntree, B. Seebohm and G. R. Lavers, *English Life and Leisure: A Social Study*. London, New York and Toronto: Longmans, Green & Co., 1952.

Rushdie, Salman. *The Wizard of Oz*, 2nd edn. London: Palgrave Macmillan on behalf of the British Film Institute, 2012.

Russell, Rollo. *Smoke in Relation to Fogs in London: A Lecture Delivered under the Auspices of the National Smoke Abatement Institution*. London: National Smoke Abatement Institution, 1888.

Ryan, Deborah S. *'Daily Mail' Ideal Home Exhibition: The Ideal Home through the Twentieth Century*. London: Hazar, 1997.

Ryan, Robert T. *A History of Motion Picture Color Technology*. London: Focal Press, 1977.

Sadler, Simon. *The Situationist City*. Cambridge, Mass.: MIT Press, 1988.

Saint, Andrew, ed. *Survey of London, Volume 49: Battersea. Part 1: Public, Commercial and Cultural*. New Haven and London: published for English Heritage by Yale University Press on behalf of Paul Mellon Centre for Studies in British Art, 2013.

Salter, Gregory. 'Cold War at Home: John Bratby, the Self and the Nuclear Threat', in Catherine Jolivette, ed., *British Art in the Nuclear Age*, 151–69. Farnham: Ashgate, 2014.

Samuel, Raphael. *Theatres of Memory, Volume 1: Past and Present in Contemporary Culture*. London and New York: Verso, 1994.

Sandbrook, Dominic. *Never Had It So Good: A History of Britain from Suez to the Beatles*. London: Little, Brown, 2005.

Sargeant, Amy. *British Cinema: A Critical History*. London: BFI, 2005.

Saunders, Gill, ed. *Recording Britain*. London: V&A, 2011.

Scharff, Jill Savage. 'The British Object Relations Theorists: Fairbairn, Winnicott, Balint, Guntrip, Sutherland and Bowlby', in Martin S. Bergmann, ed., *Understanding Dissidence and Controversy in the History of Psychoanalysis*, 175–200. New York: Other Press, 2004.

Schlesinger, Max. *Saunterings In and About London*. London: Nathaniel Cooke, 1853.

Schwarz, Bill. 'Black Metropolis, White England', in Mica Nava and Alan O'Shea, eds, *Modern Times: Reflections on a Century of English Modernity*, 176–207. London and New York: Routledge, 1996.

—. '"The Only White Man In There": The Re-Racialisation of England, 1956–68', *Race & Class* 38 (July–September 1996): 65–78.

—. 'Reveries of Race: The Closing of the Imperial Moment', in Becky Conekin, Frank Mort and Chris Waters, eds, *Moments of Modernity: Reconstructing Britain 1945–1964*, 189–207. London and New York: Rivers Oram Press, 1999.

—. '"Claudia Jones and the *West Indian Gazette*": Reflections on the Emergence of Post-Colonial Britain', *Twentieth Century British History* 14:3 (2003): 264–85.

Sebald, W. G. 'Air War and Literature: Zürich Lectures', in *On the Natural History of Destruction*, trans. Anthea Bell, 3–105. London: Hamish Hamilton, 2003.

Segal, Hanna. *Introduction to the Work of Melanie Klein*. London: Hogarth Press, 1973.

Segal, Lynne. 'Look Back in Anger: Men in the 50s', in Rowena Chapman and Jonathan Rutherford, eds, *Male Order: Unwrapping Masculinity*, 68–96. London: Lawrence and Wishart, 1988.

Selvon, Sam. *The Lonely Londoners* (1956). Harmondsworth: Penguin, 2006.

Sendall, Bernard. *Independent Television in Britain*, 2 vols. London and Basingstoke: Macmillan, 1982.

Setting Up Home for Bill and Betty. London: Whitechapel Art Gallery, in association with Oxford House, 5 June – 24 July 1952.

Sheppard, J. J. *The Romance of a London Fog*. London: Simpkin Marshall and Co., 1898.

Sillitoe, Alan. *Saturday Night and Sunday Morning* (1958). London: Harper Perennial, 2008.

Silver, Alain. 'The Untranquil Light: David Lean's *Great Expectations*', *Literature/Film Quarterly* 2:2 (Spring 1974): 140–52.

Simmel, Georg. 'The Ruin', in Kurt H. Wolff, ed., *Essays on Sociology, Philosophy, and Aesthetics*, 259–66. New York: Harper and Row, 1965.

Sinfield, Alan. *Literature, Politics and Culture in Postwar Britain*. Berkeley and Los Angeles: University of California Press, 1989.

Slater, Eliot and Moya Woodside. *Patterns of Marriage: A Study of Marriage Relationships in the Urban Working Classes*. London: Cassell, 1951.

Smart, Carol. 'Law and the Control of Women's Sexuality: The Case of the 1950s', in Bridget

Hunter and Gillian Williams, eds, *Controlling Women: The Normal and the Deviant*, 40–60. London: Croom Helm, 1981.

Spalding, Frances. *Dance Till the Stars Come Down: A Biography of John Minton*. London: Hodder and Stoughton, 1991.

Sparke, Penny, ed. *Did Britain Make It? British Design in Context 1946–86*. London: Design Council, 1986.

Spicer, Andrew. *Film Noir*. Harlow: Pearson, 2002.

Spiteri, Raymond. 'Surrealism and the Irrational Embellishment of Paris', in Thomas Mical, ed., *Surrealism and Architecture*, 191–208. London and New York: Routledge, 2005.

Stamp, Gavin. 'The Art of Keeping One Jump Ahead: Conservation Societies in the Twentieth Century', in Michael Hunter, ed., *Preserving the Past: The Rise of Heritage in Modern Britain*, 77–98. Stroud: Alan Sutton, 1996.

Stanley, Liz. *Sex Surveyed, 1949–1994: From Mass Observation's 'Little Kinsey' to the National Survey and the Hite Reports*. London: Taylor & Francis, 1995.

Steedman, Carolyn. *Landscape for a Good Woman: A Story of Two Lives*. London: Virago, 1986.

Stern, Arthur C., ed. *Air Pollution: Volume 1, Air Pollution and its Effects*. London and New York: Academic Press, 1968.

Stewart, Kathleen. 'Atmospheric Attunements', *Environment and Planning D: Society and Space*, special issue 29:3 (June 2011): 445–53.

Steyn, Juliet. 'Realism versus Realism in British Art of the 1950s', *Third Text* 22:2 (March 2008): 145–56.

Stoichita, Victor I. *A Short History of the Shadow*. London: Reaktion Books, 1997.

Stokes, Adrian. *Inside Out: An Essay in the Psychology and Aesthetic Appeal of Space*. London: Faber and Faber, 1947.

—. *Colour and Form*. London: Faber and Faber, 1951.

—. *Smooth and Rough*. London: Faber and Faber, 1951.

Stonebridge, Lyndsey. *The Writing of Anxiety: Imagining Wartime in Mid-Century British Culture*. Basingstoke and New York: Palgrave Macmillan, 2007.

— and John Phillips, eds. *Reading Melanie Klein*. London and New York: Routledge, 1998.

Stone-Richards, M. 'Latencies and Imago: Blanchot and the Shadow City of Surrealism', in Thomas Mical, ed., *Surrealism and Architecture*, 249–72. London and New York: Routledge, 2005.

Stonier, G. W. *Round London with the Unicorn*. London: Turnstile Press, 1951.

Street, Sarah. 'Cinema, Colour and the Festival of Britain, 1951', *Visual Culture in Britain* 13:1 (2012): 83–99.

—. *Colour Films in Britain: The Negotiation of Innovation*. Basingstoke: Palgrave Macmillan, 2012.

Stromgren, Richard L. and Martin F. Norden. *Movies: A Language in Light*. Englewood Cliffs, N.J.: Prentice-Hall, 1984.

Surowiec, Catherine A. 'Anthony Mendleson: Ealing's Wardrobe Wizard', in Mark Duguid, Lee Freeman, Keith M. Johnston and Melanie Williams, eds, *Ealing Revisited*, 111–24. London: BFI/Palgrave Macmillan, 2012.

Talbot, William Henry Fox. *Sun Pictures in Scotland*. London: n.p., 1845.

Tallents, Stephen. *The Projection of England* (1932). London: Olen Press for Film Centre Ltd, 1955.

Tanizaki, Junichirō. *In Praise of Shadows*, trans. Thomas J. Harper and Edward G. Seidensticker. London: Vintage, 2001.

Tarr, Carrie. '*Sapphire*, *Darling* and the Boundaries of Permitted Pleasure', *Screen* 26:1 (1985): 50–65.

[Taylor, Basil]. *The Festival of Britain: The Official Book of the Festival of Britain*. London: HMSO, 1951.

Thane, Pat. 'Population Politics in Post-War British Culture', in Becky Conekin, Frank Mort and Chris Waters, eds, *Moments of Modernity: Reconstructing Britain 1945–1964*, 114–33. London and New York: Rivers Oram Press, 1999.

—. 'Family Life and "Normality" in Postwar Britain', in Richard Bessel and Dirk Schumann, eds, *Life After Death: Approaches to a Cultural and Social History of Europe during the 1940s and 1950s*, 193–210. Cambridge: Cambridge University Press, 2003.

Thom, Colin, ed. *Survey of London, Volume 50: Battersea. Part 2: Houses and Housing*. New Haven and London: published for English Heritage by Yale University Press on behalf of Paul Mellon Centre for Studies in British Art, 2013.

Thorsheim, Peter. *Inventing Pollution: Coal, Smoke, and Culture in Britain since 1800*. Athens: Ohio University Press, 2006.

Thrift, Nigel. *Non-Representational Theory: Space, Politics, Affect*. London and New York: Routledge, 2008.

Tiratsoo, Nick. 'The Reconstruction of Blitzed British Cities 1945–55: Myths and Reality', *Contemporary British History*, special issue: 'Planning, Politics and Housing in Britain' 14:1 (Spring 2000): 27–44.

Titmuss, Richard M. *Essays on 'The Welfare State'*. London: George Allen & Unwin, 1958.

Trachtenberg, Alan. 'Albums of War: On Reading Civil War Photographs', *Representations* 9 (Winter 1985): 1–32.

—. 'Picturing History in the Morgue', in Douglas Dreishpoon and Alan Trachtenberg, eds, *The Tumultuous Fifties: A View from the 'New York Times' Photo Archives*, 20–31. New Haven and London: Yale University Press, 2001.

Trigg, Dylan. *The Aesthetics of Decay: Nothingness, Nostalgia and the Absence of Reason*. New York: Peter Lang, 2006.

—. *The Memory of Place: A Phenomenology of the Uncanny*. Athens: Ohio University Press, 2012.

Tulloch, Carol. 'Strawberries and Cream: Dress, Migration and the Quintessence of Englishness', in Christopher Breward, Becky Conekin and Caroline Cox, eds, *The Englishness of English Dress*, 61–76. Oxford and New York: Berg, 2002.

—. 'There's No Place Like Home: Home Dressmaking and Creativity in the Jamaican Community of the 1940s to the 1960s', in Glenn Adamson, ed., *The Craft Reader*, 501–11. Oxford and New York: Berg, 2010.

—. *The Birth of Cool: Style Narratives of the African Diaspora*. London: Bloomsbury, 2015.

Turner, Barry. *Beacon for Change: How the 1951 Festival of Britain Helped to Shape a New Age*. London: Aurum, 2011.

Van Den Heuvel, Dirk and Max Risselada, eds. *Alison and Peter Smithson: From the House of the Future to a House for Today*. Rotterdam: 010 Publishers, 2004.

Vidler, Anthony. *The Architectural Uncanny: Essays in the Modern Unhomely*. Cambridge, Mass., and London: MIT Press, 1992.

Wainwright, Leon. 'Francis Newton Souza and Aubrey Williams: Entwined Art Histories at the End of Empire', in Simon Faulkner and and Anandi Ramamurthy, eds, *Visual Culture and Decolonisation in Britain*, 101–26. Aldershot: Ashgate, 2006.

Walker, Lynne. '"The Greatest Century": Pevsner, Victorian Architecture and the Lay Public', in Peter Draper, ed., *Reassessing Nikolaus Pevsner*, 129–47. Aldershot: Ashgate, 2004.

Walsh, Victoria. 'Seahorses, Grids and Calypso: Richard Hamilton's Exhibition-Making in the 1950s', in Mark Godfrey, Paul Schimmel and Vincente Todoli, eds, *Richard Hamilton*, 61–97. London: Tate Publishing, 2014.

Wandor, Michelene. *Look Back in Gender: Sexuality and the Family in Post-War British Drama*. London and New York: Methuen, 1987.

Waters, Chris. '"Dark Strangers" in Our Midst: Discourses of Race and Nation in Britain, 1947–1963', *Journal of British Studies* 36:2 (April 1997): 207–38.

Webster, Wendy. '"There'll Always Be An England": Representations of Colonial Wars and Immigration 1948–1968', *Journal of British Studies*,

special issue 'At Home in the Empire' 40:4 (October 2001): 557–84.

—. *Englishness and Empire 1939–1965*. Oxford: Oxford University Press, 2005.

Whitaker, Sheila. '*It Always Rains on Sunday*: Part (II)', *Framework* 9 (Winter 1978): 21–6.

White, Cynthia L. *Women's Magazines 1693–1968*. London: Michael Joseph, 1970.

Whittaker, Nicholas. *Sweet Talk*. London: Orion, 1998.

Whitworth, Lesley. 'Anticipating Affluence: Skill, Judgement and the Problems of Aesthetic Tutelage', in Lawrence Black and Hugh Pemberton, eds, *An Affluent Society? Britain's Post-War 'Golden Age' Revisited*, 167–83. Aldershot: Ashgate, 2004.

Wickenden, James. *Colour in Britain*. London, New York and Toronto: Oxford University Press, 1958.

Wilcox, H. D. *Mass Observation Report on Juvenile Delinquency*. London: Falcon Press, 1949.

Williams, Melanie. 'Women in Prison and Women in Dressing Gowns: Rediscovering the 1950s Films of J. Lee Thompson', *Journal of Gender Studies* 11:1 (2002): 5–15.

—. 'Housewife's Choice: *Woman in a Dressing Gown*', in Ian MacKillop and Neil Sinyard, eds, *British Cinema of the 1950s: A Celebration*, 143–54. Manchester and New York: Manchester University Press, 2003.

—. 'Remembering "the poor soul walking in the rain": Audience Responses to a Thwarted Makeover in *Woman in a Dressing Gown*', *Journal of British Cinema and Television* 10:4 (2013): 709–26.

Williams, Raymond. *Culture and Society 1780–1950*. London: Chatto and Windus, 1958.

—. *The Long Revolution*. London: Chatto and Windus, 1961.

—. *Marxism and Literature*. Oxford: Oxford University Press, 1977.

—. *Politics and Letters: Interviews with 'New Left Review'*. London: New Left Books, 1979.

Willis, Ted. 'Look Back in Wonder', *Encore: The Voice of Vital Theatre* 4:4 (March–April 1958): 13–16.

—. *Woman in a Dressing Gown and Other Television Plays*. London: Barrie and Rockliff, 1959.

—. *Evening All: Fifty Years Over a Hot Typewriter*. London: Macmillan, 1991.

Wilson, David ed., *Projecting Britain: Ealing Studios Film Posters*. London: BFI, 1982.

Wilson, Elizabeth. *Women and the Welfare State*. London: Tavistock, 1977.

—. *Only Halfway to Paradise: Women in Postwar Britain 1945–1968*. London and New York: Tavistock, 1980.

Winnicott, Donald. *The Ordinary Devoted Mother and her Baby: Nine Broadcast Talks (Autumn 1949)*. London: 'Pamphlet', 1950.

—. 'Transitional Objects and Transitional Phenomena: A Study of the First Not-Me Possession', *International Journal of Psycho-Analysis* 34 (1953): 89–97.

—. *The Child and the Family: First Relationships*. London: Tavistock, 1957.

—. 'Anxiety Associated with Insecurity' (1952), in *Collected Papers: Through Paediatrics to Psycho-Analysis*, 97–100. London: Tavistock, 1958.

Wolfe, Tom. *Radical Chic and Mau-Mauing the Flak Catchers* (1970). London: Michael Joseph, 1971.

Wolff, Janet. 'Angry Young Men and Minor Female Characters', in *Resident Alien: Feminist Cultural Criticism*, 135–52. Cambridge: Polity Press, 1995.

Woodward, Christopher. *In Ruins*. London: Chatto and Windus, 2001.

Wray, J. Jackson. *Will It Lift? The Story of a London Fog*. London: James Nisbet and Co., 1888.

Wright, Barnaby. 'Creative Destruction: Frank Auerbach and the Rebuilding of London', in Barnaby Wright, ed., *Frank Auerbach: London Building Sites 1952-62*, 13–35. London: Courtauld Gallery, in association with Paul Holberton Publishing, 2009.

Young, Lola. *Fear of the Dark: 'Race', Gender and Sexuality in the Cinema*. London and New York: Routledge, 1996.

Young, Robert. *Colonial Desire: Hybridity in Theory, Culture and Race*. London: Routledge, 1995.

Zambrano, A. L. '*Great Expectations*: Dickens and David Lean', *Literature/Film Quarterly* 2:2 (Spring 1974): 153–61.

Exhibitions

'Artist and Empire'. Tate Britain, London, 21 November 2015 – 10 April 2016.

'Bailey's Stardust'. National Portrait Gallery, London, 6 February – 1 June 2014.

'Black Eyes & Lemonade: Curating Popular Art'. Whitechapel Gallery, London, 9 March – 1 September 2013.

'Fashion on the Ration: 1940s Street Style'. Imperial War Museum, London, 5 March – 31 August 2015.

'For Bill and Betty; Or Setting Up Home'. Whitechapel Art Gallery, London, in association with Oxford House, 5 June – 24 July 1952.

'Frank Auerbach'. Tate Britain, London, 9 October 2015 – 13 March 2016.

'Frank Auerbach: London Building Sites 1952–62'. Courtauld Gallery, London, 16 October 2009 – 17 January 2010.

'Lowry and the Painting of Modern Life'. London, Tate Britain, 26 June – 20 October 2013.

'No Colour Bar: Black British Art in Action 1960–1990'. Guildhall Art Gallery, London, 10 July 2015 – 24 January 2016.

'Ordinary Beauty: The Photography of Edwin Smith'. Royal Institute of British Architects, London, 10 September – 6 December 2014.

'Ruin Lust'. Tate Britain, London, 4 March – 18 May 2014.

'Southbank Celebrates the Festival of Britain'. Southbank, London, 4 May – 4 September 2011.

'Spaces of Black Modernism: London 1919–39'. Tate Britain, London, 13 October 2014 – 4 October 2015.

Filmography

The 1951 Festival of Britain: A Brave New World (UK, 2011; dir. Julian Hendy).

23 Paces to Baker Street (USA, 1956; dir. Henry Hathaway).

Black Narcissus (UK, 1947; dir. Michael Powell, Emeric Pressburger).

The Blue Lamp (UK, 1950; dir. Basil Dearden).

Brief City (UK, 1952; dir. Jacques Brunius, Maurice Harvey).

Brief Encounter (UK, 1945; dir. David Lean).

Brighton Rock (UK, 1947; dir. John Boulting).

The Cage of Gold (UK, 1950; dir. Basil Dearden).

Cosh Boy (UK, 1953; dir. Lewis Gilbert).

Dance Hall (UK, 1950; dir. Charles Crichton).

The Dead of Night (UK, 1945; dir. Alberto Cavalcanti, Charles Crichton, Basil Dearden, Robert Hamer).

A Diary for Timothy (UK, 1945; dir. Humphrey Jennings).

Family Portrait (UK, 1950; dir. Humphrey Jennings).

Festival in London (UK, 1951; dir. Philip Leacock).

Flame in the Streets (UK, 1959; dir. Roy Ward Baker).

Flames of Passion: The Other Side of British Cinema (UK, 2007, *Arena*; dir. Mick Conefrey).

The Fog (USA, 1980; dir. John Carpenter).

Footsteps in the Fog (UK, 1955; dir. Arthur Lubin).

For Better For Worse (UK, 1954; dir. J. Lee Thompson).

Gaslight (UK, 1940; dir. Thorold Dickinson).

Great Expectations (UK, 1946; dir. David Lean).

Guilty Chimneys (UK, c.1954; dir. Gerard Bryant).

The Happy Family (UK, 1952; dir. Muriel Box).

Hue and Cry (UK, 1947; dir. Charles Crichton).

In Which We Serve (UK, 1942; dir. David Lean).

It Always Rains on Sunday (UK, 1947; dir. Robert Hamer).

Lady in the Fog (UK, 1952; dir. Sam Newfield).

The Ladykillers (UK, 1955; dir. Alexander Mackendrick).

The L-Shaped Room (UK, 1962; dir. Bryan Forbes).

The Magic Box (UK, 1951; dir. John Boulting).

A Matter of Life and Death (UK, 1946; dir. Michael Powell, Emeric Pressburger).

Millions Like Us (UK, 1943; dir. Sidney Gilliat).

Miss Grant Goes to the Door (UK, 1940; dir. Brian Desmond Hurst).

Ninotchka (USA, 1939; dir. Ernst Lubitsch).

Obsession (UK, 1949; dir. Edward Dmytryk).

Oliver Twist (UK, 1948; dir. David Lean).

Passport to Pimlico (UK, 1948; dir. Henry Cornelius).

Pink String and Sealing Wax (UK, 1945; dir. Robert Hamer).

The Red Shoes (UK, 1948; dir. Michael Powell, Emeric Pressburger).

Safari (UK, 1956; dir. Terence Young).

Sapphire (UK, 1959; dir. Basil Dearden).

Saturday Night and Sunday Morning (UK, 1960; dir. Karel Reisz).

Scrooge (UK, 1951; dir. Brian Desmond Hurst).

Silk Stockings (USA, 1957; dir. Rouben Mamoulian).

Simba: Mark of the Mau Mau (UK, 1955; dir. Brian Desmond Hurst).

The Third Man (UK, 1949; dir. Carol Reed).

This Happy Breed (UK, 1944; dir. David Lean).

Tiger in the Smoke (UK, 1956; dir. Roy Ward Baker).

Went the Day Well? (UK, 1942; dir. Alberto Cavalcanti).

The Wizard of Oz (USA, 1939; dir. Victor Fleming).

Woman in a Dressing Gown (UK, 1957; dir. J. Lee Thompson).

The Yellow Balloon (UK, 1953; dir. J. Lee Thompson).

Illustration Credits

Index